THE NEW MUSEUM REGISTRATION METHODS

THE NEW
MUSEUM REGISTRATION METHODS

Edited by Rebecca A. Buck and Jean Allman Gilmore

© 1998 American Association of Museums
1575 Eye St. N.W., Suite 400
Washington, DC 20005

Cover: Snuff bottles in compact storage at the American Museum of Natural History, New York. Part of the Drummond Collection, Department of Anthropology. Courtesy Department of Library Services, American Museum of Natural History. Photo by D. Finnin.

The New Museum Registration Methods

Copyright © 1998, American Association of Museums, 1575 Eye St. N.W., Suite 400, Washington, DC 20005. All rights reserved. This book may not be reproduced in whole or in part, in any form, except brief passages by reviewers, without written permission from the publisher.

The opinions in this book expressed by individual authors are their own, and are not to be taken as representing the views of any institution or organization, including the American Association of Museums.

Library of Congress Cataloging-in-Publication Data

The new museum registration methods / edited by Rebecca A. Buck and
 Jean Allman Gilmore.
 p. cm.
 Includes bibliographical references and index.
 ISBN 0-931201-31-4 (paper)
 1. Museum registration methods. I. Buck, Rebecca A., 1946- .
II. Gilmore, Jean Allman, 1946- . III. American Association of
Museums.
 AM139.N4 1998
 069' .52—dc21
 98-16006
 CIP

TO DOROTHY H. DUDLEY AND IRMA BEZOLD WILKINSON

Those of us who follow walk a straighter path because of them

TABLE of CONTENTS

INTRODUCTION and ACKNOWLEDGMENTS

Rebecca A. Buck and Jean Allman Gilmore

*T*he *New Museum Registration Methods* has been five years in the making. The initial project, to revise *Museum Registration Methods*, 3rd ed., quickly evolved into an entirely new book with a new format and expanded contents. There were times when we were certain that the process, which included eight section editors, over 70 authors, and an advisory panel of four, had broken down and was beyond repair. There were also exciting events that spurred us on: the arrival of the first full package of manuscripts; an interview on Aug. 30, 1994, with Irma B. Wilkinson; the discovery of correspondence and parts of the manuscript for the original *Museum Registration Methods* in the files of The Newark Museum, Dorothy Dudley's first museum.

Irma Wilkinson did not like nonsense; she told us that everyone in the profession should first understand the importance of the object and that their professionalism would flow from that understanding. She said, "I think one thing is basic in the beginning: making people feel the importance of a piece of art. That you just can never forget about it… you have got to know every minute where it is and how to account for it and so on." She went on to tell us that she and Dorothy Dudley got involved in writing the first *Museum Registration Methods* because so many people requested help, so many letters were written, and it seemed that the book might begin to give people the answers.

We hope that *The New Museum Registration Methods* continues to answer questions and give the leads needed to continue the registration profession on its upward path. To a large degree it represents the collective wisdom of current "toilers in the field." The authors volunteered their time, work, and knowledge; they are art, history, and science museum registrars, preparators, conservators, archivists, architects, scientists, lawyers, and museum administrators. The purpose of their work is to help us all improve the care, safety, and documentation of the collections with which we work.

The contributors tried to include advice and procedures for all types of collections, in terms applicable to museums of various disciplines and sizes. These efforts were more successful in some instances than others. The resulting essays, if not directly pertinent to a given situation, are at least suggestive of the goals, standards, policies, procedures, sources, and areas of interest and concern to everyone professionally involved with collections today.

The Brandywine River Museum and Conservancy, where Jean Allman Gilmore serves as registrar, The Newark Museum, where Rebecca Buck is registrar, and Ms. Buck's former museum, the University of Pennsylvania Museum of Archaeology and Anthropology, have been remarkably supportive and patient during the long process of planning, writing, and editing. We wish to thank the directors of those museums: James H. Duff of the Brandywine River Museum and Conservancy, Mary Sue Sweeney Price of The Newark Museum, and Robert Dyson and Jeremy Sabloff of the University of Pennsylvania Museum, for their support. Ward L. E. Mintz, deputy director for programs and collections at The Newark Museum, was enthusiastic and helpful throughout the process; his concern for collections care is inspirational.

Our advisory committee gave specific advice from the legal and conservation professions, help we could not do without. Marie Malaro, former director of museum studies at George Washington University, Washington, D.C., spent many hours reading and advising us; her writings, too, are referenced throughout by many of the authors. Without Ms. Malaro's thoughtful advice, we would not have been able to present legal issues with confidence. Terry Drayman-Weiser, director of

conservation and technical research at the Walters Art Gallery, Baltimore, Md., offered great insight into conservation issues. Daniel Reible, curator of the Old Barracks Museum in Trenton, N.J., and Brigid Pudney-Schmidt, registrar at Kunstsammlung in Düsseldorf, Germany, read and provided us with helpful comments from the perspectives of the history museum and the international reader.

Margaret Holben Ellis, chairman and professor of conservation, The Conservation Center, Institute of Fine Arts, New York University, read various chapters expressing conservation concerns and solutions, and provided good advice with good humor. Ildiko DeAngelis stepped in to provide counsel, and Ann Craddock Albano also read and advised. Thanks, too, to Mary Case of QM2 and Cordelia Rose, registrar at the Cooper-Hewitt Museum, who lent understanding from their experience with similar projects and who always asked for excellence.

Sylvia Smith Duggan, Virginia Greene, Margaret Molnar, Vivian C. R. James, and Lisa Mazik, who worked with us in various museums, helped us through this long project. Our husbands James W. Reuter and G. L. Gilmore are, we believe, most happy that work on "the book" has come to an end.

Special thanks to Jane Lusaka, Susan v. Levine, and the other AAM staff members who worked to make this book possible.

Martha Fulton, who began this project as chair of the Registrars Committee of the American Association of Museums (RC-AAM) from 1992-1994, and who asked us to undertake the revision, adds, "My heartfelt thanks to everyone who carried on with this monumental effort. They have left a legacy to the museum profession which you now hold in your hand."

FOREWORD

Janice B. Klein

For 40 years and three editions, *Museum Registration Methods* served the museum community as the authoritative text on the registration and management of collections.

The first edition, published in 1958 by the American Association of Museums, was envisioned as a practical guide for registrars. Its editors, Dorothy H. Dudley and Irma Bezold Wilkinson, created a two-part manual, focusing first on what they called "basic procedures … adaptable to the special needs of each museum," with a second section of "Special Information," comprised of individually authored articles to be used for "occasional reference."

A second edition followed 10 years later, and in 1979 *Museum Registration Methods* was republished with a revised and expanded group of articles in the second section, which was retitled, "Specific Applications." Information about historic houses, natural history collections, and small museums were all added, acknowledging the expanded range of registrarial interests and responsibilities.

Almost 20 years have now passed since the publication of the third edition of *Museum Registration Methods*. In that time, the registration profession has undergone substantial changes, not least of which was the foundation of the Registrars Committee, one of the 12 Standing Professional Committees recognized by the American Association of Museums. The RC-AAM, whose mission is the development of professional standards and training for museum registrars and collections managers, was asked by the association to provide an updated version of *Museum Registration Methods*.

Instead of again revising and expanding the original book, a decision was made to create an entirely new structure. *The New Museum Registration Methods* reflects the increased complexity of museums and of the registrar's role, not only in the integration of computerization and conservation concerns into the text, but with the addition of articles about risk management, administration, and legal and ethical issues.

In 1958, the editors wrote "cooperative labor and support produced this manual." As it was true then, it is true now. To the great debt owed Dorothy H. Dudley and Irma Bezold Wilkinson, it is necessary to add special thanks to several other colleagues:

To Martha Fulton, past chair of the RC-AAM, for the courage to accept the challenge of not just updating, but totally rewriting the book,

To the late Margaret A. Willard, who started her registration career working for Dorothy Dudley at the Museum of Modern Art in 1965, for continuing Martha's vision,

To the editors of *The New Museum Registration Methods*, Rebecca Buck and Jean Allman Gilmore, who have embraced their assigned task with determination, good humor, and almost infinite patience,

To the authors of each article in both the original and new books, and to their collaborators, for sharing their unique knowledge and experience.

And to Patricia Williams, vice president for policy and programs of the American Association of Museums, as well as other association staff, for their continued encouragement and support.

It is hoped that *The New Museum Registration Methods* will provide the practical information needed by today's registrars and collections managers, as well as serve as a text for museum studies students. In time, this book will also need revision. Until then it will stand, as the original *Museum Registration Methods* continues to stand, as a monument to those who have gone before and as an inspiration for those who follow.

Janice B. Klein
Chair, Registrars Committee of the
American Association of Museums
April 1997

COLLECTION ROLES

Rebecca A. Buck

The New Museum Registration Methods was written for museum collections personnel. Throughout this book we refer to the registrar as the staff member who undertakes the task at hand. That person may, in reality, be a registrar (chief, head, associate, assistant, assistant to), collections manager, curator (associate, assistant), director (executive, deputy, assistant), project director, keeper, conservator, collections technician, computer specialist, exhibition technician, mountmaker, archivist, consultant, board member, or volunteer. There are, within some organizations, even greater proliferations of titles.

Title and job functions vary from museum to museum and are determined by size, discipline, and history of the institution. In order to understand a position and be effective in it, a prospective staff member should become fully aware of the organizational structure, history, and culture of the specific museum. Titles may be similar, but working within the framework of a large science museum is far different from working in a small history museum.

Small museums may have only one paid staff member. That person is charged with everything from development to housekeeping and may call on volunteers to perform registration and collections management tasks. Small to mid-size museums often rely on a curator, sometimes called a curator of collections, for the performance of collection work. As the museum grows, an employee with the title of registrar may be hired to take over many of the collections functions. Some museums include a collections manager who focuses on the physical aspects of handling and storage, while the registrar concentrates on records, logistics, and legal matters.

Registrars in art museums, where the department is central to collections management and documentation, are often charged with a full scope of collections tasks. The registrar, among other duties, develops storage; oversees computer projects; works through accessions, loans, and exhibitions; and drafts collections policy and procedure.

In very large art museums, collection departments (European art, prints and drawings) that are defined by institutional collecting focus and history care for and document specific parts of the overall collection. In these cases, the registrar serves a more specialized and centralized function; the registrar's office generally deals with accessions, deaccessions, loans, exhibitions, and many administrative tasks related to collections. Large history museums may be similarly organized.

Science museums rely on collecting departments, often staffed with collections managers in addition to curators, to care for collections. The registrar's function in the science museum may also be centralized and is often removed from collection activities, except for accessioning, deaccessioning, and loans. If departments are responsible for inventory and care, the registrar may be the auditor who assures accountability.

The following description of a registrar's job encompasses a wide range of work related to collections. It is culled from job descriptions requested for the Registrars Committee of the American Association of Museums' journal *REGISTRAR* in 1993, from the job descriptions on file with the RC-AAM, and from a model developed for a management seminar. Depending on the type and size of museum, the registrar's office may do many, most, or all of the tasks that are listed, alone or in concert with other departments in the museum.

A COMPOSITE JOB DESCRIPTION for the REGISTRAR

Rebecca A. Buck

Profile

Academic background

> B.A., M.A., or Ph.D. in museum's specialty field and/or museum studies; information sciences and business/legal studies a plus

Reports to

> Director or head of collections division

Supervises

> Assistants for loans, collections, and information management; preparators, packers, handlers, and photographers; interns, work-study students, and volunteers

Areas of Responsibility

Information management: manual and computerized

> Creates/compiles and maintains legal documents, histories of use, and physical histories of permanent collections objects and/or specimens
>
> > Legal forms and acknowledgments
> >
> > Permanent collections catalog and files
> >
> > Loan, conservation, condition, publication records
> >
> > Exhibition, insurance, and location records
>
> Develops and implements inventory projects
>
> Coordinates/assists with computer projects
>
> > Systems specifications and software choices
> >
> > Data standards committees
> >
> > Data input management
>
> Disseminates information as needed to other departments, researchers, and students
>
> Coordinates object identification services

Collections management

> Monitors legal and ethical implications and care standards of transactions
>
> Facilitates care and control of collections on site
>
> Initiates, develops, and, upon adoption, implements collection policies
>
> Oversees object movement, internal and external
>
> Oversees packing and shipping
>
> Acts as courier or designates courier
>
> Implements security procedures/works closely with security forces
>
> Designs and controls storage areas
>
> > Works with contractors
> >
> > Develops storage methods
> >
> > Oversees integrated pest management programs
>
> Contracts for outside services as needed
>
> > Conservation, rigging, packing, crating, shipping, photography, insurance

Exhibitions
 Borrowed exhibitions
 Negotiates loan contracts
 Schedules and supervises packing, shipping, condition reporting, and object movement
 Prepares grant reports as necessary
 In-house exhibitions
 Provides information to other departments as needed
 Coordinates object movement and record keeping
 Prepares or helps in preparation of label copy
 Traveling exhibitions
 Develops/reviews contracts
 Prepares documentation, packing, shipping
 Provides courier service
Other services and responsibilities
 Maintains archives
 Manages photographic services
 Supervises collections photography
 Stores photographic collections
 Maintains rights and reproductions services

Administrative Responsibilities

Administers department
 Hires, trains, and evaluates staff
 Develops and runs internship program
 Prepares and implements budgets, in whole or in part
 Departmental
 Exhibitions
 Storage and other special projects
 Contracts for services
 Purchases office and collections management equipment and supplies
 Prepares rate structures
 Loans, traveling exhibitions
 Photographic services

THE ROLE of the REGISTRAR in the MUSEUM'S WEB

Charles Hummel

"Where in the museum's organizational structure is the registrar best able to carry out his or her responsibilities and act as counselor to the director?" That question, of course, raises issues related to a registrar's authority and status as well as to the budget level and management style of the institution.

Museums do function as stewards, responsible for collecting, preserving, interpreting, and displaying collections for the public in exchange for tax exemption in the United States. Trustees assign responsibility to a director and staff for carrying out policies and activities that are responsible and accountable both to trustees and to the public.

The public of a museum consists of many constituents—trustees, curators, educators, registrars, physical plant personnel, conservators, librarians, archivists, photographers, marketing and business personnel, development staff, volunteers, scholars, students, politicians, collectors, dealers, and the general museum-going public. Who is going to help a director decide on policy recommendations and activities that serve all of these constituencies while still maintaining accountability and responsibility for the collections? Who helps the director "bell the cat?"

Based on my experiences in the museum profession, the answer should be those division or section managers just below the director or deputy-director levels in an organization's management chart. The registrar should have the same standing and level of authority as a senior curator, head of physical plant, head of public safety, head of an education division or section, and so on. In most small or medium-size museums, the registrar should report independently to the director. In large museums, the registrar should report either to the deputy director for collections or deputy director for administration and finance because the latter often has oversight of security functions and staff. If the organization is so large that it has three or more deputy directors, there should be a position at that level to whom the registrar reports.

So much responsibility and authority should be vested in the registrar, first of all, because of that position's collections audit function. Museums are unique educational institutions because they use collections to educate and inspire their constituents. In his collection of essays about museums entitled *Beauty and the Beasts*, Stephen E. Weil devotes some attention to "The Museum as Bureaucracy." Weil states:

> Museums, like any other organization, cannot devote their full energies to carrying out programs. Some substantial part must be reserved for... ensurance of their continuity. Continuity is far more critical to an art museum than it is to, say, a ballet company or a publishing house.... No one is going to entrust valuable works of art to a museum without some reasonable certainty that the museum will continue year after year to look after them.

The audit function includes inventory of collections, which, if the truth be told, is more often honored in the breach than in the practice. Registrars are not usually given sufficient human and financial resources to carry out complete inventories of collections on a regular schedule. The registrar's audit function includes the integrity of records, accession books, accession number assignment to objects and corresponding catalog cards, computerized information systems, object folders, conservation records, scientific examination records, photography, CD-ROM discs, and control of the level of access to records. If carried out properly,

this responsibility results in "one-stop shopping" by staff and the public for information about an institution's collections.

Permanent, current, and temporary location of collections is also an important part of this audit function. The movement and handling of collection objects due to special exhibitions, event-driven attendance, and rental of museum gallery space to affiliated or outside organizations has become especially critical in house, history, and decorative arts museums. In art museums, where up to 80% of collection holdings can be "somewhere" in storage, audit, movement, and handling are equally critical.

When an institution becomes involved with major or minor renovations to its physical plant, carries out routine maintenance in its building or buildings, or undertakes new construction, it is the registrar who is the logistics general, planning the movement and storage of objects in temporary location and the movement of the same objects when work is completed.

Registrars are often in a key position to remind a director or deputy director about limitations in facility space, staff resources, costs of materials, temporary storage, and overtime required when planning new programs or expanding existing activities.

No one needs a reminder of the registrar's knowledge, patience, and skills in implementing temporary exhibitions. Examination of objects for condition, crating, packing, shipping, movement, and handling are all overseen by the registrar. The reverse side of this coin, obviously, is the loan of objects on a temporary or long-term basis to other institutions. The registrar monitors these loans as well.

Copyright and control of matters related to commercial activity programs, publication activity, fees for photography and the use of color negatives, slides, or photographic prints have also become a major duty for many registrars.

As a retired museum professional who has now switched to the trustee side of museum activity, I believe that at this time, the "post-heroic" mode of management style posited by the Museum Management Institute calls for institutions to provide registrars with the authority and status that their responsibilities have earned. Directors and deputy-directors are made stars by the efforts of highly competent staff. Key positions in an organization deserve highly visible recognition and those positions should include that of the registrar.

The Getty Center, Los Angeles (detail). Photo by Elizabeth Gill Lui.

Kittu Longstreth-Brown, editor

CREATING DOCUMENTATION

The registrar manages information about the museum's collection and about transactions and activities involving works in the collection or in temporary custody. Several documents, or variants of them, are common to most museums and form the basic records about collection objects. These documents describe the object, record transactions involving the object, and define the legal status of ownership or custody. The format of any of these documents will be specific to the systems in place in a given museum, but the functions are the same for all. Essential documents include:

- Receipts
- Master log
- Worksheets
- Condition reports
- Gift agreements
- IRS forms
- Proofs of purchase
- Copyright licenses
- Loan agreements

Information in these documents may originate with the registrar, curator, donor, maker, vendor, or others, but the registrar gathers the documents, or copies of them, for the files and tracks the steps between receipt and consideration of objects through accessioning into the collection or return to the owner.

RECEIPTS

Receipts should be issued for all objects coming into the museum's custody for any reason. Elements of a receipt include:

- Name and address of the owner of the object
- Daytime phone and fax numbers
- Date the object was received by the museum
- Explanation of why the object is at the museum
- How the object came to the museum
- Description of the object
- Any temporary or catalog numbers
- Insurance value (if appropriate)
- Expiration date or duration of deposit

Terms and conditions under which the museum receives objects usually appear on the back of the form. The registrar and the depositor sign and date the receipt. The owner of the object receives a copy, and the registrar keeps one or more copies for the museum files.

If many objects are received in a single deposit, it may take time to complete an accurate count and descriptive list. A temporary receipt may be issued, indicating that details will be added later; an addendum or a superseding receipt should follow. Such a list, complete and accurate, will form the basis of all future documentation of the transaction and should be completed as soon as possible.

GIFT AGREEMENTS

The gift agreement, which may also be known as deed of gift, deed of reconveyance, statement of gift, or certificate of gift, substantiates the transfer of title of an object from the donor to the museum. The agreement is generated by the recipient museum and forwarded to the donor for signature. A gift agreement is issued on museum letterhead or on a special form bearing the museum's logo. The paper should be acid free. Two originals are generated, and both are forwarded to the donor for signature; the donor is asked to return both to the museum. The museum director or other authorized

Authors: Anne Fuhrman Douglas, Connie Estep, Monique Maas Gibbons, Paulette Dunn Hennum, Kittu Longstreth-Brown, Dominique Schultes.

official countersigns them and returns one to the donor for his/her records. The signed and dated gift agreement is kept in the object document file, or in some museums in an alphabetical file by donor's last name. The gift agreement should contain the following information:

- Name, address, phone and fax numbers of the museum
- Name, address, and phone numbers of the donor(s)
- A description of the object(s) to be accepted, including the type of object, artist or maker, country of origin, date of object, materials or medium and dimensions.
- Accession number assigned to the item (optional)
- A credit line, standard to the museum, that presents an option for change by the donor
- Expression of intention to donate
- Language waiving all right of ownership
- Language indicating that the person giving the object has the legal authority to give it
- Language that the gift is unrestricted (any restrictions that are accepted by the museum should be written into the deed of gift; those restrictions then supplant this statement)
- Language confirming the donor's belief that the object has not been exported from its country of origin in violation of the laws of that country in effect at the time of the export, nor imported into the United States in violation of laws and treaties of the United States
- A statement that the gift was not acquired illegally
- Language indicating that the donor received no goods or services in consideration of the gift
- If dealing with the artist or copyright owner, a statement passing ownership or granting non-exclusive use to the museum
- If not dealing with artist or copyright owner, a statement giving up all rights to the gift
- Language acknowledging the museum's acceptance of the gift
- A line for signature and date of signing of the donor
- A line for signature and date of signing of the museum authority

While possession of a completed gift agreement may be the optimum manner of substantiating title to an object, alternate documentation, such as correspondence from the donor or a gift acknowledgment letter, may serve the same purpose. If, however, it is determined that the documentation on hand does not support title, the museum may wish to have the donor sign a "confirmation of gift" statement indicating that the item was donated and the date on which donation took place. If the donor is unwilling to provide such a statement, the registrar should send a letter to the donor by certified mail, indicating that unless advised otherwise by a given date, the museum will consider the item a donation to the collection as of that date. (See chapter on Old Loans.)

Fractional gifts (or gifts of fractional interest) are those in which title to a fraction of a work is given to a museum; the museum often stipulates that full title must be received at a later time. It is important to note that in the case of a fractional gift, a separate gift agreement document must be issued as title for each portion of the gift transferred to the museum, unless the initial gift contract stipulates the progressive transfer on a predetermined schedule. Legal counsel must be consulted to assure transfer of title for fractional gifts.

A letter of acknowledgment is usually issued with the gift agreement. Sent as a cover letter to the agreement, this document serves to thank the donor for the gift and to provide instructions about completion of the gift agreement. The acknowledgment letter is typically signed by the director, or the curator of the department, and includes a description of the donated items. A copy of this letter is kept on file with the gift agreement.

IRS FORMS

The United States tax code changes as new legislation is passed and new regulations are accepted. It is imperative for registrars, development officers, curators, and directors to keep abreast of

new tax developments. Information in this text reflects laws in place at the time of publication.

The museum may be asked by a donor to complete Internal Revenue Service Form 8283 "Noncash Charitable Contributions" after an item has been accepted for the collection. It is the donor's responsibility to obtain, circulate for completion, and file Form 8283, but the museum may wish to keep on hand blank copies of IRS forms relating to such donations as a service to donors. The museum is required to complete only those sections of any IRS form that apply to its action, and should avoid giving tax advice, inappropriate assistance, or the appearance of inappropriate assistance to a donor completing a tax return. (See chapters on Appraisals and Tax Issues Related to Gifts.) A copy of Form 8283 signed by a museum official should be filed in the object file with the gift agreement and the original returned to the donor.

If the museum "sells, exchanges or otherwise disposes of property described in Form 8283 (or any portion thereof) within two years after the date of receipt," Form 8282 "Donee Information Return" must be filed by the museum with the IRS.

PROOFS OF PURCHASE

For objects purchased for the collection, copies of paperwork approving the purchase, invoice or bill of sale, purchase order, and receipt for payment are appropriate to the registrar's document files. In addition, any warranties the museum may require from the vendor are part of these files.

MASTER LOG

Identification numbers form the link between each object and the information about that object and should be assigned as soon as the item enters the museum's charge. Sometimes the only way to distinguish objects from one another is by number. The number for each piece must be unique, and it must appear on the object as well as on the records. The numbering system selected must be adaptable, simple, and capable of expanding as the collections grow. Since descriptive information about the object

will be found in the records, it need not be coded into an identification or accession number. (See chapter on Numbering.)

A master log, maintained by one person, prevents numbering inconsistencies and ensures that a number is not skipped or duplicated. This log provides a readily available running list of the year's accessions, in order, which serves as a reference to the card catalog and other files in which object information is kept. It need not be elaborate, but it should be clear, orderly, easy to read, and difficult to alter. A typical log consists of a bound ledger with information entered in ink. Numbers should be listed in order with enough information to identify the object and source. More detailed information or tracking of actions is better kept in other files. On a periodic basis the pages should be microfilmed or photocopied for off-site storage.

Some museums no longer list objects in bound ledgers. Instead, they keep logs on word-processed forms. Since this format is far easier to change than a bound master log, the information should be copied, dated, and taken off-site on a regular basis. It is also valuable to make a comprehensive printout of the material when a year is finished and to have it bound.

WORKSHEETS

Once an object has been purchased or formally accepted for the permanent collection, an information form called a worksheet, accession sheet, or catalog sheet should be completed. The registrar uses this form to compile from the curator or directly from the object as much information as is available about the item and its acquisition. Although accession information and catalog information are often used interchangeably, there is a distinction. Accession information includes a physical and material description of the object, acquisition information, current condition, and accession number. Depending on the type of museum, monetary value and status of copyright may be included as well. Catalog information includes provenance and history, bibliographic references, an assignment into

The Sampler Museum
123 Any Street, Any Town, USA 00000
Telephone 000-000-0000 FAX 000-000-0001

INCOMING RECEIPT **THE SAMPLER MUSEUM**

The objects described below, or on the attached pages, have been received by The Sampler Museum and are subject to the terms and conditions set forth.

Received from:

_____ _____
Name *Owner's name (if different)*

_____ _____
Street address *Street address*

_____ _____
City, state, zip code *City, state, zip code*

_____ _____
Business telephone *Business telephone*

_____ _____
Home telephone *Home telephone*

_____ _____
FAX number *FAX number*

Purpose: _____

Date received: _____ Insured by: _____

Shipped Via: _____

Packing: _____

Museum Reference Number	**Description**	**Insurance value**

Received by:

_____ _____
Signature for The Sampler Museum *Date*

Name and title

Incoming receipt, side 1.

CONDITIONS UNDER WHICH OBJECTS ARE RECEIVED

LOANS

1. If the objects covered by this receipt are the subject of a loan agreement with The Sampler Museum ("Museum"), then the terms of such loan agreement (other than any description of condition) shall control if inconsistent with the terms of this receipt.

GIFTS/PURCHASES

1. If the objects are being offered to the Museum for sale or as a gift, the owner or authorized agent ("Depositor") will be notified in writing of the approval or acceptance thereof and this receipt shall thereupon become null and void as respects the whole or part to be acquired by the Museum. If such property is declined by the Museum, the Depositor agrees to take redelivery of the whole or part declined within thirty (30) days after written notification has been mailed to him or her at the address appearing on the face of this receipt.

CARE AND HANDLING

1. The Museum will give objects left in its custody the same care as it does to comparable property of its own, but will assume no additional responsibilities in regard to such objects. It is understood by the Depositor that all tangible objects are subject to gradual inherent deterioration for which the Museum is not responsible.

2. The absence of condition notes on this receipt does not imply that the objects were received in good condition.

3. The Museum will not clean, restore, reframe or otherwise alter the objects without the written consent of the Depositor. If such work has been authorized, the cost will be subject to special written agreement between the Depositor and the Museum.

4. Attributions, dates and other information shown overleaf are as given by the Depositor. Any valuations or prices shown are those stated by the Depositor and are not to be construed as appraisals by the Museum. The fact that the objects have been in the Museum's custody shall not be misused to indicate the Museum's endorsement.

5. The Museum will not provide transportation for objects deposited with it unless special arrangements are agreed to in writing by the Museum. When objects are returned to the Depositor pursuant to such arrangements, failure to sign and return the official Museum outgoing receipt within 30 days of shipment of said objects shall release the Museum from any liability for the said objects.

INSURANCE

1. The Depositor hereby releases the Museum, its agents and employees, from liability for any and all claims arising out of loss or damage to such objects, except to the extent of the Museum's insurance coverage, if any.

PHOTOGRAPHY

1. Unless the Museum is notified in writing to the contrary, the Depositor agrees that the objects covered by this receipt may be photographed for record, publicity or educational purposes. Such photographs will not be published or sold to the public without written consent of the Depositor.

RETURNS

1. The Museum will give reasonable notice in writing if it desires to have any object taken back by the Depositor; and the Museum will make reasonable efforts to return the object to the Depositor.

If such efforts are unavailing for any reason, the right of the Museum to require the Depositor to withdraw the said object shall accrue absolutely on the date of and by mailing a notice to the address listed overleaf via certified mail. If the Depositor does not withdraw the loan within sixty days from the date of such notice, then the Museum may charge regular storage fees and enforce a lien for the fees. If after five years the loan is not withdrawn, and in consideration for its storage and safeguarding during this period, it shall be deemed an unrestricted gift to the Museum.

2. Objects covered by this receipt which are not included as loan items in an exhibition then on exhibit may be removed from the Museum by the Depositor or his or her duly authorized agent or successor in interest after reasonable notice upon surrender of this receipt or the delivery of the Depositor's written order. Unless other arrangements have been approved in writing by the Museum, objects will be returned only to the Depositor at the address stated overleaf.

3. In the event that an object, the ownership having meanwhile passed by sale, bequest or gift, is not to be returned to the original Depositor, the new owner or recipient must establish, in advance of such return, his or her authority to receive it to the satisfaction of the Museum's counsel.

WARRANTY OF TITLE

1. The Depositor warrants that he or she is the owner of the object, that the object is not subject to ownership claims of any other person, institution or domestic or foreign governments, and that all applicable domestic and foreign customs and export/import regulations have been complied with.

If the Depositor is not the owner of the objects, the Depositor warrants that he or she has full authority to enter into this deposit transaction on behalf of the owner, and the owner is fully bound hereby as the Depositor's principal. The Museum may require written evidence of the Depositor's agency satisfactory in form to its counsel.

Incoming receipt, side 2.

THE SAMPLER MUSEUM **CATALOG WORKSHEET**

Object: Accession #:

Maker/Culture:

Title:

Date made:

Where made:

Materials/Medium:

Description :

Dimensions:

Condition Note:

Source:

Credit Line:

❑ Object Numbered ❑ Accession/Object File
❑ Object Photographed ❑ Copyright Agreement
❑ Computer Entry ❑ Biography Card
❑ Catalog Card ❑ Inventory Card
❑ Inventory Card ❑ Cross reference

Catalogued by: Date:

Catalog worksheets are completed in pencil and retained in the object file.

intellectual categories as followed by the museum or its discipline, and in some museums a catalog number that differs from the accession number.

CONDITION REPORTS

A condition report should be completed as an object enters the museum's custody to provide a baseline against which future examinations can be compared. (See chapter on Condition Reporting.) Condition reports are also appropriate when placing an object on exhibit or taking it down, when lending an object or receiving it back from loan, or when monitoring a particularly vulnerable or deteriorating object. A condition review may also be part of a collection inventory. Condition reports on objects owned by others are particularly important and should be completed any time a change is noted. The condition report form may be a checklist or free text, but should include the following elements:

- Owner of the object
- Object name and number
- Maker or artist
- Object description or type (optional)
 Classification
 Date
- Measurements
- Materials
- Condition: general and specific, using standard terminology
- Description and condition of any accessories: base, frame, cover
- Date, and name of person completing report
- A dated photograph

COPYRIGHT LICENSES

For some museums documents about copyright for the object form another part of the record. Documentation relating to the copyright status of the item should ideally be generated at the time of acquisition. The museum may desire exclusive or nonexclusive copyright license for an object it acquires. If the item is acquired from the artist, maker, or copyright holder, language addressing copyright status can be incorporated into the gift or sale

agreement. If the donor is not the copyright holder, a separate document may be sent to the owner of copyright with a request for signature. (See chapter on Copyright.) These documents become part of the object file.

LOAN AGREEMENTS

A loan agreement for works coming into the museum's custody either for exhibition or on a long-term arrangement is completed before the museum accepts delivery. (See chapter on Loans.) The loan agreement describes the object(s) to be lent, the lender, the borrower, terms and conditions of the loan including who will pay what expenses, and the term of the loan. Like the gift agreement, this form will have a museum logo with the museum's address and phone numbers clearly indicated. Other elements of the loan agreement include:

- Name, address, phone and fax numbers of the owner of the object(s); for institutional lenders, the name of the contact person
- Purpose of the loan: research, exhibition, loan to collection, etc.
- Beginning and ending dates of the loan arrangement
- Credit line listing how donor wishes to be acknowledged for catalog, label, and/or publicity purposes
- Description of the object, including maker or origin, materials, dimensions, and accessories such as containers or bases
- An insurance value and indication of who is insuring
- Provisions for shipping
- Permissions for photography
- Dated signatures of borrower and lender

Often the reverse side of this agreement lists conditions that pertain to all loans the museum accepts, with language about responsibility, notification to lender of any damage, reference to any state laws about unclaimed property, and limits or exclusions to insurance coverage.

A similar agreement is used when the museum lends objects from the collection to other museums.

Usually the agreement generated by the borrowing museum is used for the transaction, although the lending museum may negotiate changes and make modifications as its own policies dictate, or even substitute its own agreement form. The information about an outgoing loan becomes part of the object's history, so the loan agreement or reference to it is added to the object's document file or record.

TYPES OF FILES

Information about objects and transactions involving objects, once organized or compiled in records and documents, is then stored in various files. The filing system may reflect the kind of information stored, or the activity that the information relates to. Typical files in the registrar's office include:

- Card catalog
- Category/subject/classification
- Accession (also referred to as object or document)
- Source or donor
- Maker/artist/manufacturer
- Location
- Object photo
- Insurance
- Incoming loan
- Outgoing loan
- Exhibition

Files that are part of the records about objects in the collection are maintained for permanent reference. Activity files are compiled, maintained, and searched while the activity itself is current. Once an exhibition is concluded, or loans have been returned to owners, some of the information may be added to a history sheet for the object file, while the actual documents may be moved to less accessible archival storage. Other activity files may be restarted each year. Since the value of storing information about objects and activities lies in retrieval, the registrar should organize data and documents in the way in which most users will logically look for them. Information files should be alphabetical, numerical, or chronological, depending on the type of information and how it will be used. Retrieval from any system is easier if the information has been entered in a uniform format, with consistent spellings and modes of display. Filing systems should be simple, clear, and consistent. Strive for systems that can be understood even if the registrar is not there to explain them. Simple systems that are kept up to date are better than sophisticated models too cumbersome to be completed by the staff available.

CARD CATALOG

The registrar compiles and maintains a central file that lists all of the objects in the permanent collection. This file contains a record for each object, retrievable in accession number order, incorporating some or all of the information that was gathered on the worksheet. It sometimes includes a small identification photograph. It may also encompass cross-referenced files that provide a way to identify specific objects or groups of objects by means other than the accession number, such as maker or artist, donor, subject matter or classification system, or geographic origin.

This list of the entire collection in numerical order is essential to the accountability of the museum registrar. The form of the central record and the complexity of data in the file depend on the resources allotted to the registrar's functions over the history of the museum. Enough information should appear to distinguish one object from all others and to identify what it is and where it came from. The central file may be a stepping stone to the greater information that the registrar collects on an object, may display all of that information, or may provide something between the two.

CATEGORY/SUBJECT/ CLASSIFICATION FILES

A category reference file should be based on an appropriate classification system, materials, or subject matter. Each discipline has its own intellectual or hierarchical categories; some are more complete or systematic than others. Each museum should clearly define the standard classification systems it uses.

Category files may present difficulties in a manual system. Often the categories are not really parallel to each other, although they may reflect the way a particular museum has divided up responsibility for its varied collections: portraits, Chinese, farm tools, wood carvings, for example. These divisions are useful to those who started them and to those who get used to them, but do not always aid the researcher or new staff. Form, content, and intellectual analysis become intertwined and confused. Accurate assignment of a particular object to one of these categories becomes a matter of chance.

ACCESSION/OBJECT/ DOCUMENT FILES

Documents created by others are also appropriate to the registrar's object files, although copies may be filed in a curatorial department as well. It is important that the museum have a central document file, as it has the central card catalog, a place where records for the entire collection will be reliably found. Accession/object/document files are usually kept in accession number order, although some museums may divide them by curatorial department. In an acid-free folder are kept documents and correspondence relating to the object and its acquisition:

- Legal documents associated with the accession, such as bill of sale or deed of gift, although some museums file these by donor
- Correspondence about delivery and acquisition of the object
- Shipping information, documents, or invoices
- Copy of a bequestor's will
- Photograph

- Worksheets
- Condition and treatment reports from conservator
- Valuation or appraisal information
- Copies of research reports or correspondence, especially those documenting changes in attribution
- Bibliographic references
- Exhibition and loan history
- Deaccession information

These files are archival in themselves, the documents being primary sources of information about the object for other files. The object file is a continuing and growing history of the object as well, incorporating bibliographic history, appraisals and valuation, exhibition history, and research notes. Information should be date-stamped as it is added to the folder. Object files are most useful when the contents are organized and duplicate pages removed.

MAKER/ARTIST/ MANUFACTURER FILES

A frequently used reference is the maker or artist file. The format of names should be consistent and clear. There are often standard references for names, and the curator is the institution's arbiter. Collection or long-term loan objects created by the person, manufacturer, or cultural group may be listed for ready capsule view. The maker may be described by life dates, active dates, places worked, manufacturing sites, biographical notes, nationality, or a designation for group, tribe, or culture. A file folder with detailed information about the maker may be maintained, although this type of information usually resides in a curatorial file.

SOURCE OR DONOR FILES

Also useful to the museum is the source or donor file, with a consistent and clear format for names, identifying the donors of objects, vendors, purchase funds, archaeological sites, expeditions, lenders, or trading institutions.

```
SAMPLE                    American Art

Object:
Artist:
Title:
Medium:
Object Date:

Dimensions:

Source:
Credit Line:
Date Accepted:                        Status:
```

Catalog card.

LOCATION FILES

Each museum must devise a workable way to report and record object movement. Location files are key to the accountability of registration. Inventory and tracking of the objects is as important as descriptive information. Location files are searched or modified as often as staff need to look at or take inventory of objects or move them. This frequency of use means that location files must be easy to read and easy to modify.

In large museums a written work request is often used to initiate object movement and record new locations, with a copy to the registrar for marking cards or changing a computer entry. At another museum a location log may be kept in the storage room, the new locations or object movements written in as they occur, and the central location file on cards or computer updated periodically.

In another system, duplicates of accession cards may be filed by location (another cross-reference file). When an object is moved, its card is refiled by the new location. This method may not record the date of the move, and it is cumbersome. Still another museum may use a rotating file of small cards by accession number. Locations are crossed out as they are changed, and dates are added. New cards are also added as needed.

Frequent moves are difficult to record in a timely manner. Backlogs of object movement work orders or logs in storage soon lead to poor inventory control. Periodic physical inventories must be done to confirm the accuracy of location information. Constant vigilance by the registrar is required to enforce reports of object movement from curators and object handlers; self-discipline is required to stay up-to-date with location records. A location file that is simple and straightforward will be maintained better than an elegant and elaborate tracking system that has too many steps or maneuvers.

OBJECT PHOTO FILES

Photographs document the collections and assist identification, condition recording, insurance claims, study, research, education, exhibition planning, publication, and publicity. The registrar's photo files may consist simply of a negative number with the photo date or may encompass storage of the photographic materials themselves.

Photographs come in several formats: negatives (individual or rolls), contact sheets, black-and-white or color prints, color transparencies, color slides, snapshots and Polaroids, and digitized images on CD-ROM or hard drive. Types of access needed and the materials being stored determine the organization of photo files. If the files are used mostly by the registrar's staff, they can be arranged by accession number. If others need regular access, it may be more useful to organize them alphabetically by artist, by classification, by place of origin, or by medium or materials. The registrar should choose a method that works best for the collection and for the institution's users, avoiding complicated or idiosyncratic systems of organization.

If the negatives are kept by someone else, it is helpful to have the negative number in the object

records. Photographs should be kept in acid-free folders. Negatives, slides, and transparencies should be kept separately from prints, in acid-free or metal boxes or in acid-free envelopes, Mylar D, or polypropylene or polyethylene sleeves. Prints and negatives should not be stored with rubber bands or paper clips.

INSURANCE FILES

Insurance values for individual objects are part of the continuing document file. Some insurance policies require a periodic schedule of new or revised values, or as part of its risk management program the museum may track values by gallery. The organization of the information and the files depends on how the information is used by the registrar, the insurer, and the museum: chronological by date of the report, by location of the objects, or by collection group. As with all files, simplicity of the system and clearly marked labels make the information easier to find and use.

INCOMING LOAN FILES

Incoming loans may be received for exhibition, research and study, long-term custody, or consideration for acquisition. The files document ownership, object condition, object use, and agreed-upon conditions of the loan, such as location, length of loan, or any special needs. Paperwork about loans for temporary exhibitions should be kept with the rest of the exhibition file. (See below.)

Long-term loans to the museum's collection are recorded, stored, exhibited, or studied the same as collection objects, except that the registration numbers assigned should immediately distinguish loans from accessions. A prefix "L" and a separate compound numbering sequence for transactions is a common and simple method. (See chapter on Numbering.) Central loan records, maintained in "L-number" order in a separate file, further aid distinction. Loan object folders should contain the loan agreements, incoming receipts, condition reports, photographs, correspondence, and other documents. An alphabetical lender file is useful in museums with many loans to the collection, while a separate "tickler" file may alert the registrar to the return or renewal date.

Short-term loans will not be in the museum's custody long enough to require extensive files. Six months is a useful dividing point. These loans will be given a tracking number, perhaps with the prefix "T" for temporary or "SL" for short loan. A log is needed to record these numbers. Each separate numbering system used by a museum (the fewer the better) must have its own integral sequence and clear prefix or other identifier to avoid any confusion between owned and borrowed materials.

The various documents pertaining to the transaction should be annotated with the tracking number and filed by the activity for which the objects were borrowed. Once incoming loan transactions have been concluded and works returned to their owners, the records should be annotated and folders or paperwork filed in a closed file. Information about long-term loans may be kept for future research in the same way that information about deaccessioned objects is kept. For all loans, the registrar may establish both an owners alphabetical reference file and a loan number reference should questions arise later on. Papers kept should include the loan agreement; official correspondence; and copies of incoming and outgoing receipts, especially those signed by the owner on return.

OUTGOING LOAN FILES

Files for outgoing loans should contain the following:
- Correspondence with the borrower prior to and during the loan
- Loan agreement spelling out terms of the loan
- Shipping papers
- Borrower's receipt
- Condition reports
- Insurance certificates

EXHIBITION FILES

Exhibition files start as working files. From initial planning through actual installation and opening of a particular exhibition, the registrar accumulates documents and notes that are used to get the work done. The registrar's working exhibition files may include the following:

- Original loan forms
- Receipts
- Correspondence with lenders, shippers, insurers
- An inventory of the show by case, catalog, hanging order, and/or accession number
- List of lenders, if any
- Condition reports
- Photographs
- Treatment reports
- Related in-house notes and memos
- Shipping bids and bills of lading
- Budget notes and estimates
- Related conservation or exhibit maintenance schedules
- Insurance lists
- Copies of information from other departments

This kind of working file has the order, or disorder, that meets the particular registrar's needs or time available. It is prudent to keep everything—even notes on tattered scraps of paper—during this time. An exhibition file may grow to become an exhibition "box," or a series of folders sorted by activity.

At the conclusion of a temporary exhibition, after all loan works have been returned and collection objects put away, or once a "permanent" exhibit is in place, it is time to organize the contents of the file: Keep those papers with information that someone may need to find in later years in an order that will aid finding, and dispose of any redundant pages and now irrelevant scraps and notes. A closed exhibition file should be as useful as any research document, with papers in logical order and an index or table of contents.

Exhibition files should be kept chronologically by exhibition date. All or part of the registration materials may become part of the institution's master archive file for that exhibition. Information about the logistics, lenders, shipping arrangements, insurance, and costs may be useful in future exhibition planning; the registrar may keep the information if not the actual documents, in an exhibition planning file for reference.

MANAGING FILES AND RECORDS

RECORD MAINTENANCE

Data about objects are put in the registration files when the objects are incorporated into the collection. Over the years, information reflecting research results, exhibition and publication history, and changes in the object's status will be added to the files. The addition to, modification of, or deletion of information must be monitored by the registrar. In a manual system it is often obvious that information has been changed; erasures, crossing out, different typeface or handwriting, different card stock tell the tale. Nevertheless, a record of who made changes on what date will provide a means of verifying the information and

its reliability. Typically, only designated staff are permitted to amend the information. Subjective information such as attributions or interpretations of subject matter, and time-sensitive information such as condition assessments or insurance values, should be initialed and dated by the person amending the file.

Within the time constraints of the museum's activities, the registrar should assign a high priority to the timely updating of information and filing of new materials. In addition to maintaining and updating information, the registrar takes physical care of the files. Acid-free papers should be used for folders, cards, and documents. Folders and cards

should be replaced when worn or degraded to ensure the preservation of contents and information. Documents in folders must be protected from creasing, paper clips, and staples. If prongs are used to hold papers, care must be taken that they do not damage the papers or neighboring files. File labels must be firmly attached, neatly typed or printed, and replaced as required.

Documents that simply carry information that can be transferred to another card or paper do not need to be acid-free. Acid-free materials should be used for documents and records that in themselves are archival, such as signature copies of gift agreements. A long-term view of preservation is essential in organizing and maintaining these files.

DUPLICATION / PROTECTION

Responsibility for the safety and security of objects extends to the safety of the documentation connected with them. Disasters do happen. Off-premises storage of duplicate records will safeguard essential collection information in the event of loss. Various methods of duplication have been successfully employed. If object cards are typed, carbon copies can be made at the time of production. Cards and documents can be photocopied, full size or reduced. Copies can be made on microfilm or microfiche, or documents can be scanned into computers. Duplicate records should be stored in a secure off-site area with controlled access, such as a bank vault. More than one person should know what is stored where and how to retrieve it.

Duplicate object records with basic descriptive information, and if possible a small photo, should be made. A record of current loans with insurance values should be made and secured regularly. If the budget allows, store copies of acquisition records (deeds of gift or bequest, receipts of sale, etc.). Establish a schedule for routinely producing and storing duplicate collection records to stay up to date with new acquisitions and new versions of records. If there is an index or "table of contents" for stored records, be sure it is dated, and keep a copy at the museum as well. The frequency of updating duplicate records will depend on the quantity of new records, the value of the objects, and an evaluation of the risks to registration records.

SECURITY OF RECORDS

The registration files with information about the collection are valuable assets to the museum. The information is essential to exhibiting and interpreting as well as responsibly accounting for the collection; insurance values and object condition make a difference in situations of loss or damage. These files must be secured and the integrity of the information safeguarded. The registrar should list risks against which to secure files, periodically evaluating these risks and taking steps to protect against them.

Fast-acting hazards that can destroy or damage records include fire, water, and theft. Slower-acting events can deteriorate or destroy as well: dirt, exposure to light, pests, handling, acidic papers, malicious alteration of data, or well-meaning but misguided and unsupervised alteration of data.

In each museum safeguards and solutions must be devised within the context of the building itself, the budget, support from museum administration, and the registrar's ability, resources, and creative problem solving. Safeguards for records in the registration area include:

- Good housekeeping practices
- A smoking ban
- Restricting food and drink
- A good automatic fire-suppression system
- Fire extinguishers and training in how to use them
- Keeping files off the floor and protecting them with water barriers
- Locking files and maintaining good key control
- Monitoring access and sign-out/sign-in procedures if files are removed
- Protection from ultra-violet light exposure

- Clean hands and respect for materials
- Acid-free papers and folders
- Metal file containers
- A procedure for effecting modifications to files, including a written record of changes and clear lines of authority to make them

The records can be considered secure if there are good, up-to-date duplicates off-site, a staff that understands and respects the importance of records, enough staff to monitor access to files, more than one reference to objects to check information against; if the registrar looks at the files often and is very familiar with the contents; if the museum's general security practices and procedures are good and the building is protected against fire and intrusion; and if access to the registration files is well controlled.

THE SAMPLER MUSEUM
123 Any Street, Any Town, USA 00000
Telephone 000-000-0000 FAX 000-000-0001

OUTGOING RECEIPT

The objects described below, or on the attached pages, have been sent by The Sampler Museum and are subject to the terms and conditions set forth.

RELEASED TO:

Name:

Street address:

City, state, zip code:

Telephone number: FAX number:

For the purpose of:

Date shipped: Shipped via:

Return date: Insured by:

Museum Reference Number	Description	Insurance value

Released by:

Signature for The Sampler Museum *Date*

Name and title (please print)

Received by:

Signature of person receiving objects *Date*

Name and title (please print)

Please sign, date and return white original to The Sampler Museum Registrar. The copy is for your files.

CONDITIONS UNDER WHICH OBJECTS ARE RELEASED

For objects returned by The Sampler Museum ("Museum") to the owner, this receipt must be signed and returned to the Museum within 30 days of shipment; otherwise the Museum will accept no further liability in connection with said property.

Objects released as loans by the Museum for exhibition, study, restoration, photography, reproduction, examination, or other purposes shall be given all due care and protection from damage or loss, including insurance if requested, while in the custody of the borrower. Objects must be returned by the date specified on the face of this form, unless an extension of the loan period has been requested by the borrower and approved in writing by the Museum.

In the event of any damage to or loss of the objects, the Museum is to be notified immediately, followed by a written report including photographs. If damage or loss occurs in transit, also notify the carrier immediately and save all packing materials for inspection.

Outgoing receipt.

Suzanne Quigley, editor

DILBERT reprinted by permission of United Feature Syndicate, Inc.

Collections management activities are greatly enhanced by computer technology. The registrar's use of computers is now widely accepted for the storage and retrieval of catalog information, but computer systems can go much farther. Many registrars track object locations, prepare exhibition lists, generate a myriad of forms (receipts, insurance forms, deeds of gift, etc.), manage images (photo records, rights and reproductions, and images themselves), and organize conservation, publication, exhibition histories, and curatorial information on computer.

As networked systems become more common, other functions within a museum also benefit from access to data from the collections management system. Education, membership, accounting, and administration use information internally, while the public searches the database in a gallery or library. To aid the registrar, who is often the system manager or program administrator, in planning for and getting the most out of the museum's collections management system, this section provides a comprehensive account of collection management system requirements, the system selection process, the structured nature of data management, and some simple technical details of system management.

Authors: Lynn Adkins, Rebecca Buck, Connie Estep, Leslie Freund, Roberta Frey Gilboe, Suzanne Quigley, David Ryan, Holly Young.

Acknowledgments: for institutional support, Roger Lidman, director, Pueblo Grande Museum, Phoenix; for expertise, Dr. Robert W. Layhe, Research Computing Facility Manager, Mayo Clinic, Scottsdale, Ariz.

COLLECTIONS MANAGEMENT SYSTEMS

SYSTEM REQUIREMENTS

A system consists of hardware, software, and the network on which they are used within the museum. It is run by human beings and must be managed. Each museum must determine who will choose, manage, and maintain a collections management system before it begins the process of computerization.

Choosing a system requires a thorough analysis of

- The information that is to be stored
- Who will enter data
- How, why, and by whom the data will be used
- Present computer capabilities
- Anticipated future growth of institutional needs

Based on this analysis, the choice is among proprietary museum data management systems, professionally designed custom systems, or in-house designed systems. Any of these may or may not be based on commercial database software. Depending on the data management system chosen, one of two types of computer operating systems will be needed: a "Graphical User Interface" (GUI) system (Windows, OS/2, Macintosh) or a text-based system (DOS).

Hardware should be selected only after the foregoing decisions have been made to ensure its adequacy for the type of data being stored, the database size, the operating system, and network capabilities. Conversely, existing hardware may limit the type of data management software that can be used.

DATABASE STRUCTURE

A database is a collection of information about something. Manual collections records are a database. The advantage of computerizing collections data is that the computer can sort data more quickly and in many more ways than a person using a manual system.

The key to a useful computerized database is the method of data organization, that is, the database structure. There are two types of database systems: flat file and relational. Flat-file databases keep information in a single, large table, while relational databases keep data in separate tables, each "related" to the other by means of a common field, such as the accession number or donor number.

Relational databases have many advantages over flat file databases. A collection might contain a number of objects given by a single donor. While there will be a separate record for each object in the collections table, there need be only one record for the donor in the donor table, linked to every record of an object in the collections table that was given by that donor. If information about the donor should change, this information need be altered in only one location in the database, thus saving work and ensuring accuracy.

A cardinal rule of good database structure is that no piece of information should ever be entered more than once. The exceptions to this are the common fields that link related tables together, such as the donor number, which must be present in both tables to enable the link.

Although the terminology and precise way they work varies among different software products, most computerized database systems have four components: tables, queries, forms, and reports.

Tables hold stored data. Each table is comprised of records, which consist of sets of data about a particular type of item, such as objects or donors. Individual pieces of information that make up a record are placed in fields, the equivalent of the blanks that must be filled in on a paper form.

Some fields can hold only text data, some only numerical data, and others only dates. The collections management software may "require" that certain fields be entered (accession numbers), while it may leave other fields to the discretion of the data entry operator. The amount of space on the disk drive that each record occupies depends on the num-

ber of fields, their allowable sizes, and the amount of data in each field. Memo and image data can consume great amounts of storage space if not used judiciously. Quantity and size of records are important factors in deciding how large a hard disk or other storage medium a computer system should have.

Queries, also known as searches, extract information from a database. They may be simple, such as one that calls up a record pertaining to an object with a specific accession number. Queries can also be complex, such as requesting a list of all objects given by a particular donor in a given year whose value was greater than a certain amount. There are two types of query: unique query, constructed to meet a particular set of criteria, and predefined query, incorporated as part of the database system and used repeatedly.

Forms are generally used for one of two purposes. Designed to represent paper records, they visually organize and simplify the data entry process and speed data entry. They can use look-up tables in the database to ensure that information placed in certain fields is valid, and that it is correctly spelled or formatted. Forms are also frequently used to specify search or sort criteria to be used by predefined queries. The query is selected from a menu presented by the software, and the criteria the query uses are then entered on an associated form.

Reports are the means by which the results of a query are displayed or printed. They may be part of the software itself, may be designed by the user, or both, depending upon the capabilities of the particular software. One-of-a-kind queries, if properly structured, can use predetermined reports to display or print their results. If a report is not used, a query usually results in a simple list that may be displayed, printed, or imported into a word-processing program for editing and formatting.

FUNCTIONALITY

It is important for a collections database system to be flexible. The collections management system should allow a museum to begin with the data it already has and to expand as need and opportuni-

ties arise. The sum of the information about any object comes from a variety of sources, such as registrars, curators, and risk managers. Each should be responsible for the timeliness and accuracy of his or her piece of information and should be able to enter it without transmitting it to a third party. The system should incorporate methods to ensure that only authorized persons are able to enter, edit, or view various pieces of information about an object. In all but the smallest museums, this generally means a networked system of computers.

HARDWARE COMPARABILITY

Although it has been a common practice in the past to design and "bundle" proprietary systems with a particular computer, this is seldom the practice today. In the late 1990s, the majority of both proprietary collections management systems and commercial database systems run on PC-compatible hardware, although there are some exceptions. Ideally, the computer or computers should be chosen only after the collections management software has been selected. If this is not possible, the software must be selected so that it does not exceed the limitations of the hardware. In such instances, it is important to select software that can be expanded in its capabilities as future hardware upgrades occur.

There is no single brand of PC-compatible computer that is better suited than another. The hardware must be evaluated on the basis of several criteria. The hardware should be manufactured by a reputable manufacturer that stands behind its warranty; it should be purchased from an established vendor. There are a number of "clone" manufacturers who claim that their product is equal to those of major manufacturers. This is often true. However, unless the museum is a large organization (or part of one, such as a governmental agency) with an information management service that can handle alternate arrangements should the clone manufacturer suddenly go out of business, a computer manufactured by an established manufacturer and serviced by an established vendor is worth the difference in cost.

In general, the rule is to buy the fastest, most powerful computer affordable. Speed and power are especially important if bitmapped images or videos will be used as part of the collections management system. The computer must have an adequate amount of "Random Access Memory" (RAM) and an adequate amount of hard disk or other storage space.

The computer must also have adequate expansion slots to accommodate equipment additions. Connecting the computer to a network, a scanner, or other electronic image capturing device, or to a sound board requires that a card be installed in the computer to handle the external connections.

CD-ROM multimedia drives are necessary. Color monitors are not a luxury, but a virtual necessity with GUI-based software. A 17-inch monitor should be considered because it can be placed farther away from the user and is therefore safer. High refresh rates and anti-glare features help to reduce eye strain. Ergonomically designed keyboards and mice help reduce the chance of repetitive strain injuries. The computer desk and the user's chair are also part of the computer equipment. Attention must be paid to the ergonomics of these items, to their situation in the work space, and to the lighting provided.

SOFTWARE SELECTION

Before selecting software for a database system, the museum must decide whether it will develop in-house software, contract with a computer programmer or computer company to develop special software, or buy software from a commercial vendor. Developing in-house systems has long been popular because of low initial cost and the unique character of museum collections. Contracts for special programs were popular when there was little commercial software tailored to museum collection needs; they, too, were often developed because museum collections and information about them is esoteric. Several museums developed software that became models for other museums or were later sold on a wider basis. The very early SELGEM (late 1970s) was a Smithsonian Institution database, for instance; REGIS (Registration System) was used at the Arizona State Museum and DARIS was developed at the Detroit Institute of Arts.

Commercial software developed specifically for museum collections management became available in the mid-1980s with developments by Art Information Systems (ARTIS), Willoughby Systems of Chicago (MILAM and MIMSY), and Questor Systems of Pasadena, Calif. (ARGUS). Some of these and other computer companies specializing in museum collections software have grown, and the programs they offer have changed rapidly since that time. From PICK to UNIX to DOS to the WINDOWS operating systems of the late 1990s, they have become increasingly complex and flexible.

IN-HOUSE DESIGNED SYSTEMS

Commercial database software, such as dBASE, Access, and Paradox, are economical, powerful, and flexible database systems capable of being configured for almost any collections management system. Although this software was designed to be customized by the user for particular applications, a reasonable knowledge of the software is required to do so. Fortunately, the advent of "object-oriented" software makes customization of database software much less dependent upon extensive knowledge and experience in computer programming. Use of commercial databases can be an economical way to begin a collections management system. However, if it is not carefully thought through and managed, this can also be the most expensive of all the routes.

One of the primary advantages of using in-house designed systems is that it requires a relatively small investment in equipment and software. The computerization project can start out small, using the information already contained in paper records, and then expand as the need and opportunity arise. This is also a very flexible approach, allowing the system to be designed for a particular museum rather than the museum being forced to adapt to a proprietary system.

There are major disadvantages to this approach as well. If done by someone whose primary task is not the development of the collections management system, that person's time is diverted from other duties. At the early stages of development, the amount of time required can be significant. If it is a poorly designed system, it can waste time and money and in the end be worse than no computerized system at all. If the person who designed it leaves the museum, it may be impossible to maintain.

A museum no longer needs a computer "guru" on its staff to develop an in-house system. However, providing the person who will develop the system with some training in database design, testing, and documentation is time and money well spent. Initially, the system should be kept simple. Only when one aspect is working well should another be developed; it is not wise to try to incorporate every desirable feature or function all at once. The new system should be integrated into office routines slowly, preferably by starting with the processing of new transactions. If properly designed and used, the computerized system should save time and effort. Only after the new system is functioning satisfactorily is it appropriate to computerize the entire collection.

COMMERCIAL DATABASE SYSTEMS

Commercial database systems, fully developed for cataloging and collections management usage, offer a museum many advantages. The system often comes to the museum as a complete package, and use can begin soon after system installation and initial training are finished. Technical support is often available by telephone or modem, training is usually available from the vendor, and upgrades come without museum staff spending time on software development. Established vendors use client feedback to focus development and make certain that needs are met. The museum finds that it can form user groups with other clients and share information, problems, and solutions.

A major drawback of the commercial database system has been the amount of money that must be spent at a single time for initial implementation. The commitment to a yearly maintenance agreement that is usually based on the number of licences a museum has purchased is also serious. There may be concerns about the stability of the company that is selling the program and questions about the continuance of the software maintenance should the company cease to exist. It is also important to consider the relationship that will have to be developed and maintained with the company of choice.

A museum must plan the configuration and implementation of a commercial system very carefully. Since development is not done in-house, it is easy to overlook the careful review of data as they are developed and used by various departments. It is often the case, as well, that the initial cost of the software does not allow further money to be spent immediately for data entry. Systems that are not useful because they do not have data entered in adequate quantity or because the museum's network cannot support their use are soon considered failures whether the software is good or not.

A single staff member should serve as the liaison between the computer company and other museum users. A second staff member should learn the program administration thoroughly and be ready to step in if needed. The program administrator is often the registrar or a member of the registrar's department; whoever takes the position should know collections management processes and collection information needs.

Commercial systems offer room for growth. Companies often have simple, pre-configured programs that may be used for small uniform collections; additional users can be added and programs can be upgraded to be more flexible. Large museums often start with flexible programs that they must configure internally; they too, can add modules (for bar coding, archaeological-site recording, circulation, etc.) as they are developed.

The increasing popularity of commercial systems proves that they meet an extremely impor-

tant need in the museum community. With the fast pace of developing technologies, it is logical that museums rely on specialists who can use new developments to improve functionality quickly. Commercial programs are becoming the collection management programs of choice in most museums.

REQUEST FOR PROPOSAL

Whether a museum has decided to purchase an off-the-shelf system or to hire a programmer, a request for proposal (RFP) is the appropriate document to send to a small group of selected vendors.

This RFP must provide the vendor with an exact, comprehensive, and clearly written outline of the product the museum needs. It must include a cover letter describing the museum and the project, an indication of the existing computer environment, a functional requirement section, and instructions for returning a proposal to the museum.

The bulk of the RFP will be the functional requirements section, which states the desired characteristics of the collections management system as determined by the museum. It is advisable to divide this section into parts. For example, the section on system requirements will contain information about the network in place and whether the museum intends to continue to use it. If it does, the vendor's system must be compatible with the network. The museum may request that the system have a specific time response, e.g., two seconds; or it may require that the system have different user groups with various levels of security. All questions throughout the RFP should be phrased so that they can be answered by the vendor with "yes," "no," or "modify."

Further subdivisions of the functional requirements section address specific issues for each of the modules the museum expects to use (object tracking, exhibition registration, accessioning, etc.).

The other significant section of the RFP contains directions for the vendors' responses:

- The deadline by which the museum must receive the proposal (usually four weeks from the date of the museum's cover letter)
- The format in which the proposal is to be sent to the museum. (It is important for the museum staff to be able to compare each of the proposals directly to each other, and to do this, consistency of format is necessary)
- Clear instructions as to what must be included

It is crucial that all vendors be treated equally. Due dates must be met and the proposal must be complete for the vendor to be eligible for consideration.

Note: A vendor is legally liable for answering the RFP truthfully, as it serves as the basis for a future contract.

EVALUATION

Evaluation of proposals and selection of a vendor is a surprisingly labor-intensive task, and it is important to let the vendors know of your selection as quickly as possible.

Upon receipt of each proposal, check to see that all the items requested in the RFP are present. As soon as the deadline is passed, organize the proposals so that they may be easily compared. Develop a rating system that everyone agrees upon; give each person on the selection committee a set amount of time to scrutinize, compare, and rate the responses.

Narrow the section to no more than three vendors and observe the selected systems in use.

- At large museums, the vendors may be asked to demonstrate the system.
- At medium-sized museums, ask the vendors to come and demonstrate, suggesting that staff from other museums in the area be invited as well.
- At smaller museums, have staff attend a national or regional professional meeting where vendors regularly demonstrate their products.

After the demonstrations, contact colleagues at similar institutions who have already installed each of the systems under consideration. Ask them to tell you honestly what they like and don't like about the system; ask about the vendor's responsiveness and any unanticipated costs they encountered during or after installation. If at all possible, the internal selection committee should visit another museum site where the system is installed and running.

It is then time for the committee to reach consensus on the product.

CONTRACT NEGOTIATION

Once the vendor is selected it is time to buy. Even if the system is for a single user, it is advisable to have a contract with the vendor outlining exactly what is included. The proposal provided by the vendor in response to the RFP is the cornerstone of the agreement and should be referenced in the contract. The contract need not be elaborate. Many vendors will provide a sample contract that both parties are free to amend as long as they both agree on any amendments. The contract should set dates for acceptance of the system and a schedule of payment to the vendor. (See chapter on Contracts).

IMPLEMENTING A COLLECTIONS MANAGEMENT SYSTEM

IMPLEMENTATION

The who, what, where, when, and how of a computerized file management system come together in a concrete fashion during the implementation process. During implementation, the system manager, using the chosen hardware and software, strives to achieve a working system. The adequacies of the chosen system, hardware, software, and site need to be tested during the initial implementation process. During the course of implementation, the objective is to identify and correct defects so that the ultimate goals of efficiency and productivity can be achieved.

SITE PREPARATION

Site preparation takes into account the safety and efficiency of all aspects of the system: hardware, software, and the people using the equipment. Sites can take many forms, each of which requires a different type of preparation. Sites can be centralized or dispersed, independent or connected, permanent or mobile, and specialized or general.

Centralized vs. Dispersed

Centralized sites avoid the need for extensive networking and may allow for the design of a specialized computer room. Such a room should provide maximum efficiency of computer use: easily available technical support, comfortable and safe working conditions, tight security, etc.

Dispersed sites allow for customized or specialized work stations that fit the needs of particular museum users. For example, registrars can enter acquisition information, loan inventories, etc., from their work space without having to take materials into a central area with more traffic flow. Likewise, conservators can set up a work station to use when doing condition and/or treatment reports, or secure work stations can be set up for visiting researchers in areas that will not be in the way of other museum functions.

Independent vs. Connected

Whether sites are centralized or dispersed, connectivity may or may not be desirable.

Connected sites permit easy communication, standardization, and control, but these networked sites almost always necessitate a system administrator, increased security, higher costs, and modifications to architectural infrastructure. Wiring a museum for networking can be a problem; the construction of many old buildings that house museums is so solid that passing cables through walls, ceilings, or floors may not be possible. In these cases, wireless networks may be the solution. Thinking ahead and wiring during times of remodeling or new construction when a museum's computer networking infrastructure can easily be installed will save money and headaches in the future.

Permanent vs. Mobile

The mobility of a computer site is also important to consider. Permanent workstations usually provide greater computing power, full-sized keyboards, and larger monitors. When computing sites are permanent, ergonomic furniture, lighting, and security issues are also easier to resolve. The ability to move computers, however, is advantageous in many situations. Computers can be taken into collection areas for direct data entry during inventory, condition checks, or environmental monitoring. Having the means to take computerized records or images to meetings, libraries, and off-site locations is convenient and can solve potential access and security problems. Mobile computing, however, has its drawbacks. Theft becomes a greater issue when using small, portable computing equipment and, if networking is required, using a wireless system becomes the only practical solution.

Specialized vs. General

Computing sites can be specialized or generalized. Specialized sites are advantageous in that they allow for the customization of space, furniture, security, hardware, and software. Not having to duplicate particular items of computer hardware or software at each computing site can save substantial amounts of money. On the other hand, having to order, configure, and maintain custom equipment can be very

labor intensive, and museums may opt for both spaces and equipment that are standardized. Having generalized work sites can save large amounts of time in maintenance and upgrades and can potentially save money by allowing for quantity discounts when purchasing hardware, software, and furniture.

Whatever the configuration of computing sites, the computers and/or network equipment should be assembled and tested prior to installation. If possible, the main data storage units should be kept in a secure area where they are accessible to authorized personnel but protected from vandalism and theft. Diskettes, backup tapes, and other portable data storage units also need to be secured in a safe place.

Like other machinery, computer hardware should not be exposed to extreme changes in temperature and humidity and should be protected from particulates (dust, crumbs, etc.), liquids (leaky pipes, spilt coffee, etc.), and other debris. Adequate and stable energy sources and sufficient access to them should be provided to avoid data loss and undue stress on the computer hardware. Electrical outlets, telephone, and network connections are usually included in the plan for installing or upgrading computerized file management systems. Like other electrical equipment, computer hardware should be placed in a low static area away from magnetic fields. Wires and cables should be isolated in such a way that people do not walk or trip on them, equipment does not roll over them, and animals do not chew them. Cables and the backs of computers should still be easily accessible. System disks, warranties, and other legal documentation should be safely stored in a place where they will be safe but accessible when needed.

Many work-related injuries are caused by inadequate equipment and poorly designed work areas. Chairs and work surfaces should be ergonomically designed and organized to avoid injuries from typing at a keyboard, sitting, and viewing a monitor. Light sources should be as low as possible; focusing them away from computer monitors will help eliminate eye strain.

The goal of an efficient work space is data integrity. Ideally, a work space will provide enough space to organize necessary paper work and support documentation without jeopardizing the quality of data entry or the safety of equipment and objects. If accessioned objects are to be worked with at the computer for cataloging, condition and/or treatment reports, etc., the work space must be arranged to eliminate the risks of knocking pieces over, placing documents or other objects on top of them, or losing pieces altogether.

SCHEDULE

The schedule for implementing a computerized file management system can be divided into two stages: installation and execution. The actual time needed to develop a functioning system will depend on the hardware and software planning and testing that was undertaken prior to implementation. The implementation process actually begins when a museum first undertakes a needs assessment and concludes that change is needed and can be achieved. Whether a museum chooses an in-house solution to meet its computer needs, purchases an off-the-shelf product, or hires a programmer to customize a system, the same implementation process is required: analysis of the institution's needs; assessment of available resources; evaluation and selection of a system; and purchase, installation, and testing of the system.

Expect the conversion from the old to the new system to take a certain amount of time. At a minimum, conversion to the new system will involve training existing employees to use it. If importing files/data from another system is needed and possible, converting and getting the data ready for use in the new system may be quite time consuming. Find out how this conversion will work prior to starting the implementation process. At the other extreme, an interruption in the use of your file management system may involve hiring and training new employees to transfer data manually (initial entry from manual card files, individual "tweaking" of computerized records, etc.) and training existing employees on future applications.

Good system design results from reverse engineering. Determining the needed results ahead of time will lead to the appropriate software and hardware. Many museums start a new system without knowing what they will or will not be able to do with it. This usually results in increased "down time" of the system, general frustration, and low morale. How these factors affect individual institutions depends on size, type of system, and type and frequency of use. Ideally, scheduling will be structured enough to be completed at a time that is appropriate for the museum (taking into consideration impending deadlines needing system-generated data or reports, etc.), yet flexible enough to allow for unpreventable or unexpected set-backs (sudden limitations in staffing or staff time, faulty hardware or software, etc.).

TESTING

Testing should be done in stages. A museum should know the quality of the hardware, software, and technical support available for a product prior to purchase and certainly prior to the testing process. During the testing process, the museum should derive the actual long-term cost of the system in staff time. This includes the length of time it takes staff members to be trained on the system, enter data, conduct queries, generate reports, and make changes in the system's format. Initial testing is best done by those designing or installing the system. Secondary testing is essential and should be conducted by the day-to-day users of the system; small, workable amounts of actual data should be used for tests. All desired operations of the system should be tested, as should vendor's claims about capacity and performance. Although this may not prevent software errors that result from using larger amounts of data, more files, or different configurations of data, it is an initial, short-term way of testing a system.

DATA MANAGEMENT

Data are both a resource and an asset. The data preserved about an object give that object its depth of meaning and value. An automated system opens up new avenues of access to the information recorded about an object, and the most important element of any information management system is the data that are entered into it. Poorly managed information in a manual system will continue to be poorly managed information when moved into an automated system. All of the expected benefits of automation, especially the sophisticated searching, comparison possibilities, and statistical reporting, will not be met if the data is inconsistently entered and controlled.

When choosing an automated system, a museum will review its requirements and intended uses. The institution will examine how information is currently maintained in paper files or in an existing automated system. It will determine how a new automated system will streamline existing processes and how automation will increase its current capabilities. Perhaps a data model that outlines how information will relate to other information in the automated system will be developed. The institution will understand what it expects of a new automated system before that system is installed.

The collection system manager should undertake an inventory of existing documentation systems and standards, both manual and automated, to determine what departments or individuals collect and record data and how they do so. This will not only identify data sources within the museum, it will also help to determine what data should be used in a new automated system and by whom it is to be provided or entered.

When information is added from a variety of sources, each source must be responsible for the accuracy and consistency of its information. Each department must understand its responsibilities toward the object and the object's documentation; everyone needs a clear idea of precisely where in the system they enter their data and how it relates to other information and other users. If there are a large number of sources for the data, it is a good idea to route the entered record to one person, often a registrar, who can review it for accuracy and consistency.

Data entry and upkeep are expensive processes. In the past, much of the expense involved the cost of storing data on-line. Now that there is much greater memory capability for many computers, the cost of storing large amounts of information is much lower. The cost of entering that data, however, can be prohibitive. While it is useful to access all the available information about an object in an automated system, there may be data entry constraints. Not all data must be entered on-line; it is perfectly acceptable for certain kinds of information to remain in a manual system that has pointers from the automated system. For instance, complicated dimensions, bibliographic references, long descriptions, and detailed provenance information may all remain in a manual file, each with some indication in the automated file that directs the user, such as "see curatorial file for provenance."

Define what the institution considers to be the minimum content of a record to identify, locate, and otherwise control the object. All information that goes into an automated database should be dictated by the museum's needs and not by the computer system. It is not necessary to enter data just because there is a field in an automated system that will accommodate it. Create documentation standards that will guide users to enter correct and complete information concerning an object. It may be possible to program an automated system to prevent users from adding new records unless they enter certain fields, such as a location or an identifying number.

For guidance in developing documentation standards for an institution, it may be useful to review "Minimum Information Categories for Museum Objects" (MICMO), currently being developed by the International Documentation Committee

(CIDOC) of the International Council of Museums (ICOM). This project aims to provide guidelines, especially for small museums and museums in developing countries, for the development of documentation standards that will aid the museum community in preserving information for identifying, locating, and controlling objects. While not yet regarded as a official standard, MICMO is a useful resource for provoking thought and discussion about what information a museum currently records about its objects.

DATA DICTIONARY

When a museum is developing Data Content Standards, creating a data dictionary can provide the institution with a powerful tool for documenting and preserving information about those standards. A data dictionary furnishes a definition of each of the fields or data elements that combine to create a documentary record of an object. Assembling a data dictionary offers a museum the opportunity to examine the nature of the information it preserves about an object by breaking it up into data elements and documenting those elements.

Data dictionaries are particularly valuable in a museum that has more than one department entering information about an object. A data dictionary entry guides users throughout an institution to enter data consistently. When provided with a data dictionary, each department has documentation that details the scope of its own and other departments' responsibilities for entering data concerning an object. It is also helpful to establish a cataloging manual in conjunction with the data dictionary. Such a manual outlines the steps required to catalog an object within an institution and those a cataloger must take, working with the data dictionary, to enter data into an automated system.

While a data dictionary will usually be developed in-house, it also may be provided by the vendor of an automated collections management system. If the vendor has provided a data dictionary, users should review it carefully, determine if they agree with the vendor's definitions for the data elements, and revise it, if necessary, to suit their own particular needs.

Data dictionaries do not require a set amount of information; when developing a data dictionary, concentrate on those things that assist in effective use of the documentation. A selection of the following information can help create a data dictionary entry:

Database Name/File Name:
In a relational database there may be more than one file into which information is entered. Identify the file where the user will find this particular data element.

Field Name:
The name of the category, field, or data element.

Attributes:
Identify the attributes of the field. Note whether it is of fixed or variable length, alpha/numeric, repeatable, etc. Note if there is a controlled vocabulary that will verify this field or special key stroke commands or controls that are required to use this field.

Access:
Identify which departments or users may access this field and enter or change data within it.

Description:
Define the field, stating its purpose and the character of the information that will be entered.

Data-Entry Rules:
Provide a list of conventions for data entry in this field. Note any exceptions to the rules; for instance, is a different standard applied to backlog records? Note, among other things, whether names are inverted or if dates are entered month or day first, etc. If an authority or controlled terminology is in use for this field, provide directions for using the authority and definitions of controlled terms, or direct the user to the appropriate information.

Examples:
Provide examples of data entered in the field.

Indexed:

Note whether the field is indexed.

Remarks:

It may also help users if you note whether the field is related to other fields in the database or in another database.

Sample data dictionary entry for an accession value field:

Database Name:

Collection File

Field Name:

Accession Value

Attributes:

Fixed length, 12 characters, numeric

Access:

Registration only

Description:

The monetary value placed on the object when it came into the collection, i.e., the purchase price, donor-stated value of a gift, or the appraised value of a bequest

Data-entry Conventions:

1. Accession value is entered once and never updated. All changes to the value of the object are entered in the Insurance Value field.
2. Enter the value with no commas.
3. Press the period key [.] to end entry of the dollar value. The program automatically rounds to the nearest dollar.

Examples:

2000. (will display $2,000.00)
3. (will display $3.00)

Indexed:

No

Remarks:

See also Insurance Value field

Useful data dictionaries are never created in a void, and no matter how thorough the documentation is, there is always a unique problem or detail that will be exceptional. Meetings with users provide the opportunity to discover elements of information that each field entry in a data dictionary can and cannot accommodate. Meetings should include information supervisors such as curators and registrars, should be regularly scheduled, and should be goal-oriented:

- Hold meetings with users while the data dictionary entry is being developed.
- Listen to suggestions and implement them.
- Use meetings as an opportunity to build consensus, because data dictionary conventions that are imposed on users will be ignored.
- Always provide a reason for a convention; users are more likely to use a data dictionary that makes sense.

Finally, data dictionary entries constantly evolve and adapt to new uses and unique situations. It is essential that they be kept up to date; otherwise, users will not be able to depend upon them as a reliable and definitive source of information.

DATA STANDARDS AND VALIDATION

In a museum, there are many different applications of standards and many contexts in which they are used. Data Standards focus on how information is structured and entered in a collections management/cataloging system (manual or automated) and how that system maintains the information and provides a framework through which the information may be retrieved and manipulated. Data Standards are concerned with three elements: structure, content, and value.

Data Structure Standards provide guidelines for the structure of a documentation system: what constitutes a record, what fields or categories of information are considered essential information, what fields are optional, and how those fields relate to one another. Data Structure Standards determine how much and what kind of documentation will meet the organization's criteria for security, accountability, and access to the object. These standards are established both by the strictures of

the automated system and by the demands of the museum. It is the museum that should choose all the categories of information that are required for its needs. An automated system may determine the structure of the files and how information is recorded, but it should never determine what information is recorded.

Data Content Standards provide guidelines for defining each individual data element or field and what information should be entered into it. Data Content Standards clearly describe the content of a defined field or data element and provide guidelines for controlling the syntax, style, grammar, and abbreviations used within each field. These standards are usually internally developed cataloging rules with institutional data dictionaries and procedural manuals that outline the rules and applications.

Data Value Standards determine the vocabulary to be used for individual fields or data elements and the authorities that will build consistency into a database or documentation system. Terminology standards that are used consistently enable an automated system to provide indexes that find like objects quickly and connect them in interesting and sometimes unexpected ways to other objects. A consistent use of Data Value Standards protects the museum's investment in its data and provides many more points of access to an object than can be provided in a manual system. These standards may be externally or internally developed authority files, lexica, thesauri, and controlled vocabularies.

The benefits of the consistent application of Data Standards in a collection management system include:

- Maximum investment in the data in a system
- Enhanced accountability for a collection
- Enhanced access to records and thereby to objects
- Consistency in retrieval of related information
- Enhanced quality and accuracy of the individual record
- Data that adapts more easily to new

technological and documentation developments
- Data that can be exported more efficiently into a new system
- Simplified exchange of information with other programs within an institution or with other institutions

Even when Data Standards have been established and are in use, it is necessary to review and revise them. Examine where they work and do not work. When first organizing the information that will go into an automated system, it may happen that strict controls are instituted for fields that are never used for searching or indexing. Review usage patterns and consider whether it is useful to control information that is not being utilized. There will invariably be object information that cannot easily fit into any organized system. Remember that while the aim of using standards is to be consistent, it is also necessary to be flexible enough to accommodate unique objects.

It is useful to become familiar with current efforts in the museum community to create Data Standards. Already much work has been done to define the categories of information that combine to form a record and the terminology standards to use in those categories. Use these efforts to guide the development of standards in a museum and to avoid repeating work that others have already done.

The following list, by no means comprehensive, provides some information about organizations that are currently involved in the development of standards in the museum community:

The International Documentation Committee (CIDOC), a part of the International Council of Museums (ICOM), is involved with the development of standards in the international museum community. The Data and Terminology Working Group of CIDOC seeks to develop a set of guidelines for an international standard that defines the minimum categories of information required to document, identify, and give access to a museum object—"Minimum Information Categories for

Museum Objects" (MICMO). Other CIDOC working groups that work to create standards and disseminate information to museums internationally are the Archaeological Sites Working Group, the Data Model Working Group, Iconography Working Group, Ethno Working Group, Multimedia Working Group, Database Survey Working Group, Museum Information Centres Working Group, and the CIDOC Services Working Group.

The Getty Information Institute (GII) promotes the development of art information standards, sponsoring the development of the *Art and Architecture Thesaurus*, the *Union List of Artist Names*, and the *Thesaurus of Geographic Names* to encourage institutions to use common terminology and reference resources. The Getty Art Information Task Force (AITF) is one of several GII projects involved in the development and dissemination of standards. AITF has developed a comprehensive set of categories for describing works of art and related images and a format for electronic exchange of information. Contributors include art historians, curators, and registrars. AITF has developed the "Categories for the Description of Works of Art," which is intended to provide standards for art information that are useful to scholars, information managers, and system developers.

The Museum Computer Network (MCN) is an organization that seeks to promote the development and use of computer technology in the museum community. MCN sponsors an annual conference featuring workshops to promote the growth of knowledge and understanding of computer applications for museums. The conference also provides an opportunity for developers to demonstrate products.

The Computer Interchange of Museum Information Project (CIMI) is currently working to develop standards that will encourage the international interchange of information concerning museum activities and collections. CIMI is committed to promoting museum awareness and participation in resources like the Internet, to providing application protocols that will allow museums to exchange information, and to providing guidelines for museums to build uniform databases that can be shared. CIMI hopes to support information exchange among museums for scholarly and research purposes and to encourage the development of practices and services that will make cultural heritage information more widely available.

The Canadian Heritage Information Network (CHIN) offers a variety of services to Canadian museums, including an automated collections management system, advice on documentation standards and new technology, and data dictionary standards for data entry. The organization maintains three national databases of Canadian collections that cover humanities and natural sciences objects and archaeological sites. CHIN is currently evolving into an organization primarily concerned with promoting and supporting the development of documentation standards and computerization in the Canadian museum community.

The Museum Documentation Association (MDA) is an organization that has worked to promote the development of documentation standards in the United Kingdom. The MDA's work has included the development of the "MDA Data Standard," a detailed breakdown of the data elements that comprise object information, widely used in the United Kingdom in both manual and automated collections management systems. The MDA has recently published "SPECTRUM, The U.K. Museum Documentation Standard," which outlines the procedures required to provide documentation for museum objects and for collections management activities and describes the information needed to support those procedures.

TERMINOLOGY CONTROL: RESOURCES

An automated system expands the points of access through which an object or group of objects may be located. Many manual systems use catalog cards that provide only a limited number of access points for information retrieval, such as by accession number, by classification, or by media. An auto-

mated system can provide many additional points of access, and many more in combination with each other. An automated system, however, demands a much greater degree of precision in the use of language for cataloging and data retrieval than does a manual system.

Terminology control is necessary because natural language has a number of different words that mean the same thing (synonyms) and identical words that mean different things (homonyms). If synonym terms have been entered in a field, it will be impossible to retrieve all the similar objects without knowing and searching for each synonym term individually. To control synonyms in an automated system, it is necessary to choose a single "preferred" term and use it in place of all "non-preferred" terms. If homonym terms have been entered in a field, a search on that field will retrieve unrelated terms. To control homonyms, it is necessary to distinguish one homonym term from another, for instance "barrel (container)" and "barrel (firearm component)"; otherwise, an automated system may not be able to differentiate one from the other in a search.

To develop a consistent vocabulary, it is necessary to use some form of terminology control, for instance, an authority list or a thesaurus, for each data element or field in an automated system for which it is determined that there are terminology control requirements. An authority list is a controlled list of terms considered to be acceptable for entry in a field. A list of acceptable vocabulary terms can be assembled for each controlled field and, often, an automated system can verify that only one of the terms from that list has been entered into the field.

Authority lists vary in sophistication. A simple authority list may provide only a set of preferred terms, while a more complex authority list may provide non-preferred terms with cross-references to the preferred terms. It may also provide terms that relate to the preferred term in a broader or narrower sense, and it may provide some levels of hierarchical structure.

A thesaurus is a highly structured authority that defines the terminology and vocabulary that most accurately describe an object or concept for indexing and retrieval purposes. Terms in a thesaurus may be restricted to a selected meaning, because a single meaning serves indexing purposes best. If the same concept can be expressed by two or more terms, one term is chosen to be the preferred term for indexing purposes. A thesaurus is structured to distinguish one term from other similar terms and to note if these terms are non-preferred terms, synonyms, homonyms, variant spellings, narrower and broader terms, or related terms.

It is not necessary to control the vocabulary for every data element in a collection management system record. Focus on those fields that will be essential for indexing and retrieval purposes. Fields in a cataloging and collection management system for which a museum may decide to develop terminology controls include:

- Classification
- Object name
- Subject heading
- Location name
- Medium
- Technique
- Condition
- Geography place names
- Period/style
- Acquisition terms
- Deaccession terms
- Department names
- Artist/maker names
- Artist/maker roles

When considering what terminology controls to use in a database, it is imperative that a museum consider the use of established resources that are available for the entire field before developing in-house resources. While these in-house terminology controls provide a level of consistency for the individual institution, they do not conform to a standard that will unify the whole community of museum users. On a more practical level, developing internal authorities can be a time-consuming

and labor-intensive process. An externally developed authority may help a museum avoid repeating authority work that has already been done and has been accepted as a standard by the museum community. Internally developed terminology controls will reflect only the content of the local collection and, often, will lack a hierarchical structure or links to related terms, unless the users have spent time building an authority in accordance with standards developed by the International Organization for Standardization (ISO).

When an institution chooses an external standard, it joins a larger group that uses those standards and contributes to the development of consistent terminology controls throughout the museum community. An externally developed authority will provide a carefully developed and structured framework for its users in accordance with international standards. There are some disadvantages: It takes time to familiarize users with an externally developed authority, terms that are irrelevant to an individual museum's collection will be included, and updates may take some time to reach users. The benefits of an externally developed authority are that a community of users have agreed on the use of the terms and have contributed their expertise to develop the terminology. If the developers of the terminology are committed to long-term maintenance and updating of the terminology and structure of the authority, the benefits far outweigh the disadvantages.

AUTHORITIES AND LEXICONS

There are many projects that have developed terminology and terminology standards. A sampling includes:

The *Art and Architecture Thesaurus* (AAT) is a thesaurus of art-historical and architectural terminology developed as a controlled indexing language for use by libraries, archives, and museums in cataloging book and periodical collections, image collections, and museum objects, particularly art-related objects. AAT terminology has been validated by users in the scholarly community and includes index terms that may be used to control a variety of fields in a cataloging/collections management system, including object names, object genres, attributes, style and period terms, people roles, materials, and techniques. The AAT provides a list of single concepts arranged both alphabetically and hierarchically. It is designed for use in indexing and retrieval. The AAT continually develops terminology and is especially responsive to user feedback. It is available in both an electronic and a print edition and is sponsored by the Getty Information Institute (GII) of the J. Paul Getty Trust.

ICONCLASS is a system of iconographic classification designed to provide subject and content terminology for art and historical visual images. ICONCLASS features a series of decimal codes with a hierarchical structure. It has nine main divisions that feature the primary subject headings of Religion and Magic; Nature; Human Beings, Man in General; Society, Civilization, Culture; Abstract Ideas and Concepts; History; The Bible; Literature; and Classical Mythology and Ancient History. Within these numbered divisions are additional numbers and letters that, when combined in a string, represent important elements in an image using a descending hierarchy of concepts, beginning with a major concept such as "History," and ending with a specific concept such as a precise event in history.

ICONCLASS is not the only system that concentrates on subject content. Other projects include the Garnier System (Thesaurus Iconographique, Système Descriptif de Représentations) used widely in France; the Yale Center for British Art Project; and the Glass System (Subject Index for the Visual Arts) developed for the Victoria and Albert Museum. ICONCLASS is available in English in a 17-volume print edition from the Royal Netherlands Academy of Arts and Sciences.

The Revised Nomenclature for Museum Cataloguing (Nomenclature) is an authority list of object names for man-made artifacts designed as a tool for cataloging museum collections; it is particularly useful for collections of historical objects.

Nomenclature is indexed alphabetically and hierarchically. Object terms in the *Nomenclature* system are based on the original function of the object, with hierarchical divisions that include Structures, Building Furnishings, Personal Artifacts, Tools and Equipment for Materials, etc. Under the category Building Furnishings, additional subdivisions include Bedding, Floor Covering, Furniture, etc. Object terms are inverted with the noun first, followed by a comma and the modifier: e.g., Chair, Dining; Chair, Easy; Chair, Folding. In an alphabetical listing of object names, all the chairs or other like objects will appear in the same place in the list. Preferred terms are displayed in caps and non-preferred terms direct the user to the preferred terms. *Nomenclature* is available in a print edition and is sponsored by the American Association of State and Local History (AASLH).

Thesaurus of Geographic Names (TGN) is a thesaurus of hierarchically arranged geography terms to aid libraries, museums, and archives that enter and index geography terms for object and people records. Place names are arranged in a structure that illustrates their context in terms of broader and narrower localities, and the thesaurus features preferred and non-preferred terms. Available in electronic form, TGN was developed by the Vocabulary Coordination Group, a project of the Getty Information Institute (GII) of the J. Paul Getty Trust.

Union List of Artist Names (ULAN) is neither an authority list nor a thesaurus. It was developed to serve as a terminology resource for museums, libraries, and archives that research and use artist names. It is a database that lists approximately 200,000 names that are linked to 100,000 individual artists. ULAN features a "cluster" format that displays and links all the variant spellings and versions of an artist's name, as well as basic biographic data that includes life dates, roles, and nationality information. It is up to the user to choose the name that is preferred for cataloging and indexing, although ULAN provides some helpful information concerning the sources of the names and the use preferences of the sources from which the names have been drawn. It is available in both electronic and print editions and was developed by the Vocabulary Coordination Group, a project of the Getty Information Institute (GII) of the J. Paul Getty Trust.

The above-mentioned projects do not form a comprehensive list of available resources. Other terminology projects include the *Social History and Industrial Classification* (SHIC), widely used in the United Kingdom to provide classification terms. It is available in a two-volume print edition, published by the University of Sheffield, Centre for English Cultural Tradition and Language.

The *Library of Congress Thesaurus for Graphic Materials: Topical Terms for Subject Access (LCT-GM)* is designed to provide terms for subject content of images in library and archival collections. *The Library of Congress Descriptive Terms for Graphic Materials: Genre and Physical Characteristic Headings*, developed to provide genre and media terms for image collections, features hierarchical and alphabetical display with broader and narrower terms and related terms. The *Hertfordshire Simple Name List*, sponsored by the Standing Committee for Museums in Hertfordshire, is an authority list for museum object names with an alphabetical display that features broader and narrower terms.

DATA ENTRY

TRAINING

Museums have begun to hire technical personnel to oversee computerization efforts, such as programmers, system technicians, and system managers. This new class of museum professionals may have no background in museology or even the subject content of the museum, but they do have highly developed computer skills. They will require training in museum standards and the way museum professionals handle information about their collections. For example, a programmer may not understand that the title of a work is not the most important information about it. Another area that may require attention is the importance of data security for particular fields and limiting access to confidential information about works in the collection.

These new museum staff should be encouraged to be active members in professional organizations, such as the Museum Computer Network, the International Council of Museum Documentation Committee, and any special interest groups that address computerization's effects on collection documentation and information dissemination. Annual meetings held by such organizations offer updates on new technologies and the sharing of case studies that allow ongoing professional development to take place. These memberships should not preclude participation in any non-museum oriented groups devoted to computers.

In lieu of a specific position dedicated to overseeing the development and use of computers in the museum, usually one or several people on staff will act as surrogate gurus. While their developing expertise should be encouraged and supported, undue pressure should not be placed on them to provide all the computer expertise for the museum. It is not uncommon for a designated group of gurus from different departments to be trained. They, in turn, go back to their departments and train their colleagues.

Training responsibilities can be divided into two categories: initial and ongoing. Initial training is generally for those who are new to a specific software program and must be shown the basics. Such training must be repeated whenever a major change in hardware or software takes place, such as the installation of a network or a new collections management system. Ongoing training includes keeping the museum staff informed of software upgrades and new software and can often be as simple as reminding staff of the importance of good housekeeping for computer files or the importance of backups.

Staff training can be accomplished through different methods, including outside training, contracting with private companies, vendors, and individuals. To receive outside training, staff travel to another location to learn a specific program or programs. Museums located on university campuses or those with access to such facilities can explore options offered through staff enrichment programs focusing on computer use.

Vocational or technical colleges provide similar programs. A determination has to be made whether it would be a good investment for the entire staff to go for outside training or if it would be more efficient to send one member who would come back and conduct training. Museums purchasing proprietary museum software can explore offers by the vendors for training sessions to teach their particular programs.

With in-house training, private companies, vendors, or consultants come to the museum to conduct training for staff. This allows more flexibility for the museum, which may find it difficult to operate with staff members away. If it is decided to keep all training in-house, the museum might foster an in-house user group that meets periodically to exchange issues and ideas. Many museums have in-house newsletters with tips. Collegial sharing of information through newsletters, users groups, and conferences greatly demystifies computer use.

Training staff to perform data entry is the most exacting computer task within a museum because of the need to establish an accurate database. Training data-entry personnel for this task has been effectively accomplished by many museums through the use of data standards and carefully designed manuals to explain the process. (See section on Data Dictionaries.) The fewer decisions the data-entry person has to make, the cleaner the database. It can be beneficial to hold regularly scheduled training sessions for those working in various areas of the museum. These classes can be presented by staff members whose job it is to oversee the production and maintenance of the data being collected and entered.

DATA ENTRY

Data entry into a new system can be one of the most expensive and time-consuming aspects of implementing a collections management system. It must be planned as carefully as other aspects of a computerized collections management system. Furthermore, data entry is never completely done unless the collection is static. Not only does retroactive data entry often have to be done, but responsibility for ongoing data entry must be delineated. If there are data in "machine-readable form," then there is a good chance they can be "mapped" by the vendor into a new data structure. It is a good idea to plan this within a computer project rather than reenter all the data from another system manually.

When there are no data in machine-readable form, they must be entered into a system. The museum may have personnel enter data from cards or catalog sheets. This takes a long time because the source material is often inconsistent and because there is a tendency to record all the information possible for a given object into the database. It is generally better to identify 10 or 12 key fields of data to enter for each object so that there is a minimal identifying record for each object. It can be elaborated on later, as time permits. Data entry by hand can be exceedingly slow. Six to 10 records per hour may be

entered, if a data entry person is really fast. Even at 10 records per hour, that is only 60 to 75 records per day, 300 to 450 records per week, or (assuming a 48-week year) about 14,400 to 21,600 records in a year. Even a collection of modest size would require hiring a full-time person to do nothing but data entry.

There are other ways to enter data much more quickly, enabling a museum's staff to use the collections management system shortly after it is installed.

SERVICE PROVIDERS AND SCANNING

Some system vendors will take data, usually in the form of catalog cards, and enter the key fields for an extra fee. Most vendors will provide this service only to museums that have purchased collections management systems from them, but there are some service providers that will turn records into machine-readable form that can then be loaded into any software purchased by the museum. The MCN maintains a current list of vendors and consultants.

Another option for data entry entails scanning the cards or catalog sheets into a word processor and then editing the resulting files, parsing the data, and adding breaks and markers into the text. This prepares the data for mapping into the collections management system. Scanners are becoming more and more accurate, but extensive editing is still required.

PLANNING DATA ENTRY

A commitment to record all current collections management activities on the computer as soon as the database structure is up and running is important, and a plan must be made for the systematic data entry of backlog records. Priorities for data entry may be determined by the museum's mission. For example, an art museum might plan to enter the most valuable items in the collection first to accommodate insurance tracking and reporting. A history museum might choose the items currently on exhibit.

It is logical to enter backlog records chronologically, working from the most recent to the oldest. Other approaches may be based on object type, donor or source, least problematic, or objects currently loaned out. Whatever the priority, a goal-oriented plan should be drawn up to complete data entry systematically and make the database useful immediately.

Develop a system for keeping track of progress; count or estimate the number of paper records and measure daily progress against this total. Objects with no accompanying records should be dealt with by giving them current numbers, assigning the source information as "found in the collection," and entering minimal working fields for each object.

DATA CLEANUP

Raw data can be entered as they exist and cleaned up later, or they can be corrected before or during data entry. Cleanup during entry will necessitate using highly skilled data-entry people who have subject-specific knowledge and understand the need for consistency. Cleanup during data entry rarely works, so a plan must be developed to clean up data either before or after entry.

Cleaning up data before entry will almost double the time required to get a database up and running. You must first transcribe the existing data to another paper form with a standardized format and correct for content, spelling, and punctuation. This procedure yields good results and allows the use of minimally skilled people for data entry, but it is very time consuming.

Most museums cannot afford the time required to correct data before data entry, and must therefore rely on cleaning them up after they are entered. Reports can be generated for registrarial or curatorial editing, with subsequent corrections made individually or globally, depending on the type and amount of information being corrected.

PROOFREADING

Human beings make mistakes, and any computer database will reflect the errors of the person who entered the data. If minimally skilled people enter data, the chances are great that many mistakes in spelling, punctuation, capitalization, etc., will occur. These mistakes may be derived from the original paper records. It is important for the person overseeing the project to identify the source of the errors and take corrective action. A representative sample of entered records, selected either randomly or in conjunction with another project, should be proofread on a regular basis. Proofreading and corrections should be the responsibility only of the person in charge of the project. Error-prone data-entry personnel should be replaced if they cannot improve.

SYSTEMS MANAGEMENT AND INTEGRATION

SYSTEMS MANAGEMENT

Management is the backbone of a computerized file system. Systems management, supervised by the system administrator, involves the maintenance and protection of the system hardware, software, and data and their integration into museum operations. While the system administrator is the designated leader, all individuals using the system should take part in systems management. Researchers and other individuals who may have access to the system should be trained in how to report problems, whether they are glitches or inconsistencies in the directions for using the system or malfunctions in the computer; and staff members should have an efficient means for communicating their needs to the systems administrator.

Systems management in museum settings may include scheduling with an in-house system manager, on-line technical support from an outside vendor, data-logging notebooks or "bugsheets" that are periodically reviewed, and faxes and phone calls to non-institutionally affiliated technical support advisors. Effective systems management relies on honest and thorough communication among all individuals working with or supporting the system. An institution with many computer applications may designate a systems manager and a program administrator. The registrar is often one or both.

MAINTENANCE

Maintenance relies on thorough and efficient communication between system users and system managers. While scheduled maintenance tasks—such as backing up, spot-check testing of data, and monitoring for dust and debris in keyboards and on monitors—should be conducted regularly, meetings with systems users to determine the continued usefulness of the system as a whole are also a part of general maintenance. If the system no longer functions at its maximum level of usefulness, changes or upgrades should be considered and imple-

mented if possible. Many institutions with independent workstations face the simple question of whether or not another staff member has acquired or is in the process of acquiring certain types of data. Maintenance of the system involves centralizing information so that all users can report what they have completed, what they are working on, and what projects using the system may be ready to start. The systems or program administrator should maintain a master schedule of projects and progress.

SECURITY

A computer system, with the information it contains, represents a major institutional investment. Just as employees are informed of the general museum security plan, users of the computer system must be educated regarding electronic security. There are three main aspects to computer security that are very similar to the security requirements for a museum collection:

- It must be protected from physical loss or damage by human actions or environmental causes.
- Information must be protected from unauthorized changes or deletion, either by accident or design, with possible criminal intent.
- Information that must remain confidential for legal, ethical, or security reasons must be safeguarded. Confidential information includes normal collections records regarding donors, valuations, and storage locations; museum security systems and procedures; and employee records and personnel files.

An institution with more than two employees, or one that is part of a wider electronic network, needs password protection for its computer system. For relatively simple systems, single password entry may be sufficient. Do not rely on screen-saver password programs; they are easy to defeat. If a system has multiple users, is on a network, or relies heavily on computerized collections management data,

a hierarchical system of passwords should be in place. Password protection can cover an individual's files or the official museum records. Levels of access and authority can range from total restriction to "read only" access, to the capability to add information, to the capacity to change or delete information. Confidential fields in a database may be restricted to owners of certain passwords.

A password is most secure if it is a random string of upper- and lower-case letters and numbers. However, it is also the most difficult for the user to remember, at least initially. Random passwords are worth using for the highest levels of access and security. Lower-level users may have passwords that they find more memorable. Care should be taken to choose passwords that are not easy to guess. For continued effectiveness, passwords need to be changed periodically.

To protect the museum's records against an external threat, it is possible to construct an electronic firewall to prevent unauthorized access. Security systems, however, are not foolproof. Much like professional burglars, hackers have the knowledge and the "tools" to defeat security systems.

Computer viruses are another external threat. These are programs that interfere with the normal operation of the computer system. Viruses are carried by vectors such as free programs, utilities, and games and by infected diskettes. They are caught by opening or executing the program file that contains them, or by a program command to initiate when the computer's internal clock reaches a particular time and date. Vaccines exist in the form of virus detection and eradication programs, but they must be used conscientiously and updated frequently to be effective. To prevent contracting viruses, users should not be permitted to install personal software or software downloaded from external sources such as computer bulletin boards.

Physical security includes not only restricted access but also favorable environmental conditions. Computers should be cleaned and maintained on a regular basis. Much like collections objects, computers and computer media require a relatively high level of environmental control. They are especially sensitive to heat. Keep computers and media at an even temperature and away from windows and internal heat sources. Avoid power surges by using a good suppressor and an outlet dedicated to computer equipment. Other electrical appliances and equipment, especially heavy power users, should be plugged into a different circuit. If outages are frequent, consider investing in an uninterruptible power source. In any event, keep hard copies of computer files and backup media in a separate, protected location. For computer media, this includes protection from magnetic fields, such as those in telephones, office magnets, and electronic equipment, including computers themselves!

BACKUPS

Unlike museum collections items, information can be duplicated. A regular backup schedule is the key to a computer disaster recovery plan. "Backup" can be used as a verb or a noun, referring to creating a copy of computer files or to the copy itself. As a precaution against information loss, this activity is so important that it must be considered when choosing computer software and hardware. When determining a backup schedule, the key question is: How much work can the museum afford to lose? The frequency will depend on how often computer files are updated or how fast information is added. Full backups—copies of everything on the computer system—can be made periodically, for example, monthly. Incremental backups—copies of all files that have been added or amended—can be scheduled more frequently.

Very active or very cautious computer users may wish to maintain backups of their own files, but generally, a system manger is responsible for the backup program. The process of backing up computer files on a networked system is best done at slack times (at night or on weekends) as the activity degrades computer performance and currently open files are not included in the backup. The backup system can be fully automated, so a system manager need not be physically present dur-

ing the process. Computer backup media exist in a number of different formats, e.g., magnetic tape, disks and diskettes, optical disks. Each has advantages and disadvantages based on the medium's reliability and cost per byte of data stored. For the short-term purpose of backing up files, longevity of the medium is not a critical factor, but the ability to reuse it reliably may be very important and should be researched as part of the cost analysis conducted when selecting a system.

SYSTEM ADMINISTRATOR

Information systems managers or system administrators may interact with the museum in a variety of ways. Whether an outside contractor or an in-house staff member, whether working full-time or part-time, their abilities to train staff, handle unforeseen problems, and manage the overall system play a pivotal role in its success. If the system administrator is a full-time museum staff member, he or she will be the most likely person responsible for trouble shooting, adding and deleting users, and coordinating with other museum personnel for disaster preparedness and emergency backups needed during evenings, weekends, and holidays.

When deciding on a systems manager, museum administrators need to consider both short-term and long-term costs. If staff members are adding systems administration to their already overtaxed schedules, the short-term costs may be low since no new employees are being added, but the long-term costs can be quite high when the employee attempts to find time in his or her schedule to get the system in running order and other employees back to work. Contract system administrators may be cost effective, as they can be used on an as-needed basis; but scheduling these individuals may be difficult or inconvenient.

Ideally, a systems administrator keeps a database of all of the hardware and software for each work station within the museum as well as the types of files and data in use. This ensures protection against problems with software licensing, crashes, theft, configuration problems, and unrelated software that tends to fill up hard drives. For example, with DOS PC workstations, copies of the config.sys and autoexec.bat files with their associated drivers should be kept with the systems administrator. This type of backup is routinely done with larger systems but often is overlooked with smaller PC-based systems.

The system administrator may also be the person responsible for determining whether or not an upgrade to the system is needed and then coordinating the upgrade within the museum. Managing a system involves not only administering hardware and software but also checking and ensuring data integrity. A systems manager should know the percentage of a museum's records that are on-line, the accuracy percentage of on-line information, and how up to date the digital records are. These accuracy data are important for insurance purposes, management and planning, and research. Many times the systems administrator will have museum staff members spot check the data relevant to their particular area of expertise. Systems administrators should also work with museum staff to build redundancy checks into databases. Most important, a comprehensive data backup plan should be maintained and duplicate data sets kept off site. (See section on Backups.)

SYSTEM MANUAL

A system manual can take many forms: an on-line hypertext application, a bound paper manual, or a loose-leaf binder that allows for changes to the system or improvements in documentation. A system manual may include the following:

- Information on the specific hardware and software being used including any identification or serial numbers that may be needed for accessing the technical assistance departments of a specific vendor)
- The names of and ways to contact the systems manager or other technical assistance people
- Policies on systems use
- Instructions on how to use the system

For a system manual to be effective, it needs to provide employees with step-by-step guidance on exactly how to use the system, how to enter the information for which it is being set up, and exactly how to obtain what is needed. A system manual should not be seen as a static document. As technology and/or an institution's computer needs change, the system manual should reflect those changes and continue to provide the service that is expected from it. Currently, many museums do not use system manuals or even have them in place because they are seen as bothersome to produce; and many museums that do have system manuals do not keep them updated because they hope to avoid the cost in staff time. Actually, system manuals can save staff time by answering questions people may have about the system and by serving as a tutorial on systems use. Writing out instructions for what one already knows how to do may seem like an exercise in redundancy, but documenting procedures so that they can be followed by any anticipated user will save an institution time and money in the long run.

INTEGRATION INTO MUSEUM OPERATION

The ideal computerized collections management system involves the entire realm of museum records relating to collections. Links should eliminate the need for entering information more than one time. Museum objects, whether accessions or loans, should be constantly tracked once they enter an institution. Once basic information is entered, the system should be able to produce necessary receipts, loan forms, gift agreements, etc. Bar coding of objects may simplify object tracking while eliminating typographical errors (see chapter on Marking), and the inclusion of visual records greatly enhances a collection management system.

In addition to tracking an object and being a repository for the object's data, the collections management system should make data available to various departments. Terminals or networked computers should be available in storage areas, collections management areas, curators' offices, exhibit design areas, and/or central locations where staff can efficiently utilize the information. Cross links may be made with photo files, exhibition files, and membership and development files to simplify access. Public access within the institution to object-level data can be made with terminals in areas set aside for researchers as well as terminals in exhibit galleries. Public access outside the institution may be made available through the Internet.

Palace of Fine Arts, San Francisco. Photo by Elizabeth Gill Lui.

Kittu Longstreth-Brown, editor

Museums have tried many numbering systems over the years. The most important thing about a number, either permanent or temporary, is that it be unique. It must be the key between the object and the documentation about the object.

Sequential numbering (1,2,3,4) is simple and has been used by many museums, but over time it will not adapt and expand with a collection. Systems with alphabetical prefixes become cumbersome if the prefix refers to a collection category, a geographical location, or a department. All of those categories may become obsolete or inaccurate with the renaming or reorganization of the referenced categories. A prefix may be useful for temporary numbers or for subsidiary collections used for teaching purposes but is not recommended for permanent collections.

Museums with several numbering systems may find their record filing complicated and the systems confusing. Some museums have found it helpful to retire old complicated systems and implement a single standard system, although there can be no attempt to re-number a large permanent collection. A single system applied from a certain date forward will simplify record keeping for current and future activity. Computerization can overcome the difficulties caused by varied early systems if every number used by the museum is unique.

It is important for a museum to be consistent in its numbering systems. Systems must be used for both temporary and permanent holdings, and each system must have its own sequence. If several departments use different systems, they must communicate and make certain that their systems do not overlap. Computerized collections systems often use the assigned number to identify a record about an object, and duplicate numbers lead to confusion.

TEMPORARY HOLDING NUMBERS

A temporary number system helps track objects until they are accessioned and given a permanent number or are returned to the owner. The temporary number may be structured the same as an accession number, as described below, but with a T (Temporary) or other prefix (L for loan, E for exhibition, etc.) to distinguish it; or it may be structured as an accession number in reverse, that is, "16.1996" instead of "1996.16."

PERMANENT ACCESSION NUMBERS

The most common accession numbering system now used is a compound number separated by a point or hyphen. The first number indicates the year the object is accessioned and may be the whole year: 1995; or a part: 995, 895, 001 or 95, 34, 76. The whole year is recommended; if it was not used in the past, it should be started with the year 2000.

The second number indicates in sequence the transaction by which the object(s) was formally received or purchased: 1995.1, 1995.2, 1995.3. If there is only one object in the transaction, the two-part number typically suffices. If title to more than one object passes to the museum in a given transaction, a third number is assigned to each item in the group: 1995.4.1, 1995.4.2, 1995.4.3. If an object is a set or portfolio of objects, the accession number for each individual part within the whole can be 1995.4.3.1, 1995.4.3.2. An object may be one item with component parts, such as a box with a lid, a chest with removable drawers, or a sculpture that can be disassembled. The whole object is

"Collections Management" edited by Allyn Lord. "Numbering" written by Anne Fuhrman Douglas, Connie Estep, Monique Maas Gibbons, Paulette Dunn Hennum, Kittu Longstreth-Brown, Dominique Schultes.

assigned an accession number, such as 1995.5.2, and each part of the whole is given a letter suffix: 1995.5.2a, 1995.5.2b, 1995.5.2c.

In this system, each separate item has its own distinct identification through the accession number. The accession transactions for each year can be accounted for and the years noted separately from each other. The system allows for growth but does not demand it; each year starts with 1 and ends with the last transaction. Parts can be identified with wholes. Future research that changes the intellectual classification of objects will not interfere with an identification system based on when and in what order the museum acquired them.

Subsidiary or departmental number systems that refer to a systematic classification of the objects, the archaeological site of origin, or some other information useful in research may be used within a museum. Cross-reference lists to and from the accession numbers are useful for identification of the correct object, for rapid retrieval of stored information or object location. These different numbers should be maintained separately, using the cross-reference lists to move back and forth.

Reba Jones

Calvin and Hobbes by Bill Watterson

Objects are at greatest risk of damage when they are handled. Planning moves ahead of time and training museum personnel in the safest possible methods of handling can minimize the risk to objects and ensure their survival for the future.

Handling entails care, cleanliness, and common sense. It is important to handle all objects with equal care, regardless of value. The following rules assume that objects are stable, pest-free, and under 200 pounds. Unstable objects should be referred to the appropriate conservator to arrange for treatment. Professional handlers are recommended for monumental sculpture, vehicles, large furniture, etc. (See chapter on Rigging.)

General Rules:

- Wear clean, comfortable clothing with no protruding jewelry, watches, or buckles. Do not wear your ID badge or chain around your neck. Wear clean cotton or thin nitrile gloves unless the object is very slippery (some glass, some highly glazed ceramic, some sculpture) or the object's surface texture or protruding parts will cause gloves to catch. Change gloves as often as they get dirty. Wear an apron or carpenter's apron to hold gloves and equipment. Remove tools from pockets before handling objects.

- Know exactly where you will put an object before you pick it up. Map out a moving operation ahead of time to anticipate problems. Check to make sure doors and elevators are clear and can accommodate the object. Avoid stairs unless absolutely necessary.

- In case of damage, carefully follow your institution's procedures for incident response and reporting. Save and report anything found in storage or a gallery that might have come off an object. Do not try to repair or restore the object; seek the services of a conservator.

- Carry only one object at a time, no matter how small, using two hands. Use two or more people to handle large, unwieldy, or heavy objects; do not hesitate to ask for help.

- Do not hand an object from one person to another; instead, set the object down and have the second person pick it up.

- Do not make sudden or unnecessary movements, and never walk backwards. Be aware of what is behind and around you.
- Move the object in its most stable position, usually in the position in which it is displayed or stored.
- Protect the object from being bumped, skidded, or jostled. Never work with tools over the object. Do not lift one object over another; move objects one at a time to reach those on the back of a shelf.
- Handle each object as little as possible. Bring carts or moving vehicles to the object.
- Use clean pads or carpet squares on the floor or cart. Protect objects on carts from each other with padding (carpet squares, Fome-cor®, bubble wrap). Use tissue between object and padding. Secure any object being moved on a vehicle. Do not put objects of very different sizes or weights on the same vehicle.
- Check carts and vehicles for cleanliness, stability, and movability before loading. For large carts, use three people: one person pulling or pushing; one person on the side to be sure nothing shifts; and the third person to handle doors, elevators, etc.
- Take your time. When handling many objects, work at an even pace, take breaks often, and do not continue to work when you are fatigued.
- Do not eat, drink, or smoke around objects. Confine these activities to an approved area away from storage or galleries.

Framed Works of Art:

- Check to make sure the work is secure in its frame and the hanging device is stable and adequate for the weight.
- Handle the work only by the frame using two hands, one on a side and one on the bottom or one on each side. Do not lift by the top section of the frame. Consider a work oversize or overweight if it cannot be easily handled by one person; always use two or more persons when there is any question.

- Move and set down a work the way it hangs. A work attached to a mount at the top can have hinges displaced by being set on its side. Always carry and set a work in a vertical position, especially if it is under glass.
- Hold a frame by its strongest part. Gessoed and gilded frames are especially fragile; the gilded surface should not be touched. Always hold a gessoed frame by the uncarved back edge and set it on its back edge so the gesso is not damaged. A padded 2 x 4 under the back edge will prevent resting the frame on delicate carved projections.

Unframed Paintings:

- Never touch the front or back of a canvas, and never allow any object to rest on either surface.
- Carry works by the edges unless the design area wraps around. Never let your fingers touch the back of the canvas or your hand touch the front. Place works on padded surfaces such as carpet squares, blankets, or foam blocks.
- Carry large works as close to the floor as possible. Move works too large for carts on sculpture dollies. Use at least three people, two to carry and one to watch for hazards and control the cart.

Works of Art on Paper:

- Handle mounted works only by the mount and in a horizontal position, face up. Use padded trays or carts.
- Lay unmounted works on clean hardboard, face up, and handle on the board. Lift to the board by sliding a card or spatula under the edge and support the entire work from below. Carry works in a tray or Solander® box or between hardboard sheets with tissue or glassine to protect them. Keep the surface level.
- If works on paper are done with charcoal, pastels, or other materials that could be damaged by touching, rubbing, or static, move them individually. Do not stack.

- If unmounted works are in a stack, lift each one off the one below by the separation sheet. Do not slide one work across the work below it or pull one work from under others. Do not let anything rest on the stack. Move stacks in Solander® boxes or deep trays.

Sculpture:

- Check for loose parts, cracks, breaks, and flaking surfaces before handling. Consult a conservator if moving the sculpture might damage it.
- Always carry sculpture in the position in which it is exhibited or stored. Never lift or tug on a projection that is not designed to carry the weight of the entire piece. Do not drag a piece of sculpture.
- Choose cotton or nitrile gloves depending on whether the surface texture or protruding parts can snag. If gloves cannot be worn, wash your hands carefully before handling with a soap that does not contain cream; dry them thoroughly. Always use gloves when handling metal sculpture.
- Protect sculpture with felt or furniture pads. Be sure all ropes or supports are padded. Pad and support all projecting members in transit.
- Always move sculpture on dollies or flat carts. Do not attempt to move large sculpture without adequate help. (See chapter on Rigging.)
- Carry small sculpture with two hands, one under the base and the other steadying the object. Be sure the base is firmly attached before lifting.

Decorative Arts and Household Goods:

- Carry only one object at a time. Use cotton or nitrile gloves unless the surface might catch on the fabric of the gloves or is too slick to be safe (e.g., some high-glazed ceramics, some glass). Carry the object by its body, never by handles or projections. Always check the object for stability before lifting it; separate parts, remove lids.

**CAREFUL HANDLING
 LIKE A MOTHER CAT DOES**

Logo from the Yamato Truck Company, Tokyo, Japan. All over the world, registrars and shippers agree that object movement must be done with great care.

- Always wear gloves when handling metal objects.
- Place the object in its most stable position to move it. For instance, a bowl might be safer on its rim than its base; an umbrella stand might be more stable lying on its side.
- Always rest an object on a padded surface and protect it from other objects with padding. Do not move objects of very dissimilar sizes on the same tray or cart.

Furniture:

- Move furniture in its normal use position. If there are any removable parts (e.g., glass or marble tops), remove and move them separately in a vertical position. Loose or hinged parts (e.g., drawers, drop leaves) should be tied down with soft cords or cloths before moving.
- Handle furniture by its strongest members. Lift chairs by the seat rail, chests from the bottom, and tables by the counter.
- Do not drag furniture. Be careful of pedestals and spindly legs. Pad furniture edges and projections when carrying furniture through doorways or other areas where it may be bumped.

Textiles and Organic Materials:

- Always handle textiles with clean gloves.

- Carry garments already on hangers or mannequins by the hangers or framework of the mannequin, being sure the garments do not drag on the floor.
- Carry fragile fabric, including mounted, sewn, or otherwise attached textiles, horizontally on a support. Separate textiles incorporating leather, fur, bone, horn, etc., from materials that might be stained. Use acid-free tissue or blotter paper between the object and the support.
- If small accessory items (e.g., buttons, beads) come loose, save and label them for the conservator.
- Roll quilts, blankets, rugs, etc., face side out on a storage roll of sufficient diameter, and fully support the roll when carrying it (e.g., on a rod through the roll). If hanging devices are attached or planned, roll the textile so the end to be hung is on the outside of the roll.

Living History Collections:

- The handling rules mentioned above may not pertain to living history collections. Collections policies at these museums may establish more lenient handling rules (e.g., some objects may be directly handled, no gloves or padded carts may be used). Policy development should be a collaborative effort among collections staff, conservators, curators, educators, and interpreters.

Archival Materials:

- Treat archival materials as you would works on paper.
- Always handle with clean gloves.
- Do not fold or roll archival materials.
- Protect photographs, negatives, etc., in Mylar® or polyethylene sleeves or files before handling.

Geological Specimens:

- Handle specimens as little as possible. Breakage and abrasion are the most common types of damage.
- Be sure to have adequate support for very large specimens before moving them.
- Never stack or crowd specimens. Use padding between specimens if they are not separately stored.
- Handle crystals from their base.
- Always wear gloves when handling specimens.
- Use a face mask or respirator and protective surgical gloves when handling toxic materials (e.g., mercury, arsenic, thallium).

Biological Specimens:

- Avoid overhandling specimens and always wear cotton gloves.
- Pick up animal or bird skins by the body, not an appendage, wing, or tail. Carry mounted specimens by the base or the armament. Taxidermy mounts may contain arsenic; always wear non-permeable gloves and a mask when handling.
- Use padded trays or carts to transport specimens.
- Treat herbarium sheets as works of art on paper.
- Move insect specimens carefully and only in their display boxes.
- Handle fluid specimens and fluid specimen jars with surgical gloves.
- Acquire specific training in handling specialized materials (e.g., frozen tissue, microscopic collections).

Holly Young

All accessions must be carefully measured in English and metric units. Paintings are measured face down.
Photo by Peter Harholdt © 1997.

Measurements are used in many phases of curatorial and registrarial processes. Size, weight, and color are important for several reasons. They may assist staff in identifying the object. Size is often a factor in the selection of objects for exhibit or research purposes. Object measurements and weight are used to determine space and material requirements for exhibit cases, storage furniture, and packing crates. As part of the permanent record of an object, initial measurements can help track the condition of an object subject to breakage or dimensional changes.

The equipment used to measure objects ranges from simple linear measures to instruments that allow electronic data capture and record information directly into a computer file. The registrar selects the kind of equipment that will be most useful for the institution, based on three major considerations: the types of objects to be measured, the measurement system used, and the amount of precision necessary.

Linear measures, such as rulers, yardsticks, and measuring tapes, are the most widely available and frequently used pieces of measuring equipment.

They are particularly well suited to measuring two-dimensional objects and very large objects. Metal measuring tapes are the most durable, but can damage the object being measured. Plastic measuring tapes have the advantage of being flexible, but are easily stretched or warped, resulting in inaccurate measurements. Cloth measuring tapes and flexible fiberglass tapes are more durable than plastic and, although they can become distorted, represent a good compromise.

Calipers and osteometric boards are useful for measuring three-dimensional objects. They consist of a linear measuring scale with one stationary and one sliding arm that are used to measure the distance between two points on an object. These devices yield a more accurate measurement of a three-dimensional object than is possible using a straight rule. Digital calipers can be used to record measurements directly into computer data files. Calipers with both straight and pincer arms are useful; pincers are particularly good for recording thickness.

Templates and gauges can be used for more analytical measurements, if necessary. Similarly, color can be measured using standard charts, such as the Munsell Soil Color Chart. When weighing is necessary, there are a variety of electronic and spring-loaded scales and balances from which to choose. A sturdy, easy-to-calibrate triple beam balance is useful for small to medium-sized objects. Tiny objects will require a more delicate balance.

For institutions that include several disciplines, or those that frequently engage in international loans, choosing whether to use an English or metric measurement system is important. Many scientific disciplines and most nations use the metric system, as do many institutions in the United States. For those institutions that use the English system, an alternative is to record measurements in both systems.

Another important issue to consider is the amount of precision necessary. Normally, metric measurements are expressed in centimeters to one decimal place (or the nearest millimeter) and English measure in inches to within 1/16 of an inch. If a measurement falls between significant increments, the reading is rounded up to the larger measurement. If increased precision is necessary, measuring implements must be selected that are similarly fine-tuned.

The registrar should define a standard procedure for object measurement as part of the written procedures of the registration department to ensure consistency among individuals and through time. While inter-observer variability can never be eliminated, it can be reduced, making measurements more reliable. Keeping the equipment clean, calibrated, and in good working condition and properly storing it after use are important components of the measuring procedure.

Use particular care when handling an object for measurement. More so than when simply moving an object, measuring requires a certain amount of manipulation of both the object and the measuring device. For this reason, it is prudent to remove rings, watches, bracelets, pendant necklaces, or other items that may inadvertently come in contact with the object. Hands should be free of lotion or soap residues. Cotton or nitrile gloves should be worn when appropriate. (See chapter on Handling.) Make sure that an adequate amount of space is cleared and prepared for the activity and that necessary auxiliary materials, such as padded supports, are readily available. When using calipers, be careful not to crush the object or damage delicate edges by applying too much pressure. To record measurements, use a pencil rather than a pen or marker, which can inadvertently leave a permanent mark on the object.

TWO-DIMENSIONAL OBJECTS:

In general, height (or length) and width are the two basic measurements taken for flat objects. Thickness should also be recorded for framed or mounted objects. By standard practice, height precedes width.

Paintings: For square or rectangular formats, make at least two measurements from the back of the work in each direction, one at the middle of the stretcher or panel, the other at an edge; record the

larger measurement, if any variation occurs. Record a diameter for a circular painting, and two axes for oval or lozenge-shaped works. Measure the thickness of paintings on heavier supports, such as panels, and those with auxiliary supports, such as stretchers or cradles. If the frame prevents such measurements, record a sight measurement of the painting surface and the dimensions of the frame, and indicate them as such.

Textiles: This category includes two-dimensional items such as flags, rugs, wall-hangings, and bedding. Simple woven textiles should be measured along the weft (stationary element) and the warp (moving element). Be clear as to whether or not fringe, borders, or tassels are included in the overall measurement; in any case, their length or width should be measured and noted separately. More complex pieces, such as flags or quilts, should be measured in two dimensions according to their orientation in use. If a textile has a significant pile or loft, include this as a third dimension.

Work on Paper: Unless otherwise indicated, works on paper are measured along the left side for height, and the lower edge for width. In addition to measuring the paper support, dimensions should be taken of the design area and plate mark if the piece is a print. Historic documents require similar measurements, including the area covered by text. If the paper support has been hinged and matted, consider it an auxiliary support and take the measurements of the mat as well.

THREE-DIMENSIONAL OBJECTS:

Generally, the overall height, length or width, and depth or thickness of these objects should be measured; take these measurements at the point of greatest dimension. It may be practical to take a few additional measurements that are specific to the type of object and that may be important to the identification, display, or use of a particular object.

Amorphous items: At times, objects with odd shapes and no true orientation (e.g., clumps of charred botanical materials, clods of fired adobe, crumpled pieces of metal, slag, fire-cracked rock) will need to be measured. Place the object on a flat surface in its most stable position, and take measurements in three dimensions from that orientation. Record the orientation or draw a simple diagram. A weight is also useful for amorphous specimens.

Boxed collections: Archival paper documents, with the exception of large-format materials, are usually measured by the linear foot. Large-format documents, such as maps and plans, are measured by storage volume. Some repositories measure all archival collections by volume, specifically by cubic feet. This figure is determined by adding the exterior dimensions of the storage containers. Large collections of artifacts and samples that are stored in boxes are similarly measured in cubic feet.

Coins: By convention, coins are measured in millimeters; if an institution is using the English system, a conversion should be made. Measure the diameter and the thickness of the coin. For coins with central perforations, give the internal dimensions of the perforation.

Furniture: The measurements for furniture may be less ambiguous if expressed as height, side-to-side, and front-to-back dimensions. Since dimensions may vary, take several measurements and record the largest. In addition to the basic measurements, measuring the height and depth of seats, and the length of aprons, table leaves, and legs may assist in developing exhibit groupings and identifying particular pieces. Since furniture is susceptible to dimensional changes, areas of loss, decay, cracks, and splits should be noted and measured.

Historic hardware and tools: Record the weight of hardware in addition to gauges. Indicate measurements of handles, including circumference, and working edges.

Natural history specimens: A wide variety of materials falls under this classification. In addition to covering the entire spectrum of "animal, vegetable, or mineral," it includes auxiliary items

such as nests, specimens in various stages of growth, and variously preserved specimens, including mounts and dried or cross-sectioned specimens. Registrars are advised to consult one of the references provided, or to look to the individual curatorial departments for guidance. In general, overall dimensions and often weight will be useful. Specimens in containers may have the container volume recorded as well.

Personal items: For items of clothing, in addition to overall dimensions, tailoring measurements are usually taken, such as inseam length or inside waistband. If a standard size is marked on the object, this can be recorded as well. Accessories, such as hats or bags, should have careful measurements made of applied parts that may be subject to damage, especially feathers or trim. Component parts of jewelry should be measured, for example, the watchband or chain, as well as the watch itself. Measure diameters and restrictions for items of personal adornment such as bracelets or labrets.

Prehistoric tools: Record basic measurements of projectile points, blades, axes, etc.; for artifacts that were originally hafted, also measure hafting features such as grooves, holes, and tangs. The hollowed-out area of artifacts such as grinding stones or mortars should be measured. Elongated artifacts such as awls, needles, or shafts should be measured for length, and diameters or thicknesses at mid-shaft and at the base.

Sculpture: Record standard dimensions; include the pedestal or other support only if it is an integral part of the sculpture. For portraits, record measurements from the proper aspect (i.e., from the depicted person's left or right, not the viewer's).

Toys: Record standard dimensions. Toys made of separate components should have a count of the pieces and a range of measurements given.

Vessels: The objects in this category can be made from many different materials, including botanical materials, ceramic, glass, and stone. For bottles and jars, measure the height and maximum diameter;

other measurements that may be taken include the orifice diameter and the neck height, where the neck is specifically delineated. Similarly, bowls should be measured for height and maximum diameter; occasionally wall thickness is measured. At least three overall measurements should be taken for eccentric forms and other vessels such as scoops or effigies.

Weapons: In addition to basic measurements, record the length of the barrel and size of the bore for firearms. Weapons with a cutting edge should include measurements of the blade and haft.

IMAGES AND OTHER MACHINEPRODUCED/ MACHINE-READABLE MEDIA:

Static images: If matted and framed, these objects should be measured as flat works of art. If they are unframed, record the support and image size for positives. Record film size, length of strip (when applicable), and a count of the individual images for negatives. For slides and transparencies, give a count and the size of the mount.

Moving images: Film and video can be measured in a number of ways, including length in feet or in playing time. Generally, the format and size of the reel or cassette are recorded.

Sound recordings: Although there are many formats, including historic cylinder and wire recordings, tapes of varying sizes and formats, and disks of different media and speeds, sound recordings are generally measured as moving images.

Computerized information: In addition to the above methods of measuring, computerized information can be measured by the byte. Other measures, such as the number of digitized images, should also be recorded.

Marie Demeroukas

OVERVIEW

A good condition report is an accurate and informative account of an object's state of preservation at a moment in time. It provides a verbal and/or visual description of the nature, location, and extent of each defect in a clear, consistent manner. A condition report written by a registrar, curator, or collections manager (as discussed in this chapter) is not the same as a condition report written by a conservator; the former aids collections management whereas the latter is a tool for planning and performing object treatment.

A condition report can:

- Establish the exact condition of an object at the time of a loan or upon its return
- Benchmark the type and/or rate of deterioration
- Differentiate identical objects from one another
- Document an object's condition history, providing past evidence for future problems
- Set priorities for conservation care and treatment
- Suggest a default monetary value on an object in lieu of an actual value for insurance purposes
- Make future handlers aware of seen and unseen problems

TOOLS

A variety of tools are helpful in conducting object examinations.

Documentation

- Soft lead pencils (pens can leave a permanent mark)
- Writing paper
- Examination forms
- Computer
- Camera

Measurement

- Cloth tape measure, without metal caps (caution: some tapes can stretch)
- Calipers
- Clear plastic flexible ruler

Handling/Support

- Clean white cotton gloves
- Nitrile gloves
- Acid-free, lignin-free board
- Buffered and unbuffered acid-free, lignin-free tissue paper
- Padded muslin rolls
- Padded blocks
- Flat-bed dolly

Illumination

- Flashlight
- Pen or crevice light
- Portable incandescent lights, such as a mechanic's drop light
- Ultraviolet light

Magnification

- 10x hand lens
- Jeweler's loupe
- 55x microscope
- Head-mounted magnifier

Miscellaneous

- Hand mirror
- Dental mirror
- Magnet (to identify ferrous metals)

Acknowledgments: Special thanks go to the following authors of Basic Condition Reporting: A Handbook *(3d ed.)—Sharon Bennett, Paisley S. Cato, Mary Giles, Patti A. Hager, Helen B. Ingalls, Elise V. LeCompte, Allyn Lord, Douglas MacCash, Martha Tonissen Mayberry, Anne E. Motley, and Stacey Savatsky. Thanks also to Richard D. Buck, Margaret Holben Ellis, and to Rachel Vargas and the Straus Center for Conservation, Harvard University Art Museums, for glossary terms.*

- Natural hair brushes in a variety of shapes and stiffness
- Probes (dentist's tools)
- Tweezers
- Forceps
- Blow-ball

EXAMINATION

Examine objects in a clean, secure, well-lit work area where eating, drinking, and smoking are prohibited. For small and medium-sized objects, pad a sturdy table or desk with polyethylene foam. For large objects, a padded flat-bed dolly may be useful. Cover the examination surface with clean, white, acid-free paper to help detect signs of flaking, infestation, etc.

Use cotton or nitrile gloves to handle objects. Nitrile gloves are especially important when handling ethnographic and natural history specimens, since many of them were treated with fumigants and chemicals in the past. Nitrile gloves are also smoother and less likely to disrupt loosely adhered paints. Follow all appropriate handling guidelines, making sure each part is properly supported; large, awkward, or fragile objects may require several handlers. Be aware of an object's visible faults, such as cracks or tears, and potential weaknesses, such as weak handles or brittle veneer. (See chapter on Handling.)

Make sure lighting is adequate to the task. **General lighting**, which illuminates the object overall, **raking light**, which illuminates at an angle, and **transmitted light**, which illuminates from the reverse, can reveal a variety of surface and subsurface irregularities. Other types of light, which should be used judiciously, include ultraviolet (UV), for detecting adhesive residues, paints, resins, etc., and x-radiography (X-ray), for detecting subsurface cracks, losses, etc. Avoid light damage by reducing long-term exposure, filtering UV from general lighting, minimizing intense exposure, and reducing heat buildup. (See chapter on Preventive Care.)

To understand and identify an object's defects and weaknesses, it is important to determine its composition. Objects can be made of organic materials (e.g., bone, cotton, hair) and/or inorganic materials (e.g., gold, clay, flint). These materials may be in their original form, such as marble, or may have been modified, such as brass (an alloy of copper and zinc). Objects made from a combination of materials may suffer from a variety of problems, such as weak joints, dissimilar rates of expansion and contraction, or chemical incompatibility.

Inherent faults or other types of damage also affect an object's condition. An **inherent fault**, also known as an inherent vice, is a weakness in the construction of an object or an incompatibility of the materials that constitute it, such as a thin handle on a heavy teapot or metallic salts added to 19th-century silks. Pests and mold, which feed on organic materials or deposits, cause **biological damage** as they weaken an object's structure or create problems such as riddled wood or discoloration. **Physical damage**, caused by mechanical stress, includes abrasions, losses, tearing, etc. **Chemical damage** is the result of a reaction between a material and an energy source (heat, light) or a chemical (water). It is evidenced by corrosion, tarnish, fading, etc.

Always distinguish between historic and "modern" damage or repair. Other condition-related factors to keep in mind:

- One type of damage may encourage another (e.g., embrittlement can lead to tearing).
- Some objects have important evidence of a past function (e.g., stains on a ritual blade, dried residue in a medicine bottle).
- Burial may affect an object's condition (e.g., salts efflorescing on pottery).

Whenever possible, examine objects by category (e.g., hats, bird mounts, paintings) and/or by types of materials (e.g., stone, paper, wool); grouping will promote consistency, thoughtful observations, and accuracy. Determine an appropriate examination pattern and follow it each time (e.g., top to bottom, proper left to proper right, front to back, exterior to interior).

DOCUMENTATION

An object's condition can be documented by text (physical description), sketch (rough representation), and/or video, photographic, or computer image (exact representation). A combination of these methods provides a complete account of an object's condition at a moment in time. Textual documentation can take the form of a narrative or a checklist.

A condition report should include:

- Identifying numbers (accession, loan, field, catalog)
- Object composition
- Types of damage
- Extent of damage
- Location of damage
- Previous repairs (historic and modern)
- Dates of and/or reason for damage (if known)
- Examiner's name
- Date of examination

A photograph should include:

- Identifying numbers
- Scale
- Date of photograph

Whether an object's condition is recorded on paper, computer database, or film, make sure that documentary materials are archivally sound and that the completed documentation is stored in a physically secure and environmentally stable area. Black-and-white film is more stable than color, although modern color film is more stable than its predecessors. Process film according to American National Standards Guidelines. Always duplicate and archive data in a separate, secure location.

When writing a condition report, consider the nature, location, and extent of damage. To ensure accuracy and minimize handling, completely discuss one type of damage on one portion of the object before moving on. Keep all reference materials (e.g., glossaries, locational nomenclature) on file for future reference; use terms consistently.

TL	TC	TR
CL	C	CR
BL	BC	BR

A zone system provides a generalized method for locating damage on two-dimensional objects.

Type of Damage

What is the nature of the damage? If the examiner is trained in conservation, it may be possible to determine whether it is biological, physical, or chemical in nature or the result of an inherent fault; if cause is not apparent, leave etiological statements to the conservator. Describe damage in terms of texture, color, shape, odor, and/or other physical properties, as appropriate. A glossary, whether established or constructed, can be used to assign a descriptive term to a specific condition. Speculative assessments should be indicated with a question mark.

Location

Where is the damage located? Whenever possible, use a recognized nomenclature to indicate the exact position of damage (e.g., proper left, viewer's right) or describe the damaged part of the object (e.g., hammer: face, neck, handle, grip, cheek). Sources include museum nomenclatures, collectors organizations and publications, product manufacturers, and reference texts. (See chapter on Data Management.) The object itself may suggest locational names (e.g., the "shirt" or "face" areas on a figure in a painting, or "to the right of the handle at the base").

stain: center at (450,400mm)
tear: from (100,0mm) to (350,125mm)

The matrix system is a more precise system for plotting damage on two-dimensional objects.

A **zone** system provides a generalized method for locating damage on two-dimensional objects. Each zone or square is labeled, such as TR (top right) or C (center), and the damage is placed within a zone. The **matrix** system, also for two-dimensional objects, is more precise, as the damage is plotted in millimeters on the x and y coordinates. The x coordinate represents the bottom edge of the object; the y coordinate represents the left edge. A stain near the top right corner of a document might be plotted as 450mm along the x (bottom) axis and 400 mm along the y (left) axis; this is represented as (450,400mm). Sketches, photos, or Mylar® overlays on photos offer locational guidance for three-dimensional objects.

Indicate whether measurements are taken metrically or in inches. Whenever possible, lay the measuring device alongside the object to avoid touching it. Other ways to describe location include:

- Direction (horizontal, vertical, diagonal)
- Object side (obverse/reverse, interior/exterior, proper left/proper right, verso/recto)
- Range (scattered, overall)

Extent

What is the extent of the damage? Proceed from the general to the specific (e.g., object yellowed overall, especially in BR corner). Some damage can be readily measured, such as a tear or a loss. Damage that cannot be conventionally measured, such as foxing or yellowing, can be described in the following standardized degrees of severity: "negligible," "slight," "moderate," "marked," and "extreme." Recognized condition standards have been established for a variety of objects (e.g., coins, stamps).

CONDITION REPORTING GLOSSARY

The following are some of the many terms used to describe conditions.

GENERAL TERMS

Abrasion: A wearing away of the surface caused by scraping, rubbing, grinding, or friction; often superficial.

Accretion: Any external material deposited on a surface, most often from burial conditions on objects or accidental deposits on paintings (splashes, drips, flyspecks, etc.) (cf. **inclusion**).

Adhesive residue: May be from glue, paste, pressure-sensitive tapes.

Bleeding: The suffusion of a color into adjacent materials, often caused by water or other solvents.

Bubbly areas: A type of deterioration found in cellulose nitrate and acetate.

Chip: A defect in the surface caused by material that has been broken away.

Corrosion: The chemical alteration of a metal surface caused by agents in the environment or by reagents applied purposely. Corrosion may affect an object's color and texture without altering the form (bronze disease) or it may add to the form, producing hard nodules or crusts (rust). Bimetallic (or galvanic) corrosion results from incompatible metal contact.

Crack: A surface fracture or fissure across or through a material, either straight-line or branching in form; no loss is implied. A crack may be described as **blind** when it stops part way; as **hairline** when it is a tiny fissure; and as **open** when it is a large fissure.

Crease: A line of crushed or broken fibers, generally made by folding. A **dog-ear** is a diagonal crease across the corner of a paper, parchment, etc.

Crocking: Rubbing off of color, resulting in the loss of dyestuff but not loss of fiber.

Delamination: A separation of layers; splitting.

Dent: A defect in the surface caused by a blow; a simple concavity.

Discoloration: A partial or overall change in color caused by aging, light, and/or chemical agents. **Yellowing** and **darkening** can occur, along with **bleaching**, the lightening of color, and **fading**, a loss of color and/or a change in hue.

Disjoin: A partial or complete separation of a join between two members of an object, as distinguished from a crack, tear, check, or split.

Distortion: A warping or misshaping of the original shape; **shrinkage** may occur.

Dry rot: Decay of seasoned timber caused by fungi that consume the cellulose of wood, leaving a soft skeleton that is readily reduced to powder.

Efflorescence: Powdery or crystalline crusts on the surface of stone, plaster, ceramics, etc., formed when transmigrating water reacts with an object's chemical makeup or extraneous deposits from burial.

Embrittlement: A loss of flexibility causing the material (e.g., paper, parchment, leather) to break or disintegrate when bent or curled.

Gouge: A defect in the surface where material has been scooped out.

Fraying: Raveled or worn spot indicated by the separation of threads, especially on the edge of a fabric.

Inclusion: Particle accidentally bonded to the surface of an object during manufacture (e.g., ceramic, plastic, cast metal, paper).

Iridescence: Color effect in glass due to the partial decomposition of the surface and the formation of innumerable thin scales, resulting in an uneven, flaky surface.

Loss: Missing area or hole.

Mildew: See **mold**

Missing element: Loss of an integral component of, or an addition to, the material or appendage (e.g., handle, tassel).

Mold: Biological in nature, mold or mildew can be in the form of **foxing**; of colored, furry, or web-like surface excrescences; and/or of musty odor.

Odor: Smell of sulfur, camphor, vinegar, etc.; produced by the degradation of cellulose nitrate or acetate products. Strong odor indicates severe degradation.

Oozing: See **sweating**

Patina: A colored surface layer, either applied or naturally occurring.

Pest damage: Surface loss, tunneling, holes, fly specks, etc., obviously caused by insects or other pests.

Pitting: Small, irregular, shallow pinhole-size losses scattered over the surface of metal caused by acid conditions or resulting from the casting process.

Powdering: Stone surface that is crumbling or pulverized.

Red rot: Powdery red substance found upon vegetable-tanned objects resulting from a chemical reaction with pollutants in the air.

Scratch: Linear surface loss due to abrasion with a sharp point.

Sheen: A polish produced by handling, often occurring on frequently touched locations.

Silvering: Shiny or mirror-like discoloration in the shadow areas of a photographic image caused by the aging of excessive residual silver compounds.

Spalling: Shallow losses or flaking from the surface of stone or ceramic.

Soil: A general term denoting any material that dirties, sullies, or smirches an object. **Dust** is loose soil generally distributed on surfaces; **grime** is soil tenaciously held on surfaces; a **smear** and a **fingerprint** are types of local grime. A **spatter** or **run** is the result of dried droplets or splashes of foreign material.

Stain: A color change as a result of soiling, adhesives, pest residue, food, oils, etc. A **diffuse** stain is without a distinct boundary; a **discrete** stain has a distinct boundary; a **liquid** stain has a discrete boundary or **tide-line** that is darker than the general area of the stain; a **centered** stain has a darker or more intensely colored center within its general area. In **metallic staining**, adjacent materials are discolored as a result of metal corrosion.

Sugaring: Erosion of the surface of marble creating a very granulated or "sugary" surface appearance.

Sweating: A clear or yellow oily liquid found on the surface of a deteriorated cellulose nitrate or acetate object.

Tarnish: A dullness or blackening of a bright metal surface.

Tear: A break in fabric, paper, or other sheet material as a result of tension or torsion.

Wear: Surface erosion, usually at edges, due to repeated handling.

Weeping: On glass, a reaction between water and formic acid.

PAINTING TERMS
Painting Layers

Ground: Layer(s) of material applied to prepare a surface for painting; usually a pigment in a binding medium.

Paint layer: Layer(s) of colored pigment and binder used to make the design.

Varnish: A clear resinous film applied over the paint layer for protection and to saturate the colors.

Painting Supports: Panel, Fabric, Board

Cradle: On a panel, a system of wood or metal ribs fastened parallel to the grain, with perpendicular sliding members; used in an attempt to prevent warping.

Lining: The addition of a new layer of material to the reverse of the original, using one of a number of adhesives such as wax-resin, glue, paste, or synthetic resins.

Strainer: A fixed-joint, non-expandable, wooden frame auxiliary support for fabric.

Stretcher: An auxiliary wooden-frame support for fabric that has one of several types of expandable joints to permit dimensional enlargement.

Stretcher keys: Wooden wedges used in the slots of the joints of some stretchers to expand them mechanically.

Tacking edge: The edge of a fabric painting support that is turned over and attached to the stretcher or strainer, usually with tacks or staples.

Problems with Paintings

Blanching: Irregular, obtrusive, pale or milky areas in paint or varnish; not a superficial defect like **bloom** but a scattering of light from microporosities or granulation in aged films.

Blister: A separation between layers appearing as an enclosed, bubbled area.

Bloom: A whitish, cloudy appearance in the varnish layer caused by exposure to moisture or resulting from wax-based media. Sometimes called **efflorescence**.

Buckling: Waves or large bulges in a canvas from non-uniform tension around the stretcher or strainer.

Chalking: Loss of a paint or emulsion layer by powdering off.

Check: Splitting of wood along the grain, from the edge of a board or panel for a part of its length. Checking is usually in response to repeated dimensional change brought on by fluctuations of temperature and humidity (cf. **split**).

Cleavage: A separation between the paint layers and the support producing **tenting** (gable-like ridges) or **cupping** (concave flakes); caused by the contraction of the support, forcing the paint layer up off the surface.

Crackle: A network of fine cracks found in a variety of objects including paintings, lacquers, inlays, and ceramics. The **crevice** has a narrow aperture and often penetrates more than one layer; the **rift** has a relatively wide aperture and penetrates only a single layer. A **traction crackle** has an "alligatored" pattern of complex branching, with wide, disfiguring apertures. **Mechanical cracks** resulting from a blow can cause a radiating crackle pattern (bulls-eye or spider web) or the bending or creasing of a canvas (e.g., along the inner edges of stretcher bars).

Crazing: A fine system of crackling in a varnish layer, usually found in aged films in their final stages of drying and embrittlement.

Cupping: See **cleavage**

Dishing: A defect in the stretcher caused by the torque of a drawn fabric. If the stretcher members are twisted out of a common plane, a shallow dihedral angle is formed at the corners. **Dishing** is a common cause of corner wrinkles in stretched canvases (cf. **draw**).

Draw: A local distortion at the corner of a painting, marked by diagonal **cockling** from the corner toward the center of the mount (cf. **dishing**).

Fill: The material used to replace areas of loss; fill is then inpainted.

Flaking: Lifting and sometimes loss of flat areas of the surface layer.

Impasto: Thickly applied paint, often with pronounced brushwork; generally a trouble spot because of cleavage or flattening during lining.

Inpainting: New areas of paint to restore design or color continuity; restricted to areas of loss.

Overpainting: Areas of repainting over existing original surface.

Split: A rupture running along the grain of a piece of wood from end to end, usually caused by exterior mechanical stress (cf. **check**).

Stretcher crease: A crease or line of **cracks** in the ground and paint layers of a painting on fabric, following the inside edges of stretcher members or the edges of cross-members; caused by the flexing of the fabric against the edges of these members.

Tenting: See **cleavage**

Warp: In a panel, the planar deformation of the support caused by changes in relative humidity.

Wrinkling: Small ridges and furrows of crawling paint or varnish caused by improper methods or materials

PAPER TERMS

Buckling: A soft, concave/convex random distortion.

Cockling: A soft, concave/convex distortion characterized by parallel, repeated ripples, usually either horizontal or vertical.

Crease: A line of crushed or broken paper fibers, the residue of a fold.

Dimpling: A local distortion, usually in the corner, marked by a distinctly concave area; usually caused by local adhesion of the support to the secondary support.

Draw: A local distortion at the corner, marked by diagonal cockling from the corner toward the center of the mount.

Drumming: A type of matting where the support is adhered on all edges to the window mat, causing problems if the relative humidity becomes too low.

Fold: A turning over of the support so that the front or back surface is in contact with itself; the line of flexing may or may not be creased.

Foxing: Small yellow, brown, or reddish-brown spots on paper; caused by mold or oxidation of iron particles in the paper.

Wrinkling: An angular, crushed distortion.

PHOTOGRAPHY TERMS

Ferrotyping: Glossy patches found on the surface of photos; resulting from lengthy contact with a smooth-surfaced storage enclosure, such as polyester or glass.

Frilling: Separation and lifting of the photographic emulsion from the edges of the support.

THE SAMPLER MUSEUM
CONDITION REPORT FOR COLLECTION PAINTINGS/DRAWINGS/PRINTS

Acc.#_____

Examiner _____ Date _____
Title _____
Artist _____
Medium _____ Date _____
Stretcher/panel Size H_____W_____in.
Sheet Size H_____W_____in.
Image Size H_____W_____in.
Frame/mat Size H_____W_____in.
Sig./Date(where) _____
Marks/Labels(where) _____
Conservation Priority 1 2 3 4 5
Curatorial Priority 1 2 3 4 5

Description	*Defects*	*Remarks*
Frame		
Framed ____	Broken ____	
Backed ____	Disjoins ____	
Glass ____	Glazing touches	
Plexi ____	artwork ____	
Unframed ____	Paint loss ____	
	Hanging devices	
	insecure ____	
	Accretions ____	
	Abrasions ____	
	Other ____	
Auxiliary Support		
Stretcher ____	Keys missing ____	
Keys Intact ____	Checks ____	
Strainer ____	Infestation ____	
Secured/nails ____	Adhered to backing ____	
Secured/plates ____	Acidic materials ____	
Cradle ____		
Matted ____		
Support		
Fabric ____	Brittle ____	
Lined ____	Tear ____	
Wax Lined ____	Hole ____	
Wood ____	Dent ____	
Masonite ____	Bulge ____	
Paper ____	Sagging ____	
Illust. board ____	Draws ____	
Other ____	Infestation ____	
	Fungi ____	

Sample condition report, side 1.

Description		Defects		Remarks
Framed	____	Crackle	____	
Oil	____	Cleavage	____	
Watercolor	____	Cracking	____	
Tempera	____	Buckling	____	
Pastel	____	Flaking	____	
Gouache	____	Powdering	____	
Charcoal	____	Loss	____	
Pencil	____	Blistering	____	
Ink	____	Accretions	____	
Mixed media	____	Abrasions	____	
Other	____	Soiled	____	
Varnish				
Varnished	____	Crackle	____	
Unvarnished	____	Bloom	____	
		Scratched	____	
		Cracking	____	
		Crazing	____	
		Grime	____	
		Accretions	____	

Action Taken upon Receipt:

Is further work needed? ____yes ____no
Describe: ____new mat ____new frame ____repair frame ____other (itemize)

Is professional attention indicated? ____yes ____no

Conservation Record

Date	Conservator	Treatment Given

Marks and Inscriptions:

Face

Reverse

Sample condition report, side 2.

A steady hand is needed to paint small numbers on the reverse of this tiny Egyptian Aegis. Collection of the Detroit Institute of Arts. Photo © 1998 Detroit Institute of Arts.

The number has been marked on the reverse, avoiding any areas of decoration. White numbers have been used on a base coat of clear varnish. Collection of the Detroit Institute of Arts. Photo © 1998 Detroit Institute of Arts.

Terry Segal

INTRODUCTION

Marking or labeling museum objects with their identification number is an important part of the registrar's responsibilities. Regardless of whether the object is part of the permanent collection, on loan for a special exhibition, or on temporary deposit for purchase or gift consideration, the number provides immediate identification and serves as a link between the object and its documentation. Marking is one of the most invasive procedures undertaken in registration, and methods and materials should be selected with care.

GENERAL PRINCIPLES

Numbers must be secure enough that they cannot be removed accidentally, yet can be reversed easily in the future. The marks themselves consist of the object's accession or catalog number and, occasionally, the museum's name or acronym (e.g., 1978.4 or DIA 1978.4). Care should be taken that neither the initial marking of the number nor the materials required for any subsequent removal of the number damage the object's surface. In view of this, permanent marking methods are not recommended for general use; however, there are some collections where permanent marks may be desired. (See that section for a complete discussion.) Generally, museums have found labeling the object directly with semipermanent markings to be the most suitable method for marking their permanent collections. Temporary methods are used for marking loans, temporary deposits, and any other objects that cannot be marked directly.

It should be noted that even when temporary or semipermanent marks are used, no given method can be considered completely reversible in all situations. For example, acrylic varnish base coats, used to prevent the absorption of inks or paints by the underlying object, may leave permanent discoloration on porous objects, and stitches may leave permanent holes in some textiles. Ties and tags can abrade or cut the surface of some objects. In addition, many of the commonly used products and methods have not been systematically tested to determine their long-term effects. Such concerns need to be weighed against the value of a durable mark.

Develop a set of written guidelines for marking objects, as well as a list of recommended supplies that are regularly stocked. Allow a choice of materials and methods to suit the needs of all objects in the collection, but minimize the range of methods for each collection type to enable staff to develop familiarity and expertise. Staff who are new to marking should experiment on non-museum objects before working on collections. When in doubt as to the appropriate method for a specific object, consult a conservator.

LOCATION

The number should be placed in a location that is unobtrusive while on display, yet clearly visible or easily accessible when the object is in storage. Choose an area that is unlikely to be displayed or photographed. Do not obscure maker's marks, major design elements, or old inventory numbers. Marks attached by previous owners should be retained as they contribute to the object's history.

The number should not be applied to physically unstable surfaces, such as loose or flaking paint, or to pitted or corroded areas, as numbers will be difficult to apply and remove and may harm the object's surface. The number should not be placed in an area that receives wear, friction, or pressure from the object's own weight or its mount. With the exception of small objects with concave bottoms or objects that have ornamentation or decoration that would make numbering elsewhere difficult or unsightly, avoid marking the bottom of an object.

Since handling of museum objects is the greatest single source of damage, the number should not be placed where excessive handling will be necessary to locate it. Large, heavy objects should be marked on the reverse near the base, not on the bottom, to avoid the need to lift or tip the object to read the number. Large paintings may be marked at diagonal corners of the frame or backing so that the number can be easily located whether hung low or high on a storage screen or wall. Rugs and other large textiles may also be marked at diagonal corners so that the labels can be easily located regardless of the direction in which the pieces are rolled for storage. If the number will not be visible in storage, an auxiliary tag should be used; the tag can be left in storage to represent the displaced object.

All detachable parts and accessory pieces should be individually marked (e.g., 1978.120A and 1978.120B). Examples are a snuff box and cover, a knife and sheath, or fragments of a broken object. The number should never be applied solely to a bracket, arm, or trim piece that could become separated from the object.

Choose a consistent location on objects of the same type. When a conflict arises, the highest priority should be given to ensuring the least disruption to the object. Some objects may have no readily apparent location on which to mark the number (e.g., complex abstract sculptures, automobiles). When an object is marked in an unusual or difficult-to-find location, make note of the location in the object's file. Add an auxiliary tag if necessary.

SIZE

Marks should be unobtrusive yet clearly legible. Use common sense guided by the size of the object, the location of the number, and the marking method, when determining the size of the numbers. Numbers may range from less than 1/8 inch for very small objects to 3/8 inch for larger objects. Some types of collections call for larger numbers, such as large-scale industrial artifacts or living history collections where numbers must be located in dark historic interiors. Numbers applied to areas such

as backing boards of paintings, textile storage boxes, or auxiliary tags may be as large as desired, as they are not applied to the object itself or visible when on display.

RECOMMENDED MARKING MATERIALS

Materials used to mark objects must be as chemically stable as possible and demonstrate excellent aging characteristics to ensure the longevity, long-term legibility, and reversibility of the number. The products suggested throughout this chapter were selected after reviewing the marking materials reported in current use in a 1995 survey of 205 museums. An effort was made to include conservation and archival quality materials, as well as products that are easy to use, inexpensive, and readily available. It is recognized that many museums will not have the expertise or facilities for mixing chemicals or may be located in areas where the recommended products are difficult to obtain.

Conservators have not reached a consensus on these materials, and there are pros and cons for each. New products continue to enter the market, and updated testing may cause some of the materials listed here to fall out of favor. Keep in mind that the performance of a commercial product may vary as formulations change from time to time. It is recommended that products be tested on non-museum objects before use. Simple tests such as exposure to sunlight, water, or solvents can be easily performed. A Material Safety Data Sheet (MSDS) can be obtained from the product's manufacturer. This is a useful way to identify materials that may be harmful to museum objects, as well as staff, since the manufacturer is required to list all toxic, flammable, and corrosive materials.

When choosing marking materials, evaluate the risks to which your objects, and the numbers with which they are marked, are likely to be exposed. Will the objects be on display for long periods of time? Light fastness of inks and paints will be a prime concern. Are there oils on the surface that cannot, or should not, be removed? Plastic ties and

tags may be preferred in place of paper and cotton string so that oils do not damage the tag. Will the objects be at risk for accidental water contact, such as overhanging water pipes or outdoor display? Waterproof materials will be desired. Are pests a problem? Insect resistant materials may be preferred to paper and other natural materials that provide food for pests.

TEMPORARY MARKING METHODS

Temporary marking methods include tying or attaching a tag to the object, marking the storage box, sleeve, vial, etc., or placing loose labels, tags or entry receipts with the object. Temporary marking methods should be used as a primary method for any objects that cannot be marked directly, such as:

- All loans and temporary deposits
- Objects that have an unstable, highly uneven, or friable surface (e.g., weathered wood, severely corroded metals) or a very powdery surface (e.g., painted ethnographic wooden objects, some leather objects)
- Very small objects, such as jewelry, coins or stamps. (Marking the number on coins or stamps may also cause a loss of value.)
- Objects that are stored or displayed outdoors, such as farming equipment, vehicles, cannons, or sculpture. Normal marking media may not withstand extreme heat or cold, moisture, and sunlight
- Most plastic, vinyl, and rubber objects

Use as an auxiliary method for:

- All objects in storage
- Large objects on which the direct marking is not easily located

If possible, tie a tag marked with the accession or loan number loosely to the object. Use Tables 1 and 2 (pages 86-87) to select appropriate tags and ties. Consider all conditions to which the tags and ties will be exposed: weather, oil, water, chemicals, insects. Use the same archival-quality materials for tagging permanent collections and loans, as tem-

porary loans sometimes remain longer than initially anticipated. Pencil is recommended for writing the numbers on paper tags. If corrosion-resistant wire or metal tags are used, both ends of the tag should be secured to prevent the tag from moving and continually abrading the object.

Tags should be placed in locations that will not be seen when the objects are on display so that tags can remain attached to the object in the gallery. If tags must be removed while objects are on display, the tags should be reattached as soon as the objects are removed from their display location.

If it is not possible to tag the object, it should be placed in an archival sleeve, vial, box, tray, or small polyethylene bag that is marked with the number; or a loose tag or label should be placed with the object. If the object will be stored in polyethylene in a location with wide variations in temperature, several small holes should be made in the bag, or the points of the corners should be cut off the bag, to prevent condensation. Avoid other plastics that may exude plasticizers and other harmful substances. Tags placed inside bags should be marked with pencil, not ink, as direct transfer of the ink or off-gassing may damage some objects. Textile fragments may have loose tags placed in their wrappings, or the numbers can be marked in pencil on the wrappings. Matted objects may have the number marked in pencil on the reverse of the mat. Framed objects may have the number marked on the backing board in pencil, or tags may be attached to the screw eye or metal hanger. Permanently sited objects, such as large public sculptures, do not need to be marked or tagged directly as they are unlikely to be moved. The accession number can be included on a commemorative marker.

In the case of paintings, drawings, prints, and other framed works that are lent to special exhibitions, a label is sometimes applied to the reverse of the protective backing or stretcher bar. The label usually includes the loan or catalog number, the title or a description of the object, medium, artist or maker's name, and the title, location, and dates of the exhibition. This label is left on the object

when it is returned to the lender as a record of exhibition history. Labels in common use include both pressure-sensitive (self-stick) adhesive labels, as well as gummed paper labels that must be moistened with water for application. Gummed paper labels are preferred because the adhesive of some pressure-sensitive labels can deteriorate to a sticky ooze; such labels pose the risk of detachment and possible transfer to the surface of another painting or object. The adhesive can also permeate wood, leaving a permanent stain and possibly a tacky residue. Gummed labels can be removed and reapplied if the backing board is replaced.

Some natural history specimens require special tagging considerations. Fluid-preserved specimens often have two levels of labeling. Fluid-resistant tags or labels marked with the catalog number are tied to specimens or placed inside the jar, and a label with more extensive information is placed on the outside of the container.

Vertebrate specimens may have numerous tags representing past owners or treatments. These tags usually remain attached to the specimen, and a new tag is added when needed. The existing tags may represent a variety of materials (paper, metal, wood, leather) that may or may not be archival. If it is necessary to remove such tags for any reason, they should be retained in an archival object file.

Specimens may come into contact with many fluids during treatment and cleaning. For this reason, Resistall® paper has sometimes been used for tags on dry specimens. However, some experts advise that the preferred pH range for labels in contact with proteinaceous tissues is 6.0 to 8.5, and the pH level of Resistall® paper ranges from 4.5 to 5.2. A pH-neutral paper (lignin-free or 100% rag, not alkaline-buffered) or an inert material (polyester or polypropylene) is preferred.

Alkaline-buffered paper is sometimes used for labeling dry botanical specimens because it is desirable for maintaining cellulose stability. There has been concern, however, that the alkalinity may negatively affect non-cellulose components of plants, such as resins, and impair future study of these materials.

SEMIPERMANENT MARKING METHODS

The following methods are suggested for marks that can be applied directly to museum objects, will not cause deterioration, and can be removed in the future. Four methods are discussed: barrier coat with ink or paint, adhered labels, sewn labels, and pencil.

Method 1. Barrier coat with ink or paint

Recommended for most three-dimensional objects except paper, textiles, plastics, leathers, and fibrous materials.

1) Examine the object to determine a suitable location for marking the number.
See the Location section of the introduction and the Marking Specific Kinds of Objects section for recommended locations. If an object is constructed of more than one material, place the number on the smoother, harder, less porous surface, if possible.

2) Clean the area to be marked.
The area to be marked should be clean and free from dust and surface dirt. Dust the surface with a soft, clean brush. Some objects may need additional cleaning before a number can be applied. Do not use a solvent (including water) to clean an object without the advice of a conservator. If you are using a solvent, stop the process immediately if you see a change or "bloom" in the surface of the object. Never clean flaking, crazed, or unstable surfaces such as deteriorating ancient glass.

3) Apply a base coat of clear varnish.
A base coat should be used on most surfaces, including non-porous ones. Ink or paint may not adhere well to smooth surfaces; some inks bead, and both ink and paint are easily abraded from non-porous surfaces. Some permanent inks are formulated to etch metal and other materials to improve their adherence, and metal oxide pigments in paints

have the potential to react with the surface of metal or organic objects. A reversible varnish provides a smooth, hard writing surface and may add a measure of security for the number as it is not readily removable without the appropriate solvent. In addition, mistakes can be corrected as you are working, and numbers can be removed with a solvent at a later date without affecting the surface of the object.

Choose a varnish that is compatible with (i.e., will not dissolve or damage, during application or removal) the surface of the object to be marked. See Tables 3 and 4 (pages 88-90) for recommended varnishes and solvent compatibility. When choosing a location for the number, keep in mind that the varnish may leave a permanent stain. Apply a neat rectangle of varnish just large enough to contain the accession number with an artist's brush. Allow the varnish to dry 10-15 minutes, or until it is no longer sticky to the touch, before applying numbers.

Porous materials, such as unfinished wood, may need more than one coat of varnish. Use a thickened varnish to prevent extensive penetration into porous materials. Apply one coat of varnish at a time, allowing each coat to dry, until a discernible film is visible on the surface. Thickened varnishes will require a longer drying time.

4) Write the number on the base coat.

Numbers can be written with a permanent pigment-based ink or acrylic paint using a fine-point technical or crow quill pen, or a fine artist's brush. Disposable marking pens may be used but are not highly recommended due to the variability of light fastness. (See Tables 5, 6, and 7, pages 90-92) Do not press too firmly when using a crow quill or metal-nibbed pen as the nibs can cut through the base coat and scratch some surfaces. Take care not to drip inks or paints.

Choice of color is determined by the color of the object to be marked as well as the past practice of the institution. (See Table 5, page 90) Carbon black and titanium dioxide white are recommended; they are very stable pigments and should meet the needs of most collections. Dark objects are marked with white numbers, or a base coat of white is placed on the clear barrier coat before the number is written. White numbers are commonly used on glass objects as white is less obtrusive for display purposes. Other colors may be used, particularly if they have been used consistently by the institution in the past. Check with the manufacturer regarding the light fastness of the pigment. Red can be used successfully on most objects except those with very dark, or red or green backgrounds; on the latter, such as patinated bronzes, red creates an optical illusion and is difficult to read. Keep in mind that many red pigments are not light fast, and red numbers cannot be read by color-blind individuals.

5) Apply a small rectangular patch of varnish over the number.

A protective top coat is used to prevent accidental removal of the accession number from contact with water or solvents, or abrasion or chipping due to handling. It will also help prevent number loss in the event of a disaster. Allow the number to dry at least 30 minutes before applying a top coat. The top coat should be a slightly smaller rectangle than the base coat, particularly if a different material is used. Allow the top coat to dry 30 minutes, or until it is no longer tacky, before moving the object.

If the top coat removes the number during application:

1) Dot the varnish on the number rather than applying it in a single stroke.
2) Load the brush with varnish and apply it in a single light stroke. The bristles float over the varnish film and don't rub the number.
3) Use a material containing a solvent which will not soften the base coat, e.g., Acryloid B67 in mineral spirits over Acryloid B72 in acetone, Acryloid B72 in ethanol over Acryloid B72 in acetone, or a water-based emulsion or dispersion over a solvent-based varnish.

Objects with Special Concerns:

Plastics, vinyl, and rubber

When dealing with plastic objects, it may not be possible to identify which type of plastic is present; there are many types of plastic and each has its own specific chemistry. In addition, many plastic objects have painted or printed surfaces, and the marking media that are safe for the plastic may not be safe for the surface treatment and vice versa. To complicate matters, some plastics resist the adhesion of varnishes and adhesives; however, they may be stained by the dyes and pigments in marking media if a base coat is not used. Therefore, it is difficult to make specific recommendations.

Solvents should be avoided. The solvents used as carriers for acrylic resin varnishes, such as acetone and toluene, may dissolve the surface or cause stress cracking or crazing, or may affect the gloss finish or surface texture of plastic objects. Acrylic resins dissolved in mineral spirits pose the least possible risk for most plastics, although caution is still advised. Some petroleum solvent blends may contain a small percentage of other solvents.

Base coats of water-based acrylic or PVA emulsions are not a safe choice as older plastics, such as cellulose nitrate, may be damaged by moisture. Water-based materials can also initiate stress cracking upon application or over time. In addition, these materials are not reversible in water when dry, and stronger solvents or mechanical methods, which may damage the plastic, will be necessary for their future removal. Also, the numbers may not be durable as these emulsions have a tendency to peel over time. Oil paints are not recommended as both the oils and their solvents can soften or otherwise damage some plastics with long-term contact.

Most rubber products are adversely affected by oils and hydrocarbon solvents and some by alcohol. Synthetic rubbers vary as widely as plastics in their properties. Take care when using inks as they often contain metallic elements that may cause degradation of the rubber. *Rigid* rubber objects may be marked with acrylic paint or other water-based materials. Base coats and top coats of solvent-based acrylic varnishes are not recommended as they may not adhere well and the solvents may attack the rubber, fillers, or colorants. *Flexible* rubber objects are difficult to mark directly as marking media have a tendency to peel.

The following marking alternatives are suggested for plastics, vinyls, and rubbers:

1) Mark a non-plastic component if possible.
2) Tie a tag to the object and/or mark its storage container.
3) Mark hard plastics and rigid rubbers directly with a wax or grease pencil, Stabilo All® pencil, or acrylic paint. (See Table 5, page 90.) Keep in mind that these numbers may not be durable.
4) Mark the object directly with pigmented ink or India ink for film. Consider this method permanent as it may stain the plastic or rubber.

Painted, Japanned, and other finished surfaces (e.g., tole ware, lacquer ware, frosted or painted glass, varnished wood)

The organic solvents used as carriers for acrylic varnishes can permanently damage painted or finished objects by dissolving the surface finish; mark an unfinished area, if possible, or use a varnish composed of acrylic resins dissolved in a petroleum solvent. Mineral spirits, petroleum benzine, or related petroleum solvents are safer for more surfaces than acetone-based varnishes. Test objects carefully in an inconspicuous location to determine if the solvent affects the finish. *Do not use petroleum solvents on wax or waxed surfaces.*

Water-based acrylic emulsions may be used as a base coat on finishes that are not water soluble; however, these media will not redissolve in water when dry. Organic solvents or mechanical methods needed for future removal may damage the surface. *Avoid the use of commercial artists' acrylic media on copper, brass, or sterling silver, as they may contain ammonia that will stain the metal. Ammonia may also etch resinous coatings.*

Leather and hide

Soft, porous leathers and skins cannot be marked directly with varnish and are permanently stained by inks and paints. Do not mark these directly unless you have determined that permanent marks are appropriate. Hard-finished, impervious leathers may be sealed with a base coat of a petroleum solvent-based varnish; seal minimally as excessive varnish may stiffen the leather and cause cracking around the varnished area. See the Marking Specific Kinds of Objects section for additional marking suggestions.

Baskets, mats, bark cloth, and other fibrous materials

These materials can be difficult to mark. Some basket fibers are resistant to the application of varnishes and adhesives, or may be too narrow for a legible written number. Marking media can stain the objects, and inks applied directly may bleed. Do not apply the number directly without a varnish base coat unless you have determined that a permanent number is appropriate. See the Marking Specific Kinds of Objects section for alternative suggestions.

Paintings

Never write a number on, or apply a label to, the face of a painting or the reverse of a canvas. Paintings are marked on the reverse of their frames, protective backings, and supports, such as stretcher bars or panels. If the stretcher or panel is covered by a protective backing, the number is marked on the backing in the same location that would be marked if the stretcher or panel were visible. The number can be marked on the backing with pencil or ink according to the standard practice of the institution. Ink is easier to read. Gummed paper labels marked with the accession number and other information may be adhered to protective backings or stretcher bars.

Some paintings, such as miniatures on ivory, contemporary paintings with no frame or stretcher, or reverse paintings on glass, may pose numbering problems. If in doubt as to the appropriate method for a particular piece, use a temporary method or consult a conservator. Ivory miniatures are often thin, translucent, and extremely fragile. It is generally recommended, therefore, that the accession number not be applied directly to the ivory. If the miniature is framed or mounted in a case or locket, the number should be applied to one of these supports. If the miniature is unframed, the number can be marked on its storage box.

Method 2: Adhered labels

Adhered labels may be substituted for Method 1. The papers and adhesives should be chosen carefully. Most commercial adhesives are not stable or can be difficult to remove. If instituting an adhered label system for the first time, consult a conservator. The label should be as small as possible and placed in an area that does not receive light exposure as the label will cause uneven fading of the object's surface. Adhered labels should not be placed over paint, lacquer, or other original finishes that could be pulled away. Also, they should not be placed on flaking or insecure surfaces.

Japanese tissue paper with starch paste

Recommended for use on bark cloth, mats, and plant materials; may be used on some basketry items and leathers. Less intrusive than Method 1. Less foreign material penetrates the surface and most of the adhesive is removed with the paper, leaving only a small amount of residue that can be easily removed.

1) Water-tear a small rectangle of Japanese tissue large enough to easily accommodate the number. Do not cut the tissue; it is important that the long fibers of the tissue be exposed to add strength to the bond.

2) Place the piece of tissue on top of blotting paper and carefully write the number on the tissue with ink. The blotting paper should draw off moisture from the ink and prevent bleeding. Be careful not to rip the paper fibers with the nib of the pen when writing; it is best to use no pressure at all. Allow the ink to dry *thoroughly* before proceeding.

3) Turn the piece of tissue over on the blotting paper and coat the back of it with wheat or rice starch paste or methyl cellulose with a brush. Use as dilute a solution of paste as possible. The blotting paper should draw off excess moisture from the paste.

4) Lift the tissue carefully from the blotting paper with tweezers and place it right side up on the object in the selected marking location. Using a stiff stencil brush, gently tamp the tissue into place to ensure good contact.

5) Place a piece of blotting paper on top of the number and gently rub it with a finger to draw off excess moisture.

6) Insert a piece of spun-bonded polyester (Reemay®) between the number and the blotting paper; if the object is flat and not brittle, a weight without sharp corners or projecting points may be placed on top of the blotting paper. The Reemay® will prevent the blotting paper from sticking to the number. Allow the paste to dry weighted for 10-15 minutes, then remove the weight, blotting paper, and Reemay®, and allow the paste to dry thoroughly.

7) To remove the label, roll a slightly moistened cotton swab over the paper surface until the paper is damp. After a few moments, the label may be lifted off with tweezers.

Some materials, such as baskets, may require a paste with greater adhesion. A stronger adhesive can be made using equal parts starch or methyl cellulose paste and an acrylic emulsion. For leathers and other materials that cannot tolerate moisture, a heat- or solvent-reactivated tissue made with Rhoplex® AC-234, an acrylic emulsion, is recommended.

Acid-free paper labels adhered with acrylic or PVA emulsion

Recommended for most three-dimensional objects except paper, textiles, and plastics. May be useful for very small items or items with a broken surface as very small legible numbers can be printed with a laser printer.

1) Determine the size of lettering required on the label. The lettering size depends upon the size of the item and the surface available for label placement. Some guidelines:
 a. Courier 7 (96-206-200) or 8 (96-206-200) point on large items.
 b. Courier 6 (96-206-200) point is used to label medium sized items.
 c. Courier 4 (96-206-200) to 5 (96-206-200) point is used to label small items or items with a very small marking area.

2) Create numbers in the appropriate word-processing package, load the laser printer with acid-free photocopy paper, and send the print job. It is important to use laser-quality paper; cotton rag paper requires stabilization of the print. Do not use labels printed on daisy, dot matrix, or ink jet printers.

3) Cut the labels with rounded, rather than square, corners if possible. It is generally not feasible to round the corners of the smaller letter point sizes.

4) Attach the label using a base coat and top coat of an acrylic or PVA emulsion. Do not let the base coat dry before applying the paper label. For less intrusion to porous objects, apply the adhesive to the label, not the object. A second application of the top coat may be necessary to create a sufficient, protective top coat.

5) Allow the label to dry completely and lose its tack. During dry periods (RH lower than 30%) the drying process might be completed within an hour. During more humid periods (RH higher than 45%), the drying process might last a day or more. Solvent-based adhesives will require less drying time and can be used for objects that cannot tolerate moisture; however, solvents will remove laser print. Try a dot matrix or desk jet printer. Let the print dry thoroughly before applying the adhesive.

6) Labels can be removed with acetone or by mechanical methods.

Method 3: Sewn Labels

Recommended for most textiles. Do not sew a label on textiles that are disintegrating or in very poor condition. May also be used for some basketry materials and leathers.

1) Choose a material for making the label.

Fabric tape (cotton, polyester, or linen) is usually used for making labels for costumes, rugs, tapestries, and other textile objects. Fabric tape is available in widths from 1/4 - 1 inch and wider. Use a size that is appropriate for the size of the object. Both white and unbleached tapes are acceptable. Use a tape that is firmly woven as it will make writing the number easier. Using fabric tapes of varying widths is preferred over cutting rectangles out of fabrics, such as unbleached muslin, as the double selvages will prevent the edges from raveling.

Some museums use an inert material such as non-woven polyester (Reemay®) for sewn labels. An advantage of this material is that it does not ravel at the edges and can be cut to any desired size. Reemay® and related materials are purchased in bolts and are available in various weights, some of which may be abrasive to delicate fabrics. Choose a light weight with a smooth finish dense enough to accept the number. Some conservators caution against using Pellon®, another non-woven polyester, because the material has a resin finish that may be harmful to some museum objects. Only *non-fusible* fabrics should be used. Soft grades of Tyvek® may also be used for sewn labels.

2) Write the number on the label.

The number is written on fabric tape or Tyvek® with permanent ink using a fine point technical marking pen or permanent disposable pen. Tyvek® may require sealing with B72 to prevent bleeding of the ink. The numbers are usually typed on non-woven polyesters such as Reemay®. The Reemay® is cut into sheets and fed into the typewriter like a sheet of paper. *Non-correctable or one-strike* carbon ribbons are recommended as they tend to be the most durable, but they are becoming obsolete and may be difficult to obtain. Most *correctable* carbon ribbon impressions become tough and smudge-resistant if allowed to cure two to five days after application, but some stay soft indefinitely. Fabric ribbons are not recommended as they tend to smear continually. Do not put Reemay® or Tyvek® in a laser printer.

Regardless of whether a marking pen or a typewriter ribbon is used, the ink must be tested for fastness. Some brands labeled "waterproof" may not live up to their reputation when tested. Formulations of inks change frequently; check each new batch of markers or ribbons, even if the same brand is consistently purchased.

To test a marker or typewriter ribbon, write or type a series of sample numbers on the labeling material. Rub the numbers to see if the ink smears, and eliminate any pens or ribbons that do. Second, rinse the tags in hot soapy water to see if the ink runs when wet. Third, rub each number while it is still wet. If the ink is fast in each of these tests, the marking material may be used.

3) Wash the fabric tape and let it dry before cutting the tags apart.

Laundering the tags will remove acid liberated by some kinds of marking inks. Some museums size the label to provide a better writing surface or seal the label with varnish before and after marking the number to prevent the ink from bleeding. Sizing will result in a stiffer tag that may be abrasive to some textiles. Sealing the tape should not be necessary if the earlier steps for testing the ink and laundering the tag are followed. If you do choose to size or seal the tape, leave the ends untreated so that they can be turned under for stitching. Reemay® may be swished through an acetone bath to remove excess typewriter ink.

4) Stitch the label to the object.

Labels should be gently stitched, never attached with staples, pins, or adhesives. Select a sturdy area on the reverse side, preferably at the hem or near a strong selvage. Be consistent in your choice of location. See the Marking Specific Kinds of Objects section for suggested locations for specific items.

Place the stitches between the warp and weft threads of the fabric; do not pierce the threads. See Table 9 (page 93) for suggested needles and thread.

While all conservators agree that the number of stitches should be limited, opinions vary as to where the stitches should be placed. Some conservators recommend stitching the tag around all four sides with a loose running or basting stitch to prevent the possibility of picking up the textile by the tag or accidently catching a finger in the tag and thereby snagging or tearing the textile. Other conservators recommend only a few tacking stitches at each end to avoid piercing the textile in so many places. A good rule of thumb is to evaluate your own collection. How often will it be handled and by whom? Are the fabrics strong and in good condition or weak and deteriorating?

Select a stitching method that best meets your needs with the least possible intrusion to the textile. For fragile textiles, such as lace, the label can be attached with a single loop of thread, leaving the tag hanging loose. Use a loop long enough for easy positioning of the tag, yet as short as possible to avoid snagging. This method can be used for small flat items so the tag can be tucked out of sight when the object is on display. Some very fragile textiles, such as silks, may not be able to be tagged directly without causing extensive damage. Alternatively, the accession number can be marked on the storage container. Permanently mounted textiles should be labeled on the mount.

Use a single strand of thread. Do not use small, tight stitches that will cut the threads of the textile or distort the fabric. Machine-wound spool threads shrink for about a year after being unwound and may pucker the textile if the stitches are pulled tight. Begin and end the stitching with several backstitches in the label, not the textile. Do not use knots that tend to break or disassemble, or may pull through the textile creating holes. Fabric tape should be turned under 1/4 inch at the ends to prevent raveling; tack down the corners. To remove a tag, cut each stitch, taking care not to cut the textile, and carefully pull out the individual threads.

Method 4: Pencil

Recommended for paper and photographic materials.

1) Select a location for marking the number.
Works of art on paper, such as prints, drawings, and photographs, should be marked on the reverse side behind a non-image area at the lower margin. The number should be consistently placed in the same corner on every object. If the object is mounted or hinged, in addition to marking it directly, mark the number with pencil on the back of the mount or on the face of the mount, below the object. This will eliminate unnecessary handling to locate the number. Framed objects should be marked on the frame and backing in the same manner as framed paintings.

See the Marking Specific Kinds of Objects section for suggested locations for other paper and photographic materials.

2) Select an appropriate pencil.
Most paper objects are marked with a medium lead pencil; hard lead can crease or dent paper, while soft lead has a tendency to smudge. Recommended grades are #2, HB, F, and H. For a further discussion of pencil grades, see Table 5 (page 90). If you are uncertain about the performance of a particular pencil, test it on several weights and finishes of paper prior to using it to mark objects. Modern resin-coated photographic papers and other glossy papers may resist standard pencil markings. Try a #1 pencil, a Stabilo® All Graphite pencil, or a wax pencil. Do not stack objects marked with these materials without interleaving with acid-free tissue to prevent the markings from transferring to the image below, or place the items in individual acid-free sleeves.

3) Place the object on a firm surface and write gently to avoid indentation.
This is especially important for coated photographic papers, such as cibachrome prints, on which the emulsion is easily bruised, and thin sheets, such as tissue and albumen prints, particularly if the image is printed to the edge of the sheet. Use only #2 or

HB pencils, or softer, on these objects. Dull the point of a newly sharpened pencil by scribbling on a sheet of paper. Remove excess lead by blotting once, not rubbing, with a vinyl eraser.

In cases where an object cannot be marked directly see the Temporary Marking Methods or the Marking Specific Kinds of Objects sections for alternatives.

BAR CODES AND OTHER TECHNOLOGY

A small number of museums have used bar code labels or tags with varying degrees of success. The most successful use has been as an auxiliary method for inventory purposes where objects are still marked directly with accession numbers. The production of bar code tags requires a computer, a dot matrix or laser printer, and an inexpensive software package. The bar code information can be printed on any type of paper or label, including acid-free stock. The number itself can be the actual catalog or accession number for the object or a dummy number. The bar code can also include the storage location for the object. Additional information such as the culture or artist can be included on the tag.

Reading the numbers requires a scanning device. The least expensive type is a pen scanner that is attached to a computer that functions in place of a keyboard. This type of scanner is not recommended as it is necessary to almost touch the bar code, and the pen must remain tethered to the computer so that objects must be brought to the scanner. The more expensive hand-held scanners with a built-in keypad are preferred. The bar code can be read at a greater distance, and the scanner can read upside down, sideways, and through Mylar®, although reflection is sometimes a problem. The light emitted is cool.

The major disadvantage with bar codes as a primary marking method is that tags can become separated from objects. With the exception of larger objects, there are no satisfactory methods of adhering the tags, which are usually larger and less discreet than a simple accession number. In addition, the bar code tags cannot be read when the scanner is out of order.

On the horizon are radio frequency identification (rfid) tags that can be as small as 1mm x 5mm. At the present time the tags are cost prohibitive for most museum applications although the chips are being used to tag small zoo animals.

PERMANENT MARKING METHODS

Permanent marks, although rarely used, may be considered for some types of collections. Examples include archeology or anthropology collections that include thousands of bone fragments or pottery shards. Such artifacts may be virtually impossible to identify, even with photography. The separation of the artifact from its identification number may completely destroy that object's value for future study purposes. Natural history specimens are often marked directly with permanent ink. More labor-intensive methods, such as the use of a varnish base coat, may make the semipermanent marking of some objects (e.g., all bones of a bird skeleton) both impractical and potentially impossible.

Permanent marks may also be useful as a deterrent to theft, as in the case of firearms. While permanent marks may decrease the monetary value of such objects, the gain in terms of security may be significant.

Other collections might offer no means of applying and maintaining a durable, reversible mark. Examples include objects used by interpreters in living history settings, such as cooking pots, utensils, and farm implements, as well as objects that are stored or displayed outdoors. Reproductions used in demonstration collections should have permanent numbers to prevent the objects from being identified or sold as authentic if the numbers wear off.

Permanent marks should not be used without careful consideration of the ramifications of permanently disfiguring objects. The location for such marks should be chosen with extreme care. Permanent marking methods for various types of objects are discussed below.

When marking authentic objects, choose the method least destructive to its surface. A discreet number applied with permanent ink may be less damaging than etching the object's surface, for example. Do not use any method that will cause future corrosion or continued deterioration of the object. Museums often use a separate prefix and/or color code to distinguish reproductions or demonstration collections from the permanent collection.

Paper can be marked with permanent ink, or a sharp, 2H (#3) or harder pencil may be used to indent or emboss the paper. In the past, many museums stamped their name or mark with ink on the reverse of prints and manuscripts to indicate ownership. This practice has been largely discontinued by museums because the marks are not reversible and the ink may migrate to the front, leaving stains on the image and causing permanent damage. Libraries or manuscript collections that wish to continue the practice of stamping materials with ink should obtain the Library of Congress's publication, "Marking Paper Manuscripts," cited in the bibliography.

Numbers can be engraved, branded, or stamped on wood. Leather, hides, and pelts can be marked with permanent ink or a stamping tool. Textiles can be marked with permanent ink. When using ink on porous materials, be sure that the ink does not bleed, thereby obliterating the number. Semi-porous materials such as bone, plastic, and ceramics, can be marked with permanent ink or can be etched or imprinted with an engraving tool or stamping tool. Non-porous or impervious materials, including metals, can be etched with a scriber or engraving tool, or the number can be imprinted with a stamping tool.

UNACCEPTABLE MARKING METHODS AND MATERIALS

The following materials should *not* be used:

Pressure-sensitive tape (including cellophane, masking, adhesive, and embossing tapes): With some of these tapes, the adhesive sticks more and more tightly to the object as time passes and may be difficult to remove without strong solvents. Other tapes dry out and fall off, leaving behind a sticky residue or stain. Even those that do not fall off may discolor and stain.

Pressure-sensitive labels: The adhesive on many pressure-sensitive (self-stick) labels can deteriorate within several months to an ooze that penetrates paper products. Some adhesives can corrode metals around the periphery of the label. After removal these labels leave irreparable dark areas on finished wood, especially wood exposed to excessive illumination. The labels also have a tendency to fall off over time as the solvent in the adhesive evaporates.

Gummed (water-moistenable) paper labels: The adhesives on these labels can stain and are difficult to remove from some materials. On other materials they have poor adhesive quality and are not durable. (They may be used on the reverse of painting frames, stretchers, or protective backings of framed objects.)

Rubber cement: This adhesive behaves somewhat like pressure-sensitive labels and should be avoided. It can stain organic materials and tarnish metals.

Silicone products: Silicones are generally nonreversible, and other marking materials will not adhere well to them.

Spray varnishes: It is difficult to control where the spray will land. In addition, the product composition may change and some materials may yellow and become brittle or difficult to remove.

Typewriter correction fluid: This material is widely used as a white base coat on dark objects. Correction fluids are white paints of varying composition; most use 1,1,1,trichloroethylene as the solvent although some are water based. While some formulations may not harm the surfaces of objects, many correction fluids have poor durability and tend to dry out and flake as they age. Others may prove solvent resistant with age.

Nail polish: Clear nail polish is in wide use as a base coat and top coat. Nail polishes are usually made from cellulose nitrate that yellows, turns brittle, and shrinks with age. Modern formulas may be composed of more stable acrylic resins but may be a mixture of the two. The resin is dissolved in a mix of solvents, which may include acetone, xylene, alcohol, or toluene. The exact formula and aging properties of these polishes cannot be determined. Some polishes will peel with age, taking the accession number and part of the surface of the object with them.

Nail polish remover: Commercial nail polish remover may contain additives such as perfume, oil, dyes, and gelatin, in addition to the solvent.

Ballpoint ink: Most ballpoint inks tend to smear and can be difficult to remove with age. Many are not light fast. Some contain iron gall, which is very acidic and corrosive.

Chalks: These materials are not durable. They smear indefinitely and can be difficult to remove from porous materials without strong solvents.

Fusible iron-on fabrics: These materials should not be used for labeling textiles. The adhesives leave a residue and may damage textiles.

Metal-edged tags: The metal can corrode and stain objects.

Wire: Wires can corrode or abrade objects and may tear fragile or soft surfaces. (An exception is the use of aluminum or annealed stainless steel wire, or plastic or vinyl coated stainless steel for large industrial artifacts or outdoor use. See Table 2, page 87.)

Nails, pins, staples, screws, and other metal fasteners: Metals may corrode, thereby staining objects, cause corrosion of metal objects that they are in contact with, leave permanent holes, or cause splitting or cracking of woods and other materials.

MARKING SPECIFIC KINDS OF OBJECTS

Albums: See **books**

Amphibians: See **reptiles and amphibians**

Armor: Mark with ink or paint over a base coat inside each element, or tie an acid-free 2- or 4-ply mat board tag to the object with fabric tape, or polypropylene cord. Metal tags stamped or engraved with the number are sometimes used; however, more inert, non-abrasive materials are preferred.

Bark cloth: Apply Japanese tissue paper labels with wheat or rice starch paste or methyl cellulose at one corner.

Basketry and mats: Mark at the center bottom of the basket or inside the rim using ink or paint over a base coat, or use an adhered label. Choose location carefully as varnishes and adhesives will stain porous fibers. For less intrusion to porous materials when using adhered labels, apply the adhesive to the label, not the object. If the reeds of the basket are not long or wide enough, or will not accept the application of a base coat or adhesive, tie or sew a tag or label to the fibers. Use caution with fine materials such as spruce root. Label or tag mats and other flat objects at one corner.

Beads: Number large beads on a flat undecorated surface, if possible. Use method appropriate for the material. Place small beads in a padded, marked container. String loose beads with polyester thread and tag.

Birds: Number with ink on the leg or toenail. Label mounted specimens on the base near the right rear corner. Tag skeletons or number the bones directly with ink in the center or on the largest part of each bone. Attach a tag to skins around the ankle of one foot. Use non-absorbent tag and tie materials for oily skins and specimens. Label fluid-preserved specimens both on and inside the jar. Mark dry eggs with pencil or ink, usually above or below the opening. Tag nests or mark the tray holding the nest.

Bone (including cultural artifacts and artwork; for natural history specimens see individual listings for specimen type): Seal bone with varnish to prevent ink or paint numbers from bleeding or staining the object.

Books (including manuscript albums, periodicals, portfolios, scrapbooks, and sketch books): Number with pencil on the reverse of the title page and inside the front cover at the lower right side near the spine. If the inner cover is marbleized or decorated mark the number on the first blank page. Number all loose or weakened pages, portfolios, and containers individually. Number scrapbooks in several places as they are often cheaply bound or in weakened condition and the pages are liable to separate from the binding. For books of moderate value, attach a bookplate bearing the number inside the front cover with starch paste or methyl cellulose. For rare books, or books that are works of art in which every page is precious, insert an acid-free paper marker bearing the number in pencil. See also: **manuscripts and documents, paper and cardboard objects**

Botanical Specimens: Attach labels to herbarium sheets or write the number in pencil on the lower right corner of the sheet. Label the vial or box containing the specimen. When type photographs are made, fasten a small scale with the number of the print to the herbarium sheet and photograph along with the herbarium labels of the institution to which the original specimen belongs. Use of alkaline-buffered paper may negatively affect non-cellulose components of plants, such as resins, and impair future study of these materials.

Bronzes: See **metal objects**

Buttons: Mark on the reverse, if possible, using a method appropriate for the material. Store small buttons in a labeled container or attach a tag.

Ceramic objects: Apply the number with ink or paint over a base coat in an inconspicuous place not likely to be worn by handling and not obscuring any marks. Unglazed, porous ceramics may require more than one application of the base coat. Choose the location carefully; the base coat will leave a stain. Use a thickened varnish to prevent extensive penetration into porous materials. Use a solvent-based varnish on low-fired pottery; water-based materials may dissolve the surface. Avoid marking cracked areas. Place the number where it will not be scraped when the object is set down or moved; it is often placed under the base, if recessed. If necessary, place the number near the lower edge of the back or near the base on a side not likely to be displayed. Mark vessels inside the lip. Mark pottery shards on the side without decoration, never on the break edge. Mark pottery pipes on the bottom of the bowl or on the pipe stem.

China: See **ceramic objects**

Clocks: Number on the back of the case at a lower edge or corner. Number clocks with a hinged door inside the door as well. Use method appropriate for the material.

Coins and medals: Mark on the edge or rim if possible, using a method appropriate for the material; if not, mark on the box, envelope, or coin holder in which the coin is kept. Do not mark coins on their faces, and never use permanent marks. Thoroughly photodocument any unmarked pieces. Number medals in a smooth undecorated area on the reverse.

Costumes and costume accessories: Sew a label to textiles; for details on preparing and attaching the label, see Method 3: Sewn Labels. The label should not obscure any maker's labels. For items composed of non-textile materials, use method recommended for the material. Some museums choose a standard location for all garments, such as "inside lower edge near the proper right side seam." See below for additional suggested locations. Standardize the location for all items of the same type. *Dresses,* *coats, shirts, and other upper garments with sleeves:* sew the label on the back neckband or, if a tag in that location would be visible on display, in one sleeve on the underarm seam or inside the cuff, usually at the left sleeve. *Vests and other sleeveless garments:* inside the left armhole at the side seam. *Skirts, trousers, and other garments with waistbands:* at the center back at the waistband. *Hats:* inside the band at the center back, or if no band, at another suitable cloth location; mark leather, straw, or other materials at the center inside back of the crown using a method suitable for the material, or carefully attach the label to one edge, or the reverse, of the maker's label. *Stockings and gloves:* inside near the top edge. *Neckwear, sashes:* on the underside at the center back or at one end. *Flat items (handkerchiefs, scarves):* at one corner. *Carpet bags, muffs, purses:* inside near the opening. *Belts:* inside near or on the buckle. *Footwear with heels:* mark on the bottom of the sole in the rise before the heel or on the inside face of the heel. Cloth footwear may have a textile label sewn to the inside lining at the heel end. *Footwear without heels (flats, sandals, slippers):* at the back of the shoe in the heel area. *Umbrellas, canes:* on the handle or knob or on the shaft near the handle.

Documents: See **manuscripts**

Dolls: Number on the back of the head at the nape of the neck or, if this is not possible, on the foot. Use a method appropriate for the material. An auxiliary tag is recommended for dolls in storage so that the number may be seen without having to handle the doll. Label each item of clothing as for textiles.

Drawings (including watercolors): Mark in pencil on the reverse of the work at a lower corner. Mark two-sided drawings with separate accession numbers for each side of the work (e.g., 1991.1A recto and 1991.1B verso) on both sides. If the work is mounted or hinged, mark the number on the back of the mount or on the face of the mount below the edge of the drawing. If framed, mark the frame as for paintings.

Embroideries: See **textiles**

Enamels: See **glass objects**

Ephemera (including greeting cards, postcards, trade cards, etc.): Mark in pencil on the reverse in an undecorated or blank area, usually at one corner. Use a Stabilo All® pencil or wax pencil for glossy papers, or plastic or foil items. Mark materials with double-sided printing on the side least likely to be displayed. Mark envelopes on the reverse at a lower corner.

Fans: Mark folding fans on the reverse of the rear guard so that the number is visible when the fan is closed, but not while on display. Mark other fans on the reverse end of the handle or stick. Alternatively, apply the number on the ring if wide and sound enough. Use method appropriate for the material.

Feathers: Mark with ink or paint, on a base coat, on the shaft or on the bottom of the quill, or attach a tag. Items that cannot be marked directly or tagged should be placed in a marked storage container or labeled on their mount. Natural history specimens may be marked directly with ink if permanent marks are desired.

Firearms: Mark on the metal butt plate if available, on the handle or stock near the butt end, or on the underside or interior of the trigger guard. *Long arms and rifles:* on the breech end of the barrel or near the trigger on the floor plate. *Revolvers:* on the cylinder, turned out of view while on exhibit. *Powder horns and flasks:* on the back edge near the opening. Use method appropriate for the material.

Fishes: Tag fluid-preserved specimens with solvent-resistant labels placed inside, and also label the jar, or tie a tag through the mouth or gill opening or around the caudal peduncle (the narrow end before the tail). For skeletal material, apply the number with ink directly on the bone; use a base coat and top coat if permanent numbers are not desired. Place small bones in labeled containers. Label mounted specimens on the mount.

Fluid-preserved specimens: Place a label that is resistant to the preservation fluid inside the jar and also label the exterior of the jar. Resistall® paper or 100% linen-rag heavyweight record paper marked with waterproof, alcohol resistant ink, or Tyvek® embossed with solvent-resistant ink numbers or an impact printer are recommended. Do not put Tyvek® in a laser printer.

Fossils: Number on a base coat with ink or paint on any smooth flat surface, or use an adhered label, but not on any part that will interfere with study. (Consult a conservator regarding fossil resins. They may be dissolved by solvents.) In the case of specimens consisting of several pieces, such as disarticulated vertebrates, mark the number on each fragment. Label microscopic invertebrates at one corner of the slide mount with ink. Store micro-fossils in labeled vials.

Furniture: Mark on a base coat with ink or paint or use method appropriate for the material. Use a base coat that will not dissolve or damage any finished surfaces. Avoid painted areas. Attach an auxiliary tag to large pieces in storage. Number all removable parts such as shelves, keys, etc. *Commodes and chests:* on the back at the bottom left or bottom right corner; mark low chests at an upper corner. *Highboys and multiple case pieces:* at a top corner of the lower piece and the corresponding lower corner of the upper piece. *Chairs and sofas:* at the back of one leg at the height of the seat, or for less visibility on display, on the inside of the leg. If a piece is completely upholstered, sew a textile label near the left or right back leg. *Tables:* on the underside of the top near one leg, on the apron, or on the inside edge of one leg just below the apron. *Beds:* on the back of the rail at the head of the bed near one leg, or on the outer edge of both legs at the head of the bed. *Lamps:* on the lower right-hand side at the back, or on the base if there is one. *Mirrors and sconces:* on the reverse at diagonal corners of the frame. If the object is extremely heavy, place the number on the bottom of the lower edge of the frame near one corner.

Geological specimens (including gems, minerals, and rocks): Mark with ink or paint on a clear base coat, placed so as not to obscure any important feature. Use a white primer or white numbers over the clear base coat on dark objects. Adhered labels may also be used. If the specimen is too small to number directly, place it in a padded vial or polyethylene bag on which the number is marked. Store gems in labeled acid-free boxes or gem papers. See also: **stone**

Glass (including enamel): Mark on a base coat with ink or paint. Avoid directly marking etched or frosted glass or deteriorating ancient glass, as well as areas of airbrushed or painted design. Make the number as small and legible as possible. Use white lettering on clear glass to minimize the visibility of the number when the object is on display. Place the number on the back edge of the foot if wide enough, underneath the foot if recessed, or on a lower back edge. Mark blown glass in the recessed area near the point where the glass has been cut from the rod.

Gold: See **metal objects**

Hats: See **costume and costume accessories**

Insects: Mark dry-pinned specimens with pencil or ink on unbuffered, acid-free paper labels that are pinned directly below the specimen. Tag fluid-preserved specimens with solvent-resistant labels placed inside the jar, and also label the jar. Label microscopic specimens with ink on the slide mount.

Invertebrates: Use acid-free paper tags tied to the specimen for dried crustaceans. Mark mollusks with ink; use a base coat if permanent numbers are not desired. Adhered labels may also be used. Tag fluid-preserved specimens with solvent-resistant tags or labels placed inside the jar, and also label the jar.

Ivories: Mark with ink or paint on a base coat of a petroleum solvent-based varnish. Use white ink or paint to number dark pieces. Some ivories resist the adhesion of varnish or adhesive. Attach a tag or mark the storage container. Do not mark portrait miniatures on ivory and other thin fragile ivories directly as they are highly susceptible to damage.

Jewelry: Mark in an inconspicuous place not likely to be worn by handling. Use a method appropriate for the material. If the piece is very small, attach a small acid-free tag bearing the number, loop a cloth tag marked with the number around the piece, or use a small adhered label. Do not use paper jeweler's tags with colored strings. The paper is usually acidic and the dyes in the string may run when wet. Place numbers on the back of pendants, watch cases, charms, and fobs.

Lace: Sew a textile label bearing the number at a corner or near the end of the piece with a small loop of thread or with one or two stitches on the reverse.

Lacquer: See **wood**

Leather: Do not mark soft leathers with varnish or paint; use ink only if a permanent number is desired. For soft leathers, attach a textile label or acid-free tag with stitches passed carefully through an existing hole in the leather or around and underneath the assembly stitches, thongs, etc., provided that the existing stitching is strong enough to withstand such manipulation, or tie to a sturdy appendage. Inert, chemical-resistant tags and ties will be more resistant to tannins. (See Tables 1 and 2, pages 86-87) Sew cloth labels to linings or loop them around a strong appendage such as a strap or belt loop. Adhered labels may sometimes be used, but consult a conservator and avoid painted surfaces. Place the number on a metal decoration or hardware if no other suitable location can be found.

Seal extremely stiff, impervious leather such as rawhide with a small amount of a petroleum solvent-based varnish, on a smooth, inconspicuous surface. Avoid alcohol and acetone as they may cause drying or cracking. Do not use water-based materials as they will stain. Apply the number with ink or paint.

Linens: See **textiles**

Machinery: Mark on the right lower rear corner in close proximity to a manufacturer's plate if present. Attach an auxiliary tag with non-absorbent oil-resistant materials on large artifacts.

Mammals: Mark bones with ink in the center of the largest part of the bone or near the proximal end of long bones. Mark skulls with ink on the cranium and the mandible. Use a base coat unless permanent numbers are desired. Limit the marking of skeletal material to bones that can be easily and legibly labeled. The numbering is done on the most completely ossified portion of the bone, as marking materials will spread in porous bone, particularly from immature mammals. Use a thickened varnish on very porous bone. Keep small bones in numbered containers. Number mounted specimens on the mount near the base of the right rear leg or at the back edge. Number small skins in ink on the reverse, on the inner part of the neck or near the leg, or tie a tag to the ankle of the right rear leg. Number large skins on the reverse or use a label attached through a natural opening that is unlikely to tear, such as the eyes or nostrils; perforate large skins with a three-cornered awl in the middle of the lower back. Attach specimen labels or tags of heavyweight permanent record paper, 100% cotton or linen rag, with a cotton or linen thread or tie. Use non-absorbent oil-resistant tags and ties on oily specimens. Tag fluid-preserved specimens with a fluid-resistant label placed inside the jar or attached to a rear ankle of the specimen, and also label the jar.

Manuscript albums: See **books**

Manuscripts and documents: Write in pencil on the reverse or blank side of the document near an upper or lower corner. Mark envelopes on the reverse side at a lower corner. *In cases where an object cannot be marked directly* (e.g., an illuminated manuscript with decorative elements extending to the edge of the paper on both sides), mark an acid-free storage sleeve or box with the number. A stamped ink identifying symbol is used for some manuscript collections but is not generally recommended for museum collections. For complete information, see the Library of Congress's Preservation Leaflet 4, "Marking Paper Manuscripts," cited in the bibliography.

Marble: See **stone**

Masks: Number on the inside or reverse near the bottom. Use method appropriate for the material.

Metal: Mark with ink or paint, on a base coat, in an inconspicuous place. Avoid areas of corrosion and painted decoration. Use a solvent-based varnish on unfinished metals. Water-based materials may initiate corrosion at the application site. (If the metal has a surface coating, use a varnish that is safe for the coating.) Do not use materials containing ammonia on copper-based metals (including sterling silver). Mark flatware on the back of the handle so as not to obscure hallmarks. If flatware is to be exhibited with hallmarks up, place the number on the other side. If the piece is too small for numbering, attach a tag bearing the number or place the object in a self-sealing polyethylene bag or other container that is marked with the number. Make one small hole in polyethylene to prevent condensation. Use soft ties and tags to avoid scratching.

Musical instruments: Mark on a base coat with ink or paint. Avoid areas that will be worn if played. Mark pianos and harpsichords as for commodes and chests (**furniture**). Mark string instruments on the back of the heel at the base of the neck, or on the back of the body near the base. Mark wind instruments on the underside along the shaft. Mark horns on the stem near the mouthpiece or inside the bell. Many instruments have a lacquer coating that will be dissolved by solvent-based varnishes. Use a petroleum solvent or water-based material. Do not use materials containing ammonia on copper-based metals (including sterling silver).

Natural history specimens: See listings for specific types of specimens. For more information contact the Society for the Preservation of Natural History Collections (SPNHC).

Paintings: Mark with ink or paint on the stretcher and frame over a base coat, or with pencil or ink on the protective backing. Never mark a number on the face of a painting or reverse of a canvas.

Consistently mark objects in the same location, e.g., upper right corner of the frame and panel. Mark large paintings at opposing diagonal corners so that the number can be easily located whether the work is hung high or low on a wall or storage screen. This is not necessary in the case of small works. If both sides of an object are in view, mark the number on the bottom edge at one corner. For exhibition loans, a gummed paper label is sometimes pasted on the protective backing. See also: **scroll paintings**

Paper and cardboard objects: Mark with pencil in an unobtrusive place. See Table 5 (page 90) for information regarding pencils. Place paper items on a firm surface. Write gently to avoid indentation. Mark pamphlets as for books or mark on the back cover at one corner. Mark sheet music on the reverse at one corner, and also mark individual loose pages. Three-dimensional paper objects may be tagged. See also: **books, drawings, ephemera, manuscripts and documents**, and **prints**.

Photographs: Mark lightly with pencil on the reverse, preferably in a non-image area at a corner of the lower margin. Mark all items consistently in the same corner. See Table 5 (page 90) for information regarding pencils. If the photograph is hinged in a mount, place the number on the unhinged end. Also number the mount and, if framed, mark the frame as for paintings. Some modern photographic papers resist pencil; place in a labeled archival sleeve; or try a #1 pencil, Stabilo All® pencil, or wax pencil. In the latter case, interleave photographs with acid-free tissue to prevent transfer of the marking material. Do not use alkaline-buffered materials in contact with cyanotypes or color photographs. For cased tintypes, ambrotypes, and daguerreotypes, apply the number on a base coat with ink or paint on the lower back of the case by the hinge, or tag the object. Do not attempt to disassemble cased photographs without the advice of a conservator. Uncased tintypes, ambrotypes, and daguerreotypes are not usually marked directly; place in a labeled container.

Photographic negatives cannot be labeled with pencil, but can sometimes be labeled directly with inks such as India ink for film. The number should be placed on the non-emulsion side in a non-image area. Since such areas are usually very small it is difficult to write the number legibly without the aid of magnification. More commonly the number is written in pencil on an archival storage sleeve before the negative is slipped in.

Plastics (including celluloid and vinyl): Modern plastics may be damaged by solvents, older plastics by solvents and moisture. Acetone and toluene will damage most plastics, and alcohol and mineral spirits will damage some plastics. Mark on a non-plastic component if possible. Mark numbers on plastic directly with acrylic artist's paints. Tag with acid-resistant tags and ties (Teflon®, polyester, polypropylene). Some plastics give off acids as they deteriorate that can damage paper and cotton tags and ties. Apply the number directly with a wax pencil or Stabilo All® pencil, although the numbers may not be durable. Mark directly with India ink for film but consider these numbers permanent.

Porcelain: See **ceramic objects**

Portfolios: See **books**

Potsherds: See **ceramic objects**

Pottery: See **ceramic objects**

Prints: Mark lightly with pencil on the reverse, preferably in a non-image area at a lower corner. If the print is hinged in a mount, place the number on the unhinged end. Also number the mount and, if framed, mark the frame as for paintings.

Reptiles and amphibians: Attach tags to the larger parts of skeletal specimens or write the numbers with ink directly on each bone. Use a base coat if permanent numbers are not desired. Do not mark small bones directly if the numbers will obscure study features; store them in labeled containers. Attach tags to skins and skulls through a natural hole or opening if strong enough. Tag fluid-preserved specimens with a solvent-resistant

tag tied to a leg or around the neck, and also label the jar. Mark dry eggs with ink above and below the opening.

Rocks: See **geological specimens**

Rubber: Use water-based products such as acrylic paint on rigid rubber objects. Do not use acetone. Flexible rubbers are difficult to mark directly as marking media tend to flake or peel. Mark on a non-rubber component, attach a tag, or write the number directly with a wax pencil. Mark the number directly with India ink for film but consider the numbers permanent on light-colored objects. Enclose rubber objects in polyethylene bags or film labeled with the number (use a sulfur scavenger to absorb harmful gases, available from conservation materials suppliers), and isolate from other media since many rubber formulations contain sulfur compounds that can damage adjacent materials through direct transfer or off-gassing.

Rugs (including tapestries): Sew a textile label to reverse diagonal corners so the number is easily found when the rug or tapestry is rolled. Attach a tag to the roll's tie.

Scientific instruments: Mark on a base coat with ink or paint in an inconspicuous place near the base, or use an adhered label. Number all removable parts. Number instruments that have revolving parts, and revolve the part to the far side when exhibited. Metal parts may have a shellac coating that could be damaged by solvent-based varnishes.

Scrapbooks: See **books**

Screens: Mark on a base coat with ink or paint on a lower edge on the back of the frame near an outside corner, where it can be seen when folded.

Scroll paintings: Mark on a base coat with ink or paint on one knob of the scroll; also mark the box. Attach an acid-free tag to the cord at the opening end of the scroll.

Sculpture: Use a method appropriate for the material type. For sculpture in the round, apply the number at the lower rear base or, if there is no base, in an inconspicuous place not likely to be worn. Mark removable pedestals at the lower rear. Mark relief sculpture on the bottom edge, not the back, where it can be seen without lifting or moving the object. For unusual objects, such as complex abstract sculpture, note the location of the number in the object file and attach an auxiliary tag in storage.

Shell: Mark on a base coat with ink or paint in an inconspicuous place not likely to be worn by handling. Natural history specimens may be marked directly with ink. Adhered labels may also be used. See also: **invertebrates**

Shoes: See **costumes and costume accessories**

Silver: See **metal objects**

Sketch books: See **books**

Stamps: Not usually marked directly, although the number is sometimes written lightly in pencil on the back. Direct marking may lower the monetary value of stamps. More commonly, place the stamp in an acid-free envelope or sleeve that is labeled. Number mounted stamps with pencil on the back of the mount and on the hinge beneath the stamp.

Stone: Some stone, such as marble, is semi-porous and easily stained. Use a base coat, particularly on sculpture and cultural artifacts. See also: **geological specimens**

Tableware: Use a method appropriate to the material. Mark the number under a recessed foot or on one side at the base, and on the inside of lids. Individually mark all removable parts. For flatware, see: **metal objects**

Tapestries: See **rugs**

Terracottas: Mark on a base coat with ink or paint. Extremely porous items may need more than one application of the base coat. Use a thickened varnish to prevent extensive penetration of the varnish.

Choose the location carefully, as the base coat will leave a stain. Use a solvent-based varnish as water-based varnishes may dissolve or damage the surface. Place the number where it will not be scraped as the piece is set down or moved. It may be placed under a recessed base, if the piece is small, or at the lower edge of the back. Mark roundels or medallions on the back or on the bottom edge.

Textiles (flat textiles, including draperies, embroideries and linens): Sew a textile label at one corner on the reverse of small pieces, preferably along a hem or selvage. Label large textiles at opposing corners so the number is easily located when rolled. Tie a tag to the roll's tie. When textiles are wrapped on tubes or mounted on boards, also mark the support. Attach tags to fragile textiles with one loop of thread between the weave of the fabric as for lace. Do not sew a label directly to very deteriorated textiles. Label or tag fragile mounted textiles on the mount only. *Draperies and curtains:* sew on the reverse lower left or right corner of each panel; if very sheer, sew on the reverse but on the outside corners where it will be less conspicuous. *Bed coverings and quilts:* sew on reverse diagonal corners. *Pillow cases:* sew inside the left corner of the bottom half on or near the hem. *Decorative pillows:* sew on the reverse lower left or lower right corner. *Flags, banners, and pennants:* sew on the reverse side at the top of the hoisting edge. See also: **costumes and costume accessories**

Tools: Mark on the butt end of handles, along the shaft, or on the bottom edge of the head. Mark planes at the back of the stock; mark wedge and iron. Use method appropriate for the material.

Vehicles: Mark at the lower right rear corner of the body or stern or on the rear axle. Use method appropriate for the material. If a manufacturer's plate is present, mark the number in close proximity to it. Attach an auxiliary tag if the direct marking is not easily located.

Watercolors: See **drawings**

Weapons (including those with long shafts such as arrows, clubs, harpoons, knives, and spears): Place the number on the handle of clubs and tomahawks near the butt end, on the shaft of arrows, and on the inside end of bows. Number swords and knives on the blade below the counterguard or hilt, or at the base or butt end of the handle. Use method appropriate for the material. See also: **firearms**

Wood (including lacquer): Mark on a base coat with ink or paint in an inconspicuous place not likely to be worn by handling. Very porous wood may require more than one application of the base coat. Choose the location carefully as the base coat will leave a stain. Use a thickened varnish to prevent extensive penetration into the wood. Avoid finished or painted surfaces or use a base coat that is compatible with, i.e., will not dissolve or damage, the finish. Varnishes dissolved in a petroleum solvent will be safe for more finishes than acetone, but do not use petroleum solvents on waxed surfaces. Water-based products, such as acrylic paint or artist's acrylic matte or gloss medium, will be safer for more finishes than solvent-based varnishes, but may not be as durable and will require a solvent or mechanical methods for future removal, which may damage the finish.

Zoological specimens (live): Each category of animal is generally marked in a standard way. Methods include tags, bands, and tattoos. Radio frequency identification tags (rfid) are used to tag small zoo animals. The "transponders" or chips are usually inserted at the right shoulder or under the neck. See also "Survey of Marking Techniques for Identifying Wild Animals in Captivity," cited in the bibliography (although some marking material in this publication may be outdated). For up-to-date standards contact the American Zoo and Aquarium Association (AZA) located in Bethesda, Md.

TABLE 1: TAGS

Material	*Uses/Comments*
Acid-free card stock	100% cotton rag or lignin-free, pH neutral tags are recommended for general use both to protect the object and to ensure the longevity of the tag. Tags can be purchased with cotton string ties or made from card stock. A pH testing pen can be used to check acidity. Rounded corners are preferred to prevent piercing delicate surfaces. Not waterproof or oil resistant. Alkaline-buffered materials are not recommended for use in contact with some objects, including cyanotypes, color photographs, and proteinaceous materials, as they are thought to hasten the degradation of these objects. 100% linen rag heavyweight permanent record paper is sometimes used for fluid-preserved specimens. Can be laminated in plastic for outdoor use.
Reemay®	Non-woven polyester; inert; acid resistant. Used as drop tags or for textile labels. Insect resistant.
Tyvek®	Spun-bonded polypropylene; stiff and soft varieties. Water, oil, and chemical resistant. May be used for fluid-preserved specimens (marked with solvent-resistant ink or an impact printer). Insect resistant in general usage. (Consumed by dermestids.) Good for outdoor use. Soft varieties are sometimes used for tagging textiles and baskets. *Do not put Tyvek® in a laser printer.*
Resistall® paper	Coated or impregnated with melamine; recommended for labels placed inside jars containing fluid-preserved specimens (alcohol or formaldehyde), pH 4.5-5.2. Rounded corners are preferred to prevent piercing delicate surfaces.
Metal	Limited use. Aluminum tape (non-adhesive) or aluminum sheets can be used to make tags for large industrial artifacts and machinery. The numbers can be embossed with a Dymo® labeler or metal stamp, or an impression can be made with a pencil or knitting needle. Other types of metal tags are *not* recommended. Relatively soft but may scratch. Secure both ends of tag.
Teflon® tape	Non-adhesive, can be marked with a Dymo® labeler (the tape must be .015 cm thick and 1 cm wide). Water, oil, and chemical resistant. Use for tagging plastics that give off acids as they degrade. Insect resistant.
Mylar®	Clear, inert; sharp edges. Round corners. Water and oil resistant. Insect resistant.
Plastic corrugated board	Water and oil resistant. Brand names include Coroplast®, Primex®, Cor-x®. Good for outdoor use or for large machinery. Insect resistant. May have sharp edges.
Formica®	Carved or etched. Water, oil, and chemical resistant. Good for outdoor use. Insect resistant.

TABLE 2: TIES

Material	Uses/Comments
Thread/string	Undyed or natural cotton thread or string can be used to attach small tags. Polyester thread is more durable but may be too strong for use on fragile materials. Do not use jeweler's tags with colored strings; dyes may run when wet.
Fabric tape	Cotton, linen, polyester. Use to tie string tags onto large objects or mark with the number directly and loop around an object. Non-abrasive.
Cord	Polyester or polypropylene cord can be used for large objects or strong materials such as suits of armor that tend to cut finer threads. Shoemaker's supply companies carry 2, 3, and 4-ply polyester cords. Use unwaxed types. Cotton cord is soft and non-abrasive but is not as durable. Nylon cord has a short lifetime and is not recommended.
Polyethylene straps or ties	Plastic "zap straps" (such as those used to tie garbage bags) and thinner ties with male/female ends can be useful for objects that have oily surfaces. (Cloth or thread ties wick oils into paper or cloth tags.) Inert and relatively non-abrasive, these materials can be used in outdoors, although prolonged sunlight exposure may cause deterioration of the plastic ties and straps with long-term usage. They can be obtained from plastics suppliers. Use polyethylene, not nylon. Insect resistant.
Wire	Limited use. Annealed stainless steel, monel, or aluminum wire may be used to attach aluminum tags to large-scale industrial objects or vehicles. Aluminum wire may corrode in outdoor conditions. Stainless steel will discolor but will be corrosion-resistant. *Caution: Wire can scratch; use only in situations where other materials would not suffice. Wire can also be covered with surgical tubing or heat-shrink polyethylene tubing.* Vinyl-coated stainless steel cable, with the ends secured by a crimp connector, can also be used. Vinyl-coated cable is softer and less prone to scratching until the vinyl deteriorates. Avoid PVC, as off-gassing can cause deterioration of objects. Insulated copper is not recommended due to corrosion problems associated with the copper.
Glide dental floss	A Teflon® monofilament; other dental floss is made from nylon, which deteriorates. Resists water, oil, and chemicals. Use to tie tags on oily specimens, such as birds, or oily or greasy objects. Use unflavored and unwaxed Glide, a W. M. Gore product. May cut soft or fragile surfaces. Insect resistant.
Teflon® thread tape	Non-adhesive plumber's tape; chemically inert and soft; can be used to tie tags onto objects with fragile surfaces. Water, oil, and chemical resistant. Good for ties for plastic, rubber, and leather objects, which may cause cotton thread or string to deteriorate. Insect resistant.
Tyvek® #1422	Chemically inert; soft; no fibers. Water, oil, and chemical resistant. Insect resistant in general use. (Consumed by dermestids.)

TABLE 3: SOLVENTS

Most solvents are flammable and highly volatile, i.e., they evaporate rapidly and vapors quickly fill an enclosed space, causing both fire and health hazards. In addition, all solvents (and marking materials containing solvents) are toxic to some extent; use them only in well-ventilated areas. Keep bottles tightly capped when not in direct use and wipe up spills immediately. Avoid skin contact and wash hands frequently. Keep a Materials Safety Data Sheet (MSDS) on site for all solvents and marking materials. Do not attempt to remove varnishes from the surface of an object without the advice of a conservator. If you see a white "bloom" develop on the surface of an object, discontinue use immediately.

Materials	Uses/Comments
Alcohol	Alcohol, including ethanol (ethyl alcohol) and isopropanol (isopropyl or rubbing alcohol), can be used to remove some inks and varnishes, including B72. It will damage shellac finishes on wood and historic metal objects and some plastics. Do not use alcohol on moisture-sensitive materials such as ivory, wood, or leather, as it may cause excessive drying or cracking.
Mineral spirits	A petroleum distillate used to dissolve B67 and to thin Soluvar, mineral spirits can be used to clean brushes or remove base coats and top coats of these materials. Mineral spirits are sold at hardware stores as paint thinner. Check the label and look for a product that is labeled "pure mineral spirits." Similar petroleum solvents may also be used (e.g., heptane, petroleum benzine, Stoddard's Solvent, naphtha). Do not use on wax or waxed surfaces.
Acetone	Acetone is used to thin and prepare varnishes (including B72), clean brushes, and remove varnishes. It is used in commercial nail polish and nail polish remover. It will harm most finished surfaces and plastics. Do not use on plastics, lacquered or painted surfaces. Do not use acetone on moisture-sensitive materials such as ivory, wood, or leather, as it may cause excessive drying or cracking. *More toxic* than alcohol or petroleum solvents.
Toluene	It is *very toxic* and not recommended for use outside a laboratory setting. Used for preparing varnishes, toluene may be found in small amounts in commercial paint thinners and nail polishes. Will harm finished surfaces and plastics.
Xylene	Xylene is in the toluene family. Some disposable marking pens contain xylene. Will harm finished surfaces and plastics. It evaporates more slowly than toluene but is also *very toxic.*

TABLE 4: BARRIER MATERIALS FOR BASE COATS

Material	Uses/Comments
Acryloid B67®, Rohm and Haas	An acrylic resin; can be purchased in pellet form or as a 40 % solution in mineral spirits from conservation suppliers. Dissolve it in mineral spirits or a related petroleum solvent, not toluene or xylene. Reversible in mineral spirits; may yellow slightly over time. The resin may need to be thinned with mineral spirits periodically as the solvent evaporates. Do not use on wax or waxed surfaces.
Soluvar®, Liquitex	A commercial varnish composed of Acryloid B67®, possibly combined with another acrylic resin, Acryloid F10®; may yellow slightly over time. Easily obtained and ready to use. Reversible in mineral spirits as well as as stronger solvents such as acetone, xylene, and toluene. Mineral spirits are are safer for more surfaces than acetone or toluene. The gloss version is recommended. The matte version may cloud if successive layers are used; contains other additives including a small amount of methyl alcohol. Thin with mineral spirits or a related petroleum solvent. Do not use on wax or waxed surfaces.
Acryloid B72®, Rohm and Haas	An acrylic resin; can be purchased in pellets, as a 40 % solution in toluene from conservation suppliers, or as a 25 % solution in acetone. The most stable acrylic resin used by conservators. Disadvantages are that its least toxic solvent is acetone and it is reversible only in acetone, xylene, or toluene, which may damage some surfaces. For lower toxicity, dissolve it in acetone, not toluene, or in an ethanol/acetone mix (at least 10 % acetone). The resin may need to be thinned periodically as the solvent evaporates. Do not use on plastic, painted, or lacquered surfaces.
White base coats	White acrylic artists' paints, or white paints made by adding titanium dioxide pigment to B67, Soluvar, or B72, can be used as a base coat on dark objects. They should be applied over a clear base coat to avoid leaving a white "ghost" on the object.
Acrylic emulsions	These white, water-based materials turn clear when dry. They are available commercially at art supply stores as "acrylic medium"; manufacturers include Golden, Liqui-tex, and Aqua-tec. They are not as durable as the previously listed materials. Acrylic emulsions are also available from conservation suppliers (Rhoplex AC-33® is one example). Soluble in ethanol or acetone, not water, when dry. Some water-based emulsions may contain ammonia, which should not be used on copper-based metals (copper, brass, bronze, sterling silver) as it will stain the metal. Ammonia may also etch resinous coatings. Do not use water-based materials on objects that are dissolved or damaged by water.
Polyvinyl acetate (PVA)	There are a wide variety of PVAs, both solvent-based and water-based. Solvent-based PVAs are soluble in ethanol or acetone when dry. The water-based emulsions are soluble in water when wet, but can be difficult to remove even with stronger solvents (e.g., acetone, toluene) when fully cured. Removal of the base coat at a later date may not be possible without causing damage to the surface of the object. They are white in liquid form but turn clear as they dry. (Elmer's® glue

TABLE 4: BARRIER MATERIALS (Continued)

is a PVA emulsion.) PVAs can be hygroscopic and may turn white or swell with moisture contact, causing damage to some surfaces including plastics. They may soften or become sticky in warm temperatures. Most release acetic acid when degrading, which corrodes lead and plastic. Most PVAs are not recommended as a base coat. Acrylic resins are preferred. However, Jade 403®, a water-based PVA emulsion, tested well in pH testing conducted by the Canadian Conservation Institute (CCI). It is reversible in acetone. Observe cautions regarding acetone.

TABLE 5: WRITING MATERIALS

Material	Uses/Comments
Acrylic paints	Water-based emulsions; manufacturers include Golden and Liquitex. "Fluid" acrylics are especially easy to use as they do not need to be mixed. Paints composed of ground mineral pigment, rather than dyes, are more light fast. Recommended pigments include titanium dioxide white, carbon black, and vermillion or cadmium reds. Acrylic paints are soft and may abrade or peel from glossy surfaces when dry without a top coat of varnish. Some acrylic artists' paints contain ammonia which stains copper-based metals and sterling silver. Acrylics can be dissolved in ethanol and acetone when dry, or use mechanical methods to remove. They can be applied with a brush or crow quill pen nib.
Inks	Inks should be quick drying, non-acidic and light fast. They should have good adhesion, abrasion and fluid resistance, and the ability to write well on a variety of porous and non-porous surfaces. Inks containing a mineral pigment rather than a dye are recommended for light fastness. Inks that contain carbon are very light fast. India ink for film adheres better to glossy surfaces. More than one ink may be needed for different applications. For example, an ink may show good resistance to alcohol (beneficial for marking labels for fluid-preserved specimens) but may write poorly on acrylic varnishes or glossy surfaces. Rotring 17® Black and Pelikan® Drawing Ink FT, Black were rated highly in a 1986 study by Stephen L. Williams and Catherine A. Hawks. Black ink is recommended, although white inks can be used on dark objects. Chinese white ink or titanium dioxide ink is recommended. White fluid acrylic artists' paint can also be used as an ink. White inks and paints should not be used in Rapidograph pens as they clog the pens.

TABLE 5: WRITING MATERIALS (Continued)

Wax or grease pencils	Can be used to write directly on plastic, foil, and resin-coated photographs. Easily abraded, hard to keep a sharp point. Berol China® Markers, black or white.
Stabilo All®Pencil	Can be used to write on glossy surfaces, including resin-coated photos, glass and plastic. Standard pencil size and hardness, easier to keep a fine point than wax pencils. 8008 Black or 8052 Titanium White. May abrade.
Drawing or Writing Pencils	Writing pencils are graded Nos. 1, 2, 2.5, 3, and 4, which reflect the degree of hardness of the lead, with No. 1 being the softest. Drawing pencils have a broader range of designations. Medium-grade pencils are used for marking numbers on paper objects. No. 2 writing pencils are recommended, as well as drawing pencils graded HB, F, and H (listed from softest to hardest). HB = No. 2, F and H = No. 2.5. The No. 2 or HB pencils are recommended for most papers as they will leave a dark mark with less pressure on the pencil point. They may smear slightly if rubbed. Numbers can be blotted gently one time, not rubbed, with a vinyl eraser to remove excess lead. The harder grades (F and H) are less likely to smear but may indent the paper if applied too forcefully. A No. 1 may be used on some glossy papers, but check for smearing.

TABLE 6: WRITING TOOLS

Material	Uses/Comments
Pens	Crow quill pens or fine steel-nib technical pens, such as Rotring® or Koh-I-Nor Rapidograph® pens, are recommended for applying ink numbers. A variety of nib sizes (e.g., .25 very fine, .35 fine) can be used for different size numbers. Crow quill pens can be used to write with acrylic paint as well. Do not scratch the object or splatter or drip ink. The ink should flow well enough to write without pressing down. If rapidograph pens clog, try shaking the pen or dipping the tip in water. Pens should be cleaned frequently.
Brushes	Very fine sable or camel's hair artists' paint brushes (000-00000) are used to write numbers. Slightly larger brushes can be used to apply base coats (0-1). Larger brushes also may be used to paint numbers on large objects such as vehicles or machinery.

TABLE 7: DISPOSABLE MARKING PENS

Disposable technical marking pens are easy to write with, and most do not require loading or cleaning. Disadvantages are that many of the inks used in these pens are not light fast, and the tips are easily damaged. Some pens contain alcohol, xylene, or other solvents that may damage some surfaces. In addition, manufacturers frequently change the formulation of the inks; each new batch of pens should be tested before use. A pen that contains a pigmented ink is more durable and light fast. The first two pens listed below were rated highly in a 1988 study by Rose M. Wood and Stephen L. Williams (cited in the bibliography).

Materials	Uses/Comments
Pigma® Pen, Sakura Color Products Corp.	Permanent, pigmented, pH 8-9; fibrous plastic tip; doesn't write well on plastics (including acrylic base coats); good for fabric tape. Alcohol resistant. Good light fastness.
Pilot®, SCA-UF	Permanent, ultra fine point, no xylene; writes well on most non-porous surfaces; high bleeding potential on paper and textiles; soluble in alcohol; porous plastic tip. Fair light fastness.
Sharpie®, Sanford®	For most non-porous surfaces; writes well on glass and plastic; bleeds on fabric and some paper; ink does not have good color value, very little pigment; soluble in alcohol; porous plastic tip. Fair light fastness.
TRIA pen, Letraset®	An inexpensive, refillable disposable pen. Golden fluid acrylic paints and India inks can be used to fill the pens, which also have replaceable tips.

TABLE 8: ADHERED LABELS

Materials	Uses/Comments
Acid-free paper	Labels can be made from 100% rag, lignin-free, or acid-free paper. Acrylic emulsions (Rhoplex AC-33®) and PVA emulsions (Jade 403®) are used to adhere labels. See discussion of PVAs in Table 4. The number can be written with ink or printed with a laser printer. Use laser-quality acid-free paper. Do not use labels printed on a daisy, dot matrix, or ink jet printer. Solvent-based adhesives such as B72 can also be used on solvent resistant surfaces but will remove type printed with a laser printer. Use solvent-resistant ink, or try a dot matrix or ink jet printer. For the least intrusion to porous objects, apply the adhesive to the label, then apply the label to the object. Do not use on friable or painted surfaces.
Japanese tissue paper	Wheat or rice starch paste or methyl cellulose is used to adhere Japanese tissue paper labels. Used for bark cloth, baskets, wood objects with uneven surfaces, and occasionally leather. Heat- or solvent-reactivated tissue can be used for materials such as leather, which cannot tolerate moisture (Rhoplex AC-234® adhesive). Consult a conservator. Starch paste may attract pests. Do not use on friable or painted surfaces.

TABLE 9: SEWN LABELS

Materials	Uses/Comments
Fabric tape	Cotton twill tape, bleached or unbleached, is recommended for textile labels. Plain woven cotton, linen, or polyester tape may also be used. Sizing is sometimes used to stiffen or seal the tape but is not generally recommended. The number is written with ink. The ends are turned under 1/4" before sewing.
Reemay®	Labels may be cut from non-woven polyester interfacing. The numbers are written with a typewriter.
Tyvek®	Soft grades of Tyvek® are sometimes used for making textile tags. Numbers are written with ink. *Do not put Tyvek® in a laser printer.* Tyvek® 1073 B is recommended. Round corners.
Threads	Cotton thread (#50 or #60), undyed or white, is recommended for sewing labels on textiles. Ideally, the strength of the thread should be equal to or less than the strength of the fibers of the textile so that the thread will not tear the textile if the tag is snagged. Cotton/polyester or polyester thread may be used for very strong fabrics but may tear fragile textiles. Silk threads deteriorate quickly and are not recommended. Silk thread is also very slippery and stitches may pull out easily. Dark, colorfast thread may be used for stitching tags on dark-colored objects if the stitches will be visible on display. Test the thread to make sure that the color does not run when wet.
Needles	Fine, sharp-pointed needles (#8 quilting in between, #9-10 crewel, #10-#12 sharps) are recommended for medium and fine textiles. Small-size tapestry or ball-point needles are recommended for sewing labels on textiles with a heavier, open weave. A sharp pointed needle can be blunted with fine sandpaper.

Victoria Pointer

Photo set-up: three-dimensional object on seamless. Courtesy the Newark Museum. Photo by Lisa Mazik.

PHOTOGRAPHING YOUR COLLECTION: THE BASICS

Photography of objects is an integral part of the documentation of a museum collection. In its most basic form, photography of an object serves as visual documentation, but photography can also aid in research, object retrieval, and education. It documents the condition of an object for future comparison and serves a purpose in publications. For a photograph to fill all these needs, quality photography is a necessity.

Photographing objects does not require a full knowledge of photography. A basic understanding of the equipment and the steps necessary to create a photograph are all that is needed to produce documenta-tion of the objects in your collection. High-quality photographs for documentation purposes can be obtained in-house using a 35mm format camera; for photography specifically for reproduction purposes a professional photographer should be hired.

Equipment:
- Camera
- Cable release
- Filters
- Easel
- Copy stand
- Lighting kit
- Film
- Gray card
- Seamless (backdrop material)

- Bubble level
- Tension clips
- Tape
- Extension cord
- Large sheet of white board
- Color chart/gray scale
- Ruler
- Spring clips

To get started you need the right equipment. The basic set-up for documentation of an object includes a camera, tripod, support for the object, and lighting. Staff photographing objects should be reasonably familiar with operating a 35mm camera. The best camera to use for copy work is a 35mm single lens reflex (SLR) camera with a light meter and 50mm lens. The camera should be either fully manual or an automatic that offers manual override. It is necessary to have a tripod to support the camera, whether you have a copy stand or not. A copy stand is most useful when shooting flat work but if you do not have or do not plan to purchase one, you may want to put extra money into your tripod and get one with a head that will allow you to angle the camera to shoot straight down at an object. A photograph cannot be created without light, and lighting equipment can be purchased inexpensively in a kit containing two reflectors, sockets, and stands. Light stands are much more effective than the clamps that sometimes come with a lighting kit.

Another important piece of equipment is film. One of the first decisions to make when photographing an object is whether the film should be black-and-white or color. For most documentation purposes black-and-white will be the best choice. Black-and-white photographs are the most stable form; they remain consistent in quality, while color photographs lose color accuracy in time. When color is necessary, a decision must be made between slide film and negative film. Slide film offers the greatest versatility because slides can be projected and printed. Slides (transparencies) are most often used in publishing, and they can be easily scanned with the proper equipment for database use. If, however, you want to obtain multiple color prints that are not for publication purposes, color negative film should be used.

If you decide that your project requires color photography, it is important that the correct film and lighting combination be used; the wrong combination can result in noticeable color inaccuracies. In photography, light is rated by its temperature in degrees Kelvin, and color film is balanced to match two of these temperatures: daylight and tungsten. For the greatest control, the recommended combination is tungsten film with tungsten lights. There are two types of tungsten slide film: Type-B, which is available in many brands, such as Agfachrome, Ektachrome, and Fugichrome; and Type-A, such as Kodachrome. Color negative film that is balanced for tungsten is sometimes referred to as Type-L; each manufacturer has its own version of Type L. Type-B slide film and any color negative film can be processed at local professional photo labs. Kodachrome requires special processing and must be mailed for developing.

To convert film to match lighting	Wratten filter number	Filter color
5500K (Daylight) to 3200K	80A	Blue
5500K (Daylight) to 3400K	80B	Blue
3200K (Tungsten) to 5500K	85B	Coral
3400K (Tungsten) to 5500K	85A	Coral
3200K (Tungsten) to 3400K	81A	Yellowish light coral
3400K (Tungsten) to 3200K	82A	Light blue

Code	Wattage	Temperature	Film	Rated Life	Type
EAL	500W	3200K	Type-B slide		
			Type-L negative	15 hours	Frosted
ECT	500W	3200K	Type-B slide		
			Type-L negative	26 hours	Unfrosted
DXC	500W	3400K	Type-A slide	6 hours	Frosted
EBV	500W	3400K	Type-A slide	6 hours	Unfrosted

The best tungsten lights to use for color and black-and-white photography are 500-watt photo floods. Type-B slide film and tungsten negative film are balanced for 3200K tungsten lamps; Type-A slide film is balanced for 3400K lamps. Every photo flood bulb has a lettered code that is standard among manufacturers. A 500-watt, 3200K bulb with a frosted face, which offers an extra degree of diffusion, will have the code EAL; without the frosted face its code is ECT. A 500-watt 3400K bulb with a frosted face will have the code DXC; without the frosted face the code is EBV. The diffused face is not necessary, but it will reduce harsh lighting edges. It is important that you do not use the wrong temperature bulb with the film you are using. Using a 3200K bulb with Type-A slide film will give photos a warm cast, and using a 3400K bulb with Type-B slide film or tungsten negative film will give photos a bluish cast. When photographing in black-and-white, it does not matter which bulb is used; but if you shoot Type-B slide film or tungsten negative film exclusively, there is no reason to purchase 3400K lamps.

These lamps also have a "rated life," the length of time for which the color temperature of the bulb is guaranteed. For this reason, the bulbs should be used in pairs; a new bulb should not be used with an older bulb. The rated life varies among bulbs: EAL = 15 hours, DXC and EBV = 6 hours, ECT = 26 hours. Due to their limited life spans, these bulbs should not be used needlessly and should only be used for the amount of time that they are rated

to avoid inaccurate color. Shifts in color can also occur when light of a different temperature from that being used, leaks into your photo area. It is important that the only light turned on in your proximity are the photo lamps being used.

There are precautions that can be taken when you are faced with situations where your film and light do not match; filters can be used to make adjustments. If the only film you have is daylight film and the only lighting available is 3200K, a blue filter numbered 80A will correct the lighting to match your film. Filters can prove very helpful, and it is a good idea to have on hand the ones you think you will most likely need.

Two-Dimensional Framed Work

When photographing a two-dimensional work, the object must be set upright, hung on a wall, or placed on a sturdy easel. Easels often prove to be more practical than a wall, as they provide a mobile photo unit and the option to set up in an area with restricted space. Finding wall space that can be dedicated to photography can be a difficult task. Very large works that are too heavy or awkward for an easel can sit on the floor and lean against a sturdy structure.

Place the object on the easel, resting on its longest edge. Placing works on the easel in this manner allows for minimal camera adjustment. When shooting slide film that you know will be used for projection purposes, the object should always appear upright in the slide's horizontal format. Maintain-

ing this format when shooting slides will help when the slides are projected, because all images will be the same height. When photographing vertical works in a horizontal format, you will create a large amount of space on either side of the object that can be masked out later with slide masking tape.

After the work is securely mounted on its support, position reference material such as a color chart, gray scale, object identification number, and ruler next to the object or on the support. With the reference material in place, center the camera and tripod in front of the object and frame it in the viewfinder. Fill as much of the viewfinder with the object as possible so that the maximum reproduction quality can be obtained. Next, you must square up the camera with the object. This means that the face of the lens and the film plane of the camera must be parallel to the plane of the object.

To determine if the camera and the object are parallel, look through the viewfinder; the object should be square with the viewfinder and should not look askew or as if it were receding on any side. If the object is on an easel, its top will most likely tilt back; through the viewfinder it will appear that the top is narrower than the bottom. To compensate, the camera should be raised above the center line of the object and tilted forward to match its angle. The same steps are taken if the object appears narrow at the bottom, except the camera is lowered and tilted up. If either of the image's sides appear narrower than the other, the entire camera and tripod must be moved left if the left side of the object is narrower, or right if the right side is narrower. After moving the camera, the camera must be adjusted by rotating the left or right side, respectively, closer to the object.

With your camera in place, the lighting can be arranged. To set up the lighting, raise the photo floods to the same height as the camera and place them approximately six to eight feet from the camera and the object. Next, direct the reflectors toward the work; they should form an angle of approximately 45 degrees with the object. With the lights

in position and turned on, look through the viewfinder to make sure that there is no glare on the object and that the frame does not cast a distracting shadow.

Whether you are shooting a glazed or unglazed object, glare can occur. To decrease glare, polarizing screens can be placed in front of the lights and/or a polarizing filter can be added to the camera lens. You can also adjust the lights. Although the best position for the lights is at a 45-degree angle with the object, sometimes this positioning produces a glare even with polarizing equipment. If this is the case, move the lights straight forward a few feet, maintaining the same side-to-side distance from the object, and angle them toward it so that the light grazes the object more than before. Also try increasing the distance of the lights. As you move the lights, try to maintain even lighting by moving both lights the same distance. The equality of the lights can be tested by turning one on at a time and comparing how each light hits the object. When you set up the next item to be photographed, return the lights to their original position. You will most often move only the camera and tripod and not the lights because every time you move the lights a new light reading must be taken.

Two-Dimensional Unframed Objects

A paper object that is not in a support, such as a mat or frame, must lie on a flat surface with the camera positioned over it. The best equipment for this situation is a copy stand that serves as both tripod and flat surface for the object. If you do not have a copy stand, a low table and a very sturdy tripod that can be adjusted so that the camera is parallel with the surface of the table will work. Position the tripod so it leans against the table, and extend the outside leg longer than the other two. When using a copy stand the camera will automatically be parallel with the surface on which the object will lie; if you use a tripod then the camera must be squared up to the object as described for framed works. Either way, adjust the

camera so that the object fills the viewfinder, following the instructions provided for two-dimensional framed work.

If you are planning to purchase a copy stand, be aware that some come with attached lights. This feature is not necessary if you already have photo flood lamps with light stands. When using photo floods on light stands to photograph flat objects, position them just as you would with upright objects. Raise the lights to the height of the camera, or higher if the photograph is a close-up, and place them the same distance from the camera and the base of the stand. The lights should then be pointed at a 45-degree angle to the object. For an object that does not lie flat, or for copy work from a book, a piece of glass can be placed on top of the object. You must use your discretion to decide if the object can withstand having glass laid on top of it. To check whether your lights are equally spaced and angled, hold a pencil vertically above the center of the object and move the lights until the two shadows appear equal.

When photographing objects, be aware of the surface on which they are lying and ensure that it does not show through the paper. If the paper is lightweight, a piece of white mat board may be needed under it to maintain accurate color. Also, when photographing objects, be careful of the heat given off by the lights. If the temperature seems extreme, move the lights farther from the object.

Three-Dimensional Objects

The preparation of three-dimensional objects for photography can be more involved than for two-dimensional objects. When photographing 3-D objects, the background is an important part of the image. The background should not detract from the piece, but it should offer contrast. It also should be wide enough to fill the viewfinder when the camera is at shooting distance. Backgrounds can be a variety of materials; large rolls of paper or large pieces of fabric, referred to as the seamless, are often used. Wide rolls of paper in a variety of

colors can be purchased through a photo supply catalog.

A sturdy working surface such as a table should be used to support the object; the table should be wide enough to support the seamless so that the edges do not bend over the sides. Place the table next to a wall and adhere the seamless to the wall behind the table high enough that the top edge will not be visible through the viewfinder. Instead of using a wall to support the seamless, two stands and a rod can be placed to hang the roll of paper or other kinds of backgrounds.

From its attachment to the wall or support, the seamless should flow without kinks to the front of the table, creating a gentle curve toward the back of the table. The seamless can roll over the front edge of the table but should be fastened to the table with strong tape or spring clamps. Spring clamps can also be used to weight the paper and keep it from rolling back up.

With the support and background in place, position the object on the table, centered from left to right. Do not place the object too close to the curve of the seamless. Position the camera and tripod at a distance from the object to fill the viewfinder with the entire object but not so close as to offer no breathing room around the object. As you position the camera, try different angles and a low or high perspective; try rotating the object. When photographing the piece, a variety of perspectives will only help the documentation.

The correct way to light three-dimensional objects is not as straightforward as it is for two-dimensional ones, because the lighting depends on the object. The basic set-up is to have a main light and a fill. The main light should most often be softened, since the direct light that is appropriate for two-dimensional object is not always recommended for three-dimensional object. The main light can be softened by bouncing it or diffusing it. To bounce it use a photographic umbrella, a white wall, or a large piece of white board. When bouncing light, be sure to bounce it off a white surface, because the

light will reflect the color of the surface onto the object you are photographing. To diffuse the main light, clip a diffuser onto the reflectors, or place a semi-opaque piece of plastic between the light source and the object. When placing diffusers close to the lights, be sure that they are a non-flammable material. The strength of the main light can also be diminished by moving the lights farther away from the object.

The main light should be positioned where it best defines the object's contours, shape, and textures. A good place to start with the position of the main light is to the left of the camera, elevated above the camera, and pointed down at the piece. Do not use this as an absolute; move the light around until you feel the object is well represented. When shooting a two-dimensional object, there are usually no shadows. When shooting a three-dimensional object, shadows define the edges, the recessions and projections, and the textures. The shadows, however, should not be cast over important parts of the object, nor should they be so dark as to obscure a view of what is in them. A strong contrast is prevented by using a light source called the "fill." The fill reduces contrast and provides detail in the shadow areas created by the main light. The fill can be as simple as a reflection of the main light that is bounced off a piece of white board and back onto the object. You can also use another photo flood for the fill that is more heavily diffused than the main light. Play around with the lighting until you feel you have best represented the object.

Exposing the Film

When your camera, lights, and object are set, you are ready to take the picture. Now all you have to do is expose the film correctly. The correct exposure will allow for detail in both the highlights and dark areas of an image. A camera controls film exposure through shutter speed and aperture settings. The shutter speed controls how long the film is exposed to light and the aperture (f-stop) controls the strength of the light reaching the film. The cor-

rect exposure occurs from a correlation between the two and the film that is used. The best film for copy work is a slow film with an ASA (American Standards Association) rating of 100 or less. A slow film requires a longer exposure than a fast film, but it offers greater color saturation, greater sharpness, and less graininess than fast films.

When a camera's light meter reads a scene, the exposure it recommends is one that will result in an 18% gray or medium gray. This is fine if you are photographing something that is 18% gray or a combination equal to 18% gray. However, if you are shooting a pen and ink on paper that is mainly white paper, however, and you expose it as your camera meters, the final image will be a pen and ink on a gray sheet of paper instead of white.

To avoid this problem, use a gray card that is a photographic 18% gray. By taking a light reading from this card, you will obtain the correct exposure. No matter what you are photographing, place the gray card in the same light that the object receives. The gray card should fill the metering area of the camera; if you are too far away to do so then remove the camera from the tripod and move closer. When metering the card be sure that the light is not blocked and no shadow is cast on the card.

As you meter a scene, start by setting either the f-stop or the shutter speed. When photographing a two-dimensional object, a middle aperture of about f/5.6 or f/8 will suffice. Set your camera to f/5.6 or f/8 and take a reading from the gray card to obtain the correlating shutter speed. When photographing a three-dimensional object, the smallest aperture possible should be used because it will offer the greatest depth of field. Depth of field is the area of focus within a picture measured by depth; the smaller the aperture the greater the depth of focus. Also, the smaller the aperture the longer the exposure. If you are using color film, you should not expose the film at a shutter speed longer than 1/2 second because it may result in reciprocity failure, which can cause a color shift in the film. If you are using black-and-white film at a shutter speed longer than

1/2 second, you should overexpose your film. So when photographing three-dimensional objects in color, first set the shutter speed to 1/4 second, which is one stop faster than 1/2 second, and take a reading from the gray card to acquire the correlating f-stop. If you are using black and white film, you can adjust your aperture to its smallest setting and then take a reading from the gray card. Remember that if your correlation shutter speed is longer than 1/2 second, you must overexpose your film to compensate for reciprocity failure.

As long as you do not move the lights, the reading taken from the gray card will be the center point for your exposures. If the lights are moved, a new reading must be taken. Shoot a bracket of exposures of each object or of each view of a three-dimensional object. Bracketing allows for over- and underexposing to compensate for inaccuracies in your camera and to ensure properly exposed film. Most often the setting that is changed when bracketing is the shutter speed, but there are times when the aperture changes.

When bracketing by shutter speed, a standard bracket includes an under exposure (one stop faster than the center point), the center point (the reading taken from the gray card), and an over exposure (one stop longer than the center point). A bracket of three is all that is needed when shooting black-and-white or color negative film. If you are shooting slide film, which is more difficult to correct when an exposure is incorrect, just one-half of a stop off can give the wrong exposure. When shooting slide film begin with a bracket of five, in half stops instead of full stops, until you get to know your camera. Because slides are the final product with slide film, be sure to take multiple exposures at each bracket setting to avoid having to make duplicates, which create lower image quality.

With everything in place and your exposures decided, check your focus and make sure that everything is sharp. During the photography session check your focus continually. Use a cable release to depress the shutter release button to reduce vibra-

tions. In between exposures, wait for the camera to stop vibrating from the film advancement and exposure adjustments before taking the next shot. These precautions will reduce the possibility of obtaining a blurry image. Once you have finished with the object, move on to the next. If you had to move the lights, put them back in their original position, and remember to take a new light reading when the next item is ready to be photographed. If the lights were not moved, a new light reading is not needed.

CONCLUSION

It may take a few rolls of film before you are fully familiar with the camera and the steps necessary to obtain a truly representational photograph of an object. There are a number of variable factors in photographing objects that you will discover as your photography experience progresses. Following a set of procedures will help you obtain quality images that support the documentation of the objects in your collection. It is important to remember that photography can enhance a system of documentation and provide multiple benefits to a collection.

Genevieve Fisher

Light levels should be measured after installation to ensure compliance with conservation standards. Courtesy the Newark Museum. Photo by Lisa Mazik.

From the moment of their creation, all objects are vulnerable to physical deterioration. This process can be mitigated by careful handling and by storage in a clean, stable environment. (See chapters on Storage and Preparation.) It has been estimated that a lack of proper routine maintenance is responsible for 95 % of conservation treatments; the remaining 5 % result from inappropriate handling (Randolph 1987, p. 3). Museums seek to preserve their collections in ways that are environmentally safe and economically prudent. Preventive care, also called preventive conservation, is the most cost-effective strategy. It is defined as the mitigation of deterioration and damage to cultural property through the formulation and implementation of policies and procedures for the following:

- appropriate environmental conditions
- handling and maintenance procedures for storage, exhibition, packing, transport, and use
- integrated pest management
- emergency preparedness and response
- reformatting/duplication

Conservation is the profession devoted to the preservation of cultural property for the future. Its activities include examination, documentation, treatment, and preventive care, supported by research and education. Along with staff conservators, museums may use the expertise of freelance professional conservators, regional conservation facilities, and conservators from museums that provide outside services. For institutions requiring outside assistance, the Foundation of the American Institute for

Conservation of Historic and Artistic Works provides a referral system that identifies conservators by specialty, membership level, and geographical area.

In institutions with permanent conservation staff, the responsibility for monitoring as well as treating objects may be the province of conservators. Nevertheless, registrars and collections managers should be fully informed about preventive care practices. In museums without permanent conservation staff, they may take the lead. Indeed, a museum's collections maintenance program will meet the greatest success when staff understand and support its goals.

THE ENVIRONMENT

Long-term preservation of collections is affected by relative humidity, temperature, light, air pollution, and pests. Responsible collections management can be achieved by understanding the potential for damage that each of these factors presents, the preferred environmental conditions for different object types, and strategies for approaching that environmental goal.

RELATIVE HUMIDITY

Relative humidity (RH) may be defined as the proportion of the amount of water vapor in a given quantity of air compared to the maximum amount of water vapor that the air could hold at that same temperature, expressed as a percentage. As air temperature increases, so does its capacity to hold moisture. Therefore, as the temperature goes up, the relative humidity goes down, and vice versa. These two measurements are usually considered together.

Maintenance of stable RH is desirable, as extremes and rapid fluctuations ("cycling") can result in severe damage by changes in shape and size, chemical reactions, and biodeterioration (Thomson 1986, p. 82) of materials comprising an object. Bronze disease, an active form of corrosion occurring on archaeological copper alloys, develops at high RH levels. Hygroscopic (readily taking up and retaining water) materials, such as bone, wood, ivory, paper, textiles, parchment, basketry, animal hides, and some adhesives, will expand with increasing RH, resulting in overall dimensional changes. Absorbed salts in porous archaeological materials can also be activated. When RH decreases, these materials will give up moisture and dissolved salts, causing efflorescence.

Extreme RH values are to be avoided for many materials. A high RH (above 60-70%) can produce mold growth on organic materials, leaching of salts from unglazed ceramics and fossils, and corrosion of metals. Conversely, a low RH (below 40-45%) produces desiccation, cracking, and embrittlement in organic materials such as wooden objects, furniture, panel paintings, furs, and lacquers. For unstable iron and bronze and for unstable glass, RH should not exceed 40-45% (Thomson 1986, p. 84).

The appropriate RH for any object is the range at which change is minimized. Recent research (Erhardt and Mecklenburg 1994) stresses the importance of identifying appropriate RH values based upon consideration of an object's component materials and the frequency and circumstances of its use. Many museum objects are composed of multiple materials; in order to provide a good environment for the entire object, the ideal conditions for a certain constituent may be compromised.

A constant RH within a range of 50-60% for mixed collections has generally been preferred (Plenderleith and Philippot 1960) in museums, but this is too high for metal and approaches the range at which mold is formed. 50% +/- 5% is safer. Mixed photographic collections should be stored at an RH of 30-50%, although those that incorporate hygroscopic mounts or housings are better stored at 40-50% RH (IFLA 1992). A low RH of 20-30% is recommended for nitrate and "safety" (acetate and polyester base) photographic films (IFLA 1992). An RH of 30-35% is appropriate for glass plate negatives (IFLA 1992).

It is also important to take the building itself into consideration. Museums that include buildings as part of their collection have an additional problem: The external environment, against which most collections are protected by the structures housing

them, is in these cases in direct contact with the collection itself. Condensation within the exterior walls can form as the outside temperature drops. Lowering the internal RH as the external temperature falls reduces the possibility of condensation formation. The installation of vapor barriers and insulation can reduce the migration of moisture from the building's interior to exterior.

For buildings without mechanical air-handling systems, relative humidity can be modified within rooms by the use of dehumidifiers and unheated evaporative humidifiers. Within smaller areas, micro-environments can be produced to maintain desired temperature and RH levels. In exhibition cases, humidity can be buffered or reduced through the use of silica gel, a porous, non-crystalline form of silica (Lafontaine 1984) or saturated salts (Creahan 1991a, 1991b; Piechota 1992). These materials must be properly conditioned in order to be effective. In storage, a quantity of cellulosic materials may be incorporated in the object's container in order to buffer fluctuations in RH and temperature (Piechota 1978). Each institution should weigh the cost of creating specially controlled rooms or cases against that of installing a building-wide heating-ventilation-air-conditioning (HVAC) system.

TEMPERATURE

Since temperature directly determines RH levels, its control is critical. Increased temperature will produce chemical deterioration, biological activity, and minor physical expansion of hygroscopic materials (Thomson 1986, pp. 43-44). It also can cause dimensional changes in metal, may cause enamel to pop off, and can cause rock crystal to "explode."

Ideally the environment should be stable, as fluctuations in temperature affect relative humidity. Changes in both temperature and RH should occur gradually as the seasons change. For most objects, the optimum temperature range is 68°-72°F (20°-22°C) with 2-3°F fluctuation within 24 hours. Temperature and relative humidity should be constantly monitored in storage and exhibition areas

A hygrothermograph should be placed in an inconspicuous but accessible place. Courtesy the Newark Museum. Photo by Lisa Mazik.

with the use of a properly calibrated and maintained hygrothermograph.

The deterioration of materials such as furs, paper archives, and textiles is reduced by storage at 41°-50°F (5°-10°C) (Thomson 1986, p. 45). Certain types of materials benefit from temperatures below this range. Color photographic material may be stored at temperatures as low as 25°-40°F (-4°-4°C) (IFLA 1992).

In the mid-1990s a debate over the value of flat-lining (as above, keeping temperature and humidity within a small range) emerged in the conservation field. There is some indication that materials can withstand a broader range of environmental fluctuation than has been previously accepted. It will take much research before this theory is substantiated and present environmental standards are changed.

LIGHT

Light is radiant energy that permanently damages light-sensitive materials by catalyzing degradation reactions. Both the type (proportion of ultraviolet and infrared light) and intensity (amount of illumination) of light affect an object's condition.

Radiant energy may be characterized by where its waves fall on the color spectrum. Three types of radiation affect the condition of objects:

(1) Visible radiation, measured in lux or foot-candles (fc), provides illumination. Visible light can be monitored through the use of a photographic light meter.

(2) Ultraviolet (UV) light, invisible short-wave radiation, is the most damaging component of the light spectrum. A UV monitor can be employed for determining the amount of UV radiation as microwatts/lumen (mw/lm).

(3) Infrared (IR) or long-wave radiation is manifest as both heat and light.

The recommended light level for sensitive materials, including textiles, botanical and zoological specimens, pigmented objects, works on paper, and organic materials, such as feathers, fur, and skins, is no more than 50 lux or 5 fc. Moderately sensitive materials, such as oils and acrylics on board or canvas and composite inorganic objects, should be exposed to light levels of not more than 150 lux or 15 fc. Levels for the least light-sensitive materials, such as stone, ceramics, metals, and glass, should not exceed 300 lux or 30 fc. Care should be taken at these higher light levels to avoid the generation of excessive heat (Lull and Merk 1982a, p. 20; 1982b, p. 9). Do not install lighting fixtures inside cases or directly in contact with a case. Remote ballasts with UV-filtered fluorescents or light pipes that carry light from a remote source can be used.

Daylight is most hazardous to objects because of its intensity and high UV and IR components. However, the amount of daylight entering a building can be reduced by shutters, curtains, or blinds. Excessive UV radiation from daylight can be mitigated by covering windows and skylights with plastic solar control film, varnish, or UV-filtering acrylic sheeting.

At the reduced levels appropriate for object safety, natural lighting appears gloomy and, during evening hours and in windowless areas, must be supplemented by artificial lighting. Determining the most appropriate supplementary lighting sources requires balancing costs against risks. Fluorescent, mercury, and metal halide high-intensity lamps emit undesirably high amounts of UV radiation, although housing fluorescent bulbs within UV-filtering sleeves or behind acrylic diffusers reduces the received amount of this radiation. Low UV levels but high IR heat output characterizes tungsten lighting, including tungsten-halogen and mercury-tungsten lamps. A glass sheath may be necessary to reduce IR radiation from tungsten-halogen lamps.

A museum's lighting scheme may require a combination of sources. In exhibition areas, indirect light providing general illumination is often combined with direct light to accent specific objects. Recommended types of lamps include tungsten (most applications), low UV fluorescent (heat-sensitive objects), and color-corrected high pressure sodium (large objects) (Lull and Merk 1982b, p. 20). Storage areas can be evenly illuminated by indirect light. Recommended lighting sources include high-pressure sodium lamps (Lull and Merk 1982a, pp. 23-25) and low UV fluorescent lights.

In exhibit areas, unacceptable light levels can be addressed by installing movement-sensitive lights, which reduce exposure times and by limiting the length of time light-sensitive objects are on display. In addition, the object itself can be shielded by a fabric covering over the case exterior.

AIR QUALITY

Particulate pollutants such as pollen and dust, fibers, and soot can enter the museum through open windows and doors, through unfiltered ventilation systems, or from people's clothing and bodies. Interior particulate pollutants may be generated by con-

struction and maintenance activities and cigarette smoke, among other sources. Particulates leave a disfiguring and abrasive layer on objects that must be mechanically removed.

Gaseous pollutants (primarily sulfur dioxide [SO_2], nitrogen dioxide [NO_2], and ozone [O_3]) can catalyze deleterious chemical reactions. Ozone, for example, which comes from photocopiers and electrostatic air purifiers, produces a chemical reaction that breaks down both inorganic and organic materials. Other pollutants can cause metals to tarnish.

Air filtration systems, either through water-washing mechanisms or activated carbon or synthetic fiber filters, clean incoming air of its particulate and gaseous contaminants (Thomson 1986, pp. 133-135, 156-158). They are, however, expensive to maintain. For further protection, individual objects can be stored in neutral tissue or untreated cotton or linen under polyethylene sheeting or in boxes constructed of acid-free corrugated board. Potential off-gassing by cleaning materials, paints, and varnishes should all be reviewed before collections are exposed to these substances. Storage and display materials should be tested in advance for potential off-gassing.

PESTS

Pests such as insects and rodents feed on the organic constituents of objects and their storage materials. In addition to the grazing damage caused directly by pests, consequential wastes foul objects. Many institutions follow an integrated pest management (IPM) program (Harmon 1993). Pest activity should be monitored by visual inspection and pest traps. If an infestation occurs, material should be isolated, treated, and cleaned. Future infestations can be prevented by:

- inspecting objects brought into the museum
- controlling the sites at which pests enter the museum
- removing pest attractors, such as food residues, pest carcasses, and mold
- establishing environmental conditions (cool, dry, good air circulation) inhospitable to pests

Prompt attention to an infested object will avoid a massive infestation later. (See chapter on Integrated Pest Management.)

Chemical pesticides pose risks to museum personnel and objects (Webster 1990), and are not recommended unless absolutely necessary. The long-term effects of the residue of chemical pesticides, both upon objects and humans who will handle them in the future, should be fully considered. Non-chemical alternatives currently employed by conservators include subjecting infested materials to freezing or oxygen-free environments for periods sufficient to destroy all stages of the insect's life cycle. (See chapter on Integrated Pest Management.)

RECORD KEEPING

Building-wide records of environmental conditions should be retained. Monitoring the conditions in which an object is housed enables museum staff to determine whether the environment considered to be ideal has been realized and to record environmental effects upon the collections. Condition information, including treatment records and traveling condition reports, should be incorporated into an object's permanent file. Visual images should supplement textual records. Full and accurate record keeping is of crucial importance when objects have been treated with pesticides, such as arsenic and ethylene oxide, which are themselves hazardous to humans. (See chapter on Managing Files and Records.)

Storage of paintings and framed works on paper on sliding aluminum art racks. Courtesy the Heard Museum, Phoenix. Photo by Craig Smith.

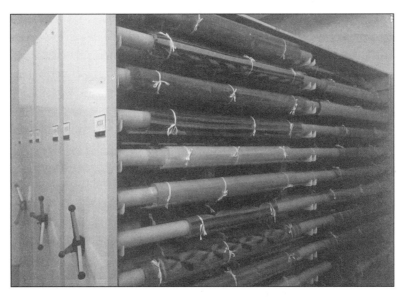

Storage of rolled textiles of powder-coated metal compactor shelving. Courtesy the Heard Museum, Phoenix. Photo by Craig Smith.

Lynn Swain

Collections rest at the center of a museum's mission and they drive the museum's programs. Since more than 80% of museum collections nationwide reside in storage, proper housing and care in storage areas are critical to preserving objects for the future.

Traditionally storage was the province of curators and conservators. However, as these positions have become more specialized, storage issues have also become a major concern of collections managers and registrars. This chapter is intended to provide guidance in storage methods, materials, and equipment.

For many small museums with limited funds, sophisticated cabinets and unlimited acid-free boxes may seem unattainable. Yet even the biggest and most well-funded museums struggle with storage issues, as larger collections often create larger problems. Traditionally, storage is not a high priority in the budgeting process because it has limited appeal to the public. However, without good storage the collections may not be available in 50 or 100 years. A course of gradual improvements consistently implemented can make a dramatic impact on the life span of objects, often at low cost if volunteer labor is plentiful.

The goals of good storage are to protect and preserve collections. Disasters, environmental factors, physical damage, and problems from poor-quality storage materials can all be mitigated or prevented with adequate planning and information.

STORAGE AREAS

Collections storage should be located in an area separate from all other activity, removed from exhibition, preparation, and general administrative functions. Many museums have a centralized storage area or a building divided into sections by material type or scholastic discipline. Some museums have found separate warehouses or buildings away from the main museum to use for off-site storage or for storage of less-frequently needed objects, but such facilities can present difficulties with access, monitoring, and security. Other museums develop open (or visible) storage areas where collections can be viewed by the public, although the practice may mean an increase in light, dust levels, and environmental problems. Depending on the space available, separate rooms or areas within buildings can be used for discrete portions of the collections. Historic house museums sometimes adapt spaces like attics or closets into storage for smaller objects. Careful consideration should go into such adaptive uses, however, to avoid pipes, windows, and skylights, along with the heat, humidity, infestation, and disaster potential of attics and basements. Storage spaces should be planned to address issues of access to collections. Consulting conservation and architectural professionals is useful in planning any storage project.

Under ideal circumstances, separate areas physically distinct from the rest of storage should be established for several purposes: temporary storage for processing objects in transit, a place for researchers to study the collections, and a space for keeping storage supplies. Office supplies and cleaning materials should be isolated from collections storage.

Temporary storage for processing objects moving into or out of the museum should be maintained at the same relative humidity as the exhibition or storage areas to which the objects will proceed next. Allow sufficient time for the objects to equilibrate to the climatic conditions inside the museum building. This time should also be used to monitor arriving objects for signs of pest infestation. If pests are discovered, objects should be sealed and treated before the problem can spread to other parts of the collections.

Security against theft and vandalism is a critical component of all good storage areas. Art objects and jewelry are often considered theft concerns, although other objects such as prints in 19th-century magazines, autographed documents, certain minerals, and insects of value to collectors may be vulnerable. An increasing proportion of theft in museums is carried out by employees, so good hiring practices and procedures for monitoring access to storage are important. Staff should be logged into storage, either by key card systems, key control logs, or sign-in sheets in the storage area.

A key control system should be established to determine who has access to storage. Curators, conservators, collections managers, and registrars who need to work with collections should be able to obtain access easily, but unauthorized personnel and members of the public should not. Often this is achieved by keying separate storage areas with different but related locks. Staff needing access to one storage area have a key that works only in that lock, while registration or security staff members who need access to many areas have a master key. Key lists should be kept by security, and keys should be turned in when staff members leave the institution. If keys are lost or stolen, locks should be changed immediately.

Key card systems with computer monitoring are considered more secure than hardware systems, and tracking of persons entering and leaving storage is possible with such systems. It is important, regardless of the method chosen, to have written policies and a clear line of command protecting access to storage.

Physical changes to storage areas can improve security. Storage should be designed with a minimum of entrances and exits, so access can be easily monitored. If a building is retrofitted for storage, eliminate unnecessary doors and block all windows. Alarm systems can generate an alert if unauthorized entry or departure has taken place. Often these can be low-cost magnetic contacts on normally unused doors and windows. A vault should be available to protect high-value objects from theft and valuable documents from fire.

Monitoring the use of storage is critical to security. Closed-circuit video systems can be installed either inside or at the entrance to storage areas. A separate work space outside the storage area can be created for researchers to study collections. If researchers are permitted in storage areas, staff should personally oversee them at all times. Visitor logs should be kept to track who is using which parts of the collections. Regular inventory procedures add to security by identifying missing or damaged objects and locating misplaced objects in a timely fashion. Good records of who had access to storage may help track the thief or vandal if such an event occurs.

Disaster preparation for large- or small-scale disasters or emergencies, whether natural or manmade, is covered elsewhere in this book, along with more detailed information on preventive care. (See chapter on Disaster Mitigation Planning.) Storage-specific issues of disaster prevention include many building maintenance concerns. Install monitoring and alarm systems for fire, smoke, water, and intruders. Be aware of water pipes running through storage, and avoid placing objects beneath them. Keep objects elevated off the floor in case of water leaks in the area. Store objects in closed cabinets to keep out leaking water and to provide shelter and insulation in case of fire. Mount storage furniture on vibration-dampening pads in earthquake-prone areas. Install emergency lighting and have flashlights handy. Train staff in the locations and uses of emergency systems.

Fire suppression systems should be installed in storage areas. Halon systems, in use in the 1980s, are no longer recommended; the potential danger to staff trapped in the area when the systems discharge and the damage to the ozone layer have discredited this method. Current thinking recommends a water sprinkler system with air-charged pipes. The air in the pipe prevents water leaks and gives a time delay to stop the system if a false alarm

is triggered. In most instances, the potential fire damage, possibility of the fire spreading, and smoke damage are considered higher risks than water damage from the sprinkler system, but this should be evaluated carefully for each particular collection with input from local fire officials and conservators. Mist systems should also be considered. Fire extinguishers should be positioned regularly throughout the building and staff instructed in their use.

Worker safety is assured by good training programs. Training should cover appropriate lifting techniques for large objects, and workers should be alerted to possible health hazards in the storage environment, such as radioactive minerals or bird skins treated with arsenic. Chemicals like paint thinners and acetones used in preparation of some specimens also pose hazards. Material Safety Data Sheets (MSDSs) available from manufacturers of chemicals and storage materials should be kept on file for all materials used in storage. It is also helpful to post at the entrance to all storage areas a list of all hazardous materials housed therein. (See chapter on Hazards in the Workplace.)

Handling places objects at a much higher risk of damage than when they are sitting on a shelf or in a drawer. (See chapter on Handling.) Staff should be trained in appropriate techniques for handling the range of objects in the collections and in the use of moving equipment. Precautions include padding lifts and dollies, moving small fragile objects on carts instead of carrying by hand, lifting objects from underneath by the sturdiest part of the object, and taking extra time and care when on ladders or stairs. If each object can be stored in its own box, the box can be lifted out of a drawer and direct contact with the object can be avoided. Easily visible labels or accession numbers also minimize handling needs. Since most inks are not easily removed, limit writing implements in storage and research areas to pencils only.

Housekeeping in storage areas should be given special consideration. For security and handling reasons collections management staff may prefer

to perform these duties rather than delegate them to the janitorial staff. Staff members who clean storage areas should be trained in the concerns of each particular collection. Collections areas should be cleaned regularly to minimize dust and potential pest attractants. MSDSs should be reviewed and cleaning solutions should be chosen carefully to avoid accidental introduction of corrosive or dangerous chemicals. When maintenance workers are required to be in storage areas, staff with collections responsibilities should oversee them.

Accessibility of objects in storage is critical. One method is to organize objects according to their composition or material (e.g., wood, bone, glass). When possible, each material should be stored in a separate area, with temperature and humidity conditions adjusted for its specific needs. Within material categories, objects are usually grouped by type (e.g., costumes, rugs, and laces under textiles) or arranged by size, geographic origin, cultural area, or accession number. Scientific collections are stored by their discipline-specific classification system (e.g., taxonomically for biological collections, by mineral families for mineral collections). Each storage area, from room to bank of cabinets to individual drawer, should be clearly labeled with its contents. Positioning objects in storage with their accession numbers, labels, or tags visible, and maintaining up-to-date inventories greatly facilitate access and minimize object handling.

Light levels should be kept low in storage areas to protect against both intense visible and ultraviolet (UV) light, which can cause fading or trigger chemical reactions. Light damage is permanent and irreversible but easy to prevent by keeping objects in the dark. Eliminate windows in storage, or black out existing windows. Use banked lighting systems, and turn off lights when the storage area is not in use. Closed cabinets minimize exposure of objects while staff members are working in the storage area. Light levels can be monitored with a relatively inexpensive light meter that small museums may be able to borrow from larger institutions nearby or from

a state museums organization. Fluorescent bulbs have a high UV output and should be fitted with filters. Halogen bulbs generate significant heat in confined areas, which can trigger or exacerbate chemical decay. Often, a little ingenuity in rearranging light placement, using different types of bulbs, and adding filters can minimize the potential for light damage.

Environmental stability concerns temperature and relative humidity (RH). Fluctuations in either cause stress to collections materials by forcing them to expand and contract on a microscopic level. This stress eventually wears out the collections. Keeping the temperature and relative humidity as stable as possible in storage areas is one of the most critical ways to prevent deterioration.

Each type of material has an optimum temperature and relative humidity range based on its chemical composition. (See chapter on Preventive Care.) General solutions to temperature and relative humidity problems are usually begun by monitoring levels and fluctuations with hygrothermographs. Although expensive, these instruments are necessary to determine base levels and to demonstrate improvements after changes are made. They must be calibrated as recommended by the manufacturer in order to function optimally. Museums with small budgets may be able to borrow one or fund the purchase through a conservation grant.

A centralized HVAC (heating-ventilation-air conditioning) or climate-control system maintains temperature and relative humidity at constant levels. Historic house museums may find it challenging to retrofit their buildings without destroying the historical integrity and generating structural challenges by installing HVAC. The building may need different RH levels than those best for storage of objects. Optimally, collections storage should be placed in a separate building or wing that can be climate controlled without confronting these issues. At the room level, humidifiers or dehumidifiers can be used to bring relative humidity closer to optimum levels.

Pollutants also cause gradual deterioration in storage. They come in many forms from dust to cigarette smoke to off-gassing from chemicals in cleaners or preservatives. There may also be corrosive gasses generated by certain storage materials or even the objects themselves. Common culprits are unsealed wooden shelving (especially plywood and composite wood products), paints and solvents, and acidic paper products. Sealing the building to minimize the intrusion of dust and fumes is one way to reduce pollutant problems. Developing an air filtration system, often as part of the HVAC unit, is another. Regular housekeeping by staff trained in handling objects provides opportunities for inspection of materials for possible problems.

Pests come in many forms from insects to small mammals such as rodents, and they infest organic collections of all types; some are dangerous to humans as well. Routine fumigation can add levels of toxic chemicals to the collections. Current theory recommends the Integrated Pest Management (IPM) approach, based on intensive monitoring of sticky traps for insects and other traps for rodents, locating and eliminating pest entrances and attractors based on the monitoring, banning food in collections areas, and, as a last resort, chemical treatment. Treatments should always be carried out with the advice of a professional conservator or pest manager. (See chapter on Integrated Pest Management.)

STORAGE EQUIPMENT

Good-quality storage equipment is a worthwhile investment for any museum. Well-built storage cabinets and shelving, although expensive, can help preserve and protect collections. By housing objects in good storage furniture, museums that cannot provide centralized climate control can still provide protection from the vagaries of light, temperature fluctuation, pollutants, and pests. Grants can help even small museums purchase such storage units.

Most collections may be properly stored in closed cabinets or on open shelving with dust and light covers. Metal cabinets are available with sulfur-free

heavy-duty gaskets to keep out dust and with filtered vents if air circulation within the cabinet is desired. Cabinet interiors may be designed with modular shelving and drawers or hanging options to meet the needs of many types of small to mid-sized objects. Preferred cabinets are painted using an electrostatic process to avoid the problem of paint solvents off-gassing and harming the objects stored inside. Wood and wood-composite shelving and cabinets are considered less than optimum because of the acids they contain. If wood storage must be used, it should house no objects except those made solely of wood, stone, ceramic, or glass, and shelves and drawers should be lined, preferably with Mylar®.

Stable storage environments can be created without a central climate control system. Closed cabinets with good sulfur-free gaskets provide a considerable buffer from exterior environmental fluctuations. Individual acid-free boxes can add another layer of insulation. Silica gel conditioned to a specific RH can be used in individual drawers or cabinets to minimize and slow down changes in the relative humidity. These micro-climate techniques can be used to meet the humidity needs of special materials, even within a climate-controlled situation. Striving for stability in relative humidity at the micro-climate level is one of the most important goals of good storage.

Pollutant problems can also be mitigated without a centralized air filtration system. Closed cabinets can minimize dust problems, but certain types of materials stored together in a closed environment can react with each other (e.g., sulfur, a component of natural rubber, will corrode silver). Dust covers on individual open shelves are a low-cost method to minimize exposure. Covers can be made of cotton muslin if air circulation and reduced light are important, or of an inert plastic film, like polyethylene sheeting, if reduced air movement and visibility of objects on the shelves is a higher priority. Plastic films should be checked often, since they can cause condensation and mold problems. Dust covers should not touch or rest on objects.

Museum-specific storage equipment has advantages over commercial storage units designed for other purposes. Some are specifically designed to handle particular types of collections. Large racks on wheels or tracks are available for paintings and other framed artworks or oversized wall hangings. Large rollers can help prevent the stress of folding quilts and large textiles. Zoological fluid-preserved collections should be stored in an appropriate preservative in airtight jars, then placed on sturdy shelving with light covers. Safes or vaults are available for high-value and fire-sensitive objects, although floors may need special reinforcement to support their weight. Oversized objects like farm wagons, sculptures, or mounted elephants can be stored in open shelving in a warehouse arrangement.

When space is at a premium, many cabinets and storage units can be mounted onto compactor tracks that eliminate the need for aisles between every bank of cabinets or shelves, thereby effectively doubling the amount of usable space in a given area. Compactor units and stacked cabinets need extra attention to safety to prevent accidents.

Several manufacturers specialize in museum storage equipment, with a good deal of variability in price. Storage cabinets can range from several hundred to several thousand dollars depending on their size, material, paint finish, air-tightness, and arrangement of drawers or shelves. Consult a conservation professional about the optimum system for the particular project.

STORAGE MATERIALS

Specialized storage materials can be used to support and pad objects to protect them from bumps and snags caused by overcrowding, vibrations, or internal structural failure. (See chapter on Preparation.) Within each storage unit, each object should have a place to stand or lie by itself on a shelf or in a drawer, rather than being stacked or crowded with others in the same compartment. Adequate padding and supports should protect objects from collisions and vibrations caused by

walking or by retrieving other objects. Objects being hung should be supported in more than one place to prevent the weight of the object from tearing the edges away from the hanger. Individual boxes can add an extra layer of micro-climate insulation and make moving objects easier. The old adage of "a place for everything and everything in its place" helps with accessibility and inventory as well as protecting objects.

The types of materials and supplies used in storage can directly affect collections. Many commonly used office supplies do not have archival qualities. Unknown materials should not be used. Unless materials have been tested and proven to be inert, they put the collection at risk. Use storage materials recommended by a conservator for specific collection situations.

Storage Materials to AVOID:

- Cellophane tape dries out, and the adhesive stains.
- Cotton wool can snag on rough textures and be impossible to remove.
- Foam rubber and urethane foam produce fumes that cause objects to deteriorate; they are also flammable.
- Masking tape contains an adhesive that is not easily removable.
- Metal paper clips rust and stain.
- Nail polish and polish remover can cause adverse chemical reactions.
- Paper products must be carefully checked. Some office paper, paper towels, cardboard, and cigar boxes are highly acidic.
- Most plastics (e.g., kitchen plastic wrap, dry-cleaning bags) contain chlorinated compounds and plasticizers that give them flexibility; these compounds can migrate out and harm objects. In addition, materials trapped in airtight plastic wrap may mold or mildew.
- Rubber bands crumble as they deteriorate.
- Rubber cement stains.

- White glue can become acidic and is not reversible.
- Wood products (especially unsealed) produce damaging acids.

Tested Storage Materials Recommended TO USE:

- Acid-free paper products (e.g., tissue paper, writing paper, photocopy paper, file folders, archival boxes) may be either buffered or unbuffered. Unbuffered paper has a neutral pH and is used for housing photographs, textiles, and most other types of objects. Buffered paper is impregnated with calcium carbonate, giving it an alkaline pH. Used for storing paper objects, it absorbs the acids they emit and keeps the micro-environment from becoming dangerously acidic for a longer period of time. All paper products will gradually acidify over time, so even acid-free storage materials need to be replaced after a period of years. Boxes and trays in modular sizes designed to fit standard cabinet drawers can be used to house a wide variety of objects.
- Cotton fabrics and threads may be used; they should washed to remove sizing chemicals. Linen may also be used.
- Plastic paper clips do not rust and stain, but they easily bend and distort paper. Use with care.
- Polyester batting can be used for all sorts of padding projects; it is particularly good with textiles.
- Polyester film (sometimes called by the brand name Mylar®) is used in paper preservation and as a vapor barrier.
- Polyethylene microfoam (often referred to as Ethafoam®, the brand name of the Dow Chemical Company version) is an inert foam that comes in a variety of thicknesses. It has a multitude of uses in the storage environment, from lining drawers and shelves (usually 1/8" or 1/4" thicknesses) for padding and slip protection to cutting special mounts or cradles (2" or thicker).

- Polypropylene bags come in a multitude of sizes, with or without zip closures, and are useful for containing all sorts of small objects. They should be ventilated to prevent condensation.
- Special adhesives that are based on methyl cellulose or wheat or rice starch, which are water soluble and non-toxic.
- Special envelopes and mounts are available for many objects; these include coin envelopes, frames, gem papers, and doll stands.

Conservationally sound storage materials are available from a variety of specialty suppliers. In some areas, museums have banded together to form purchasing cooperatives to buy supplies at discounted rates. Storage materials should be kept in a clean and environmentally friendly place separate from collections, such as a preparation area.

SPECIFIC COLLECTIONS NEEDS

Appropriate storage methods depend not only on the size, shape, and function of objects, but also to a great extent on the objects' composition. The eventual decay of some objects, such as organics, can be delayed by adjusting climatic conditions and providing inert storage materials that do not cause destructive chemical reactions. This requires a basic understanding of chemical properties of objects based on the materials from which they are made. Since relative humidity plays a critical role in the rate of deterioration, objects of like materials are usually grouped together and the humidity adjusted in the storage unit (building, room, or cabinet) to meet those needs. Fluctuations in humidity levels have proven to be the most damaging, so stability is more important than occasionally reaching the optimum level listed below.

Bone/ivory (e.g., human and zoological collections, tooth materials such as carved ivories or scrimshaws, miniatures painted on ivory): 50-55 % RH. It should remain constant, as old ivory is particularly susceptible to sudden changes in temperature.

Ceramics (e.g., porcelains, terracottas, pottery, potsherds): about 55 % RH. The less firing and glazing, the more sensitive the ceramic is to relative humidity and dust. Fugitive paint surfaces may also be light sensitive. Special mounts cut from microfoam or box nests may be needed to support pieces that will not stand on their own. Archaeological ceramics must have stable temperature and RH in case soluble salts are present; an RH around 45-50 % is preferable for these.

Composites (objects made of more than one material, e.g., jewelry, weapons, natural history mounted specimens, dolls, enamels, fans, paintings, masks, musical instruments, scientific equipment): 50 % RH. Preservation needs of the components often conflict. Determine relative humidity, light levels, and mounting needs based on the most sensitive component. A conservator should be consulted.

Glass (e.g., archaeological glass, art glass): 40-50 % RH. Pad storage shelves or drawers with microfoam or polyester batting.

Leather/skin/fur (e.g., fur and hide collections, ethnographic and archaeological, parchment, leather in books, on shields, or in tack, saddles, and harnesses): 45-55 % RH. Objects need moderate light and air and no draft, and should be properly supported. Metal buckles corrode when in contact with tannic acid used in curing leather, so some type of barrier (like Mylar®) should be placed between them.

Metals (e.g., gold, copper, bronze, iron, tin, silver, or steel, or objects made from them, like jewelry, armor, shields, coins, enamels, sculptures, battleships): below 40 % RH. Store silver in anti-tarnish tissue or cloth and keep in an airtight container to minimize corrosion. The surface of sterling silver or copper should not be in direct contact with anti-tarnish materials. Archaeological materials should be stored at 45 % or lower; if active corrosion is present, 35 % or lower is preferable.

Paintings: 40-55% RH. Storage methods include metal bins, shelves, and rolling or sliding racks; avoid wooden units. The environment preferred depends on the substrate of the painting (wood, fabric, copper, etc.); it is best that temperature and humidity remain stable.

Paper (e.g., prints, drawings, watercolors, books, illuminations, folding screens, scrolls, archaeological papyrus, archival documents, stamps, mounted herbarium specimens): 45-50% RH; 55% RH for papyrus. Light and dust can also cause severe degradation. Use only acid-free storage materials. Many unframed works of art are mounted in acid-free mats with a water-soluble adhesive on the hinge, then stacked in special boxes to keep out light and dust. Alternatives to matting include folders, envelopes, and encapsulation.

Photographs (e.g., prints, films, negatives, plates): 20-50% RH; never above 60% RH, while 30-35% RH is optimum. Store in acid-free paper or inert plastic enclosures (uncoated polyethylene, cellulose triacetate, or polyester). Store glass plates vertically and daguerreotypes in small acid-free boxes.

Plaster (e.g., sculpture, decorative elements): 35-50% RH. Calcium carbonate will deteriorate at high humidity levels; drier conditions may cause the surface to lose water and turn to dust.

Plastics (various 20th-century objects, particularly after World War II): 50% RH. Longevity and sensitivity to deterioration depend on specific chemical composition. Get advice about particular plastics from a conservator.

Stone (e.g., archaeological specimens, sculpture, fossils, rocks, minerals, meteorites, gems): below 50% RH. Humidity should remain constant. Note: opals desiccate and crack in humidity below 35% RH. Some minerals are light sensitive and should be stored in light-tight cabinets. Pad metal shelves with polyethylene foam.

Textiles (e.g., costumes, embroideries, laces, rugs, tapestries): 40-50% RH. Humidity should remain constant. Because molds and mildews attack easily, filtered ventilation is important. Monitor storage areas regularly for insect infestations. Storage containers and supports should use acid-free and other conservation-quality materials. Most textiles should be stored unfolded and horizontal, but some textiles, as well as their supports, may need to be padded or gently stuffed with acid-free tissue or polyester batting. For most oversized objects, careful rolling is preferred to folding; stuffed quilts and other thick textiles are an exception and should be folded. If large textiles must be stored folded, it is necessary to pad them well and refold them periodically to relieve the fold lines. Support fragile objects with additional layers of inert fabrics.

Wood/bark (e.g., furniture, bark cloth, baskets, boats, woven matting, panel paintings, lacquer objects): 50-55% RH; 60-65% RH for baskets and basket fibers. Metal shelving with dust covers is recommended for furniture.

Ideal storage, with each object in an individually labeled acid-free box, in a drawer within a metal cabinet, inside a climate-controlled room, in a well-maintained building, may seem like a daunting goal, but each layer of protection increases the longevity of an object. As conservators learn more about the nature of museum materials and what causes them to deteriorate, the definition of good storage changes as well. Federal grants, such as those available from the National Endowments for the Arts and Humanities, the National Science Foundation, and the Institute of Museum and Library Services, can help pay for a conservator's assessment of storage situations and for implementing improvements on a matching fund basis. Checking with a conservator before undertaking storage improvements is always a good idea. The primary storage goal is always to do no harm and to protect and preserve collections for future generations.

Suzanne Cowan

Why inventory? One of the primary responsibilities of a museum is the preservation and care of objects in its collections. Accountability for objects is a large part of that care. Inability to locate an object is at best embarrassing and may be more serious, threatening the reputation of a museum and creating legal problems. In addition, if a theft goes unnoticed and unreported, a museum may be hindered in claiming the object if eventually it is found. Basically, museums perform an inventory so they will know where objects are located and ensure records are accurate. Inventory also provides:

- an opportunity to update location information
- a way to identify objects that need conservation
- a method to establish control of poorly documented collections
- a basis for planning and budgeting any collection-related project
- a means by which the museum can fulfill its legal and ethical obligations to its governing authority and the public
- a way to retrieve information after a catastrophic loss
- an aid to security
- help for collections development or deaccessioning
- an aid to research

TYPES OF INVENTORY

There are several types of inventory; all involve checking the physical location of a particular object against the location record.

- A complete wall-to-wall inventory of the entire museum collection is the most thorough inventory. The inventory crew views every object and records its location or status.
- A section-by-section inventory is thorough, but its scope is limited by some logical unit, such as one area, one collection, or high-value objects. This inventory is very useful when done on a scheduled basis, rotating areas or collections for inventory.
- A spot inventory is very limited in scope and checks the accuracy of records and the location of a small percentage of the collection.

Generally a complete wall-to-wall inventory is done first, and then the other two inventories are performed on a regular schedule to ensure that record keeping and storage locations are current.

How often an institution inventories the collection will depend on many factors such as size and type of collections, staff size and availability of personnel, the types of records, percentage of the collection cataloged, and computerization. Ideally the collection should be inventoried annually, but this may not be practical if there are many thousands of objects. Establishing a rotation schedule for the inventory of specific areas and doing spot checks of other areas may be more realistic.

Objects on loan to other institutions and objects lent to your institution should be inventoried and their records reviewed at least annually to avoid losing contact with a lender. Losing contact with a lender causes many problems. (See chapter on Old Loans.) These "old loans" have been created in our collections by procedures used in the past, but the objects still need to be accounted for during inventory. It is important to determine whether your state has any statutes that offer guidance regarding unclaimed loans or undocumented objects. Some states have statues that specifically address these problems in museums.

ESSENTIALS OF INVENTORY

Decide on the goals of your inventory. If there has never been a complete inventory or if it has been many years since a complete inventory, the goal should be to locate every object in your collection. A section-by-section or spot inventory may be your

goal if you simply want to update your records, correct cataloging mistakes, or locate objects for conservation, or if you do a complete inventory frequently.

The first step is to know exactly what information you need and can obtain in the time allowed. Plan your inventory carefully; a well-planned outline for inventory will save time. Develop a schedule and determine the number of staff members needed for the project. The best way to determine the schedule is to do a trial run with a limited but representative portion of the collection. Then, using a breakdown of the appropriate inventory time needed per object, estimate your final schedule, allowing for time taken by other work tasks. Closing your collections during the inventory can be very helpful; be sure to let other museum departments know ahead of time that collections will be closed for inventory and for how long.

A well-organized storage area helps the inventory go more quickly and smoothly. Assign identifying numbers or names to all shelves and storage spaces before beginning the inventory.

Objects on exhibit should be inventoried as well. It is important to check objects on exhibit, especially in "permanent" exhibits, against collection records and to record any damage or change in the objects. Consider closing the gallery or inventorying either on days when you are closed to the public or after hours.

Develop your inventory paperwork, keeping your goals in mind. One method is to develop data sheets to record each object found in the location you are physically inventorying, and then to cross check each object against its catalog or accession record. You should make a note of objects for which you have a record but no matching object. A second method is to use your catalog records and check off objects as they are located. This method is quicker, but you risk missing objects that are out of place or not cataloged.

Developing a code system for taking notes about problems may be helpful. Such a system allows information to be recorded quickly and the problems to be dealt with at a later date. The types of prob-

lems to note include double numbers, missing objects, objects not described properly, conservation needed, missing numbers, missing records, and unclaimed property.

Forming inventory teams of staff and trained volunteers is important. Ideally teams should have one handler, one recorder, and one reader who refers to the current catalog record for the object description and other information. All team members should be trained specifically for the inventory, including handling techniques, forms, problem areas, and amount and kind of information to record.

Many objects have multiple components, so understanding the cataloging procedure is necessary. Objects such as a pair of shoes or a teapot and lid will probably have a single catalog number with a lettered extension and should be counted, therefore, as one item in the inventory. Specimens such as a dinosaur skeleton may have more than 100 bones; all bones should have the same catalog number, but they may be stored in several locations. In such a case, a more detailed description may be needed. It is important that you record all of the components for each object.

One of the best arguments for computerization may be its use in inventory. A computer-generated list of all cataloged objects and locations sorted by the most useful field (e.g., location, catalog number, artist) can greatly speed the process of inventory. A computer can also randomly pick a percentage of objects from your collection to allow a spot inventory.

During inventory it is important to record the catalog number of each object, along with its name and description. Using the catalog number as the unique identifier may avoid problems of nomenclature, especially if object names have changed.

Reconciliation between inventory results and museum records is an important step in the inventory process. Accession records, donor files, photographs, and any original paperwork about the acquisition are examples of records to check during reconciliation. Slides and measurements of objects can be valuable in determining the identity of an object in question. Keeping records, whether com-

puterized or manual, updated as to location and other information is extremely useful. Recording historic location information for every object indicates what has happened to the object since it came into the collection (e.g., loan, exhibit, restoration/conservation, name change, loss of a component). This information is useful in reconciling current records with the original records.

BACKLOGS OF UNCATALOGED MATERIAL

Most museums have uncataloged objects that must be accounted for during inventory. Assigning these objects some type of inventory control number is important; an accession number, a field number, or a locality number may be used. The inventory control number should be marked on all containers or storage locations for the object.

INVENTORY IN DIFFERENT INSTITUTIONS

Art and History Museums

Many art, history, and other museums have existed for many years, some more than a century. Accounting for all objects has proven challenging as old records are usually incomplete, if present at all. There may be many storage areas throughout the museum and in off-site locations. Regularly scheduling inventories can be useful for these museums: comprehensive inventories every five to seven years, annual inventories for objects on loan and objects of high value, and frequent spot checks.

Natural History Museums

Natural history museums often have large numbers of objects in their collections separated by scientific field: vertebrate and invertebrate paleontology, vertebrate and invertebrate zoology, botany, petrology, mineralogy, and anthropology. Even separated into these disciplines, objects may number in the thousands, and some objects may be large and have many components, such as dinosaur skeletons. Many specimens, such as those collected from the same site at the same time, can be cataloged as a single lot (e.g., shark teeth from one locale). Wall-to-wall inventories are often difficult because of the size of the collection, but section-by-section inventories and spot checks have proven useful. Careful cataloging and updating are critical to inventory control.

Living History Museums

Many objects in the collections of living history museums are used in demonstrations for the public, so these museums must deal constantly with replacement of objects. Periodic inventory of collections can identify problems, such as objects losing their numbers due to handling. Living history museums may have several additional goals for inventory, such as distinguishing between original and replica objects, identifying cycles of use and maintenance requirements, and scheduling replacements of objects.

Archives

Inventory by collection is one way to keep up with inventory control in archives. Section-by-section inventory allows a discrete unit to be inventoried and accompanying records to be updated. One problem that archives face is the continuing alteration of storage configurations, which may change with the addition of new cabinets or shelving. Maintaining a log of collection movement as the archives grow can help with inventory control.

Zoos

Inventories in zoos present unique problems. Inventory may need to be done frequently, in some sections as often as every two weeks. Recording of large animals may be easy but others, such as reptiles and birds, are more complicated. For example, many zoos have open exhibition areas for birds that are visited by migratory birds; in this case the zoo birds must be inventoried and not mistaken for visiting birds. Banding zoo birds is one way to deal with this problem. Burrowing animals are not easily found, and individuals sometimes are presumed dead, only to reappear months later. Consulting with curatorial staff on species habits may help with this problem. Poisonous animals must be closely inventoried. Another problem for inventory in zoos is the frequent lending of animals for exhibit and breeding; these must be closely tracked.

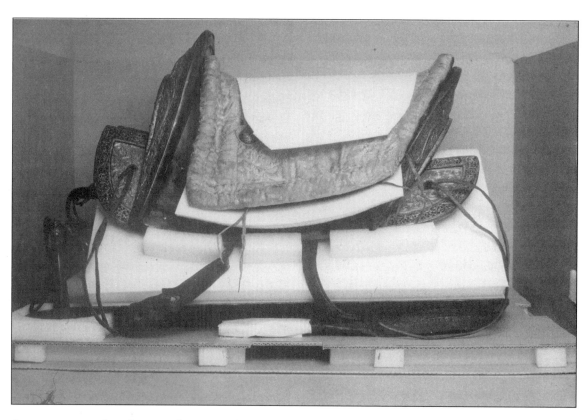

Storage mounts, such as the one used to support this Tibetan saddle, should both protect objects and allow easy access and viewing. Courtesy the Newark Museum. Photo by Lisa Mazik.

Claudia Jacobson

In preparing collections for storage, exhibition, loans, and research, the goal is to ensure long-term preservation of the physical and chemical condition and research potential of collections. Methods of preparation are determined by the nature and condition of the material as well as by the current and potential use. All preparations should be based on common principles of collection care. For example:

■ Use reversible procedures and stable, non-reactive materials.

■ Retain the association of objects and their documentation.

■ Document all activities that affect collections.

■ Respect the integrity of the object and the originating culture; consult with representatives of that culture as appropriate.

■ Provide support for objects that either cannot support their own weight or can possibly fall or tip (especially in high vibration or earthquake zones).

Many preparation activities require the specialized knowledge and training of curators, conservators, or preparators. Other staff without such expertise may acquire additional training, but it is important to keep treatments within one's level of skill and knowledge, to document such activities, and to call in professionals when needed.

Collections preparation begins with an examination, condition report, and assessment of object needs. Catalog numbering and labeling should be done or checked. (See chapter on Marking.) Objects that have acidic, inappropriate, worn, fragile, or inaccurate labeling should be re-marked. Removed labels should be recorded and filed with condition reports or other documentation. If an old label is adhered to or written directly on an object, you may need the services of a conservator to remove it.

Conditions that pose a hazard to an object's long-term preservation should be corrected if it can be done without damaging the object. Objects that are matted, framed, or mounted should be examined to ensure that the matting materials are archival and that the technique is appropriate. All objects, especially organics, should be carefully monitored for possible infestation. New acquisitions and incoming loans that are susceptible to pests should be bagged, quarantined, examined for signs of infestation, and treated if necessary.

Objects may need additional housing beyond that provided by storage furniture. (See chapter on Storage.) Boxes and other enclosures often provide a better environment, additional support, and surface protection, and can limit handling, facilitate movement, and enable safe access to the collection. In determining the need for additional enclosure or support, consider:

■ Is rigidity or a solid enclosure important, or will a framework that supports the covering away from the surface of the object be suitable?

■ What kind of environment must be provided?

■ Is light or relative humidity control important?

■ Is there a need for pest protection or a micro-environment?

■ What is the potential for off-gassing of materials?

MATERIALS AND METHODS

All materials used with museum objects, whether by direct contact or by environment, must be benign both to the collection and to personnel. In general, this means using acid-free (neutral pH) and inert materials, without dyes or other additives, which will remain stable over a long period of time. Materials for construction should be as lightweight as possible, but should provide proper support. The construction design should be simple. Mechanical closures are preferred to adhesives, which should

be stable and kept well away from the objects or used with a barrier. Conservators can be consulted about materials and can test materials that you are considering for preparation.

COVERINGS

Some objects, especially large objects like furniture, textile racks, dinosaur bones, and farm equipment, may be best protected simply with a covering. Coverings provide protection from dust and water leaks and buffer changes in relative humidity. Fabric (e.g., unbleached muslin) is washable, allows air circulation, and is opaque and inert; it should be washed before use. Polyethylene sheeting is stable, translucent, waterproof, and low cost, and comes in very wide widths; however, it generates static electricity and must not be used in proximity with flaking or loosely attached surfaces. To prevent crushing or loss of air circulation, coverings should not touch objects; a framework of PVC pipe, closed-cell foam (e.g., Ethafoam®), or other inert materials covered with polyethylene sheeting is one way of preventing contact. The PVC should be tested for off-gassing before use. Care should also be taken to avoid the creation of an unfavorable microenvironment of high relative humidity or air pollutants inside such an enclosure.

CONTAINERIZATION

Boxing objects is a cost-effective alternative to other types of housing. Boxes must be able to bear the weight of the contents, and, if stacked, must bear the weight of items on top. Handling devices (e.g., handles, straps) must be effective or not used at all.

Containers made of paper products provide additional relative humidity buffering, but some products are acidic and all will deteriorate when wet. Stable plastic containers provide water, vapor, and some insect protection. Simple tests can be performed to identify some unsuitable materials. Additional padding or support can be added to provide cushioning or to prevent movement within the box.

Large or heavy materials may require the structural stability wood and metal containers give.

However, wood emits harmful, acidic gases which appropriate paint or other coatings decrease but do not eliminate. Wood storage containers, especially those used for long-term storage, must be lined with a vapor barrier such as aluminum foil or an aluminum/plastic laminate and stored in well-ventilated areas. Rather than baked enamel, metal storage containers should be made of stainless steel or anodized aluminum, or should be electrostatic pigment or powder coated.

Time and material costs influence whether to buy or make enclosures. Pre-made boxes are more expensive than sheet goods, but the size of the project, availability of staff and time for production, and end quality and uniformity are also factors. Consider purchasing boxes in a limited number of "standard" sizes suitable to the collection and storage furniture. Boxes can also be manufactured to fit pre-existing storage systems or unique collection needs.

MATTINGS AND ENCLOSURES

Enclosures such as mats, folders, encapsulation, and frames are used for flat or shallow items such as paintings, works on paper, and flat textiles that need surface protection and support. The type of enclosure depends on the stability of the object's surface, the flatness of the object, the volume of material, and the available storage space, as well as time and money.

Folders are simple and quick to make and a good choice for large, flat items such as maps. Folders can be made by folding in half a piece of acid-free stock that is large enough to enclose the object along with a margin, and which has a weight sufficient to support the object. Matting provides excellent protection, but more labor is involved, materials are more expensive, and a fair degree of training and practice is required. Some museums use the services of commercial framers.

A mat is composed of a window mat and a backing hinged together along one side. A window cut in the top mat allows examination, yet limits

Above: Photo supported with folded paper strips and linen tape.
Below: Hinged art on paper in a window mat.
Drawings by Hugh Phibbs, National Gallery of Art.

touching. Double-window mats where one or both windows have Mylar® or fine net attached for support reveal both sides of the object. The surface of the window mat must project above the surface of the object being matted and can be augmented by spacers or multiple mats. For artwork, photographs, or archival materials, the object is held in place either by hinging it to the back mat board or by corner mounts or rails; an interleaving sheet is placed between the work and the window mat. For textiles, the backing board is covered with padding (e.g., polyester fiberfill) and then covered with washed muslin to which the textile can be lightly sewn along one edge; care must be taken to use a thread softer than the textile. Consult a conservator when mounting fragile textiles. Using standard-sized mats and frames throughout the collection makes mounting exhibitions easier and less costly. Matted objects are usually stored in special drop-

fronted boxes (Solander® boxes) or in map cabinetry. Do not over-stack materials prepared this way.

FRAMING

Frames provide surface protection, support, and a method of hanging, and often are an integral part of the work. Whether to use an existing or a new frame is a collections care, curatorial, and aesthetic decision. Existing frames can have artifact status in their own right, so careful consideration must be taken when replacing or modifying an old frame.

The frame must fit the work. There should be room for the backing, the work, and a mat, separator, or barrier between the work and the face of the frame, as well as room for expansion between the work and the frame sides (rabbets) and enough depth for glazing, if used. If the frame is not deep enough, it may be built up on the reverse. The backing provides buffering and keeps fingers and dust away from the back of the work. Mending plates are attached to the frame and hold the package together under slight pressure. Taping around the perimeter prevents dust infiltration. A label with basic information is placed on the backing, never on the work itself.

Whether to glaze and what material to use (glass, non-glare glass, Plexiglas®, UV filtering Plexiglas®, or Lexan®) depends on curatorial, collections care, and safety concerns. Traveling glazing should be UV filtering Plexiglas®, but if glass is used, it must be taped in case of breakage in transit to prevent damage to the work and other contents in the same container.

If the painting is to be hung, hanging hardware (e.g., D-rings, eye screws, security hangers), not picture wire, should be attached; it should be strong enough to withstand the weight of the painting. Old hardware may be weak and inappropriate and usually should be replaced. Works stored in a rack rather than hung should have protruding mounting hardware or picture wire removed to prevent snagging and scratching.

SUPPORTS AND MOUNTS

Supports and mounts provide form and stability and alleviate stress, thereby preventing distortions, creasing, and eventual structural damage. Supports also facilitate the transportation of objects. Their design is determined by the object and how it will be stored or exhibited.

A successful support is not overly complex, is easily removable, provides as much visual access as possible, and takes up very little space. It need not be elaborate and may be as simple as crumpled acid-free tissue or a pillow or a snake made of muslin filled with polyester batting. An exhibit mount can require the services of mount makers skilled in metalworking and Plexiglas® construction. However, a successful mount can be made with mat board, polyethylene foam, and other easy-to-use materials.

Exhibit supports or mounts need not be invisible, but should not be visually intrusive or obscure important details of the object. Areas of contact must be located at stable points and properly distributed for the weight. A cushion or barrier should be placed between the object and the mount.

MANNEQUINS

Exhibiting clothing on mannequins is often desirable, but commonly used store mannequins are rigid, and their size and contemporary fashion proportions are not suitable for historic period clothing. Such mannequins are difficult to dress, put stress on garments, and are often aesthetically unsatisfactory. The ideal mannequin is soft-bodied, flexible, and custom designed to fit the garment being displayed without stress, and provides support throughout. Some mannequins are made with flexible, jointed appendages, and may be posed.

If hard-bodied mannequins must be used, one smaller than the clothing should be selected and covered with muslin or stockinette to provide a barrier. The covering can be padded as needed for form and support with polyester batting. Attention must be paid to the method by which the mannequin itself is supported. If the mannequin is to wear shoes from the collection, the support cannot come up through the bottom of the foot. Nor should the weight of the mannequin rest on the shoes.

CULTURAL COLLECTIONS

Increasingly, collections staff are interacting with the cultures that created the objects they care for. Individuals make arrangements with museum staff to prepare objects for storage or exhibition in their own ways. These may include the use of cornmeal, tobacco, or herbs; special ceremonies; the orientation of objects within the museum; or other preparations that follow native beliefs.

Most cultural collections can be prepared following the basic principles previously discussed.

Clothing and textile collections are often soiled with dirt, grime, food stains, and perspiration, all of which are damaging to the collections and attractive to pests. Cleaning most of these textiles should be done only by or under the supervision of a conservator. The fragile and flexible nature of textiles requires padding or special supports. Garments that are stable enough to be safely hung should be placed on padded hangers. Cotton straps sewn inside the waistband can help redistribute to the hanger the weight, for instance, of heavy skirts. Textiles stored flat (e.g., beaded dresses, fragile textiles) should have folds padded to prevent creasing. If flat textiles can be hung for exhibition, Velcro® or a pocket for a rod may be sewn to the reverse and used for hanging. The textiles may need the additional support or protection of a muslin backing.

NATURAL HISTORY COLLECTIONS

Natural history collections have some very special requirements. However, as with any museum collection, the most stable and protective materials and techniques should be selected.

Techniques and materials for drying, fluid preservation, skeleton preparation, tanning, taxidermy, and consolidation change constantly. New preparation methods include freezing, slide pro-

duction, Scanning Electron Microscope (SEM) preparations, and DNA samples. It is not uncommon for parts of the same specimen to be preserved in many different forms; maintaining the documentation link between them is important.

Botanical collections such as herbarium sheets should be placed in folders and arranged in a systematic fashion. Material too bulky for herbaria sheets should be placed in separate packets or boxes.

Paleontological material in geology collections may be placed in a field jacket (a plaster, burlap, and structural support). Supports must bear the specimen's weight, prevent it from collapsing, and assist transportation, often with mechanized equipment such as forklifts.

Zoological "dry" collections include study skins, skeletons, and mounted and pinned collections. A study skin is prepared by defleshing, drying, and stuffing to restore the original form. Skeletal collections often employ dermestid beetles for the final cleaning.

The process of producing a mounted specimen destroys much of the research use of the specimen. The skin is tanned, usually commercially, and a variety of materials are used to reproduce the animal body. These are usually supplemented by metal wires or armatures to lend support and the ability to position the mount. Fillers, modeling compounds, and pigments reproduce lost or shrunken features and colors.

Insect pinning is another specialized technique. The insect is dried and positioned with an entomological pin inserted through the body, through cataloging labels, and into the bottom of a storage box with a tight-fitting, often glass-topped, lid.

For freeze-drying, the whole specimen is positioned and placed in a freeze-drier that removes the water content through sublimation. Unfortunately, a freeze-dried mount is very attractive to dermestid infestations. Since most of the activity takes place inside the body cavity and can be well advanced before becoming apparent, monitoring is critical.

Zoological "wet" collections preserve specimens in fluid. Specimens are "fixed" in formalin as soon as possible after death to halt enzymatic processes, then transferred to long-term storage, usually to 70 % ethyl alcohol (ethanol), which preserves research potential. Fluid collections are prone to evaporation, so the fluid levels of wet collections must be regularly checked and maintained. Such actions, as well as the type of preserving fluid, must be recorded.

LIVING COLLECTIONS

Living collections have their own challenges, but many of the same preparation principles apply. Collections management must not only maintain the collections' well-being, but in some cases foster reproduction. Many museums, arboretums, and botanical gardens maintain living collections for research and education. Since museums are frequently recipients of zoo animals that have died, it is important to be informed of any potentially hazardous infections, pest problems, etc. Antibiotics, for instance, can affect dermestid cleaning.

CONCLUSION

Keeping up to date in new techniques, materials, and the status of research in preparing collections is critical in order to provide the best possible care for collections. Current and past practices must be documented so that proper decisions can be made in the future.

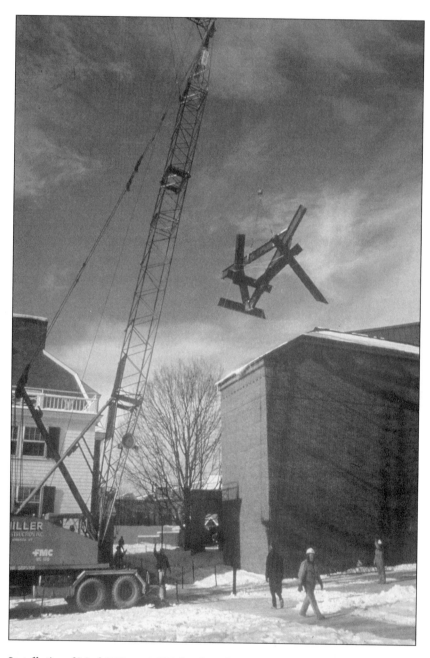

Installation of Mark DiSuvero's X-Delta (1970) at the Hood Museum of Art in 1989.
Photo courtesy of the artist and Oil and Steel Gallery, Long Island City, N.Y.
Photo by Stuart Brakesman.

Larry Francell and Perry Suggs

Rigging in the museum world is both the art and the process of moving and installing large or heavy objects, such as sculpture, furniture, or agricultural machinery. Although all rigging jobs require consideration of the physical properties and limitations of the load, the usual focus of crane and rigging companies is repetitive work. The requirements for rigging museum objects are unique and usually non-repetitive, and museum staff must take this into account when selecting equipment and contractors needed for the work.

Technically, rigging is the procedure of attaching lifting equipment to an object in order to hoist it safely. The hoisting may be done by a crane, some type of automatic lift, or even by hand with block and tackle. Matching the load to be moved with the right hoist is important; proper rigging must be the first consideration when moving museum objects.

Riggers must be able to determine or estimate the weight of objects and to assess the center of gravity of objects, including those of unusual shape. Riggers must also have knowledge of the various slings, ropes, and straps that can be used in heavy lifting, and know how best to protect objects from abrasion and breakage. Riggers must be experienced in proper mounting and installation techniques in order to ensure the stability of the object after the job is complete.

Once an object is rigged, it is ready to be hoisted. Lifting equipment ranges from large cranes to chain hoists and gantries to block and tackle on simple "A" frames. Inside museums, the use of "A" frames and gantries is common; a forklift or other specialized hydraulic lift also may be used. Outside, the preferred equipment is a mobile crane. Cranes come in a variety of sizes, rated for lift capacity, and can be adapted to the site.

Cranes are rated by tonnage. The rating refers to the weight that can be lifted with the boom as vertically as possible, and the load as close as possible to the center pin of the equipment. Thus an 18-ton crane can lift that much only if it is backed directly to the object to be hoisted and the boom is directly overhead. In reality, the crane is usually placed further from the object and the boom is at an angle. To determine the size crane required, the rigger will refer to a chart that provides a formula for weight versus the required reach and angle of the boom. Only a professional rigger knowledgeable of these formulas should specify equipment size.

Whenever a crane or similar equipment is used to move museum objects, a professional rigger must be on hand. Crane work requires skilled teamwork among the operator, the rigger, and any assistants. Proper communication and coordination are imperative, and the safety of the team and the object is paramount. When hiring riggers, be sure they can provide references and recommendations for comparable work.

It is recommended that an experienced rigger be employed even with smaller jobs not requiring crane operations. Knowledge about "pick points," the proper slings and hitches to use, proper safety, and how to protect the object being rigged is important even for small jobs. An example of a common problem is the attempt to move an object using a rigid "A" frame or gantry where the object can only be rigged at an angle away from the crossbar of the hoisting equipment. If the frame is rigid and the rigger does not plan properly, the hoist will be pulled over in the direction of the object, or the object will swing dangerously towards the frame. Either circumstance is hazardous to the object, the hoisting equipment, and the people doing the work.

It is important to hire someone who is experienced and qualified, and who knows the rules that apply to the art of rigging:

- Know the weight of the object to be moved.
- Know the capacity and limitations of the crane or lifting device.
- Know the rated capacities of various slings and rigging straps. Check their condition; they can fatigue in ways that are not obvious.
- Know the proper hitches for handling the load. Different hitches change the safety capacity of straps.
- Know how to equalize the object when multi-leg hitches are used.
- Level equipment or set up equipment on a level surface.
- Apply skill and experience to assess the center of gravity of the object and rig to that point.
- Use nylon straps, not wire rope, for museum objects.
- Protect the object from damage and abrasion from the rigging.
- Keep the load line plumb. Always lift straight up and down.
- Set tag lines prior to any lift.
- Keep non-essential personnel away from the work area. Use a team leader and maintain open and clear sightlines at all times.
- Know and use the proper hand signals for communication.
- First lift the object a few inches and check all rigging and lines; start and stop slowly.
- "Travel" with the load as low as possible. One must always keep in mind that the law of gravity is immutable, so be alert.

Of all the moving and installation activities performed in a museum, rigging is one of the most exciting and dynamic; however, it is also one of the most dangerous to the object being handled and to the people doing the work. Unless someone on staff is specifically trained, rigging should be contracted with a professional company.

Inner Packing Box

Example shown using two hanging scrolls and one book of Chinese album leaves

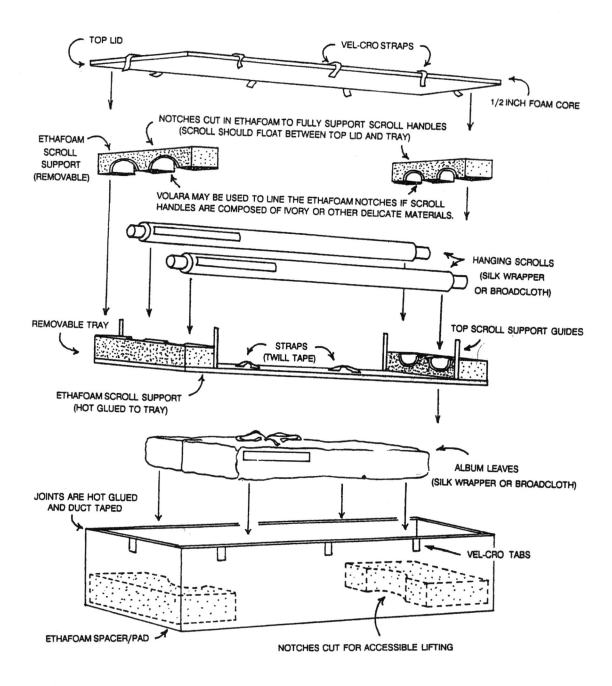

TOP LID

VEL-CRO STRAPS

1/2 INCH FOAM CORE

NOTCHES CUT IN ETHAFOAM TO FULLY SUPPORT SCROLL HANDLES
(SCROLL SHOULD FLOAT BETWEEN TOP LID AND TRAY)

ETHAFOAM
SCROLL
SUPPORT
(REMOVABLE)

VOLARA MAY BE USED TO LINE THE ETHAFOAM NOTCHES IF SCROLL
HANDLES ARE COMPOSED OF IVORY OR OTHER DELICATE MATERIALS.

HANGING SCROLLS
(SILK WRAPPER
OR BROADCLOTH)

REMOVABLE TRAY

TOP SCROLL SUPPORT GUIDES

STRAPS
(TWILL TAPE)

ETHAFOAM SCROLL SUPPORT
(HOT GLUED TO TRAY)

ALBUM LEAVES
(SILK WRAPPER OR BROADCLOTH)

JOINTS ARE HOT GLUED
AND DUCT TAPED

VEL-CRO TABS

ETHAFOAM SPACER/PAD

NOTCHES CUT FOR ACCESSIBLE LIFTING

USING THIS PACKING DESIGN, THE RECEIVER SHOULD ONLY
NEED TO REMOVE THE TOP LID AND INNER TRAY. THE INNER
BOX SHOULD REMAIN INSIDE THE CRATE.

Inner packing box for hanging scrolls, as presented in the P.A.C.I.N. Technical Drawing Handbook. Drawing by Dale Bensen. Courtesy the Nelson-Atkins Museum of Art.

Sally Freitag and Michael Smallwood

Museum objects are at great risk while being moved. Whether moving from storeroom to gallery, across town, or across countries, they must have the best protection using the most appropriate methods of packing and the safest materials. Recent technical developments in conservation studies and cumulative practical knowledge have helped to determine the best packing methods and safest materials from which to choose.

CRITERIA FOR PACKING/ RISK ASSESSMENT

An object designated to travel must be evaluated to determine if it is inherently sound, as even the best packing cannot reduce the risks to an unstable object. Risk assessment must be performed, generally by a conservator, before arrangements are made for packing and shipping. This entails a careful and complete examination of the object and its support, as well as recommendations regarding its environmental and installation requirements and the need for supervision in transit to monitor condition or complex assembly. (See Mecklenburg 1991, section 1. See also chapters on Preparation and Outgoing Loans.)

The facilities report of the institution to which the object is traveling must be carefully reviewed; if possible, hygrothermograph charts for the time period similar to the loan should be checked.

The route and duration of travel and the borrower's facility influence the type and size of the packing case. Will the object fit on normal conveyances when packed? Can it fit through the doors of the borrower's facility? Are handles for carrying necessary? Must it be disassembled, or is special rigging necessary because of its size, weight, or placement? How many times will it be packed and unpacked? Will the crate be so large or heavy that it is impossible to move? Will long- or short-term storage be involved? Should it be soft packed, crated, or hand-carried? Can multiple objects be combined into one case? What is the packing deadline, and how much will it cost? (See chapter on Shipping.)

Packing must be done by experienced personnel with knowledge of museum standards. New materials are continually being developed, but they must be tested before being used with museum objects. It is imperative to understand the properties of materials, what type of protection they offer, and what type of interaction they may have with the object they are meant to protect. Misuse of materials can cause considerable damage to objects.

Packing contracted to a commercial firm should be clearly outlined in writing and closely supervised in order to meet museum standards. The packing process should be as simple as possible; keep in mind that those who receive the shipment must unpack it. Complex packing methods should be documented by photographs and/or simple diagrams that accompany the shipment and are placed inside the lid of the case. All layers should be numbered, and if necessary, the instructions should be included in the language of the country to which the object is traveling.

GENERAL GUIDELINES FOR PACKING

The basic rules for packing a museum object are as follows:

- Examine the object carefully to ensure that it is structurally stable.
- Prepare the object for packing and transport.
- Provide a strong, totally enclosed, waterproof case.
- Protect the object(s) within the box against movement, vibration, shock, and rapid temperature or humidity fluctuations.

■ Plan the packing with unpacking and repacking in mind, making it as uncomplicated as possible.

Methods of protecting an object within the case differ for each kind of object and material and should be approved by the various museum personnel responsible for the object's safety, especially the conservator. Current methods, of course, are subject to improvement as new materials are discovered, tested, and approved.

CASE CONSTRUCTION

The standard packing case is closed on all sides, strong enough to hold the object(s) packed within, and capable of withstanding transit hazards. It should also protect the contents from impact and puncture, protect against the weather, and have handles and skids for moving. Never assume that it will not be turned over or laid on its side.

■ Construct the case from strong materials such as wood (kiln dried), plywood (exterior or marine grades), aluminum or fiberglass, polyethylene, particle-board or hardboard, or a combination of these. Plywood is used most commonly because it is relatively inexpensive, needs no special tools or equipment, and has a high strength-to-weight ratio. Plywood thickness of 1/2" to 3/4" is recommended for strength. Exterior or marine-grade plywood generally gives off less formaldehyde than interior grade plywood.

■ Screw or nail and glue the edges and corners together for strength. Gluing is very important to provide extra strength and to create sealed joints resistant to vapor penetration; choose the glue according to conservation guidelines. Reinforce all exterior edges with 1" x 4" pine battens. Oversize boxes may require diagonal battens as well to provide additional structural rigidity.

■ Install handholds or handles for lifting all cases. On larger crates install blocks or skids beneath which the tines of a forklift or pallet truck can slide.

■ Fasten the lid with screws or bolts, never nails. Nailing subjects the contents to unnecessary vibrations and makes the cases hard to open.

■ Paint the exterior to form a vapor barrier, improve the appearance, cover old markings, and provide a clean surface for new markings. Line the interior of the case with a vapor barrier such as Tyvek®, Marvelseal™, Critics Choice™, or plastic sheeting. Avoid waterproof papers as they may contain tar that becomes liquid when exposed to moth-proofing chemicals; they also off-gas and harm objects. Cover the floors of cases designed for heavy objects with masonite so that objects can slide in and out with ease.

■ Mark the case exterior with its weight, its measurements, and the names and addresses of the consignee and consignors. Remove old markings from reused boxes. Add cautionary symbols and directional markings. For security reasons, do not indicate the nature of the contents (e.g., Work of Art or Rembrandt Exhibition).

Types of Cases (From P.A.C.I.N):

■ Slat/skeleton crate. This crate has a minimal amount of wood, does not have solid sides, usually has a solid bottom with wood slat sides, and sometimes is lined with cardboard.

■ One-time/one-way case. This is a very simple crate for transporting an object one-way only. Often is destroyed after one use.

■ Two-way case. This case is built for transportation there and back, but not to withstand extensive travel.

■ Traveling case. The traveling case is built to withstand a multi-stop tour, usually with reusable fastening hardware on the lid. It is built to withstand abuse from handling and is weather- and usually water-resistant.

■ Breakaway case. A breakaway case is built with removable sides and top, leaving a pallet with the object on it.

Materials Generally Regarded as Safe for Museum Use (from Mecklenburg):

- Acrylics
- Ceramics
- Cotton and linen (unsized and undyed)
- Glass
- Inorganic pigments (those that do not contain sulfur)
- Metals
- Acid-free paper and matboard made from rag or lignin-free pulp
- Polycarbonate
- Polyester (polyethylene terephthalate)
- Polyethylene and other polyolefins (e.g., polypropylene)
- Polystyrene
- Polytetrafluoroethylene (Teflon®)

Unfortunately, additives to many products, such as fire retardants, plasticizers, slip agents, and foaming agents, can cause damage, even though the primary material is stable.

Materials Known to Cause Problems (from Mecklenburg). This is not a complete list. Always test material first or consult a conservator.

- Cellulose acetate: Some samples may be stable, but others have been known to release acetic acid; test before use.
- Dyes: Many dyes contain sulfur or other reactive agents.
- Nitrocellulose: Problems with early manufacturing processes resulted in a variable, often highly unstable product. Though the modern product is more consistent, it still cannot be recommended for use in conservation.
- Polyvinyl acetate (PVA): Some samples may be stable, but others, especially some emulsions, release acetic acid; test before use.
- Polyvinyl alcohol: Prepared from polyvinyl acetate, it is subject to the same provisions.
- Polyvinyl chloride (PVC): This and other chlorinated hydrocarbons can release hydrochloric acid and often contain volatile additives.

- Polyurethanes: Inherently thermally and photolytically unstable, these materials always contain additives.
- Noncollagenous proteins: Most proteins contain sulfur and can cause tarnishing and discoloration; highly refined gelatin is free of sulfur.
- Wood: No wood can be regarded as acid-free. Oak is especially bad.
- Particle board
- Rubber: Most rubber, natural and synthetic, contains sulfur, which can damage works of art. Always test first.

INTERNAL PACKING

- Protect objects within the case from contact with other objects, from foam (which can be abrasive), from contact with the walls of the case, and from the transmission of external shock, vibration, or rapid temperature or humidity change during transit.
- Use materials that do not scratch, abrade, or chemically interact with the object. (See soft packing below.)
- Do not seal object in plastic if the object is acclimated to a RH above 70%, as this may cause condensation or promote mold growth. If the object has been maintained in a typical museum environment, sealing it in plastic creates a microenvironment that further protects the work in transit.
- Provide adequate shock-absorbing material in the packing. Too little cushioning material, or material that is too soft, will allow excessive movement of the object, possibly allowing it to hit the walls of the case or to become abraded. Too much cushioning material, or material that is too hard, will not allow enough movement of the object to absorb shock. It is important to use cushioning materials properly in packing cases. Check the *Art In Transit Handbook* for guidelines on how to use a dynamic cushioning curve and how to determine optimum static loads.

- Use insulation and vapor barriers to reduce rapid changes of temperature and relative humidity. Completely lining cases with foam will add an insulation layer, and completely wrapping an object in polyethylene will form a vapor barrier. Never use vapor barrier materials, like polyethylene, when objects are damp or in high relative humidity (above 60-65%) because of the potential for condensation and/or mold growth. Be sure to assess the moisture content of the object and the degree of adverse temperature and humidity ranges the traveling object must endure.

- Use travel frames (see soft packing) in cases as additional protection for ornate frames, paintings without frames or minimal frames, flat sculptural works, and other objects with surfaces that should not be touched by any packing material. The travel frame can be totally wrapped in polyethylene and placed in a foam-lined crate.

- Use double-crating for extremely fragile works, such as those made of ceramic, glass, or plaster, where unusual shock or vibration must be prevented.

Types of Internal Packing (From P.A.C.I.N):
- Cavity-pack/foam cut-out: The object fits into a space cut or made to conform to the shape of the object. Cavities can be lined with tissue or soft inert fabric.
- Foam-lined box: The object is placed in a box lined with foam that does not fit the contour of the object; the voids are filled with material such as tissue paper or scraps of foam.
- Tray-pack/drawer: Objects are placed in a tray or drawer using a foam cut-out to cushion each object. Trays or drawers can be stacked in a foam-lined case; the weight is borne by the sides of the tray or drawer, avoiding pressure on the objects.
- Double-crating: One box or case fits inside another with cushioning between.

- Contour bracing/yokes/guillotines: Generally used with large, heavy objects, this packing technique uses padded braces fitted to an object's contour, attached to the inside of a wooden crate to keep the object from moving. The braces are removable and should be marked to indicate the order in which they are to be removed. It must be done in such a way that impact and vibration are not transferred to the object through the braces.

SOFT PACKING

Soft packing is generally defined as packing an object without enclosing it in a hard shell box or case. There are various materials used to soft pack objects: blankets, tissue, bubble wrap, cardboard, Fome-Cor®, transit frames with soft sides, different packing foams, Styrofoam peanuts in boxes, and straps which tie an object in place in a vehicle so it does not move while being transported. Enclosing an object in a non-plywood (e.g., cardboard) or hard case plastic box is also considered soft packing. When done correctly, many of the soft pack methods are acceptable for the transit of certain museum objects within the museum facility or via ground transportation to other facilities around the country. The decision to soft pack should not be made solely on the criteria of cost and time; a conservator, packer, and registrar or collections manager should help make such a decision.

Internal Use:
For transporting objects within the museum facility, soft packing is a convenient method. A container made of cardboard, Fome-Cor®, basketry, plastic, or wood will help keep the object within a confined area for transit. Various materials can be used to cushion the object during the move. The container can then be moved on a cart, platform or four-wheel dolly, hand truck, or pallet mover.

As in all packing jobs, be aware of the materials used against the object. It is always best to have a compatible buffering material between

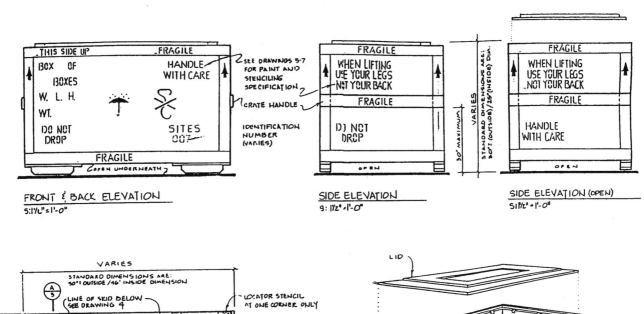

FRONT & BACK ELEVATION
S:1½"=1'-0"

SIDE ELEVATION
9: 1½"=1'-0"

SIDE ELEVATION (OPEN)
S:1½" = 1'-0"

PLAN
S:1½"=1'-0"

PERSPECTIVE VIEW
NO SCALE

Elevations and plans for crates as presented in the P.A.C.I.N. Technical Drawing Handbook. Courtesy of Mary Dillon Bird, Office of Exhibits Central, Smithsonian Institution.

the object and the packing material unless the packing material used is non-reactive. Check with a conservator regarding compatibility.

Short Trips:

For trips within a 250-mile radius of the museum, packing considerations include environmental changes (temperature and humidity), shock and vibration, handling, and the method of transportation. Any of the approved materials can be used but some will be less appropriate depending on the circumstances. If there are many other objects on the truck, the object may need a soft shell

(cardboard, Fome-Cor®, or polypropylene board) to provide additional support and protection. Use buffering material inside to avoid condensation with temperature change. Clear package marks and straps added to the outer shell can assist with handling. If the object may be subjected to humidity fluctuations, the entire package should be wrapped and sealed in polyethylene sheeting (4 mil) or Tyvek® paper. As mentioned above, vapor barrier wrapping materials like polyethylene should not be used when the relative humidity is high or with damp objects. All objects should be securely strapped within the truck to eliminate shifting and movement during

the transit. Great care should be taken in making sure the straps are placed properly and safely.

Hand-Carried:

Hand-carried objects need a protective shell to safeguard them from being crushed or broken in handling; remember that they can be accidentally dropped. The shell can be made of cardboard, Fome-Cor®, acid-free cardboard, polystyrene sheeting, or some other easily manipulated material. The package with the object inside should be easy to handle. While providing protection to the object, the package should not bring attention to itself, making others curious as to its contents; many hand-carries are put into an additional carry bag with straps or handles to avoid this problem. Because the courier might be asked to open the container for inspection (e.g., for airline security), the object should be easily accessible. If it is going via air transit, the package must meet airline guidelines for carry-on packages unless a separate seat has been purchased for the package; check with the airline for specific guidelines. The package must be secured in the vehicle or plane during the transit; additional strapping material may be needed.

Materials Commonly Used in Soft Packing Objects Include:

- Acid-free tissue: Unbuffered tissue, neutral pH; 12- or 18-lb. weight. Laminating tissue, a soft form of acid-free tissue, is used to stuff costumes and folded areas of textiles.
- AirCap or bubble wrap: This 100% recycled polyethylene with nylon coating on both surfaces is available in clear, pink (anti-static; coloration built into extrusion of the plastic process), or green (fire retardant; is amine-free; will not etch metal.) This material may be wrapped around an object to protect against minor shock and vibration. Bubble wrap should not come into contact with the object; use a tissue barrier. The bubbles should face into the object, when an inner wrapping or buffer layer is used. Otherwise, the bubbles should face away from the object.
- Archival cardboard/blueboard: Single or double wall and acid-free, this material may be used for boxes or mounts
- Blankets: Packing pads or blankets such as those used by moving companies should be kept clean with an intermediate material (e.g., tissue, plastic sheeting) between the pad and the object itself. They can be reused.
- Cardboard: Corrugated sheets come in various sizes and weights. Cardboard boxes, envelopes, and other forms of packages can be constructed as a shell for the object. Inexpensive and easy to use, this material is subject to moisture breakdown, may be very acidic, and should be restricted to short-term use only.
- Fome-Cor®: Sheets of a styrene foam sandwiched between paper sheets come in 3/8" and 1/2" thicknesses and are usually sold in 4' x 8' sheets. This material can be used like cardboard, providing a cleaner appearance and surface, but it is more expensive. It, too, should be reserved for short-term use only unless an acid-free Fome-Cor® is used.
- Gatorfoam®: These sheets are similar to Fome-Cor® but are denser and stronger.
- Glassine: Glazed, semi-transparent paper, glassine is usually used to wrap paintings and other art work. It is available in an acid-free version; it, too, should be reserved for short-term use only.
- Hot (melt) glue: Used for adhering archival cardboard, Ethafoam®, Volara®, and other packing materials.
- Kempak: A recycled kraft paper with a shredded paper interior and edges crimped by pressure, this paper is not acid-free. It may be used as padding and should be limited to short-term use only.
- Kraft paper: A standard brown wrapping paper, this material is not acid-free and should be limited to short-term use only. Do not use it in the space with the object.

- Microfoam: This thin polyethylene foam (usually 1/8" thick) similar in thickness to Volara®, but not as smooth, may be used for padding surfaces in contact with objects.
- Muslin: This plain-weave, cotton fabric should be unbleached and unfinished or desized, and washed in hot water prior to use. This material is a good choice for dust covers or covering padded surfaces when a smooth surface other than a polyethylene may be necessary. It is used primarily with textiles and costumes.
- Mylar®: This 100% polyester film is a chemically stable polymer with a neutral pH. This material provides a barrier in packing to keep objects from contact with non-archival materials. This material is also used in the form of envelopes or sleeves for paper objects.
- Pellon®: This is a 100% nonwoven polyester that is usually 1/8" to 1/4" thick. A thicker polyester batting, known as bat garrett, is also available for padding.
- Polyester foam (Esterfoam™): This packing foam used for cushioning the object against shock and vibration will also help insulate if it surrounds the object. Be certain that the polyester foam is genuine; there are look-alikes.
- Polyethylene foam (Ethafoam®): This polyethylene plastic that is expanded into a foam, made up of many tiny, closed cells or bubbles filled with air, is used in cavity packing of objects, mounting forms, or padding. It is inert as long as it is free of additives. Ethafoam® is the best-known variety of this material; Volara® is a type that works particularly well when in contact with objects because it is exceptionally soft.
- Polyethylene sheeting: Use this inert plastic to protect against humidity, water, or dirt. It should be of good grade and quality without residues, grease, talc, or other substances added to it. Look for virgin plastic with no impurities or other plastics mixed in.

- Polystyrene sheeting: This translucent material may be used for making sides of transit frames or added to the sides of cardboard boxes.
- Expanded polystyrene pellets and peanuts: These should only be used with a light object that will not migrate through the pellets to the bottom of the package. It is advisable to place these pellets in zipper-closing plastic bags to control them, to limit shifting, and to contain particles and dust. Use only with great caution.
- Polyurethane foam: This foam is available in white or grey and in several densities. It is fairly inexpensive and easy to cut; the quality varies tremendously with different manufacturers. In general, polyester urethane foam is of better quality than polyether urethane foam. All varieties should be limited to short-term use and must not be reused.

Tapes:

No tapes with adhesive should be applied directly to an object.

- Double-sided tape: Use only archivally safe varieties.
- Duct tape: This tape is strong and easy to use; it is very flexible and good for sealing Fome-Cor® boxes.
- Filament: This clear, reinforced strapping tape is very strong.
- Linen tape: This woven, gummed tape is pliable; the adhesive is acid free and is activated with water. Use this with archival board for making boxes.
- Masking tape: This is a non-archival paper tape. It may be used for short-term packing as long as tape is on outside of packing and not in contact with objects.
- Plastic tape: This economical tape has strong adhesion and a high strength plastic back. It can be used in mounts or for carton sealing.
- Reinforced paper tape: This gummed, water-activated tape is a very strong, waterproof tape.

■ Twill tape: A 100% cotton woven tape that comes in different thicknesses and widths, it is used to tie loose parts of objects together, to tie objects or pieces to mounts or pallets, to tie boxes shut, etc.

■ Tyvek®: Adhesive tape made of Tyvek® with an archival, acrylic, pressure-sensitive adhesive applied to one side; can be used with archival board to make boxes.

Other Materials:

■ Tissue: Buffered or unbuffered, tissue can be used to wrap the object as a layer against cushioning materials. It can also be wadded and put around the object as cushioning. Buffered tissue is often more abrasive than unbuffered tissue. Buffered tissue is alkaline and should only be used when specified; it is best to use neutral pH tissue.

■ Transit/traveling frames: These are an open framework to which paintings are attached with screws or metal brackets (e.g., Oz-clips®.) Provide a shell and structure around the painting and use foam pads between the bottom of the painting and the frame in case the screws fail. Much less expensive than a crate, traveling frames can be reused. The back and front can be covered with polystyrene sheeting, cardboard, or Fome-Cor® to provide additional protection for the painting. For maximum protection, the entire package can be placed in a wooden crate.

■ Tyvek®: This spun, fiber-bonded olefin, composed of high-density polyethylene fibers that are bonded together under pressure and intense heat, is very strong and resists tearing, chemicals, and mildew. It is good for providing moisture protection and a clean surface.

■ Volara®: Volara® is a soft polyethylene foam with a smooth surface. It can be bonded to other polyethylene foam with heat or hot melt glue and is often used to pad objects where they come into contact with rough or hard surfaces. It is best when used with other foams

that provide additional cushioning support.

■ Waterproof paper: This material is reinforced asphaltic paper used to wrap boxes for waterproofing; it should not be used inside boxes or crates.

CREATIVE ALTERNATIVES

Not every museum object can be neatly contained in a box or case for protection. Due to the unique nature and size of many objects, it is often necessary to devise creative alternatives to the box or case for packing.

Oversize objects can be addressed in several ways. The truck itself can become a container for large objects, with the loaded truck driven onto a cargo plane for shipment. Airplane pallets can be modified or specially constructed to accommodate large objects. Special cradles or supports can be constructed to transport large cases at angles that will permit them to ride stably within airplanes or trucks. Airplane containers can be used as a protective outside structure for objects safely positioned within. Containers can often be delivered to the museum where museum staff can load them and design internal bracing for the contents.

Flatbed trucks are often used with simple frameworks and tarps to transport odd-shaped objects. Objects can be suspended within trucks or containers when wrapping them is not possible.

Moving large numbers of objects down the hall or across town to an off-site storage facility can be addressed in a number of creative ways. Trays can be used to carry numerous objects that are either wrapped or divided from one another by padding. Trays can be stacked on moving carts that can be rolled onto trucks and secured for short trips. A variety of carts can be padded with tissue, cotton batting, sandbags, etc., and used to transport objects.

There is no single correct way to pack museum objects. Common sense and experience must apply to packing along with using new materials and research. Continuing dialogues among packers, registrars, conservators, and vendors will help us to protect collections more effectively.

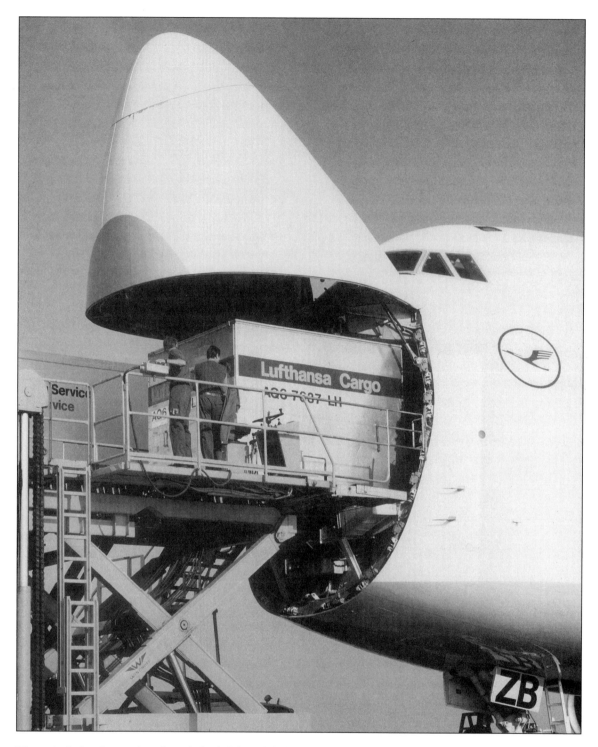

The main decks of cargo aircraft can be loaded through both the nose loading door and the side cargo door. Photograph no. P115-21-C12 by Werner Krüger. Courtesy of Lufthansa Cargo AG.

Irene Taurins

SHIPPING BY LAND, AIR, AND SEA

Choosing a method of transportation requires consideration of the museum object. This includes but is not limited to value, size, historical or cultural importance, condition, fragility, rarity, state of packing, crate and shipment size and weight, timetable, and expense. The best method offers the highest level of control of the object. Clear documentation and instructions must then be given to the carrier.

SHIPPING BY LAND

Types of Vehicles and Carriers: When using commercially available carriers, find a company experienced in transporting museum collections; recommendations of reputable carriers are best sought from other registrars. If museum specialists are unavailable, moving companies that specialize in handling delicate electronic equipment, using vans with air suspension systems and climate control, are a next best alternative.

Common carriers (also called regular route motor carriers) are not generally used for shipments of fragile or high-value material. However, for heavy or bulky shipments of moderate value, they provide an economical method. This service usually involves considerable handling or "cross-docking," which is the transfer of cargo from truck to dock to truck one or more times.

Types of Trucking Service Available.

Exclusive Use: This service deals exclusively with one institution's cargo, with all stops and deliveries defined by that institution. This is door-to-door delivery service. Exclusive use affords maximum control of timing and security. The registrar chooses the day, time, and route and can make arrangements for special guards or museum couriers to accompany the shipment. This is naturally the most expensive service.

Last On, First Off (LOFO): Other freight may be on the truck, but the LOFO shipment is guaranteed to be the last freight loaded and the first unloaded. There is slightly less control of the timing and slightly less cost than with Exclusive Use. This is a uniquely American service, not available in Europe.

Expedited Use: With this service, the shipper specifies a certain finite range of dates during which your shipment as well as other freight is loaded on the vehicle; each shipment has a reserved space. This service is less expensive than Exclusive Use.

Shuttle Service: This service is defined as "less than truck-load lots" (LTL) or smaller "space reservation" with no special time or route restrictions. Shuttle service is the least expensive method and can be safe, but in some cases it may be more time consuming. Ask for the details of the route and whether your cargo will be off-loaded or "cross docked."

Features to Consider: The major features to consider when booking a trucking service include air-ride suspension, double driver teams, and climate control. Air-ride is available on larger vans and trucks and provides a cushion of air to absorb road shocks. Double driver teams protect the freight if one of the drivers becomes ill or tired, and allow the truck to be supervised at all times, including during rest stops. Climate control can include full-range temperature and humidity control in which exact settings are determined by the kind of objects shipped; however, most climate control is temperature control only, which may be adequate for certain objects. Ideally, the driver monitors and controls the climate from the cab; some trucks are equipped to generate a graphic record of conditions during the trip. Ask vendors to specify what services they provide.

Planning Your Shipment

You can use the following diagrams to help plan efficient placement of your pieces.

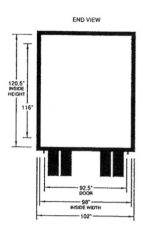

Environmental Control, Lift-Gate Trailer

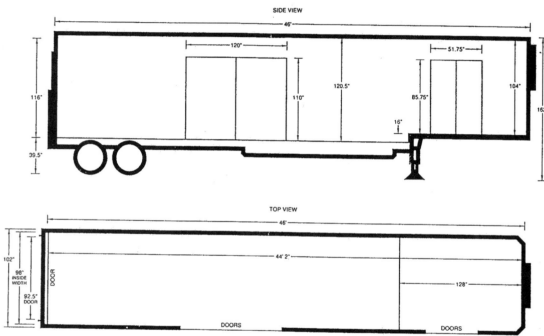

Although truck size varies among carriers, the above diagram represents a typical trailer size. When transporting large objects, the actual door size of the truck is probably the most important measurement to consider.

Another feature to consider is an adequate interior strapping or tie-in system. The truck should be equipped with sufficient furniture pads, dollies, and other equipment such as a J-bar. The truck should also have lockable doors and a security system. If the load is heavy, if there is no loading dock, and/or if the loading dock at either end is inadequate, you may also need to request a lift gate to ease the crates on and off the truck.

Depending on the service you require, it may be wise to choose a company that provides drivers who can double as handlers and packers, although not every company provides this service. This feature is particularly useful when picking up objects from private collectors who may not have the ability to pack their own objects. Other services to consider when booking a truck are extra security or the ability to accommodate a courier on the truck or in a follow car. These requests should be discussed fully when booking the shipment.

Good communication and understanding are important, both when booking and also during the

transit. For long-distance and/or sensitive trips, make certain that you are able to reach the owner or dispatcher of the company during off hours in case of emergency. For communication, it is best to hire trucks equipped with cellular telephones and a CB radio. Some companies track their vehicles via two-way satellite communications, in-route status reports, and on-board computer tracking.

Truck size and equipment availability vary among carriers. The size of the shipment may determine the choice of carrier. If the load is small in size, it may be best and more economical to transport it in smaller ("straight") trucks or vans, which run from 12 to 24 feet. The smaller trucks can also be equipped with air-ride and climate control with varying degrees of sophistication. Height is often a determining factor in the size requirement of the truck; discuss your height requirements fully before booking a truck.

Some transports require larger (30 to 48 feet) vans and tractor trailers. The determining factor is the size of the shipment, particularly height and volume, but other considerations include the distance to be traveled and the need for sophisticated climate control. Tractor trailer doors can vary in height, usually between 105 and 117 inches. You may also ask for the more specialized high cube vans, which have an interior height of up to 125 inches. To determine your needs, provide all shipping dimensions to a vendor before booking.

Trucking companies offering interstate transport were governed by the Interstate Commerce Commission (ICC) until Jan. 1, 1996. Although the Interstate Commerce Commission is no longer a regulatory body, its guidelines are often still used for classifications, rules and regulations, rates, mileage guides, and the services offered by the interstate moving companies. The Department of Transportation (DOT) is now the main regulatory body that basically regulates safety in interstate transit. Each state also has intrastate regulations. Companies operating motor vans or trucks within a city or state are generally subject to the approval of regulator bodies in each jurisdiction. The conditions under which shipments are accepted by carriers appear on the bills of lading issued to shippers. It is a good practice for the registrar to read the back of the bill of lading (see section on Documentation).

It is also common and safe to engage non-commercial carriers, such as a museum-owned or staff-owned car, van, or small truck, to transport museum objects. The main advantage is that the handling is completely under the control of the museum. However, the same common rules for commercial vehicles should also apply here. For security, two people should travel in a car. It is best to have a cellular phone in case of emergency. Always let other museum staff know the full route, schedule, and itinerary. Be sure the vehicle is large enough to permit the object to ride safely; tie downs or other devices may be necessary to secure it from shifting. (See chapter on Couriering.)

Freight services offered by the railroads are not generally used for museum shipment, as the ride on the tracks produces too much vibration. The train, however, is an acceptable mode of transport for objects that can be hand-carried.

SHIPPING BY AIR

Airlines offer the most rapid means of transportation for long-distance domestic and foreign shipments. Ideally, all arrangements for the air shipment of valuable and fragile museum objects should be handled by museum personnel or by reliable agents. These personnel or agents must be able to supervise all movements from shippers to airports, through terminals into planes, from planes, to and through terminals, and from terminals to final destinations. Supervision at cargo terminals is especially advisable to ensure safe handling at airport assembly areas where loading and unloading equipment are active.

TYPES OF AIRCRAFT

Different types of aircraft have certain limitations for carrying freight. Although "all-cargo" planes afford the most control, all-cargo aircrafts and destinations have been drastically reduced in number and are therefore not readily available to every destination. However, the size of the freight may necessitate the use of planes with larger door openings. Freight over 63 inches high can only fit in an air-

craft with main deck (the upper part of the aircraft generally reserved for passengers) cargo capacity, such as "all-cargo" or "combi" aircraft. "All-cargo" flights do not generally take passengers, but arrangements can be made to allow for a courier aboard. "Combi" flights are part passenger and part main deck cargo, with doorways high enough to take oversized freight. It is generally easier to engage an agent to arrange for cargo flights.

When using passenger flights, wide-bodied aircraft such as Boeing 747s and 767s, Douglas DC10s, Lockheed L1011s, Airbus 340s, and other airbus models are best, because cargo space is large enough to permit the loading of containers and pallets. Wide-bodied passenger planes can generally accommodate freight up to 63 inches in height. Containers are large receptacles, usually metal, of different configurations depending upon the size of the aircraft. Always inspect containers before loading for holes and dents that could allow leaks. Pallets are low, portable platforms, usually metal, on which cargo is placed and "built up" to conform to the aircraft size. When shipping museum objects, ask the airline crew to place polyethylene plastic sheeting on the floor as well as over the entire build-up on the pallet or around the interior of the container to protect the cargo in case of rain or other inclement weather. The pallet must also be tied down with special straps to keep it stable. Care should be taken in the orientation of crates on the pallet to minimize the effects of stress on the contents during take-off and landing. Beware, also, of including potentially hazardous materials on the pallet.

Smaller aircraft, such as Boeing 707s and 727s and Douglas DC8s and DC9s, cannot accommodate containers or pallets. Cargo must be loaded loose, so there is significantly more handling and risk of mishap. Individual pieces are loaded and unloaded on a conveyor belt. If you do not have wide-bodied service to your destination, it is probably best to truck the objects rather than use air freight. If trucking is not possible, very careful supervision is recommended.

SERVICES

Air freight rates apply from airport to airport. Delivery to and from airport terminals can be

arranged by the airlines at additional cost, but this is not recommended for museum collections because airport trucks do not follow museum standards (single drivers, non-air-ride, non-climate trucks, no means of securing the cargo within). If possible, make your own pickup and delivery arrangements or have door-to-door transportation arranged by reliable agents.

A registrar can book directly with an airline without the use of an agent. In this case, it is advisable to call the cargo terminal and personally talk to the cargo manager to explain your requirements, e.g., the freight must be "booked to ride," that is, made a priority shipment guaranteed for the flight, and museum personnel must be able to supervise the containerization and palletization of the cargo and to remain with it until it is on the plane and airborne. The cargo manager can complete an "air waybill" for you to sign. Get the name of the person who will be the cargo manager on duty during the time of your delivery and flight, and make contact with that person before you arrive.

Air freight services will also arrange to transport door-to-door. There is a loss of control in this type of shipping, as freight is often bundled together with other freight that may not be as sensitive. It is best to use air freight services for only the sturdiest and best-packed objects. If air freight is the only option, establish a good relationship with plenty of personal contact and communication.

Freight forwarders can be used for both domestic and foreign shipments to book the shipment, complete an air waybill, communicate effectively with airport personnel, and provide supervision (see International Shipping and the Use of Agents.)

Good supervision is important to assure the safe handling of collections at the airport. Supervision is necessary to be certain that a crate is properly placed in a container or on a pallet, that it is secure, and that it is not shipped with hazardous materials. Optimally, you or your agent should follow the freight onto the tarmac and witness the loading onto the aircraft. Full supervision includes staying at the airport until your flight is airborne for at least 20 minutes. On rare occasions flights return to the

ground soon after takeoff, and someone should be available in this case.

A freight forwarding agent or cargo manager can help with flight planning. Also, the OAG (Overseas Airline Guide) Cargo Guide is published monthly, lists almost all flights available for cargo, and provides information necessary for advance planning of your shipment. A quarterly supplement gives plane sizes and container and pallet capacity information.

Cargo managers can provide information about the availability and schedules of planes that will meet the requirements of shippers. They must be told the sizes and weights of the boxes when asked to reserve space on the desired flight.

Always book on a non-stop flight. If a non-stop is unavailable, a flight with stops but without a change of plane is the next best routing. If a flight must stop en route, emphasize and receive assurances from the cargo manager that your freight will not be off-loaded. Avoid flights that have plane changes; if you cannot, it is advisable to contact an agent in the stopover city to supervise the transfer of the freight.

INTERNATIONAL SHIPPING AND THE USE OF AGENTS

It is best to engage a customs/freight forwarder for export and import of museum objects. The proper documents are important, and communication is essential when choosing a customs/freight forwarding agent. For international shipments, museums generally engage customs brokers, freight forwarders, and cargo agents who are specially trained and licensed in importing and exporting. Customs brokers not only arrange for international transportation, but also make certain that shipments comply with all importing and exporting regulations. They prepare the documents required by the U.S. Customs Service and the customs offices of other countries. They can provide supervision, an important service that will actually see the shipments through all the processes of handling and customs. (See chapter on Import and Export.)

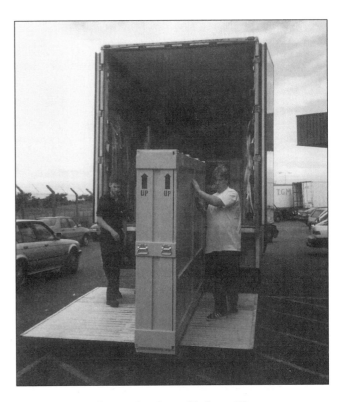

Crates are carefully raised to the truckbed on a liftgate and tied to the interior sidewalls of the truck with straps. Photo by Rebecca A. Buck.

Freight forwarding agents or other specialized museum agents also offer help in arranging transportation, including pickup and delivery and, if desired, packing of museum shipments. Care should be taken in selecting agents who are well informed about the policies and requirements desired by a museum.

SHIPPING BY SEA

Ocean transportation is not recommended for most museum objects because of the lack of control in scheduling and handling. For extremely bulky and sturdy objects, it may be an economical but slow solution. It is complicated by the fact that many documents are required, both by the carriers and by the governments of the United States and foreign countries. Museums generally engage ocean freight forwarders to handle these shipments.

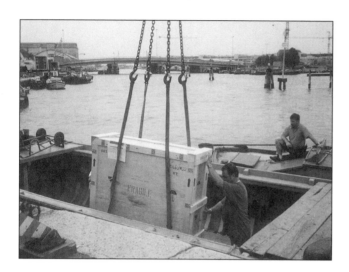

In Venice—shipping methods must sometimes adapt to the destination. Photo by Rebecca A. Buck.

SHIPPING BY U.S. MAIL AND AIR-EXPRESS SERVICE

Shipment by mail is not recommended for valuable and/or fragile objects because of transit and handling hazards, the Postal Service's limitations on the size and weight of packages, and the limited value for which underwriters are willing to insure mail shipments. For small shipments of replaceable and nonfragile objects of low value, parcel post may prove economical and convenient. It is common practice, for example, to send some natural history specimens by mail. If mail shipment is used, special care should be taken to see that containers are strong enough to ensure protection from the weight of other parcels, from pressure and friction, and from climatic changes and repeated handling.

When shipping by mail, it is often best to use express mail. This method offers the fastest delivery and therefore the least amount of handling. The other options in descending order of preference are registered mail, certified mail, numbered mail, priority mail, and regular mail.

Air-express companies offer a wide range of services, from small air cargo agents who use commercial carriers and contract truckers to major forwarders who own their own planes and trucks. Their small package services have size limitations that are marked on their air waybill or readily available by telephone. With good packing, this kind of service can be an effective option for transport, with the understanding that there will be a great deal of handling. Again, the fastest service is preferable in order to limit handling and time spent on loading docks and in warehouses.

Other advice when using express mail service is to ship early in the week in order to avoid weekends. Use only services that can provide tracking and require signatures upon delivery. Pack well, address the package clearly, and mark it "fragile." Most important, develop a relationship with one or two local forwarding companies and try to elicit their help and understanding of your special needs.

INSURANCE/INDEMNITY AND LOAN AGREEMENT CONSIDERATIONS

When deciding on the best shipping method to use, always keep in mind that guidelines from your insurance carrier, indemnity application, or loan agreement must be considered and honored. Shipments must be properly insured. In most cases the insurance should be through the museum policy. Carriers assume only a limited liability unless excess value is declared. A shipper making an excess declaration is, in effect, purchasing insurance coverage through the carrier. (See chapter on Insurance.)

DOCUMENTATION

The general rule of documentation when shipping is always to obtain a signature of receipt when transferring possession of a museum object. Always read documents carefully when your signature is requested. Receipts, bills of lading, and air waybills are contracts between shippers and carriers as well as receipts for the material accepted for shipment.

The bill of lading is a legal document, and your signature in theory releases the shipper from any liability for damages discovered at the time the cargo is received. Always examine the crate or package for any damage and never sign for a damaged package. Always use a disclaimer phrase such as "Condition unchecked, contents unknown" or "We are signing for the receipt ONLY. By signing this document, we are NOT issuing a clean bill of lading."

Racine Berkow

GUIDELINES FOR INTERNATIONAL SHIPPING

Museums and galleries, both large and small, exchange objects with their colleagues abroad. After the loan has been negotiated and the terms and conditions approved comes the physical process of exporting the object from one country to another. Although international exchange is becoming more a part of many museums' activities, there is still much confusion, misunderstanding, and lack of information about procedures. If the parties involved have not had previous experience with international transport, the first step might be to call a museum that has done international shipping and ask for a referral for an international transportation agent.

Information on export from the United States and return import covered below is relevant for U.S. agents only and may vary from port to port within the United States. The following information regarding procedures may change, and the museum should check with its own agent to verify procedures at the port of entry or departure that the museum is using.

EXPORT FROM THE UNITED STATES

Museum X (U.S.) is lending a very important object from its collection to Museum Y (overseas). The terms of the loan have been agreed to, the loan has been arranged, and the shipping date is approaching. The object must be accompanied by a courier. Museum X has contacted a crating firm to pack the object, and has secured the assistance of an agent to arrange shipping. The following information must be supplied to the agent by the museum:

Schedule: When must the object be at the final destination? What dates are best for the courier for installation?

"Have you brought back any phobias, neuroses, psychoses, paranoias, delusions or manias?"

Airline: Is there a preference for an airline? Has Museum Y secured airline sponsorship? If so, are there any special instructions for the export agent?

Crate Dimensions and Weight: This information is *essential* and must be correct. It determines the type of aircraft the object must be booked on and will determine the final flight schedule. For air transport, the dimensions should be given L x W x H, in accordance with IATA (International Air Transport Association) regulations. The height should always be last. It is also important for the agent to know if the crate can be turned or transported flat.

Special Requirements of an Object and Courier: Who is responsible for payment? What are the cost considerations? Is it okay to consolidate or send as a partial shipment? Is there a particular agent overseas that Museum Y wants to use, or can the agent consign the shipment to an agent of his choice?

Services Requirements: Museum X should also inform the agent if trucking services, armed guard services, special security, or airport supervision is required.

All details of the shipment should be discussed. The agent will offer guidance, since he or she is familiar with museum protocol and the shipping of museum objects.

It is usually up to Museum X to prepare a commercial or shipping invoice. It must contain the following information and be on museum stationery:

Shipper: Name and address
Consignee: Name and address
Inventory: Artist (Maker)
 Title (Object Name), Date
 Media
 Dimensions
 Value
Purpose: For exhibition? For sale?
 For examination?
Declaration and Signature:

If antique, the object must be certified as more than 100 years of age. If for an exhibition and return, this should be stated.

Documentation should be given to the shipping agent at least three days prior to export. Three copies of the commercial invoice should accompany the shipment. They should all have original signatures.

There are different information requirements for different countries, and certain objects require special documents. Your agent will advise you. However, the museum must supply the agent with proper documentation and information. After the museum has given the agent all necessary information, it becomes the agent's responsibility to book the shipment, prepare appropriate export documenta-tion, make the necessary arrangements with the airline to allow warehouse access, provide truck-ing to the museum's specifications, provide securi-ty (if required), and coordinate arrangements with the overseas agent for Museum Y. The agent will also procure the courier's ticket or make arrange-ment for the courier to board a cargo flight. Secu-rity access, as needed, will also be arranged by the agent. At this point, it is best for Museum X to allow the agent to do his job unencumbered; it becomes problematic if both the museum and the agent call the airline.

The agent will work with the information supplied by Museum X in the following way:

Schedule: The agent will try to work within the requested schedule. The museum must leave enough time for unforeseen events. Flights do get canceled, weather conditions can be a factor, civil unrest does occur, airplanes do break down, and airlines do change aircraft. These factors are beyond the agent's control. Allow a couple of days leeway. Airline schedules change from month to month. Many airlines will not take freight bookings more than two to four weeks in advance. It is good to start planning early, but the booking cannot be finalized until the airline schedule is confirmed and it is assured that the correct type of aircraft for a particular shipment will be utilized on that date.

Airline: Different airlines have different rules and regulations. The agent will do everything possible to arrange airline access for the courier to watch all stages placing the cargo on pallets and ramp access. It must be stressed here that even though this may be the most important object in your col-lection, to the airline it is only a box representing a minimum of revenue and a maximum of hassle. It is critical that the courier follow airline rules and procedures. Allow your agent to negotiate with the airline. Your agent has a working relationship with the airline and understands the airline's restric-tions. Most of all, the museum must not make unrea-sonable demands on the airline unless it is prepared to pay for them. For example, if you require your

object to be secured in a particular way inside a container, and you will not allow the airline to load freight touching your crate, you must be prepared to pay for the entire container. Above all, it must be stressed that it is a privilege, not a right of the museum, to be a guest in the airline's cargo area; this is a live operation with heavy equipment in motion. The courier must cooperate with the airline and agent for the move to be successful and without damage to the object or personnel.

Crate dimensions and weight: If this information is not correct, your agent may not make the proper booking arrangements. Crates higher than 63 inches must be booked on freighters or combi (combination passenger/freighter) aircraft.

Special requirements for object and courier: If the agent is advised about the object's fragility or special temperature/humidity needs, then all precautions will be taken (e.g., climate-controlled vehicles for long truck rides both in the United States and overseas). Also, if the packing is particularly complicated or the crate difficult to manage, the agent will make sure that the overseas agent knows what to expect and has the proper equipment available. Special arrangements for the courier are another story. Your agent's primary concern is the proper handling and safety of the artwork. Your cargo agent is glad to supply your courier with his plane ticket and will make sure that he or she is met on the other side and has a place to stay. However, your agent does not want to, nor should he, be involved with the courier's personal agenda and vacation planning. Your agent will be glad to help the first-time courier do his or her job, but the museum must be wise enough to select a courier with flexibility, stamina, maturity, interpersonal skill, and the good judgment not to antagonize customs, airline, and transport officials.

Payment/cost considerations: These factors should be clearly defined before the shipment takes place. As the details and parameters of the shipment change, so does the cost. For everyone's protection, it is best to have everything in writing.

However, there are times when unforeseen circumstances necessitate schedule changes and may cause costly delays. Shipping isn't an exact science, and the museum should allow a budget cushion to cover contingency planning.

IMPORT

Assuming that the loan has arrived safely at Museum Y, it will eventually be time for Museum Y to return Museum X's object. All arrangements will be reversed. There will be additional paperwork. In general, objects valued at more than $1,250 require a formal entry filed with U.S. Customs. An individual or corporation may clear its own shipment; however, this is a time-consuming and sometimes complicated process, depending on what commodity is being imported. In order to facilitate the process, one often hires a customs broker.

In the case of returning object, proof of exportation will be required to avoid the merchandise processing fee that is levied on all imports. A bond might also have to be posted. In order for your agent to do his job properly, it is important that there be either a pro-forma invoice from your museum (proforma means instead of) or shipping invoices from Museum Y. These documents can be faxed to your U.S. agent. If your museum wants to pick up the returning object as soon as it is available after arrival, the entry documentation must be submitted to U.S. Customs prior to the arrival of the flight. The entry package cannot be submitted to DAU (Document Analysis Unit, which is really a central computer station) for release until the aircraft is "wheels-up" in the foreign country. Hopefully, the shipment will be cleared and released by U.S. Customs by the time the plane lands.

The agent arranges warehouse access, trucking, and security for the returning shipment, according to the museum's requirements. The agent can have access to the shipment between one and six hours after landing, and many international flights land in the late afternoon. By the time the shipment and courier get to the museum, it can be quite late.

It is, therefore, important that the museum have adequate personnel to unload the truck or allow the agent to hire sufficient labor to handle the shipment properly. Thess arrangements can be quite costly and must be budgeted.

IMPORT—LICENSED BROKER

The brokerage company should be licensed by U.S. Customs, which is under the jurisdiction of the Department of the Treasury. To obtain this license, the company has been investigated and meets fiscal, organizational, and security requirements as described in the "Customs Regulations of the United States of America." A licensed individual who has passed a very difficult examination and whose background has been investigated must be responsible for running the day-to-day operations of the company. The company must have a valid permit to operate in a particular port of entry. The company must also be bonded.

Many companies perform import services in conjunction with a licensed broker. However, by law, the client must be allowed to have contact with the broker directly.

Working with a licensed company guarantees that you are working with a corporation that meets very stringent legal standards. In order to maintain its permit, the company must continue to comply with the most recent customs regulations. Should the company not perform in an acceptable manner, the client has the right to redress under specific procedures within U.S. law.

EXPORTS

Your agent should be an IATA (International Air Transport Association) forwarding agent. In the United States, this means the agent has been endorsed by the CNS (Cargo Network Services, an IATA company). Although many companies arrange export through IATA agents, working directly with an IATA agent will assure the following:

- Your agent issues his own airway bills in-house and books directly with the airline. The documents are not being issued or processed in any way by an intermediary party.
- Your agent or someone in the company has successfully passed both a written and oral examination of worldwide regulations and procedures that govern air cargo transport.
- Your agent's handling warehouse has been investigated and complies with international standards.
- Your agent meets the worldwide financial and security standards for necessary IATA endorsement.

SECURITY

Although regulations and criteria differ from airport to airport, your agent should have an airport identification pouch. At Kennedy Airport in New York, for instance, this means that the company as an entity and those individuals who actually have a pouch have been approved by the Port Authority Police to have access to some controlled areas. This pouch must be worn conspicuously when working at the airport. In addition, the agent should have a U.S. Customs ID. This allows access to customs-controlled areas, and must also be worn conspicuously in conjunction with the Port Authority ID.

Having these badges indicates that the agent is bonded by U.S. Customs and meets airport security standards. Airline access can also be arranged by your agent directly with the airline and does not necessarily require a pouch. Certain airlines will only allow access under the Escort Principle. Thus, they assign an airline staff member to escort their clients while in the cargo area; airlines are heavily fined for non-compliance, and agents' privileges can be revoked.

Import and export of museum materials are complicated matters. The agent you choose should have all the right credentials and must also meet the museum's needs in terms of quality of service and price. In order to accomplish this, the museum must specify what is wanted, and museum staff must be realistic about what the agent can actually do or not do. The agent and museum must work together as a team, with mutual trust and respect.

Cordelia Rose

Airline agents assemble crates onto pallets. Photo by Jean Gilmore.

The basic principles of couriering can be applied to local, national, and international travel. Journeys can be as short as a 10-minute walk to lend a specimen to a neighboring science museum or as long as a 30-hour combination of road and air transportation to lend an object to a foreign art museum.

The high value; fragility; scientific, historical, or artistic worth; political or cultural sensitivity; or complexity of transit of some objects may justify the use of a courier, generally someone on the museum's staff, to accompany the shipment. It is important to select the appropriate person as courier who can be relied upon to get the shipment to the correct destination in unchanged condition. The courier must also be able to evaluate the conditions at the borrowing institution and be able to assure that the security and environmental and other specifica-

tions for the object are met before leaving the object. In some cases of surface transport, a security guard may be necessary to escort the shipment, leaving the courier free to concentrate on the safe handing of the shipment. (See Statement of Courier Practice for courier qualifications.)

Whether the shipment is by surface or air or a combination of both, the courier must:

- stay with the shipment at all times;
- be accompanied before and after the flight and at plane changes;
- supervise the shipment's loading and unloading;
- know how each box is packed and its special handling and stowage requirements;
- be familiar with all routine procedures at ports of departure and arrival, including customs clearance; and

■ notify the museums and the shipping agents, if any, when the shipment has arrived safely, or if there is any change in itinerary.

In general, when dealing with a shipment, the courier must:

■ before the packing case is finally closed, look at the condition of the object and fully understand the packing method used.

■ before leaving the museum with the shipment, check: passports, visas, and, where necessary, health certificates; the object's documents, permits, and licenses; destination meeting instructions; and the museum's credit card in case there is an unexpected expense.

■ before leaving the museum, prepare for a long wait by taking along a small snack and by visiting the lavatory; the facilities at airport cargo sheds can be inconvenient.

■ before any vehicle leaves the museum, verify with all drivers the agreed-upon route and convoy order, check the escort's communications with the truck, and rehearse the contingency plan.

■ before the vehicle door is closed, check that the shipment is safely loaded or, if a hand-carry, stowed out of sight, if possible.

■ for an air transport hand-carried shipment, on arrival at the airport, go through the ticket check and bomb check. After boarding the aircraft, stow the box within view, or properly secure it if it is on the adjacent seat (a seat belt extension for the box can be ordered in advance). Upon arrival disembark last and go through immigration. At customs declare a hand-carried object on the personal customs form and ask for the shipping agent to clear the shipment. Try not to open the box at the airport but show a photograph of the contents instead.

■ for air transport on a combination passenger and cargo flight, go to the cargo shed with the shipment and monitor loading onto pallets or into containers; go to the passenger terminal and board the aircraft while the shipping agent monitors the loading of the shipment into the cargo hold of the aircraft. Upon arrival, go through immigration and customs and meet the shipping agent in the arrivals hall to be taken to the shipment in the cargo shed.

■ for air transport on an all-cargo aircraft, board the aircraft at the cargo shed with the crew. Upon arrival, go through immigration and clear customs at the cargo shed with the crew.

■ for surface transport, keep traveling with the shipment until the final destination, never leaving the vehicle unattended. Upon arrival, be sure to have the driver deliver the shipment directly to the entrance and stay until everything is safely inside the building. After unloading the vehicle at the borrower's location, make sure the shipment is properly and safely stored until unpacked.

■ for foot transport, walk so that escorts can stay close by. Risks include tripping on uneven sidewalks and being jostled by pedestrians, skaters, or bicyclists.

■ travel with the shipment from the airport to the borrower, monitoring its loading and unloading.

AIR SHIPMENTS

As with unaccompanied shipments by air, forwarding on all-cargo aircraft is preferred. For these shipments, the courier must:

■ arrive at the port of departure with the shipment well in advance of cargo close-out time;

■ witness the placement of boxes in the containers or on the pallets, the sealing of each container, the weighing of the shipment, and the loading of the aircraft;

■ know the identification and seal number of each container and its position on the aircraft;

■ usually ride on a seat just behind or in the cockpit;

■ watch the unloading and reloading of cargo at all stops to make sure that the museum's shipment is not misplaced, mishandled, or offloaded for a priority shipment;

- see that the museum's shipment, unloaded for repositioning in the cargo holds, is not left in adverse or dangerous conditions (rain, snow, or extreme cold or heat) before being reloaded;
- hold copies of all shipping papers and export permits that travel with the shipment and
- transmit documentation in advance to the agents handling the shipment.

If a combination cargo and passenger flight is the only alternative, shipments may be put in cargo holds or may be hand-carried. For cargo shipments on passenger flights, the museum or its shipping agent is advised to provide the courier with an assistant at the port of departure and to prearrange clearance with airline officials. The courier must:

- check in at the passenger terminal, while the assistant is present at the cargo terminal, to make certain that the shipment is carefully handled and taken to the passenger terminal for loading;
- ask the assistant to accompany the cargo to the aircraft, witness the loading, and send a confirming message to the courier aboard the aircraft;
- arrange with the airline in advance to have access to the cargo door of a passenger aircraft (this access may be denied for security reasons);
- be certain a seat with a view of the cargo doors is reserved;
- engage a local shipping agent with airport clearance at each intermediate stop to ensure that the museum's shipment is not unloaded and to keep the courier informed of any changes;
- telephone a local shipping agent for assistance if an unscheduled stop is announced; do this in advance of landing if possible;
- do everything possible to obtain permission to go to the aircraft's side and observe any movement of cargo (the shipping papers, export permits, a copy of the air waybill, and the

courier's museum identification badge will assist in establishing the courier's identity to the airline crew); and

- arrange to be met at the port of arrival by a local shipping agent, who will make sure that the cargo is carefully unloaded from the aircraft and safely delivered to the cargo area to await the courier from the passenger terminal.

A shipment that is to be hand-carried (never checked) as baggage by the courier rides in the cabin of the aircraft on or under a seat in view of the courier. In this case the courier must:

- verify under-seat dimensions during planning and, if not sufficient, purchase an extra seat (seat-belt extensions for the packing case must be requested in advance);
- not carry any other baggage that may impede safe handling of the shipment;
- carry a photograph of the object to show the X-ray or security inspector and do everything possible to avoid unpacking; uncontrolled unpacking can create problems, particularly in the case of delicate, specially packed objects that should not be unpacked or repacked in passenger terminal areas with fluctuating or unfavorable temperature and humidity conditions;
- enter a hand-carried shipment in accordance with each country's customs regulations;
- list a hand-carried shipment (but not freight) and its value on the personal customs declaration, stating that it is carried for the museum, and comply with the usual customs regulations;
- arrange to be met in the customs area at the arrivals building by the importing museum's shipping agent, who will take the shipment under customs seal or warning label and make the official customs entry (if the courier is not met by a shipping agent, the shipment cannot be released upon arrival and will be taken to the airline cargo area for later clearance);

- supply the shipping agent with the name of the courier and the pertinent flight information in advance, as well as the signed commercial invoice in duplicate;
- verify customs regulations in the port of arrival before departure with a shipment; and
- plan for a shipping agent to meet the courier, as safe handling and security measures for the transportation of an impounded shipment from the passenger terminal to the cargo area are always difficult, and often impossible, to arrange.

SURFACE SHIPMENTS

Couriered shipments by van or private car allow for continuous supervision and easier shipment monitoring. The shipment can be delivered directly, resulting in less handling and less change in temperature and climatic conditions. The courier must:

- always be accompanied by at least one other person;
- ensure that the van or car is never left unattended during rest or fueling stops;
- obtain permission from the shipping company in advance for the courier to ride in the van with the driver and co-driver (the courier rides in the center seat, enabling the co-driver to assist the driver);
- after supervising the loading of the shipment and checking the correct number of packing cases, require the consignor to sign the waybill releasing the shipment;
- verify before departure that the van's side and back doors are secured and note the numbers of the seals (if an escort is to be provided, the courier may travel in the follow car with the security escort);
- ensure before departure that the van driver and the escort agree on the best route, and, if necessary, verify that the police of each state have been warned that a convoy is passing through their jurisdiction (for extra security, large numbers can be painted on van roofs for easy identification from the air);

- make certain that any required climate control is turned on as necessary; and
- supervise the unloading upon arrival and check the number and condition of the packing cases before the waybill is signed by the consignee, releasing the shipper.

Small surface shipments can be made by private car, car service, or taxi. For these shipments, the courier must:

- never be the driver of the vehicle; the courier must stay with the shipment while the driver seeks help, if needed;
- only abandon a broken-down vehicle and seek other means of transport if the shipment is small enough to be hand-carried and the courier can open a door and carry the box safely at the same time; and
- insist when arriving at the destination that the driver wait until the courier and shipment are safely inside the building before leaving.

Upon arrival at the destination, the courier must:

- during unpacking, make sure the borrower has an identifying system so objects are not confused with one another.
- after unpacking, make a condition report pointing out problems to the borrower, photographing any damage for an insurance claim. Receive an agreement for treatment of any object and obtain written authorization if repairing or remounting an object are required.
- before installation, make sure the object is properly handled and will be safely installed under the specified light level, within the guard's sight line, and after risks of construction and painting are over.
- before leaving, verify climate, security procedures, and fire detection and suppression systems within the museum in order to determine whether or not the Standard Facility Report was an accurate reflection of reality.

- when satisfied that the object is safe, have the borrower sign their own or the courier's receipt of delivery; custody of the object is thus handed over to the borrower.
- before leaving, initiate planning for the pickup of the object at the close of the exhibition; plans will be finalized closer to return date, but it is useful to discuss potential problems while still on site.

When returning to the borrower's museum at the close of the exhibition the courier must:

- examine the object to make sure it has come to no harm and complete the condition report, pointing out problems to the borrower as before.
- after the condition report is completed and the object verified as safe to travel, oversee or actually do the repacking; be prepared for the borrower to be preoccupied with incoming couriers and shipments for the next exhibition.
- reversing the procedure described above, transport the object safely back to the museum using the best possible method and route. Take care not to relax until the object is safely inside the museum and its condition checked.

University Art Museum, Arizona State University. Photo by Elizabeth Gill Lui.

Clarisse Carnell and Rebecca Buck

PERMANENT COLLECTION

INTRODUCTION

The acquisitions section of a collections management policy carefully defines the types of collections that a museum holds: art, history, archival, science, anthropology, archaeology, etc. It should mention all permanent collections and should acknowledge special collections, such as those for educational use or special loan. The policy should also stipulate the means by which decisions are made for accepting objects to the permanent collections, who is responsible for the decisions, and the legal and ethical framework that is followed by the museum. The acquisitions policy should be augmented by a set of procedures that allow objects destined for the permanent collection to be accessioned, and objects for secondary collections, research, or sale to be accounted for.

All accessioned objects are acquired, but not all acquisitions are meant to be accessioned. An acquisition is made by a museum when title of an object is transferred and the museum becomes the owner. Acquisitions made for the museum's permanent collection are accessioned into that collection. The word accession may be used to denote (1) an object acquired by a museum for its permanent collection or (2) the act of recording/processing an addition to the permanent collection. It is the act of recording an addition to the permanent collection by means of assigning a unique number that allows the museum to connect an object to its documentation. (See chapter on Numbering.)

It is not necessary for a museum to accession every object that it acquires. However, the process of deciding what to accession must be very clear. If the object is a gift, the donor should be informed of the museum's intended purpose for the gift before it comes to the museum. How the museum intends to use the object could affect the tax consequences of the gift for the donor. (See chapter on Tax Issues Related to Gifts of Collections.) Objects acquired by the museum may go, as noted above, to an educational project or hands-on loan collection, or they may be destined for the library or archives. They may be accepted for research (which may mean the eventual destruction of the object) or to be sold at a later date.

Acquisitions may be made by:
■ Gift title passes during the life of the donor
■ Bequest title passes under a will
■ Purchase direct, auction, bargain sale, exchange
■ Field collection
■ Conversion the unauthorized assumption of ownership of property belonging to another. See chapter on Old Loans.

GIFTS

Gifts can be outright, fractional, or promised. They may be unrestricted or made with some restrictions.

UNRESTRICTED GIFTS AND GIFTS WITH RESTRICTIONS

An outright and unrestricted gift is always preferred, although there will be some circumstances in which the object is such an important addition to a collection that some restrictions are acceptable. Depending on the donor and the nature of the restrictions requested, it is often possible

"Processes" edited by Jeanne Benas, Jean Allman Gilmore, and Renee Montgomery.

Acknowledgements: Jan W. M. Thompson, Ted Greenberg, Marie Malaro.

for appropriate museum personnel to discuss the potential restrictions with the donor, discover the reasoning behind the restrictions, and negotiate a more acceptable gift agreement.

Requests to exhibit permanently or to keep a collection together are the most common restrictions requested by donors. Neither is practical, and this type of request should be discouraged. A reasonable restriction might be one that keeps an important album of photographs together in their original binding rather than unbinding and matting each one separately; the museum must weigh its current desire to have the album with the possibility that future generations will be hampered by the restriction. All restrictions, if accepted, must be carefully considered and documented in the object records.

FRACTIONAL GIFTS

Fractional gifts are generally made for tax reasons, because a taxpayer's deduction in any one year is limited. (See chapter on Tax Issues Related to Collections.) Upon advice from his or her tax advisor, the donor offers the museum a percentage interest in an object amounting to the allowable deduction. If the museum accepts the offer, a deed of gift detailing the arrangement is produced by the museum in consultation with its legal counsel or by the donor's lawyer. The deed may convey one portion only, or it may transfer title automatically to further portions of the work through several years. (See chapter on Creating Documentation.) The museum should not accept a fractional gift unless the donor agrees to give the remaining portion to the museum within a set time period or to leave the remaining portion of the object in a will. The museum does not want to find itself in a position where only a forced sale of the object can resolve who actually controls it.

A fractional gift should go through the same acquisition process as an outright gift. As a rule, a fractional gift must be in the museum's possession for the part of the year that reflects the percentage of ownership in the work. A fractional gift of 50%, for instance, must be in the possession of the donee

(museum) for six months of each calendar year. A donor can leave the object at the museum on "loan" for the donor's portion of the year but it should be recorded and insured as a loan for that time. (See chapter on Loans.)

PROMISED GIFTS

Promised gifts may be made by a donor in the form of a letter expressing the donor's intent to give a specific object to the museum at some future time. Although many museums have a draft format for promised gifts to act as a guide for donors, it is preferable to have the donor initiate the promised gift letter on the donor's letterhead. The museum may wish to encourage the donor to include the gift to the museum in his or her will to ensure that the donor's promise is carried out if the donor is unable to make the gift during his or her lifetime.

A promised gift may be in the custody of the museum; if it is, it should be treated as a loan. (See chapter on Loans.)

BEQUESTS

A bequest is the transfer of property to the museum under the terms of a deceased person's will. It is important to have on record, as evidence of the transfer of title, a copy of the provision of the will that concerns the bequest to the museum and a copy of the final receipt the museum signs accepting the bequest. A deed of gift is not appropriate documentation for a bequest. If objects come to the museum not under the terms of a will but as gifts by heirs of objects included in the estate—that is, if title passes first to the heirs and they, in turn, make a gift to the museum—the appropriate evidence of transfer is a deed of gift.

A museum may or may not know of a bequest in advance. Museums are usually notified of a bequest by the executor (legal representative) of the estate or the law firm representing the executor. It is important to deal with the official representative of an estate. The museum should ask for a copy of the will that concerns the bequest to the museum. The museum should then decide whether it

wishes to accept the bequest, accept only part of the bequest, or refuse the bequest. It should then communicate its wishes to the legal representative of the estate. If a museum accepts objects, it will be asked to sign a receipt for them. The museum should be aware that the transfer to the museum is not final until the administration of the estate is finally approved by the court.

PURCHASES

Purchases for museum collections can be made in a variety of ways: at auction, from or through dealers, or directly from individuals. If an object is purchased, it is important that the museum have a bill of sale and proof of payment, and such documentation should be part of the acquisition file.

A hybrid form of purchase is a "bargain sale." In this instance the donor offers an object to a museum at substantially lower than fair market value with the intention of benefiting the museum by virtue of the reduced price. Properly done, there are tax benefits for the donor. The method of transfer of title is a bill of sale, but the museum acknowledges in correspondence to the donor that the price of the object has been reduced to favor the museum. It is up to the donor to establish his/her tax benefits with the IRS. The museum, for its part, wants to be secure in its opinion that the sale price is substantially reduced. An independent appraisal is advisable to document the discount. The bill of sale and all related correspondence should be part of the acquisition file.

Exchanges are in fact a form of purchase. In this case the payment is in kind, not in currency. The terms of an exchange should be set forth in writing and a museum, for its records, should establish the fairness of the exchange by means of appraisals and other expert opinions. The written agreement concerning the exchange and all relevant documents concerning the justifications for the exchange and the execution for the exchange should be part of the acquisition file. (See chapters on Appraisals and Managing Files and Records.)

FIELD COLLECTIONS

Field collections are made more frequently by science, anthropology, history, and archaeology museums than by art museums. They may be a series of purchases acquired during an expedition, or they may be collections of scientific or archaeological specimens that are collected in a field research project or archaeological excavation. Purchases are generally made from persons who made or used the objects, and the recording of provenance, materials, techniques, and use are vital to the purchase record. Archaeological material should also be accompanied by complete field notes.

Field collections are increasingly subjected to legal restrictions, particularly regulations on export from the country of origin and laws dealing with repatriation to Native American or Native Hawaiian groups and endangered species. (See chapter on NAGPRA.) The museum must be aware of all potential restrictions and obtain applicable permits and customs releases before bringing material from the field to the museum. The registrar should, with help of legal counsel, research the legal title to the collections returned to the museum before they go through the acquisitions process and are accessioned into the permanent collection.

CONVERSION

Most museums have objects on loan that remain unclaimed by the owners. Several states have adopted legislation to enable a museum to acquire title to these objects if the owners cannot be located and if specified procedures are followed and waiting periods met. (See chapter on Old Loans.)

THE ACQUISITION PROCESS FOR PERMANENT COLLECTION OBJECTS

A cogent collecting policy that takes into account current collection strengths and weaknesses must be put in place for each collecting area if the museum is to acquire collection objects intelligently. A typical museum policy sets forth the practical and legal considerations that precede an acquisition.

THE SAMPLER MUSEUM
123 Any Street, Any Town, USA 00000
Telephone 000-000-0000 FAX 000-000-0001

DEED OF GIFT
 Date Page of
Name
Address

Telephone

Description of object(s)

Donor hereby transfers and assigns without condition or restriction all right, title and interest free of restrictions or encumbrances in the tangible personal property listed above (the "Object"), and all rights (including trade marks and copyrights) associated with it (the "Rights") to The Sampler Museum Association, a corporation existing under the laws of the State of disposition by The Sampler Museum, Any State, for use and Donor warrants and represents that Donor has the full power and authority to transfer the Object to The Sampler Museum Association.

Donor certifies that to the best of the Donor's knowledge, the Object has not been exported from its country of origin in violation of the Laws of that country in effect at the time of the export, nor imported into the United States in violation of United States laws and treaties.

Donor _____ Date: _____
Donor _____ Date _____
Accepted for The Sampler Museum

by _____ Date _____
 Director

This deed of gift represents an agreement between The Sampler Museum and the donor(s) named on the face hereof. Any variation in the terms noted must be in writing on the face of this form and approved in writing by both parties.

Gifts to The Sampler Museum are deductible from taxable income in accordance with the provisions of Federal income tax law. However, Museum employees cannot, in their official capacity, give appraisals for the purpose of establishing the tax deductible value of donated items. Evaluations must be secured by the donor at his/her/their expense.

The donor received no goods or services in consideration of this gift.

Limited gallery space and the policy of changing exhibitions do not allow the Museum to promise the permanent exhibition of any object.

Deed of gift, sides 1 and 2.

Practical considerations:

- Is the object consistent with the collection goals of the museum and the specific goals of the curatorial department?
- Will the object be useful for exhibition and educational purposes, and for research and scholarship?
- Is the object in a reasonably good state of preservation?
- Can the museum properly exhibit and/or store the object?
- Is the price asked for purchased objects reasonable?
- Will the acquisition of the object result in major expenses for the museum for conservation or maintenance or because it opens a new area of collecting?
- Can the acquisition of the object be construed as a commercial endorsement?

Legal and ethical considerations:

- Can valid title to the object be passed to the museum? Does the possessor of the object appear to be the sole owner or the legal agent of the owner?
- Is the object authentic?
- Can all rights in the object be conveyed to the museum?
- Does the acquisition of the object violate applicable state, national, or international laws or conventions that protect the rights of artists, or the rights of countries to their cultural history, or an endangered species?
- Is the object subject to repatriation to a Native American or Native Hawaiian group?
- Is the object free of donor restrictions or qualifications that inhibit prudent use of the object by the museum?

Acquiring objects for the permanent collection is a complicated process for most museums. It must be thoughtful and undertaken with care. It usually begins with curators who seek gifts by developing donor relationships and seek objects for purchase by becoming familiar with the market in

their area of specialization. Gift offers and purchase opportunities also come unsolicited to most museums. In science, anthropology, history, and archaeology museums, field collecting has been important in the past and is still a possibility in some collecting areas.

Between the time an object becomes available to the museum and the time it is actually acquired, a number of things take place (the order differs among museums):

- The object is transported to the museum.
- Curatorial proposal for acquisitions and/or worksheet is done.
- Consultation among curator, director, conservators, registrars, outside specialists, or board members takes place.
- Legal concerns (permits for endangered species, copyright licenses, title issues) are reviewed.
- If the object is a gift, intent to give is established, usually by the issue of a deed of gift that is sent to the donor for signature.
- If the object is a purchase, warranty of title is developed.
- An agenda for the acquisitions committee is developed.

The curator usually consults with the director after an initial gift offer is received or purchase possibility is determined. Museums have many variations of the acquisition process that follows after the director and curator decide to pursue an acquisition, but the registrar is always central to that process.

The registrar is generally charged with coordinating objects and their documentation, bringing objects to the museum, and making recommendations, in conjunction with a conservator when possible, about the feasibility of caring for and properly storing new objects; it is also the responsibility of the registrar to make certain that title to the object is transferred and needed licenses and permits are acquired.

If the object offered for gift or purchase is not already in the museum's custody for loan or examination, the registrar must arrange to bring it

THE SAMPLER MUSEUM

123 Any Street, Any Town, Any State 00000
000-000-00000
DEED OF GIFT OF FRACTIONAL INTEREST

I hereby give and deliver to The Sampler Museum ("the Museum"), an undivided _____ percent (
%) interest in the work of art or object described below, as an unrestricted gift.:

< artist/maker >

< title >

< description of object >

As owner of an undivided _____ percent (_____%) interest in the work of art or object, the Museum shall be entitled to possession, dominion, and control of the property for that number of days during any twelve-month period after the date hereof which in sum are equal to the percentage of the Museum's ownership in the work of art or object. The Museum shall have sole discretion to decide the days during which it shall have possession of the work of art or object. (The period of initial possession of the property by the Museum shall commence upon the acceptance of this gift by the Museum.)

I give further fractional interests in the work of art or object in the following fractions, said gifts to be effective on the date(s) specified below:

Fraction	Date
_____percent (_____%)	beginning January 1, 19___ and
	continuing each _____ of succeeding years.

In the event of my death, then all of the remaining fractions of interest in this work of art or object shall pass to the Museum at the time of my death.

I understand that it is the purpose of the Museum to promote by all appropriate means a wide public knowledge of and appreciation of fine arts, and I further understand that the management, use, display, or disposition of my donation shall be in accordance with the professional judgment of the trustees and director of the Museum.

This deed of gift of fractional interest shall be binding upon my executors, administrators, heirs, and assigns.

Signed and sealed this _____ day of _____ , 19 ____

By: Witness:

< donor signature > _____ < witness signature > _____
< donor name > < witness name >
< donor address >

State of _____

County of_____

On _____ , 19 ____ , < donor name > _____ personally appeared before me and acknowledged the foregoing instrument to be her free act and deed.

< notary signature > _____
Notary Public

The Museum hereby accepts the foregoing gift and delivery. The donor has not received and shall not in the future receive goods or services in consideration of this gift.

The Sampler Museum

By < museum official signature > _____
< museum official name >
< museum official title >

Deed of partial gift.

to the museum. The curator writes a proposal for acquisition that should explain in detail the reasons the object is desirable for the collection. The registrar begins an acquisition file and makes certain that a temporary number is assigned to the object, that proper receipts have been issued, condition reports completed, and the location of the object noted. It is also wise to have a Polaroid or 35 mm photograph made at this point. (See chapters on Managing Files and Records, Numbering, and Condition Reporting.)

The deed of gift, a document that is developed with help of legal counsel, is generated by the registrar. It can serve as evidence of both an intent to donate and an acceptance by the proper museum authority.

Three elements are normally needed to complete a gift.

■ Intent to donate, preferably in writing. A deed of gift is the preferred instrument to demonstrate this intent.

■ Proof of physical receipt of the object by the museum.

■ Written acceptance of the gift by the proper museum authority.

At least two original copies of the deed of gift are sent to the donor with a letter requesting that the donor sign and return both copies to the museum. The signed copies are held until the acquisitions committee meets and approves the gift. After the committee meets, the designated officer for the museum, usually the director, countersigns the deed of gift and sends one copy to the donor with a letter of appreciation. The other signed copy goes to the registrar for inclusion in the acquisition file. In some museums, three originals are made and the third is sent off-site for security purposes. (See chapter on Creating Documentation.)

Many museums do not include copyright releases in the deed of gift. Often, too, the donor is not the holder of copyright. If copyright in the object is an issue, and it is not covered in a deed of gift, a separate non-exclusive use agreement should be sent to the copyright holder. The donor of an object,

unless that donor is the artist, is usually unaware of whether he or she holds copyright to a work. (See chapter on Copyright.)

Depending on the acquisition policy of the museum, gifts, purchases, bequests, or exchanges proposed for accession will be reviewed and/or approved by a collections or acquisitions committee. That committee may meet monthly, quarterly, semi-annually, or as needed and may consist of board members, staff members, collectors, specialists in the field, friends of the museum, and, in a university museum, faculty members. This committee may have the authority to approve or reject acquisitions or the authority to recommend objects to the board of trustees for final approval. In any case, acquisitions are formally recorded in the minutes of the board meeting.

The agenda for the acquisitions committee is usually prepared by the registrar. It should be a clear listing of all objects to be considered for acquisition. The listing should include complete descriptions of the objects, donor and vendor names and addresses, credit lines for gifts, and, as appropriate, the price and funds to be used for purchases. The recording secretary for these meetings may be the registrar, deputy director, chief curator, or other member of the staff appointed by the director. Regardless of the recorder, the registrar should be officially notified as soon as possible after the meeting of works accepted or rejected for acquisition. Rejected objects should be returned to the donor or vendor. Accepted gifts should be acknowledged with a letter of appreciation from the director (and in some cases the curators) and a countersigned deed of gift or other official form that describes the gift(s).

ACCESSIONING

Once the object(s) have been approved for acquisition into the permanent collection and the deed of gift signed or the sale completed, title passes to the museum and the registrar begins the process of accessioning. Accessioning is the act of recording or processing an addition to the permanent col-

THE SAMPLER MUSEUM
Confirmation of Gift

The Sampler Museum
123 Any Street
Any Town, USA 00000

Gentlemen:

I hereby confirm my agreement to give to The Sampler Museum ("Museum"), at or before my death, the work or works of art listed below or on the attachment hereto:

You have informed me that other collectors, Trustees and friends of the Museum have indicated their intention of giving to the Museum works of art which they own in order to enhance the Museum's collection. As I believe that definite commitments to make such gifts or bequests will be of great value to the Museum, I have agreed to give the above described work of art to the Museum on the understanding (i) that you will do your best to obtain similar commitments from others and may refer to this agreement in inducing others to make such commitments; (ii) that this agreement shall be governed by the laws of Any State.

I may, according to my own convenience, give this work of art to you during my lifetime. Should this gift not be completed during my lifetime, it is understood that this agreement shall be binding on my heirs, executors, and administrators, and that omission from my Will of a specific bequest of this work of art to the Museum shall not release them from delivering the aforementioned work of art to the Museum in accordance herewith, or otherwise impair the force and effect of this agreement.

Neither the Museum nor I shall be under any obligation to insure this work of art during my lifetime. In the event I do not own this work of art at my death because of loss by casualty, the Museum shall have no claim against my heirs, executors or administrators with respect to this undertaking on my part.

I have entered into this agreement on the date indicated below with the full intention that I will be legally bound hereby pursuant to the applicable provisions of the law relating to written obligations and that this agreement shall be binding as well on my heirs, executors, administrators and assigns.

Dated: _____ Very truly yours,

_____(Seal)

We confirm the above correctly states the agreement between us.

The Sampler Museum

By: _____ Date:_____

Statement of promised gift.

lection. An accession number is assigned, and the file that has been made to track the potential acquisition becomes the accession file. (See chapters on Numbering and Creating Documentation). The file is checked for supporting documentation, and the accessioning process begins. The process includes:

- Gathering all gift or purchase documents, noting the accession number(s) on each.
- Creating a curatorial worksheet. If one has not been done, the registrar completes the basic worksheet and sends it to the curator for approval and additions, if any.
- Numbering the object. (See chapter on Marking.)
- Photographing the object.
- Entering information into the manual system. This may include:
 source card (vendor or donor)
 fund card (for purchase)
 cross-reference cards, as used by the museum
 biography card or artist card, as used by the museum
 location card (or new card changed from the temporary to the permanent number)
 accession or catalog card, as used by the museum.
- Entering information into the computerized system and printing out the cards outlined above. Some museums decide to keep none, all, or some manual files, generated by computer.
- Developing accession and/or object and/or source vertical files as necessary.

The accession number associates the object with its file and all its documentation. It is vital to have unique accession numbers that will take the staff member, curator, or researcher directly to the documentation. (See chapter on Numbering.) An accession folder may be developed and stored by consecutive number; if a volume of documentation exists for a single object within the accession, an object file may be broken out from the accession file to hold that information. Some museums have files for every object; others have accession files; still others keep both accession and source files so that all information about an accession can be retrieved or all transactions with a single donor or vendor can be traced. (See chapter on Managing Files and Records.)

After the accessioning is complete, the registrar must review the file for compliance with the collections management policy. The accession file becomes the repository of all information that comes to the museum regarding the group of objects in it, and object files become filled as research, photography, condition reports, loans, conservation work, and publication take place.

Policies and procedures should be developed to govern access to permanent collection records. Confidential information such as shipping and insurance histories, appraisals, tax documents, purchase orders, donor addresses, and telephone numbers may be available only to certain members of the professional staff. Condition notes, conservation treatment reports, and some provenance information may also have limited access. The general public should have access (usually in the form of the accession card) to descriptive information about the object, the accession number, credit line, reference notations, and the exhibition and publication histories of an object. In developing policy about access to records, legal advice should be sought concerning the existence of any applicable freedom of information or privacy laws.

Martha Morris

INTRODUCTION

Museums have engaged in the practice of deaccessioning for decades. In fact, disposing of collections that have been acquired and cared for by museums has been a common practice. The concept of deaccessioning in the last 25 years has frequently been controversial as the profession has been ever more alert to legal responsibilities, the public's expectations of museums, and ethical codes for institutions and individuals. Museums became painfully aware of the need for strong deaccession policies and practices in the early 1970s when several institutions, including New York's Metropolitan Museum of Art and the Museum of the American Indian, were scrutinized for certain collections disposal practices. The Brooklyn Museum, the Henry Ford Museum in Dearborn, Mich., the Barnes Collection in Merion, Pa., and the New-York Historical Society are just a few of the institutions whose actual or proposed deaccession activity has created public or professional controversy in the last 25 years. In some cases the criticism emanated from offended donors disappointed that their gifts were no longer worthy of museum status. Frequently, certain objects were considered treasured cultural assets of the community. In other cases, legal and ethical codes were violated when museum staff or trustees personally benefited from collection sales or when proceeds of deaccession sales were used to support operations or reduce financial obligations of the institution. Internally, controversy swirled as museum staff were reluctant to dispose of objects that might be significant treasures in the future.[1]

These experiences have caused museums to conduct much more conscientious reviews of their decisions to dispose of collections, and this is reflected in the types of policies, procedures, and ethical statements that have been adopted in more recent years by their governing bodies. A museum's fundamental mission to preserve and build collections for the benefit of present and future generations can be challenged when it seeks to remove objects from the collections. Such activity, if not carried out thoughtfully and carefully, can be a serious liability for the museum. There is probably no more sensitive current issue for museums, unless it be the controversial nature of some exhibitions or the blurring of lines among the nonprofit, public, and for-profit sectors.

However, while deaccessioning is controversial, there is a compelling case for the practice. Many museums have collected material that is clearly outside the scope of their mission, that may have deteriorated beyond a useful life, or that could be better used by other educational institutions. Managing collections is a rigorous and costly task, and some museums simply do not have the resources to care for properly or make accessible all of their collections. Informed and responsible choices and decisions have to be made. To assure the highest level of public accountability, museums must codify policy and procedure for deaccessions, and these policies must be endorsed and fully embraced by the museum's governing body and staff.

Following are practices that all museums should employ in the process of developing deaccession policies and procedures, including collecting plans, deaccession criteria, decision processes, disposal options, record keeping, alternatives to deaccessioning, and special problems. The registrar's role in deaccessioning is to be vigilant about the creation of and adherence to the museum's policy and procedures and to remain knowledgeable about the best practices of the profession.

THE FIRST STEPS: DEFINING COLLECTIONS RATIONALE

In order for a museum to make intelligent decisions regarding deaccessions, it must first have clearly articulated collecting goals. A museum defines its collections by reference to its operating charter and mission statement. From its mission the museum must define its scope of collections in a written document approved by its governing body. Once the museum defines a broad scope of collections—which should cover object type and origin, intellectual themes, and subjects at a minimum—there is a need to form a collecting plan. This plan, usually crafted by the curatorial staff, evolves from the scope statement to a formal assessment of the strengths and weaknesses of existing collections. This assessment looks at collections in specific collecting areas, comparing them to other objects in the museum and to similar collections in other museums. This assessment process can be a time-consuming effort and in some cases may require hiring outside specialists to supplement the expertise of existing staff or collections records. The registrar, collections manager, curator, and conservator will be active partners in this effort as they provide information about the legal and physical status of objects as well as critical information about their provenance. Once the assessment is completed, the priority of collecting objectives must be established in order to target new acquisitions. Certain items in the collection can be earmarked for deaccession and disposal, if not within the parameters of the plan. The museum can benefit from an analysis of the ongoing costs associated with collecting and maintaining collections, including not only the cost to acquire— e.g., purchase cost, transportation and insurance, initial conservation—but also long-term costs such as cataloging, storage, conservation, photography, and inventory control. This analysis is particularly important as a tool to project the costs of ongoing maintenance and the future growth of collections. It will assist museum management in strategic planning for new resources and inform the governing body as it makes decisions. This type of analysis is complementary to the planning that should be ongoing for developing inventory control systems, full documentation of collections, and surveys for preservation. Once these analyses are completed, they will be helpful to any museum that is undergoing AAM Museum Assessment Program or Accreditation reviews or that is in the process of applying for funding for programs or mounting a capital campaign.

DEACCESSIONING POLICY AND PROCEDURE

The museum's collections management policy must clearly explain criteria for making decisions about deaccessions. Deaccession and disposal are two different things. Deaccession is the formal change in recorded status of the object. Disposal is the resulting action taken after a deaccession decision. No matter what the object's accession status, it should go through a thoughtful disposal process. Indeed, the museum's collections management policies should define the various categories of objects and the steps needed to acquire, deaccession, and dispose of them. For example, a collection that is composed of materials used for school programs, study, or exhibition props probably would require less rigorous levels of review before disposal. In fact, such items might be disposed of at the discretion of the curator or educator. Other objects, such as those in the permanent collection, usually may only be disposed of after review by the museum's management and the board's unanimous written approval. Of course, the type of objects and their monetary or intrinsic value determine the best approach. All decisions must take into consideration the processes associated with proper records review and disposal options. In all cases, the collections management policy should clearly address the criteria and process associated with decisions and actions to deaccession and dispose of collections.

Decision criteria are needed in order for the museum's collections committee (usually a

trustee group working closely with staff) to make thoughtful and justifiable decisions. With reference to the museum's mission and its collecting plan, deaccessions should be considered only when the objects in question are

- Not within the scope or mission
- Beyond the capability of the museum to maintain
- Not useful for research, exhibition, or educational programs in the foreseeable future
- Duplicates of other collections
- Poor, less important, incomplete, or unauthentic examples
- Physically deteriorated/hazardous materials
- In the case of zoos, the death of a specimen
- Originally acquired illegally or unethically
- Subject to a legislative mandate, e.g., repatriation
- Subject to contractual donor restrictions the museum is no longer able to meet

Decision Process

Deaccessioning is the result of a thoughtful and well-documented process.

The following are critical steps in the process and should be documented. The registrar plays a key role in coordinating the steps in this process and providing key information from the museum's records.

- Written curatorial justification linked to the collecting plan, outlining the decision criteria that apply.
- Verification of official legal title, checking records to ascertain if any restrictions exist for the original gift/bequest or purchase. In particular, any copyright or trademark restrictions might be reviewed by legal counsel since those rights won't automatically transfer to a new owner.
- Physical examination by conservator to help establish appropriate means of disposal, including possible sale or destruction.
- One or more outside appraisals, especially for objects of value and those that might be sold or traded.

- Outside opinions for items of value, especially if there is any uncertainty about provenance or authenticity.
- Internal review by all curatorial staff to assure full awareness of the plan to dispose of a collection item.
- CEO/director and governing board approval. This is where the final decision is made. In most cases, deaccessions must be approved by the board, often by unanimous vote. Some decisions may be delegated to the CEO/director, depending on the value of the objects. For example, the Smithsonian Institution has assigned the threshold of $50,000 for items that may be deaccessioned without the approval of the Board of Regents. Beyond the governing body, each museum should check its own charter and relevant state laws to see if there are any external limitations on disposal.
- Working with external stakeholders. There is no obligation to notify the donor if the gift was unrestricted and the museum owns the material free and clear. However, many museums do contact donors or relatives as a courtesy. Conferring with members of local community advisory groups is important to assure concurrence and avoid possible public outcry when the deaccession is officially announced. Special interest groups may include collectors, other museums, volunteers, and museum membership groups.

Disposal Options

The following are common options for disposal of deaccessioned material. The best course may vary from case to case based on the type of material and the needs of your museum. Of course, no items should be acquired by museum staff, board members, or their relatives. Of concern to most museums is the need to assure that items are seriously considered for placement in other educational institutions. There may also be some need to retain an object in the community, region, or country, if it has any relevance as an item of cultural patrimony.

Donation of the objects to another museum, library, or archive for educational purposes. A museum can determine if there is a way to retain the objects in the community or develop an ongoing collecting agreement with another museum. For example, the National Park Service maintains a clearinghouse for material that can be placed in other museums. Other regional or national networks could be a valuable outlet for disposal.

Exchange with other museum or nonprofit. This is also a customary method of assuring that objects stay accessible to the public. Exchanges should be made in such a way that there is relatively equal value of the items involved. Trading objects with private dealers or collectors can be perilous, and it is most important to be sure that the monetary and historical value of the exchanged materials is equal. Furthermore, the museum should be able to justify the trade, including any exceptional circumstances that would favor a particular dealer or collector. As earlier noted, obtaining good independent appraisals of the items being acquired is mandatory.

Educational and research programs. Often, items can be used for scientific study, school programs, hands-on demonstrations, exhibition props, or testing in conservation research. In these cases, it is expected that the objects will be subject to physical deterioration or destruction over time.

Physical destruction. Objects may have deteriorated due to inherent vice, natural disaster, vandalism, accident, or other causes. In other cases, items may be considered hazardous, such as those objects containing drugs, chemicals, explosives, or asbestos, and should be disposed of. There are strict standards for disposal of these types of material, which can be determined by consulting appropriate regulatory agencies or experts in the field. Another possible justification for physical destruction might be to eliminate from circulation unauthorized or counterfeit materials. The method

of destruction will vary depending on the type of material, but generally it should be irreversible. Records of the disposal method should be retained. Archival collections are frequently destroyed as a method of disposal. There is also the possible use of collections in research, often the case with natural history museums, where collections go through "destructive analysis." In this regard the importance of the test results should be weighed against the loss of the object and its value as a specimen.

Repatriation and/or cultural sensitivity. Repatriation is a legal issue that can have an impact on the method of disposal of objects. Human remains or certain items of religious or cultural sensitivity might need to be handled in a prescribed way in order to meet legal requirements or cultural standards. (See chapter on NAGPRA.)

Private sale. This method is not a standard alternative but may be justified in some circumstances. If it is pursued, the museum must keep good records and be ready to respond honestly to outside inquiries. In some cases where public auction is not possible or practical, material can be consigned to a dealer for sale with a caveat that the museum provenance may not be revealed.

Return to donor. This alternative is not usually the best option for the museum. Museums hold collections in trust for the public, and putting objects into the hands of private citizens does not meet this objective. Returning objects to donors also sets a dangerous precedent and raises expectations of such actions in the future. There might also be tax complications. The most legitimate reason for returning material would likely be that the museum has failed to meet the requirements or conditions of the original gift or bequest. In any event, this option should be used rarely and only after careful consultation with legal counsel.

Public Auction

One frequently selected option for disposal of deaccessioned collections is a public sale. This method is especially important when there is a need to gen-

erate funds to improve the prospects for future collecting. In considering this option the museum should, among other things, weigh the staff time and other costs associated with an appropriately administered sale in comparison to the anticipated proceeds. Since this option is subject to close public scrutiny, it is important to review the procedures in some detail.

Selection of auction house: It is important to interview several potential auction houses and check their references carefully with other muse0um clients. Issues that should be considered are the costs that will be covered by the firm, its marketing strategy, and its reputation for reliability and timeliness. The location of the sale should also be considered if that has an impact on potential market or publicity.

Request for proposal: Your approach will be subject to the procurement and contracting practices of your organization, but you should prepare a scope of work describing the collection and your requirements for the sale, and allow several firms to bid on the sale. This allows for a fair competition among possible auction houses and gives the museum an opportunity to select the best possible firm in which the material will be sold. The scope should include expectations for the sale, a description of the material, the time frame, and criteria by which you will judge the bidder. These criteria might include the production of fully illustrated sales catalogs, previous sales records, or specialized staff expertise.

Museum records and provenance: Before entering into a consignment agreement, be sure that every effort is made to catalog the objects fully, checking provenance and reviewing the museum's official registration records. Any problems of provenance or attribution should to be discussed with the auction house. If objects are on loan to another museum, be sure to alert the museum so the objects can be recalled with plenty of lead time. This step will be a primary job for the registrar.

Contracting with the auction house: A detailed sales/consignment contract must be prepared. Most auction houses have a standard contract. The museum should carefully review this document, sharing it with legal counsel. In some cases, a customized contract may be needed to cover all contingencies. For example, one may want to specify how publicity will be handled, how commission and fees will be arranged, how a reserve will be placed, how unsold materials are to be handled, the date for the sale, physical care and insurance for the objects, responsibilities for photography, and potential for withdrawal of items.

Be sure that staff of the auction house are fully conversant with the terms of the contract. Invite them to meet with you and discuss your concerns and expectations. It is important to determine roles and responsibilities of various players and to clarify who speaks for the firm and who speaks for the museum. Likewise, the museum should assign a principal spokesperson. If any questions arise during the course of the sales period, be sure that they are clarified in writing and that you know who is authorized to make commitments or amend the agreement.

Care and handling: The registrar will negotiate with the auction house regarding costs and methods of packing, shipping, insurance, staff travel, interim storage, and availability of objects for previews. Insisting that a museum staff member be present as an escort or handler is a legitimate request. The museum should invest in sending a staff member to inspect the firm's facilities, security, and handling to underscore that the sale is of paramount importance and concern.

Marketing: Be sure to agree on how advertising is to be done and on who approves the final ad copy, issues and approves press releases, and conducts press interviews. In addition, previews and receptions may also be used to promote the sale, and the museum should consider how it will be portrayed in those settings. Care should be taken to assure

THE SAMPLER MUSEUM
123 Any Street, Any Town, Any State 00000 USA
000-000-0000

DEACCESSION AND DISPOSAL RECORD

Photograph

1. Description of Object:
 Acc. # _____
 Title _____
 Artist
 Medium _____Date _____

2. Documentation

3. The Museum must have a legal right to dispose of the object. How has this been determined?

4. What was the means of acquisition of the object?

5. If the object was a gift, answer the following:
 a. Is the donor still alive? _____
 b. Has the donor (or heirs of the donor) been informed of the Museum's intentions?_____
 c. Is the donor likely to make a further gift or bequest to the Museum? _____
 d. Has the donor (or heirs) objected to the deaccession or disposal? _____

6. Describe the overall condition: _____

7. Current market value: $ _____
 How determined: _____

8. When was the object last exhibited? _____

9. Does the object have future value _____
 a. for exhibition? _____
 b. as a loan? _____
 c. as part of a research or teaching collection? _____

10. Does the object form part of a large category of similar objects at the Museum? _____

11. Specific reason for deaccessioning the object: _____

Deaccessioning worksheet, side 1.

the museum's collections are not mixed in with materials from other sales if there is any concern about the sensitivity of the sale.

Post-sale activities: A press release may be issued to announce the result of the sale and to explain once again how the museum intends to use the proceeds. Unsold materials may remain the property of the museum or the auction house, depending on your contract. Be sure to negotiate how to handle these remaining objects, either through inclusion in future auctions or in private sales.

Public Relations and Deaccessioning

Whether it is a sale, a donation to another museum, or a destruction, the museum usually must face the issue of public relations. Concerns can be raised inside the museum, among staff and volunteers, or with any number of public stakeholders. Generally, the museum can and should provide at the earliest possible time as much information as possible. Keeping staff informed throughout the process of a deaccession is critical. The public can be informed through issuing a press release targeted to museum members, donors, funders, and the general public. For major deaccessions, it might be advisable to host a formal press conference where general and trade (specialty) press could actually see the objects being deaccessioned. For a major deaccession, it is best to provide a statement from the director or board chair, and possibly a supporting statement from the donor or other significant stakeholder in the community, along with photographs and descriptions of the items and a full disclosure of the proposed use of proceeds. Assure that an official statement from the director or board chair is printed in the sales catalog. Statements from the museum should address the rationale for deaccession, the decision-making and approval process, and the proposed use of proceeds. Notifying the donors of the deaccession and then acknowledging them in

any publicity is critical. Remember to communicate with colleagues at other museums as your plans might raise interest or questions in their institutions. Appointing a spokesperson for the museum will help keep various parties fully and accurately informed.

Ethical Considerations and Use of Proceeds

Several professional codes of ethics address deaccessioning. All museums should consider ethics codes as they develop their own policies. Common in these codes is the prohibition on sale or transfer of collections items to museum trustees or staff or their relatives and the need to restrict the use of proceeds of sales. In looking at the latter restriction, the following represent recommended practices in 1997:

Association of Art Museum Directors: Proceeds should be restricted to acquisitions of new works of art, with the added caveat of a potential penalty for violating this code.[2]

American Association of Museums: Requires disposal solely for "advancement of the museum's mission. Proceeds from the sale of nonliving collections are to be used consistent with the established standards of the museum's discipline, but in no event shall they be used for anything other than acquisition or direct care of collections."[3]

American Association of State and Local History: "Collections shall not be deaccessioned or disposed of in order to provide financial support for institutional operations, facilities maintenance, or any reason other than the preservation or acquisition of collections."[4]

International Council of Museums: Use of proceeds "should be applied solely for the purchase of additions to the museum collections."[5]

Society of American Archivists: Each museum must determine the best approach for its own mission and circumstances. However, the use of proceeds should be restricted to maintenance of collections.[6]

12. Opinions to substantiate deaccessioning recommendations: _____

Contrary opinions: _____

13. Is there another museum, public institution, organization, or individual which might consider the object for exchange, purchase, or gift? _____

14. The undersigned recommend the object be deaccessioned. ❑ yes ❑ no

15. The undersigned recommend disposal of the object. ❑ yes ❑ no

16. Preferred means of disposal: ❑ public auction, ❑ exchange, ❑ private dealer,
 ❑ other (give details) _____

17. Signatures:

_____ _____
Curator of Collections Date

_____ _____
Director Date

_____ _____
Chairman, Acquisitions Committee, Board of Trustees Date

18. Board of Trustees Action Taken: _____ Date: _____

19. Comments or restrictions on disposition made by Board:

20. Disposition of Object:

Value received: _____ Date: _____

The Sampler Museum Deaccession and Disposal Record ~ Page 2 ~ Acc. # _____

Deaccessioning worksheet, side 2.

Record Keeping

The Registrars' Code of Ethics outlines the responsibilities of the registrar in the deaccession process.[7] (See Appendix.) Since official documentation is critical to the fair and thorough approach needed to remain accountable, the registrar plays a very important role. The following steps are needed in reviewing and maintaining records of the deaccession.

- Fully document justification and review process, as well as disposal, and include transfer of title and transfer of any copyright owned.
- Before deaccession approval, clearly research title and note any restrictions on disposal, particularly if specific expectations were written into the deed of gift or the purchase or bequest instruments.
- Notify the donor in advance of actual disposal.
- Notify the IRS by filing Form 8282 in cases where objects have been disposed of within two years of the date of a donation that was reported to the IRS on Form 8283, Summary Appraisal. (See chapter on Tax Issues Related to Collections.)
- For Financial Accounting Standards Board (FASB) requirements, assure appropriate records are made in the museum's annual audit process.
- Photograph the objects for the record.
- Retain all records permanently.
- Produce an annual report on deaccession activity.
- Give credit to the original donor via a fund name that is applied to any purchases made with the proceeds of sales.

ALTERNATIVES TO DEACCESSION

Long-term Loan

Many museums lend collections for an extended period, usually three or more years, for public display or study by other qualified museums or educational organizations. Clearly, there is value in considering this practice in order to meet a number of concerns:

- Relieve overcrowded storage areas.
- Provide the public access to collections that might otherwise remain in storage.
- Assure that the objects remain the property of the museum, thus meeting expectations of donors and assuring curators that future generations may benefit from access to the collections.

Drawbacks to this Approach Include:

- The costs associated with monitoring the use of the objects by borrowing organizations
- Possible loss of interest in the material (out of sight, out of mind)
- Reassignment of storage space to new collections
- Lack of access to objects for study and research
- Possibility of borrower's inability to return objects, due to financial problems

Shared Ownership

Some museums have elected to enter into agreements with other museums for shared ownership of specific objects. This allows the museum to retain and display the object for a certain time in consideration of community interests, while sharing the costs of its care with the co-owner.

Collaborations

Another option is a special affiliation between or among museums and other organizations to share collections and exhibitions that is like a long-term loan arrangement. Collaborations between museums, such as the Smithsonian and the University of Alaska Museum, or the Whitney Museum and San Jose Museum of Art, illustrate long-term affiliations that involve a transfer of collections for exhibition or research over a long period of time, such as 10 years. This collaboration often includes an exchange of staff or a collaboration among staff working on exhibitions, publications, conservation, or research projects.

SPECIAL PROBLEMS WITH DEACCESSIONING

The Shared Collection

In some instances the museum may not be the sole owner of an object. The object may have been jointly purchased with another museum or not-for-profit agency, or the museum may have only acquired a partial gift. In such cases it is important to seek legal advice before any deaccession action is taken.

What If You Have No Record of Ownership?

In this situation you are sure the item is not an unclaimed loan, and it has been in your possession for some time, and it is no longer relevant to the museum's mission. Move carefully toward disposal of this type of material. After checking all records, including loan files, for evidence of title, you should create a file and assign an accession number if this has not already been done. Your next steps regarding disposal should consider the consequences of any future claim of ownership to the objects. A sale may not be a prudent alternative if the museum cannot provide an absolute warranty to the buyer. Again, such situations should be fully reviewed with your legal advisor.

What If You Own It, But It Is Not Accessioned?

In this case, the process of disposal should follow similar steps to assure that a careful decision is made. Even if items have not been accessioned because they are unrelated to the mission of the museum, they are museum assets and thus require care in the decision to dispose. Therefore, going through the process of reviewing the stated decision criteria for deaccessions is a prudent approach.

What Code of Ethics Do You Follow?

In light of the varied ethics codes promulgated about the deaccession of collections, the museum's board must consider what is an appropriate deaccession policy, given its charter and mission. Being aware of the various ethical codes is critical in the decision process. Once selected, the code should be formally adopted as a part of the deaccession policy and fully understood by all board and staff members.

In conclusion, it is important to weigh all the factors associated with deaccessioning, including museum mission and collecting objectives, ethical codes, policy, and procedure for justifying the action, as well as the most appropriate disposal options, before embarking on deaccession activity. Thoughtful review of legal, ethical, and practical implications of deaccessioning and clearly articulated policy and procedure should allow the museum to move with confidence in this area.

NOTES

1. There are many references that detail specific cases listed in the bibliography. A consistent source of information on this topic is the published proceedings of the ALI-ABA Course Study: *Legal Problems of Museum Administration,* 1973-present.

2. *Professional Practices in Art Museums* (New York: Association of Art Museum Directors, 1992).

3. *Code of Ethics for Museums* (Washington, D.C.: American Association of Museums, 1994), p. 9.

4. *Statement of Professional Ethics* (Nashville, Tenn.: American Association for State and Local History, 1992).

5. Marie Malaro, *Museum Governance* (Washington, D.C.: Smithsonian Institution Press, 1994), p. 155.

6. F. Gerald Ham, *Selecting and Appraising Archives and Manuscripts* (Chicago: Society of American Archivists, 1993), p. 92.

7. Mary Case, *Registrars on Record* (Washington, D.C.: American Association of Museums, 1988), p. 232.

Sally Freitag and Cherie Summers

Loans are made between museums or from private individuals to museums for several reasons.

- Loans for exhibition are the most common type of loans. Objects are borrowed for specific periods of time for a specific purpose.
- Loans for traveling exhibitions are similar to one-exhibition loans, but the issues are multiplied by the number of venues.
- Exchange loans are made for two reasons. They may be for the mutual benefit of the museums, or a lending institution may request a loan to fill the resulting gap in its permanent exhibition from a museum borrowing an important work.
- Study loans are made between museums or between museums and individuals. The latter type of study loan is more common in science and archaeology museums than in art or history museums.
- Promised gifts in the museum's custody are loans until title has passed to the museum.
- The donor's remaining interest in a partial gift (also called fractional interest gift) should be treated as a loan whenever the object is in the museum's custody.
- Long-term loans from individuals to a museum or from one museum to another are common. The former was standard fare for many museums in the early and middle decades of the 20th century but is less common today.
- Unsolicited objects are often received for loan or acquisition. The sender should be notified immediately that the unsolicited parcel will be returned at the sender's expense in the same manner that it was packed and shipped. The sender also should be notified that he/she will be required to carry and pay for any insurance desired.

- Property with unidentified sources in the museum's custody should be treated as a loan until it has been identified. (See chapter on Old Loans.)

Loans should be requested and made with great care. A written loan policy should include sections on both incoming and outgoing loans. It should be supplemented by written procedures that are implemented as thoroughly as possible.

APPROVAL PROCESS: INCOMING LOANS

Museums differ in their administrative policies regarding internal approvals needed to request a loan. If the borrowed object is to be exhibited, the director, curator, and/or project manager must normally approve. Long-term loans or loans of promised gifts may require the approval of a committee within the museum or may follow the acquisitions procedure. The department that controls the budget required to pay for the loan arrangements must be consulted.

Customary protocol for requesting loans calls for the director, curator, or project manager of the borrowing institution to send the prospective lender a detailed letter describing the purpose of the exhibition and the objects desired. This "loan request" should contain the following key information:

- Title of the exhibition and/or purpose of the loan
- Length of the loan period
- Location(s) of the exhibition with dates

The borrower's responsibility to pay for all expenses incurred in preparing a loan (e.g., packing, shipping, insurance) should be acknowledged at this time. The deadline for the lender's response should be noted to allow sufficient time for the loan approval. A copy of this letter, which

is normally addressed to the director or curator if the lender is an institution, must be forwarded to the registrar as soon as possible so he or she can begin processing the loan and respond to the lender's queries.

APPROVAL PROCESS: OUTGOING LOANS

When a request for a loan is received, the lending institution's approval procedure for outgoing loans should involve the following "key players":

- The curator should approve the project in general and indicate the availability of the loan based on any unannounced projects he or she may know about.
- The conservator or registrar examines the condition of the object(s) to be loaned.
- The registrar also checks for other commitments during the period in question and checks for any other legal restrictions, such as donor's restrictions or possible U.S. Customs or Fish and Wildlife restrictions.
- Final approval by the director and/or the board of trustees is required in many institutions after the various departments have submitted their input.

In general, there should be good communication within the lending institution from the time a loan is requested until it is returned. It is critical that the curator, registrar, conservator, and director all keep one another apprised of any pertinent information. It is up to the registrar to coordinate the process and to make certain that the object and the borrowing institution are evaluated.

In evaluating the object's condition, the following questions should be considered:

- Is the object able to withstand the rigors of travel and additional handling?
- Is the object too fragile to be displayed safely?
- Should special restrictions be placed on light levels or general environmental exposure?
- Has the object recently traveled extensively or been subjected to long periods of light exposure?

Many objects, such as works on paper, photographs, or latex materials, may require limitation of the length of time they can be exposed to light and adverse climate conditions during packing, display, and shipping. If your museum does not have an in-house conservator, it is advisable to seek professional advice from a freelance conservator in deciding whether the object can travel safely.

The borrower's current facility report must be considered when evaluating a loan request. The standard facility report developed by the Registrars Committee of the American Association of Museums (RC-AAM) is often used by American museums; some institutions, especially foreign museums, may submit their own forms. The RC-AAM form is extremely thorough in the questions contained and is recommended as a standard. Accuracy and honesty are essential in filling out the facility report, and information on the form should be updated on a regular basis or as changes occur. The borrower must be prepared to meet certain minimum museum standards to secure loans. The lender wants assurance that the borrower has a history of professional and responsible care of museum artifacts. Because information could be checked by the lender, false answers may jeopardize the loan or future exchanges. When reviewing the borrower's facility report, the lender should question any unclear answers and work with the borrower to improve unacceptable conditions if at all possible. Although not applicable to foreign institutions, AAM Accreditation can indicate that a borrowing institution has met certain minimum standards.

Shortly after the loan request has been received, the borrower should be given preliminary notification of all standard loan terms and fees normally required by the lending museum. Standard protocol between museums and collectors normally calls for the borrower to pay all expenses relating to temporary and long-term loans, incoming gifts, study or research loans, or any other loans of primary benefit to the museum. The lender may be asked to pay costs associated

with loans of benefit to the lender, such as loans deposited for private conservation, photography, consideration for purchase, or exchange. Responsibility for costs should be discussed prior to the loan or prior to any charges being incurred. Museum collections management policies or manuals should clearly designate which museum personnel have authority to approve these costs.

Loan costs include the cost (materials and labor) of any crate, preparation, display case, base or mount, conservation, shipping, courier, and loan fee. Prior to the actual loan contract or loan agreement, the lender may ask the borrower to sign a preliminary form acknowledging unusual loan conditions such as special environmental requirements. The borrower can, after reviewing the costs and special conditions, decide if it is in a position to proceed with the loan request. Some museums have preprinted forms stating their general conditions of loan, including care of the loan, insurance, courier costs, publications, publicity, conservation, rights and reproduction of items being requested, etc. The borrower is normally responsible for all costs incurred in the loan arrangements unless otherwise discussed and agreed. Some institutions have reciprocal agreements with other museums to waive certain costs, such as loan fees. In cases where the loan fee makes the loan impossible for the borrower, the lender may be willing to try to negotiate a fee reduction.

The delicate condition or high value of some objects may dictate special loan conditions. It is important that these conditions be justified and essential in protecting the object. All costs or requirements must be clearly stated with as much notice given as possible so that the borrower can budget adequately. These costs can include a special frame, base, mount or environment, a courier or supervisor, or an insurance premium.

The lender may stipulate that a courier must accompany his or her loan during all transits. The lender may accept another museum professional to act on his or her behalf as a courier in consolidated shipments or may agree to his or her own courier in transit to the first venue and its return from the last venue in the case of exhibition tours. It is normally the responsibility of the borrower to arrange and pay for costs related to the courier, including transportation, lodging, and per diem. The loan agreement may stipulate the amount of per diem to be allotted. If not, the amount should be negotiated in advance. The courier may receive the per diem in cash upon arrival, or the lender may bill the borrower later for reimbursement of expenses. Arrangements should be clear and in writing. (See chapter on Couriering and the Statement of Courier Practice.)

Final approval or denial of a loan should be communicated in writing in a timely fashion once all in-house and board of trustees approvals have been received. Should a loan be denied, the reason(s) should be clearly stated so the borrower can address any aspects of his or her facility or methods needing improvement. If the loan is approved, the approval letters and the completed loan agreement forms are then signed and returned to the borrower. Special conditions of the loan are restated on the loan form. In-house records should be "flagged" or "coded" to indicate the object is reserved.

LOAN DOCUMENTATION

Either the borrower or lender can issue the final loan agreement; it is usually done by the borrower. If the lender and borrower both have loan contracts, they can sign each other's forms. In the event of a controversy over which form to use, the lender's form normally controls; however, it should be clearly stated which form overrides the other in the case of conflicting loan terms. All special requirements or charges must be approved by the borrower before the lender begins to prepare the loan. The borrower must decide if the lender's special requirements can be met, both physically and financially. Further negotiations between museums may be necessary.

The loan contract or loan agreement is a legal agreement between the lending and borrowing institutions. This document protects both parties by specifying all conditions to be agreed upon. The signed loan agreement overrides all other

THE SAMPLER MUSEUM
123 Any Street, Any Town, USA 00000
Telephone 000-000-0000 FAX 000-000-0001

OUTGOING LOAN AGREEMENT

AGREEMENT The Sampler Museum hereby lends to the borrower identified below the object(s) described herein for the purposes and subject to the terms and conditions set forth.

BORROWER

Borrower:
Address:
Telephone: FAX:
Contact: Title:

OBJECT

Accession Number:
Artist/Maker:
Object/Title:
Medium:
Date of Work:
Dimensions of actual object: with frame or mount:
 Weight (if applicable):
Credit Line (for use in exhibit label and catalog):

EXHIBITION

Period of Loan:
Exhibition Title:
Venue(s) and Date(s):

INSURANCE

Insurance value (in U.S. dollars):
_____ To be carried by borrower
_____ To be carried by The Sampler Museum, premium billed to borrower

SHIPPING/ PACKING

Unless otherwise specified, all objects will be released from and returned to:
The Sampler Museum, Receiving Entrance, 123 Any Street, Any Town, USA

DISPLAY

Temperature range: Humidity range: Light levels:
Special display requirements:

SIGNATURE

The borrower acknowledges that he/she has full authority and power to enter into this agreement, that he/she has read the conditions above and on the back of this form and that he/she agrees to be bound by them.

Signature:_____ Date:_____
 The Sampler Museum

Signature:_____ Date:_____
 Borrower

Please sign white original and return to The Sampler Museum Registrar. The copy is for your files.

Outgoing loan agreement, side 1.

documents and understandings, whether written or verbal. The loan contract is completed by the registrar and is signed before any preparation of the objects begins or costs are incurred. Institutions differ on who signs this form—director, curator, or registrar. Should someone other than the registrar sign the contract, the registrar should review it first. Most museums have a general loan contract containing certain standard clauses. To this, an addendum can be made addressing any special clauses desirable for individual loans.

Many museums have a standard contract for outgoing loans in addition to a separate contract for incoming loans. Occasionally, museums will tailor a unique loan contract for a particular exhibition. When developing a standard or special loan contract, it should be reviewed by legal counsel as well as by the museum's insurance broker.

The borrower should never commit itself to conditions that it cannot uphold or that cannot be supported under the terms of its insurance policy. Approving special requirements placed by the lender may require various internal approvals. Unanticipated loan fees and unexpected requests may have such an impact on the budget that the loan must be withdrawn.

The lender signs and returns the loan contract with an accompanying letter calling special attention to any changes, which should then be countersigned by the borrower.

INSURANCE

It is standard loan protocol for the borrower to accept responsibility for insuring loans. A few museums have administrative policies stipulating that they, as lender, must continue their own coverage in effect when making outgoing loans. The borrower is normally billed for the cost of the insurance premium, which should be agreed upon in the early stages of the loan negotiation.

In accepting the borrower's coverage, lenders are advised to review a copy of the borrower's current insurance policy to ensure the coverage is indeed adequate. Key areas to look for are:

- Limits of coverage
- Deductibles
- Exclusions
- Property insured
- Policy terms
- Terms of cancellation

Coverage should be "all risk," not based on "named perils" that are less inclusive. Coverage should be "wall-to-wall" or "nail-to-nail," meaning that the loan object is insured from the moment it is picked up to the moment it is examined upon return to the lender.

A certificate of insurance from another institution acts as evidence of coverage only. Even with this certificate in hand, the borrower has no real assurances that the policy has not been amended or canceled. The certificate should name the lender as "additional insured" and must be issued to the lender before the object is released for shipment. If the lender prefers to maintain his or her own coverage, the borrower should request an insurance certificate or waiver of subrogation from the lender. (See chapter on Insurance.)

Insurance values for each object are determined by the lender. The assigned values should reflect the "fair market value"—the price at which the property would change hands between a willing buyer and a willing seller, neither being under any compulsion to buy or sell and both having reasonable knowledge of the relevant facts; auction values are commonly used as the basis for insurance values. The borrower should question an exceptionally high value or value that seems out of line with other similar objects. All values should be confirmed internally by the curator. It is the lender's responsibility to keep the value of the loan updated.

If a lender should insist on a specific situation the borrowing institution believes may be hazardous to the loan object, e.g., installing the object without a barrier, using push pins to mount the work, displaying an artwork in harsh light, or allowing the general public to touch the object, the lender should be asked to sign a "hold harmless" agreement.

OUTGOING LOAN CONDITIONS

CARE AND PRESERVATION

Objects borrowed shall be given proper care to insure against loss, damage or deterioration. The borrower agrees to meet any special requirements for installation and handling. The Sampler Museum (the "Museum") certifies that the objects lent are in condition to withstand ordinary strains of packing, transportation and handling. The Museum is to be notified immediately, followed by a full written and photographic report, if damage or loss is discovered. If damage occurred in transit, the borrower will also notify the carrier and will save all packing materials for inspection. No object may be altered, cleaned, repaired or fumigated without the written permission of the Museum, nor may framing, matting, mounting or glazing be changed without written permission; nor may objects be examined by scientific methods without written permission. Objects must be maintained in a fireproof building under 24-hour physical and/or electronic security and protected from unusual temperatures and humidity; excessive light and from insects, vermin, dirt or other environmental hazards. Objects will be handled only by experienced personnel.

PACKING AND TRANSPORTATION

Packing and transportation arrangements for the loan must be approved by the Museum. The borrower agrees to meet any special requirements for packing and shipping. Unpacking and repacking must be performed by experienced personnel. Repacking must be done with either original or similar materials and boxes and by the same methods as the object was received.

INSURANCE

Objects shall be insured at the borrower's expense for the value stated on the face of this agreement under an all-risk wall-to-wall policy subject to the following standard exclusions: wear and tear, insects, vermin, gradual deterioration or inherent vice; repairing, restoration or retouching processes; hostile or warlike action, insurrection, or rebellion; nuclear reaction, nuclear radiation or radioactive contamination. The Museum shall determine whether the borrower insures the objects or whether the Museum insures them and bills the borrower for the premium. If the borrower is insuring the objects, the Museum must be furnished with a certificate of insurance or a copy of the policy made out in favor of the Museum prior to shipment of the loan. The Museum must be notified in writing at least 30 days prior to any cancellation or meaningful change in the borrower's policy. Any lapses in coverage, any failure to secure insurance and/or inaction by the Museum will not release the borrower from liability for loss or damage.

REPRODUCTION AND CREDIT

The Museum will make available, through an outside service, photographs of objects lent, which may used for catalog, routine non-commercial educational uses, publicity and registrarial purposes. No further use of such photographs can be made and no other reproduction of objects lent can be made without the written permission from the Museum. Each object will be labeled and credited to the Museum in the exact format provided on the face of this contract, both for display labels and publication credits.

COSTS

The borrower will assume responsibility for all expenses incurred by the Museum in work by conservators to prepare the object for loan, in packing, crating, transportation, couriers, insurance, photography and any and all other related costs. The Museum will make every effort to provide the borrower with estimates in advance of all applicable costs.

CANCELLATION/RETURN/EXTENSION

The loan is made with the understanding that the object will be on view during the entire exhibition period for which it has been requested. Any intention by the borrower to withdraw the loan from the exhibition at any time must be communicated to the Museum immediately. The Museum reserves the right to recall the loan or cancel the loan for good cause at any time, and will make effort to give reasonable notice thereof. Objects lent must be returned to the Museum by the stated return date. Any extension of the loan period must be approved in writing by the Museum Director or his designate and covered by written parallel extension of the insurance coverage.

INTERPRETATION

In the event of any conflict between this agreement and any forms of the borrower, the terms of this agreement shall be controlling. For loans to borrowers with in the United States, this agreement shall be construed in accordance with the laws of the State of Any State.

ADDITIONAL CONDITIONS FOR INTERNATIONAL LOANS

Government regulations will be adhered to in international shipments. Unless otherwise stated in writing, the borrower is responsible for adhering to its country's import/export requirements. The borrower will protect objects from possible damage during its customs inspections and will make every effort to ensure that customs examinations are made only the borrower's premises. If the nature of the material to be exported falls within the types addressed by the UNESCO Convention, its status in the importing country should be verified before this loan agreement is signed by the borrower. The Museum requires a declaration of immunity from seizure if available. The provisions of this loan agreement are subject to the doctrine of *force majeure*. If U.S. Government Indemnity is secured, the amount payable by indemnity is the sole recovery available to the Museum in event of loss or damage, and objects will be insured in U.S. dollars at their value as of the application date. Current fluctuations affecting value of claims at a later date are not recognized under indemnity.

Outgoing loan agreement, side 2. Courtesy Margaret Molnar.

PACKING AND SHIPPING ARRANGEMENTS

Packing and shipping arrangements must be mutually agreed upon between the lending and borrowing registrars. The borrowing registrar normally contacts the lender to discuss considerations for packing, shipping methods and scheduling, and courier needs. The borrowing registrar may wish to consolidate the loan with other loans. The lending registrar must clearly convey specific requirements such as object fragility, special needs, courier schedule, and preferred mode of transportation, stating them in the loan agreement. Frequently, the borrowing registrar will contact the lending registrar many months in advance to obtain an estimate for packing and any preparation, insurance, or courier costs in order to prepare a budget for the loan.

The packing method to be utilized is determined by many factors, including the travel distance, route, type of conveyance, size, media, fragility, and value. Whether soft-packing for short trips or crating for longer trips or for extra safeguards, the same packing principles apply, that is, the need to protect the object from shock, vibration, and rapid changes in temperature or humidity. The packing technique should be simple enough for the average borrower to understand easily.

Instructions for unpacking and repacking should accompany the shipment, in the form of diagrams, photographs, or video tape. Appropriate packing materials should be used. (See chapter on Packing and Crating.)

If the lender has the facility, staff, and time to do their own packing, they will do so and normally bill the borrower for expenses. Packing charges can be based either upon an exact record of the hours worked and the actual cost of materials used, or upon a system of flat rates to cover different sizes of boxes or special packing jobs. If a crate or packing material already exists for the loan object, the lender may pro-rate the cost of this existing material or may not charge the borrower at all. If the lender does not have a suitable crate or the capa-

bility to produce one, a commercial packer must be engaged, either by the lender or the borrower; it should be approved by both registrars. Any special packing, handling, or shipping instructions that the lender might have must be communicated to the commercial packer. The commercial packer might bill the borrower directly, or occasionally the lender will pay and expect reimbursement from the borrower.

The borrowing museum generally makes arrangements for transporting the loans, again subject to the lender's approval; it is responsible for all shipping costs. The registrar discusses such factors as preferred routing, mode of transportation, special rigging needed, consolidations, and possible additional security required. The shipping schedules will determine the deadline for packing and must be negotiated with the lender to make sure both can be met as planned. In general, depending on the nature of the object and the cost to the borrower, the lender should request the most direct route for the shortest amount of time. Consolidated shipments can be the most cost-efficient option for the borrower if the safety of the object is not jeopardized in the process. (See chapter on Shipping.)

Couriers may be required to accompany shipments for a variety of reasons, such as to oversee the transit, to install the object, or to hand-carry the object. The Registrars Committee of the American Association of Museums has established courier guidelines that define and discuss acceptable reasons for requiring a courier. Courier per diem should cover the courier's travel and living costs for the period he or she is attending to the loan. (See chapter on Couriers.)

International loans are generally handled through shipping or forwarding agents in the countries from which the loans are being borrowed. The borrower's registrar or agent contacts the foreign shipping agent for a bid on packing, shipping, and export/import documentation. An agent is selected and approved by the lender. The agent prepares

all necessary documentation for the export; he or she can also arrange packing, delivery to the airport, and airport supervision. Qualified agents can be recommended by the lending institution, by forwarding agents in the U.S., or by other U.S. museums that have negotiated loans with other countries. Some export documentation and licenses take several weeks to prepare; international loans should be arranged far in advance. (See chapter on Import and Export.)

Confirm all packing and shipping arrangements, as well as cost estimates, in writing. Specific deadlines, special requirements, and names and phone numbers of contact persons should be given to vendors and agents.

PROCESSING THE LOAN OUT

The outgoing object must be prepared adequately for travel. A conservator may need to make minor repairs, reattach loose fragments, or touch up small losses. Major conservation treatments required prior to loan should be negotiated with the borrower first, if the borrower will be expected to take responsibility for any of the cost. Generally, the borrower is expected to pay for all preparation expenses, but conservation treatment needed despite the loan is open for negotiation.

The registrar should check the framing, glazing, mounts, hardware, and accompanying vitrines or bases to ensure they are fit to travel. The object must be secured in the frame with mending plates and spacers. Glass should be replaced by UV-filtered Plexiglas for works on paper, textiles, or other light-sensitive media. If glass is not removed, it must be taped with low-tack tape to prevent damage if the glass breaks in transit. Any loose elements must be removed and wrapped separately. Two-dimensional framed objects must be protected with backing boards. Finally, all mounting hardware should be checked to ensure it is adequate for display and has not become "fatigued" from wear. (See chapter on Preparation.)

If a documenting photograph does not already exist in the object file, one should be taken for identification, condition, and insurance purposes.

An outgoing condition report is prepared to document any obvious blemishes, instabilities, old repairs, or pre-existing conditions. A condition report is made for the frames, bases, or any accompanying elements as well. Annotating a photograph, in addition to the written notes, is an effective way of describing the object's condition. A space should be provided on the form for the borrower to add comments or to note any changes. All condition reports should be dated and signed by the person who wrote them. (See chapter on Condition Reporting.)

The lending museum sends a receipt to the borrower, along with a copy of the outgoing condition reports. The receipt, signed by the registrar of the borrowing institution, serves as formal notification of the loan's arrival and provides the lender with the borrower's official acknowledgment of the loan. It is standard for two copies of an outgoing loan receipt to be sent on the same date that the loan is shipped. One copy is returned with the borrower's signature and date the loan arrived. The other copy is retained by the borrower. The outgoing loan receipt should reiterate the conditions under which the loan has been granted. These conditions should be identical to those detailed in the loan agreement form.

Once the loan has been shipped to the borrower, the lending registrar updates internal files and computer systems to indicate the new location of the object. Pertinent departments are notified of the absence of the object and estimated date of its return, e.g., curator, education, information office.

TRACKING OBJECTS ON LOAN

The registrar must establish a system to track the object while it is out of the museum; the estimated return date of the loan or the date it is anticipated to move to the next venue should be included. Loans are occasionally made for extended periods (e.g.,

over a year). It is important that the registrar have an effective system for remembering or "calling up" all loans out. Tracking systems can be manual (e.g., tickler file) or on a computer database. Some museum auditors require annual confirmation of loans that are out and will send letters to borrowing museums to verify the location of objects.

WHEN THE LOAN OBJECT ARRIVES

Upon receipt of the loan object, the registrar of the borrowing institution should carefully check the exterior of the packing case or soft-pack material for signs of damage. The registrar should document any damage in case the contents are affected. A photograph should be taken of any exterior damage to the crate; all packing material should be kept.

When unpacking the loan, the registrar should carefully note how the object was packed so that it can be returned to the lender in the same manner. A photograph of how the object is situated within the case may be helpful in documenting the packing method. The borrowing museum should save the packing materials for reuse; if that is not possible, replacement material should duplicate the original materials. It is generally agreed that an object should be repacked in the same manner in which it arrived. If problems are experienced or if packing materials are inadequate, packing may be changed with lender approval.

The original case or packaging material should be stored in a clean, dry area, preferably in a climate-controlled environment. If an off-site storage facility of non-climate controlled space is used, the case should be brought back into the museum environment in adequate time to acclimatize it prior to repacking.

As soon as the objects are unpacked, they must be inventoried; condition reports should be done promptly. It is important that the contents be assessed to verify that all objects have been received. A written notation and/or photograph should be taken of all removable parts, elements, or accessories. Each element should be tagged or labeled until the object is installed or returned to the lender.

This condition report prepared by the lender becomes the basis for comparison upon receipt of an incoming object. Condition reports often become key documentation in the event of an insurance claim, and it is important that they be thorough and understandable. The condition report is also referred to at the end of the loan period to check for any changes. Condition report formats vary from museum to museum and according to type of material examined. They should be brief but accurate, and should clearly describe the nature, location, and extent of the object's condition. A photograph of the object's condition upon arrival is a highly recommended addition to the written report. (See chapter on Condition Reporting.)

The lender should be notified immediately if objects or parts of objects have not been received or if the registrar believes an object has been damaged or has experienced a change in condition. If the registrar thinks the damage may warrant an insurance claim or if the lender requests a claim, the museum's insurance agent should be notified immediately. (See chapters on Condition Reporting, Creating Documentation, and Insurance.)

Each loan and each object within that loan must be assigned a unique number and be promptly tagged or labeled. The number may be a "temporary deposit" number or a catalog number in the case of a special exhibition. A temporary label can be used until the final disposition is determined for the object. All labeling or marking methods that are utilized for loans must be reversible. (See chapters on Numbering and Marking.)

Handling and installing the loan must be done in a fashion consistent with the lender's requirements and based on high standards of museum care. Care should be taken to pad and protect each object during movement until it is installed or stored. The borrower must also seek the lender's approval before modifying the loan object in any fashion or before employing the object for a purpose other than that

originally agreed upon. Adding hanging devices or a mount, displaying the object in an outdoor atmosphere, etc., must be discussed in advance. Any hardware that is removed should be saved and returned to the lender with the loan object. Any issues that might arise concerning the safety of the object should also be discussed with the lender. All modifications to the loan, its accessories, or packing should be documented for the file to facilitate their replacement at the end of the loan. (See chapter on Handling.)

Entry records and receipts must be prepared to document the loan transaction properly. If the lending institution sends a receipt, it should be completed and returned by the borrower. If it does not, the borrower should produce a receipt and send it to the lender. Receipts may be done by both institutions. Information should include:

- Name and full address of lender, preferably with telephone and fax numbers
- Purpose of loan, e.g., long-term loan, special exhibition
- Exhibition title
- Pertinent curatorial department responsible for loan
- Arrival date and method of shipment
- Loan numbers assigned to objects
- Name of artist/maker
- Exact title of work or name of object
- Medium or materials
- Dimensions
- Insurance value or name of insurer, if lender is to insure
- Condition
- Location

Receipts must be issued promptly and accurately. The wording on the loan receipt should agree with the conditions stated on the loan agreement form regarding purpose, duration, insurance coverage, and value. Only the registrar should issue receipts and record loan information; this guarantees consistency and proper loan management. (See chapter on Creating Documentation.)

ONGOING LOAN MANAGEMENT

Loans must be tracked and updated by the borrowing museum on a regular basis; an annual inventory can identify expired loans and help the museum avoid problems that could develop. Loan expiration dates should be carefully monitored so that loans are returned to the lender on time. If the object is to remain on loan, the loan contract must be updated and the insurance coverage extended. Insurance values should be reviewed periodically by the lender. If contact has been lost and the lender cannot be found, the loan is regarded as an "old loan." Many states in the U.S. have established laws regarding the disposition of old loans. The registrar should seek legal advice for disposition of unclaimed or old loans within his or her jurisdiction. (See chapter on Old Loans.)

WHEN THE LOAN IS RETURNED

Requests for the return of a loan must agree with the terms of the original loan agreement. All objects should be returned to the lender at the same place from which they were collected unless otherwise stipulated in writing by the lender and agreed to by the museum. In the event of a possible dispute between lenders, such as a divorce or dissolved partnership, the registrar should seek legal advice. A loan should not be returned to one partner without the written consent of the other. If the loan is to be returned to a different location or address, the change of return site should be documented in writing. If the loan is to be returned to a location farther away than the original point of collection, any additional cost associated with the new location can be negotiated, unless this change was a condition of the loan. If someone else imported the object, the registrar should seek proper import documentation. (See chapter on Import and Export.)

When the loan period has expired, the registrar contacts the lender to arrange the return. The return shipment date and method of transit are discussed

with the lender in advance. The object is prepared for the return by inventorying all elements and accessories. If the object was framed or reframed, or if the original hardware was removed, these elements will normally be replaced unless otherwise agreed upon with the lender. An outgoing condition report that refers to the incoming report or any interim reports is made. The registrar must ensure that the object returns in the same condition as it was received. The object is repacked in the same fashion as received unless packing modifications have been approved. Finally, an outgoing receipt is issued; the lender is asked to sign and return a copy after verifying that all objects have been returned in satisfactory condition.

The loan file is closed by noting the destination, date, and method of return. Internal departments should be apprised of the loan return as necessary. All bills for packing, shipping, agents, insurance premiums, and courier costs must be received and processed for payment. In the event that some costs are to be shared by the lender or other museums for a touring exhibition, invoices must be prepared for such costs as shipping, photography, or insurance premiums. If the loan object happens to be acquired by the museum, the registrar accessions and catalogs the object, changing the incoming loan numbers to permanent accessions numbers. (See chapter on Acquisitions and Accessioning.)

PROCESSING LOANS BEING RETURNED

Upon return of the object, the lending registrar unpacks the object as promptly as possible after acclimatization and compares it against the outgoing condition report for any significant changes. If new conditions or damage is apparent or suspected, the borrowing registrar is contacted immediately. The lending registrar ultimately decides whether an insurance claim should be filed. Incoming photographs should be taken if any changes have occurred. If the damage could have occurred during transit, all packing material must be saved and photographed, too. The lending registrar checks to see that all loan objects as well as all parts or accessories and any installation hardware have returned.

An "incoming receipt" is signed, evidencing the return of the loan in satisfactory condition. Either the borrower or lender can issue this receipt. The lending registrar then notifies all pertinent museum departments of the loan's return. Files and/or computer records are updated as to location of the object. A loan history for the loan object is maintained to document the object's exposure. (See chapter on Managing Files and Records.)

A history file on different borrowers should be kept to document problems or concerns for future reference. This file can include notes on agents or shippers used by the borrower that proved problematic. Loan histories can also be useful in negotiating later loans should the lending museum wish to borrow objects from the borrowing museum in the future.

Shortly after the conclusion of the loan, either the registrar or the museum's business office prepares a final invoice, billing the borrower for all agreed costs related to the loan, e.g., crating, conservation, courier costs not paid directly by the borrower, and any insurance premiums. Timely accounting of these costs is appreciated by both the borrowing and lending institution. Agent's bills should be directed to the borrower, or the lender should be reimbursed for agent's costs as appropriate. Loans can be shipped to borrowers "prepaid" with the borrower later invoiced or can be shipped "collect" to avoid billing.

LOAN ISSUES

Damage: If the object is damaged at any time, the lender must be contacted immediately. Any damage, however slight, must be documented. A conservator should be consulted as to possible remedies for the lender's information. If damage is serious, an insurance claim should be made.

Change of ownership: If the ownership of the object changes or if its status changes, e.g., if it is donated, promised, or placed on extended loan, the

change must be properly documented in writing. A new loan agreement must be signed by lender and borrower.

Change of information: If loan information simply needs to be updated, a new agreement is not required. However, the change in information should be confirmed in writing by the lender or his or her representative.

Loans to third parties: In the case of loans to third parties, (i.e., an object currently on loan to your museum sent for loan to another museum) the owner must provide written permission for the object to be released. The borrower is normally responsible for paying all charges in connection with a third-party loan. There should be a clear understanding of exactly when the borrower's insurance takes effect. If the loan is to return to your museum, its file and loan number can be continued. When the loan finally returns, it is prudent to ask the lender if any information needs to be changed.

Requests for loan extensions: Requests for loan extensions or date or venue changes are normally subject to the same review and approval process as the original loan request. Minor changes in dates can be handled by a simple letter from the borrower countersigned by the lender.

Loans to traveling exhibitions: Several concerns may be raised by loans to traveling exhibitions. Facilities reports for each venue should be reviewed by the lending institution. Large gaps may exist between venues, and it is the borrower's responsibility to inform lenders of the arrangements that will be made to accommodate such lapses: shipments to the next venue may be postponed, or the loans may be stored. No loans should ever be stored at sites other than the exhibition venues without the lender's advance permission. The organizing institution is usually responsible for insuring the tour, processing invoices, and relaying lender requirements to venues unless other arrangements have been separately made with each venue. Should an early release from the traveling

exhibition occur, all parties concerned should be informed in advance. (See chapter on Organizing Loan and Traveling Exhibitions.)

Exchange loans: Exchange loans may be reciprocal loans for long or short periods, or they may be used when an object requested for loan must be replaced at the lender's site for the duration of the loan. They are handled in the same fashion as other outgoing loans, with outgoing and incoming loan contracts to document the transaction. Shipments to and from the same lender can often be consolidated for a savings. Since both institutions benefit, it is important that there be a clear understanding regarding which museum is responsible for which costs.

GENERAL ISSUES OF RECIPROCITY BETWEEN MUSEUMS

In the mid-1990s, the Museum Loan Network (MLN) began as an organization to encourage loans between museums. Both borrowing and lending organizations benefit from participation. Lending museums are given grants to survey their collections, choose objects that might be available for long-term loan, and get estimates for conservation of objects. They prepare information for a database, the MLN directory, which potential borrowers can use for access to brief descriptions of artworks available for long-term loan. Grants to borrowing institutions for conservation help defray their loan costs.

In recent years, the cost of organizing exhibitions has mushroomed. It is incumbent upon museums to work cooperatively to find ways to control loan costs. Without risking the safety and long-term preservation of the object, costs can often be reduced by waiving or consolidating couriers, by waiving loan fees, by invoicing expenses "at cost" only, or by re-using recycled crates. Loans will remain a mainstay of museum exhibitions for the foreseeable future, and it is vital that the process be as efficient as possible.

IN-HOUSE EXHIBITIONS

In-house exhibitions are important to museums and must be planned and executed as carefully as loan and traveling exhibitions. They may be long-term or temporary exhibitions that afford the museum an opportunity to display objects from its own permanent collection. The focus on permanent collections does not preclude loan objects from important local collections, so loan procedures may be involved. On the whole, however, in-house exhibitions are less complex than major loan or traveling exhibitions and consequently are easier for the registrar to coordinate. There are usually few packing, shipping, and insurance problems to solve; the budgets are usually small and easy to manage. As a result, the main challenge of the in-house exhibition is to frame an efficient preparation and installation schedule that is sensitive to the needs and safety of the objects and the workloads of the personnel involved.

EXHIBITION PLANNING

Museums may have prescribed exhibition production schedules. Some have committees in place to plan exhibitions, while others make planning a primary responsibility of a curator or an exhibition coordinator. Timelines for exhibition development also vary from museum to museum; it is ideal to have a year to plan an in-house exhibition, to have a pre-production meeting approximately eight weeks before opening, and to have all pre-installation work completed three weeks before the opening date.

Exhibit preparation, however, begins with two documents, the preliminary checklist and the budget. These two documents become the basis for the exhibition. The checklist, drafted by the curator, includes the following:

- Accession number (or loan number if loans are involved)
- Artist or maker
- Title or object name
- Object date
- Medium or materials
- Dimensions
- Credit line (always used in art museums, sometimes used in history museums, seldom used in science museums)

The budget is based on the preliminary checklist. Curator, registrar, and exhibition personnel should have input into the budget, and categories for all exhibition costs should be included. The registrar's section should cover all packing, shipping, and insurance costs if loans are included and, when an in-house conservator is not available, consultation and conservation costs. If there will be a need to hire preparators or art handlers to work on the exhibition, or truck objects from off-site storage areas, those costs should be included as well.

EXHIBITION DEVELOPMENT

In all stages of planning and development, the tracking of objects is the responsibility of the registrar. Accession numbers and, if loans are included, loan numbers, are vital for tracking. (See chapter on Numbering.)

As the curator works on the exhibition's concept and develops a floor plan, the checklist will undergo many transformations. The entries on the checklist should not be numbered (from #1 consecutively to the last number on the list) until it is certain that the checklist is final. The list might not become final until the exhibition is completely installed, at which time a final accurate checklist

"In-House Exhibitions" written by Gwen Bitz, "Organizing Loan and Traveling Exhibtions" written by Julia Bakke, and "Hosting Traveling Exhibitions" written by Deborah C. Slaney.

with numbers can be completed. The final checklist is valuable for security and registrarial checks and serves as archival information about the museum collection.

Upon receipt of each draft of the checklist, the registrar will consider the availability of each work from the permanent collection and pass necessary information about the objects on to the curator. This is most important in early stages of planning. The following questions should be asked about each work:

- Is it in good condition? If not, will it require conservation treatment?

- Is it out on loan or promised for loan during the exhibition period?

- Is it stored at an off-site facility?

- Are special mounts, cases, or security devices necessary for installation?

- What are the lighting restrictions for the object?

- Does the object include new technology? If yes, is the equipment available and in good running condition?

- Are there existing preservation and running copies of the originals of any new technology works (videotapes, audio tapes, videodiscs, CD-ROMs, etc.)?

- Are there good instructions in the files for complicated installations?

- Will special signage be needed, e.g., "Do Not Touch" or "Touch the Screen to Start the Program"?

The answers to these questions will help the curator make the final selections for the checklist.

To determine if the permanent collection works on the first draft of the checklist are in good condition, it is necessary for the registrar to inspect each work physically and to research the object file for condition history. (See chapter on Condition Reporting.) If the registrar learns during this inspection and research that the condition is questionable, a conservator should inspect the work and prepare a treatment proposal with cost estimates.

The curator and registrar can then determine if the exhibition budget can bear the total cost of all estimated treatments.

When the conservation proposal is approved, the registrar immediately schedules the treatment to ensure that it can be completed several weeks prior to the opening date.

In its working stages, the checklist may be entered into an exhibition database that will then serve as the digital file from which all other documents needed to track the objects during the exhibition process can be generated. Traditional manual files may also be established to record the history of the planning and production of the exhibition. (See chapter on Files.) All information pertaining to an exhibition should be available and accessible not only to the registrar in charge of the project, but also to anyone in the registration, exhibition, and curatorial departments who needs it. A typical in-house exhibition file will eventually include:

- Budget
- Checklist
- Conservation information
- Installation notes
- Label copy
- List of lenders, A-Z, if any
- Loan agreements and receipts, if needed
- Packing, shipping, and consolidation information
- Photographic materials
- Security notes

A pre-production meeting should be held several weeks before the opening; at this meeting, the curator, registrar, and exhibition staff, along with other staff members who are involved, study the floor plan and develop strategies for installation. A schedule can then be developed to make each department accountable for a timely completion of its responsibilities. The number of extra art handlers or technicians required to accomplish the installation safely can also be decided.

The registrar oversees the completion of conservation work and, depending on the organization of the museum, sometimes has responsibility for cleaning and basic preparation of the objects in the exhibition. The registrar may also be responsible for preparing label copy for the objects; if not, it will be the registrar's responsibility to review and check the label copy for accuracy. Each museum has a specific in-house procedure and style for producing label copy, and the museum guidelines must be carefully followed.

INSTALLATION

Approximately three weeks prior to the opening of the exhibition, all of the objects that will be included should be on site. Conservation should be complete, and all of the tasks that the many museum departments did for the preparation of the gallery space and objects should be finished. The objects are then moved into the galleries.

The gallery floor plan serves as a map for the placement of the works, and installation begins. For large exhibition installations, many museums hire art handlers to supplement their staff. The registrar should conduct an object handling briefing for this temporary staff and ask permanent employees to attend as well. It is important that all crew are as alert as possible to the basic rules of object handling. (See chapter on Handling.)

There will probably be some changes in the final placement of the works as the curator oversees the installation. When it is certain the placements are final, the appropriate security devices can be installed, labels can be distributed and placed, and lighting can be adjusted.

The day before the exhibition opens, the registrar and curator should walk through the exhibition with security staff to explain potential guarding problems. During this tour, specific safety needs for each work can be identified. Audible alarms can be pointed out, and the instructions for responding to the alarms when they are activated by patrons can be reviewed. Vulnerable surfaces and complicated installations should be explained, and locate the best vantage point for observing the works easily. The security staff can express concerns they have about protecting the objects as they are installed. If there are interactive works or works with many parts, instructions and inventory lists should be distributed for easy reference.

It is important that the objects on exhibit be monitored carefully. Guard staff as well as registration and exhibition staff share this task. In-house rules for department and staff responsibilities should be followed.

DEINSTALLATION

Prior to the last week of the exhibition period, the registrar and the exhibition staff should plan the deinstallation of the objects. The return of any exhibition loans to local collectors must be arranged and the important final paperwork—receipts for signature upon delivery—prepared. Permanent collection objects slated for off-site storage must be packed and local drayage arranged. Other permanent collection works will be returned to their appropriate locations in the storage vaults.

The registrar continues the tracking of objects after deinstallation and records the location information on databases, in manual files, or in both places. An exhibition history is prepared for each object and filed in the appropriate place. The exhibition file is closed, and the in-house exhibition is officially concluded.

ORGANIZING LOAN AND TRAVELING EXHIBITIONS

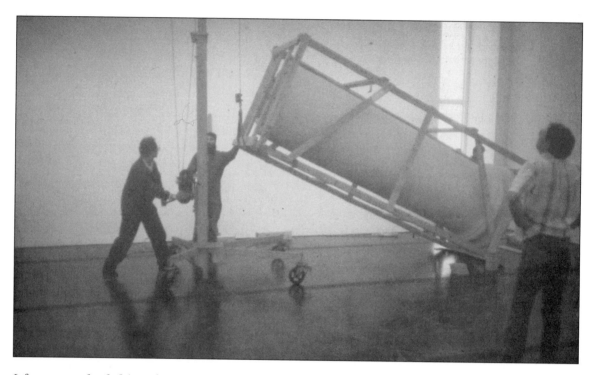

Inform venues ahead of time what type of equipment will be needed to safely move and install the objects.

The registrar's role in organizing a traveling exhibition begins in the planning stage. In cooperation with the exhibition team, the registrar contributes to the development of the exhibition budget. At this point, the curator of the exhibition provides the registrar with a preliminary checklist of objects and perhaps an exhibition schedule, including the proposed number and location of exhibition venues. The registrar is usually asked to provide estimates for crating, shipping, insurance, and any other projected expenses related to the loans to the exhibition that would be passed on to the organizing institution by individual or institutional lenders, such as loan fees, courier expenses, and costs of preparing objects for loan, such as framing or special mounts. Based on the material to be exhibited, its relative fragility and value, and the level of complexity of the installation, the registrar, in consultation with a conservator when possible, determines whether couriers will be needed. A courier

may accompany the shipment of the objects between venues and/or may travel to each venue to supervise the unpacking and installation of the exhibition and later the deinstallation and repacking. The registrar budgets for these costs varies according to the decision made.

When exhibition venues have been confirmed, the registrar obtains facilities reports from each participating institution, so that, upon request, lenders can be sent copies for their own review. The registrar is often responsible for drafting an exhibition contract that is sent to and signed by each participating host institution. This contract should clearly and specifically state the delineation of responsibilities—both financial and logistical—between the organizing institution and each host institution. (See chapter on Contracts.)

At this point loan request letters, accompanied by loan forms, are sent. While the loan request letters are usually generated by the organizing

institution's director or curator, the loan forms are most often generated by the registrar. (See chapter on Loans.) As loans are approved and loan forms are returned, the registrar reviews the loan forms and notes any special lender requirements and restrictions, such as specific light levels, climate control, security hangers, locked cases, floor barriers, shipping specifications, and photography and rights and reproductions limitations. In larger institutions, this information is often distributed by the registrar to the various departments (rights and reproductions, curatorial, exhibitions). When the exhibition travels, the registrar must provide each venue with a list of the installation requirements and photography restrictions well in advance of the arrival of the exhibition. This information might, in fact, be included in a preliminary packet of exhibition information, consisting of a final checklist of the exhibition, a press kit, and installation photographs.

INSURANCE

It is the organizing institution's responsibility to make all insurance arrangements for the exhibition, and it is usually at this point in the exhibition planning phase that the method of insurance and insurance carrier are chosen. There are basically three types of insurance for any one exhibition. Objects may be insured:

- By the organizing institution
- By the lender, who then may bill the organizing institution for the premium
- By government indemnity

An exhibition may incorporate any and all of these types of insurance, and it is up to the organizing registrar to be certain that adequate and accurate coverage is provided for all objects from the time they leave the lenders' premises to the time they are returned.

INSURANCE BY THE ORGANIZING INSTITUTION

Ideally, all works can be covered for the entire exhibition tour under the organizing institution's own insurance policy or under a special policy

negotiated with the organizing institution's usual insurance carrier. For budgetary purposes, the organizing institution may elect to cover the exhibition under its own fine arts insurance policy for the entire tour under one of the following conditions:

- The total value of the exhibition falls under the appropriate limits of maximum probable loss.
- Extra layers of insurance can be purchased to raise the limits of liability to cover the total value of the exhibition.

While this method is the least costly way of insuring an exhibition, it is also the riskiest for the organizing institution in that it essentially puts the institution's permanent collection at greater risk by "borrowing" a portion of its coverage. Thus, it is more usual for the organizing institution to negotiate a special insurance policy specifically for a particular exhibition. In either case, however, the organizing institution bears the burden of ultimate responsibility and accountability for any damages that might occur over the course of the exhibition tour. For this reason, it is essential that the organizing registrar be completely familiar and comfortable with each venue's facilities and staff. In addition, for exhibitions with particularly fragile and/or high value works, the organizing institution's registrar typically travels to each venue prior to the opening of the exhibition and at the close of the exhibition to monitor the condition of objects and to supervise object handling.

INSURANCE BY LENDERS

Many times, individual lenders prefer to maintain their own insurance coverage. The organizing institution is then responsible for the cost of the insurance premium for these loans. This extra cost must be anticipated when establishing the initial exhibition budget. The organizing registrar should review all outside insurance policies and their provisions, passing on any unusual stipulations to the other host institutions. The registrar should obtain a waiver of subrogation from the lender's insurance company to ensure that it

TREASURES OF THE SAMPLER
An exhibition organized by the Sampler Museum
THE SAMPLER MUSEUM
123 Any Street
Any Town, Any State USA 00000
telephone 000-000-0000
fax 000-000-0001

CONDITION REPORT

Venues:	The Sampler Museum, Any Town: September 8, 1996-November 27, 1996
	Second Museum of American Art, New York: December 16, 1996 - March 5, 1997
	Other Museum of Contemporary Art, Washington: March 25, 1997 - June 4, 1997

CONDITION REPORT

Note: This form is used in conjunction with accompanying annotated photograph.

[Artist] Checklist/Catalogue No.
[title or description of object]
[date of work] Lender: [Lender name]
[date of object]
[medium]
[dimensions]

FRAME RECORD: Frame Backing Mat D-rings
 Mirror plates Stretcher Labels Glass Screw eyes
 Security hangars Keys Plexiglas Wire

Frame description and condition: _____

Reframing record: _____

Hanging devices changed: _____

THE SAMPLER MUSEUM INCOMING CONDITION NOTES:

EXAMINED BY: _____ DATE: _____

Condition report, side 1.

TREASURES OF THE SAMPLER
Condition Report —Page 2

THE SAMPLER MUSEUM OUTGOING
❏ condition unchanged ❏ new damage ❏ additional notes

EXAMINED BY: _____ DATE: _____

SECOND MUSEUM INCOMING
❏ condition unchanged ❏ new damage ❏ additional notes

EXAMINED BY: _____ DATE: _____

SECOND MUSEUM OUTGOING
❏ condition unchanged ❏ new damage ❏ additional notes

EXAMINED BY: _____ DATE: _____

OTHER MUSEUM INCOMING
❏ condition unchanged ❏ new damage ❏ additional notes

EXAMINED BY: _____ DATE: _____

OTHER MUSEUM OUTGOING
❏ condition unchanged ❏ new damage ❏ additional notes

EXAMINED BY: _____ DATE: _____

Condition report, side 2, with spaces for comment at each venue.

will not sue any participants in the exhibition. (See chapter on Insurance.) The organizing registrar is responsible for obtaining certificates of insurance for these loans, often directly from the individual insurance companies.

GOVERNMENTAL INDEMNITIES

Application for U.S. indemnity must be made well in advance of the exhibition opening, and the registrar must be prepared to provide detailed checklists and support documentation. The registrar should be aware of the various requirements of U.S. indemnity and budget for the probable expenses that will be incurred as a result of these requirements, e.g., arranging for condition reports for all objects before they leave the lender's premises and after they are returned at the close of the exhibition. The organizing registrar is responsible for providing each venue with copies of the indemnity provisions and for informing the indemnity office of any changes to the conditions outlined in the original indemnity application that may occur during the course of the exhibition, such as a change in exhibition site, exhibition dates, security, or shipping arrangements. U.S. indemnity requires that some or all of the exhibition come from countries other than the United States; it also precludes objects made of certain fragile materials. There are deductibles associated with indemnity, and these must be covered by other insurance.

GATHERING THE LOANS

Shipping Arrangements

Once the majority of loans have been confirmed, the registrar establishes an overall shipping schedule based on the projected installation schedule, and considers the methods of transportation available for the various loans: air or overland or, in some cases, a combination of the two. (See chapter on Shipping.) The registrar then reviews the lenders' loan agreements, noting any special shipping requirements, such as couriers or preference for a partic-

ular carrier and/or shipping agent. It is often helpful at this point to generate a shipping worksheet (see sample on page 199) to organize and keep track of the information pertaining to each loan. The worksheet can be organized geographically, grouping the loans by location in order to produce a working list of possible ways to consolidate some of the shipments. At this stage, the registrar can solicit bids from different commercial carriers. For domestic loans, this usually means contacting one or more fine arts trucking firms, providing them with a list of loans to be collected, and any other pertinent requirements, such as exclusive use, climate control, two drivers, non-stop, overnight security, courier on the truck, etc. For international loans, shipping estimates can be obtained in one of two ways: by contacting the foreign agent or by providing the museum's own shipping agent with a list of foreign loans to be collected and asking that the agent obtain the bids. (See chapter on Import and Export.)

Crating

For private lenders, it can usually be assumed that crates do not exist for their works and that crating arrangements need to be made by the organizing registrar. Most lending institutions prefer to make their own crating arrangements, either in-house or with their own preferred commercial packer. For those loans that do need to have crating arrangements made, it is helpful, again, to group the lenders by general region. The registrar then obtains bids from one or more commercial fine arts packing firms in each of the regions by providing each packer with a list of works to be crated, and any specific crate design requirements, such as thermal insulation, waterproofing, reusable closure system, or travel frames. For loans that are coming from smaller towns where no commercial packing firms are known to the organizing registrar, it is helpful to ask a colleague in a museum or gallery in close proximity to the lender names of one or more small packing companies or even an individual whose work is reputable and known locally. For foreign

loans, most international shipping companies provide crating services as well, and it is usual practice to use the same company for both shipping and packing. (See chapter on Packing and Crating.)

Contacting the Lenders

Once the various carriers, packers, and agents have been selected, the lenders are contacted. While most fine arts firms will, if necessary, handle this entire process, it is good professional practice for the registrar to make initial contact with each lender to discuss the proposed packing arrangements, shipping method, and dates, and to have each commercial firm follow up directly with the lenders to confirm precise pick-up dates and times. At the same time, the registrar can find out other specific information about the works to be borrowed. It is important to know if a two-dimensional work is framed or unframed, if there are any known condition problems, and if there are any logistical problems in getting the object out of the lender's residence. (Ideally, in lieu of this step, a condition report can be made on the lender's premises prior to making final packing and shipping arrangements.) Most commercial crating companies can provide secure, climate-controlled storage and can therefore consolidate the objects at their warehouse, doing the actual crating there. Not only is this more cost-effective for the borrower, but in many cases the private lender prefers this method to on-site crating. If the registrar believes this to be an appropriate arrangement for the object, it should be discussed with the lender to be sure that he has no objections or concerns about the object being transported locally with minimal packing.

After all of the lenders have been contacted, the registrar refines the list of works that must be crated and gives it to the various packing firms, discussing in more detail the exact packing method and crate design desired. For large exhibitions, in which there are many loans from one location, it is often desirable for several works to be packed in one crate, particularly if there are many small objects.

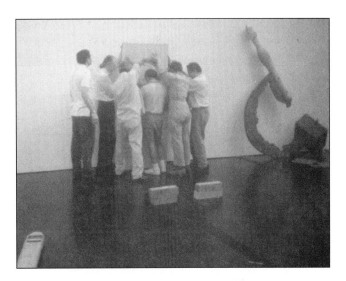

Inform venues of any objects that will require extra manpower to move and install.

The registrar needs to take into consideration whether there are objects in the exhibition that will not travel to all of the venues; these objects should not be included in a multiple crate.

Receiving the Works at the First Venue

Most often, the first venue of the exhibition is the organizing institution's own museum. However, sometimes the first venue is a museum other than the organizer's. If that is the case, it should be decided, and clearly stated in the exhibition contract, what the first venue's responsibilities will be, e.g., whether the loans are to be delivered directly to the museum or whether all of the loans are to be consolidated in a nearby warehouse and then delivered en masse to the museum. This will also affect the overall exhibition budget and should be planned for accordingly.

Once the works are received at the initial host institution, the registrar carries out the usual procedures for receiving and documenting incoming works of art:

■ Confirming crate dimensions, noting how each work is packed, including comments as to whether any packing revisions need to be considered

- Labeling or tagging each object
- Making incoming condition reports
- Sending out receipts to the lenders, confirming safe arrival of their loans

THE EXHIBITION TOUR

Documentation

Once all of the information is gathered, the registrar can begin to organize the pertinent documentation for the exhibition that is to be passed on to the various exhibition venues. The documentation should include the following:

- A checklist of the exhibition, including complete object data and credit line for each work
- A crate list, including crate sizes and, when possible, crate weights, and a list of the crate contents. (It is common practice to establish a crate numbering system specific to the particular exhibition, and to mark the crates accordingly when they arrive at the first venue.)
- A list of equipment necessary to receive the exhibition and/or install objects (e.g., forklift, dollies, gantry, crane, etc.)
- A list of display furniture, mounts, and graphics that will travel with the exhibition
- A packing list with explicit packing instructions for each object
- A list of lenders' special requirements, such as light levels, relative humidity and temperature levels, barriers, photography/filming restrictions, etc.
- A certificate of insurance naming the museum as additionally insured
- Indemnity documents, when appropriate

The Condition Report Notebook

The format for the traveling condition report should be clear, concise, and easy to use. In many institutions, a photograph forms the basis for the condition report, thereby minimizing the detailed descriptive condition report. Black-and-white, 8-x-10 photographs work best, as they provide the clearest image for reference. Photos can be request-ed from lenders for this purpose, the extra cost being included in the exhibition budget. The photo can be inserted into a plastic sleeve and notations made with colored markers on the sleeve. On other occasions, when black-and-white photographs are not available, color proofs from the exhibition catalog or photocopied images of the objects can be used. However, these images are often not accurate in color nor sharpness, so they are used more as a way to indicate the location of a particular condition note than as photographic document-ation of a pre-existing condition. (See chapter on Condition Reporting.)

The condition report sheet itself should have the following information:

- Checklist or catalog number for the object
- Complete object data
- Incoming condition report, including condition notes on frame, glazing, and mounts

A space, adequate in size, should be provided for each venue to make incoming and outgoing notes and comments, and each space should include a line for the signatures of the persons doing the incoming and outgoing condition checks and the dates. (See sample condition report.)

If a lender's condition report is sent with the object, it should be incorporated into the master condition report notebook, and the subsequent condition notes and comments should be made directly to the lender's condition report. At the close of the exhibition tour, the organizing registrar is responsible for returning these condition reports to the lenders.

If damage to an object does occur while the exhibition is on tour, it is the organizing institution's responsibility to report the damage to the lender and to determine, with the lender, the appropriate course of action: conservation treatment, insurance claim, and/or withdrawal of the work from the exhibition. Whether the damage is significant or insignificant, the organizing institution's registrar must be contacted immediately. In the event of an insurance claim, the organizing institution's registrar handles all aspects of the insurance claim. If con-

Lender		Artwork	Insurance/Indemnity		
Location: *Czechoslovakia, Prague* Nationalgalerie Prague Hradcanske namesti 15 11904 Prague 012 Czechoslovakia	Contact contact name PHONE 530 895 FAX 211 42 2 24510722 Loan Status: Venues: Yes 12/7/92 NY, H, C LA rcd ❑	18 ***Der Familienausflug*** (The Family Outing) **c. 1919** Oil on cardboard 14-3/16 x 10-1/4 in. 36 x 26 cm	Indemnity No Condition Report informed lender ❑ report done ❑	USD (Currency) $0 VALUE FOR INDEMNITY APPROVED INDEMNITY VALUE INSURANCE: A.P. Bahrainis INDEMNITY CERTIFICATE ❑ INSURANCE CERTIFICATE ❑	SHIPPER Hasenkamp OK 613.

Shipping worksheet (detail). This form organizes and tracks information pertaining to each loan.

servation treatment is required, the organizing institution, in consultation with the lender, chooses a conservator, and arranges for the treatment to be done, coordinating the logistics and scheduling with the host institution's registrar.

Shipping Arrangements Between Venues

Several months before the exhibition is due to open at the next venue, the organizing registrar contacts the next host institution's registrar to discuss a proposed shipping schedule. The organizing registrar then determines the shipping method and carrier and later informs the host institution of the proposed shipment delivery date or dates. The organizing registrar is responsible for making arrangements, if required, for a courier on the truck or in a follow car. The organizing registrar is also usually responsible, unless otherwise agreed by the host institution, to make per diem and hotel arrangements for lenders' couriers at each venue, as required.

Dispersal of the Exhibition

Dispersal of the exhibition usually is done directly from the last exhibition venue. The organizing registrar must be in especially close contact with the last venue's registrar well before the closing date of the exhibition in order to set a concise and workable shipping schedule. Again, the organizing registrar makes all shipping arrangements, including accommodation of couriers. Before the exhibition

closes, the registrar should review the exhibition loan list and/or loan forms, noting any frame, mount, or hanging device changes that were made during the course of the exhibition, so that the works can be returned to the lenders in their original state (unless the lender has specially requested otherwise). The registrar also reviews special instructions for the return of works, such as returning it to a location other than the lender's premises. If a lender's condition report accompanied the loan, the registrar removes the complete original condition report from the condition report notebook after the final condition check is done, and returns it with the loan to the lender.

After all of the works are dispersed from the last exhibition venue, the organizing registrar generates receipts and sends them to each lender for his signature to confirm the safe return of each object.

HOSTING TRAVELING EXHIBITIONS

As an integral part of an exhibit team, the registrar plays a major role in hosting a traveling exhibit. The registrar must understand the ramifications of contracts negotiated with the hosting institution, insurance providers, and shippers in the course of hosting an exhibit in order to ensure that the terms of these contracts are carried out. In essence, the registrar's role is to facilitate the safe shipping, handling, movement, tracking, storage, and display of exhibit objects for the duration of the exhibit at the hosting museum. This role may also extend to the care and tracking of non-collections items such as props, exhibit furniture, mounts, educational materials, and packing/crating materials. Through the reduction of risk, the registrar assists the museum in meeting its contractual obligations and ensures that the exhibit arrives at the next venue having received the best care possible.

The responsibilities assigned to the hosting registrar of a traveling exhibit vary greatly from museum to museum. In smaller museums, the registrar often assists with many of the functions of the museum's exhibit team, including exhibit selection and scheduling, gallery design, collections care and preventive conservation, risk management, and gallery security. In larger museums, the role of a registrar within the exhibit team is usually more specialized. To work well with the team, it is essential that the registrar have an understanding of the team's professional makeup and how internal responsibility for various aspects of each exhibit is delegated. In addition, every traveling exhibit is different; each shipment presents new challenges; and every traveling exhibit project is a learning experience. Ultimately, the registrars who are able to tackle these responsibilities the most effectively are the ones who are organized, flexible, and unflappable.

PLANNING

Advance planning is critical to the success of a traveling exhibit. Exhibit meetings, attended by the registrar, are the best places to plan, discuss progress, present issues, and make group decisions. The questions most often raised during initial exhibit meetings, which the registrar must be prepared to discuss, most often relate to the logistics of getting exhibit materials to the facility by a specified time. Early on, a registrar may be asked to provide a facility report to the organizing institution and should be prepared to discuss the contents of the facility report with the organizer should questions arise.

As soon as they are available, marketing materials and legal documents provided to the exhibit team by the organizer are reviewed by the registrar. Marketing materials may provide basic information useful to a registrar, such as the number and types of objects, gallery environment and security requirements, and current venues. Catalogs with object illustrations may often be available as part of the marketing package.

As one who is knowledgeable about the museum facility from a collections care point of view, the registrar often assists with the review and negotiation of the exhibit contract. The registrar reads the contract carefully and is prepared to call attention to any requirements that cannot be fulfilled by the hosting institution. Particular attention is paid to clauses describing requirements for environment, security, insurance, borrower responsibilities for packing, shipping, couriering, conservation, and storage of ancillary materials. Because many parts of an exhibit contract often overlap with loan agreements, the registrar checks with the organizer to determine if the contract will serve as the loan agreement, or if a separate loan agreement will be negotiated. If there will be two separate documents, both are reviewed and discussed internally with the team, then negotiated with the organizer.

The registrar reviews inventories of objects and other exhibit materials; the crate list and individual crate inventories; a condition report book with photographs, condition reports, and conservation information; instructions for unpacking, handling, and installation; a full list of venues; shipping

documents and copies of export and customs documents; and indemnity instructions, if applicable. These documents, which often arrive in the form of an exhibit manual, can help determine how the exhibit materials will be managed once they arrive at the museum. Crate statistics, for example, allow the registrar to determine points of entry into the museum, the number of staff required to unload and unpack the exhibit, the type of moving equipment needed, and the space required for staging and crate storage.

The registrar also contributes information that helps the exhibit team formulate a project budget. Crate statistics, combined with the list of venues, may be used to obtain quotes from shippers for transporting the exhibit to or from the museum; or the organizing institution may be able to provide rough estimates. If the contract stipulates that new packing materials are to be provided, crate and object inventories, packing instructions, and condition reports may be used to develop materials lists; supply catalogs can then be used to compile the estimates. Off-site storage space, couriering and customs costs, environmental monitoring devices, conservation, framing, mounting, and insurance costs may also be required to fill out the budget.

EXHIBIT DOCUMENTATION

Since planning for a traveling exhibit requires that information be provided in advance of the exhibit itself, records received by the registrar are often compiled into a working exhibit file. Appropriate documents are then converted to an incoming loan file when the exhibit is received. Ideally, these records are assigned a loan number and are stored in acid-free folders in a locking, fire-resistant file cabinet. The loan and exhibit files might include

- The exhibit contract
- Loan agreement
- Relevant checklists and instructions from the organizing institution
- Gallery layouts and lists of object locations
- Conservation records

- Computer reports
- Installation photographs
- Gallery climate and pest monitoring records
- Purchase requisitions
- Shipping records
- Correspondence relating to the exhibit

The file may also include information about where related materials such as condition report books and crates can be found. If incoming or outgoing changes to condition reports are noted, copies of the condition reports should be included in the loan file as permanent documentation. If loan records are maintained in computer files, backup disks are created and hard copies generated for the loan file (or document names are listed in the loan file). The loan file should be set up so that other curatorial staff could coordinate the tracking and return of the exhibit in the registrar's absence. (See chapter on Managing Files and Records.)

Prior to the actual release of the shipment by the organizer, additional documents are often requested by the hosting museum. Copies of hygrothermograph records may be requested as proof that the museum can maintain a stable climate for the exhibit. If insurance is to be provided by the borrower, the lender may request that a certificate of insurance be issued by the insurer as proof of coverage for the duration of the exhibit. If the organizer provides insurance coverage, the registrar requests a certificate of insurance, naming the hosting museum as an additional insured, or a waiver of subrogation from the organizer.

RECEIVING THE EXHIBIT

It is important to become as familiar as possible with the lender's intentions for shipping and installing the exhibit. The exhibit contract may stipulate which institution is financially responsible for inbound or outbound shipping, but it may not stipulate who will be responsible for making shipping arrangements. Although the organizer usually takes on this responsibility, the registrar of the hosting institution is prepared, should questions or problems arise, to communicate with the packer,

shipper, customs broker, freight forwarder, or courier. Both lender and shipper are informed of any unusual characteristics pertaining to arrival at the loading dock. Specifically, the shipper is made aware of the museum's loading dock hours and any special equipment needs. If equipment and operators are not or cannot be provided by the shipper, the museum must be prepared to borrow, buy, or rent them.

If the exhibit is to be accompanied by a courier or if an installation team is provided by the organizer, the registrar must learn how responsibilities will be shared once the exhibit arrives. Some organizers prefer to unpack, condition report, and install the exhibits with minimal assistance; others expect that the hosting institution will supply the human resources needed. Finding out in advance if the courier assists with unpacking and condition reporting, if the conservator assists with installation, and if the drivers assist with moving crates into the facility (beyond the loading dock) allows the registrar to coordinate in-house resources more effectively.

As the hosting institution prepares to receive the exhibit, the registrar maintains communication with the organizer's registration staff. Both institutions should agree on a receiving date that takes into account the shipper's schedule, the hosting museum's loading dock hours and workload, and personnel resources. The registrar works with the shipper to determine the approximate arrival time and must often be prepared to mobilize earlier or later than expected. Security personnel should be alerted to the impending arrival. If security monitors progress at the loading dock, it can be helpful to provide them with a copy of the crate list.

In further preparation for arrival, in-house travel routes are checked and cleared in advance. The loading dock is cleared of unneeded materials and equipment, vehicles, and unauthorized persons. Any required equipment must be on hand. The route should be free of onlookers so as to reduce distractions and minimize the risk of damage. If entryway dimensions are restrictive, the registrar

determines alternate routes in advance and tests them with prototypes if necessary. If special environmental requirements have been requested, display cases should be conditioned before the arrival of the objects.

When the exhibit arrives, the registrar meets the shipper and communicates the route to the receiving/holding area. As crates and other exhibit materials are brought into the building, the registrar uses the crate list to confirm that all materials are accounted for. Although the shipper may conduct his or her own inventory, it is important that the museum keep its own institutional records and confirm total arrival of the exhibit. The waybill should not be signed until all materials have been accounted for and a visual inspection has verified that the containers have not been damaged in shipment.

Any missing or damaged containers are noted on the waybill, and photographs are taken to document any suspected damage. At this point, the registrar determines whether it is necessary to unpack any damaged containers in order to document the extent of damage prior to signing the waybill. After the shipment has been secured, the registrar advises the organizing institution that the shipment has been received; and together they determine if materials are indeed missing. Alternative arrangements can then made to locate the original or obtain replacement materials.

Incoming exhibit containers should be provided a "rest period" prior to unpacking. A rest period allows the containers and their contents to reach an equilibrium with their new environment; 24 hours is a standard acclimatization period. In some cases, the temperature and relative humidity of the receiving/holding area must be adjusted to meet the organizer's exhibit contract or loan agreement requirements. Incoming materials should be stored in an area that can best meet the environmental requirements of the objects in the exhibit. If an exhibit manual, condition reports, or receipts were sent with the exhibit, the registrar determines

the location of these items and retrieves them first. The receipt is then signed, dated, and mailed back to the organizer to document receipt of the exhibit.

UNPACKING AND STAGING

A secure staging area is furnished with clean, padded storage equipment (tables, pedestals, shelving, and cabinetry are ideal) in preparation for unpacking. The order of unpacking may be governed by a variety of conditions, including size or fragility of objects, space, organization of the condition reports, and installation needs. In general, it is best to work with one crate at a time, so that crate inventories can be used as a checklist to confirm receipt of each item on the object list. This way, if the registrar must break away from the unpacking, the integrity of the inventory can be maintained. In addition, packing materials (if they are to be reserved) can be replaced in the crate and the crate resecured for storage.

Before individual objects are unpacked, the registrar reviews their condition reports and any handling instructions to get a sense of how best to handle and examine each object. As the objects are unpacked, the registrar puts notations on the crate regarding repacking, checks that no parts of objects have been left in the packing materials, and notes whether any packing materials need to be replaced and whether existing silica gel needs to be reconditioned. Using his or her knowledge of how handling, shipping, and environmental conditions affect different types of materials, the registrar looks for evidence of changes as well as condition information that may not have been recorded prior to shipping. By recording this information, the registrar protects the museum from claims for damage that actually occurred prior to receipt.

Condition reports should be completed as soon as possible after receipt of the exhibit. If objects are placed into temporary storage for an extended period of time, the organizer may require a second review prior to installation. If condition reports are not required by the organizer, it is best to produce in-house condition reports or a summary condition report and send a copy to the organizer as a safeguard against a potential future claim.

Other exhibit materials such as props, furniture, mounts, graphics, and educational materials are not normally treated as collections objects and may be subject to different levels of storage, handling, and security. However, these materials are part of the loan and are often included in the total value of the exhibit for insurance purposes. Therefore, the registrar will often track the condition and location of these materials in a general way until the exhibit moves to the next venue.

The location of each collection object should be tracked individually until the exhibit is installed. Since the objects should be handled as little as possible, it is ideal if the staging area can occur in the gallery itself, provided that storage-level security is provided. If not, objects may need to be relocated to a temporary holding or staging area or to the museum's collections storage area until installation. If the storage area must be utilized for traveling exhibit storage, the registrar must be aware of several concerns. One concern is that intellectual control must be maintained; exhibit objects are tagged with loan numbers and segregated from the museum collection to avoid confusion with the permanent collection or possible misplacement of objects. In addition, there is the potential of introducing undesirable activities and materials (such as wooden containers, organic packing materials, debris, and pests) into the storage area. To reduce these risks, the registrar checks each object thoroughly for pest activity, bags any suspect items, isolates the objects from the permanent collection, stores the material near the storage entrance if possible to avoid as much activity as possible in the storage area, and stores as much packing material as possible in an alternative location approved by the organizer.

If pest activity or active deterioration of an object is noted during unpacking and condition report-

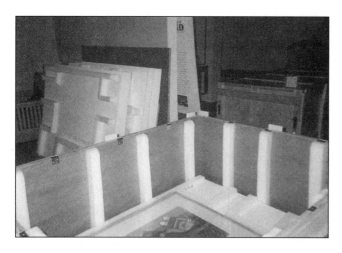

Framed works of art are crated for shipping in a gallery at the Albuquerque Museum. Photo by Deborah C. Slaney.

ing, the registrar contacts the organizer as soon as possible. Permission may be granted to freeze infested objects or to use an in-house or contract conservator to stabilize the objects. If a conservator or registrar travels with the exhibit, this person will usually coordinate arrangements for treatment. However the process takes place, the registrar receives copies of any treatment proposals, reports, and photo documentation and ensures that the organizer also receives this documentation. In cases where an object cannot be stabilized for further exhibition and travel, the registrar may be asked to return it to the organizer. Keep in mind that removal or replacement of objects from a traveling exhibit affects many of the exhibit documents, including the loan agreement, certificate of insurance, object list, crate list, crate inventory, condition report book, and shipping waybill, which are then modified.

INSTALLATION

During installation, the registrar provides assistance to the exhibit team through a knowledge of object handling, movement, tracking, monitoring, and security procedures. Objects are protected during movement by pads, weighted bags, and wedges until they are installed. If professional handlers or installers are part of the team, the registrar provides them with handling instructions. If customized inte-

rior boxes are provided by the organizers, objects are stored and moved in them until they are installed. During installation, objects are again checked off the inventory and their new locations are noted.

Before exhibit cases and vitrines are secured, the registrar checks again to be certain gallery climate and light levels meet the specifications provided in the contract. Hygrothermographs and thermohygrometers can provide information on temperature and humidity levels in the gallery, as well as inside the cases and pedestals themselves. This information can determine how adjustments may be made to the gallery's HVAC system, or determine if buffering materials will be needed to meet the organizer's climate requirements. Lux meters and ultraviolet meters help to determine current light levels; this information will determine how to adjust the gallery lighting or relocate light-sensitive objects. As final adjustments to casework are made, the registrar may also provide temporary security or assistance to the installers. In some cases, the registrar provides inert materials to the installers to pad folds, create protective surfaces, and otherwise cushion objects while on display to protect them from structural stress.

Prior to opening the gallery, the registrar takes a moment to review the exhibit from a security perspective. Small, valuable, and "fenceable" or "approachable" objects are particularly vulnerable to theft or vandalism. Any concerns the registrar may have are communicated to the team member coordinating gallery security, so that they may be addressed before the public opening.

MAINTENANCE

Once the exhibit has opened to the public, periodic inspections of the gallery are desirable and often required by the exhibit contract. The registrar, who may be one of a number of staff keeping watch over gallery conditions, communicates with the design team and with the organizer to provide solutions to any breakdowns of educational materials or audiovisual equipment discovered during gallery inspections. If the registrar is responsible for the muse-

um's integrated pest management program, the gallery is monitored with sticky traps in selected locations so that any potential infestation can be discovered before damage occurs.

If an object is damaged during the course of the exhibit, the registrar completes a condition report, photographs the damage, and works with the exhibit team to determine if the object should be removed from the gallery. A note indicating that the object has been removed from exhibit, by whom, and the removal date is left in its place, and the organizer is contacted for instructions on how best to proceed. In the event an object is noted as missing from the gallery, the registrar notifies security to set internal risk management procedures into motion. If the object is then determined to have been removed without authorization and is actually missing, the organizer is notified immediately so that its procedures may also be set into motion. The registrar works with administrative staff and the organizer to provide information on the object's value and determine whether an insurance claim will be filed.

Before the exhibit closes to the public, the registrar begins planning the outbound shipment. With the input of the organizer, the shipper, and the contact for the next venue, a shipping date is identified and the waybill and any necessary permits or documents are completed and forwarded. If the next shipment requires exportation, the organizer's preferred customs broker assists the registrar with preparation of export declarations and customs documents. (See chapter on Import and Export.) If the organizer arranges the outbound shipping, a completed waybill is mailed to the registrar, or blank waybills may be obtained in advance from the shipper.

DEINSTALLATION

While most exhibits are disassembled and repacked in the reverse of how they were installed, some details may have changed during the course of the exhibit, especially if objects or other exhibit materials have been replaced. The registrar checks to make sure that all crating materials are sound,

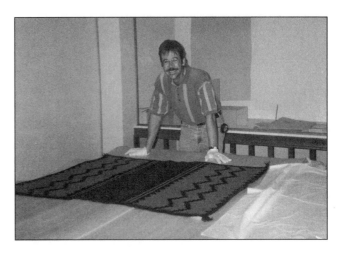

A textile is prepared for rerolling at the close of an exhibit at the Albuquerque Museum. Photo by Deborah C. Slaney.

or are repaired, prior to repacking. Silica gel or other buffering materials requiring conditioning are readied for packing. The organizer may also request modifications to the crates, based on the information provided on the incoming condition reports. New packing materials may be required by the exhibit contract, so the registrar will obtain the materials and have them ready to use by closing time. After the gallery has been secured, the exhibit objects are inventoried, condition reported, and repacked as they were received. Props, furnishings, mounts, graphics, and educational materials must also be accounted for and repacked prior to shipment.

DISPERSAL

Occasionally, a museum that hosts the last venue on an exhibit will be asked to take on the responsibility of dispersing the exhibit for the organizer. As dispersal can add complexity to the project, it is important for the exhibit team to consider the impact of the request upon time, space, budget, and personnel. The exhibit contract, or a separate contract, should define which institution will pay for shipping objects back to original lenders, as well as crate construction and renovation costs. The contract should also stipulate which organization will take possession of non-collections materials. Make

sure that the organizer provides the information required to determine which objects are returned to which lenders.

SHIPPING

When the entire exhibit has been accounted for, the crate lids are secured and, where security procedures require, the crates are inspected and sealed by security staff prior to loading. The registrar uses the venue list to determine the street address, phone number, and contact for the next venue. This information is added to the waybill, and individual address labels are affixed to the containers in place of the former label. Each container must be accounted for by the registrar as the exhibit is being loaded by the shipper. The registrar is also attentive to the manner in which the exhibit is loaded and discusses any unusual circumstances with the shipper and/or the organizer before the shipment leaves the loading dock.

After the exhibit has left for its next destination, the registrar contacts the organizer and the contact at the next venue to inform them that the shipment is on its way. Copies of any condition reports that reflect changes during the course of the exhibit are forwarded to the organizer, along with a release that is signed, dated, and returned t o the hosting institution as documentation that the museum has released custody of the materials. In addition, the next venue contacts the registrar to advise him or her that the exhibit has been received. The loan files are closed, and all loan and exhibit records are maintained as part of the permanent exhibit history of the hosting museum.

The National Gallery of Art, Washington, D.C. Photo by Elizabeth Gill Lui.

INTRODUCTION

Registrars have three main areas of administrative responsibility: personnel management, the budget process, and contract negotiation and implementation. The degree to which an individual staff member is involved with each of these services depends on the size of the institution and the placement of the individual's position within the museum's organization. However, these skills are no less important for a one-person registration department than they are for a department with several staff members, if the registration function is to be efficiently and effectively implemented in the museum.

ADMINISTRATIVE FUNCTIONS ▪ *Budget*

Paisley S. Cato

A budget is a tool used by a manager to monitor and control funds that come into and are expended by a "unit"; that unit might be a small project, a one-person department, or an entire institution. The manager responsible for the budget might be an individual who obtained a grant for a specific project, the department head, or the director of the museum. The general principles governing a budget are the same, regardless of the size and extent of the budget; however, the size and scale of the budget determine the levels of controls needed to monitor revenues and expenditures.

A budget is developed to support the objectives of the department or project. The written statement that clarifies the objectives for a museum registration department should provide the rationale for revenue and expenditure projections for the department. If the objectives for the fiscal year are clearly stated, the budget will be easier to develop and substantially more credible to administrators. The same logic holds for a project budget; the objectives of the project should be clearly stated to facilitate projections of revenue and costs. A project is unlikely to be funded either internally or by a granting agency if the dollar figures in the budget are not supported by the written description of the project and its objectives.

The budget consists of a projection of revenues and expenditures for the project or operating unit for a specific time period, frequently a fiscal year. The projections should be as accurate as possible, and the manager needs to be able to substantiate why specific amounts are needed. Obvious starting figures are actual revenues received and actual expenditures from previous years or similar projects. These may need to be adjusted simply for inflation or in response to changes to the department's operating plan for the year. For example, next year's budget may need to reflect additional personnel services for data entry of a large collection that has just been received by the institution. The dollars needed for that service depend on issues such as whether the museum will use contract personnel, personnel from a temporary employment

"Administrative Functions" edited by Paisley S. Cato

Acknowledgments: Rhonda Knighton and Pat Christenbury, Virginia Museum of Natural History, for secretarial support; to the Virginia Museum of Natural History for institutional support; and to Malinda Collier, Museum of the Confederacy.

agency, or an added full-time position. Full-time personnel will incur additional costs for benefits while temporary personnel may have a higher cost per hour but no benefits. Additional personnel services may also require an adjustment in expenditures for office supplies.

Another source for estimating costs is the commercial suppliers of materials and equipment. Cost figures can be obtained from catalogs, but it is usually necessary to obtain quotes. Shipping for cases of paper or heavy equipment such as fireproof cabinets can easily reach 10% of the cost of the equipment. Quotes should routinely be requested from the supplier for specialty equipment because catalog prices become outdated quickly.

Estimates for revenues can be difficult to make because the sources are not consistent from one year to the next. For a museum registration department, revenues may result from loan fees, user fees associated with providing copies of data, rights and reproductions, donations by museum members, or a grant received for a specific project.

Once a budget has been established and approved for the project or department, it becomes a tool to monitor revenues and expenditures for the time period covered by the budget. Whether an individual in the department or the business office tracks revenues and expenditures, the actual figures should be routinely compared to the budget figures. Depending on the size of the budget, the comparison might be monthly or quarterly. This comparison helps the manager to evaluate expenditures relative to the project's objectives and estimated costs. If some aspect of the project has cost more than anticipated, it is generally necessary to adjust expenditures for other tasks to avoid exceeding the bottom line dollar figure of the budget. On rare occasions, the manager might be able to request emergency funds to cover unanticipated expenditures. Budgets do have to be adjusted at times, and these adjustments might be the basis for requesting increased funding for the following year. However, if the budget must be adjusted too frequently, the manager's ability to project revenues and expenditures will be seriously questioned.

The budgeting process varies from one institution to the next, as does the role of the registrar in this process. Some institutions rely on a "zero-based budget" process whereby each year a department's budget is developed from "zero dollars"; this requires that every objective be scrutinized, justified in light of the museum's mission, and reflected directly through the projection of revenues and expenditures. Other institutions allot a certain dollar figure to each department and expect the department to develop a budget that fits within that set amount. The role of the registrar depends on the fiscal system of the institution as well as the position of the registrar in the staff structure.

A project often involves more than the registration department, and some budgets originate in a department other than registration but include that department. It is important to establish solid communication for exhibitions, storage upgrades, computerization projects, and other efforts that involve several departments within a museum. The primary department must be recognized and must be able to count on all others to contribute to the budget process.

Generally, the process is a cyclical one including:
- Development of revenues and expenditures for the time period
- Approval
- Implementation with monitoring and adjustments
- Evaluation
- Summary

Even a small budget of a few hundred dollars should proceed through this cycle. The evaluation and summary steps should not be skipped, as they may well provide clues to better budgeting for the following time period.

Regardless of the institution's requirements, all collection staff should develop good budget skills. These skills are transferable from one job to another and from project management to department management. Strong budgeting skills allow the registrar to put each dollar to its most effective use.

Paisley S. Cato

Staff are the most valuable resource a museum has for registration and management of collections. As such, it is vital that efforts be made to create a working environment that is productive, progressive, and respectful of the needs of the individuals as well as the institution.

Staffing patterns to fulfill museum registration responsibilities depend on the institution's size, mission, discipline, budget, and collection sizes and contents. Museum registration might be the responsibility of an individual who also handles education programs, or it might be the responsibility of a group of staff positions with a variety of specialties and unique responsibilities. Several factors common to standard human resource management practices will assist the museum in developing an effective staffing structure to fulfill museum registration responsibilities:

- Clearly defined, accurate job descriptions
- Clearly stated expectations for each position with regular periods of evaluation
- Methods for staff to provide feedback concerning staffing needs and positions
- Methods for staff to continue education and professional development

Most of these issues apply equally to full-time, part-time, and volunteer positions.

The head of the registration department must develop skills in hiring, training, and evaluating personnel. The registrar must also lobby for needed staff and be innovative and assertive in developing volunteer and internship roles within the department.

Job descriptions must be developed to reflect departmental priorities relative to the registration functions of the museum. Recognizing that some functions are essential and remain constant over time, while others may fluctuate as institutional objectives shift, it is important to evaluate job descriptions every year to be sure the job reflects institutional needs. This process should involve the individual in the position as well as the supervisor. Examples of job descriptions from other institutions are useful tools for analyzing one's own position, but they should be kept in perspective of the differing organizational structures, sizes, and priorities.

Volunteers and interns should also have formal job descriptions. Though these descriptions will frequently be more narrowly defined and less complex, they should clearly outline the tasks and responsibilities for the position. It is important for the individuals in these positions to understand precisely what is expected of them and how their tasks relate to other staff in the registration department and other functions in the museum. These job descriptions also provide a focus for training volunteers and interns.

Clearly defined expectations for each position must be established annually. It is easy for expectations of a supervisor to vary from those of the individual in the position, and there must be a dedicated effort to clarify expectations relative to content, schedule, quality, and priorities. Efforts to establish performance expectations should include opportunities for individual staff members to provide suggestions relating to the position and tasks involved. This feedback process can help focus the work that needs to be accomplished as part of the position, as well as help identify gaps and staffing needs. Volunteers and interns should also be provided with written expectations. As with the job descriptions for these unpaid positions, the expectations will not be as exacting as for paid staff, but they are equally important in guiding the development and productivity of the individuals in these positions.

Discussions concerning expectations should include plans for continuing education and professional development. Job preparation for most collection staff is as diverse as the individuals in the positions. In the absence of academic programs for museum registration, most staff have combined academic training in a discipline (art, history, science) with on-the-job experience and attendance at workshops and meetings. Staff need opportunities to learn specific skills, such as project management techniques and computer database management; and they need to improve levels of knowledge in specialized areas, such as legal issues that affect museum registration. With a constructive analysis of how the museum registration services can be improved in the institution and how an individual might better or differently fulfill certain tasks, a well-defined plan for professional development of staff will benefit both the institution and the individual.

A plan for professional development must address both the individual's and the institution's needs and priorities, with an assessment of how museum functions will be improved. Issues relating to training and professional development for collection-related museum positions have been discussed in a few recent publications including the *Cooperstown Conference on Professional Training* and *Developing Staff Resources for Managing Collections*. Both of these publications focus on identifying the core knowledge and skills needed for museum registration and collection management, followed by an analysis of the individual's current level of knowledge, and an assessment of the institution's needs. An institution is unlikely to fund development opportunities without an indication that these efforts will benefit the institution in the most cost-effective manner.

Museum staff should also develop and implement plans for training volunteers and interns. These plans should state clearly the goals, objectives, and methods for training relative to the positions and needs of the individual. A larger insti-

tution may have a department whose sole responsibility is managing the volunteer and intern programs, and the museum registration staff will interact with that department to ensure applicability of training programs to registration and collection management. However, in most cases, collection staff must develop training plans that focus on the needs of registration, management, and care as described in the job descriptions for volunteers and interns. There are several useful publications that discuss training volunteers and interns, for example the *Intern Preparation Manual* developed by the Registrars Committee of the American Association of Museums. However, it is necessary to adapt the principles and suggestions of these publications to the specific knowledge and skills required for the institution and job description of the internship or volunteer position.

Plans for training and professional development should include an evaluation component. It is important to evaluate the quality of the development opportunity itself, how well or whether the individual benefited from the opportunity, and whether the institution may benefit in the short or long term. Paid staff might be evaluated on how successfully they incorporate material learned from workshops into specific tasks or whether a series of workshops has improved the overall effectiveness of the work completed. Volunteers and interns might be evaluated on their ability to learn and implement new skills. Although the evaluation component is important, it should be clearly indicated as a formal part of the development plan at the beginning of the process, so that a staff member or volunteer is not surprised suddenly, after the fact, with an evaluation.

Paisley S. Cato

Registration services fulfill a clearly identified need in museums. Those services are provided through a series of tasks, some of which can be isolated as independent, unique activities, but most of which are interwoven with one or more other activities. The completion of these tasks is dependent on the existence of resources (money, staff, space, equipment, and time). The administrative services described in this section are tools that should be used to ensure completion of these tasks in the most effective manner possible. However, the effectiveness of the registrar's office depends on staff members' abilities to manage the administrative services and resources. Collection staff should be concerned with evaluating and improving the overall level of quality of registration services as well as with solving specific problems that appear all too frequently. Management skills can be learned, and all staff should consistently strive to improve their skills.

Several philosophies and techniques can help staff improve the overall quality and effectiveness of the registration services. There is no single method to improve a department's level of effectiveness, but a knowledge of different approaches helps staff members identify techniques useful for evaluation, improvement, and problem-solving. A few of the more common concepts implemented in both profit and nonprofit organizations include:

- Total Quality Management
- Team-building skills
- Cooperative decision-making
- Benchmarking
- Performance measurements

Total Quality Management (TQM) has four basic elements: customer satisfaction, commitment and leadership of management staff, quality assurance and results through continuous improvement, and employee empowerment and teamwork.

This program encourages participation of employees in improvement efforts and relies on measurements of activities or performance to provide feedback relative to improvements.

Most evaluation techniques, including TQM, require criteria against which feedback can be provided and improvement can be measured. Benchmarking, for example, is a comparison of programs or processes to establish reference points for continuous improvement. A similar technique involves the use of performance measurements, which quantify outcomes of the system. Benchmarks and performance measurements need to be quantifiable outcomes that can be consistently measured and that have some meaning relative to the basic objectives of the system. To use either of these systems, a museum registration department must:

- Clarify the basic objectives of the department relative to the museum's mission.
- Develop measures that reflect implementation of that objective.
- Gather data over time for those measures.
- Evaluate data.
- Institute improvements as needed.

Inherent in TQM and many management philosophies is the concept of team-building. As the phrase implies, different activities may be used to help a group of employees work together more effectively as teams. Team skills are important for solving problems in most institutions, and an example of a structured technique is the "Cooperative Decision Process." As presented by Mary Case and Will Phillips at the 1993 Annual Meeting of the American Association of Museums, this process includes a series of steps that a group of individuals may follow to explore an issue and arrive at a decision.

Another framework for problem-solving is presented in *Open Conversations: Strategies for*

Professional Development in Museums. The authors identify the following critical steps to resolving a problem:

- Develop a problem statement to identify the issue correctly and clearly.
- Determine whether your problem is worth solving.
- Select the problem that is first priority and analyze it.
- Determine restrictions on solutions.
- Examine possible solutions.
- Decide how to implement and evaluate the best solution.
- Implement the solution and follow up with documentation.

These steps are not effective unless they involve all of the individuals affected by the problem and are moderated by a team member to be sure all the steps are included.

It is important to stress that there is not a "best" way or "only" way to manage services and resources. Techniques need to be molded to the staff and situation. A technique that is appropriate for a large department with multiple personalities and expertise may be absurd for a small department with two staff members. At the same time, however, it is essential for staff members to improve their knowledge of management skills and to implement these skills.

Suzanne Quigley

Contracts are legally binding agreements between two or more parties detailing the responsibilities and obligations of each party. Some contracts are more formal in appearance than others and are often developed from "boiler plates," forms with blanks to be filled in. In another example of a contract, a "letter of agreement," the points to be agreed upon are articulated much as they are in the contract format while the document itself may not appear quite as formal. Museums should have a legal review process for all contracts they develop.

Many registrars have occasion to deal with several kinds of contracts. Although registrars should not write contracts on their own, they often work on contract drafts for legal review, and they are asked to read contracts to be certain that all elements relating to registrarial work are covered. It is best, in the first instance, if the registrar provides a thoughtful list of needs for an attorney to include in a contract.

The most common contracts, discussed below, are exhibition contracts, personal services contracts, and computer contracts. Although an insurance policy is not traditionally considered a contract, it too has clauses that are agreed upon. An insurance policy is a guarantee of service in the eventuality of a claim exchanged for money. Because insurance policies have standard clauses, they should also be considered contracts.

Exhibition contracts of the "boiler plate" variety have several standard clauses. Most important to the registrar are the clauses that cover his or her responsibilities to the exhibition:

- Schedule of venues
- Design and installation
- Security and climate control
- Packing, transport, and couriers
- Condition and conservation
- Insurance

- The attachments, which often include a detailed checklist

A list of clauses recommended in an exhibition contract can be found below.

Registrars often have to deal with personal services contracts. These contracts might apply to the services of a mount maker, a private conservator, a free-lance registrar, a free-lance photographer, temporary data entry staff, etc. Before entering into a personal services contract, the registrar should consult the museum's legal advisers to determine whether the employment situation meets the IRS definition for independent contractor or whether the individual should be hired as a regular, part-time, or casual employee. If counsel determines that a contract is appropriate, it is vital to indicate that the job is a "work for hire"; "work for hire" is carefully defined under copyright law, and has been interpreted by the courts. It is important, for instance, to be certain that a photographer hired to take pictures of the museum's objects for a catalog does not have ownership of all negatives, slides, transparencies, or prints. The copyright to the photos for such work should also lie with the museum. The contract should be developed so that the photographer does not have the right to use the negatives at a later date for his or her own purposes.

In addition, the terms of employment must be spelled out, including to whom the contractor is to report, the schedule for the completion of the work, an outline of the compensation agreement, and a clear indication of the status of the contractor with regard to worker's compensation, holiday and sick pay, etc., as determined by the legal advisor's review. Usually a contractor is also required to maintain and provide proof of insurance and to accept an indemnification clause, wherein it is stated that the contractor will hold harmless the museum and all its parties for any liabilities that might arise from

negligence, wrongful acts, breaches, failures, etc. An outline of issues to consider in a personal services contract follows below.

As is the case with all contracts, computer contracts protect both the vendor and the museum. Whether a museum buys a packaged system (pays for license to use it) or contracts with a programmer to write a program, computer contracts can be difficult to understand. Some of the main clauses in a computer contract include:

- Clarification of the functions the software is expected to perform
- The type of support the museum can expect from the vendor
- The number of persons who may use the system (if a multi-user site license, the number of concurrent users allowed)
- The nature and duration of maintenance that will be provided
- The nature of support provided by the vendor
- The schedule for implementation and acceptance of the system
- The frequency and cost of periodic upgrades and charges

- The amount of training, a description of the documentation
- Fees and associated costs

Other contractual considerations are data conversion, post-installation modifications, and the cost of future program modifications after acceptance. It is particularly important to spell out exactly who owns the software, especially the source code. If the programming is done as a work for hire, then the source code is owned by the museum. If the program is written by a vendor, generally, he or she will retain all rights to the source code.

The negotiation of an escrow agreement for the source code is advisable. An escrow agreement is a side agreement (but can be incorporated into the main contract) guaranteeing the museum access to the source code should the vendor's business fail or should there be breach of contract on the part of the vendor. When the source code is held in escrow, it is held by a third (neutral) party in the event that the client museum might find itself without any possibility of support from the vendor.

A computer contract should also contain a warranty clause and a termination clause. If

Works for Hire:

[Name of Consultant] ("Consultant") agrees to assign all of its right, title and interest in the [work product], including copyrights, patents, trade secrets, tradenames, trademarks, or other proprietary rights, to [the museum] ("Museum"). Consultant agrees to execute any and all documents necessary to effectuate this assignment. Consultant represents and warrants that it has not granted any other part any rights in or to the [work product] nor received any written notice or claim that the [work product] infringes on the proprietary rights of any person.

Some of the above may not be applicable to each situation, e.g., patents, etc., would not be applicable to a photograph. Also, if the arrangement is that the consultant will own his own copyright but that the Museum will retain certain rights, the agreement should provide that the consultant grants to the Museum a [non-] exclusive, irrevocable, royalty-free license to [use the work product for exhibition and/or publication purposes.]

The above language should be included in work-for-hire contracts.

the museum does not fulfill its responsibilities, (e.g., non-payment or unallowed redistribution), the vendor has the right to terminate the museum's license to use the software.

The individual responsible for preparing a contract should obtain examples of similar contracts from other institutions. Several examples of contracts as well as checklists of issues to consider are included in recent study guides for the ALI-ABA course, "Legal Problems of Museum Administration." If the museum has no purchasing officer who routinely reviews and processes contracts, it is advisable to have contracts reviewed by the museum's lawyer to ensure accuracy and clarify liability issues. Contracts for specialized services require more extensive research, drafting, and review before they can be processed.

EXHIBITION CONTRACTS ADDENDUM

1. Introduction
 a. State exhibition name
 b. Name the parties
 c. Name this as an agreement
2. Organization and Content
 a. Cite object list as Exhibit A
 b. Have consulting committee (optional)
 c. Prohibit deletions/additions unless written agreement
 d. State organizer's responsibility for obtaining all loans
 e. State organizer's responsibility for overall organization
 f. Authorize organizer to remove an object for reasonable cause
3. Schedule
 a. List venues and dates
 b. State that changes must be made in writing
4. Design and Installation
 a. Name design committee of curators at each venue (optional)
 b. Assign responsibility for exhibition furniture, alarms, mounts, labels, didactic panels, etc.
5. Security and Climate Control
 a. Overall facility
 1) Fire prevention and detection systems requirements
 2) Heating, ventilation, and air conditioning standards
 3) Security systems requirements
 b. Temporary storage, staging area, exhibition space
 1) Security requirements
 2) Climate control standards
 3) Staffing requirements
 4) Object handling standards
 c. Exhibition area
 1) Humidity requirements
 2) Temperature requirements
 3) Exposure restrictions (heat, light, air sources)
 4) Light levels, UV-protection standards
 5) Food, drink, and smoking restrictions
6. Packing, Transport, Couriers
 a. Assign responsibility for packing, shipping customs
 b. State minimum number of days before and after exhibition allowed for shipping
 c. Indicate that organizer may designate courier(s) (optional)
 1) Assign responsibility for courier expenses
 2) State whether expenses will be reimbursed or prepaid
 3) State whether expenses to be paid on receipts or per diem
 d. Assign unpacking/repacking responsibility
7. Condition, Condition Reports, and Conservation
 a. Assign responsibilities for the following:
 1) Outgoing condition reports and book

 2) Photographs

 3) Signatures

 b. Prohibit unframing and photography

 c. Specify hanging mechanisms, mounts, and case requirements

 d. Prohibit treatment without written permission except in an emergency

 e. Require immediate notification of organize"s registrar upon loss or damage

8. Insurance

 a. Describe coverage, usually all risk wall-to-wall

 b. Participants co-insured or waiver of subrogation

 c. Organizer will handle all insurance claims, etc.

 d. Damage in transit or on premises (take photos), notify organizer's registrar

 1) Documentation

 2) Save all packing materials

 3) Notify carrier

 e. If loss not covered by insurance, liable if negligent

9. Immunity from seizure (optional)

 a. International loans coming to states

 b. Exhibition in another country

10. Catalog

 a. Describe

 b. Assign pre-production costs (optional)

 c. Indicate number provided free to venues

 d. State number venues must purchase at what price

11. Didactic Materials

 a. Indicate what will be provided: wall labels, text panels, etc.

 b. Indicate format: available as panels, on computer disk, etc.

 c. State whether foreign language translation will be available (optional)

 d. List materials available for sale from organizer

 e. State that materials produced by venues are subject to approval by organizer

12. Education Adjunct

 a. Media programs

 b. Must show/use

 c. Distribution rights rest with organizer

 d. Cost is in total exhibition fee (optional)

 e. Format delivered per agreement with venues

13. Publicity, Promotion, Photography, Reproduction

 a. Each venue responsible for publicity

 1) Media may tape in exhibition

 b. Available for publicity and education only

 1) Press release

 2) Black-and-white photos

 3) Color transparencies

 c. Photography by public prohibited

 d. Venue will give to organizer N copies

 1) Installation views

 2) Black-and-white photos during public hours

 3) All printed matter produced

 4) Reviews

 5) Attendance statistics

 e. Extra requested materials at borrowers cost

 f. All materials produced by venue using images must

 1) Give full catalog information on artwork

 a) Artist name

 b) Title, date

 c) Medium

 d) Name of lender (as provided)

 e) Name of photographer

 2) No cropping, bleeding, printing in color other than black-and-white, nothing superimposed

14. Financial Arrangements

 a. Participants agree to pay per schedule

 1) $N upon signing

 2) $N upon receipt at museum

 3) $N upon close

4) Shipping pro rata (optional)

5) Shared costs per attached schedule (optional)

b. No responsibility for financial loss at a venue

c. Local costs + staff time venue's responsibility

d. Shared costs invoiced by organizer (optional)

e. Purchase of items for sale subject to another agreement

15. Development and Credit Lines

a. All to abide by sponsorship requirements

b. Credit lines acknowledge funding

1) Approved by organizer

2) Use in all promotional literature

c. Additional local sponsors' credit line

d. Organizer's credit line

e. Sponsorship of opening events

16. Cancellation

a. If organizer cancels, venue gets refund

b. If venue cancels

1) Full fee

a) Unless another venue found

b) Termination fee

2) If *force majeure*, then just settlement of costs

17. Miscellaneous

a. N articles + N exhibits equals entire agreement

b. Exhibition available to all without discrimination

c. Agreement supersedes any other

d. Agreement cannot be assigned unless in writing

e. Governing law

18. Signatures, Dates

19. List of Attachments

a. Object List

b. Loan Agreement Forms (optional)

c. Shared Cost Budget (optional)

d. Catalog Budget (optional)

e. Insurance Package (optional)

f. Payment Schedule (optional if written into contract)

g. Corporate Sponsor Agreement (optional)

PERSONAL SERVICES CONTRACTS ADDENDUM

1. Engagement

a. Contract for hire

b. Subject to terms outlined here and in performance of services specified

c. Reports to

d. Schedule for completion of work

e. Agreement to bring professional skills and adequate time to job

2. Compensation

a. Agreement of amount

b. Discussion of fringes (applicable or not)

c. Reimbursement for out-of-pocket expenses as agreed with documentation

3. Status

a. Independent subcontractor— not employee or agent

b. Museum not liable

1. Worker's comp

2. Pension

3. Holiday/vacation/sick pay

4. Personal injury insurance

5. Personal property insurance

c. Shall not incur obligations on behalf of museum

4. Other terms

a. Agree to maintain own insurance and furnish proof thereof

b. Information gained through job confidential except to the extent necessary to do the job

c. Agree to be bound by the terms of the contract

5. Indemnification

a. Agree to indemnify, hold harmless all museum parties for liabilities, etc., arising out of services including negligence, wrongful acts, omissions, breaches or failures

6. Signatures, dates
7. Attachments
 a. Itemization of services to be rendered

COMPUTER CONTRACT ADDENDUM

1. Delivery
 a. Definition of software
 b. License agreement
 1) Number of users
 2) Number of locations
 c. Delivery and payment
 1) Schedule for delivery
 2) Schedule of payment
 d. Client responsibility
 1) Hardware compatibility
 2) Operating system compatibility
2. Maintenance and Support
 a. Initial maintenance period
 1) Discovery of problems
 2) Corrections supplied
 3) Telephone support
 4) Elective modifications, refinements, enhancements, etc.
 b. Extended maintenance period (subject to separate agreement)
 c. Implementation
 1) Museum's obligation to load modifications
3. Ownership of Software
 a. Definition of vendor's rights
 b. Agreement by museum to protect vendor's rights
4. Warranties
 a. Indemnification of museum by owner
 b. Non-conformance of product to documentation
 1) Notification by client
 2) Termination of lic ense by client
 3) Deferment of payments to vendor
 4) Client receives escrowed materials

5. Termination
 a. Breach of contract
 1) Declaration of unremedied period
 2) Written notice of reasons
 a) Failure to pay
 b) Bankruptcy
 b. Termination of license
 1) If vendor is in breach
 a) License is allowed the client
 b) Client receives escrowed materials
 2) If client is in breach
 a) License is terminated
 b) Software must be destroyed
6. Miscellaneous
 a. Scope of the agreement
 b. Additional software purchases from vendor fall under same agreement
 c. Assignment of rights by either party only by agreement of both parties
 d. Governing law
 e. All notices in writing
 f. Use of clients' name by vendor
7. Signatures, dates
8. Attachments
 a. Implementation Schedule
 b. Training Schedule
 c. Extended Annual Maintenance Agreement
 d. Source Code Escrow Agreement

Paisley S. Cato and Stephen Williams

Policies for managing collections provide the framework for decisions that determine the long-term development, care, and management of an institution's collections. They must provide guidance for situations that may not have occurred; thus, they must be broad enough to be flexible but not so broad as to be useless. Procedures, by contrast, provide the mechanism and details needed to implement the policy. A policy may be as short as a single paragraph, whereas the procedures for implementation of the policy may require several pages of text and forms. In final form, written policies and procedures provide direction, continuity, and predictability.

There are several approaches to developing policies for the management and care of collections. By far, the best approach is to start from scratch and develop a holistic document that addresses all major issue and ensures that they complement and supplement each other in the most efficient and effective manner possible. More realistically, many institutions may be faced with revising a set of existing policies, adding individual policies not previously developed. However, a committee that has been formed to revise a set of policies should expect to rewrite major sections if the entire set of policies would be made more effective by doing so.

The process of developing a set of policies is as important as the resulting document. The ultimate determination and approval of policies is the responsibility of appropriate level of authority (e.g., board of trustees, director). However, staff should be responsible for recommending specific policies. A committee assigned this task should represent differing perspectives within the institution: researchers, collections managers, conservators, administrators, and public program staff (education, exhibits). There should be a mix of those who manage the procedures with those who implement them. A small museum with few staff might develop an advisory committee comprised of volunteers, board members, and colleagues from other institutions. This advisory committee can provide expertise and serve as reviewers.

Like strategic planning, policy development is a time-consuming process. Issues should be discussed from a variety of perspectives, including museum functions related to collections (use, management, preservation), disciplines represented in the museum, and the specific institutional context. How does the ideal fit the institutional mission and resources?

Developing the content of a policy requires attention to and clarification of several basic elements:

- The mission of the institution
- Organizational structure and available resources
- Purpose and objective of the policy
- Authority for implementation
- Levels of approval required for the policy
- Laws, professional guidelines, and ethical standards

These topics are not necessarily simple or straightforward, but the process of researching, discussing, and arriving at a consensus for each can be a constructive, educational effort for all involved.

Policies governing collections management must be based on and must support the mission statement of the institution. The mission statement provides focus and direction for collection development and determines resource needs at both institutional and departmental levels. Collections policies should be developed first at the broadest institutional level possible (e.g., museum-wide policies) before more specific discipline-oriented policies can logically be completed.

The objective of each policy should be clearly stated. Making an effort to state the objective in one or two sentences helps focus discussion

and formation of the policy. It is easy to be too inclusive and mix several issues that confuse rather than clarify an issue. Questions that should be addressed include:

- Does the policy have impact most directly on the collections-related goals of the museum (e.g., documentation), or are the collections only one component affected by the policy (e.g., health and safety)?
- Is there an institution-wide issue that should be stated as an umbrella policy, with the expectation that certain collections/departments might develop more restrictive policies (e.g., sampling of specimens for analysis)?
- Does the issue have legal or fiscal implications that require formal approval by the governing body?

Focusing the intent of the policy is a necessary precursor to identifying who in the museum has the authority and responsibility for its implementation. Both the objective and the level of authority must be defined before determining whether the policy needs approval by the board of trustees, or whether it is more appropriately an internal policy that requires director-level approval.

Regardless of the institution's size, discipline, or mission, its policies for managing collections must be based on current legal and ethical standards. Care must be taken during the development process to research and discuss relevant laws, guidelines, and standards. Basic references useful for developing policies include Malaro's book, *A Legal Primer on Managing Museum Collections*; Porter's AASLH Technical Report, "Current thought on collections policy: Producing the essential document for administering your collections"; *Professional Practices in Art Museums*; a previous article on this subject by Cato and Williams, "Guidelines for developing policies for the management and care of natural history collections"; a recent publication edited by Hoagland for the Association of Systematics Collections, *Guidelines*

for Institutional Policies and Planning in Natural History Collections; and study materials published annually for the "Legal Problems of Museum Administration" workshops held by the American Law Institute-American Bar Association (ALI-ABA). Other basic references include the recent *Code of Ethics for Museums* developed by the American Association of Museums and the ICOM *Statutes and Code of Professional Ethics*.

Early in the development process there should be a session devoted to terminology. It cannot be assumed that all members of a committee define a term the same way. A simple glossary of basic terms provides a standard for committee members to use. This seems absurdly simplistic and possibly offensive to committee members; yet, how can an acquisition policy be developed if the term "accession" is used differently by individuals from different disciplines? For example, staff in an herbarium traditionally use "accession" in the same way that other disciplines use "catalog"; or some might use "collection" to describe the institution's total set of objects and specimens, whereas others might use it to refer to an individual disciplinary component.

The development process should also include a routine procedure for discussing, writing, reviewing, revising, and approving a policy. An established procedure for the process lessens the "threatening" aspect of a new policy. If staff members understand there is a point in the process at which they can review and comment on a drafted policy, there is a greater likelihood that the policy will be implemented effectively in the future.

The final content and appearance of policies for managing collections depend on institutional needs. However, it is useful to develop a rough outline at the beginning of a development process so that committee members and staff reviewers understand the range of issues to be addressed. As the policy is developed and major issues are addressed, the outline is likely to change.

A sample outline might include the following:
Introduction
Mission Statement or Statement of Purpose
Statement of Authority
Definition of Collections
Collecting Plan
Ethics
Collections Management Activity
 Documentation
 Acquisition
 Deaccession
 Access
 Loans
 Incoming Loans
 Outgoing Loans
 Courier Policy
 Care and Maintenance
 Conservation
 Storage
 Environment
 Inventory
 Risk Management
 Insurance
 Integrated Pest Management
 Disaster Planning
 Security
Monitoring, Revising, and Compliance

The mission statement and statement of authority will be in place for most museums and need only be placed in the policy. Those two documents, however, drive the rest of the collections policy and should be referred to often throughout the policy development process. It is standard for a museum to develop the policies necessary for its most important activities first; thus, accessioning, access, deaccessioning, and loan portions of the policy are often among the first to be written. The process should be completed systematically, however, and the issues of monitoring, revising, and compliance should become normal parts of the museum routine.

SUMMARY

The development of written policies for the management and care of collections should begin with a clear understanding of the nature and objectives of the document to be produced. This will help define the working parameters and promote conciseness and continuity within the document. A holistic approach will substantially improve the effectiveness of the document. The usefulness of collection policies depends on the effort made during the development process to research issues, to solicit extreme and contrasting perspectives, to encourage staff participation in the development and review process, and to arrive at recommended policies that can realistically be implemented. The development of policies should be an on-going process, changing with the needs of the institution. Policies must be periodically reviewed to ensure their compliance with current laws and professional standards as well as to ensure their usefulness for managing and caring for collections.

Mary Holahan

Museums are among the world's richest sources of images for reproduction in printed and electronic media. Dissemination of reproductions of objects in museum collections advances the educational mission of the museum and may generate income. Before undertaking any reproduction services, museums must determine what, if any, legal limits exist for reproduction and distribution of images in their collections. That is, museums must know if, and to what extent, they own the copyright to collection objects and photography of collection objects.

Copyright is a complex legal issue, governing a wide range of created works including, but certainly not limited to, paintings, drawings, photographs, sculptures, films, video, and musical and literary works. It may also extend to non-utilitarian works of craft and design. The complexity of United States and international copyright laws is such that museum professionals with responsibilities in the area of rights and reproductions should have source material such as Marie C. Malaro, *A Legal Primer on Managing Museum Collections*, Smithsonian Institution Press, Washington, D.C., 1985. They should also keep current, through professional publications and conferences, with changing laws pertaining to copyright, especially in the rapidly developing area of electronic media. (See chapter on Copyright.)

If the museum does not own copyright or does not have a non-exclusive agreement with a copyright holder, images may be provided with the explicit understanding that the person requesting image use is responsible for procuring copyright release.

Once a museum has established that it has the right to grant permission to reproduce images in its collection, it should maintain close control over the process through appropriate contracts. If the collections photographer is not a staff member of the museum, a contract specifically giving rights in the photographs of objects to the museum should be entered into with the photographer.

Several basic conditions should govern the permission to reproduce photographs of art and artifacts in the museum collections:

- Request must be made in writing.
- Reproduction rights are granted on a non-exclusive basis only for one usage in one North American publication, one edition, and one language; permission to publish in each subsequent edition or reprint must be obtained in advance.
- Special permission must be granted for world rights and additional languages.
- All reproductions must be made from photographic materials supplied by the museum; these materials remain the property of the museum.
- Unless the museum agrees otherwise in writing, each object must be reproduced unaltered and in its entirety; the reproduction must be full-tone black-and-white or full color and must not be bled off the page, printed on color stock or with colored ink; nothing may be superimposed on the image; when a detail is used, the word "detail" must appear in the caption with the complete credit line.
- The reproduction must be accompanied (directly under the reproduction, on the facing page, on the reverse, or in an index or list of illustrations) by the full caption and by credit lines as specified by the museum.
- The museum must see a proof before color reproduction is approved.

Acknowledgment: John Magill, Historic New Orleans Collection.

In addition, the museum should include a statement alerting users of its photographic materials to certain legal ramifications. Such a paragraph should include the following:

The museum makes no warranties or representations and assumes no responsibility whatsoever for any claims against applicant or museum by artists, their agents, estates, or by any parties in connection with the reproduction of works of art in the collections of the museum. The applicant agrees to indemnify the museum and hold it harmless against any and all such claims, including copyright infringement claims, royalty or fee demands and/or actions, including the costs thereof, arising as a result of the applicant's reproduction of the works of art in the museum's collections. Any and all royalty payments or other requirements specified by the copyright owner of such a work must be paid or honored by the publisher or agent requesting reproduction permission.

Most museums charge for the services of providing photographic materials and granting the right to reproduce, usually required in advance in U.S. currency or international money order. The client should also provide a gratis copy of the publication to the museum. A photographic and reproduction fee schedule should clearly set forth the costs for each service, including:

Photography (color and black-and-white):
- Photographs from existing negatives
- Photographs for which a negative must be made
- Color transparencies (ordinarily rented for three months)
- Slides

Reproduction:
- Rights for one-time editorial use
- License agreements
- Royalty agreements
 License and royalty agreements require special contracts defining the limits of usage and fee arrangements.

- Image resolution restrictions for CD-ROM and related media

Fees (sliding scale)

For-profit clients:
- Film, video, advertising
- Book jackets, magazine covers, album/CD covers
- Illustrations in books, journals, magazines

Not-for-profit clients:
- Museums and other not-for-profit organizations/publications
- Scholars
- University-level students

Shipping costs (may be charged to client's account on museum-specified carrier)

While many large museums have fully staffed photographic services offices, smaller museum often rely on the registrar to handle these services, including rights and reproductions. Some museums contract with commercial services such as Art Resource for handling rights and reproductions. It is in the museum's interest for staff to be fully aware of the complexity of rights and reproduction services and to consult with legal counsel when developing such services.

K. *Sharon Bennett*

Archives are created and maintained to preserve records of lasting value and to make them accessible for use. In addition to providing physical control of the materials, a museum must consider the intended use and intellectual control of these materials. The maintenance and retention of important records can be relatively simple once proper policies and procedures are established by the board, administration, and archivist or person serving in an archival capacity. Since there are similarities between the registrar's record-keeping activities and the archivist's responsibilities, the registrar may be charged with administering the institutional archives in small and medium-sized museums. There are several excellent publications on starting and maintaining an archive that will aid the successful archival administrator. Some of these resources are noted in the bibliography.

Among the initial difficulties faced in establishing an archive are determining what to consider archival and understanding the terms applied to various types of materials. As stated by Julie Bressor in *Caring For Historical Records*, the term "archive" can have several meanings depending on its use. It can be the physical area housing the records; the agency responsible for selecting, preserving, and making the materials available; or a non-current record of an institution preserved because of its continuing value.

In many institutions, for convenience of storage and handling, library and archival materials are housed in the same areas. There are, however, some important distinctions that must be made between library and archival holdings, which differ in both form and function. Library materials generally are published resources concerning a single topic or series of related topics, whereas archival materials are generally the non-published and non-current records of an institution. These materials are usually compilations of records important to the operation or history of the institution but no longer active or needed for their original purpose. Some, such as annual reports, may be published. Other materials include manuscripts and printed items and might include departmental records, correspondence, financial and personnel information, minutes, publicity, membership records, etc. These records come in a variety of formats, including ledgers, scrapbooks, photographs, computer-generated records, audio-visual materials, and others, as noted by Bressor.

ESTABLISHMENT OF POLICIES AND PROCEDURES

For the most part, the archival records retained will be the products of institutional activities. A vital step in beginning an archive is to establish the policies and procedures that will govern the acquisition, arrangement, and use of the materials. The policies should be approved by and have the full support of the administration and governing body. They provide the framework for procedures and decisions. The following statements should be created.

Mission Statement

Essentially a statement of purpose and goals, the mission statement should indicate the authority under which the archive is established and define its place in the overall organization of the institution. This statement may also define which records will constitute the archive and who assumes the responsibility for carrying out the necessary task. Statements regarding collecting focus should also be included. The mission statement should clearly indicate which materials created or compiled in the course of business are the property of the organization.

Statement of Authority/Organizational Placement

A clear and concise statement of authority is necessary to establish internal support and should indicate where in the organization of the institution the archive is positioned. The higher the archival program is placed in the overall organizational structure, the greater the chance of achieving the goals set forth. This statement can be, but does not necessarily have to be, a part of the mission statement, according to Elizabeth Yakel in *Starting An Archives*.

It should make clear the authority, schedule, and frequency by which materials will be collected or transferred to the archive, the availability of the information, and conditions or restrictions governing the retention of materials. The policy may also indicate the types of materials that will not be included because of overlap with another department. In any organization certain materials and records have a defined period of use, past which the frequency of use declines. It is at that point that the materials should be considered archival and transferred to the archive, provided that the information is considered to have lasting value. Establishing a schedule for transfer to the archive can facilitate the separation of vital from valueless and prevent the archive from becoming a storage area for unwanted records. Transfer schedules also help discourage an accumulation of inactive records that can lead to the loss of vital records through improper "house-cleaning." These schedules, as well as access policies, should be reviewed by counsel.

Access and Use Policies

Every archive should have a policy defining its intended use. This should include statements regarding general access, restrictions, and use limitations. Procedures for requesting and copying records are based on this policy. In some cases it may be necessary for several staff members to have daily access to the archival materials. In such cases, the development and implementation of standardized procedures regarding access is critical to maintaining good control over the records. It is important to have general statements about which records are considered open and which are subject to restrictions, about the conditions of restriction, and about procedures required for use.

Collections Development/Management Policy

The needs of the institution, its staffing, and its financial ability to maintain the records it creates are important considerations in establishing an archival collection policy. Collecting priorities should be based on input from the staff and administration. The collection policy should state what materials are acceptable and set priorities and limitations for collecting.

SCOPE OF THE COLLECTION

Acquisition

Once physical control over the collection has been established, it is necessary to consider intellectual control and to make a determination regarding the permanent value of records. This will determine what will be kept.

Various types of media, including paper, audio or video tapes, computer-generated records, photographs, film, other works on paper, and objects often are included in the archival record. Arguments can be made against the archive's assuming responsibility for artifacts and some types of media. However, if no one else in the organization is able to care for these materials, the archivist may choose to assume the responsibility.

Appraisal is the process by which archivists evaluate the enduring value of records. The archival value can be assessed by projecting possible uses of the records for reference and research determined by the information they contain on personnel, places, events, and activities. In some cases individual items have an intrinsic value, that is, they are deemed worthy because of the creator, use, physical form, and/or content. Items or documents with intrinsic value are always kept in their original form.

In *Selecting and Appraising Archives and Manuscripts*, F. Gerald Ham notes five considerations

that form the basic tools necessary to appraise records and identify and select those of enduring value. There should be:

- A record's functional characteristics: Who created the record and for what purpose
- The vital information contained in the record and how this information relates to other documentary sources
- The potential uses for the record
- The physical, legal, and intellectual limitations on access
- The cost of preserving the record weighed against the benefit of retaining the information

Records should be evaluated on the basis of their administrative, fiscal, legal, historical, and informational value. Typically, institutional archival records should include architectural and building plans, financial records, personnel records, board minutes, annual reports, publications, photographic records, audio and video tapes, correspondence, departmental records, ephemera, and memorabilia.

Arrangement and Description of the Collection

Archival arrangement is based on two important principles: provenance and original order. Most records of institutions will come to the archive with a pre-existing order indicating the particular way they were handled by the person or department creating them. The most important factor in the organization of archival records is their provenance, maintaining the context in which the records were created. As stated by Ann Pederson in *Keeping Archives*, the term provenance refers to the place of origin of the records, i.e., the organization or person that created, received or accumulated, and used the records in the conduct of business or life. Since archival records are the byproduct of an institution, activity, or person, maintaining the context in which the record was created is essential to the future historical understanding of the organization, individual, or activity. Simply stated by Yakel, materials from one records creator or compiler should not

be intermingled with those of another, despite similarities in subject matter.

The second principle of arrangement is original order. In other words, groups of records should be kept in their original order and not rearranged by the archivist. Any order originally imposed by the creator of the records should be observed and followed. For example, it is not necessary to organize materials in a chronological manner if the creator did not. This again provides information about the context of the records. Rearrangement can be very time consuming and subjective. As a result, archivists tend to keep almost all existing coherent filing systems, even if they are not ideal. As Miller points out, original order is preserved unless it is clearly detrimental to the use of the records being retained. If records do need to be rearranged, a careful plan should be prepared and outlined before any materials are actually moved. It may be necessary to remove special forms of materials from a collection, formats such as photographs or architectural drawings, to provide them with proper safe storage. If this is done, a note should be inserted identifying the item removed and its new location. This will preserve the context while allowing for safe storage. *Guidelines For Arrangement And Description Of Archives And Manuscripts*, a manual for historical records programs in New York State, provides these and other useful recommendations on arrangement.

Archival description is the process of gathering information about the origin, context, provenance, and original order of a group of records, as well as describing their physical and intellectual arrangement and recording that information in a standardized form. In order to describe a collection adequately, information should be included on the filing structure, format, scope and content, relationships with other records, and the ways in which information can be located.

For the most part, institutional records are often in the form of a series, defined as a body of documents, maintained as a unit, and arranged according to a filing system. As stated by Pederson,

"a series consists of records which have been brought together in the course of their active life to form a discrete sequence. This sequence may be a discernible filing system, or it may simply be a grouping of records on the basis of similar function, content, or format." Typical series include minutes, correspondence, reports, newsletters, ledgers, etc. (See Miller's list of "Common Types of Functional Records Series.")

The primary goal of description is to provide access to the information easily. The level of description chosen for each record should correspond to the research value and anticipated need for the information contained in the record.

When materials are transferred to the archive, the archivist must determine whether value of the individual record is sufficient to warrant description by the item or by the file, or whether an overall description will be adequate to retrieve the necessary information.

Two excellent resources on what to consider and how to begin describing institutional records can be found in the publications *Guidelines for Arrangement and Description of Archives and Manuscripts*, published by the State University of New York, and *Starting an Archives* by Elizabeth Yakel.

Finding Aids

Archives exist to house non-current records in a useful manner. In institutional archives, use will be primarily by staff of the institution for internal research and documentation. On occasion, the records will be used by historians and other researchers. To provide ready access to the information, finding aids are necessary.

The finding aid, whether in the form of an index or narrative, should include the following:

- Information on the creator
- The volume of materials—is it a file folder or several boxes?
- Type of record—is it paper-based materials, are there photographs, maps, magnetic media?
- Intellectual contents; and arrangement—are they organized by topic or medium, chronologically or alphabetically?

A condition statement is important, particularly if the materials are in poor physical condition. Any use restrictions or limitations due to condition or content should be noted.

It may be necessary to take the processing of some collections to a more detailed level than others. As there are varying levels of arrangement and description that can be used in the processing of collections, flexibility is needed in the types of finding aids or user guides that are provided. For example, use by institutional staff may require the best-stated, most current, or succinct records available; a historian or external researcher may require all available sources on a particular topic for an historical approach to the subject.

When examining a set of records and during the arrangement and description inventory, all possible uses of the collection should be noted; this can save time when writing the finding aid for the records.

Depending on the overall size of the collection, it may be necessary to provide physical finding aids for locating particular items within the collection. This is best handled by creating a container list indicating which box contains which information. Sometimes a folder list for each box is helpful or necessary.

Records Transfer/Retention Schedules

A schedule of periodic transfer from the creator of the records to the archive should be established by the administration. Prior to the transfer, it may be helpful to establish procedures that outline the steps to be followed in preparing the material for transfer. It may be necessary to provide a receipt for the items. Due to the nature of institutional records and record keeping, the archive will receive transfers from the same provenance over time. The establishment of transfer guidelines will help ensure that the records are received in the same format and can be more easily integrated into the established series. Some records, such as personnel and financial materials may be considered sensitive, and any restrictions on their use and access should be noted at the time of transfer.

Storage and Handling

As with all museum collections, the storage and handling of archival materials play a critical role in their longevity and thus represent an important factor in the determination of the formats used to retain the information. Good storage equipment and cabinetry must also be accompanied by proper handling by staff. In some cases it will be necessary to limit use of certain records groups; any photocopying and handling of such records should be conducted by trained personnel.

Most, if not all, of the records retained by the archive, no matter what the medium—paper, disc, tape, photographs—will deteriorate over time due to their inherent vice. In paper collections this can be the amount of acid incorporated in the paper during production. For discs and magnetic media it could be the result of binder failure or deterioration of the binder layers. These problems are often exacerbated by poor environmental conditions, including exposure to light, humidity, high temperature, air pollution, pests, and mold. An examination of proper environmental conditions for museum collections is discussed in another chapter. (See chapters on Preventive Care and Storage).

Most archival records are housed within a micro-environment provided by folders and boxes. Any materials that come into contact with records should be conservationally sound. Housekeeping is often a problem in records storage areas, and particular attention should be given to keeping these areas neat and dust free. As with all collection areas, there should be no eating, drinking, or smoking in the storage area or in any areas where the collections might be used. For a comprehensive discussion on the storage and housing of archival materials, before any new housing materials are acquired, see *Preserving Archives and Manuscripts*, by Mary Lynn Ritzenthaler.

Shelving and Cabinetry

All shelving and cabinetry used in the storage of archival records should be heavy-duty non-damaging metal, strong enough to provide good physical support for the collection. Shelving with any physical problems such as sharp or damaged edges or rust should be avoided. All shelving should be secured, bolted to the floor, to the wall, or to each other across the top, to prevent falling. The location of the storage units is important. If possible, shelving should not face a window, since natural light can cause fading and produce heat. If this is not avoidable, shades or curtains can provide some protection from light damage. It is also important to avoid housing cabinetry units on exterior walls, since the danger of moisture problems and leaks in those areas is greater. Bottom shelves should be at least six inches from the floor to guard against problems from water damage due to flood. If the institution has a sprinkler system or other water pipes near the ceiling, it is advisable to have canopies over shelving to prevent water problems from above.

Materials and finishes to be avoided include wood and wood products containing formaldehyde and materials that produce harmful gas as they age or deteriorate. These would include press-board, chip board, plastic laminates, polyurethane paints and varnishes, and pressure-sensitive materials. Wooden shelves, drawers, and filing cabinets are not suitable storage and should be avoided since they typically off-gas, and the acids that naturally occur in wood can leach into the items stored. As a general rule, if the storage container or cabinet has produced or is producing an odor, it is not suitable storage for archival records.

Storage of Paper Records

In most cases, paper boxes, folders, envelopes, and sleeves provide the best storage for archival records. Any materials that come into contact with the records should be non-acidic and buffered. While many companies advertise "archival" materials, it is important to make sure that the advertising is truthful and that proper supplies are purchased.

The terms acid-free, lignin free, and 100% rag are all designations for conservationally sound materials. There are different types of enclosures available with a variety of details, such as reinforced hinges or a wider margin at the top; if possible, examine a variety of different styles to determine

those best suited to the collection. Paper enclosures have a number of advantages for storage: they provide support for the item enclosed; the alkaline reserve can help slow or prevent acid migration; and they are easily labeled.

All marking and labeling of folders should be done in pencil, not ink, since many inks are water soluble or can flake off when dry. Pressure-sensitive adhesive labels are not suitable as they have a tendency to peel off over time, leaving a sticky residue.

One recognized disadvantage of paper enclosures is the inability to view the contents without pulling the object out. This can result in mechanical damage of some items, particularly brittle paper. When ordering supplies, it may be best to purchase those enclosures that do not have a thumb cutout so that the contents are not always grasped in the same spot.

Plastic enclosures are also available for archival material, but should be used with caution since moisture problems can develop inside the sleeves if there are any problems with temperature and humidity fluctuations. The plastic chosen should not exude harmful material or gas. Plastic should be internally plasticized so that the plasticizer does not migrate into the stored materials. Good choices include polyethylene and polyester. These sleeves have a number of advantages, particularly for housing photographic collections: They are clear and allow immediate identification of the materials inside without the problem of fingerprints being transferred to the object inside. There are several disadvantages for the use of plastics in addition to possible moisture problems: They can be difficult to label; they do not protect documents in a disaster by absorbing water; they are less permeable than paper and can trap decomposition products, rather than allowing them to dissipate. Plastic enclosures are not suitable for some media, such as pastels, or for any items with loosely adhered media since plastic can generate static electricity.

Both paper and plastic folders are suited for housing in archival boxes or in hanging-file systems. For most purposes, storage in acid-free boxes, on proper shelving is considered optimum storage. Storage in boxes creates a microenvironment that protects against light damage, dust, and fluctuations in temperature and relative humidity. Folders and boxes come in a variety of sizes. Housing for a collection should be determined by the physical size of the documents to be stored. Due to the depth of standard shelving units, it will be advantageous to use letter- and/or legal-sized supplies where possible. The size of container used for a group of records should be determined by the dimensions of the majority of items in the set. Mixing folders of different sizes within the same box is not good practice.

Boxes should be relatively full to prevent the folders from sagging or curling and to keep the records from shifting unnecessarily as they are being transported. The use of additional support inside a partially full box, such as acid-free mat board interspersed with the folders, can help alleviate this problem. In some cases it may be necessary to use a filler, such as an envelope or folder rolled into a tube or a commercially available box spacer to keep the records upright. Most plastic sleeves are very flexible and will require additional support. Care should also be taken not to over-fill a box, as this can result in mechanical damage to the records as they are removed and replaced.

Before permanent housing, non-paper materials and metal fasteners, such as rubber bands and paper clips, should be removed, since they will deteriorate over time and result in damage to the items. The use of Post-it notes on anything considered archival is not acceptable, since they are known to leave a slight residue that over time will attract fingerprints and dust. All items should be unfolded and should fit inside the folder with no edges exposed in order to prevent damage.

Oversize items such as mechanical drawings, blueprints, and maps should be housed in cabinetry or boxes designed to accommodate them. Many vendors provide a custom box service and can make enclosures to the exact dimensions needed. Storage of oversize boxes can be a problem since they need

to be stored flat, on a secure table. It is tempting to stack numerous boxes on top of one another, but this practice should be avoided or limited to stacks of no more than three boxes depending on the weight of the records inside. The optimum storage for oversize materials is to group them roughly by size for storage in a map or architectural file. The same rules for foldering and labeling will apply. Many large items require additional support for storage and transport. Ideally, they should be placed in heavy-weight folders within the drawer and supported by pieces of mat board, cut to the size of the drawer and interspersed between every few folders. This will aid in the retrieval of items in the bottom of the drawer. It is important to have adequate work space in areas where large records will be stored. This will minimize the distance for transport and encourage the user to take greater care in their use. While several items may be placed in the same folder, common sense should dictate the number, based on the weight and fragility of the records.

Items such as blueprints should be stored separately since they emit gas and are considered chemically unstable. Likewise, newsprint, which is highly acidic, should not be intermingled with other records in storage. A suitable photocopy on acid-free paper should be made to replace the newsprint in the record group and the actual newsprint itself stored separately.

Storage of Photographic Material

Special care should be taken with photographic materials, as they are highly susceptible to changes in temperature and relative humidity, light levels, and air purity. Easily damaged through environmental factors and improper handling, photographic prints and negatives require good storage and use practices to ensure their longevity. Under improper storage conditions, particularly high temperature or relative humidity, both positive and negative images will stick to an enclosure.

As with works on paper, there are several types of storage enclosures available, each with distinct advantages and disadvantages. It is important to take note of several factors in determining the proper care of photographs. Due to the diversity of photographic processes, and the inherent problems of each due to the chemical processes used, photographs are best stored individually. When organizing photographic collections, care should be given to note any materials, such as nitrate negatives, which are unstable and highly combustible. These materials should be isolated and stored apart from the rest of the collection. Ideally, a copy negative of the image should be made on safety film, and the unstable materials removed to a safe storage area.

Black-and-white photographs are much more stable than color. When generating photographs as a means of documentation, good quality black-and-white film should be used rather than color. The film should be processed by a professional photographic lab that adheres to ANSI standards. In some institutional archives, there is a photographic file that documents the activities of the organization. In other cases, the photographs may be supplementary information in an existing records file. In cases where the photographs will remain in other files it is important that the photograph be housed in a stable enclosure, which separates it physically from the rest of the file.

Prints should be stored separately from negatives, due to differences in the chemical stability, and to guard against a complete loss in the event of disaster.

Storage of Electronic Records/Magnetic Media

Increasingly, records are being created as discs, microfilm, microfiche, audio and video tape, CD-ROM, and a variety of other media that require special storage considerations. Since technology is rapidly changing and many types of media used and stored have not been in existence long enough to establish set guidelines for their care and use, the term archival is not considered applicable. It is known that many paper-based records will deteriorate over time due to inherent instabilities, overuse and handling, and possible environmental problems. Reformatting heavily used paper items as

electronic or magnetic media can be essential to their preservation. The disadvantage of some of these media is that they will constantly require upgrading as technology changes; it will be necessary to maintain the equipment on which the media were generated in order to use them unless they are transferred to another medium each time the technology changes.

The newer the technology, the less is known about its stability and longevity. The following section discusses some considerations necessary for the proper storage and handling of these items, based on current practices and information available on their longevity.

Storage of Magnetic Tape

Manufacturers consider the physical make-up and particular characteristics of their tapes a trade secret. This makes it difficult to obtain reliable information on the physical components of various brands. The quality of both audio and video tape varies greatly between manufacturers and types of tape. When purchasing tape for archive use, buy the highest grade possible. Shorter reels, while more expensive, are preferred since they are thicker and have greater durability.

Most magnetic media have a static charge and can easily attract a variety of debris. If possible, storage of magnetic media should be in uncarpeted, unwaxed areas that are damp-mopped. Storage should be on fixed metal shelving away from sources of heat, light, airborne contaminants, and mechanical equipment that might create magnetic fields. Tapes should be stored vertically in enclosures that protect them from dust and debris. The housing that tapes are purchased in is rarely suitable. Good quality, inert plastic enclosures provide the best support and should include an interior hub to support the weight of the tape during storage. For long-term storage, tapes should be played through at normal speed in the environment in which they are to be stored. Rewinding the tape can, on occasion, result in the breaking of the leader at the beginning of the tape; stopping in the middle of the tape can result in cinching or fold-over of the tape in the pack and

can irreparably damage it. Tapes should be rewound and played through at least every three years to help prevent any sticking or transfer of information. The tape itself should never be marked, as this can introduce contamination.

Storage of Optical Disks

Digital technology allows the storage of large quantities of information on a small surface and will probably provide the basis for records storage in the future. No standards have been developed, and there is insufficient information to judge the physical stability of the discs themselves since this technology is still in flux. The general storage requirements governing magnetic media also apply to disks.

It is important never to leave any type of magnetic media lying in the open where it is susceptible to dust, damage, or scratching. This is especially true of the common practice of placing disks on top of a computer, a source of heat, in between use. Use lint-free cotton gloves when handling these materials to safeguard against the transfer of fingerprints and debris. Electronic records should be stored vertically with support; leaning or slanting can cause a distortion of the disc.

As with all museum collections, archival records should be examined periodically as a preventive measure. Since many will be housed in folders and boxes, it may be difficult to discover a developing problem unless a collection survey, if only a random sampling, is done on a periodic basis.

The Newark Museum. Photo by Elizabeth Gill Lui.

Paisley S. Cato

Risk management is an integral component of museum operations, although many of these operations are frequently initiated and managed as independent tasks. This section discusses briefly the concept of risk management as it applies to the management and registration of museum collections. Some of the most common operations that registration staff might be involved with are described more extensively. These operations include disaster planning, security and fire systems, integrated pest management, and insurance.

Recent publications by R. R. Waller and S. Michalski apply risk management methods as decision-making tools for preventive conservation operations in museums. In his 1995 chapter entitled "Risk Management Applied to Preventive Conservation," Waller defines risk as "the chance of an undesirable change occurring," and risk management as "the application of available resources in a way that minimizes overall risk." Staff responsible for museum registration should be directly involved in developing and implementing the basic steps that result in strategies to minimize overall risk to the collections.

The steps for developing a risk management approach include:

- Identification of all risks and assessment of the potential magnitude of each
- Identification of strategies to eliminate or mitigate risks and determination of the costs and benefits of each
- Setting priorities for developing a plan for their implementation, periodic evaluation, and revision or modification

As a result of this process, an institution may determine the need to transfer the assumption of risk through the use of insurance. This occurs when the institution identifies limitations on its ability to mitigate potential risk to the collections.

Risks to collections can be grouped according to 10 basic types, as summarized by Waller: physical forces, fire, water, criminals, pests, pollutants, light and radiation, incorrect temperature, incorrect relative humidity, and custodial neglect. Waller and Michalski discuss ways to assess and rank the potential magnitude of each type of risk. This step is an essential precursor to the identification and development of mitigation strategies. As identified in their respective papers, there are five stages for controlling risks, and within each stage, there are eight possible levels of control. The five stages are:

- Avoid the source
- Block the agent
- Detect/monitor the agent
- Respond to mitigate the problem
- Recover from the problem or treat the result of the problem

The eight levels of control that must be considered for each stage include: (1) location, (2) site, (3) building, (4) room, (5) cabinet, (6) specimen, (7) policy, and (8) procedure. These parameters can be analyzed for a particular collection, resulting in a matrix of possible strategies for mitigation. The type of risk is categorized as potentially catastrophic, severe, or mild/gradual, and then assigned appropriate levels of control. These levels are ranked relative to their importance in mitigating the risk. From this type of assessment, staff determine the costs and benefits of these controls and develop priorities and a plan to ensure implementation of the controls.

"Risk Management" edited by Paisley S. Cato.

It is important to understand the risk management framework to place other functions in perspective. Why should a museum implement an integrated pest management program? Why should a museum develop emergency preparedness plans? Why should a museum assess the extent and quality of fire and security systems? In all cases, it is to minimize the overall risk to the collections. There will be limitations on the quantity or quality of the resources a museum has available, however. In view of those limitations, the museum may decide to transfer the risk through insurance to a commercial business.

Sean Tarpey

It has been said that there are no accidents; there are, instead, events that result from a failure to plan properly. Risk management is the "proper planning," that is, the recognition, analysis, and control of risks. Once the risks have been identified, it is possible to deal with them one by one. Some may be avoided by initiating controls designed to eliminate hazards (e.g., hire guards to protect objects from vandalism); other risks may have levels of acceptance (e.g., do not hire guards and expect a level of damage each year); for other risks, the consequences are shifted to others (e.g., purchase insurance to pay for possible damage).

It is not always possible to isolate all of the risks to museum collections, and it is even more challenging to decide how to handle each hazard. Seek expert advice in isolating and categorizing potential perils. Some easily identified risks include inadequate record keeping; handling; transportation; environmental hazards such as fire, water, smoke, pollution; and loss of climate controls. More complex analysis may be required to identify exposure to theft and vandalism, and hazards involving exhibition and storage. Policies and procedures should be reviewed and strategies developed to eliminate and minimize threats. Insurance must be purchased if you are borrowing objects and should be purchased to protect the museum's permanent collection.

Insurance should be integrated into the risk-management program. Its purpose is to offer financial protection by insulating the museum from catastrophic monetary loss. The extent of the collection covered and the dollar amount of coverage can vary. The insurable interests generally include the full value of all objects owned by the museum (i.e., the permanent collection), all property owned by others on loan to the museum (i.e., the loan collection), and other property such as a historic site that is significant to the museum's mission. The amount of insurance coverage will by necessity have a limit. The limit will be established by one of two methods: loss limit, a blanket amount to be allocated as needed; or scheduled, where coverage is based on a list submitted periodically to the insurer.

The loss limit option provides coverage for any property under the museum's "care, custody, and

Touching the adventures and perils which the said Assurers are contented to bear, and take upon themselves, they are of the seas and inland waters, men of war, fires, enemies, pirates, rovers, assailing thieves, jettisons, letters of mart and counter-mart, reprisals, takings at sea, arrests, restraints an detainments of all kings, princes or people of what nation, condition or quality soever, barratry of the master and mariners, and all other perils, looses and misfortunes, that have or shall come to the hurt, detriment or damage to the said goods and merchandises, or any part thereof.

—a passage from a marine indemnity insurance policy.

Acknowledgment: Patricia J. Hayes

control," without regular inventory reports to the company. An object damaged or lost will be appraised after the loss, and the claim will be based on the fair market value at the time of loss (or, in the case of the loan collection, as stipulated in the loan agreement). Most recent museum policies avoid the tedious task of reporting and are based on well-considered limits of liability. A museum's limit is usually calculated to reflect a probable maximum loss (PML), as established by the senior staff of the museum and endorsed by the governing board. The probable maximum loss is usually large enough to cover the loss incurred should one discrete area of the museum suffer a catastrophe. Total destruction of a storeroom, a wing, or, in the case of a small museum, the entire structure, may be used to determine probable maximum loss. One should envision the worst possible disaster in that area (100-year flood, long-burning fire, etc.). When calculating this figure, it is important to remember that all property owned by others for which there are binding loan agreements requiring the museum to maintain insurance coverage will account for the first dollars paid out in any catastrophic loss. Examine the loss limit frequently, especially in a time of rapid collection growth, volatile art market, or increased exhibition activity. A loss limit sufficient for an entire storage vault a decade ago might be absorbed by a single item today. Separate limits need to be established for objects in transit, on loan to other locations, and on exhibition loan. The premium will be based upon the likely limits of exposure for the year.

Scheduled policies will pay only for losses of or damage to the objects listed on the schedule, and for the dollar amount stated on the schedule. This type of policy is extremely labor intensive for museums with active collecting and exhibition programs. All incoming loans with values and coverage period must be submitted in advance to the company. Each new acquisition and object arriving for purchase consideration, gift, or bequest must be immediately and accurately assigned a value and report-

ed to the company. Any subsequent fluctuation in the value of individual objects must be reported to the company. The premium will be based upon reported values. These types of policies are rarely seen in the 1990s.

Once the degree of acceptable risk has been established, it is time to meet with insurance representatives. Contact a museum insurance specialist, a professional well versed in issues affecting museums. This will result in several beneficial side effects. The contact person will have a clear understanding of questions or concerns. A fine arts specialist will not try to shoehorn the exhibition program into a policy designed for manufacturing. The better the reputation of the agent and underwriter, the more at ease lenders will be. The policy can be tailored specifically to the museum's needs, and premiums may be lower with a fine arts insurer than with a multi-purpose insurance agent.

REQUEST FOR PROPOSAL

Insurance policies may be purchased from a broker or an independent agent. The independent agent has access to all insurance markets (underwriters) and will canvass the market to help the museum find the underwriter and policy best suited to the museum's situation. The agent will then work with staff and negotiate with the underwriter to be sure the coverage meets the museum's expectations. For this service, the agent will receive a percentage of the premium. As noted above, insurance companies that have traditionally insured fine arts and have solid museum relationships should be sought. It is also important to check the Best's Rating Guide for the company you ask to quote; an A + + is the highest rating, Bs are adequate, and ratings in the C range are not.

When reviewing insurance needs, put together a Request for Proposal (RFP). The bidding process serves several functions. First, it allows the museum to complete a self-assessment. The museum should examine the elements of the current insurance program and collections procedures

(collections management, written statements, loan practices, security, climate control, packing, storage, hiring and training of personnel, etc.). Second, it allows the museum to get outside opinions about risk. As part of the bid packet, the museum should submit a facility report and expect a site visit from the insurance company and/or agent. The museum will discover its deficiencies and its strengths in the process. Be prepared to discuss in detail exhibition plans for the next several years and address plans for overseas loans, building plans, and many other activities. The bid process is expensive for the agent, and it is generally requested only every five to 10 years.

Once the policy is bound, the agent should continue to work with the museum on several issues: risk management, management of the allocations of coverage, and the need for temporary additional coverage for loans or exhibitions. A special exhibition with unusually high values detracts from the coverage provided to the permanent collection. In this case, it may be necessary to purchase additional coverage in the form of an endorsement to the policy.

POLICY CONTENT

The museum policy is a form of inland marine insurance, derived from the earliest insurance available for items in motion, those easily transported from one place to another. The policies vary, but most contain many similar clauses. It is important to become familiar with insurance terminology; much of it is very specific to the insurance industry. A reputable insurance representative will not hesitate to answer questions and clarify concepts if asked.

PROPERTY

Property insured: The policy should specify classes of property, such as permanent collection, loan collections (including long-term and short-term loans), items on purchase approval, and objects in which the museum has an insurable joint inter-est. This may also include promised gifts and bequests. Some policies may cover special exhibitions organized by the museum, including loan objects, in transit and at other venues.

Categories of materials: In addition to specifying classes of property, the policy should describe the categories of materials in the collections. This list needs to be exhaustive; if the policy details certain categories, such as paintings, sculpture, and prints, but fails to mention scientific specimens or historical artifacts, the museum may not be covered for the false teeth once used by George Washington. The wording in this section should be as broad as possible, stated in a way that includes all of the objects to be insured. A sample list might include prints, drawings, photographs, paintings, antiques, rare books, manuscripts, coins, glass, all types of artifacts, rugs, objects of historical interest, and so on. Do not impose a test of artistic merit or value; objects accessioned into the collections should qualify, since the intellectual tests have been passed during the acquisition process.

Property excluded: This section of the policy lists categories of property not covered by the policy, such as the building, mechanical systems, office furniture, and other non-collections property. These properties should be covered under a separate policy.

Valuation: The valuation clause is the key to the policy. Valuation may be scheduled or fair market value at the time of the loss or damage. A scheduled policy means that an inventory detailing the value of each item must be reported to the insurance company on a periodic basis. If an object is omitted from the list, or the value is incorrectly stated, the museum will not receive adequate reimbursement for the object. The amount paid in a loss will follow the list of record. Fair market value, with an agreed-upon policy limit, is often the preferred option. The value for an object involved in a loss will be determined by an appraisal after the fact, making the need for good photographs and records

evident. The exception is for objects on loan to the museum, and in this case the prevailing loan agreement should state the value agreed to by the owner of the object and the museum.

Appraisal: Read this clause of the policy very carefully. Should a loss occur, the museum and the insurance company must agree on the value of a total loss, or on the resulting loss of value and cost of restoration in the case of damage to an object. Failing that agreement, an appraiser is hired to determine the value. If an agreement still is not reached, many insurance policies call for the selection of various referees. Courts and judges are alluded to in the wording of the policy.

Loans: Property of others in the museum's "care, custody, and control" is usually governed by the terms of a loan agreement signed by the owner and by the registrar or director of the borrowing institution. It is best that the museum countersign after the lender has indicated his valuation on the agreement. Some argue that a museum should verify the owner's stated value, perhaps by obtaining an independent appraisal. Naturally, extraordinary values need to be questioned and considered, but a museum is not in the business of verifying values; the issue continues to be debated. If the value is extraordinary, do not countersign; renegotiate the loan. The agreed-upon value is a meeting of the minds. This value will be the payoff figure should a total loss occur, and it must be a realistic value.

LOCATION

Off premises: The blanket of coverage will extend beyond the front doors or shipping dock. Works in the permanent collection lent to exhibitions, at the regional conservation lab, or at the mount maker's shop, will be covered under this section of the policy. Check the wording carefully; the policy should clarify the locations or restrictions on locations that are covered. It may stipulate North America, or it may cover risks worldwide. If the coverage is restricted and it is necessary to send an object outside the

territory covered, it will be necessary to arrange for extra coverage.

Transit: The policy should discuss limits on insurance coverage of objects in transit. Examine the shipping history and arrive at a value limit for objects in transit. It is advisable to try for a high transit limit in the initial negotiations; increasing the limit after the policy is in effect may prove to be costly. Too low a limit will require repeatedly asking for endorsements. Since premiums are generally based on premises limits, it is wise to negotiate a high transit limit.

PERILS AND EXCLUSIONS

Circumstances in which a loss is not covered must be explicitly stated in the policy. Although one might ideally prefer a policy that covers all perils, many types of coverage are available only with expensive premiums. Sections describing exclusions and restrictions should be analyzed carefully and discussed with the agent to determine the likelihood of the peril relative to the museum's collection. Request the removal of restrictions that will inhibit the museum's mission. Each peril is ultimately negotiable, but the dollar cost in premiums may be too steep to be acceptable.

Standard exclusions: Examples of exclusions are acts of war, nuclear reaction, vermin, inherent vice, insurrection, rebellion, government seizure, perils of customs quarantine, and illegal transportation. It is quite common to have certain types of shipments restricted, such as regular mail unless first-class registered; or dollar limits might be placed on the use of overnight express carriers. Loans to politically volatile cities or countries might be restricted, as might loans to earthquake-prone regions.

Lost in inventory: This section might include language concerning unexplained or "mysterious" disappearance. The insurance company does not want to be responsible, in the first year of a new policy, for the unexplained losses of the past 50 years. Some policies will state that losses for objects not

physically identified and recorded within a stated number of years are excluded. Many agents will not write a policy for an institution that does not have an up-to-date inventory.

Territorial limits: The policy may be limited to a specific region or be worldwide. The broader the range, the less reporting the museum may be subject to.

"Wall-to-wall" coverage: Such coverage implies that the object is covered from the moment it is removed from its normal resting place, incidental to shipping; through all phases of packing, transfer, consolidation, exhibition, and repacking; until it is returned to the original resting place, or the place designated by the owner, and the museum's involvement is finished. Coverage thus includes damage to the object from the first instant it is touched until the loan is officially terminated. Termination should be in writing, preferably by receipt, and should note that the owner has accepted the object in a condition that is acceptable. If arrangements for further museum involvement are made (for instance, the museum agrees to have someone reinstall the work a week or month later), a written release should be obtained when all involvement is finished.

TERMS, DUTIES, LIMITS, LIABILITIES

Terms: The terms of the policy define the parameters for premiums, record keeping, reports, and notices. The policy specifies the amount and payment terms of the premium. The museum will be required to maintain accurate, comprehensive records of the collection; this may entail photographs of the most valuable objects. The policy may include the address to which all formal correspondence (notice of loss, etc.) should be mailed.

Duties of the insured: The policy stipulates that the museum agrees to use the best professional judgment and practice with respect to packing, handling, security, and fire safety.

Loss: Once the insured is aware of an incident resulting in loss, it should notify the agent. A claim may need to be filed within a specific time to be valid. Once a claim is paid, in the case of a total loss, the insurance company will have the right to take title and possession of the object, should it be recovered. The best policies give the museum the right-of-first-refusal to purchase the object back.

Additional insured: Owners of loan objects and temporary borrowers of insured property can be considered "additional insured." Packers and shippers not employed by the museum but hired as fee-for-service providers are generally not covered. Anyone requesting to be named as an additional insured on the museum's policy must have his name added to the policy by means of an endorsement. This will provide him with some legal protection.

Limits of liability (amount of coverage): These limits are the maximum amount of insurance dollars to be paid in any one loss occurrence, in any number of categories. Limits will be set on premises, at any other location (which may be worldwide or restricted to North America), and per conveyance while in transit (by car, truck, plane, etc.). Limits will be for the total of all costs, whether partial or total loss, salvage fees, or other covered expenses.

Probable maximum loss: Most museums are unable to afford the cost of insuring to full market value. It is much more common to assess the risks, and settle upon a probable maximum loss value in case of a single event or incident on premises (loss of a gallery or wing, single storage vault or floor), in transit, and at any other location.

Deductibles: Deductibles are an agreed-upon lower monetary threshold for which the insurance company will not be responsible. A deductible should only apply to property owned by the museum. The loan collection should not have a deductible, nor should objects in transit. Deductibles may range from a few dollars to many thousands of dollars and will be reflected in savings to the museum's

premiums. In order to maintain a low loss record, agents frequently discourage frivolous claims (i.e., claims less than a few hundred dollars).

Legal liability: The policy will pay, within established limits and subject to restrictions, amounts the museum shall be legally obligated to pay if a loss occurs to an object in the museum's care that the museum has been instructed not to insure (as when a lender elects to maintain his own insurance coverage and a waiver of subrogation has not been received). This refers to legal costs incurred should someone agree to maintain his own insurance, then attempt to collect from the museum in the event of a loss. Some policies state a specific limit of liability, while others do not; if not stated, the limit is the policy limit.

Other insurance: Should another policy or national indemnity coverage be in effect at the time of the loss, the policy may limit payment to the amount not paid by the other insurance. The museum cannot collect twice on a single loss.

Insured not to assume liability: This clause directs the museum not to assume voluntarily any liability on behalf of the insurer. In other words, the museum should not make any promises for the insurance company. The museum must also agree to assist the company in resolving claims if requested.

OTHER PROVISIONS

Loss buy back: This provision states the terms by which the museum can purchase recovered property. If the object is recovered after the museum has cashed the insurance check, the object belongs to the insurance company according to the terms of the policy. However, by this provision the museum may repurchase the object from the insurance company. Commonly, the museum pays the same amount that it initially received, plus expenses incurred in recovering the object; some policies include interest as well, and some allow the current market value of the object to be the buy-back price. Some policies also stipulate a time limit. This clause varies from policy to policy. When a damaged object is deemed

to be a total loss and the claim has been paid by the insurance company, the museum may "purchase" the piece from the insurer for the newly adjusted fair market value if it believes there is still some merit in keeping the object in the collection.

Pairs and sets: If the museum has a set of six objects and one is lost due to theft or damage, the museum may not want the other five. The museum will have the option under this clause of turning over the remaining portion of the set to the insurance company; the museum will then receive the full value of the set.

Subrogation: This clause states that the insurance company, in return for paying a claim, takes the museum's rights to any possible legal action. Should the museum have reason to take action against an individual or company (for example, a deliberate act of vandalism by a known individual), the insurance company may ask to have the museum's right to action transferred to the company. The insurance company will then try to collect all or part of its expenses from the responsible party. A waiver of subrogation is intended to convey to a borrowing institution a pledge that the insurance company will not sue the borrower to recoup expenses in the event of a loss. Most insurance companies will not subrogate against a nonprofit entity.

No recourse: A no recourse clause states that the insurance company will not try to sue or collect from the museum's packers, crate makers, shippers, or others, with some possible exceptions.

Endorsements: These documents constitute formal changes to the details of the policy. They may adjust the limits, extend territories, name additional insured, or cover special temporary exhibitions for specified dates. Endorsements are also called riders.

Certificates of insurance: A certificate of insurance is issued to lenders or borrowers, depending on the loan situation. This document is for information purposes and is not a legal document. A lender or borrower may be named as an

additional insured, or a waiver of subrogation may be specified on the certificate of insurance. If this is done, similar language should be placed in the loan agreement, the document that actually governs the transaction.

CLAIMS

Reporting procedures are critical when handling a claim. Should a loss occur, start taking notes immediately. Gather all possible information and put it in writing as soon as possible. Take photographs of damage, collect environmental data, and take statements from witnesses. Notify the museum's agent by telephone and in writing; the agent will contact the claims representatives. In case of suspected theft or vandalism, contact the appropriate authorities (police, Federal Bureau of Investigation, etc.).

If the nature of the loss is catastrophic, the insurance company will respond by sending members of its staff to assist on site. The priority must be to contain the loss and prevent further damage. These representatives should be able to authorize funds as needed to hire additional security or provide temporary storage or mobile equipment needs, such as portable climate-control facilities and freeze-drying units. If immediate action is required to minimize or avoid continued destruction, the museum's policy should provide the funds.

FEDERAL INDEMNITY

Federal indemnity is available in the United States, as it is in many other countries around the world. This program transfers liability from commercial insurance to a pledge of the full faith and promise of the United States Treasury. The Treasury, upon an act of Congress, pays claims for losses under this program. The indemnity program in the United States has been a favorite of the U.S. Congress. It does considerable good, is high profile, and costs next to nothing. The program has been run very well and losses have been minimal.

In the United States, the Arts and Artifacts Indemnity Act is administered by the Arts and Artifacts Indemnity Program, an office within the Museum Program of the National Endowment for the Arts, on behalf of the Federal Council on the Arts and Humanities. The program has been run for many years by an indemnity administrator who coordinates the issuing of instructions and review of applications by the Indemnity Advisory Panel and the Federal Council. The program provides an indemnification—an agreement to "hold harmless" eligible objects borrowed from foreign institutions or individuals while on exhibition in the United States—and for objects owned by U.S. collections while on loan to exhibitions abroad. There is a stated preference for exchange exhibitions between two countries. A recent broadening of the program provides indemnity coverage for objects owned by institutions and collectors in the United States while on loan to domestic exhibitions, provided that the seminal objects in the exhibition are borrowed from abroad.

Objects deemed "eligible" include a broad range of art and artifacts of educational, cultural, and scientific importance, which have been certified by the director of the United States Information Agency to be in the national interest. Panel paintings, paintings on metals, pastels, and other extremely fragile objects are excluded.

The application process is rigorous but not oppressive. There are two deadlines per year, each three months before the indemnity period commences. Notice of future exhibitions for which an application is in process may be made to the administrator for allocation purposes. There is a $300-million ceiling on the indemnity of a single exhibition. The comprehensive limit at any moment cannot exceed $3 billion. A deductible amount slides in relation to the value of the exhibition. Commercial insurance is normally obtained for this threshold amount.

The application requires a justification of the project, full and extensive details of all participating museums' operations, a plan for obtaining each work prior to packing, descriptions of packing and shipping methods, identification of the firms responsible, security arrangements on-site and in transit,

controls during unpacking and inspection, and the names and qualifications of all staff members involved. Each work covered by the application must be accompanied by a photo, value stated in U.S. dollars, loan agreement, and name and address of owner. The panel will review the objects and their assigned values, the merits of the exhibition, and the standards of care outlined by the museum.

Adherence to statements made in the application is to be taken very seriously. All changes in details outlined in the application must be approved by the panel and council. Lenders must agree to accept U.S. indemnity and will receive a copy of the act, the regulations governing the act, and a certificate of indemnity.

The trend in the last few years has been for the panel to indemnify only a portion of the value requested. This necessitates the provision of private insurance to cover the value of each object in excess of this agreed figure. The applicant should check with its broker or agent to determine if this excess is covered by its basic fine arts insurance, or if additional insurance must be purchased. It is also prudent to ask if the deductible for indemnification can be covered by the regular insurance policy. Generally, if a separate policy is secured for an exhibition, both the excess and the deductible coverages will be part of the package. In many cases, even though the basic fine arts policy provides these coverages, the museum's administration may elect to purchase a separate policy in order to limit the exposure of and potential claims against its basic policy.

Ann Fuhrman Douglas

Still from a German film entitled The New Office Table *(c. 1914). Courtesy K. Longstreth-Brown.*

A collections management policy should address all issues of security and protection, including disaster mitigation responsibilities. Museums exist as much or more for posterity as for the present, and careful steps must be taken to ensure the protection and preservation of the collection for generations to come. A museum disaster-preparedness plan focuses on preparing for and mitigating the damage from catastrophic events that endanger people and collections. In addition to the objects in its collection, as a public space a museum is responsible for the safety of visitors and employees.

The project of writing a disaster preparedness plan may be given priority for other reasons. Accreditation by the American Association of Museums indicates a museum's adherence to accepted professional standards and to public accountability. An institution's security policies, including emergency preparedness, are analyzed as part of the accreditation and re-accreditation processes. Museums that are part of a larger organization (e.g., a college,

university, or corporation) may be required to develop an emergency plan as part of an overall commitment to safety.

Surprise is often a key feature of an emergency, and no museum professional would plan to experience a disaster. Rather, such plans focus on preparation and outline procedures to be implemented during and after an emergency. The most important parts of disaster planning are anticipation and prevention. Anticipation includes determining the likelihood of various disasters, evaluating the environment and the facility, and planning what to do with the collection in case of trouble. It notes communication lines, lists materials and tools needed, and plans for moving the collections. Prevention includes identifying and correcting existing hazards; it can range from locking doors to constructing buildings that can withstand earthquakes.

Emergencies get rapidly and progressively worse if they are not dealt with quickly and positively. A recoverable situation can be transformed into a total loss in the days and weeks following a catastrophic event. Established procedures can significantly reduce the loss of resources (people, collections, building, essential operating equipment, and supplies) during this dangerously vulnerable period. The primary objectives of emergency planning are to anticipate and, if possible, to avoid emergencies; to retain control when an emergency occurs; and to recover control as quickly as possible if it is lost.

To be successful, the essence of a museum's disaster plan must be absorbed into the consciousness of the museum's staff. The creators of the plan should therefore take into account the people who may be called upon to implement it. While a written document alone will work for some, others may benefit from audio or visual supplements. The specifics of a disaster plan must be written down, however. The idiosyncrasies of the institution, collection, and staff must be considered when determining the format of the plan. The plan might contain the following sections:

- Chain of Command and Individual Responsibilities
- Duties of Response Coordinator
- Administrative Responsibility for Emergency Response Plan
- Avoiding a Disaster
- Damage Assessment and Documentation
- Evacuation Procedures
- Floor Plans
- Emergency Preparedness and Response for Specific Disasters;
- Collection Priorities; Maintenance Checklist
- Damage Assessment Form
- Post-Disaster Report Form
- Bibliography
- Supply Checklist and Suppliers
- Staff Information

The mechanics of producing a disaster plan will vary from institution to institution; there must, however, be support from above and interest from below for the plan to be successful. Large museums may form committees and subgroups to accomplish the task; small museums may have one or two people write the plan. In either case, one person must spearhead the project to completion. Once written, the job of regularly reviewing, updating, and otherwise maintaining the plan must be assigned to a specific person or group. Disaster planning is an ongoing process, and reviews and drills must take place at least annually for any plan to be useful.

The first step in writing a disaster plan is to decide what the final product should look like. A sectioned three-ring binder provides a useful format. If the museum's parent institution, town, city, or county has a disaster plan, tailor the plan to fit the bigger picture. As a public institution, the museum should not write a disaster plan in isolation; contact local police and fire departments to find out what kind of response procedures are already in place. Some initial research pertinent to the museum's situation and locale may have already been done by someone outside the museum, and local

emergency personnel need to be aware of the museum's plans so that all can work cooperatively in the event of a disaster. Consult the comprehensive bibliography published by the Southeastern Registrars Association for additional reference materials. Information about general emergency planning and specific disasters is available from such organizations as the National Trust for Historic Preservation, the Federal Emergency Management Agency, and the National Fire Protection Association.

Prepare a checklist for the museum and scrutinize the facility and grounds inside and out. Consider the following:

- Are there water pipes running through collection areas?
- Are there signs of rot, termites, or rodent activity?
- Are hazardous materials such as gas cylinders, solvents, paint, etc., properly stored?
- Are any exits, corridors, aisles, or stairwells blocked?
- Are EXIT signs clearly visible?
- Are there any water-stained ceilings, suggesting possible leaks?
- Is any wiring worn and exposed?
- Are any sockets overloaded?
- Are any electrical cords in dangerous positions?
- Are books, boxes, or files stored on the floor or kept in precarious piles?
- Is the building located in an area subject to brush or forest fires, flash floods?
- Are fire alarms and extinguishers easy to find and operate?
- Are there smoke detectors?
- Is there a sprinkler system?
- Have fire extinguishers been recently inspected, and is the pressure correct?
- Are emergency evacuation maps clearly posted?
- Is the area subject to severe storms—hurricanes, tornadoes?
- Is the building situated near a body of water?
- Is the building in an area prone to avalanches or landslides?
- Is the area subject to earthquakes or volcanic action?
- Does the building have a flat roof, skylights, or roof access doors?
- Are collections stored in the basement?
- Are trees and shrubs planted close to the building?
- Is there adequate exterior lighting?
- Is there sufficient access for emergency vehicles?
- Are signs and flagpoles situated to avoid damage to the building if they are knocked over?
- List the collections on each floor that might be damaged during a disaster (e.g., artwork, computers, files, staff members, etc.).

Itemize the disasters that may affect your building or collection. Rank them in order of likelihood, and envision the worst-case scenario in each situation. ("Flood" is a good starting point, because many emergencies can cause flooding.) What damage will each disaster cause? Consider both localized and widespread disasters. Is it likely that your institution might be needed by the community as a temporary command post or hospital?

Think about what will have to be done to prevent or minimize probable damage. Take immediate steps to implement preventive measures, and establish a schedule for longer-term projects. Good housekeeping procedures can help prevent disaster. Use the three-ring notebook to describe in detail how staff will deal with the damage caused by each potential disaster. Gather emergency supplies and store them in easily accessible areas throughout the building and grounds, using a cart as described by Harris (1992).

Identify which staff members will be needed to respond to a major disaster, and decide who has the right personality to direct the recovery effort. This does not have to be, and often should not be, the museum's director. Assign specific jobs to specific people so that everyone knows exactly what is expected. This can prevent chaos in an emergency. Distribute "telephone trees" to those staff members whose presence will be essential in an emergency.

Upon completing a draft of the disaster plan, make it available for review and comment by the entire staff. At least one copy of the final version should be in each office, and the head of each department should receive another copy to keep at home or in a car. The disaster plan must be required reading for all new employees. A schedule for reviewing the plan, inspecting supplies, and ongoing staff training should be established. Mock disasters, quizzes, and videos can make staff training both fun and informative. The written disaster plan should always be considered a work in progress and must undergo rigorous and regular testing and evaluation.

Paisley S. Cato

Control of some risks to collections may be handled through a variety of security and fire protection systems. It is beyond the scope of this section to provide extensive descriptions of various systems, but it is important to understand the basis for policies, procedures, and equipment to implement these systems.

SECURITY

To safeguard collections from theft and vandalism, one can consider the general levels of risk control described in Waller's 1995 article, that is, location, site, building, room, cabinet, and specimen. Keller and Willson's recent article, "Security Systems," provides a similar listing for consideration: grounds, public area, gallery (exhibit areas), offices, work space, storage, and vault. For both systems, one must determine the primary problems or risks faced at each level, and subsequently, the appropriate methods for mitigating the risk. The process of identifying security risks at each level applies regardless of the institution's size, whether it is a small, single building or a large, multi-building complex.

Protection begins with the design of the landscaping and structure relative to its position in a neighborhood. Most staff members have little control over design and location and must focus instead on mitigating the risks that come with the building.

The ultimate security of the object depends on several levels of protection, beginning with effective policies and procedures that are developed and implemented by honest staff. Security systems are comprised of both human and equipment components. Staff develop and implement policies and procedures; equipment is used to monitor events that may pose risks to the security of the collections and to alert humans to breaches of security.

Keller and Willson propose, in their 1995 article, three factors that affect and determine museum security:

THE FAR SIDE By GARY LARSON

© 1984 FarWorks, Inc./Dist. by Universal Press Syndicate

DO NOT TOUCH

DO NOT TOUCH

10-20

The Far Side © 1984 FarWorks, Inc. Used by permission of Universal Press Syndicate. All rights reserved.

access control, parcel control, and internal security. Control of who enters and leaves the building (e.g., administrative or curatorial employees, visitors, contractors), where they go after they are inside (galleries, offices, collection storage vaults), when they are permitted to enter (day, night, weekends, holidays, etc.), and what they carry in (razor blades and spray paint) and carry out (items from the collection, computers, money) is essential to achieving good security.

Policies and procedures can define some of the controls for these three factors; for example, they should clarify who is permitted to enter which sec-

tions of the museum during what hours. Security equipment can be used to implement the policies (e.g., key controls on 24-hour clock), to detect events that indicate a failure to follow the policies (e.g., intrusion detection systems), and to summon police or guards in such events.

Keller and Willson stress that internal security is provided by hiring honest people and providing deterrence for dishonest behavior. This may require doing background security checks, not only for staff but also for volunteers. It also involves training to improve awareness among staff and volunteers about the security of the collections and how to handle situations involving potential security breaches.

An effective security system is tailored to the museum, its staff, and its level of resources. The following checklist provides issues to consider when developing security systems. In addition to further reading, staff should consult security experts and insurance representatives; both can provide assessments, information, and recommendations directly relevant to the institution.

CHECKLIST OF ISSUES TO CONSIDER FOR SECURITY SYSTEM COMPONENTS

Policies and Procedures

- Staff authority for security program
 Position responsible for program
 Additional positions to assist
- Access restrictions (who, where, when)
- Procedures to monitor access
 Sign in/out
 Passes
 Identification badges
- Procedures for inspection of packages (in and out)
- Procedures for daily opening and closing of museum
- Emergency response procedures

Staff and Volunteers

- Background security checks during hiring process

- Formal security staff
 Visible, professional
 Contract agency or use in-house staff
- Staff training and awareness
- Drills for emergency responses
- Drills to test security systems and procedures

Equipment

- Purpose of equipment
 Intrusion detection
 Tampering detection
 Interruption of building systems (e.g., power)
 Contact with people to initiate response
- Types of contact systems (examples)
 Telephone
 Radio
 Pager
- Types of detection systems (examples)
 Magnetic contact
 Photo electric ray
 Ultrasonic
 Sound
 Motion
 Infrared
 Weight/press
 TV monitor/closed circuit
- Test systems routinely
 Fire protection systems

Fire safety programs also rely on a combination of human and mechanical components. Either one alone is not a sufficient safeguard, yet each brings essential elements to the program. In a 1995 article, Wilson identifies five elements of a basic fire safety program:

- Policy development and enforcement
- Staff training and selection
- Equipment selection and location
- Inspection and maintenance
- A fire emergency plan

Policies and procedures set the framework for a fire safety program. They establish who in the institution has primary authority for establishing

GUARD IN:

COMMENTS:

GUARD OUT:

DATE:

Gallery plan for security inventory check. Courtesy the Walker Art Center.

and implementing the program. They should also clarify the responsibilities of other staff positions in support and implementation of fire safety programs. Procedures for fire prevention and safety need to address clearly the situations that pose risks to the collections. These situations include, for example, exhibit production, conservation labs, research labs, staff and catering kitchen facilities, building equipment, etc. In other words, almost every function and space in the museum is subject to risks from fires. Staff involved with each of the different functions and spaces should work with the safety officer to establish appropriate procedures for fire prevention as well as response to fires.

Staff training is a continuous process if the institution is to minimize its risk from fires and fire damage. Volunteers should also receive training to improve their awareness of the need for prevention and appropriate responses. Wilson (1995) suggests a number of issues in which staff should receive training:

- How to recognize and correct fire hazards
- General housekeeping standards to improve prevention
- Compliance with regulations (e.g., smoking, fire doors)
- How to store, use, and dispose of hazardous materials
- How to notify fire department and museum staff
- How to evacuate building and perform other duties in response to fires

- Practice using portable fire extinguishers
- General information about automatic sprinkler systems and location of control valves

Sources for staff and volunteer training can be found in any community. The local fire department usually has one or more individuals available to provide training for agencies in its region. Departments generally welcome opportunities to tour facilities they might have to protect and to develop training sessions for staff of such institutions.

Fire protection equipment includes detection systems, signaling systems, and extinguishing systems. Selection and location of the most appropriate equipment for the facility should be done in consultation with an expert. Selection of the equipment should involve a thorough discussion of the maintenance needs over time, because equipment that is not regularly maintained will not respond adequately if an emergency arises.

Detection systems respond to one or more of the following: smoke, heat, and flames. The detection system should trigger a signaling system that is monitored continuously by an individual responsible for dispatching appropriate response personnel. It is important to have a person available to receive the signal on a 24-hour basis if the risk due to fire damage is to be minimized. Automatic sprinkler systems comprise the most common and most effective means of suppressing a fire. As Wilson states in his 1995 article, these systems "are designed to detect fires at the point of origin, cause the sounding or transmission of alarms, and control or extinguish the fire." Types of automatic sprinkler systems include: wet pipe, preaction, on-off, and dry pipe. Halon automatic systems are no longer available.

Occasionally all fire prevention efforts fail. Thus, it is imperative that the museum have a response plan to mitigate potential damage from fire, smoke, and water. Staff need to have undergone emergency drills to be comfortable with individual roles and responsibilities. Resources for responding to the crisis must be available. (See chapter on Disaster Mitigation Planning.)

A fire safety program requires a staff that is aware and trained to prevent and respond to fires. Even if a registrar is not directly responsible for designing a fire safety program, he or she should be active in the development and implementation of policies, procedures, and training programs for both staff and volunteers.

Nancy L. Breisch and Albert Greene

All buildings need pest control, but museums are among the facilities presenting the greatest challenges for this service. Like schools, hospitals, and zoos, collections of specimens, art, and artifacts are considered "sensitive," with precious, irreplaceable contents requiring constant protection from damage. Since many of the traditional chemical methods characterizing pest control since the 1950s are themselves potentially harmful either to the collections or to human health, the task is difficult.

Museums are at risk from four overlapping categories of pest problems:

Stored product and fabric feeders: Many different insects, most of them small beetles or moths, feed on a wide array of dry, organic materials. Common examples include carpet and hide beetles (*Dermestidae*), drugstore and cigarette beetles (*Anobiidae*), spider beetles (*Ptinidae*), and clothes moths (*Tineidae*). Because they are virtually ubiquitous, can easily escape detection, and are often introduced as eggs on new acquisitions, these insects are usually the most important pest threat to collections.

Wood destroying insects: As in the above category, members of this group tend to be extremely cryptic. Items made of wood and other types of cellulose may arrive in a museum already infested by several different types of beetles, most commonly powderpost beetles (*Lyctidae, Bostrichidae,* and *Anobiidae*), furniture and deathwatch beetles (*Anobiidae*), and bark and timber beetles (*Scolytidae*). Some of these insects are capable of reinfesting additional dry, seasoned wood upon emergence. In addition,

THE FAR SIDE By GARY LARSON

"There's one of 'em! ... And I think there are at least three or four more runnin' around in here!"

The Far Side © 1985 FarWorks, Inc. Used by permission of Universal Press Syndicate. All rights reserved.

termites and powderpost beetles damaging structural wood in buildings can spread to stored cellulose objects under some circumstances.

General feeders: Several very common types of pests, including cockroaches, silverfish, crickets, and rodents, are general feeders that may damage many different materials by feeding or defecation.

Appreciation to Virginia Greene "for valuable discussions, suggestions, and insights from behind the scenes." Thanks to Robert Koestler and John Scott for the description of oxygen deprivation treatments.

These pests are much more readily detected than those in the first two categories, and tend to be problems in other areas of a museum in addition to the collections.

Nuisances and health hazards: Most buildings harbor numerous animal species that cause little damage to property but are considered undesirable because they annoy, disgust, or frighten the human occupants. The majority of ants, flies, and spiders found indoors fall into this group. However, many nuisance pests also present a continuum of more tangible health risks (bites, stings, and disease transmission), the severity of which depends greatly on individual circumstances.

Detailed discussions of pests associated with buildings are provided by Bennett et al. (1988) and Mallis (1990). Several primers on pest biology and identification written specifically for museum personnel are also available (Appelbaum 1991, Harmon 1993, Pinniger 1990, Zycherman and Schrock 1988), and collection staff should have a working knowledge of the major groups. Unfortunately, insect identification is notoriously difficult, even for those with some specialized training. There is often no substitute for a professional entomologist if a specific determination is critical. It is far more important for collections managers to understand the general principles of modern pest control, which should be applied as an ongoing process even in the absence of immediate pest problems.

THE PROCESS OF INTEGRATED PEST MANAGEMENT

Objectives

Modern pest control has evolved into a complex, specialized discipline that is often termed "Integrated Pest Management," or IPM. Those responsible for implementing this process should be aware of three principal objectives:

Protection of property: Although this is the obvious *raison d'être* for IPM in a museum, it is important to realize that effective pest control for collections and the structures that house them goes far beyond either killing bugs or applying pesticides.

Protection of health and safety: The transformation of pest control from an almost exclusively chemical-based activity into modern IPM has been driven by widespread concerns over the potentially harmful effects of pesticides. Although pests themselves can sometimes be a serious threat to both human and environmental health, the public expects building managers to control them without compromising either indoor air quality or the safety of food consumed on the premises.

Legal compliance: The use of pesticides in workplaces is governed by a bewildering array of laws and regulations. At a minimum, museum staff responsible for pest control should be thoroughly familiar with the label and Material Safety Data Sheet (MSDS) for every pesticide used in the facility, whether applied by contractor or in-house staff. The label is more than a set of directions; it is a strict, legal commandment. If pesticides are stored in the building, there are often specific state-mandated requirements for security, fire protection, and signage. Other pesticide-related edicts that may apply under some circumstances or in some jurisdictions involve pesticide applicator certification for personnel and associated record-keeping requirements, posted notification prior to pesticide use and similar right-to-know actions, locally mandated prohibition of certain pesticides, and accommodations for chemically sensitive individuals in compliance with either state law or the Americans with Disabilities Act of 1990. A detailed summary of pesticide regulations is provided by McKenna & Cuneo and Technology Sciences Group (1993). When in doubt, consult your state pesticide regulatory agency.

Strategy

What exactly is IPM and what are its basic ground rules? Every pest management professional has a slightly different definition of the term, but there is

a general consensus that any control program can legitimately be called IPM if it emphasizes the following three elements:

Prevention: This is the single most important pest management concept. IPM strives for "built-in" control solutions by minimizing or eliminating the resources that pests need to enter or live in a particular area. Like all preventive maintenance processes, IPM's fundamental assumption is that it is cheaper, safer, and more effective to anticipate and protect rather than continually react to chronic breakdowns. Pest control in the modern sense thus signifies control of pest access to critical areas, control of pest habitat and shelter ("harborage"), and control of pest food and water. It is an environmental manipulation strategy that attempts to make direct control of the pests unnecessary.

Least-toxic methods: Although modern pest control tries to emphasize physical methods such as exclusion, sanitation, and inspection, there are some situations where chemicals must be used as well. Furthermore, pests are famous for occasionally circumventing even the best preventive efforts. When this occurs, direct, corrective measures are essential, and pesticides frequently are the most efficient tools at hand. Despite the widely held misconception that IPM is a pesticide-free methodology, the discipline regards these chemicals with pragmatism if they are necessary to achieve its objectives. What distinguishes IPM from old-fashioned pest control practices are the principles that least-toxic methods are tried first and that all pesticides are considered to be, at least in theory, temporary measures only. The overall program aims to reduce both pesticide use, through alternate control techniques, and pesticide risk by favoring compounds, formulations, and application methods that present the lowest potential hazard to humans and other non-target organisms.

Systems approach: The characteristic of IPM most difficult to convey to the uninitiated is its extraordinary scope and diversity. Even a building that does not house delicate, precious objects is subject to many different types of pests that enter through, live in, and feed on a bewildering variety of resources. Aging structures in need of repair are even more vulnerable. Factor in the additional burden of safeguarding collections, and the difficulties of museum pest control would seem to be almost insurmountable. The secret to an IPM program's success, as well as its greatest challenge, is effective coordination with all other relevant programs that operate in and around the building. Plans and procedures involving design and construction, repairs and alterations, custodial and solid waste management, food service operations, landscape maintenance, etc., should all be guided in part from a centrally developed pest management perspective. Unless the IPM process truly incorporates activities throughout its surrounding infrastructure, it can never achieve optimal results.

Contracting for Expertise

For many institutions, particularly those with a history of pest problems, modern pest control is not a task that can be delegated to generalists. Experience has shown that personnel whose primary responsibilities and training are in other areas will simply not have the time, talent, or inclination to manage a meaningful control program. IPM is an expert-dependent process. The specialists who practice it most effectively in museums have a thorough knowledge of facilities management procedures, pest biology, pesticides, and alternative control technologies adapted to a wide variety of collection types. Normally, the curatorial or preservation staff carries out many of the routine, common-sense components of pest control that directly affect the objects under their care. However, most institutions periodically require two types of expert assistance:

■ Consulting entomologists
■ Pest control companies

Common situations requiring the services of a professional entomologist involve discovery of an unknown pest or type of damage, technically difficult pest problems, the need for impartial rec-

ommendations on specific control products, or the need for an expert witness or advisor in a pesticide-related legal issue. At the very least, a museum's actions for developing and implementing an upgraded IPM program should be guided and reviewed by a knowledgeable expert who can also provide the necessary staff training.

In the field of pest management, the term "entomologist" takes on an expanded meaning. "Applied biologist" would be more appropriate, since a consultant's expertise usually encompasses mammals and birds in addition to invertebrates. Credentials typically include at least a bachelor's degree in entomology and the title "Board Certified Entomologist" (BCE), conferred by the Entomological Society of America's professional certification program. As with any sort of technical specialist, recommendations from colleagues and a review of the candidates' referral lists are probably the best method of selection. Additional recommendations for consultants can frequently be obtained with a call to the entomology department of the nearest state university.

Unless the museum is extremely small or unusually free of pests, a consulting entomologist may not be able to provide all the specialized help needed to suppress pests adequately. It is particularly important that the IPM program for the collections include, or at least be coordinated with, routine pest control service for the entire building. From a pest manager's point of view, the overall structure is both reservoir and portal for pests entering into the collection areas. Perfunctory spraying of this surrounding habitat serves no protective function whatsoever and is now considered to be an unacceptable risk to the health of children and other pesticide-sensitive individuals.

A consulting entomologist may be able to recommend a local pest control firm, or, ideally, may be associated with one. Worst case scenarios are when pest control manpower for a building is provided by a facilities manager who is interested in little more than cost. At a minimum, the con-

tract's technical specifications should include the following items:

Pesticide applicator certification of all on-site personnel: Although passing the state-administered exam for certification is no guarantee of technical competency, personnel who have done so generally represent a considerable investment in training on the part of their employer. Do not accept uncertified technicians "working under the supervision" of a certified applicator.

Clear statement of pests included and excluded: Standard contract language lists common pests to be controlled (e.g. "cockroaches, ants, flies, spiders, rats, mice . . . and all other pests not specifically excluded"). Typical exclusions are those pests that require specialized skills and equipment (such as termites, birds, and mammals larger than rodents), that are usually contracted for separately.

No scheduled pesticide treatments: This provision directly contradicts what many building managers and tenants think that an "exterminator" should do. However, it is inspection for pests that should be rigidly delivered by schedule, not pesticide application.

Conservative pesticide use: Pesticide use should always consist of the least hazardous materials, most precise application techniques, and minimum quantities of material necessary to achieve control. Solid, paste, or gel bait formulations should be used whenever possible. Conventional sprays or dusts should be applied only to crevices, and even then only in exceptional circumstances. Labels and MSDS sheets should be provided for all products used.

Service frequency by need: Service frequency should reflect what is necessary to achieve program objectives, and varies from on-call only to temporary daily service for severe infestations. Scheduled monthly visits are typical for property with minimal pest problems. In general, it is better that service for non-public space be delivered during

normal working hours, to maximize interactions between pest control technician and staff. There should also be a contractual provision for same-day emergency service.

PREVENTIVE TECHNOLOGY AND PROCEDURES

The Preventive Approach

Regardless of the type of building in which they occur, pest problems and their resolutions tend to follow a logical progression of events: detection, identification, correction, deterrence, and evaluation. The degree and effectiveness with which each stage is accomplished varies according to the resources applied to them and the general approach of the pest control process. In the most neglected, unplanned, and reactive programs, detection of a pest problem is made either by an unsuspecting patron in the cafeteria or by the staff's discovery of significant damage in the collections; identification of the pest is too superficial to be of much use in selecting optimal control strategies; the immediate corrective response is either unfocused or too narrow in scope; "deterrence" signifies merely a scheduled repetition of corrective efforts; and evaluation is mainly concerned with immediate costs.

With a preventive approach, an ongoing inspection protocol will be in place and detection is more likely to be made at an early stage of infestation; there will be an established procedure to obtain rapid and precise identification; immediate corrective responses are therefore more likely to be safe, efficient, and effective; the "deterrence" stage will be characterized by an informed analysis of the problem to select or refine the best feasible protective actions; and evaluation will be an ongoing process that attempts to improve all aspects of the system with a bearing on the problem. IPM is very much a "Total Quality Management" approach to pest control, in the sense that it tries to be continually anticipatory. Collection staff should be an integral part of a team that develops and implements IPM procedures for the institution.

Following is a review of three basic types of procedures for reducing a building's vulnerability to pest problems. Unfortunately, the preventive aspect of IPM is often its most frustrating administrative challenge. Despite being simple in conception, these actions are often quite difficult to consistently implement.

Inspection

All meaningful pest control begins with inspection. In museums, this includes continual monitoring of collections, careful examination during the quarantine period for new (i.e., potentially infested) acquisitions or returned loans, and routine surveillance of the general facilities and grounds. The process of inspection is by far the cheapest form of insurance against unexpected pest damage and other pest-related liability. Following are five components of a basic inspection program. Occasionally, these may need to be augmented with more specialized technologies, such as the use of x-ray equipment to examine wooden objects suspected of harboring borers.

Visual: The best form of inspection is simply looking. Scheduled, systematic reviews of all areas and items at risk are ideal. At the least, constant vigilance by personnel trained to recognize pest signs should be part of the culture of any museum staff. All that is required is an eye for detail and a mental image of about a dozen out-of-place items: termite tubing and shed termite wings; the tiny piles of fine powder or sawdust-like "frass" produced by insect feeding; fresh exit holes from cellulose objects; the shrimplike cast skins of dermestid beetle larvae; rodent, cockroach, and spider droppings; and insect bodies or body parts.

Sticky traps: The humble cardboard sticky trap has become the symbol of modern pest monitoring. Liberal use of these simple tools should be part of all indoor pest control programs. Inexpensive, easily concealable, and capable of immobilizing any flying or crawling bug that touches them, sticky

traps constantly yield surprises for even the most diligent pest manager.

Pheromone traps: A rapidly expanding surveillance technology, these compact devices lure in stored-product and fabric-feeding pests by means of synthetic, species-specific attractants. They are primarily employed in warehouse and market facilities, but any museum that includes textiles or natural history specimens would greatly benefit from their use. At present, not all pheromone-based trapping products are equally effective; consult an entomologist for up-to-date recommendations.

Expert identification: An essential part of any early warning system is skilled interpretation of the results. Are the unrecognizable insects on the sticky trap significant pests or merely incidental intruders? Is the trapped rodent a resident house mouse or invading deer mouse? Are the shed wings from subterranean or drywood termites? Distinctions that appear trivial to the layperson often distinguish among totally different types of problems requiring distinct control solutions.

Record keeping: As with any other program, record keeping is a necessary evil for pest control surveillance. Obviously, the emphasis should be on the "necessary." Schooled in a data-oriented discipline, consulting entomologists tend to recommend IPM reporting and logbook systems that border on the obsessive. Records of inspection and trapping results often prove invaluable for detecting patterns and trends in a facility's pest problems, but the goal should always be to match record keeping with needs.

Exclusion

The fortress concept is at the heart of the preventive approach to pest control. Regardless of location, a museum can be thought of as a vaulted island in a sea of vermin. In fact, the facility-as-leaky-boat is one of the oldest IPM metaphors; traditional pest control confines itself to bailing, while IPM concentrates on plugging the leaks.

Sealing is an important technique. Filling or screening gaps is fundamental to reducing pest access into a structure, from one part of a structure to another, and to harborage (protected hiding and living space) within the facility. The same sealing principles apply to the building envelope as to the display or storage envelope that ideally surrounds all vulnerable objects in the collection. Remaining gaps must be smaller than the target pests, and the protective barrier must be resistant to pest chewing.

Museum professionals usually are familiar with available types of pest-resistant display and storage systems. They tend to be less knowledgeable about what specifically can be done to improve the security of their outer perimeter. Active sites of pest entry into a building are universal, and include under doors, around window frames, through chases and other penetrations for utilities, weep holes in masonry, damaged or poorly screened vents, window air conditioning units, floor drains, and so forth. There are now so many different types of caulks, polyurethane foams, quick-setting cements, rubberized membranes, and weather-stripping materials to seal every type of opening and adhere to every type of building material that consultation with a maintenance or construction specialist is often essential for pest-proofing projects. The pest control industry itself increasingly employs an arsenal of specialized products for these purposes, such as finely-screened weephole plugs, stainless steel drain inserts, and rolled copper mesh for rodent exclusion. Even mundane items, such as window screening or hardware cloth, may be all that is necessary to provide a critical barrier to pest access.

Pests do not live out in the open. Most need darkness and seclusion to survive. "Harborage" signifies not only cracks and crevices but also any protected habitat created by fixtures, furniture, equipment, boxes, and other seldom-moved objects that enable small species to escape detection. Museums by their nature are "harborage-intensive" facilities, and pest control guidelines for the reduction of clutter in office buildings may not be realistic

where collections are accumulated, curated, and displayed. The design of the storage room and equipment directly affects the museum's ability to control pests. However, other than "less is better," the most universal housekeeping and storage rule is to keep items off the floor and away from the walls as much as possible. This facilitates visual inspections and reduces the risk of damage by pests such as termites and mice.

A second rule mandates the use of air conditioning to produce as cool and dry an environment as practicable for storage and display areas. Although this will not totally discourage museum pests, insect activity generally increases in warm (above 20° C), moist conditions.

Most aspects of structural or landscape design that tend to promote pest problems are either unchangeable for historic, aesthetic, or monetary reasons, or were purposely selected for their function. A classic example is raised flooring, one of the greatest gifts to indoor pests ever developed, that is also the most efficient means for housing dense arrays of telecommunication and computer cabling.

Nevertheless, opportunities do arise during renovation or retrofitting projects to make meaningful improvements in design if knowledgeable pest management specialists are consulted in the early stages. Such changes do not have to be elaborate. A facility plagued by flying insects entering through the outer doorway might benefit greatly from the installation of an air curtain unit. If most of these insects are drawn to lights around the building at night, there is an entire sub-specialty of pest control that deals with exterior lighting. Relamping from bright white mercury vapor bulbs or incandescent floodlights to lower wattage yellow sodium vapor or halogen lights, partially shielding or redirecting the lights away from doorways and vents, slightly delaying the onset of lighting at dusk to avoid the peak flight time of certain midges, and the use of bright "decoy" lights at the property's edge to lure insects away from the primary structure have all been successfully used for pest deterrence.

Landscapes can often be altered more readily than buildings. In general, problems with rodents and many types of nuisance species are increased by extensive plantings of dense shrubs or ground cover, particularly if these are close to the structure's foundation. Ivy covering exterior walls is an especially critical "attractive nuisance" from a pest control point of view. Excessively watered or poorly drained grounds, especially in drier climates, are also guaranteed to promote local pest populations. In cases where dense surrounding plantings cannot be modified, the creation of a bare strip of pavement or crushed rock bordering the foundation may reduce pest entry.

Bird-proofing of buildings, particularly historic structures, is another highly specialized branch of modern pest control. In addition to choosing an anti-roosting system that is durable, effective, and discreet, there are often equally important concerns with avoiding physical damage to the building and minimizing adverse public relations. An abundance of technologies are available. Three that should be avoided are scaring devices such as plastic owls or giant eye patterns (birds soon become used to them), repellent gels (eventually discolor and may permanently damage masonry), and ultrasonic or other electronic "pest repellent" products (totally worthless).

"Porcupine wire" is the generic name for modular arrays of protruding spikes or coils that are usually effective against pigeons if properly installed, but may actually promote nesting by smaller birds. They tend to be aesthetically unacceptable for sites in the public view, but may be useful for concealed applications. Electrically charged wire is another traditional system that has been prone to frequent breakdowns as the hardware ages as well as to masonry damage where the insulators are attached. However, newer refinements have eliminated many of the older products' flaws.

At present, the two leading technologies for bird deterrence on historic structures or any high-visibility site are "pin and wire" systems and tensioned

netting. The former consists of non-electrified stainless steel wires tightly strung at different heights along projecting structural elements such as ledges, lintels, sills, and string courses. The wires are supported by slender steel pins inserted into mortar joints. Tensioned netting installations consist of various types of synthetic net fabrics stretched taut by peripheral cables across recessed elements such as niches, colonnades, and coffered ceilings. Although employing technically simple hardware, both of these systems require a high level of skill and experience to be installed correctly.

Sanitation

For maximum effectiveness, procedures that deny pests access and shelter must be combined with those that deny them food. Once again, it is not unusual for museum staff to devote most of their attention to the immediate protection of organic collection items while neglecting far more extensive (but more mundane) sources of pest nourishment nearby. For example, a natural history museum continually treating its displays for dermestid beetle infestations may have accumulated enough organic debris in flooring cracks or under carpeting to sustain a reservoir of thousands of these insects. Similarly, it makes no sense to trap mice out of a gift shop while they continue to be replenished at an even greater rate because of poor sanitation in the adjacent snack bar.

It is also essential for employees to realize that many common, apparently inedible materials are actually extremely rich food resources for some pests. An excellent example is the widely used, biodegradable packing nuggets composed of cornstarch that superficially resemble Styrofoam but are highly attractive to general feeding pests such as cockroaches. "Sanitation" in an IPM context means the same pest-proof storage practices for this type of product as for more obvious food substances.

Cleaning is a vital activity. Careless treatment of food throughout a building is one of a pest manager's greatest headaches, since most personnel consider any sort of cleaning to be an unpleasant, tedious chore. Furthermore, contracted or in-house custodial programs tend to emphasize relatively superficial cleaning operations and rarely focus on the most critical types of sanitation from a pest's point of view. Any accumulation of edible residue on surfaces or in crevices where food is stored, prepared, consumed, or discarded puts a facility at risk for pest infestation.

To a certain extent, newer types of more efficient technologies can compensate for the human propensity to postpone or neglect meaningful "deep" cleaning. The best example is compact, electrically powered, pressure washing machines for the removal of grease and debris in food service facilities, trash holding areas, garbage receptacles, floor drains, and similar locations. However, offices and laboratories must still depend on essentially the same type of procedures applicable to residential kitchens. There is no substitute for strictly enforced staff policies on proper food storage and cleanliness around pest-prone appliances such as coffee machines, microwaves, and refrigerators.

Solid waste management must be undertaken. Garbage and food-laden trash is stored twice in a building, first in small local receptacles throughout the structure and finally in larger containers emptied by a private or municipal contractor. This solid waste represents a concentrated resource for many general-feeding and nuisance pests that is unequaled anywhere else in or around the facility. From a public health standpoint, a waste management program must effectively concentrate, isolate, and secure food debris before removing it from the premises as rapidly as possible.

Public and staff trash receptacles and beverage container recycling bins should ideally incorporate sturdy, disposable plastic liners that are replaced with every pickup. Although these receptacles are typically designed more for ease of use than security, models with tightly sealing, foot-pedal operated lids are recommended for disposal of food remains in offices and laboratories. Procedures should be in place for periodic inspection and cleaning of receptacles and trash collection carts,

particularly those used for wet garbage and recycled beverage containers.

Centralized waste storage equipment should, at a minimum, be mouse proof. This is generally defined as being constructed of steel and having no gaps greater than one-quarter inch. If rodent infestation in trash-holding areas is a problem, the traditional garbage cans or dumpster should be replaced with a self-contained compactor. These pest-resistant machines are watertight, range from one to over 40 cubic yards in capacity, and are available in horizontal or vertically compacting models. They are normally leased from a waste hauling contractor.

CORRECTIVE TECHNOLOGY AND PROCEDURES

Action Thresholds

Despite the most thorough preventive efforts, it should be taken for granted that pests will eventually be detected somewhere inside the facility. Following identification, there should be rapid selection of the best corrective response. However, long before these events occur, every curatorial staff member should have resolved the fundamental policy issue of exactly when corrective procedures will be implemented. That is, how many pests must be observed in a given situation before they are deemed a problem? This numerical decision point is termed the "action threshold" for a pest.

In many cases, all it takes is one pest specimen to justify the expense of treatment. Often, only a sign is necessary, such as a cast skin of a dermestid beetle larva in a display case or fresh mouse droppings on a desk top. An important principle is that action thresholds are site-specific. A few dermestid adults (which feed on pollen) on the window sills may not be cause for concern, particularly during the summer months.

There is sometimes considerable dispute over the justification for prophylactic treatments of collection items that are highly susceptible to cryptic feeding damage by pests. When the desired action is either limited in scope (e.g., for newly acquired

or returned material that normally would be quarantined) or nontoxic (e.g., freezing), the issue is primarily one of time and expense. However, when a corrective procedure such as a slow-release fumigation becomes a routine preventive operation, museum management must factor public health risks into their cost/benefit analysis.

Following is a brief review of the most widely used, proven methods for killing or removing pests that infest museums. Technologies that are still mostly experimental, such as the use of microwave or gamma radiation, are omitted. Similarly, although the application of heat above 50° C has been successfully used to control insects in some circumstances (e.g., herbaria, and in general is far more efficient than freezing for the majority of pest species), this procedure is potentially harmful for most specimens, art, or artifacts.

Vacuums

The use of small, canister-type vacuums for routine structural pest control operations has increased greatly in recent years. One of the most common applications is for initial "cleanouts" of cockroach infestations in desks, lockers, appliances, and other sites, prior to pesticide treatment. At the same time, the machine's narrow nozzle can efficiently remove food remains and other organic debris lodged in crevices that serve as a food reservoir for these insects. Precision vacuuming of collection storage and display areas is also an excellent preventive measure to reduce accumulated organic material such as hair and lint that feed stored product and fabric pests. Additional corrective uses include elimination of spiders and webs, rapid disposal of swarming termite and ant reproductives, and the capture of many other nuisance invaders.

Traps

Flying insect traps: Despite the marketing literature that accompanies them, most insect traps are more practical as monitoring, rather than control, tools. An important exception is the wide variety of products for eliminating flying insects inside

buildings. The most versatile and effective type, although also the most conspicuous and expensive, are electrically powered units combining ultraviolet lights that attract the pests and replaceable sticky sheets that immobilize them. One variation employs a harmless low-voltage pulse to maximize capture by stunning the insects (not to be confused with the older type of "bug zapper" electrocuter traps intended for outdoor use). Several models are in the form of decorative, wall-mounted sconces for discreet use in food service and other sensitive public facilities. Virtually every type of flying indoor insect pest, including many incidental invaders, are susceptible to these devices.

Rodent traps: Trapping is usually more desirable than rodenticide bait for the control of rats and mice inside structures since poisoned rodents often die and decompose in inaccessible locations. Traditional snap traps are still the preferred tool in most situations. Windup multiple-catch mouse traps can be very efficient in commercial kitchens or other areas with relatively dense infestations. Although effective under some circumstances, glue boards tend to allow more escapes than snap traps and have become controversial because of the extreme suffering inflicted on the immobilized animals. All rodent traps must be concealed in locations out of the public view, protected from accidental disturbance, and checked regularly.

Freezing

With an increasing number of museums concerned about the cost, regulatory, and safety issues associated with conventional fumigation procedures, freezing has become the preferred substitute for treatment of many types of infested (or potentially infested) specimens and artifacts. The ideal facility consists of a walk-in, humidity-controlled chamber capable of flash freezing its contents down to -40° C. Commercial meat lockers and refrigerated trucks with these specifications are available for rent, although still well beyond the financial resources and practical needs of many smaller institutions. Collection staff must therefore be familiar with the general protocols for successful freezing treatments to evaluate the suitability of available equipment.

It is critical to consult a professional familiar with freezing specific objects, since the process may damage certain woods, bone, leather, paint, finishes, and other materials. Many types of natural and artificial adhesives lose their bonding properties under extremely low temperatures. However, the primary technical challenge for any object is protection from ice during freezing and condensation during thawing. Unless a controlled humidity chamber is used, items should always be enclosed in airtight, polyethylene bags or similar containers. Depending on the fragility of the specimen or artifact, various procedures can be used to further minimize the possibility of damage, such as partial evacuation of air before sealing, inclusion of a water-absorbing material (such as silica gel) inside the bag, or even vacuum packing. A gradual return to room temperature over a period of 24 hours is recommended at the end of the treatment. Most museum pests will be killed after 48 hours at -25° C, well within the capability of a good quality chest freezer if not packed too densely. However, some species may require much longer freezing times and lower temperatures. It is important that the items reach the pest-specific target temperature as quickly as possible, since gradual cooling may promote greatly increased cold tolerance by insects. The most hardy pests (e.g., powderpost and some dermestid beetles, drywood termites) generally require a protocol of freezing to at least -35° C within several hours, storage at this temperature for one to two weeks, a gradual thaw to room temperature, then refreezing for at least several days.

Oxygen Deprivation

Oxygen deprivation in controlled enclosures has proven to be effective in killing all stages of insects infesting objects. The object to be treated may be enclosed, individually or in a group, in special low-oxygen permeable plastics. The atmosphere within the enclosure is then replaced with an inert gas,

such as argon, or a functionally inert gas (at normal room conditions), i.e., nitrogen. The RH and temperature are controlled during the replacement phase. An oxygen-scavenging material such as Ageless™ or Freshpax™ may be included in the enclosure to absorb any residual, out-gassing, or infiltrating oxygen. Even insects deep within objects eventually succumb to the low oxygen environment (as has been shown by measurement of insect respiration byproducts, e.g., carbon dioxide). The length of treatment to ensure 100% insect eradication by oxygen deprivation may extend to four to six weeks, depending upon the insect, lifecycle stage, gas used, object size and density, and temperature and humidity conditions. Consult a professional experienced with oxygen deprivation methods and systems to design and implement an oxygen deprivation pest control system suitable for your collection needs.

Fumigation

Although often incorrectly applied to any insecticidal space treatment, the term "fumigation" strictly refers to the use of a toxic gas (as opposed to aerosol or mist formulations) for pest control. The procedure is used extensively to treat entire structures for wood-destroying pests and food storage facilities for stored product pests. In a museum, fumigation on a more limited scale is a traditional method to treat items that actually or potentially contain pests that are highly cryptic or deeply embedded. When correctly used, fumigants can penetrate porous materials much farther below the surface than any other type of pesticide, without harming the object in any detectable way. They are indispensable for infested items that cannot be subjected to freezing temperatures as a control procedure.

On the other hand, fumigants present many drawbacks. Chamber fumigation is a highly specialized and expensive technology requiring extensive training and skill. Unlike freezing, it is usually performed as a contracted, rather than in-house, service. Matching fumigant to material is critical, since many substances can be seriously damaged if the wrong product is used. Conventional fumigation chemicals are broad-spectrum, extremely toxic poisons that must be handled with great care; environmental and public health concerns have eliminated or threatened the availability of some compounds. Conversely, despite the lethality of fumigants in general, the eggs of many beetles are remarkably resistant to harm, accounting for the majority of fumigation failures involving museum items. And of course, as with all corrective technologies, fumigation has absolutely no protective value.

Operationally, fumigation of museum objects can be divided into two basic procedures: chamber fumigation—use of a specially designed vault or chamber to confine a toxic gas is the safest and most effective type of fumigation; and slow-release fumigation—use of chemical solids that gradually release a gas used for pest control and are thus categorized as "passive" fumigants. None can penetrate very far into most materials. All are now considered to be potentially severe chronic and acute health hazards and should no longer be used by the museum community in most circumstances (e.g., PDB, Naphthalene, DDVP).

Indoor Pesticides

The role of conventional pesticides as routine corrective solutions for pests in public buildings, particularly "sensitive" ones such as museums, has steadily diminished in recent years. In general, almost any liquid or dust insecticide applied with air pressure out of a nozzle is now considered to be a weapon of last resort where exceptional measures are required. These products have a long history of excessive and haphazard use by the pest control industry. Even with special "crack and crevice" application equipment, they are intrinsically difficult to confine to precise areas. When used in close proximity to collections, virtually all compounds have the potential to damage some materials with which they come into contact.

At present, a relatively new generation of nonvolatile insecticide baits is clearly the best choice

for corrective cockroach and ant control in museums. Active ingredients of these products include boric acid, hydramethylnon, abamectin, and sulfluramid, all of which have extremely low mammalian toxicities. Formulated into solids, pastes, and gels, they are either protected inside small, plastic containers or applied in limited amounts with devices resembling syringes or miniature caulking guns. Discreet and nonintrusive in the indoor environment, they have become indispensable for those concerned about how "spraying" affects collection items and public health.

In contrast, rodenticide bait and tracking powder formulations are not recommended for routine use inside buildings because of the potential odor problems of poisoned animals that cannot be retrieved. Decomposing carcasses behind walls also serve as breeding sites for numerous species of insect pests. In addition, most types of rodent bait attract stored product beetles. Rodent tracking powder presents the same disadvantages as residual insecticidal dusts in that it is difficult to contain and may become a hazard during future renovation work.

STRUCTURAL INFESTATIONS OF WOOD DESTROYING INSECTS

Termites, powderpost beetles, and other wood destroying insects cause a multitude of problems for facilities managers beyond threatening the structural integrity of buildings framed with wood. Even concrete and steel buildings are susceptible to damage in fibrous insulation and sheathing, furring strips, trim, paneling, and hardwood flooring. Museums are particularly at risk from structural infestations spreading to stored documents and collection items composed of cellulose. In addition, swarms of winged termite reproductives emerging indoors from remote colonies can severely disrupt operations, even though the insects themselves are completely harmless.

Wood destroying insect control is also one of the most complex, specialized, and expensive areas of pest management and is undergoing an unusually rapid expansion of its technology. Unless there is an in-house employee with up-to-date expertise in this discipline, museums are strongly advised to consult a professional entomologist prior to committing to any specific course of action.

Patrick Ralston

THE REGISTRAR'S ROLE IN A BUILDING PROGRAM

A dramatic shift in the design of museum buildings has taken place over the last 20 years. Whereas most museums constructed prior to this century were "gallery designs"—built primarily for the exhibition of most or all of their collections—today's museums are usually designed to accommodate a broad range of functions, from collections management to educational programming and building rental. Of these functions, collections management is the most fundamental to the overall mission of the institution; stewardship of objects entrusted to it is, after all, a defining characteristic of a museum. Unfortunately, the failure of architects and administrators to understand the need for facilities to care for as well as exhibit collections is still a major stumbling block in the development of a comprehensive model for museum design.

To provide adequately for the management and protection of the collections, the registrar must assume the role of "collections advocate" in any alteration to the museum's physical structure. Reduced to the most basic of terms, the registrar's responsibilities include: assessment of the needs of the collection; consultation on facility modifications; and coordination of conservation, record keeping, and collection moves during construction. If there is a conservator on staff as well, the two should form a team to work on the project.

ASSESSING BOTH PRESENT AND FUTURE NEEDS OF THE COLLECTION

A registrar usually participates in no more than one or two expansion or renovation projects in his or her tenure at one institution, which makes it difficult to understand the importance of these projects and the registrar's role in the museum's master plan. As temporary stewards of the collections, registrars must learn to think in institutional time, that is, to recognize the tangible effects that today's seemingly insignificant decisions will have on the management of the collection in the future. In practical terms, this means understanding the current needs of the collection and projecting future needs. Assessing needs makes it possible to plan storage or exhibit facilities to accommodate growth and changes in the collection; understand and plan for the effects of external factors, such as the proposed construction of a nearby highway, and the hazards they might pose; and create a collections management policy that reinforces the critical nature of these issues in the institutional consciousness.

CONSULTATION ON FACILITY MODIFICATIONS

Like the building manager or maintenance supervisor, the registrar has a vested interest in preserving and improving the integrity of the museum's physical plant. But unlike the building manager, whose concerns are somewhat more comprehensive, the registrar brings to the planning process a specialized knowledge of the needs of the collection. The primary concern is, of course, the physical safety of the objects in the museum's care, regardless of whether they are on exhibit, in storage, or under observation. Changes in security, fire suppression, or environmental systems all have a direct and measurable effect on the registrar's job; so, too, do the particulate pollution, untrained personnel, and mechanical hazards associated with a large construction project. When some or all of these factors come to bear on the fragile environment necessary to maintain sensitive collections, the consequences can be catastrophic.

Acknowledgments: Vincent Wilcox, Smithsonian Institution; Christopher J. Reich, Putnam Museum; Catherine Hawks, conservator.

COORDINATION OF CONSERVATION, RECORD KEEPING, AND MOVEMENT OF THE COLLECTIONS

Even the best plans can unravel in actual practice, and this is often the case when museums undertake large construction projects. By the time ground is broken, the registrar should have a detailed inventory of collections to be affected by the construction. Enclosures and filtration should be in place to minimize particulate damage, and security should be increased to compensate for breaches in building integrity. If the project requires temporary or permanent displacement of the collection, plans should be in place for the orderly transfer of the objects to a safe holding area. Temporary climate control systems should be planned for and prepared in advance for sensitive objects during construction. In the midst of the controlled chaos that usually accompanies building construction or renovation, the registrar must be the model of thoroughness and administrative efficiency.

REDESIGNING AND REORGANIZING SPACES

Planning Space and Access

Reorganization of an existing structure carries with it many of the same challenges inherent in building construction. But retrofitting an old building to accommodate new operations or facilities also presents a number of unique constraints on the registrar's role as collections advocate. An obvious problem is the difficulty of shutting down large portions of the museum and disrupting programs while contractors install new walls, electrical conduits, and water pipes. Less obvious, but no less important, is the need to assess hazards in the existing structural design, rethink the flow of staff and collections traffic, and establish a long-term policy for use of space in the museum.

The registrar must first determine priorities for needed changes in the building's interior. High on this "wish list" might be:

- Repairs to the roof or exterior walls
- Asbestos abatement
- Construction of a secure space for the storage of collections, separate from visitor and office areas
- Installation of basic climate control systems necessary to stabilize
- Temperature and humidity levels
- Basic security or fire suppression systems

Secondary concerns might include floor and interior wall treatments, installation of fireproof doors and walls between work areas, and improved lighting. The highest priority should be given to renovations that enhance the operations of the museum, while allowing for the safe and efficient handling of the collections.

Clear differentiation of public and staff spaces is essential in any museum, but it is especially crucial in redesigning an existing structure. The registrar must establish traffic flow for collections moving into, out of, and through the museum. Such a traffic plan has clearly identified and interconnected areas for moving collections (the "Zone of Safety"). Incoming material passes through work areas much as a car moves on an assembly line; from the loading dock it travels to a shipping/receiving area, then to an examination room for inspection and condition reporting. From there it can be transferred to various non-public areas for photographic documentation, conservation, or storage. Although no two museums will share the same plan, the principles are universal.

In practical terms, the route that collections travel must be secure and clear of obstructions. Corridors should be as wide as possible, with ample overhead clearance to accommodate large or irregularly shaped objects. Doors should also be large enough to allow easy movement of equipment and collections from one area to another, while providing security for staff areas. Sharp corners or irregular floor plans are to be avoided, as they are usually difficult to negotiate and can restrict vision when it is most needed. Bottlenecks resulting from

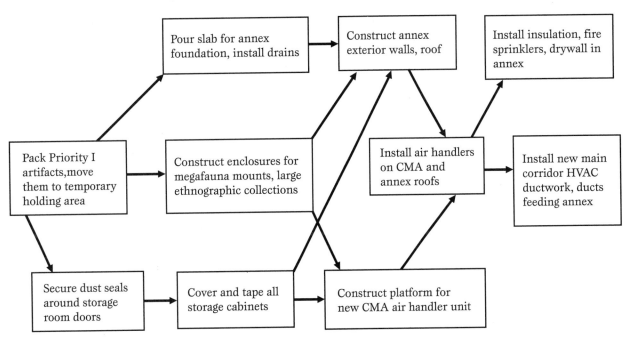

Critical path management (CPM) can be used by a registrar to integrate preservation and management of the collection with several other operations, such as the installation of the HVAC system or construction of a new wing. Each operation is dependent on the completion of prerequisite tasks—for instance, the exterior walls of the annex cannot be constructed until a slab foundation is poured, large collections are enclosed, and storage cabinets are sealed.

poor traffic planning are usually discovered at the worst possible times, and they can bring large and expensive museum projects to a grinding halt.

The registrar must have an intimate knowledge of the space requirements of the collection, and these space considerations should be reflected in every part of the new floor plan. One of the most important components in any museum is the shipping/receiving area, often represented by nothing more than a loading dock and a roll-away door. At no other point in the museum is the object more vulnerable to the effects of rain, wind, heat, cold, or theft. A loading dock should be at least partially covered, with the ideal being an enclosed, climate-controlled area. The actual size of the dock area depends on the needs of the collection, and future growth of the museum should be considered in planning the dimensions. A museum with an active exhibit or loan program will often require a bay large enough to accommodate at least one 18-wheel truck, which will in turn necessitate enough

outside street space to maneuver the vehicle into the dock platform. Most dock doors now range between 16 and 20 feet in clearance, allowing for variations in truck and trailer size.

The dock itself should have a wide, low platform for end- and side-loading trailers; adequate space for dollies and portable lift equipment should be figured into the design. If a shipping office adjoins the platform, it should afford a clear, unobstructed view of the dock and doors to enhance the security of the area. Remember that most museums will use the same dock for moving all incoming and outgoing material, from collections to packaged exhibits, construction equipment and events furniture. The dock should be planned so that collection items can be easily isolated from other potentially hazardous materials while loading or unloading. The obvious solution is to allocate a shipping/receiving area for collections separate from the loading dock. Here, objects can be packed and unpacked safely by trained personnel prior to

shipping or processing, in an environment designed specifically for collection material.

The collection shipping/receiving area is the first component in what can be collectively described as the collections management area, a cluster of non-public spaces in the museum devoted to the conservation, examination, and storage of permanent or loan collections. The collections management area is characterized by the highest levels of structural security and environmental control; it is no exaggeration to describe it as the backbone of the museum. In designing or reorganizing the spaces that make up this area, a registrar must carefully evaluate how objects are stored and moved in the existing structure. Are there inherent conflicts in the current traffic plan? An example might be a storage area accessible only through a conservation lab; this creates dangers to the objects being moved and an inconvenience for lab staff. A practical alternative is to locate the collection management area around a central access corridor, similar to that employed in the design of the Smithsonian Institution's Museum Support Center in Suitland, Md. The Museum Support Center is constructed around a wide "street" connecting storage, laboratory, and office facilities under one roof. Using this modular concept, traffic jams in the movement of people and material can be greatly reduced, and sensitive collection storage rooms and laboratories do not become throughways. The main access corridor should also provide at least one connection to the museum's exhibit hall, allowing for the safe movement of objects on display, while protecting the collections management area and staff areas from overly curious visitors.

As a general rule, collections should remain on a single level; this is an ideal rarely realized. If vertical expansion becomes a necessity, elevators are a must. The size depends on the dimensions of the objects to be moved; some manufacturers will custom-build freight elevators. It is vital that registrars grasp the present and future needs of the collection so they can help plan efficiently. Elevators should adjoin the main corridors of the collections man-

agement area, allowing for a continuity of traffic from one floor to the next. Use of freight elevators for regular passenger traffic should be avoided; such use increases maintenance costs and creates a potential hazard to staff and collections.

Having established a plan for moving collections through the museum, the registrar must also consider the designation of work spaces. Because few museums exhibit more than 20 percent of their collections at a time, adequate storage space is a very real concern. There is no simple formula for projecting a collection's space needs into the next 10 or 20 years; one must rely on past trends as a basis. For instance, a museum with a growing research collection might approach the storage problem statistically, using the collection's growth rate for the last decade to forecast its expansion in the next. The registrar identifies a 10% average annual growth rate for the last 10 years. With the aid of a computer program or simple arithmetic, she can project that today's collection of 50,000 fluid-preserved specimens will grow to nearly 130,000 if this rate is sustained for another 10 years. By using this technique and building in additional room for fixtures and equipment, the registrar can (theoretically) plan enough space to anticipate growth long before storage gets overcrowded. In the absence of hard statistical data, registrars must use what they can get.

Before an incoming artifact or specimen is introduced into the controlled environment of the collections management area, it must be closely inspected for insect or chemical contamination. This is best performed in a processing or quarantine room located between the receiving area and the collections management area. The object can be completely sealed off from the rest of the building while it is examined. Doors and vents should be tightly sealed to prevent insect migration, and an integrated pest management program should be strictly enforced. It is useful to locate freezers or observation cases in this area to handle any potential contamination. Again, isolation is essential in planning a quarantine area; it represents the last

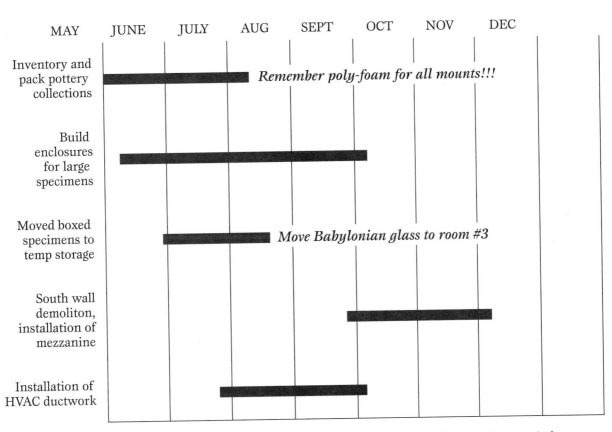

A simple Gantt bar chart, plotting the sequence of operations preparing and protecting collections during an in-house construction program. Bar charts are useful for allocating limited time and collections staff resources for such a program, but they do not illustrate relationships between operations (i.e., the need to complete enclosure of cabinetry before a wall is demolished).

defense against an insect attack, and its value in an effective integrated pest management program cannot be overemphasized. (See chapter on Integrated Pest Management.)

The location of conservation laboratories in a museum is itself a collections management dilemma. A registrar lucky enough to have a conservation lab on site needs safe and easy access to the lab from the collections management area. However, a well-equipped lab, with running water, vent hoods, and volatile chemicals can be a safety hazard if located too close to collections storage areas. If such an arrangement cannot be avoided, stringent safety precautions must be taken to insulate the lab from the collections management area. Installation of fire doors, separate ventilation systems, chemical fire

suppression systems, and floor drains should be included. As with kitchens, rest rooms, or any other "wet" facility in the museum, the lab should never be elevated above collections or exhibit spaces, because of the threat of destructive leaks.

The registrar's office is usually the last part of the collections management area to be planned, which explains why so many registrars wind up in closets or under stairways. Although having the office in close proximity to the actual objects is convenient for staff, registrars and architects should also recognize the importance of ergonomics in the administration of the collection. The office should be planned with humans in mind and should include ample room for desks, filing cabinets, and work tables. Offices should be well-lit, pleasant environ-

ments suitable for long hours of work. If this kind of user-friendly space can be safely placed within the collections management area, so much the better. But if such a plan interferes with the safe storage and handling of sensitive collections, the registrar should relocate to another area of the museum.

A final word on access and design bears mentioning. As the registration field grows, so too does the diversity of its members; any effort to improve access and traffic flow in a museum should include substantial attention to the needs of persons with disabilities. Since the passage of the Americans with Disabilities Act (ADA) in 1990, U.S. museums have made many improvements in the way they serve physically challenged members of their audience. As institutions in the public trust, museums also have a responsibility to provide adequate facilities for staff members with disabilities. Such good-faith efforts can range from the obvious (Braille signage, wheelchair ramps) to the practical (lowered lab counters and light switches, TTD terminals). In any construction project, the registrar should be aware of federal and state guidelines regarding compliance with ADA, and these concerns should be an integral part of the design philosophy.

SURVIVING RENOVATION AND REORGANIZATION

Even minor building renovations cause disruptions. Introducing untrained workers, heavy equipment, and clouds of dust into the fragile museum environment can have an effect similar to that of a small explosion. To survive this, the registrar must resort to the most basic duties of the trade: make lists, attach labels, and plan every move carefully. The first day of construction is not the time to discover that a collection of delicate prints has not been cataloged or that a box of 200 crinoid fossils needs to be repackaged and inventoried. Like the facility design itself, the registrar's protection of the collection must be painstakingly plotted with the

expectation that anything—anything—can, and probably will, go wrong.

Long before the first nail is driven, the registrar must establish a work schedule to prepare and protect the collections. The simplest and most common approach is a Gantt bar chart, often used to schedule multi-stage grant projects. This chart uses timeliness to illustrate sequences of events and deadlines for completion, and has the advantage of being simple and easy to change. Its most obvious disadvantage is its inability to show relationships between two or three separate operations, for instance, the relationship of a collections management area renovation and installation of a new HVAC system, both dependent on completion of a registration project. To schedule more complicated, multi-player projects, a critical path management system can be very effective. A critical path management chart aids in scheduling by showing which operations in a given project affect the scheduling of operations in another, allowing the registrar and contractors to work on the same timetable. While this sounds like administrative overkill, effective scheduling can actually shorten both the construction project and the registrar's role in it. Critical path management charts for most building renovations can be sketched out in a matter of minutes.

Assuming that registration records are in good order and the collection does not have to be moved, the registrar's primary concern becomes preventive conservation. Even minor exhibit construction can generate huge amounts of dust, creating airborne particulates that can literally sandblast collections over time. The first line of defense is enclosure of the objects in an airtight microenvironment such as a metal storage case or polyethylene tent. For further protection, the enclosures themselves should be covered with polyethylene sheeting, and taped tightly to prevent contamination. Doors to storage areas should be secured in similar fashion, and air filters should be changed or cleaned regularly. Meanwhile, the registrar should take an active role in removing dust from the construction area itself.

Such measures range from the mundane (insisting that contractors vacuum and sweep work areas during construction) to the sublime (construction of a polyethylene vent tube to blow airborne dust out of the building).

Two of the most obvious threats to the safety of the collections are people and equipment. This is especially true when the collections management area itself is being renovated or expanded. Few construction workers have the training to handle museum collections. The registrar should not allow contract laborers access to the collections storage area without an accompanying staff member. As with visiting scholars, students, or any other visitors to the collections management area, there is also the danger of theft. Security should be increased to compensate for increased access by non-staff during construction. The registrar must also stay well informed about materials and equipment being used in the construction, as they can potentially cause serious mechanical damage. If demolition or excessive hammering are to be done in close proximity to the storage area, measures must be taken to move or pad sensitive objects against the vibrations. Material safety data sheets (MSDS) should also be requested on all materials used in the construction, and these should be inspected carefully by a conservator and maintained in the registrar's office.

Movement of the collections should be a last resort, but it is often unavoidable during renovation or expansion of the storage area. The registrar must plan such an operation in stages, with careful attention to the sequence in which collections are moved, protection of objects in transit, and where and how they are to be temporarily stored. Sufficient equipment and trained staff must be available to make the transition in a smooth, orderly manner. Generally, the faster the move can be made, the less vulnerable the collection. The quality of temporary storage should be as high as if not higher than the permanent facility, and security must be tight. In the disarray of major construction, this is definitely no time to take chances.

BUILDING A BETTER COLLECTIONS MANAGEMENT AREA

A collections storage area can be characterized briefly as a secure and environmentally stable area. Unlike the regular staff and visitor areas, there is no need to make the collections management area inviting. Indeed, the best collections facilities are starkly functional environments designed purely for the preservation of their contents. Casual access to permanent storage spaces, even by trained staff, is to be discouraged.

The storage area itself should be structurally secure to prevent invasion by insects, humans, or the elements. Exterior walls should be constructed of inert material such as concrete or brick, with a vapor barrier to inhibit condensation and fiberglass insulation to help maintain a stable climate. Roof materials should include a vapor barrier, fiberglass insulation, and waterproofing. Interior walls should be fire retardant and have metal studs. Sealed gypsum board is still a relatively cheap and practical wall material, but material safety data sheets should be examined to ensure that no hazardous chemicals are present. Walls should be painted white for easy inspection and cleaning. Paints containing titanium dioxide or zinc oxides are especially well suited for this purpose because they absorb ultraviolet radiation; oil-based or alkyd paints should be avoided. White walls make detection of dust, mildew, and insects easier, and reduce the amount of lighting necessary to work in the storage area.

Floors and ceilings are best left bare. Although carpet enhances soundproofing and comfort, it also requires more housekeeping and provides harborage for dust and insects. White tile or concrete are the best floor treatments for collections storage, provided they are sealed with a non-reactive, moisture-cure epoxy. Avoid sulfur containing rubber gasketing or lining materials. Similarly, suspended ceilings should not be used in a storage area because they create a hidden space for insects to breed and dust to collect. They also complicate routine maintenance

of light fixtures or sprinkler systems. Assuming a layer of insulation is already built in, the ceiling's interior should be painted the same color as the walls, and beams and light fixtures should be included in the museum's regular housekeeping plan.

Security and access are the major factors in design and selection of doors for collections storage. Doors should be solid and heavy, with good seals and locks. Metal doors are generally preferred, although wooden ones can be used if they are properly sealed to prevent off-gassing. Check with a conservator to find out which woods should be avoided altogether (e.g., oak). Avoid windows in exterior doors. Even security glass is easily breached, and windows allow stray light into what should ordinarily be a darkened area.

The storage area should be lit only when it is in use, to avoid damage to collections by prolonged exposure to ultraviolet rays. Because of its energy efficiency and cool operation, fluorescent lighting is recommended, provided the tubes are UV filtered. To further limit the amount of light introduced, some storage areas are lit in sections, each controlled by a dedicated wall switch. Light fixtures should usually be ceiling mounted and should allow easy access for cleaning and maintenance. Fluorescent tubes can be purchased with factory shielding, or shielding can be applied using polyester tubing or diffusion plates.

Electrical connections should be conveniently located in the storage space, but too many can be a hazard. Because most treatment or study of collections should be done outside of the storage space, outlets are not a high priority. A good design might include a combination of wall, floor, and ceiling outlets to facilitate housekeeping and lighting operations; care must be taken if conduits are placed near sensitive collections. Electrical lines should be modular, well insulated, and easily accessible to maintenance personnel. The registrar should insist that the collections management area's power grid be centralized, feeding off main circuits located in the facility's central corridor or maintenance area.

This will help to discourage electrical contractors from creating patchwork circuits that are difficult to maintain without disrupting museum operations. Dedicated circuits, separate from the main grid, should be used to power computers or special environmental systems.

As with electrical conduits, the registrar should be extremely attentive to the placement of water pipes in and around the collections management area, especially in storage spaces. Water is a destructive agent when introduced into a controlled storage environment, and some of the worst damage in museum collections can be caused by seemingly innocuous leaks. Pipes should be routed through main corridors, allowing easy access and inspection. Seals and valves should be checked regularly. Bright industrial markings should be used to identify the direction of water flow in the pipes. Separate emergency shut-off valves should be installed centrally in the collections management area, and all personnel should be instructed in their use as part of the museum's disaster plan. Wet-pipe sprinkler systems, the kind most commonly found in museums, should also be clearly marked. Flow control heads, which shut off once a fire is contained, should be installed throughout the museum. Under most fire codes, sprinkler heads can be inverted upward without decreasing their effectiveness, thereby reducing the risk of their being bumped during housekeeping or maintenance. As a last defense against water damage, floor drains will allow easy evacuation of water in the event of a leak or fire.

Although environmental control is treated elsewhere in this book (see chapter on Preventive Care), a few architectural considerations should be mentioned. Installation of air handlers and ductwork is as disruptive to the operation of a museum as building renovation or construction; it is also vital to sustaining the stable environment necessary to house valuable collections. Basic climate control must always be a high priority in planning an architectural project; and every building

expansion or modification plan should include improvement or addition of HVAC, filtration, and humidification systems. By combining an HVAC retrofit with a general reorganization of the collections management area, the museum can reduce the disruptions caused by construction and can make the ductwork more structurally compatible than if it were installed as an afterthought. Generalizations about the design of environmental controls are hard to make, due to the variety of systems available. One appropriate design is a centralized plan similar to that used in the Smithsonian Institution Museum Support Center. By running the bulk of the facility's ducts and steam lines along the ceiling of the main access corridors, the HVAC system and its filters can be cleaned and repaired without directly affecting the collections storage areas. Like the walls and ceiling, ducts should be painted bright white and should be inspected for dust and insects regularly.

MANAGING A BUILDING PROGRAM

Vince Wilcox, former director of the Museum Support Center, once attributed most problems of museum design to museums' inability "to define themselves functionally for the architect." Without meaningful input from the people who will be using the building, an architect may pursue purity of form but neglect functional necessity.

Planning and implementation of a major building program take an enlightened, collaborative approach similar to that often used in the industrial sector. During the planning and design, the director or other administrator must encourage structured, productive communication between a staff committee and the architect. An effective planning committee might include:

- The director, representing the board of trustees and administrative concerns
- Marketing or development officers to address questions of funding

- A curatorial delegate to represent research and programmatic interests
- A registrar or collections manager to consult on questions affecting the collections
- A conservator, if there is one available

The committee should also consult a conservator who can provide vital input on environmental and material safety issues in the building design. Once the design has been approved, the committee must closely evaluate its implementation at every stage, providing immediate feedback as the building goes up. In this way unexpected design changes or structural needs can be dealt with before they become irreversible, and the architect and contractors are constantly reminded of their obligation to the functions of the museum.

Longevity is a defining characteristic of a museum, both administratively and architecturally. One must look no further than the imposing edifices of the Field Museum in Chicago, New York's Metropolitan Museum of Art, or the Smithsonian Institution to understand the importance of facility design in creating an institution's identity. The people who together create the design—the architects, the directors, the curators, and the collection staff—will be gone long before the products of their labors begin to decay, and the decisions they make today will affect the manner in which the museum operates 50 years hence. This underscores the importance of designing museums not in "real time" but in institutional time—time that is measured in decades, rather than pay periods. A museum built with this in mind is solid enough to accommodate programs and operations far into the next century or beyond.

Denver Museum of Art. Photo by Elizabeth Gill Lui.

Karol Schmiegel

Ethics are usually thought of as moral principles, social values, or proper behavior that transcends particular religious beliefs. Of course, museum staff are ethical, we think; after all, we are preserving, exhibiting, and interpreting objects for the benefit of the public. Our profession is a sacred trust that we carry out for the good of humanity. By its very nature, our goal is lofty and we must therefore be ethical. What's all the fuss about? Do we really need a formal code of ethics?

Let's think about two factors. First, public opinion is important to our museums. When museums are perceived as doing a good job and behaving responsibly, valuable support follows. Suspicions that a museum—a guardian of our heritage—is doing something illegal or socially unacceptable or is operating to the personal benefit of its staff or trustees can reduce attendance, contributions, and tax support. Ethical standards are commonly followed so that conflicts of interest can be avoided. Another aspect of ethics is personal respect for and commitment to the profession. Second, if we don't police ourselves, the government will, and it will be harder to get funds; dollars will also be wasted on the policing. This opinion is from Marie Malaro, whose definition of ethics is "conduct that a profession considers essential in order to uphold the integrity of the profession," a higher level of conduct than the law requires.[1] Thus, in order to prove that the profession is looking after its members' behavior and practices, formal codes of ethics and professional practice statements have been developed. A code provides guidelines for expected behavior and reminders of how to avoid the appearance of conflict of interest.

The basic tenets of most codes prohibit using one's position in the museum for personal gain through such activities as dealing, accepting commissions or gifts of more than trivial value from dealers or other vendors, personal collecting that competes with the museum, appraising or authenticating objects for fees, acquiring stolen or contravened property for the museum, or deaccessioning objects to provide for purposes other than enhancing collections.

Following established codes of ethics helps us avoid the appearance of conflict of interest. The codes that are relevant include those from the American Association of Museums (all three), the International Council of Museums (ICOM), the one for the particular discipline of your museum (such as those from the Association of Art Museum Directors [AAMD] or the American Association for State and Local History [AASLH]), and the one for your branch of the profession (American Institute for Conservation [AIC], Registrars Committee, etc.)

The most recently adopted American Association of Museums *Code of Ethics* recommends that each museum establish its own institutional code. This document is now also required for a museum's accreditation. The person responsible for registration and collections management tasks should be involved in creating the museum's code. The registrar or collections manager has responsibilities that often form the baseline of required conduct for an institution in dealing with its donors and collections. The process of developing an institutional code is an opportunity to educate other staff and trustees; the product also should provide you and your successors with something helpful and workable to follow.

"Ethical and Legal Issues" edited by Kristi Alexander, Rebecca A. Buck, and Martha Fulton.

One area that may be troublesome when working on an institutional code is the issue of personal collecting. Staff and trustees should be able to collect, but one should not have to get board review and approval for every visit to the local secondhand shop or craftsman's gallery. The museum must define its collecting policy, and staff must have the integrity to offer objects within the museum's collecting scope to the museum.

Public opinion is valuable to your museum. Think how your activity, of whatever kind, would look in the headlines of the local newspaper with the worst twist put on it. Review that thought before you act. Be completely above board and cover yourself and your museum with a thorough paper trail; your reputation as well as the museum's could be on the line. Your conscience may be clear, but the gossip and innuendo could destroy your career and the museum's reputation.

Registrars and collections managers should consider ethics in working with six groups of people: other staff, trustees, donors, vendors, the public, and professional colleagues.

Staff: Staff with access to the collections and its records may be seen by others as having special privileges, so it is important to show respect for collections and their records. Follow the rules and set a good example of behavior. For example, if you are seen by an educator using a pen in close proximity to an object (or what appears to be an object or document), but you have said that pens are not allowed, you are demonstrating a lack of respect for rules. That lack of respect undermines your credibility and character. If you show disrespect for another person, especially because of gender, race, ethnicity, age, or disability, you bring into question your own integrity. Your professionalism and ethics are on display when you work as part of a team or as a mentor. The attitudes that you foster when training interns, volunteers, or other, especially new, staff can be long-lasting. As a person experienced in handling collection objects, you may know when a rule can be waived for a particular work of art, but you must resist the temptation to show off for your apprentice. A difficult situation occurs when you observe infractions by another staff member or a trustee. Your institutional code should outline a procedure, but if there isn't one, it is hard to know what to do: confront the offender or take the matter to a supervisor, director, or board president. If the individual or institution is really out of line and the director or board refuse to do anything, it is appropriate to go to the American Association of Museums, AIC, or AAMD.

Trustees: In order for trustees to have confidence in your ability to keep the museum out of legal and ethical difficulties, you must operate your areas of responsibility at the highest standards you can muster. Records must be as accurate as possible and any questions or concerns about such accuracy noted, especially regarding the true ownership of objects in the museum's custody. Trustees' respect for you as a professional may have to be earned. Areas in which you may be pressured to act unethically include placing inaccurate dates on deeds of gift to put someone's gift into a different tax year and changing dates on loan agreements to decrease insurance costs. Sticking to your guns should earn you respect but could also cause you difficulties if you work for a person who doesn't understand the legal and moral implications of such acts. If you should find yourself being forced into doing something not only unethical but also illegal, have the person forcing you sign the document himself; report the matter to your director, board president, or the American Association of Museums.

Donors: Donors must have confidence in the information you supply them about their gifts, deeds of gift, appraisals, and IRS rules. Always suggest that donors contact their tax attorneys or accountants about tax matters. Donors also often ask for recommendations for appraisers, shippers, insurers,

etc., and it is appropriate to provide several names for these service providers. The museum should not appear to endorse one particular vendor.

Vendors: In dealing with vendors, there are two main issues: contracts and gifts. Most museums obtain at least three bids for major contracts (such as fine arts insurance, security and computer systems, shipping for traveling exhibitions) and may have the contract for ongoing services re-bid every three years. This process is intended to demonstrate prudent fiscal practice, since long-term relationships with a particular supplier can be suspect. However, there is also the need to reward good service over a long period of time. To be fair, any bidding process should include referrals from nearby colleagues who use other vendors. The registrar should play a major role in decisions on collection-related vendors; a comptroller or purchasing agent often knows little about the requirements for service, and the lowest bidder may be unacceptable.

Gifts of low value, such as items distributed in exhibit halls at professional meetings, mostly things with company logos, are acceptable, as are occasional meals. It is unlikely that a professional will be persuaded by a mousepad, mug, highlighter, or magnet to award a vendor a major contract. These items are appropriate reminders to include these service or product providers in your bidding or consideration processes. If a vendor gives you personal items, however, you know there's a problem.[2]

The public: The public is a group about which registrars and collections managers, as guardians of the collection, remain skeptical. They see the public as a potential danger to the objects and sometimes to the records. Achieving a balance between these valid concerns and the purpose of the museum to educate using objects (the real ones, accurately labeled), can be a challenge. The public is the beneficiary of the trust that we hold and also supports the museum, even if involuntarily. The registrar must be an advocate for the collections while the educator, development officers, and marketing people advocate for the public. It is essential to see all sides of an issue and work together to educate as well as to preserve. Access to records is another issue where the public can be perceived as a nuisance; lack of staff time to deal with inquiries is the usual cause. It is appropriate to set a policy for limited visiting hours, to reply only by mail or phone, to limit the number of folders a person can use at one time, to prevent briefcases from being used in record areas, etc. However, the public has a right to know what is in the museum and something about it: The museum exists for the public benefit. Museums are accountable to the public for collections and their records.

Professional colleagues: When you attend a professional conference or any activity where you represent your museum or wear its name on your name tag, your personal behavior reflects upon your institution. Your colleagues' opinion of it may be based on your conduct. Your commitment to work on a project carries both your personal and your institution's word and often its resources. Can you make such a commitment on your own, or do you need the concurrence of your director or board chairman? Does your museum's ethics code or personnel policy include such topics as service to the profession? Your institutional code may affect your personal behavior when you represent your museum; for example, you must publicly concur with your museum's policy and trustees' decisions, even if you don't agree with them. Whatever you say, ranging from sexist jokes to gossip about a donor, could reflect badly upon both you and your museum. If you are wearing the Registrars Committee logo on your name tag, you are seen as representing the committee and therefore this branch of the profession. What do you want the people you meet to think about you, your museum, the committee, and the profession as a whole?

Museum staff have worked hard to achieve a professional designation, and it is vital, if the profession is to maintain its status, that its workers use solid common sense and high moral standards in all aspects of their work. Codes of ethics, which are one of the defining characteristics of a profession, are a great help toward this goal.

N O T E S

1. Marie C. Malaro, *Museum Governance: Mission, Ethics, Policy* (Washington, D.C.: Smithsonian Institution Press, 1994), p. 17. This chapter has the best explanation of ethics I've seen.

2. Vendors to the museum field, especially in areas pertaining to collections, are a respectable group who have supported registrars' professional development and education; none has ever tried to corrupt me.

Ildiko Pogany De Angelis

Very few museum registrars are spared the vexing problem of "old loans." The term refers to expired loans or loans of unlimited duration left unclaimed by lenders who cannot be readily located by the museum.[1] These objects may have come in to the museum under formal loans for exhibition purposes or under temporary custody arrangements for examination or study by museum staff.[2] The lenders have long since died, moved, or, in any case, failed to maintain contact with the museum. As registrars are routinely assigned responsibility to monitor loans and to account for objects and their documentation in the custody of the museum, it is to this office that the task of resolving the old loan conundrum is usually assigned.

Because day-to-day tasks quickly consume a registrar's time, often little or none remains to spare on old loans.[3] Nevertheless, museums and registrars are well advised to make time for old loans because the mere passage of time will not cure the problem and, often, the older the loan gets, the harder it may be to resolve. Lacking legal title to the unclaimed objects, the museum can only make limited use of them, all the while bearing the costs and burdens of storage space, record maintenance, climate control, security, periodic inspection, insurance, and general overhead (Wise 1990; Tabah 1992).

To understand what must be done, it is important to appreciate the legal constraints involved. The basic legal relationship between the lender and the museum is a "bailment," under which the museum as "bailee" (borrower) generally has the obligation to care for the object until the "bailor" (lender) comes to claim it.[4] This obligation can go on indefinitely because the passage of time will not alter this legal relationship. For example, if a lender dies, his or her ownership interest in the object will pass to heirs. Often, determining the identity and location of heirs entitled to the object may be a difficult and time-consuming, if not impossible, task. To make things worse, returning the object to the wrong party may open the museum to liability for a claim brought by the rightful owner.

The key to resolving the old loan dilemma is for the museum to break the bailment relationship as soon as possible. Unfortunately, this is not easily done under general legal principles.

In recognition of these difficulties, 28 states, as of 1997, have passed old loan statutes that specifically make this task easier for museums.[5] These old loan laws spell out the mechanisms by which the lender's ownership of the object can be cut off, making it possible for the museum to move with some assurance toward gaining title to the object. With the title secure, the museum then may use or dispose of an object as it sees fit. More will be said about these state statutes and the general approaches they take, but first, a discussion of "common law" principles (principles that govern in absence of a statute) is in order. These principles usually prevail in states without specific old loan statutes, and a knowledge of these principles also assists in appreciating and/or interpreting specific old loan statutes.

I. THE COMMON LAW SOLUTION

In states without old loan statutes, museums are left with general principles of common law to guide them. Common law refers to principles whose authority does not depend on any express statute, but upon statements of principles found in court decisions. The application of these principles to old loans has not been fully tested in court. As a result, museums are left with some legal uncertainties.[6] Nevertheless, under these principles, to break the bailment relationship, the museum must take actions

inconsistent with the terms of the bailment and call the lender's attention to the fact that title to the object is being challenged and could be lost if the lender remains silent. For example, the museum should send a letter to the lender stating that the museum is terminating the loan and unless the lender comes forward to claim the objects or make arrangements for their successful return by a certain date, the museum will take title to the objects as of that date. If the lender is aware of the museum's "conversion" (a legal term meaning unauthorized assumption of ownership of property belonging to another), the lender, under general principles of law, must come forward to protect his or her ownership interests. If the lender fails to claim the object or to bring his or her claim or suit to court within a specific time after the museum's conversion of the object, the lender's ownership rights may be lost because of "statutes of limitations." These are specific time periods to bring claims to court that are provided in state laws. Lawsuits are barred that are not brought within prescribed limitation periods. The purpose of statutes of limitations is to encourage claimants to take timely action before evidence fades and witnesses die.

Statutes of limitations vary from state to state and with the nature of the claim. For example, a claim for breach of contract will have a different limitation period from a claim based on negligence causing personal injury. Although it is relatively simple to determine the length of the limitation period in any state for a claim of conversion, the more difficult issue is to determine when the limitation period begins to run against an owner to extinguish his claim. The general rule is that the owner of property "converted" by another must bring his or her claim to court within the limitation period that begins after his or her "cause of action" arises. A "cause of action" is a set of facts that give a person the right to file a suit in court.

Under the law of bailment, the cause of action usually arises when the lender demands return of the object and the borrower refuses. The lender's cause of action may also arise when he or she is put on notice that the borrower is claiming title to the object, in effect, refusing to the return the object. Thus, to utilize the statute of limitations to extinguish a lender's right to an unclaimed object, the goal for the museum is to make sure the lender has notice that the museum intends to terminate the loan and to claim the loaned object as its own if the lender fails to come and get it or arrange for its return.[7]

To ensure that the limitations period is triggered, the museum should notify the lender by certified mail, return receipt requested, to prove that the lender received actual notice of the museum's actions. Upon receipt of the notice, the limitations period should begin to run and, after its expiration, the lender who has failed to take action should be barred from any further claim to the object. Title to the object, in effect, then belongs to the museum. At this time, the museum is free to do whatever it wishes with the object—keep it, lend it, or dispose of it.

Anyone who has ever worked with old loans inevitably would ask this question: What if the lender is unknown or the lender or heirs cannot be located? Are there any alternatives to actual notice? One court decision from the District of Columbia, in the *McCagg* case, involved an old loan, and the court suggested that "constructive notice" to the lender might be legally sufficient where actual notice is not possible. The term constructive notice refers to notice to unknown or missing individuals by publication in a newspaper. If done properly, the law will presume that the notice reached the individual whether or not he actually saw the notice in the newspaper. All the old loan statutes discussed below have implemented the constructive notice approach to notify missing lenders. The question remains whether constructive notice will be legally sufficient without an applicable state statute in place that provides how and when this may be done. Until this has been tested in court,

museums must face an element of uncertainty in this area. This uncertainty should not prevent museums from proceeding, because doing nothing affords no chance of yielding any positive results. Each museum is urged, however, to consult with its legal counsel before initiating notice to lenders by publication.

In any event, the court in the *McCagg* case cautioned that constructive notice may be available only if actual notice is not possible. Thus, a museum must be in a position to show that the lender or heirs could not be located after reasonable efforts by the museum to do so. As to what constitutes reasonable efforts, once again there is little guidance in existing legal precedents. One commentator suggests that the following sources in addition to the museums' own records should be consulted in the course of a reasonable search for the lender: probate records, telephone directories, real estate records, and vital (death) records (Tabah 1992). Depending on the circumstances, other avenues such as social registers or cemetery records may be available. It is absolutely essential that the museum document every effort taken to locate lenders because the museum's records may become evidence should a lender or heir suddenly surface years later and demand return of the object. The value of the objects in question may have an impact on the extent of the efforts to locate the lenders. If, after reasonable efforts, the whereabouts of the lender or heirs are still unknown, the museum may try constructive notice by publication in a newspaper.

The notice in the newspapers should include as much of the following information as possible:

- Date of the notice
- Name of the lender
- Description of the item loaned
- Date of the original loan
- Name and address of the museum staff to contact
- Statement that the museum is terminating the loan and will take title to the object if it is not claimed by a specified date

It is suggested that this notice be published once a week for three consecutive weeks in a newspaper of general circulation in the county of the lender's last known address and the county or municipality where the museum is located (Tabah 1992). The statute of limitations should begin to run after the date set in the notice as a deadline for contacting the museum—whether or not the lender or heirs have actually seen the published notice.

If the lender fails to come forward before the date given by actual or constructive notice, the museum should amend its records immediately to reflect the ownership change for the object as of that date. In addition, the museum should note in the records the date of expiration of claims under that state's statute of limitations. Although the museum asserts ownership from the date the object is accessioned, its title to the object would be subject to challenge in a claim brought to court by the lender or heirs up to the time the applicable limitations period for filing suit had expired. Therefore, the file should note that prior to the expiration of the statute of limitations, the object should not be disposed of by the museum. For example, in the museum's published notice, the date in which title is claimed is June 1, 1995. Having failed to hear from the lender or heirs on June 1, 1995, the museum accessions the object. Having been advised by counsel that the limitations period for conversion is three years, the museum will note in the records that the object should not be disposed of prior to June 2, 1998.

In planning a systematic approach to resolve old loans in states where no statute exists, museums are well advised to seek the advice of counsel in establishing procedures and forms for this purpose. One publication highly recommended to aid museums and their counsel in this effort is "Practical Guidelines in Resolving Old Loans: Guidelines for Museums" by Agnes Tabah (see bibliography). This paper has step-by-step instructions and sample forms that may be very helpful. The publication is available from ALI-ABA at 4025 Chestnut St., Philadelphia, PA 19104-3099.

However, because of a lack of clear precedents, even if all recommended steps are taken, there are no guarantees that claims will not be brought against the museum for conversion of the loaned object. In the worst case, a lender or heirs may surface years later and institute a lawsuit. At this point, if a court should determine that the steps taken by the museum to gain title were legally insufficient, the museum may need to return the object. If the object was disposed of in the interim, the museum may be ordered to compensate the lender for the value of the object, possibly as of the date of the lender's return. Although the risk of a legal suit with the attendant adverse publicity should not be underestimated, this risk needs to be balanced against the substantial benefits gained by freeing the museum's collections from unwanted objects that are costly to maintain, and by having reliable, up-to-date records of objects in its collections. If the objects are of little value, it is unlikely that anyone is ever going to sue. If someone does threaten a lawsuit, it is a relatively simple matter to offer to pay him or her the value of the object to make the claim go away. If the museum has disposed of the object after acquiring title, it should have an excellent record of the object's value at the time of disposal. In any event, the museum's counsel may be able to negotiate a settlement without the need to resort to a formal legal proceeding.

2. LEGISLATIVE SOLUTION: STATE OLD LOAN STATUTES

A list of states that have passed old loan statutes appears as an addendum. For a museum located in one of these states, resolving old loans will require following the dictates of the applicable statute. While state old loan statutes vary in approach, they all establish specific mechanisms by which the museum may terminate the loan and take title to objects left unclaimed by lenders. In operation, the legislative solution mimics the common law approach but adds clarity and some degree of certainty of the adequacy of the procedures. In some cases, old loan statutes eliminate some cumbersome steps required under the common law approach. The usual scheme is for the law to prescribe a notice procedure by which lenders are notified by the museum that the loan is terminated. The notice procedures may apply to expired loans as well as to indefinite loans that have been at the museum for an extended period.

The notice may take two general forms. The first is by mail to the lender of record at his last known address, and the second is notice by publication in newspapers. Some statutes only require notice by mail to the name and address of the lender as it appears in the museum's records. If that information is not accurate or if it is incomplete, no further search for the lender is required. Other statutes require a "reasonable search" for the lender, often not giving much guidance as to what the term means. If the lender cannot be reached by mail, the museum may proceed with notification by publication in a newspaper. If, after notice, no one comes forward to make a claim within the prescribed time period (ranging from 30 days to seven years), title to the object passes to the museum. Several states allow museums to take title to an object without giving notice if there was no contact between the museum and the lender for a long time. For example, California allows the museum to take title if there has not been contact with the lender for at least 25 years as evidenced in the museum's records.[8]

In addition, old loan statutes may impose obligations on lenders to notify museums of change of address and changes in ownership of the property.[9] Some statutes address the issue of undertaking conservation work on unclaimed loans.[10]

An important question not yet answered is whether these statutes will pass constitutional challenges that may be brought to court by disgruntled lenders. Such challenges to state laws may be brought under the 14th Amendment of the U.S. Constitution, alleging that the old loan statute deprives the lender of his or her property without the "due process of law." The question presented in such cases is whether the law affords owners adequate

notice and opportunity to protect their ownership rights before such rights are cut off. As of 1997, there have been no published court decisions testing the constitutionality of any state old loan statute, and we have yet to see how a court may view these statutes with regard to due process questions.

One unpublished study indicates that many museums may not have begun to implement applicable old loan statutes. This conclusion is based on the sparse replies to a questionnaire on implementation of old loan legislation (Tabah 1991). The study posits the following reasons for this sluggishness. To use the statutes systematically, museums need to inventory their collections to determine which objects are in fact old loans. Inventories require time and effort and are too easily relegated to the "back burner." Also, some museums may be reluctant to implement the statutes, fearing that important objects will be lost if lenders actually come forward and reclaim loaned objects. Finally, some may fear the administrative burdens that may be presented by spurious claims. The experience reported by the few museums who have implemented the legislation shows the opposite.

Contrary to fears, large numbers of people did not come forward to claim objects. Moreover, implementation of the old loan statutes gave registrars a useful instrument to provide vacillating lenders incentive to make decisions on disposition of their loaned property (Tabah 1991).

3. HOW TO AVOID THE PROBLEM OF OLD LOANS IN THE FUTURE

Given the time, effort, and costs involved in resolving old loans, museums should institute safeguards to avoid this problem in the future. Museums should borrow objects for a limited duration only (usually one year), with the expiration date specifically stated in the loan agreement. If the object is needed longer, it is better to renew the loan than to agree to a longer initial term. More frequent contacts with lenders will avoid the missing lender situation. Loan agreements should specify that it is the lender's obligation to notify the museum of a change in the lender's address or a change in the ownership of the loaned object. Moreover, loan agreements should state that if, at the expiration of the loan, the museum is unable to contact the lender to make arrangements for the return of the object, the museum will store the object for a set period of years at the lender's expense. If, after this period, the lender still fails to come forward after notice by mail is sent by the museum to the lender's address of record, the museum will deem that an unrestricted gift of the object is made by the lender to the museum. In effect, the loan agreement will put the lender on notice of the museum's claim to the object after a set period of time if the lender fails to maintain contact or refuses to pick up the object.

Objects left at the museum for identification, authentication, or examination are more likely to be left unclaimed than objects borrowed by the museum for exhibition purposes. The negligible value of some of these objects may remove an incentive for their owners to return to claim them. To avoid this risk, these objects should be processed immediately by the museum. Each should be documented with a temporary custody receipt, signed by the owner. If an object was mailed unsolicited to the museum, the package should be returned within days to the sender. If more time is needed, the temporary custody receipt should be mailed to the sender for signature. The length of the museum's custody specified in the receipt should be limited to a period significantly shorter than the duration of a standard incoming loan. For example, a museum may decide that the maximum time for temporary custody is three months, subject to extension by special permission only. The temporary custody receipt should specify the exact method to be used for return of the object and include a provision, similar to one used in a formal loan agreement, that infers a gift to the museum if the object is not claimed after a limited storage period subsequent to the expiration date on the receipt.

CONCLUSION

As a public trust, a museum has a legal responsibility to make the best use of its assets. Prudent collections management dictates that museums pursue systematic efforts to clean up old loans that eat up valuable storage space and consume scarce staff and financial resources. But procedures should also be in place to avoid these situations. It is the registrar's office that usually plays a critical role in developing and implementing ways to banish the old loan problem in a museum.

ADDENDUM

Citations to State Old Loan Laws

This list may be incomplete as several states are considering passing old loan legislation at the time this manuscript was submitted for publication. Please check the laws of your state.

Alabama St. § 41-6-72[11]

Arizona Rev. Stat. Ann. § 44-351 *et seq.*

California Civ. Code § 1899

Colorado Rev. Stat. § 38-13-101 *et seq.*

Florida Stat. Ann. § 265.565 *et seq.*

Indiana Code Ann. § 32-9-10-1 *et seq.*

Iowa Code Ann. § 305B

Kansas Stat. Ann. § 58-4001 *et seq.*

Kentucky Rev. Stat. Ann. § 171.830 *et seq.*

Louisiana Rev. Stat. Ann. § 25: 345[12]

Maine Rev. Stat. Ann., tit. 27, § 601 *et seq.*

Michigan Comp. Laws Ann. § 399.611 *et seq.*

Mississippi House Bill 1031, approved by the governor, March 26, 1997

Missouri Stat. Ann. § 184.102 *et seq.*

Montana Code Ann. § 22-3-501 *et seq.*

Nevada Rev. Stat. Ann. § 381.009[13]

New Hampshire Rev. Stat. Ann. § 201:E-1 *et seq.*

New Mexico Stat. Ann. § 18-10-1 *et seq.*

North Carolina Gen. Stat. § 121-7(c)

North Dakota Cent. Code § 47-07-14[14]

Oregon Rev. Stat. § 358.415 *et seq.*

South Carolina Code Ann. § 27-45-10 *et seq.*

South Dakota Cod. Laws § 43-41C-1 *et seq.*

Tennessee Code Ann. § 66-29-201 et *et seq.*

Texas Property Code Ann. § 80.001 *et seq.*

Washington Rev. Code Ann. § 63.26.010 *et seq.*

Wisconsin Stat. Ann. § 171.30 *et seq.*

Wyoming Stat. § 34.-23-101 *et seq.*

NOTES

1. The term "permanent loan" was used in the profession some years ago. Loans by definition are temporary, and therefore it is unclear what the parties had in mind when the arrangements for "permanent loans" were made. Often a review of the museum's records may indicate that a gift was actually intended or completed. However, if title to the object still rests with the lender, then permanent loaned objects should be treated as loans of unlimited duration.

2. It is important to note that "old loans" does not include undocumented objects found in the museum's collections. These "found" objects lack any documentation as to how they were acquired by the museum. This chapter deals with objects that are accompanied by documentation that a loan to the museum was intended by the owner. With "found" objects, there is no evidence held by the museum that someone else owns these objects. Rather, the museum's undisturbed possession for an extended period supports a presumption that ownership was transferred to the museum at the time the objects were acquired. Unless and until someone shows up at the museum and can overcome this presumption with evidence that he or she has clearer title to the "found" object, the museum generally may treat a found object as its own. However, disposal of objects of unconfirmed ownership should involve further considerations and assistance fro the museum's legal counsel.

3. This situation may be getting worse as many museums are forced to downsize due to budgetary constraints.

4. For a full discussion of the legal problems of "unclaimed loans" and possible solutions, see Malaro, Marie C., "Unclaimed Loans," *A Legal Primer on Managing Museum Collections*, pp. 183-203.

5. In addition to these 23 states, the Mid-Atlantic Association of Museums (MAAM) Registrars Committee has established an Old Loan Task Force to draft model legislation for the region that includes Pennsylvania, Maryland, Virginia, Washington, D.C., Delaware, New York, and New Jersey. MAAM has circulated the model to member museums to gather support for legislative efforts in these states.

6. In the one reported court decision from the District of Columbia involving an old loan, the court held that the paintings on loan to the museum for decades had to be returned to the lender's heirs. *In re Therese McCagg*, 450 A. 2d 414 (D.C. 1982). The court noted that the museum had failed in that case to make

a reasonable effort to notify the lender's heirs and refused to find that the loan had expired at the lender's death. However, the court noted in a footnote that if the lenders cannot be located by the museum after reasonable efforts, notice to the lenders or heirs by publication in a newspaper may be legally sufficient. Notice by publication was not directly at issue in the case. *Id.* at 418.

7. In addition to the statute of limitations approach, the legal doctrines of adverse possession and laches may help a museum successfully defend a case brought by a long overdue lender for return of an old loan. The usefulness of these doctrines is discussed in Marie Malaro's *A Legal Primer on Managing Museum Collections*, pp. 189-194, and Ildiko DeAngelis's "Old Loans—Laches to the Rescue?" in *Legal Problems of Museum Administration*, p. 202. Actions taken by the museum under the statute of limitations approach discussed in this chapter will also support these alternate defenses and are not separately discussed here.

8. California Civ. Code Sec. 1899.10(b).

9. For example, see the old loan statutes of California, Wyoming, Missouri, and Kansas.

10. For example, see the old loan statutes of Indiana, Missouri, and South Carolina.

11. Applicable only to the Department of Archives and History of the State of Alabama.

12. Applies only to Louisiana state museums.

13. Applies to certain specified museums and historical societies.

14. Applies only to state museums in North Carolina.

FAIR USE

Must be determined on a case by case basis.
"Fair use" presupposes good faith and fair dealing. *(Harper & Row)*

FOUR NON-EXCLUSIVE FACTORS TO CONSIDER IN DETERMINING WHETHER A GIVEN USE IS FAIR, AS ENUMERATED IN § 107 OF THE STATUTE:

1. **The purpose and character of the use, including whether such use is of a commercial nature or is for nonprofit educational purposes.**

 — Purposes such as criticism, comment, news reporting, reaching, scholarship or research are not infringement (§ 107)

 — List is not exhaustive

 — Example of "news reporting" that was not a fair use: *The Nation*'s publishing of Ford memoir excerpts before book was released. Supreme Court said this went beyond reporting and "actively sought to exploit the headline value of its infringement, making a 'news event' out of its unauthorized first publication. . . ." (*Harper & Row* v. *The Nation*, 1985)

 — Every commercial use is presumptively unfair (*Sony* v. *Universal City Studios*, S.Ct. 1984): does the user stand to profit from exploitation of the copyrighted work without paying the customary price? (test stated in *Harper*)

2. **The nature of the copyrighted work.**

 — Greater need to disseminate factual works than fictional ones

 — The fact that a work is unpublished is a critical element of its "nature" (scope of fair use is narrower for unpublished works.

3. **The amount and substantiality of the portion used in relation to the copyrighted work as a whole.**

 — Was "heart" of the work taken? (absolute ratios of portion used to whole are not determinative)

 — Doesn't matter if portion used is insubstantial compared to the infringing work (Learned Hand: "No plagiarist can excuse the wrong by showing how much of his work he did not pirate.")

 — Conversely, the fact that a substantial portion of infringing work is copied verbatim weighs against the defendant

4. **The effect on the market (or potential market) for the original work.**

Four factors to consider when determining fair use. © *Woodcock Washburn Kurtz Mackiewicz & Norris. Courtesy John W. Caldwell.*

John Awerdick and John Kettle III

I. COPYRIGHT BASICS

A. OVERVIEW

There are three key copyright concepts of which museum personnel should be aware.

First, there is a difference between owning a physical work and owning rights associated with it. The stuff of museums is often both tangible/physical and intangible/intellectual. Therefore, one must look to at least two governing bodies of law. One set of laws (chiefly the Uniform Commercial Code)[1] speaks to the sale of goods and governs the rights of ownership of the physical object, (e.g., a Lichtenstein lithograph). Intellectual property law (chiefly copyright law) governs non-physical rights to the work that exist independently from ownership of the physical object (e.g., the right to make postcards of a Lichtenstein lithograph). Because two separate bodies of law simultaneously regulate works of art and other copyrighted creations, a museum may have good title to a work but no right to make copies of it. Conversely, a museum may lack good title (e.g., as a result of its wrongful loan) but arguably be free to copy the work because under copyright law the work is in the public domain and no longer subject to copyright protection.

Second, there is a "bundle of rights" that surround copyrighted works. Generally, this bundle involves rights to exploit a work—to reproduce it, to create derivative works, to distribute the work, to perform the work publicly, to display the work, and to control the digital transmission of sound recordings. The fact that one controls one of these rights does not mean that one controls another of them, and all of them are subject to limitations and exceptions.

Third, application of copyright law to any particular work is extremely date and fact sensitive. Congress enacted two major copyright laws in the 20th century. The first became effective on July 1, 1909 (the "1909 Act"), of which some provisions still apply today. The second became effective on Jan. 1, 1978 (the "1976 Act"). Amended by Congress 22 times since 1978, the 1976 Act superseded many but not all of the provisions of the 1909 Act.[2] The date on which a work was created or first published will determine which act applies, and, after consideration of other relevant factors, its copyright status.

B. SUBJECT MATTER

Copyright protects "original works of authorship fixed in any tangible medium of expression," including literary, musical, dramatic, pantomime, choreographic, pictorial, graphic, sculptural,[3] audiovisual, and architectural works, as well as motion pictures and sound recordings.[4]

C. EXCLUSIVE RIGHTS OF THE COPYRIGHT OWNER

A copyright owner may exercise, license, or transfer[5] any one or more of its exclusive rights, all of which form an express set of interests under copyright law, often referred to as a "bundle of rights." These rights include:

- The right[6] to reproduce[7] the copyrighted work in copies;[8]

The authors gratefully acknowledge the assistance of Alicia Nyce, a third-year law student at Rutgers Law School-Newark, for her assistance in the preparation of this chapter.

- The right to prepare derivative works[9] based on the copyrighted work;[10]
- The right to distribute copies of the copyrighted work to the public by sale or other transfer of ownership, or by rental, lease, or lending;[11]
- The right to perform the copyrighted work publicly;[12]
- The right to display the copyrighted work publicly;[13]
- In the case of sound recordings, the right to perform the copyrighted work[14] publicly by means of a digital audio transmission.

Under the 1976 Act, each of these rights (and, in actuality, subsets of them) may be licensed or assigned.

Under the 1909 Act, copyright was not expressly divisible into separate and distinct interests thereby creating a "bundle of rights." However, licenses were widely used in effect to authorize specific uses or to transfer certain copyright interests.

Thus, whether created under the 1909 or 1976 Act, there are many separate and distinct rights associated with any particular copyrighted work, each of which must be considered carefully. Before recommending specific policies for a museum to follow, legal counsel should spend time with museum personnel to review the rights that the museum may want to exercise in particular instances, the practical issues encountered when acquiring these rights, and the risks involved if a museum does not obtain them. The following are some additional noteworthy points with respect to basic rights issues:

- Possession of the physical work gives its owner some basic and limited rights to put the work on display. The owner of a lawfully made copy of a work (including the original) may display that copy publicly (either directly or by projection) "to viewers present at the place where the copy is located," without the copyright owner's permission.[15] Other means of display (e.g., transmission via any type of television system) require written permission from the copyright owner.[16]

- The right of reproduction is increasingly important to museums as a source of income. When considering the making of a reproduction, issues of exclusivity (exclusive copyright interests) will arise; however, it is sometimes difficult to be sure that a museum has obtained an undisputed and exclusive right to reproduce a copyrighted work. Some merchandisers prefer to avoid rights issues by reproducing only those works that are clearly in the public domain. Others are satisfied with non-exclusive licenses. A museum should review with care its approach to reproductions.

- The various "exclusive rights" of copyright are, in fact, subject to many exceptions and delineations. The right of "fair use" is one of the most significant. The fair use doctrine permits copying of copyrighted works "for purposes such as criticism, comment, news reporting, teaching . . . scholarship, or research."[17] These and other factors are weighed on a case-by-case basis. Some copyrighted works, for which a museum may own title but lack any copyright interests, may have uses that fall within the purview of this exception to copyright exclusivity. Generally, the taking, or utilization, of an entire work is not fair use. The appearance of a work in the background in an educational video, for example, may be considered fair use under copyright law. Fair use jurisprudence is complicated. A layman should not decide to rely on a fair use defense without consulting counsel and should not be surprised if the lawyer finds it hard to give a definitive answer.

- Some museums have obtained some protection to works that are in the public domain through careful use of the right to produce derivative works. For example, a museum may sell slides of works that are in its collection but are no longer subject to copyright protection. The slides are derivative art reproductions, subject to copyright protection independent from the copyright protection, if any, afforded the original. If the public is not able to access the

original in order to make their own copies, the museum will now own copyrights in the only existing reproductions—the slides. As the copyright owner of the only existing copies of the work, the museum can generally prevent subsequent copies and other reproductions of the original, as long as the original remains inaccessible to the public.

D. DURATION OF COPYRIGHT

(i) Publication Issues: Pre-1978 Works.

Museums need to examine the duration of copyright protection with respect to much of their 20th-century collections.[18] Copyright duration is an area in which the interaction of the 1909 Act and the 1976 Act and its amendments creates confusion. In some cases, that interaction even determines whether copyright protection exists at all.

For example, before 1978, a work was protected by common law copyright until it was published with the proper copyright notice or registered under the Federal Copyright Act.[19] A work created after Jan. 1, 1978, however, is protected from the time it is "fixed in a tangible medium of expression"[20] as opposed to when it is "published or registered." Under the 1909 Act, if proper copyright notice was not affixed to a work, all copyright protection in that work was lost. Under the original 1976 Act, a missing notice could be cured under certain circumstances. Following a 1989 amendment, copyright notice is no longer required for works created on or after March 1, 1989 (although it does help to prove a knowing infringement).[21]

The distinctions outlined in the preceding paragraph may be very important to a museum. As the authors of one basic treatise on art law opined:

> It is . . . paramount for any party acquiring copyright to a work of art created in the United States before 1978 to determine the circumstances relating to its publication. Although doing so may be difficult . . . it is worth the effort. Otherwise, the acquiring party—be it a museum or some other institution, a private

collector, or a gallery—may be unhappily surprised to find that the work has been injected into the public domain.[22]

A museum may have items in its collection that, although quite old, never have been registered with the Copyright Office or published in some form. As a result of their unpublished and unregistered status, they may be protected by copyright into the 21st century.[23] Although these items may be automatically protected under the present Copyright Act because of their status, in some instances, it still may be advantageous to publish and/or to register a previously unpublished work[24] with the authority of the copyright owner, if necessary. However, if a pre-1978 work was published without proper copyright notice, it is already in the public domain and much of the minutiae of copyright law is moot.

If a museum owns copyright interests in a work, it needs to know when those interests expire and if they are subject to renewal or termination. If the rights are owned by someone else, the museum needs to know when the work will enter the public domain, at which time it can freely exploit the work. If the work was created before 1978 and is unregistered and unpublished, a museum needs to determine when the right to federal copyright protection will end.

(ii) Copyright Terms

The duration of a copyright depends upon factors such as when the work was created, when it was published and the status of the "author."[25] The basics are as follows:

1. *Works created on or after Jan. 1, 1978:*

(a) Except for anonymous and pseudonymous works, some architectural works and works made for hire, works are protected for the life of the author plus 50 years.[26] In the case of joint works, protection is for the life of the last surviving author plus 50 years.[27]

(b) Copyright for anonymous and pseudonymous works, and works for hire lasts for 75 years from first publication or 100 years from creation,

DURATION OF COPYRIGHT
GENERAL GUIDELINES

NOTE: *Under the 1909 Act, copyright was secured either on the date a work was published, or on the date of registration of the unpublished work. Under the 1976 Act, which became effective January 1, 1978, copyright attaches to original works that are fixed in a tangible medium of expression.*

1. **Anything *copyrighted* (see above note) more than 75 years ago is in the public domain.**

 Works copyrighted under the 1909 Act may last for a maximum of 75 years. Copyright term lasts until end of the calendar year. Thus, all works copyrighted in 1921 have been in the public domain since December 31, 1996.

2. **Works created but not made public or registered before January 1, 1978.**

 Works are protected for the life of the author plus 50 years. If work is anonymous, pseudonymous, or for hire, protected for 75 years from first publication or 100 years from the date it was created, whichever comes first.

 In any event, these works are protected until at least December 31, 2002.

 If a work in this category is published on or before December 31, 2002, copyright protection extends until December 31, 2027.

3. **Works originally copyrighted between January 1, 1950, and December 31, 1977.**

 These works are eligible for a renewal term of 47 years.

 Example: A work copyrighted in 1962 has an initial term of 28 years and is eligible for renewal in 1990. If renewed, the work will be protected through December 31, 2037; otherwise, protection expires at the end of 1990.

4. **Works originally copyrighted before 1950 and renewed before 1978.**

 Works in this group received automatic extensions of copyright protection for a total term of 75 years from the end of the year in which they were originally copyrighted.

5. **Works created on or after January 1, 1978.**

 Works are protected for the life of the author plus 50 years. If work is anonymous, pseudonymous, or for hire, protected for 75 years from first publication or 100 years from the date it was created, whichever comes first.

Guidelines for duration of copyright. © Woodcock Washburn Kurtz Mackiewicz & Norris. Courtesy John W. Caldwell.

whichever is earlier. Anonymous or pseudonymous authors can reveal their true identities while they are still living and obtain "life plus 50" copyright protection.[28]

(c) Authors or their heirs can terminate copyright transfers during a five-year period that begins 35 years after the date of the execution of the transfer.[29] Notice must be given to the transferee not less than two years nor more than 10 years before the effective date of the termination. If the right of termination is not exercised, the grant continues to the end of the term of copyright. Also, if someone obtains the right to make a derivative work and the right is later terminated, the right to continue exploitation of that derivative work survives such termination, and existing royalty arrangements remain intact. The right to terminate may not be waived.[30]

2. *Works created prior to 1978:*

(a) As previously noted, under the 1909 Act, copyright protection subsisted upon the date of first publication or registration of a work rather than upon its date of creation.

(b) Under the 1909 Act, copyright lasted for an initial term of 28 years from the date of first publication or registration with the possibility for a renewal[31] of an additional 28 years. The 1976 Act changed that renewal period, extending the second renewal term by up to 47 years. Thus, whether in its original or renewal term at the time the 1976 Act became effective on Jan. 1, 1978, a copyright would last for a total of 75 years. Again, the copyright status of a work depends upon when it was originally copyrighted and what actions, if any, have been taken to renew it.[32]

E. DERIVATIVE WORKS

Even if a work is in the public domain, it is possible that a work derived from it is protected by copyright to the extent that it is different from the work from which it originates.[33] For example, if the copyrighted design of a Campbell's soup label were in the public domain, Andy Warhol's estate could still legally challenge an artist who creates a lithograph of such cans that resembled Warhol's well-known creations. Warhol's lithographs, although fashioned after material that are in the public domain, are different enough from the Campbell's creation that they are entitled to copyright protection as original works of authorship. Therefore, in some cases, it may be appropriate not only to examine a work, but also its derivatives, before considering exploitation opportunities.

F. THE VISUAL ARTISTS RIGHTS ACT[34]

The Visual Artists Rights Act (VARA) is a 1990 amendment to the 1976 Copyright Act that provides artists ("author(s) of work(s) of visual art")[35] with specific rights independent of the basic exclusive rights of copyright. This amendment basically provides artists with rights of attribution and integrity. This provision should be summarized in any appropriate or relevant museum policy document.

This federal provision applies to works created (or transferred by their creator) before and after June 1, 1991. Protection for works created after June 1, 1991, lasts for the life of the author. Works created but not transferred prior to June 1, 1991, are protected for the life of the author plus 50 years. Rights under the VARA may not be transferred but can be waived.[36] Some states have their own laws providing protections similar to the ones described above, although the status of those laws is uncertain since they may be preempted by VARA.

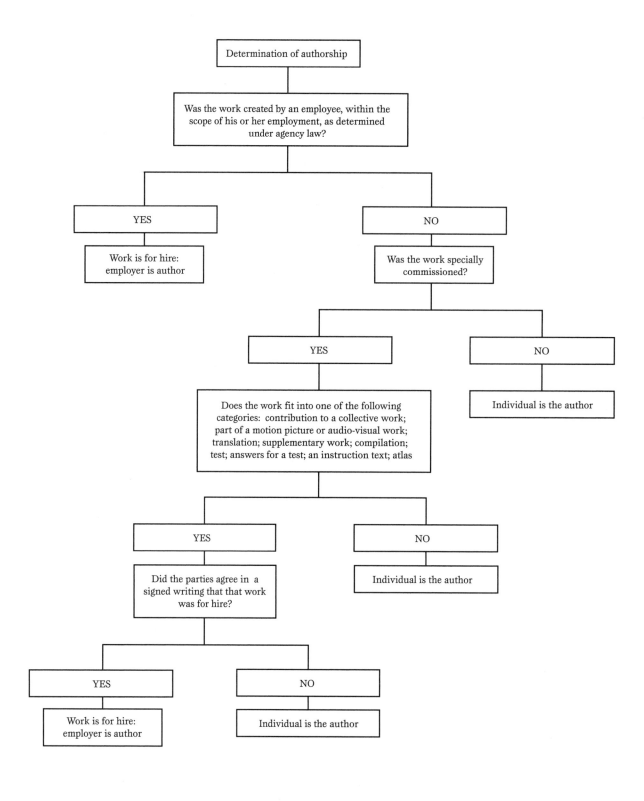

Determination of authorship

Was the work created by an employee, within the scope of his or her employment, as determined under agency law?

YES

Work is for hire: employer is author

NO

Was the work specially commissioned?

YES

Does the work fit into one of the following categories: contribution to a collective work; part of a motion picture or audio-visual work; translation; supplementary work; compilation; test; answers for a test; an instruction text; atlas

NO

Individual is the author

YES

Did the parties agree in a signed writing that that work was for hire?

NO

Individual is the author

YES

Work is for hire: employer is author

NO

Individual is the author

© 1991 Woodcock Washburn Kurtz Mankiewicz & Norris

Flowchart for determining authorship. © Woodcock Washburn Kurtz Mackiewicz & Norris. Courtesy John W. Caldwell.

II. TRADEMARKS, RIGHT OF PUBLICITY AND PRIVACY, AND UNFAIR COMPETITION

In addition to copyright matters, a museum needs to consider whether the planned exploitation of the artwork will violate any trademark,[37] unfair competition,[38] right of publicity or privacy laws.[39] When a museum obtains artwork that shows a trademark or an image of a person, it is important to determine whether the owner of the trademark and/or individual appearing in the artwork has consented to the commercial exploitation of the work. Absent consent, which in some states must be in writing, the making of copies of the artwork may be a violation of state or federal law, even though the museum owns the copyright in the work.

Under federal trademark law and other state laws, a trademark owner, or individual, can seek to stop an unauthorized use and subsequently recover damages when that use creates a likelihood of confusion as to source of the goods, or causes a false affiliation, sponsorship, or involvement in connection with the goods.[40] The unauthorized use may also give rise to a claim that the use of the trademark as it appears in the commercialized copies of the artwork "dilutes," "tarnishes," or "blurs" the goodwill associated with the trademark.[41]

Under state law, an individual may also claim that commercial copies of the artwork infringe upon his or her right of publicity. This right allows an individual to control and profit from commercial use of his or her name, image, or likeness, including symbolic representation.[42] The right in some states does not apply if the person is no longer living.[43]

Last, the commercial reproduction of artwork that incorporates facts about a living person may violate that person's right of privacy.[44] If the artwork holds the person out in a false light, invades the person's solitude, discloses private facts, or is deemed a commercial misappropriation of an image or likeness, then a privacy claim may exist.

Trademark infringement and the violation of one's right of publicity or privacy for commercial purposes are forms of unfair competition.[45]

First Amendment (free speech),[46] fair use, parody, and satire defenses are often considered when determining whether a given use is permissible. The process of assessing risk and balancing ownership interests against these policy-based defenses is complicated. If written permission can be obtained from the owner of the trademark, or from the person to whom the right of publicity or privacy applies, it should be. If permission cannot be obtained, one should consult counsel before relying on the First Amendment or fair use doctrine.

III. RECOMMENDATIONS/CONCLUSION

A. GENERAL

A museum should adopt a policy statement with related documents and procedures for acquiring art for the museum's collection. With respect to works created before 1978, the policy statement should call for an examination of the item's history to determine if it is protected by copyright, in the public domain, or an unpublished work. The same sort of detail is needed from a conventional property ownership standpoint. However, it may be impractical or inefficient to search the provenance of every item acquired to the extent a lawyer might recommend. Similarly, museum personnel should determine what rights they believe they need to acquire with respect to works under consideration for acquisition. The provenance research should include identification of rights holders, even if acquisition of rights is not expected immediately.

Whether the object to be acquired is a gift or purchase, the basic issue of examining a copyright's history should be the same, regardless of the method of acquisition.

B. SPECIFIC QUESTIONS

The following questions should be asked with respect to any acquisition. The answers may form the basis for a legal opinion as to copyright status and help determine further questions to be asked.

1. On what date was the work created?
2. Who is the artist or artists?
3. For all artists involved, what are their dates of birth and, if applicable, of death?
4. If living, what is the artist's address? If deceased within the last 75 years, what is the address of his or her estate or other representative, if known?
5. Is there any existing information about the artist's willingness to grant rights to museums, if any?
6. Does the work contain a copyright notice on it? If so, what does it say and where is it located?
7. For works created before 1978 that do not contain a copyright notice, regarding evidence of "publication:"
 (a) Has the work been displayed publicly?
 (b) Have copies of it appeared in books, as art reproductions, in catalogs, or elsewhere?
 (c) Have copies ever been displayed publicly in a situation that would permit photographing or copying?
 (d) Is the work part of a "limited edition"? If so, how many other copies exist?
 (e) Who are the prior owners, what were their dates of ownership, and how was the work displayed? Is there any other information known about transfers?
8. With respect to exclusive rights under copyright law:

 (a) Have the answers to questions posed in number 7 resulted in a determination that the work is in the public domain?
 (b) Are there any known derivative works?
 (c) Is it likely that the museum has an interest in any use of the work beyond mere display in the museum? If so, what are the potential uses?
 (d) Does the transferor represent itself as the owner of all rights of copyright? If not, can the other rights holders be readily identified?
 (e) What is the history of the work? Were there prior owners, uses, and/or rights exploitations?
 (f) Under what circumstances was the work created? Is it a joint work, work made for hire, derivative work, compilation, or other type of work that may trigger additional ownership issues?
 (g) Is there any reason to believe any rights of copyright have been assigned?
 (h) Has there been a recent search of the Copyright Office records?
9. With respect to the Visual Artists Rights Act:
 (a) When was the work created?
 (b) Is the artist living?
 (c) What type of art work is it? Is it one of the types enumerated in the definition of "work of visual art?
 (d) Is it a "work made for hire"?
 (e) If produced as a limited edition, does it meet the criteria of a "work of visual art"?
 (f) Is it signed by the artist or does it bear some other identifying mark of the artist?

(g) If it is a photograph, was it produced for exhibition purposes only? Does it meet the limited-edition criteria under the act?

(h) Was it produced for commercial purposes (e.g., is it a merchandising item, advertising, promotional, descriptive, covering, packaging, or a container)?

(i) Is it a poster, map, globe, chart, technical drawing, diagram, model, applied art, motion picture or other audiovisual work, book, magazine, newspaper, periodical, data base, electronic information service, electronic publication, or similar publication?

(j) Is the work in its original form?

(k) Is attribution information available?

(l) Will any of the museum's plans lead to an alteration of the work?

(m) Has the artist waived his or her rights under VARA?

(n) Has the artist transferred the work? If so, when?

The copyright and related intellectual property issues raised by a museum's acquisitions may be more complicated in theory than they are in practice. Routine use of form agreements can be precarious, leaving many issues unaddressed. However, museum professionals usually are aware of what problems and matters are paramount and when they should seek the advice of counsel.

NOTES

1. The Uniform Commercial Code has been adopted by all the states with slight variations. U.C.C. Article 2, 1-1B U.L.A. (1989 and Supp. 1997).

2. The "bundle of rights" are found in section 106 of the 1976 Copyright Act and include the right to reproduce a work, create a derivative work, distribute the work, publicly perform and publicly display the work, and control the digital transmission of sound recordings. 17 U.S.C. § 106 (1997). (Henceforth we refer to the Copyright Act by section numbers only.)

3. "'Pictorial, graphic, and sculptural works' include two-dimensional and three-dimensional works of line, graphic, and applied art, photographs, prints and art reproductions, maps, globes, charts, diagrams, models, and technical drawings, including architectural plans. Such works shall include works of artistic craftsmanship insofar as their form but not their mechanical or utilitarian aspects are concerned; the design of a useful article, as defined in this section, shall be considered a pictorial, graphic, or sculptural work only if, and only to the extent that, such design incorporates pictorial, graphic, or sculptural features that can be identified separately from, and are capable of existing independently of, the utilitarian aspects of the article." *Id.* § 101.

4. *Id.* § 102.

5. Assignments may be recorded in the Copyright Office, but often are not. Such registration is now permissive. See United States Copyright Office, Circular 12, Recordation of Transfers and Other Documents (1993).

6. Rights can also be in literary, musical, dramatic, or choreographic works, or motion pictures, audiovisual and multimedia works. There are additional considerations and rights if the museum is involved with these types of works.

7. The 1976 Act can be somewhat confusing with respect to reproductions of artwork. The act states that copyright "subsists . . . in . . . pictorial, graphic and sculptural works." *Id.* § 102(a)(5). Pictorial, graphic and sculptural works are defined in the act to "include . . . art reproductions." *Id.* § 101. At the same time, § 106 lists the right "to reproduce" a work as one of the exclusive rights of copyright. Artwork reproductions are therefore both copies and separately protectable derivative works. See § 103 and note 9, *infra*.

8. *Id.* § 106(1). "'Copies' are material objects . . . in which a work is fixed by any method now known or later developed, and from which the work can be perceived, reproduced, or otherwise communicated, either directly or with the aid of a machine

or device. The term 'copies' includes the material object . . . in which the work is first fixed." *Id.* § 101.

9. "A 'derivative work' is a work based upon one or more preexisting works, such as a translation, musical arrangement, dramatization, fictionalization, motion picture version, sound recording, art reproduction, abridgment, condensation, or any other form in which a work may be recast, transformed, or adapted. . . ." *Id.* § 101

10. *Id.* § 106(2)

11. *Id.* § 106(3)

12. *Id.* § 106(4). Note 13, *infra*, defines "to perform or display" publicly. The right to perform a work is limited to literary, musical, dramatic, and choreographic works, pantomimes, and motion pictures and other audiovisual works. *Id.* § 106(1).

13. *d.* § 106(5). The right to display a work is limited to "literary, musical, dramatic, and choreographic works, pantomimes, and pictorial, graphic, or sculptural works, including the individual images of a motion picture." *Id.* "To perform or display a work 'publicly' means—

(1) to perform or display it at a place open to the public or at any place where a substantial number of persons outside of a normal circle of a family and its social acquaintances is gathered; or

(2) to transmit or otherwise communicate a performance or display of the work to a place specified by clause (1) or to the public, by means of any device or process, whether the members of the public capable of receiving the performance or display receive it in the same place or in separate places and at the same time or at different times." *Id.* § 101.

14. *Id.* § 106(6).

15. *Id.* § 109(c).

16. See R. E. LERNER & J. BRESSLER, ART LAW, 2D ED., VOL. 2: 801-802 (1998).

17. *Id.* § 107.

18. In fact, as to unpublished, unregistered works, the investigation may need to go back even further.

19. "Publication" was not defined in the 1909 Act. The 1976 Act defines publication as "the distribution of copies. . . of a work to the public by sale or other transfer ownership, or by rental, lease, or lending. The offering to distribute copies...to a group of persons for purposes of further distribution, public performance, or public display, constitutes publication." *Id.* § 101. A public performance or display of a work does not of itself constitute publication." Id. The definition in the 1976 Act is generally a codification of case law under the 1909 Act. M. B. NIMMER AND D. NIMMER, NIMMER ON COPYRIGHT, § 40.03 at 4-16 (1993). NIMMER summarizes cases under the 1909 Act by noting that "publication occurs when by consent of the copyright owner, the original or tangible copies of a work are sold, leased, loaned, given away, or otherwise made available to the general public, or when an authorized offer is made to dispose of the work in any such manner even if a sale or other such disposition does not in fact occur." NIMMER AND NIMMER, § 4.04 at 4-18.

20. *Id.* at § 4.01[B].

21. See UNITED STATES COPYRIGHT OFFICE, CIRCULAR 3, COPYRIGHT NOTICE (1993) (discussion of basic notice issues).

22. LERNER & BRESSLER, supra note 16, at 791.

23. "Copyright in a work created before Jan. 1, 1978, but not theretofore in the public domain or copyrighted, subsists from Jan. 1, 1978, and endures for the term provided by Section 302 (for works created after Jan. 1, 1978). In no case, however, shall the term of copyright in such a work expire before Dec. 31, 2002; and, if the work is published on or before Dec. 31, 2002, the term of copyright shall not expire before Dec. 31, 2027." *Id.* § 303.

24. The 1976 Act provides that federal copyright protection is available for an unregistered/unpublished work created before 1978. See, *supra*, note 24.

If the work is published before Dec. 31, 2002, copyright subsists until at least Dec. 31, 2027. *Id.* § 303.

25. While "author" is an undefined term in the 1976 Act, it includes creators of all types of copyrightable works such as artists, sculptors, composers, architects, etc.

26. *Id.* § 302(a). The 1976 Act contains a series of requirements and presumptions to apply when the date of an author's death is unknown. *Id.* § 302(d), (e). See M. NIMMER AND D. NIMMER, *supra*, note 19, 15 § 9.01[A] (1992). As this draft goes to print, there is a bill pending in Congress to change the duration to life plus 70 years.

27. *Id.* § 302(b).

28. *Id.* § 302 (c).

29. If the grant includes the right of publication, the period begins at the end of 35 years from the date of publication, or 40 years from the date of the grant, whichever term ends earlier. *Id.* § 203(a)(3).

30. *Id.* §203.

31. Automatic renewal of the second term applies to works first published or registered between 1964 and 1977. *Id.* § 304(b).

32. The 19-year extension to the second term of copyright protection can be recaptured by the original author of his or her heirs by providing notice as required in § 304.

33. Id. § 103.

34. Visual Artists Rights Act (VARA) is codified as 17 U.S.C. § 106A.

35. *Id.* § 106A. "A work of visual art" is—

(1) a painting, drawing, print or sculpture, existing in a single copy, in a limited edition of 200 copies or fewer that are signed and consecutively numbered by the author and bear the signature or other identifying mark of the author; or

(2) a still photographic image produced for exhibition purposes only, existing in a single copy that is signed by the author, or in a limited edition of 200 copies or fewer that are signed and consecutively numbered by the author.

A work of visual art does not include—

(A) (i) any poster, map, globe, chart, technical drawing, diagram, model, applied art, motion picture or other audiovisual work, book, magazine, newspaper, periodical, database, electronic publication, or similar publication; (ii) any merchandising item or advertising, promotional, descriptive, covering, or packaging material or container; (iii) any portion or part of any item described in clause (i) or (ii);

(B) any work made for hire; or

(C) "any work not subject to copyright protection. . . . " *Id.* § 101.

36. *Id.* § 106(a)

37. A trademark relates to any word, name, symbol or device that is used in trade with goods to indicate the source or origin of the goods and to distinguish them from the goods of others. Similar rights may be acquired in marks used in the sale or advertising of services (service marks). The distinctive appearance, shape, and/or color of an item may also serve as protectable "trade dress" under trademark law. See 15 U.S.C.A. § 1127. The trade dress concept has also been extended to the distinctive style of brush strokes on a painting. As used in this chapter, the term trademark refers to all of the above.

38. Unfair competition can result from any "unlawful, unfair or fraudulent business practice." This includes the unauthorized use of another's name, materials, color scheme, symbols, patterns, or devices that cause a consumer to be misled as to source or affiliation of goods.

39. The right of publicity is protected by statute in about 36 states and by common law in most states. The majority of states view the right as a property right, while the remaining states view the right under the privacy theories.

40. Lanham Act 43(c), 15 U.S.C.A. § 1125.

41. Lanham Act 43(c), 15 U.S.C.A. § 1125.

42. The right has been expanded to cover, in addition to name, image and likeness, the voice, performance, biographical facts, and signature of a person.

43. In the majority of states the right is descendible as a property right. A minority of states view the right under a privacy theory and hold that it ends with the death of the person.

44. Privacy laws of a state may apply to the personal non-commercial injury that could result from the sale of copies of artwork that contain the person's image or other identity.

45. *Id.* at fn. 40.

46. The right to free speech under the First Amendment of the U.S. Constitution has allowed for reproduction and sale of items that are deemed newsworthy or beneficial to society for its commentary purpose.

Joseph Bothwell

The United States tax code changes as new legislation is passed and new regulations are accepted. As the code changes, the impact on charitable institutions also changes, and it is imperative for registrars, development officers, curators, and directors to keep abreast of new tax developments. Museums should not give advice about tax deductions to donors; donors should be encouraged to rely on their own tax counsels who are experts and have full knowledge of their financial situation.

In 1997 the United States tax code allowed individuals (and some corporations) to make charitable contributions to tax-exempt organizations and to take deductions on their tax returns based upon the fair market value of the donated property, subject to certain limitations. A charitable contribution, for tax purposes, is a donation of something of value to a tax-exempt institution. While the donation can be money or property, the registrar will deal primarily with donations of personal property, such as works of art, historic artifacts, and scientific specimens.

A taxpayer may take a deduction based upon the fair market value of the item donated if the object is used for a purpose related to the donee institution's tax-exempt status. If the donation is not used for this purpose, the allowable deduction is limited to the donor's "basis," the cost or value of the item when the donor acquired it. An instance of unrelated use (see IRS Publication 526, "Charitable Contributions") occurs when a painting is donated to an educational institution that sells the work and uses the money for programs. Since the painting is intended for fund raising and is not used directly for educational purposes, its donation falls under unrelated use.

In addition, the donor must not receive any goods or services in return for the donation, and the museum should include assurances to this effect in the deed of gift or conveying cover letter. (See chapter on Gift Agreement.) If some benefit is tied to the donation, it must be valued and reported to the donor.

When the appraised value of a donated work of art or other cultural or historical property exceeds a certain value ($5,000 in 1997) the taxpayer must complete Section B of IRS Form 8283, "Noncash Charitable Contributions," and include this with his or her tax return, along with a qualified appraisal providing an independent assessment of the item's fair market value. In completing Form 8283 the donor must have a written appraisal that supports the claimed value. Museum staff are disqualified from appraising objects donated to the museum. A qualified appraisal is one that is made no earlier than 60 days prior to the date of contribution and no later than the filing date (including extensions) for the donor's tax return on which the contribution is claimed, does not involve a prohibited appraisal fee, provides certain information, and is made by a qualified appraiser.

An individual is considered a qualified appraiser, according to IRS Publication 561, "Determining the Value of Donated Property," if he or she meets the following requirements:

- Holds himself or herself out to the public as an appraiser or performs appraisals on a regular basis
- Is qualified to make appraisals of the type of property being valued

The content of this article does not necessarily represent the position of the Internal Revenue Service.

- Is not excluded by being the donor or any party to the contribution (unless the property is donated within two months of its acquisition and its appraised value does not exceed its purchase price), or the donee, or employed by or related by blood or marriage to the taxpayer or anyone at the donee institution

- Performs a majority of his or her appraisals for other persons

- Understands that an intentionally false or fraudulent overstatement of the value of the property described may subject the appraiser to a civil penalty under section 6701

[*Editor's Note:* Donors often ask museums to recommend appraisers. It is standard practice for the museum to give the donor three names, arranged alphabetically, of appraisers who are experts in areas pertaining to the donation. It is important to refer only, and not recommend, appraisers.]

The appraisal is an assessment of the object's value. For tax purposes, the value stated must be fair market value (not replacement value or insurance value). IRS regulations use the same definition of fair market value for all three returns (Income Tax, Estate Tax, Gift Tax): the price at which the property would change hands between a willing buyer and a willing seller, neither being under any compulsion to buy or sell and both having reasonable knowledge of the relevant facts. It presumes cash or terms equivalent to cash. (See chapter on Appraisals.)

The gift of any artwork (defined broadly) valued over a specified amount ($20,000 in 1997) will be reviewed by the Art Advisory Panel of the IRS. Overall, the quality and acceptability of the appraisal is directly related to the support for the appraised value. Where an appraiser has carefully considered all of the available evidence and arrived at a well-documented, well-supported fair market value based upon that evidence, it is unlikely that a review by the IRS (or anyone else) would result in significant adjustments. When an appraisal is unsupported or relevant facts are omitted, it is more

likely to be challenged. While an appraisal for tax purposes is not the responsibility of a registrar, it is important to recognize that a logical, well-supported appraisal will result in fewer problems, should a donor's tax return be audited.

Of the four parts that make up Section B of Form 8283, one must be completed by an official of the donee institution. Although this individual is not specified in the U.S. tax code or in the IRS regulations, this responsibility is often assumed by the institution's registrar. In signing this form the registrar, or other designated official of the museum, verifies that the donee institution is a qualified tax-exempt entity under Section 501(c)3 of the Internal Revenue Service Code, acknowledges receipt of the item(s) described, and agrees that the institution will inform the IRS by filing IRS Form 8282, "Donee Information Return," if the institution disposes of the item(s) within two years of the date of acceptance.

The registrar should sign IRS Form 8283 only after the taxpayer has offered in writing to give the property and the donee institution has agreed in writing to accept the property. The museum must have actual (or, in some limited circumstances, constructive) delivery of the object before Form 8283 is signed. Accepting the property and signing the form does not represent concurrence in the claimed fair market value. If the donee institution disposes of the property within two years, it must file Form 8282 with the IRS and give a copy to the donor within 125 days after the date of disposal of the donated items(s), even if the item(s) are exchanged with or given to another charitable institution. Completing and signing these two forms are generally the only points at which the registrar becomes part of the IRS charitable contribution process.

Sonja Tanner-Kaplash

About 400 years ago, the verb *apprize* (now appraise) first came into common use and meant "to judge or estimate the quality or worth of." Its synonym, evaluation (or valuation), is a later addition from the French *evaluer*. Each of these words denotes an estimate or an opinion. Professional and informed, but an opinion nevertheless, an appraisal's validity is directly related to the appraiser's knowledge and experience and is most clearly demonstrated by a written statement of the facts upon which the valuation is based.

While the idea of "worth" includes aspects such as authenticity, historical importance or association, condition, quality, rarity, and market demand, it is invariably the matter of monetary value that is the major concern of museums, which generally have substantial in-house expertise in the former areas.

WHY APPRAISE?

Museums seek appraisals for many reasons:

- To create or update an inventory for insurance purposes
- To set a value on an outgoing loan for insurance purposes
- To determine a loss in the case of damage or theft
- To confirm the purchase price of a new acquisition
- To document a proposed deaccession or to support an application for public funding or grants.

Staff members of U.S. museums are prohibited by IRS regulation from appraising donated objects or becoming directly involved in arranging appraisals of gifts for which donors receive income tax benefits. The museum must be conscious of not only its own liability but also that of its donors, since appraisals can become a pivotal point in litigation. When the museum's representative signs the donee acknowledgment portion of a donor's tax statement, he or she does not endorse or validate the stated value of the object. However, in extreme cases of over-valuation, the museum has at least an ethical, and perhaps a legal, obligation to alert the donor in some diplomatic fashion. Few situations can sour the museum/donor relationship more surely than a tax investigation that centers on the value of a gift made to the museum. (See chapter on Tax Issues Related to Gifts to Collections.)

MUSEUM POLICIES

Since the appraisal process has potential for problems, the governing authority of the museum must ensure that appropriate, approved, written policies and procedures are in place and followed.

The concern of the museum is to ensure that competent, reputable, arm's-length appraisers are selected and that the appraisal document can withstand close scrutiny. The museum must act, and be seen to act, honestly and impartially when obtaining an appraisal so that the transaction is conducted in a businesslike and consistent manner.

Policies should determine under what circumstances in-house appraisals by curators are appropriate, and when and how an acceptable outside appraiser will be chosen. In keeping with the ICOM and AAM codes of professional ethics, most museums prohibit staff from evaluating objects for a third party on museum time and/or premises; this protects both the museum and potential donors.

METHODS OF APPRAISAL

Ideally, an appraisal should be based upon a physical examination of the object(s) by the appraiser; when this is not possible, arrangements may be made to use photographs. A valid appraisal cannot be based on a verbal description only. Photographs, if they are used, should show several different views

of the object, as well as any positive or negative characteristics that may affect values. It is important to illustrate features such as wear, damage, the extent of restoration or old repairs, maker's marks, manufacturing defects, or other irregularities. The photographs, preferably taken by a professional photographer, should be accompanied by a detailed written description, including dimensions, materials, technique, condition, and any other information that might affect value.

PRICING SOURCES

Numerous standard, published references can assist the museum in evaluating its own collections. Helpful publications range from price guides or catalogs of specialty collections (such as coins or maritime objects) to general books on "collectibles," "Americana," antiques, or fine art. Many are updated annually and report prices from a variety of sources.

Periodical publications range from glossy, coffee table magazines to serious journals, trade publications, and newsletters aimed at particular interest groups. These sources provide current pricing information, either directly (as listings or articles) or indirectly (through advertising or reports of sales).

Certain dealers circulate price lists of objects available for sale ("dealer lists") to former clients and other interested parties. Major auction houses advertise forthcoming sales by means of illustrated catalogs, which show estimated prices for each object or lot; after the auction, the final selling prices are also provided to catalog subscribers.

These references are the backbone of the published information available to museum staff; in-house evaluations of similar objects in the museum collection may be based upon prices in these sources. However, museums may decide to hire an outside appraiser when an object is beyond the area of expertise of a particular curator or curatorial department, when the object is particularly important, or when it is necessary, as in the case of an exchange, to have an objective appraisal.

Many curators and other professionals in the natural science and archaeological fields have been adamantly opposed to the monetary valuation of specimens, believing that this process encourages illicit trade in such materials. However, museums with such collections need to consider monetary value when purchasing insurance protection for their collections or evaluating a loss. In addition, they must provide values of such objects for outgoing loans. One method that the insurance industry recognizes for evaluating this type of material is to calculate the cost of a field trip to gather or excavate such material again. Clearly this makes the most sense when the museum has recent records of similar field trips to use as a guide. It can be a lengthy calculation based on a large number of variables, but it is an approach that begins to provide an idea of the monetary worth for some collections. Museums would be wise to discuss this and other methodologies with their insurers before undertaking a major valuation project.

WHO APPRAISES?

Locating a competent appraiser is not always an easy task, since this occupation is not licensed or regulated in any formal way. It is important to find someone who is knowledgeable about the type of material under consideration. Few people are truly expert in a wide range of fields, and the "generalist appraiser" must spend considerable time researching the particular object; otherwise he will probably provide a less than satisfactory appraisal. Most appraisers are commercial dealers, their sales experience enhancing and informing their appraisal services.

SELECTING AN APPRAISER

Directories published by the various professional associations of dealers and appraisers provide a starting point for finding an appraiser. The museum can also begin the selection process by securing recommendations from colleagues at other institutions. In addition, private collectors, insurance agents, and banks with trust departments in the

community may have had experience with various appraisers and their work.

When the museum first contacts likely candidates, it is appropriate to check the appraiser's credentials. Request information on the appraiser's background and qualifications to appraise a specific type of material; learn how that expertise was obtained. Inquire about membership in professional organizations, and ask exactly what that membership signifies. Some professional appraisal associations have rigorous membership requirements and act as self-regulating bodies that set standards for training and business practices, administer examinations, discipline members, and publish monographs. Others are open to anyone who pays the membership fee. Some membership requirements to look for include:

- A minimum number of years of experience
- Successful completion of competency tests
- Sponsorship by existing members or character references
- Adherence to a strict code of ethics
- Accreditation and re-certification of members at regular intervals
- A membership directory with individualized listings

Membership in an association is, however, not an automatic indication of competency, and lack of membership may be equally meaningless.

If the appraiser is a member of a firm, ask about the length of time the business has been in operation, the specialties of the staff, and whether the owner or proprietor completes the appraisal personally or turns it over to a junior staff member. It is especially important to learn if the business maintains a resource center, subscribes to relevant publications or data banks, and maintains current, well-organized records of private sales for reference.

Finally, ask the appraiser to provide references and, where applicable, a credential package of background information about the firm he or she works for; ideally, this should include a sample of a typical appraisal document. At this time, it is appropriate to discuss the fee structure and to ask for an estimate of the final cost of your appraisal. Should an appraiser be unwilling to undertake a particular project because he or she considers it beyond his or her area of expertise, do not insist. Instead, respect the appraiser's professionalism and honesty and attempt to locate another appraiser.

CONFLICT OF INTEREST

Occasionally, a museum may be obliged to eliminate an otherwise competent appraiser because he or she is not sufficiently "arm's length" from the proposed transaction. To avoid potential conflict of interest, the museum should inquire whether the appraiser has any past, present, or future interest in the object being appraised and if the individual has any other relationship with the museum or its board or staff.

Essentially, museum polices must ensure that the appraisal process is as objective, professional, formal, businesslike, and well-documented as possible. These elements may be overlooked in friendly, personal relationships.

For example, an individual who is also a museum trustee should not be commissioned to do appraisal work for that museum. If a museum intends to deaccession an object purchased some years ago from a dealer, it would be inappropriate to commission the same vendor to appraise the same object again.

LETTER OF COMMISSION

After checking references and deciding upon the best candidate, the museum should provide the appraiser with a formal letter of commission that confirms any earlier discussions and outlines the services the museum expects. The letter should identify the date by which the work is to be completed, confirm the basis on which the fee is to be calculated, provide for a personal inspection of the object by the appraiser, and specify that the value required is identified as "fair market value." (See chapter on Contracts.) The objects to be

appraised should be listed with a detailed description and accompanied by photographs if the objects are not readily available for inspection.

FAIR MARKET VALUE

In much the same way as there are many different places and prices at which an item may be purchased, there is also a range within which an item is appraised. To some extent this reflects the appraiser's own experience and position in the field. For example, specialty dealers (perhaps located in a fashionable and expensive area of a major city) sell an object at a different price level from the auction house, which is not obliged to keep a large selection of stock on hand for long periods of time. A decorating firm may pay a price for an attractive fragment or damaged piece that a serious collector would never consider. Even an auction price may be the result of a bidding duel.

"Fair market value" does, however, have a specific meaning; the IRS defines it as "the price at which the property would change hands between a willing buyer and a willing seller, neither being under any compulsion to buy or sell, and both having reasonable knowledge of relevant facts." This definition eliminates distress or liquidation sale prices as well as the bargain prices that occur when an object is purchased by a knowledgeable buyer from an unwitting vendor.

For significant or highly valued pieces, some museums secure more than one appraisal from different dealers or appraisers and then average the figures.

INSURANCE VALUE

In the past, appraisers often gave a special "insurance or replacement value" for objects being appraised for insurance purposes. These prices were usually considerably higher than fair market value. The rationale was the expectation that the insured party would immediately purchase a comparable item, probably at the highest retail price, and would incur other expenses, such as travel, in order to make the purchase. This was not, however, in the interest of a museum. Insurance companies and their adjusters rarely accept highly overblown values as the basis for settlement of a claim. An adjuster may seek additional opinions regarding the lost or damaged article and recommend that the claim be settled for a lower and more realistic amount. Most fine arts policies now insure for "fair market value" and do not require scheduling for most objects. Appraisal requirements for insurance of permanent collections depend on the museum's fine arts insurance policy. (See chapter on Insurance.)

ASSESSING THE WRITTEN APPRAISAL DOCUMENT

The format and appearance of the appraisal document are important. The appraisal firm and the owner of the work should be clearly identified. The credentials of the appraiser, particularly private individuals (such as collectors, authors, or academics without a business letterhead), should be set out in the body of the document. Anyone else involved in the appraisal process should be identified; reputable appraisers often consult colleagues, and the major auction houses employ specialists who travel to different branch locations for special assignments.

The appraisal should be dated and should indicate the date and place the material was viewed. A detailed description of each item should include its condition, dimensions, medium, technique, characteristics, title, date, attribution to an artist or maker if applicable, exhibit history, previous owners, and authenticity, along with an itemized value.

The appraisal should cite the basis for the assigned value: sales of other comparable materials, auction house prices, the standing of the artist/maker in his or her profession and within a particular school or movement, size and subject matter, and the current economic state of the art market.

Each page should be totaled, and a grand total should appear on the last page. It is prudent for the museum to check the addition and be certain that

all values are clear. The document should be signed in the original by the appraiser.

If the documentation does not meet these requirements, do not hesitate to return it for adjustment. It may not be appropriate for the museum to question the values, but it is certainly valid to question the evidence used to substantiate the appraisal, should it seem inadequate.

An inadequate appraisal should be corrected immediately, before it is paid for; if there are questions later, it is often too difficult for the appraiser to reconstruct a complicated and unrecorded line of reasoning.

APPRAISAL COSTS

Until 1984, the cost of an appraisal for tax purposes was almost always based upon a percentage of the total value of the appraised material. This formula provided such incentive for overblown appraisal values that in the United States it was finally deemed unacceptable for IRS purposes. Charges for tax appraisals must now be a flat fee or based on a *per diem* or hourly rate. Other jurisdictions followed suit. Although Canadian legislation does not require this pricing formula, museums and other clients have encouraged it, and it is now widespread.

A well-substantiated appraisal may require extensive library research, travel to the client's premises, and consultation with colleagues in the same or different firms. For these reasons, the hourly or daily pricing mechanism provides a more accurate reflection of the actual amount of work required and allows the client to receive several estimates before making a final choice of appraiser.

Museum clients should be aware that the appraiser will also charge for any expenses, and it is wise to ask for an estimate of both expenses and time required to do a certain piece of work in advance.

Museums should not seek or accept "courtesy," free, or reduced-price appraisals. Some dealers offer this service as a good will gesture, but clients should be wary. Occasionally, the appraiser may be invited to defend his or her opinion to insurers or to tax authorities, and it is inappropriate to expect a professional to undertake this responsibility without a fee.

More suitable methods of reducing appraisal costs could be a cooperative venture with neighboring institutions to hire an appraiser for a day or two a month to work at various museums in the area. Another alternative is to pay an annual retainer to an appraiser that the museum uses frequently. In such an arrangement, the appraiser makes an agreed-upon number of visits to the museum during the year to appraise several objects at once. Even these yearly fees could be shared with nearby museums that use the services of the same type of specialist on a regular basis.

International Movement of Cultural Property

Rebecca A. Buck

International trade in art and antiquities is complex and difficult to deal with on both legal and ethical levels. Museums must understand international issues, stay aware of current events in international art trade, and respond on both philosophical and practical levels; the latter must be on a day-to-day basis. Masterworks aren't always involved. In addition to cultural objects that are blatantly moved and dealt in illegal operations, many museums are approached by people who wish to have authenticated, or to donate, bits of cultural property that they may have stolen or removed illegally from the country of origin. Museums also borrow works internationally, and care must be taken to ensure that borrowed works do not fall under one of the international treaties or become subject of a court action. It falls to the museum to be extremely careful in its dealing with objects not originating in the United States.

The prime vehicles for policing international trade have been the UNESCO Convention and specific treaties with art-producing countries. In the 1990s, a UNIDROIT Convention on international movement of cultural objects was also put in place. An increasing number of cases involving art looted or seized during World War II has led to action by the Association of Art Museum Directors (AAMD); in February 1998, AAMD formed a task force and charged it with devising a system to resolve the growing number of claims on plundered art. Legislation dealing with this issue will probably be developed at both the national and international level.

The UNESCO Convention on the means of prohibiting and preventing the illicit import, export and transfer of ownership of cultural property was adopted by the General Conference of its 16th session, Paris, Nov. 14, 1970. The United States ratified the convention in 1972 and passed enabling legislation, the Convention on Cultural Property

Implementation Act, in December 1982. The United States provides protection for cultural property when requests from a ratifying country seeking restrictions on imports into the United States are accepted, thus legitimizing the export controls of the country which made the request. The United States Information Agency implements convention matters through its Cultural Property Advisory Committee.

Several museums were in the forefront of support for the 1970 UNESCO convention. The Peabody Museum of Harvard University and the University of Pennsylvania Museum of Archaeology and Anthropology, with active archaeological excavations throughout the world, were early supporters of international agreements. The Pennsylvania Declaration, dated April 1, 1970, reads in part:

> The Board of Overseers, Director, Curators and Staff of The University Museum of the University of Pennsylvania reaffirm that they will not knowingly acquire, by gift, bequest, exchange or purchase, any materials known or suspected to have been exported from their countries of origin since 1970 in contradiction to the International Convention adopted in that year, to which the Museum fully subscribes; nor will they knowingly support this illegal trade by authenticating or expressing opinions concerning such material. They will actively discourage the collection of such material, the exhibiting of such material in The University Museum, and the lending of University Museum objects to exhibitions including illegally acquired objects in other museums.

To enlarge the control on international art trade, UNESCO commissioned a study from The International Institute for the Unification of Private Law (UNIDROIT), and in 1995 a UNIDROIT Convention on Stolen or Illegal Exported Cultural

Objects was open to signature. By 1997, 23 countries had signed, but the United States had not. This convention advocates the return of all stolen cultural objects, and identifies those as unlawfully excavated or unlawfully retained as stolen; the convention has caused controversy and will not be effective until art-importing countries and art-exporting countries agree to follow its principles.

The federal government does offer some protection to museums that are dealing with international loans. Immunity from Judicial Seizure of Cultural Objects Imported for Temporary Exhibitions, Public Law 89-259, was approved in 1965. It renders immune from judicial seizure works of art imported for temporary exhibition, and involves a strict application procedure implemented by the United States Information Agency. For information, contact the U.S. Information Agency in Washington, D.C.

Museums can do several things to limit the illegal trade in cultural artifacts and protect its relationship with lenders:

- Be aware of and follow all existing laws and conventions
- Keep abreast of stolen property bulletins and UNESCO requests and agreements
- Keep current with international art news (Web sites such as http://museum-security.org/ are extremely useful)
- Educate all museum staff, particularly curatorial staff, about laws and restrictions that are in place
- Include a statement on legal export/import in gift and sale agreements
- Include a statement about legal ownership in gift and sale agreements
- Review material to be borrowed for instances of illegal import and World War II seizure
- Apply for immunity from judicial seizure for all international loans for temporary exhibition
- Include a statement about international trade in illicit cultural property in the institutional code of ethics

Museums have the minimal responsibility to follow all laws regarding export and import of cultural property, and ethically they have a higher responsibility: to hold the highest principles in trust, to act by those principles in all matters pertaining to their collections, and to educate the public on as many levels as possible.

C. Timothy McKeown, Amanda Murphy, and Jennifer Schansberg

The Native American Graves Protection and Repatriation Act (NAGPRA) was enacted on Nov. 16, 1990, to formally affirm the rights of lineal descendants, Indian tribes, and Native Hawaiian organizations to custody of Native American human remains, funerary objects, sacred objects, and objects of cultural patrimony that are in the control of federal agencies and museums. In enacting this legislation, Congress and the president acknowledged that over the course of the nation's history, Native American human remains and funerary objects have suffered from differential treatment as compared with the human remains and funerary objects of other groups. They acknowledged that objects needed for the practice of traditional Native American religions had been acquired without the voluntary consent of an individual or group that had authority of alienation. They acknowledged the failure of American law to recognize concepts of communal property traditionally and still in use by some Indian tribes. They also made it a federal offense to sell, purchase, or use for profit Native American human remains, funerary objects, sacred objects, and objects of cultural patrimony in certain situations. The primary sources of information on NAGPRA are the statute itself [25 U.S.C. 3001 *et seq.*] and its implementing regulations [43 CFR 10].

WHO MUST COMPLY?

Most federal agencies and all museums that receive federal funds are required to comply with the statute and regulations.

The statute defines *federal agency* as any department, agency, or instrumentality of the United States. This definition includes all components of the executive, legislative, and judicial branches of the United States government that either manage land or hold collections of Native American human remains, funerary objects, sacred objects, or objects of cultural patrimony.

All federal agencies are responsible for completing summaries and inventories of Native American collections in their control and for ensuring compliance regarding inadvertent discoveries and intentional excavations conducted as part of activities on federal or tribal lands. Federal agencies are responsible for the appropriate treatment and care of all collections from federal lands being held by non-governmental repositories, including those excavated or removed under the authority of the Antiquities Act [16 U.S.C. 431-433], the Reservoir Salvage Act [16 U.S.C. 469-469c], section 110 of the National Historic Preservation Act [16 U.S.C. 470h-2], and the Archaeological Resources Protection Act [16 U.S.C. 470aa-mm]. Federal agencies are subject to enforcement actions by aggrieved parties under 25 U.S.C. 3013.

A museum is defined in the statute as any institution or state or local government agency (including any institution of higher learning) that has possession of, or control over, Native American human remains, funerary objects, sacred objects, or objects of cultural patrimony, and receives federal funds.

The term "possession" as used in this definition means having physical custody of such objects with sufficient legal interest to lawfully treat them as part of the museum's collection. Generally, a museum would not be considered to have sufficient legal interest to lawfully treat human remains, funerary objects, sacred objects, or objects of cultural patrimony on loan from another individual, museum, or federal agency as part of its collection.

The term "control" means having a legal interest in human remains, funerary objects, sacred objects, or objects of cultural patrimony sufficient to lawfully treat them as part of the museum's collection. Generally, a museum that has loaned human

remains, funerary objects, sacred objects, or objects of cultural patrimony to another individual, museum, or federal agency is considered to retain control of those objects.

The phrase "receives federal funds" means the receipt of funds by a museum after Nov. 16, 1990, from a federal agency through any grant, loan, contract (other than a procurement contract), or other arrangement by which a federal agency makes or made available to a museum aid in the form of funds. Procurement contracts are not considered a form of federal assistance but are provided to a contractor in exchange for a specific service or product. Federal funds provided for any purpose that are received by a larger entity of which the museum is part are considered federal funds to the museum. For example, if a museum is a part of a state or local government or private university that receives federal funds for any purpose, the museum is considered to receive federal funds. NAGPRA applies to certified local governments. Tribal museums are covered by the act if the Indian tribe of which the museum is a part receives federal funds through any grant, loan, or contract (other than a procurement contract). The application of federal laws to institutions that receive federal funds is common, being used with such recent legislation as the Americans with Disabilities Act.

Museums are subject to civil penalties for failure to comply with provision of the statute under 25 U.S.C. 3007 and 43 CFR 10.12. The Smithsonian Institution is not subject to NAGPRA because it responds to a different piece of legislation. The National Museum of the American Indian Act [20 U.S.C. 80] was passed in 1989 and established separate repatriation requirements for the Smithsonian. Legislation to apply some of the NAGPRA terms and procedures to the Smithsonian was introduced in 1990 and eventually became law in 1996.

Private individuals and museums that do not receive federal funds and are not part of a larger entity that receives federal funds are not required to comply with provisions of the act.

In Summary:

- Most federal agencies must comply with provisions of the statute. Federal agencies are responsible for collections in their possession as well as those excavated or removed from federal land but currently in the possession of a non-federal repository.
- Any institution that receives federal funds—either directly or indirectly—and has possession or control of Native American human remains, funerary objects, sacred objects, or objects of cultural patrimony, must comply with provisions of the statute.
- The Smithsonian Institution must comply with the National Museum of the American Indian Act, which imposes requirements similar to those found in NAGPRA.

WHAT OBJECTS ARE COVERED?

The statute applies to four types of Native American items: human remains, funerary objects, sacred objects, and objects of cultural patrimony.

Human remains means the physical remains of a body of a person of Native American ancestry [43 CFR 10.2 (d)(1)]. The term has been interpreted broadly to include bones, teeth, hair, ashes, or mummified or otherwise preserved soft tissues. The statute makes no distinction between fully articulated burials and isolated bones and teeth. The term applies equally to recent and ancient Native American human remains. The term does not include remains, or portions of remains, freely given or naturally shed by the individual from whose body they were obtained, such as hair made into ropes or nets. This exclusion does not cover any human remains for which there is evidence of purposeful disposal or deposition. For the purposes of determining cultural affiliation, human remains incorporated into funerary objects, sacred objects, or objects of cultural patrimony are considered to be part of that object. This provision is intended to prevent the destruction of a funerary object, sacred object, or object of cultural patrimony that is culturally

affiliated with one Indian tribe but incorporates human remains culturally affiliated with another Indian tribe. Human remains that have been repatriated under NAGPRA to lineal descendants, Indian tribes, and Native Hawaiian organizations include complete and partial skeletons, isolated bones, teeth, scalps, and ashes.

Funerary objects are defined as items that, as part of the death rite or ceremony of a culture, are reasonably believed to have been placed intentionally at the time of death or later with or near individual human remains. Funerary objects must be defined by the preponderance of the evidence as having been removed from the specific burial site of an individual culturally affiliated with a particular Indian tribe or Native Hawaiian organization or to be related to specific individuals or families or to known human remains. The term "burial site" means any natural or prepared physical location, whether originally below, on, or above the surface of the earth, into which, as part of the death rite or ceremony of a culture, individual human remains were deposited. Burial sites include rock cairns or pyres that do not fall within the ordinary definition of grave site [43 CFR 10.2 (d)(2)]. Items made exclusively for burial purposes are considered funerary objects even if there are no associated remains. Items that inadvertently came into contact with human remains, such as historic enamel or glass fragments in prehistoric burial contexts, are not considered to be funerary objects. Certain Indian tribes, particularly those from the northern plains, have ceremonies in which objects are placed near, but not with, the human remains at the time of death or later. These items should be considered as funerary objects. The regulations distinguish between "associated funerary objects," for which the human remains and funerary objects are in the possession or control of a federal agency or museum, and "unassociated funerary objects," for which the human remains are not in the possession or control of a federal agency or museum. This distinction is only relevant for determining whether to provide information to the culturally affiliated Indian tribes or Native Hawaiian organizations in a summary or in an inventory format. Associated and unassociated funerary objects that have been repatriated under NAGPRA to lineal descendants, Indian tribes, and Native Hawaiian organizations include beads of various types; pottery jars, bowls, and sherds; tools and implements of wood, stone, bone, and metal; trade silver and other goods; weapons of many types, including rifles and revolvers; and articles or fragments of clothing.

Sacred objects are defined as specific ceremonial objects needed by traditional Native American religious leaders for the practice of traditional Native American religions by their present-day adherents. Traditional religious leaders are individuals recognized by members of an Indian tribe or Native Hawaiian organization as responsible for performing cultural duties relating to the ceremonial or religious traditions of that Indian tribe or Native Hawaiian organization, or exercising a leadership role in an Indian tribe or Native Hawaiian organization based on the tribe's or organization's cultural, ceremonial, or religious practices. While many items, from ancient pottery sherds to arrowheads, might be imbued with sacredness in the eyes of an individual, this definition is specifically limited to objects that were devoted to a traditional Native American religious ceremony or ritual and which have religious significance or function in the continued observance or renewal of such ceremony [43 CFR 10.2 (d)(3)]. Sacred objects that have been repatriated under NAGPRA to lineal descendants, Indian tribes, and Native Hawaiian organizations include medicine bundles, prayer sticks, pipes, effigies and fetishes, basketry, rattles, and a birchbark scroll.

Objects of cultural patrimony are defined as items having ongoing historical, traditional, or cultural importance central to the Indian tribe or Native Hawaiian organization itself, rather than property owned by an individual tribal member. These objects are of such central importance that they may not be alienated, appropriated, or conveyed by any individual tribal member. Such objects must have been considered inalienable by the culturally affiliated Indian tribe or Native Hawaiian organization at the

time the object was separated from the group [43 CFR 10.2 (d)(4)]. Objects of cultural patrimony that have been repatriated under NAGPRA to Indian tribes and Native Hawaiian organizations include a wolf-head headdress, a clan hat, several medicine bundles, and ceremonial masks of varying types.

An item may be considered an object of cultural patrimony as well as a sacred object. These categories are not mutually exclusive. Items fitting both categories that have been repatriated under NAGPRA include Zuni War Gods, a Sun Dance wheel, ceremonial masks of several types and functions, and a tortoise shell rattle.

It should be stressed that the definitions of human remains, funerary objects, sacred objects, and objects of cultural patrimony simply define the applicability of the statute and do not in any way attempt to restrict traditional concepts of "sacredness" or "patrimony."

In Summary:

- The statute applies to four specific categories of Native American objects: human remains; funerary objects; sacred objects; and objects of cultural patrimony.
- These four categories are not mutually exclusive.

WHO MAY MAKE A REPATRIATION REQUEST?

Within the museum context, repatriation means to return or restore the control of human remains, funerary objects, sacred objects, and objects of cultural patrimony to the lineal descendant or culturally affiliated Indian tribe or Native Hawaiian organization. Cultural affiliation is defined as a relationship of shared group identity that can be reasonably traced historically or prehistorically between a present-day Indian tribe or Native Hawaiian organization and an identifiable earlier group. Cultural affiliation is established when the preponderance of the evidence—based on geographical, kinship, biological, archeological, linguistic, folklore, oral tradition, historical evidence, or other information or

expert opinion—reasonably leads to such a conclusion [43 CFR 10.14(c)]. The regulations provide certain individuals and organizations the opportunity to request the repatriation of Native American human remains and cultural items. Lineal descendants, Indian tribes, and Native Hawaiian organizations may request the repatriation of Native American human remains, funerary objects, and sacred objects. Indian tribes and Native Hawaiian organizations may request the repatriation of objects of cultural patrimony. The criteria needed to identify who has standing to make a repatriation request are outlined below.

Lineal descendant is not defined in the statute. The statute does make it clear, however, that lineal descendants have priority over Indian tribes or Native Hawaiian organizations in making requests for human remains, funerary objects, and sacred objects. Lineal descendant is defined by regulation as an individual tracing his or her ancestry directly and without interruption by means of the traditional kinship system of the appropriate Indian tribe or Native Hawaiian organization or by the American common law system of descendance to a known Native American individual whose remains, funerary objects, or sacred objects are being requested [43 CFR 10.2 (b)(1)]. The necessity for a direct and unbroken line of ancestry between the individual making the request and a known individual is a high standard, but one that is consistent with the preference for disposition or repatriation to lineal descendants required by the statute. Reference to traditional kinship systems is designed to accommodate the different systems that individual Indian tribes and Native Hawaiian organizations use to reckon kinship. A lineal descendant may not necessarily be an enrolled member of an Indian tribe or Native Hawaiian organization. Lineal descendants may request human remains, funerary objects, and sacred objects. The statute does not authorize repatriation of objects of cultural patrimony—which by definition are controlled by the Indian tribe or Native Hawaiian organization as a whole—to lineal descendants.

Indian tribe is defined as any tribe, band, nation, or other organized Indian group or community of Indians, including any Alaska Native village, as defined in or established by the Alaska Native Claims Settlement Act [43 U.S.C. 1601 *et seq.*], which is recognized as eligible for the special programs and services provided by the United States to Indians because of their status as Indians [43 CFR 10.2 (b)(2)]. This definition was drawn explicitly from the American Indian Self Determination and Education Act [25 U.S.C. 450b], a statute implemented since 1976 by the Bureau of Indian Affairs to apply to a specific list of eligible Indian tribes and Alaska Native villages and corporations. The definition within the American Indian Self Determination and Education Act precludes extending applicability of the act to non-federally recognized Indian groups that have been terminated, that are current applicants for recognition, or have only state or local jurisdiction legal status. There are over 760 Indian tribes and Alaska Native villages and corporations that are eligible to make repatriation requests under the regulations. The current list of Indian tribal contacts is available from the Departmental Consulting Archeologist, National Park Service, Washington, D.C.

Native Hawaiian organization is defined as any organization that: (i) serves and represents the interests of Native Hawaiians; (ii) has as a primary and stated purpose the provision of services to Native Hawaiians; and (iii) has expertise in Native Hawaiian affairs. The statute specifically identifies the Office of Hawaiian Affairs and Hui Malama I Na Kupuna 'O Hawai'i Nei as being Native Hawaiian organizations [43 CFR 10.2 (b)(3)]. An earlier version of the bill [S 1980, 101st Cong. 2nd sess. section 3(6)(c), Sept. 10, 1990] that eventually became the act included a provision requiring Native Hawaiian organizations to have "a membership of which a majority are Native Hawaiian." This provision was not included in the act, however, and the legislative history must be interpreted to mean that Congress considered the additional criterion and decided not to include it in the act.

Non-federally recognized Indian groups *do not* have standing to make a direct repatriation request under the statute. That is because these groups, though they may comprise individuals of Native American descent, are not recognized as eligible for the special programs and services provided by the United States to Indians because of their status as Indians. Human remains in federal agency or museum collections for which a relationship of shared group identity can be shown with a particular non-federally recognized Indian group are considered "culturally unidentifiable." Federal agencies and museums that hold culturally unidentifiable human remains may request the Native American Graves Protection and Repatriation Review Committee to recommend disposition of such remains to the appropriate non-federally recognized Indian group. Details of this process are available from the Departmental Consulting Archeologist, National Park Service, Washington, D.C.

In Summary:
- Human remains, funerary objects, and sacred objects may be claimed by lineal descendants, Indian tribes, and Native Hawaiian organizations.
- Objects of cultural patrimony may only be claimed by Indian tribes and Native Hawaiian organizations.
- Non-federally recognized Indian groups do not have standing to make a direct claim under the statute.

WHAT IS THE REGISTRAR'S ROLE?

Registrars in both museums and federal agencies have a wide range of responsibilities, which affect acquisition, accessioning, information management, care, and deaccessioning collection objects. NAGPRA influences all of these activities.

Webster's dictionary defines *acquire* as "to come into possession or control of." Museums and federal agencies may acquire objects by gift, field collection, or purchase, and most are destined for

accession into their permanent collections. But objects may also be acquired for study collections, decoration, or sale in the gift shop. NAGPRA potentially applies to all Native American objects acquired by the museum or federal agency, for whatever reason. All acquisitions should be reviewed in light of NAGPRA's summary, inventory, and repatriation requirements.

Summaries are written descriptions of collections that may contain Native American unassociated funerary objects, sacred objects, or objects of cultural patrimony and must include, at a minimum, the following information:

- An estimate of the number of objects in the collection or portion of the collection
- A description of the kinds of objects included
- Reference to the means, date(s), and location(s) in which the collection or portion of the collection was acquired, where readily ascertainable
- Information relevant to identifying lineal descendants, if available, and cultural affiliation

The statute required the summaries be completed by Nov. 16, 1993. Specific procedures and deadlines for the completion of summaries for collections acquired after 1993, for institutions that receive federal funds for the first time, and for collections that are, or are likely to be culturally affiliated with newly recognized Indian tribes will be published in 43 CFR 10.13. Until then, the registrar should complete these additional summaries as soon as possible.

"Inventory" has a very specific meaning in NAGPRA. Inventories are item-by-item descriptions of human remains and associated funerary objects and must include, at a minimum, the following information:

- Accession and catalog entries; acquisition information, including name of source, if known, date, means, and location of acquisition
- Description of the human remains and associated funerary objects

- A summary of the evidence used to determine cultural affiliation or lineal descent

A NAGPRA inventory is not just a list of objects. It must be completed in consultation with the culturally affiliated Indian tribe(s) and Native Hawaiian organization(s) and represent a decision by the museum or federal agency identifying the lineal descendant or culturally affiliated Indian tribe(s) or Native Hawaiian organization(s). If cultural affiliation of human remains with a particular individual, Indian tribe, or Native Hawaiian organization cannot be established pursuant to the regulations, the human remains must be considered culturally unidentifiable. Pending publication of 43 CFR 10.11 addressing the disposition of culturally unidentifiable human remains, institutions must provide information regarding such human remains to the departmental consulting archeologist. In addition, institutions must retain possession of the culturally unidentifiable human remains unless legally required to do otherwise or recommended to do otherwise by the secretary of the interior. Recommendations from the secretary may be requested prior to final promulgation of 43 CFR 10.11.

The statute required that the inventories be completed by Nov. 16, 1995. Specific procedures and deadlines for the completion of inventories for collections acquired after 1995, for institutions that receive federal funds for the first time, and for collections that are, or are likely to be culturally affiliated with newly recognized Indian tribes will be published in 43 CFR 10.13. Until then, the registrar should complete these additional inventories as soon as possible.

In addition to the above requirements, the registrar should make sure that all donors, collectors, and sellers are aware of the possible consequences under NAGPRA. Donors should be informed that their gifts could potentially be repatriated. Field collectors should be made aware of the importance of documenting an object's provenance, particularly those aspects of an Indian tribe or Native Hawaiian organization's traditional property law

related to the alienation of the object. Donors, collectors, and sellers should be informed that it is illegal to sell, purchase, use for profit, or transport for sale or profit Native American human remains, or, in certain situations, funerary objects, sacred objects, or objects of cultural patrimony. Requiring payment of admission to view such objects constitutes a use for profit.

Accessioning is the process by which an object formally becomes part of the collection. This is the time for the registrar to obtain as much information about the objects as possible from the donor, collector, or seller. It often is not possible to obtain this information later. The information obtained during accessioning can greatly enhance the importance of the object, as well as make NAGPRA compliance much easier. Collection objects are merely interesting "stuff" without information on who, where, and for what purpose the objects were originally used and how the objects were originally acquired. This documentation constitutes the most readily available evidence needed to determine cultural affiliation of Native American human remains and cultural objects—something required under NAGPRA.

Information management is critical for complying with NAGPRA. Professional standards require periodic review of the collection and related records. The process of NAGPRA compliance, however, has made it clear that the Native American collections housed in many museums and federal agencies unfortunately lack documentation. NAGPRA, along with regulations on the curation of federally owned and administered archaeological collections [36 CFR 79], has provided the impetus to review Native American ethnographic and archeological areas of the collection in detail.

NAGPRA also provides museums and federal agencies with an important source of new information—consultation with Indian tribes and Native Hawaiian organizations themselves. The NAGPRA summary is intended as an initial step to bring Indian tribes and Native Hawaiian organizations into consultation with a federal agency or museum. Such consultation is required after completion of the summary. Inventories, on the other hand, must have been completed in consultation with the Indian tribes and Native Hawaiian organizations and represent a decision by the museum or federal agency as to the cultural affiliation of particular human remains or associated funerary objects. Consultation demands more than a letter. It involves a dialogue in which information is shared and, at a minimum, should be conducted over the telephone. Face-to-face consultation, while providing greater satisfaction and understanding to the parties, is not always financially feasible.

Museum officials have discovered completely unexpected things about their collections during conversations with Indian tribal representatives and traditional religious leaders. For example, a large U.S. natural history museum hosted a visit by traditional religious leaders to view the collections. As the men toured the facility and read through the catalog, they were excited to notice the mention of a peach pit game. Museum personnel had no idea this particular "game" was sacred to the tribe. Because religious leaders visited the museum to examine the collection, and shared their knowledge of the sacredness of the game, the museum gained valuable documentation. It may be possible to answer cataloging questions about some Native American cultural items with a simple telephone call.

Much of the information conveyed to registrars and other museum officials during consultation is extremely sensitive. Many religious leaders are reluctant to explain the sacredness of particular objects because the knowledge is not for everyone. Registrars should be aware of any Freedom of Information Act legislation that may apply to their institution and not promise more confidentiality than they are able to deliver. The registrar can only provide confidentiality to the extent allowed by law.

Collections care: NAGPRA also has an impact on the way museums and federal agencies care for collections. Registrars are often involved with collections managers, curators, and conservators in

the design and control of collection storage areas. There are situations in which Native American human remains, funerary objects, sacred objects, or objects of cultural patrimony that can be claimed by a culturally affiliated Indian tribe or Native Hawaiian organization remain in museum storage areas. Depending on the circumstances—and after consultation with the culturally affiliated Indian tribe or Native Hawaiian organization—the registrar may wish to recommend special storage requirements.

For example, a small historical society had in its collection human remains that had been identified, through consultation, as being culturally affiliated with a particular Indian tribe. Consultation was completed in mid-winter when the ground was frozen. During their consultations, tribal and museum officials agreed that the remains would stay at the historical society until such time as they could be buried. While the human remains were there they would be wrapped in deerskin, the material traditionally used to wrap the remains of ancestors.

Handling refers to human intervention when moving an object from one place to another. While registrars and conservators have stringent rules for how objects should be handled, sometimes Native American religious or traditional practices justify a modification of handling rules. For example, smoking is forbidden in many collection areas for fire as well as conservation concerns. Many Indian tribes, however, purify areas by burning sage or tobacco. In certain circumstances, museums have allowed purification ceremonies after taking necessary precautions. Some sacred objects and objects of cultural patrimony may be imbued with powers that create handling restrictions of their own. Many tribes send "teams" of elders (male and female) on consultation visits because some objects are not to be touched by one sex or the other.

NAGPRA repatriations usually involve use of some sort of packing and may also include shipping. The statute requires that the return of a cul-

tural item be in consultation with the requesting lineal descendant or Indian tribe or Native Hawaiian organization to determine the place and manner of delivery of such items. Registrars and other museum personnel must remember to consider tribal and individual sensibilities with regard to the return of human remains, funerary objects, sacred objects, and objects of cultural patrimony. In general, a well-made shipping container, designed in consultation with the culturally affiliated recipient should be adequate for repatriation. An often-told repatriation horror story culminates with the box containing the bones of an Alaska Native ancestor disintegrating upon arrival at its destination as the tribal elders watch aghast. Before shipping, the relevant federal, state, and local statutes covering the transport of human remains must be checked.

Objects in museum collections are often photographed as a matter of course. Some Indian tribes and Native Hawaiian organizations believe that certain items should not be photographed. Although photography is not prohibited under NAGPRA, it is a good policy—especially in the case of objects or remains that are scheduled for repatriation—to consult with the culturally affiliated groups prior to scheduling a photo shoot.

Deaccessioning is the process by which an object is permanently removed from the collection. Although a registrar may initiate the deaccessioning process, a higher authority, such as the board of directors or trustees, usually must authorize the actual deaccession. There have been instances in which a board has been reluctant to authorize the deaccession of human remains, funerary objects, sacred objects, or objects of cultural patrimony. Remember that NAGPRA is the law. If an Indian tribe or Native Hawaiian organization presents evidence of cultural affiliation and explains how an object fits a NAGPRA category and the institution cannot prove that it has right of possession to the object, the object must be repatriated. On the other hand, there have been instances in which a

museum or federal agency has been too quick to repatriate without sufficient evidence of cultural affiliation, lineal descent, or whether the object fits one of the statutory definitions. Repatriation under NAGPRA without sufficient evidence hurts everyone by distorting the consultation and repatriation process.

A museum or federal agency may not repatriate human remains, funerary objects, sacred objects, or objects of cultural patrimony prior to publishing the required notice in the *Federal Register*. A published notice is part of the due process requirement and ensures that all interested lineal descendants, Indian tribes, and Native Hawaiian organizations that may not have been previously consulted are aware of the decision. Information regarding publication of *Federal Register* notices is available from the departmental consulting archeologist, National Park Service, in Washington, D.C.

A registrar must also consider NAGPRA when evaluating disposition options. A museum or federal agency may not transfer title to human remains, funerary objects, sacred objects, and objects of cultural patrimony to an individual or institution that is not required to comply with NAGPRA. Native American objects may be transferred to another institution that is regulated by NAGPRA, but culturally affiliated Indian tribes and Native Hawaiian organizations should be notified in advance of the transfer.

THE FUTURE . . .

Museum professionals—and registrars in particular—must remember NAGPRA is forever. New collections, new applications for federal funding, newly recognized tribes, new research and opinions on cultural affiliation are all reasons for registrars to reexamine NAGPRA. Section 10.13 of the regulations will address these and other future applicability issues.

Today's registrars can help those who will take their places by focusing on documentation. Now, more than ever, a well-documented collection is important. It is inevitable that some repatriation claims will result in legal suits. In such situations, museums and federal agencies must be able to provide evidence of good faith actions. Registrars can help their institutions by assuring that accession and deaccession records are clear and complete with the maximum amount of information noted, all sources identified, and all actions documented.

If you question the applicability of NAGPRA to a certain situation, talk to your institution's lawyer or contact the office of the departmental consulting archeologist at: National Park Service, Archeology and Ethnography Program, 1849 C St. N.W., NC 340, Washington, DC 20240.

SOURCES

United States Code

 1906 Antiquities Act [16 U.S.C. 431-433]

 1960 Reservoir Salvage Act [16 U.S.C. 469-469c]

 1966 National Historic Preservation Act [16 U.S.C. 470h-2]

 1973 American Indian Self Determination and Education Act [25 U.S.C. 450b]

 1976 Alaska Native Claims Settlement Act [43 U.S.C. 1601 et. seq.]

 1979 Archaeological Resources Protection Act [16 U.S.C. 470aa-mm]

 1989 National Museum of the American Indian Act [20 U.S.C. 80]

 1990 Native American Graves Protection and Repatriation Act [25 U.S.C. 3001 et. seq.]

United States Code of Federal Regulations

 1990 Curation of Federally-Owned and Administered Archeological Collections [36 CFR 79]

 1995 Native American Graves Protection and Repatriation Act [43 CFR 10]

Webster's New College Dictionary

 1989 Merriam-Webster, Inc., Springfield, Mass., 9th ed.

William G. Tompkins, editor

INTRODUCTION

Consider the following scenarios:

- A donor offers your museum approximately 1,500 salvaged dead bird specimens, including whole carcasses, bones, and other parts.
- Your museum is borrowing a group of Kayapo headdresses for exhibition from a museum in Brazil.
- A staff ornithologist is importing scientific study skins from a museum in Peru.
- A private trophy hunter donates an imported jaguar hide and skin acquired by sport-hunting.
- You are receiving a shipment of unidentified herbarium specimens being sent from the People's Republic of China.
- An upcoming international traveling exhibition includes a contemporary sculpture containing trumpet corals.
- Your zoological park is shipping a live golden lion tamarin to a zoo in France as a breeding loan.
- A staff research scientist is importing frozen tissue samples collected in the field from an elephant in Nepal.

If any of these situations sound familiar, collection staff should know the applicable laws and permit requirements concerning fish, wildlife, and plants.

The purpose of this section is to outline federal laws and regulations concerning fish, wildlife, and plants and to assist registrars, collections managers, curators, and scientists in determining if, when, and how to apply for federal permits that allow an institution to engage in activities that are regulated under these laws. This is a general guide and is not intended to be definitive; therefore, the specific laws and regulations should be reviewed prior to undertaking regulated transactions. In addition, wildlife laws and regulations are periodically amended. Collection staff should refer to the actual text of relevant laws and regulations as well as consult with the appropriate regulatory agency to ensure compliance with current rules. This section only addresses federal laws, including the Endangered Species Act, which implements the Convention on International Trade in Endangered Species of Wild Fauna and Flora (CITES). It is important to comply with all state and local laws as well. Check with state and local authorities to determine if there are any applicable laws.

BACKGROUND

Trade in endangered, threatened, and otherwise protected wildlife has had a destructive effect on the world's flora and fauna. In an effort to curtail activity harmful to the population of certain species, the United States and other nations have entered into international treaties and have passed domestic laws designed to preserve and conserve the world's species and their habitats. These laws limit and often ban specified activities involving protected species. Under certain conditions, exceptions to prohibited activities are allowed by regulation or permits for purposes such as scientific research, public display, enhancement of species propagation, or survival of the affected species.

Federal regulations concerning possession, disposition, and transportation of animals and plants are complex, and compliance can be daunting. Current regulations broadly govern commercial activities involving a relatively small number of the world's species. However, such regulations

Authors: Julie L. Haifley, Elaine Johnston, Suzanne B. McLaren, Kim Saito, William G. Tompkins, and Kristin L. Vehrs.

significantly affect the museum community. Permits may be required when collecting, especially field collecting; lending or borrowing; arranging collection exchanges; acquiring collections through gift or purchase; and transporting objects across U.S. state boundaries, across any foreign borders, or on the high seas. It is vitally important that museum staff be aware of the various laws when museum activities involve protected species. Collection staff who have authority to collect, acquire, dispose of, loan, or transport objects and specimens bear the responsibility of complying with laws and regulations applicable to wildlife and plants. Lack of compliance with wildlife laws, whether unintentional or a knowing violation, may result in delays, seizure, and confiscation of specimens, personal liability for civil and criminal penalties including fines or imprisonment, and damage to personal, professional, and institutional reputations.

Collections management policies should establish an institution's standard of responsibility regarding compliance with all applicable laws, including wildlife laws and regulations. Internal procedures should provide guidance for staff conducting research and collection activities regarding the acquisition, importation, exportation, and transportation of wildlife and plants and the necessary accompanying documentation. The institution should also clearly address the delegation and responsibility of collecting authority regarding field research.

Frequently, museum staff do not realize that some items in their collections contain plant or animal parts or products protected by various federal laws. These laws prescribe that certain requirements be met in order to acquire, take, possess, dispose, transport, import, or export specimens or articles containing plant and animal parts or products. Under these laws, many of the routine practices of museum collection activity require a permit or compliance with other regulatory requirements. Most wildlife laws cover animals and plants, live or dead, and parts and products made of, or derived from, the protected species. No matter how small the arti-

cle or how very little of a specimen consists of wildlife parts, the wildlife laws may apply. A valid permit is required before commencing any prohibited activity concerning a protected species. Prior to such transactions, it is advisable to review the laws and regulations relating to each activity.

Many species are protected under more than one law. For example, the California condor (*Gymnogyps californianus*) is listed as endangered under the Endangered Species Act, is included in Appendix I of the Convention on International Trade in Endangered Species of Wild Fauna and Flora (CITES), and is protected as a migratory bird under the Migratory Bird Treaty Act. Any transaction involving a California condor must comply with the requirements of each of these laws. In some cases, it is possible to file a single permit application that fulfills the requirements of the multiple laws affecting the species. Contact the appropriate regulatory agency for guidance.

Wildlife laws are written very broadly and authorize that specific regulations be promulgated. Federal statutes are cited as volume number, United States Code, and section number, e.g., 18 U.S.C. § 42. Government agencies publish regulations that implement laws in the Code of Federal Regulations (CFR). The Code of Federal Regulations is a codification of the general and permanent rules published in the *Federal Register* by the departments of the executive branch and agencies of the federal government. The code is divided into 50 titles that represent broad areas subject to federal regulation. The regulations are cited as title number, Code of Federal Regulations, part or section number. Title 50—Fish and Wildlife—contains most federal regulations regarding wildlife and plants. For example, migratory birds are listed in 50 CFR Part 10, endangered and threatened wildlife in 50 CFR Part 17, marine mammals in 50 CFR Part 18. Each volume of the CFR is revised at least once each calendar year. The code is kept up-to-date by the *Federal Register*, which is published daily. These two publications should be used together

to determine the latest version of any given regulation. The latest versions of these publications may be found on the Internet.

The Department of the Interior's U.S. Fish and Wildlife Service (USFWS) has the primary responsibility to enforce federal wildlife laws that protect most endangered species, including some marine mammals, migratory birds, fishes, and plants. The USFWS also carries out U.S. enforcement obligations of certain international agreements affecting protected wildlife and plants. For the most current information on species under the jurisdiction of USFWS, contact: U.S. Fish and Wildlife Service, Office of Management Authority. Other federal agencies have enforcement authority for certain laws and regulations discussed in this chapter, as described below.

The process of applying for and maintaining federal permits has often been surrounded by confusion and controversy. In recent years, the Association of Systematics Collections (ASC) has undertaken a dialogue with USFWS to help clarify regulations and to make them more workable for scientific and educational institutions. The ASC expressed particular concern over the regulations governing the importation and exportation of taxonomic or systematic collection specimens. In 1996, such discussion led to a Memorandum of Agreement (MOA) between ASC and USFWS that allows individuals and institutions to donate, under specified conditions, undocumented natural history collections to nonprofit research or educational institutions that maintain permanent collections of scientific specimens. The MOA was necessary because private individuals were hesitant to donate specimens, and institutions were hesitant to accept them, in cases where collecting and import permits were missing. Contact the U.S. Fish and Wildlife service for copies of the forms. The ASC is a helpful source of information and guidance on compliance with wildlife laws.

HELPFUL HINTS FOR OBTAINING PERMITS UNDER FEDERAL WILDLIFE LAWS

A. Before Beginning the Permit Process
- Identify knowledgeable staff and museum permit procedures.
- Identify the species involved to the most accurate taxonomic classification reasonably practicable (be species specific, including the scientific name, common name, and country of origin); seek expert advice if necessary.
- Determine which laws cover the species and the permit requirements under each applicable law.
- Determine the provenance of the object or specimen (compile supporting documentation).
- Determine the intended uses and purposes.
- Know the type of transaction (e.g., purchase, gift, loan, etc.).
- Know the location where the permitted activity is to occur.
- Know the point of origin, destination, and all intermediary stops for any shipment of wildlife specimens.
- When field research or collecting in a foreign country is involved, researchers must be aware of and comply with applicable wildlife laws and permit requirements of the foreign country.
- Foreign collecting and exportation/importation permits should be obtained for research materials well in advance of a proposed research project.
- Live materials may require additional permits through the Animal and Plant Health Inspection Service (APHIS), U.S. Department of Agriculture.

B. Permit Process
- Begin the permit process as soon as possible.
- When filing a permit application, be as complete and detailed as possible.

- To expedite the permit process, consider sending the complete permit application by express mail or certified mail for proof of delivery.
- If an item qualifies for an exception, contact the federal or state agency for the required application and assistance.
- Under some circumstances, import and export of museum collections may be facilitated by a customs broker. Brokers are often familiar with permit requirements and can ensure compliance with the necessary procedures and documentation. Remember that your institution remains ultimately responsible.
- Couriers and shippers must know the permit requirements of your shipment, and the institution should have a system for monitoring their compliance.
- Maintain all records documenting importation, exportation, transportation, and subsequent disposition. Retain copies of all materials relating to permit application. It may be helpful to have multiple copies of your application and required documentation during shipment and clearance.
- Keep informed of new regulations by checking the *Federal Register* and agency publications.
- If any questions arise as to whether a permit is required, the permit process, or other related questions, contact the appropriate federal or state agency. Build a cooperative relationship with your local USFWS special agent and/or regional office.

C. Reporting
- There are procedures for using the permit that may include reporting, recording, declaration, and/or notification requirements. These requirements and instructions are often on the face of the permit or attached to it. Pay close attention to these instructions and any attachments that accompany the permit.
- It is the responsibility of the institution to make sure that timely annual reports or renewal applications are submitted.

- Any person accepting and holding a federal permit consents to and allows the entry at any reasonable hour by agents or employees of the permitting agency upon the premises where the permit activity is conducted. Federal agents or employees may enter such premises to inspect the location of any plants or wildlife kept under the authority of the permit and to inspect, audit, or copy any books, records, or permits required to be kept.

SUMMARY OF FEDERAL LAWS PROMOTING CONSERVATION OF WILDLIFE AND PLANTS

I. Lacey Act

18 U.S.C. § 42; 16 U.S.C. § 3371, *et seq.*; 50 CFR Part 14

The Lacey Act is the oldest and most comprehensive wildlife law in the United States. First enacted in 1900, the Lacey Act has been amended several times and its application expanded greatly. The Lacey Act Amendments of 1981 extended the protection of the act to all species of fish and wildlife, whether or not they are considered endangered or threatened. The Lacey Act also applies to plants but only to species indigenous to the United States and its territories that have been listed on a CITES appendix or pursuant to any state law protecting species threatened with extinction. The act establishes a single, comprehensive basis for federal enforcement of state, foreign, Indian tribal, and federal wildlife laws. The Lacey Act provides the legal authority for detailed regulations that implement the statute.[1]

A. Required Compliance with All Laws Applicable to Wildlife and Plants

The Lacey Act prohibits the importation, exportation, transportation, sale, receipt, acquisition, or purchase of any fish, wildlife, or plant that was taken, possessed, transported, or sold in violation of any law, treaty, or regulation of the United States or any Indian tribal law [16 U.S.C. § 3372(a)(1)]. When interstate commerce is

involved, the same prohibitions apply to fish or wildlife taken, possessed, transported, or sold in violation of any state law or regulation or any foreign law, and to plants taken, possessed, transported, or sold in violation of any state law or regulation [16 U.S.C. § 3372(a)(2)]. Under the Lacey Act, "taken" means captured, killed, or collected. Violations of the Lacey Act may result in criminal and civil penalties, including forfeiture of specimens or equipment used in connection with an unlawful act [16 U.S.C. §§ 3373-3374]. Criminal penalties require proof of a "knowing" violation of the act but civil penalties may be imposed for failure to exercise due care in compliance with the act and its implementing regulations.

B. Regulation of Importation, Exportation, and Interstate Transportation of Wildlife

The Lacey Act makes it an offense to import, export, or transport in interstate commerce any container or package containing any fish or wildlife, unless the container or package has previously been plainly marked, labeled, or tagged in accordance with regulations issued pursuant to the act [16 U.S.C. § 3372(b)]. Making or submitting false records, labels, or identifications of fish, wildlife, or plants may also violate the Lacey Act [16 U.S.C. § 3372(a)(4)].

The regulations implementing the Lacey Act requirements for importing, exporting, and transporting wildlife are found at 50 CFR Part 14. Following is a general summary of the major provisions of Part 14 that relate to importing, exporting, and transporting collection material. Of course, the actual text of the regulations should be consulted before a shipment takes place. It is important to be aware of these requirements for any wildlife shipment with which your institution may be involved. The importer or exporter of record may be held responsible for non-compliance of its agents, such as shippers, couriers, or brokers, if the importer or exporter has not provided adequate instructions or taken appropriate steps to ensure compliance by the agent.

1) Designated Ports

Except when otherwise provided by permit or specific regulation, all wildlife shipments must enter and leave this country through U.S. Customs ports designated by the U.S. Fish and Wildlife Service [50 CFR § 14.12]. Currently there are 13 designated ports: New York, N.Y.; Miami, Fla.; Baltimore, Md.; Boston, Mass.; New Orleans, La.; Dallas/Ft. Worth, Tex.; Los Angeles and San Francisco, Calif.; Chicago, Ill.; Portland, Oreg.; Seattle, Wash.; Honolulu, Hawaii; and Atlanta, Ga. Special ports have also been designated for certain shipments to or from Alaska, Puerto Rico, U.S. Virgin Islands, and Guam [50 CFR 14.19].

Dead, preserved, dried, or embedded scientific specimens imported or exported by accredited scientists or accredited scientific institutions for taxonomic or systematic research purposes may enter or exit through any U.S. Customs port or may be shipped through the international mail system. This exception does not apply to wildlife that requires a permit to be imported or exported (e.g., an endangered species), or to specimens taken as a result of sport hunting [50 CFR § 14.24].

Any article (other than scrimshaw) more than 100 years old that is composed in whole or in part of any endangered or threatened species and has not been repaired or modified with any part of an endangered or threatened species after Dec. 28, 1973, may be imported at any U.S. Customs port designated for such purpose [50 CFR § 14.22].

Marine mammals lawfully taken on the high seas and authorized to be imported under the Marine Mammals Protection Act may be imported at any port or place [50 CFR § 14.18].

Special port exception permits may be issued for scientific purposes, to minimize deterioration or loss, or for economic hardship [50 CFR §§ 14.31-14.33].

All plant shipments protected under the Endangered Species Act and CITES must be imported or exported through ports designated by the U.S. Department of Agriculture, which are listed at 50 CFR § 24.12.

2) Declaration of Wildlife Imports and Exports

At the time of importation or prior to exportation of wildlife, importers or exporters must file with the USFWS a completed Declaration for Importation or Exportation of Fish or Wildlife (Form 3-177) [50 CFR Part 14, Subpart F]. Contact the U.S. Fish and Wildlife Service for forms.

For dead, preserved, dried, or embedded scientific specimens imported or exported by accredited scientists or accredited scientific institutions for taxonomic or systematic research purposes, the importer or exporter must file Form 3-177 within 180 days of the import or export. The declaration must identify the specimens to the most accurate taxonomic classification reasonably practicable, using the best available taxonomic information, and must declare the country of origin. This exception does not apply to wildlife that requires a permit to be imported or exported (e.g., an endangered species), or to specimens taken as a result of sport hunting [50 CFR § 14.62(d)].

For other scientific specimens not included in paragraph b (e.g., wildlife that requires a permit), imported for taxonomic or systematic research or faunal survey purposes, the importer may describe the specimens in general terms on the Form 3-177, which is filed at the time of import. Within 180 days, the importer must file an amended Form 3-177 to identify the specimens to the most accurate taxonomic classification reasonably practicable, using the best available taxonomic information [50 CFR § 14.62(c)].

3) Inspection and Clearance Requirements

Wildlife imported into the United States must be cleared by a USFWS agent before it can be released from customs. Wildlife to be exported from the United States must be cleared by USFWS before it is packed in a container or loaded onto a vehicle for export. To obtain clearance, the importer or exporter must make available to the USFWS agent all shipping documents; all permits, licenses, or other documents required under the laws and regulations of the United States or of any foreign country; the wildlife being imported or exported; and any documents and permits required by the country of export or re-export of the wildlife [50 CFR §14.52]. In certain circumstances, wildlife may be cleared by a U.S. Customs Service officer [50 C.F.R. § 14.54].

Dead, preserved, dried, or embedded scientific specimens imported or exported by accredited scientists or accredited scientific institutions for taxonomic or systematic research purposes do not require USFWS clearance. This exception does not apply to wildlife that requires a permit to be imported or exported (e.g., an endangered species), or to specimens taken as a result of sport hunting [50 CFR § 14.55 (d)].

Any article (other than scrimshaw) more than 100 years old that is composed in whole or part of any endangered or threatened species and has not been repaired or modified with any part of an endangered or threatened species after Dec. 28, 1973, does not require USFWS clearance if it has been properly declared to and released by customs [50 CFR § 14.55(c)].

Marine mammals lawfully taken on the high seas and imported directly into the United States do not require USFWS clearance [50 CFR § 14.55(b)].

USFWS and customs officers may detain and inspect any package containing wildlife, including all accompanying documentation, upon importation or exportation [50 CFR § 14.53].

A USFWS or customs officer may refuse clearance of imported or exported wildlife upon reasonable grounds to believe: a federal law or regulation has been violated; the correct identity and country of origin have not been established; any

permit, license, or other documentation required for clearance is not available, is not currently valid, has been suspended or revoked, or is not authentic; the importer or exporter has filed an incorrect or incomplete declaration form; or the importer or exporter has not paid any fees or penalties due [50 C.F.R. § 14.53].

Prior notice (72 hours recommended) to the USFWS of all wildlife imports and exports is advisable. USFWS requires 48 hours notice to be available for inspection of live and perishable wildlife [50 CFR § 14.64].

4) Marking Requirements

All wildlife imported, exported, or transported in interstate commerce must be marked on the outside of the container with the names and addresses of the consignor and the consignee. An accurate identification of the species and the number of each species in the container must accompany the shipment. Specific marking requirements and the contents of accompanying documentation are set forth in 50 CFR Part 14 Subpart G.

II. The Endangered Species Act
16 U.S.C. § 1531 *et seq.*; 50 CFR Part 17

The Endangered Species Act (ESA) of 1973 is the most comprehensive U.S. law for the preservation and protection of species that have been determined to be in danger of extinction. The Endangered Species Act was designed to prevent the extinction of native and foreign species of wild flora and fauna. The law also provides for protection of the "critical" habitats of protected species.

The act defines an "endangered" species as any animal or plant that is in danger of extinction. A "threatened" species is defined as any animal or plant that is likely to become endangered within the foreseeable future [16 U.S.C. § 1532]. A procedure has been established under the ESA by which the USFWS determines whether a species should be listed as endangered or threatened. The determination is published in the *Federal Register*,

and the lists of endangered and threatened species are compiled annually in the Code of Federal Regulations. The Endangered Species List is found at 50 CFR § 17.11. The Threatened Species List is found at 50 CFR § 17.12. For the most current information on a given species, contact the appropriate agency with jurisdiction over the protected wildlife or plant in question.

A. Prohibitions Under ESA

The act prohibits a wide range of activities and transactions with respect to endangered species [16 U.S.C. § 1538]. By regulation these prohibitions have also been extended to threatened species [50 CFR §§ 17.21 and 17.31]. The prohibitions apply equally to live or dead animals or plants, their progeny, and parts or products derived from them.

The act and implementing regulations prohibit:

Importation into or exportation from the U.S. of any endangered or threatened species

Taking any endangered or threatened species within the U.S. or on the high seas

> The term "take" means to harass, harm, pursue, hunt, shoot, wound, kill, trap, capture, or collect or to attempt to engage in any such conduct.

Possessing, selling, or transporting any species taken in violation of the act or regulation

Delivering, receiving, or transporting any endangered or threatened species in connection with interstate or foreign commercial activity

> Loans and Gifts: Lawfully taken and held endangered and threatened species may be shipped interstate as a bona fide gift or loan if there is no barter, credit, or other form of compensation or intent to profit or gain.

Selling or offering for sale endangered or threatened species in interstate commerce

> Sales of legally acquired endangered or threatened species that take place entirely in one state are not prohibited by the ESA but may be regulated under applicable state laws.

B. Permits Under the ESA

Under certain conditions, scientific and educational activities may qualify for permits allowing activities that are otherwise prohibited. General permit application requirements and issuance criteria are set forth in 50 CFR Part 13. Special rules for certain species are set forth in 50 CFR §§ 17.40-17.48. Permits may authorize a single transaction, a series of transactions, or a number of activities over a specific time period.

Permits may be issued for prohibited activities for the following purposes:

Endangered species permits may be granted for scientific purposes or to enhance the propagation or survival of the affected species, and for "incidental takings" or economic hardship [50 CFR §§ 17.22 (wildlife), 17.62 (plants), and Part 222 (marine mammals)].

Threatened species permits may be granted for scientific purposes; the enhancement of propagation or survival of the affected species; zoological, horticultural, and botanical exhibition; educational purposes; or special purposes consistent with the act [50 CFR §§ 17.32 (wildlife), 17.72 (plants), and Part 227 (marine mammals)].

C. Exemptions

Certain situations may be exempt from the prohibitions of the act. In these exempt situations, a permit is not required. The burden of proof that the specimen or activity qualifies for an exemption lies with the person engaging in the relevant activity. All supporting and authenticating documentation must be maintained with the specimens, particularly when they are in transit.

Pre-act wildlife: The prohibitions applicable to ESA species do not apply in the case of wildlife, except for African elephant ivory, held in captivity or in a controlled environment on (a) Dec. 28, 1973, or (b) the date of publication in the *Federal Register* for final listing of the species as endangered or threatened, whichever is later, provided that the wildlife has not been held in the course of a commercial activity. An affidavit and supporting documentary evidence of pre-act status is required [50 CFR § 17.4].

Antiques: Objects or specimens more than 100 years old, composed in whole or in part of any endangered or threatened species, that have not been repaired or modified since Dec. 28, 1973, with any part of a listed species, are exempt from the ESA prohibitions. The import and export of such antiques is allowed only through a designated port and must be accompanied by authenticating documentation [16 U.S.C. § 1539(h)].

Alaskan natives may take or import endangered or threatened species if such taking is primarily for subsistence purposes and is not done in a wasteful manner. Non-edible byproducts of lawfully taken species may be sold in interstate commerce when made into authentic native articles of handicrafts and clothing [50 CFR § 17.5.]

Seeds from artificially propagated threatened plants: No permits are required for interstate or foreign commerce, including import or export, of seeds from artificially propagated specimens of threatened plants. The seeds must be accompanied by a label stating that they are of cultivated origin.

Captive-bred wildlife: USFWS registrations provide exceptions allowing the importing, exporting, taking, and interstate commercial transactions, including delivery, receipt, and sale of certain living endangered and threatened species, provided the purpose is to enhance the propagation or survival of the species. The regulation covers only living animals that are not native to the United States. The regulations prescribe detailed requirements for registration of captive breeding programs and other conditions that apply to captive breeding of protected species [50 CFR § 17.21(g)].

D. Enforcement

Both U.S. Fish and Wildlife Service (USFWS) in the Department of Interior and National Marine

Fisheries Service (NMFS) in the Department of Commerce enforce the Endangered Species Act. By agreement between the USFWS ad NMFS, the jurisdiction of NMFS has been specifically defined to include certain species, while jurisdiction is shared in regard to certain other species. USFWS is the primary agency that administers the ESA and has jurisdiction over most wildlife and plants. For the most current information on species under the jurisdiction of USFWS, contact the U.S. Fish and Wildlife Service, Office of Management Authority. For information on species under the jurisdiction of NMFS, contact the NMFS Office of Protected Resources.

III. The Convention on International Trade in Endangered Species of Wild Fauna and Flora

16 U.S.C. § 1531 *et seq.*; 50 CFR Part 23

The Convention on International Trade in Endangered Species of Fauna and Flora (CITES) is an international wildlife treaty that regulates the import and export of endangered and threatened animal and plant species. The USFWS oversees CITES implementation in the United States, which became a party to the treaty in June 1975. The convention, with over 130 party nations, protects over 25,000 species by establishing import and export restrictions on wildlife threatened by international trade. The United States implements CITES through the U.S. Endangered Species Act.

The animals and plants protected by CITES are divided into three lists called appendices, which are published in 50 CFR § 23.23. Amendments to species listed in the CITES appendices are published in the *Federal Register*. Consult the USFWS Office of Scientific Authority for the most current information on listed species. A species may be listed in any one of the three appendices, depending on the degree of protection deemed necessary.

- Appendix I includes species threatened with extinction that are or may be affected by trade.
- Appendix II includes species which are not necessarily under present threat of extinction but may become so unless strictly regulated.
- Appendix III includes species for which a country party to CITES has internal regulations to prevent or restrict exploitation and needs the cooperation of other parties in control of trade.

A. Prohibitions

The U.S. laws implementing CITES prohibit the import, export, or re-export of CITES-listed species without the required permits and also forbid the possession of any specimen imported, exported, or re-exported into or from the United States in contravention of the convention. All living and dead specimens and all readily recognizable parts and derivatives are subject to the prohibitions. Note that there are some exceptions for plant parts and derivatives.

Some species protected under CITES also are protected by other U.S. laws under which permit requirements may be more stringent, such as the U.S. Endangered Species Act, African Elephant Conservation Act, Marine Mammal Protection Act, Migratory Bird Act, Eagle Protection Act, and the Lacey Act. Permit applicants must satisfy the requirements of all laws under which a particular species is protected.

B. Permits Under CITES

Permits are required to import or export wildlife or plants listed in Appendix I, II, or III. Re-export certificates are required for the export of specimens that were previously imported, including items subsequently converted to manufactured goods. Permits are issued by the management authority of nations belonging to CITES. Similar documentation is required from designated authorities of countries that are not members of CITES. The USFWS Office of Management Authority can provide information regarding the relevant foreign authorities and documentation requirements. Permit application procedures and issuance criteria are found in 50 CFR Part 23.

There are different permit requirements for importing and exporting CITES-protected species,

depending on which CITES Appendix the species fall under:

Import into the United States
CITES Appendix I species:
U.S. import permit and valid foreign export permit issued by the country of origin or a valid foreign re-export certificate issued by the country of re-export
CITES Appendix II species:
Valid foreign export permit issued by the country of origin or a valid foreign re-export certificate issued by the country of re-export
CITES Appendix III species:
Valid foreign export permit issued by the country that listed the species, a valid foreign re-export certificate issued by the country of re-export, or a certificate of origin issued by countries of origin other than the listing country

Export or Re-export from the United States
CITES Appendix I species:
U.S. export permit or re-export certificate and a copy of foreign import permit issued prior to export permit
CITES Appendix II species:
U.S. export permit or re-export certificate
CITES Appendix III species:
U.S. re-export certificate or certificate of origin

C. Exceptions

Although CITES provides exceptions relating to some wildlife or plants listed in CITES Appendices, those species may also be subject to regulation under other U.S. laws. An exception provided under CITES does not necessarily allow activities that are prohibited under other U.S. laws.

CITES permits may not be required under the following circumstances:

Pre-convention specimens: Wildlife or plants held in captivity or a controlled environment prior to listing of the relevant species in a CITES appendix do not require import or export permits. Pre-Con-vention Certificates are required to prove that a specimen comes within this exception [50 CFR § 23.13(c)].

Captive-bred certificate/certificate for artificially propagated plants: No CITES permit is required if the specimen is accompanied by a Captive-Bred Certificate or Certificate of Artificial Propagation from the country of origin, stating that the wildlife was bred in captivity [50 CFR § 23.13(f)].

Scientific exchange program: Scientific institutions may register with the CITES Secretariat to facilitate importation and exportation of accessioned specimens as non-commercial loans, donations, or exchanges between CITES-registered institutions [50 CFR § 23]. No permit is necessary for these activities, requiring only specific labeling, reporting; a copy of both scientific institutions' Certificate of Scientific Exchange must accompany the specimen. If only one institution has a certificate, then the regular permit process must be followed. The Scientific Exchange Certificate only authorizes activities for specimens maintained in a scientific or museum collection. The certificate is not a collecting permit. Newly collected, unaccessioned specimens of listed species require full CITES documentation and permit issuance. In addition, the Certificate for Scientific Exchange only authorizes activities regulated by CITES. If a species is protected by other laws (e.g., U.S. Endangered Species Act) additional permits and authorizations are required. The USFWS Office of Management Authority can provide information about participating in the Scientific Exchange Program.

In-transit shipments: When a shipment is merely transiting a country, no import or export permits issued by that country are required, as long as the wildlife remains in customs custody. 50 CFR § 23.13(b). This may vary from country to country. For example, specimens listed under the Endangered Species Act generally may not transit the United States.

IV. Marine Mammal Protection Act

16 U.S.C. § 1361 *et seq.*; 50 CFR Part 18 subchapter C

The Marine Mammal Protection Act (MMPA), enacted in 1972, protects all marine mammals, dead or alive, and their parts and products, including, but not limited to, any raw, dressed, or dyed fur or skin. The protected species include whales, walruses, dolphins, seals, sea lions, sea otters, dugongs, manatees, and polar bears. The taking, possession, and transportation of northern fur seals for scientific research and public display is regulated separately under the Fur Seal Act [16 U.S.C. § 1153; 50 CFR Part 215].

A. Prohibitions

The act prohibits the unauthorized taking, possession, sale, purchase, importation, exportation, or transportation of marine mammals and their parts and by-products. The MMPA also authorizes the establishment of moratoria and a quota system for determining how many individuals of a marine mammal species can be taken without harm to those species or population stocks.

B. Permits issued under MMPA

Permits are granted for purposes of scientific research, public display, incidental taking, commercial fishing, and enhancing the survival or recovery of the species or stock. Permit application procedures and issuance criteria are found at 50 CFR § 518.31 and 50 CFR Parts 220-222.

C. Exceptions

Pre-act specimens: The prohibitions of MMPA do not apply in the case of marine mammal specimens or articles consisting of, or composed in whole or in part of, any marine mammal taken on or before Dec. 21, 1972. To establish pre-act status, it is necessary to file an affidavit with the agency responsible for the management of the species in question [50 CFR §§ 18.14, 18.25, 216.14].

Alaskan natives may take marine mammals for subsistence purposes or for purposes of creating and selling authentic native handcrafts and clothing to be sold in interstate commerce [50 CFR §§ 18.23, 216.23(c)].

Marine mammal parts: Collection of certain dead marine mammal parts by beach collecting may be authorized, provided specific conditions are met. 50 CFR § 216.26.

Salvaging specimen material: Regulations allow the utilization of specimen material salvaged from stranded marine mammals by authorized persons. Such salvaging must be only for the purposes of scientific research or the maintenance of a properly curated, professionally accredited, scientific collection and must be reported to the appropriate regional office of the NMFS [50 CFR § 216.22].

D. Enforcement

By agreement, the MMPA is jointly administered by the USFWS and NMFS with jurisdiction specifically defined to include certain species. USFWS issues CITES permits for marine mammals under the jurisdiction of NMFS.

V. Migratory Bird Treaty Act

16 U.S.C. § 703-712; 50 CFR Parts 13 and 21

The Migratory Bird Treaty Act (MBTA), enacted in 1918, covers any migratory bird, any part, nest, egg, or product made from a migratory bird, part, nest, or egg. The act is administered by the U.S. Fish and Wildlife Service. Protected birds are listed at 50 CFR 10.13.

A. Prohibitions

The act prohibits the taking, possession, import, export, transport, sale, purchase, barter, or offer for sale of any migratory birds, and the nests or eggs of such birds, except as authorized by valid permit [50 CFR § 21.11].

B. Permits Under MBTA

Permits may be issued for banding and marking migratory birds [50 CFR § 21.22].

Permits may be issued to import and export migratory birds [50 CFR § 21.21].

A scientific collecting permit is required before any person may take, transport, or possess migratory birds, their parts, nests, or eggs for scientific research or educational purposes [50 CFR § 21.23].

Permits may be issued for other purposes, such as taxidermy, waterfowl sale and disposal, falconry, raptor propagation, and degradations control [50 CFR §§ 21.24-21.41].

C. Exceptions

Possession or transportation of specimens acquired on or before the effective date of protection of the species under the act does not require a permit [50 CFR § 21.2(a)]. Import, export, barter, purchase, or sale of pre-act specimens is prohibited without a permit.

The MBTA provides a general exception to permit requirements for public museums, public zoological parks, accredited institutions of the American Zoo and Aquarium Association (AZA), and public scientific or educational institutions to acquire by gift or purchase, possess, transport, and dispose of by gift or sale lawfully acquired migratory birds. The specimen must be acquired from or disposed of to a similar institution, federal, or state game authorities, or the holder of a valid possession or disposal permit [50 CFR § 21.12].

The MBTA regulations, except for banding and marking permits, do not apply to the bald eagle or golden eagle [50 CFR § 21.2(b)].

VI. Eagle Protection Act
16 U.S.C. § 668; 50 CFR Part 22

The Eagle Protection Act (EPA) protects bald (*Haliaeetus leucocephalus*) and golden (*Aquila chrysaetos*) eagles, alive or dead, their parts, nests, or eggs. It was first enacted in 1940, and amended in 1962 to include golden eagles. It is administered by the USFWS.

A. Prohibitions

The act prohibits taking, buying, selling, trading, transporting, possessing, importing, or exporting eagles or their parts, nests, eggs, or products made from them.

B. Permits Under EPA

Permits may be issued for taking, possession, and transportation of bald or golden eagles, their parts, nests, or eggs, for scientific, exhibition, and Indian religious purposes. No permits are allowed for import or export, sale, purchase, or barter of bald or golden eagles. Permit application procedures and issuance criteria are found at 50 CFR Part 22 subpart C.

C. Exceptions

A permit is not required for possession or transportation of bald eagles lawfully acquired before June 8, 1940, or golden eagles lawfully acquired before Oct. 24, 1962. Pre-act specimens, however, may not be imported, exported, purchased, sold, traded, or bartered or offered for purchase, sale, trade, or barter.

VII. African Elephant Conservation Act
16 U.S.C. §§ 4201-4245

In an effort to assist in the conservation and protection of African elephant populations, the United States passed the African Elephant Conservation Act (AECA) in 1988. This act works in conjunction with the CITES Ivory Control System to protect the African elephant and eliminate any trade in illegal ivory. Currently, the African elephant is listed in Appendix I of CITES and as such any import or export for other than commercial purposes must be accompanied by valid CITES documents.

A. Prohibitions

The act prohibits:

The import of raw African elephant ivory from any country other than an ivory-producing country (any African country within which is located any part of the range of a population of African elephants)

The export from the United States of raw ivory from African elephants

The import of raw or worked ivory from African elephants that was exported from an ivory-producing country in violation of that country's laws or the CITES Ivory Control System

The import of worked ivory from any country unless that country has certified that such ivory was derived from a legal source

The import of raw or worked ivory from a country in which a moratorium is in effect

B. Exceptions

Worked ivory may be imported for non-commercial purposes, if the item was acquired prior to the date CITES applied to African elephants (Feb. 4, 1977) and is accompanied by a valid pre-CITES certificate.

Articles more than 100 years old may be imported or exported for non-commercial and commercial purposes under a pre-CITES certificate, provided they have not been repaired or modified with elephant ivory on or after Feb. 4, 1977. Proof of antiquity must be provided.

VIII. Wild Bird Conservation Act
16 U.S.C. § 4901; 50 CFR Part 15

The Wild Bird Conservation Act was enacted in 1992 to limit or prohibit the importation of exotic birds to ensure that their populations are not harmed by trade. The act assists wild bird conservation and management in the countries of origin by ensuring that trade in species is biologically sustainable and is not detrimental to the species. The WBCA is administered by the USFWS.

A. Prohibitions under WBCA

The act prohibits the importation of any exotic bird in violation of any prohibition, suspension, or quota on importation and the importation of any exotic bird listed in a CITES appendix that is not part of an approved list, if the bird was not bred at a qualified facility. The WBCA authorizes the establishment of moratoria or quotas for import of certain exotic birds.

B. Permits issued under WBCA

Permits to import protected species may be issued if the importation is not detrimental to the survival of the species, and is for scientific research, zoological breeding or display, or cooperative breeding programs designed to promote the conservation and maintenance of the species in the wild. Permit application procedures and issuance criteria are found at 50 CFR Part 15 subpart C.

SUMMARY OF LAWS APPLICABLE TO INJURIOUS SPECIES AND PROTECTION OF LIVE ANIMALS

The laws discussed above are generally intended to promote the conservation of wildlife and plant species. Activities of museums, and especially zoos and aquaria, may also be affected by laws designed to protect against potential damage caused by injurious species or to protect live animals. These laws can be quite complex and are discussed very briefly here. Institutions that conduct activities with live animals or potentially injurious species should become familiar with these laws.

I. Lacey Act
18 U.S.C. § 42; 16 U.S.C. § 1378(d); 50 CFR Parts 14 and 16

A. Injurious Wildlife

The Lacey Act, other aspects of which are discussed above, prohibits the importation, transportation, or acquisition, without a permit, of any wildlife (or their eggs) designated as injurious to the health and welfare of humans; to the interests of forestry, agriculture, or horticulture; or to the welfare and survival of wildlife resources of the U.S [18 U.S.C. § 42]. The species listed as injurious wildlife are found at 50 CFR Part 16, subpart B. Permits are available for importation of such injurious wildlife for zoological, educational, medical, or scientific purposes. The permit requirements do not apply to the importation or transportation of dead scientific specimens for museum or scientific collection purposes [50 CFR § 16.33].

B. Humane and Healthful Treatment of Live Animals

The Lacey Act also prohibits the transport of wild mammals or birds to the U.S. under inhumane or unhealthy conditions [16 U.S.C. § 1378(d)]. Detailed rules for humane and healthful transport required under the Lacey Act are set forth at 50 CFR Part 14, subpart J.

II. Animal Welfare Act
7 U.S.C. § 2131; 9 CFR Parts 1-4

The Animal Welfare Act (AWA) was enacted in 1966 to regulate warm-blooded animals used for research, exhibition purposes, or as pets, ensuring that they are provided with humane care and treatment. The AWA regulates aspects of transportation, purchase, sale, housing, care, handling, and treatment. Regulations provide for the licensing or registration of animal dealers, exhibitors, operators of animal auctions, research facilities, carriers, and intermediate handlers. The Animal and Plant Health Inspection Service (APHIS) of the Department of Agriculture is the agency responsible for administering the act.

III. Public Health Service Act
42 U.S.C. §§ 216, 264-272; 42 CFR Parts 71-72; 21 CFR Parts 1240 and 1250

The Public Health Service Act (PHSA) was enacted in 1944. One of the purposes of the act is to prevent the introduction, transmission, or spread of communicable diseases from foreign countries to the United States or between states. It authorizes the surgeon general to promulgate regulations necessary to carry out this purpose. Under this authority, restrictions on importation and movement of turtles, rodents, bats, psittacine birds, and non-human primates have been implemented. Permits may be issued to engage in regulated activities for exhibition, educational, or scientific purposes. The Center for Disease Control (CDC) in Atlanta, Ga., is responsible for implementing the act.

IV. APHIS Authorization Act/Animal Quarantine Regulations
21 U.S.C. §§ 101-136; 9 CFR Parts 75, 82, 92, 93-94, 98, 130

The Animal and Plant Health Inspection Service (APHIS) Authorization Act provides authority to protect the U.S. livestock, poultry, and agricultural industries against infectious or contagious diseases. The act regulates the importation and exportation of certain animals and animal products into the U.S. that are or have been affected with or exposed to any communicable disease. Permits may be issued to import or export covered species and may impose quarantine requirements and other protective measures. The Animal and Plant Health Inspection Service (APHIS) is responsible for implementing the act.

As these regulations are extremely detailed, it is important to refer to the specific sections of the regulations applicable to the species or products with which you are concerned. Permit applications and inquiries should be submitted to the APHIS Office of Import/Export.

CITES & INTERNATIONAL SHIPPING OF ART

At first glance, one might consider an art museum an unlikely place for U.S. Fish and Wildlife problems to occur. With the possible exception of ivory, many materials requiring special consideration when importing or exporting works of art might be overlooked by even a conscientious museum staff member. For example, a silver dagger with a skin-covered handle, a tortoise-shell hair ornament, or a hat adorned with colorful feathers could present potential problems if imported from a foreign country without proper documentation.

As in other endangered species situations, the time to begin asking questions is at the very beginning of any transaction involving importation or exportation. Since the export documents must originate with the foreign country, sometimes it is necessary to alert the appropriate museum officials

to the need to begin the application process. In the case of one exhibition coming to the Smithsonian's National Museum of African Art from Europe, it was necessary to go through the exhibition catalog and identify potential problems based on materials listed by each entry. A list of "problem objects" was then provided to the organizing institution, which initiated the paperwork while the exhibition was still on its premises. Many questions arose about the types of materials involved, requiring correspondence with lenders, curators, and CITES officials. When the time came to ship the exhibition to the United States, the requisite documents had been obtained and the importation proceeded smoothly.

Not so fortunate was the purchaser of a 1920s Érard piano in Paris. A concert pianist, the new owner arranged for air shipment of the instrument back to the United States, only to have it seized by U.S. Customs agents upon its arrival because it did not meet the requirements for exemption under the African Elephant Conservation Act. In spite of the owner's protests, the ivory was eventually stripped from the keys, a sad event for all concerned.

What other types of materials could be subject to CITES enforcement? For works of African art, the most common are skin and fur products, feathers, claws of mammals or raptors, primate parts (hands, feet, tails), tortoise shell, and other types of shells. Coral, which is often used in Asian works of art such as inlaid boxes and writing instruments, is another potential problem, as is rhinoceros horn, which is used in Chinese drinking vessels as well as in ceremonial dagger handles made in Yemen. Certain types of hardwood such as mahogany and rosewood could also require CITES permits.

After identification of potential problem materials, the next step is to determine specific identification, including both the common name and the scientific name of each material. This step can be very straightforward or may require consulting an expert or scientist. In one instance of a Kongo *nkisi* containing unidentified feathers, the assistance of a well-known British specialist was needed to determine that the feathers in question were from a domestic fowl and, therefore, were not subject to CITES. In a similar situation, the crowned eagle feathers adorning a mask from the Democratic Republic of the Congo were easily identified as *Stephanoatus coronatus* by the foreign lending institution, which then applied for the required permit. If only the common name is known, one may consult the CITES Appendices for the scientific name.

Perhaps the most critical information in deciding whether one needs an export/import permit or a pre-convention certificate is the date when the object was made or collected. For many African works, the date of manufacture is unknown, although it may sometimes be assumed to date from the period of Western colonization. One solution to the dating problem is to request an examination of the lending institution's accession records. If the object has been recorded as being in the collections of a museum before 1973, then one can be assured that it is pre-convention. However, U.S. Fish and Wildlife may still require an "Expert's Affidavit." To qualify as an expert, the individual must be over 21 years of age, state his or her years of experience in the field, and swear before a witness that he or she has carefully examined the object(s) in question. The witness may be another museum staff member; the affidavit does not have to be notarized. A description of each object, including an approximate date of manufacture, must accompany the affidavit, e.g.,

> Anthropomorphic face mask. Wood, pigment, animal hide, and hair (monkey, *Colobus abyssinicus uelensis*), Democratic Republic of the Congo, probably 20th century (collected between 1952-1956).

An exhibition date, if it is documented, or a publication date may also be used to prove pre-convention eligibility. Authenticating documentation must accompany the shipment. A statement by the affiant, such as the following, must also be included [50 CFR 17.4]:

To the best of my knowledge and belief, the

aforementioned objects were created before 1973 and have not been repaired or modified with any part of an endangered species on or after Dec. 28, 1973 [50 CFR 14.22]. They are therefore pre-convention and are exempt under the Endangered Species Act of 1973 [15 U.S.C. 1531-1543].

Another type of exemption that may be useful for shipping purposes is the "Exception to Designated Port." Such an exception may be made for a single shipment or for a series of shipments over a specified period of time. Unless there are special circumstances precluding their use, all wild-life shipments must enter and leave the United States through a designated customs port. Availability of direct flights, loan requirements of institutional lenders, the need for continuous supervision by museum professionals to prevent deterioration or loss, or undue economic hardship all may be grounds for an "Exception to Designated Port." In case of economic hardship, the applicant must provide a cost comparison for inland freight, customs clearance, bonding, trucking, associated fees, etc., between the designated port and the non-designated port. An exception may also be granted for scientific purposes, although this factor would not be applicable in an art museum.

In addition to federal endangered species law, some states have more restrictive laws. To determine whether a particular state has endangered species law(s), one should check with the appropriate state conservation agency prior to the transaction.

In summary, one must anticipate CITES issues well in advance of international shipping in order to allow sufficient time for research and obtaining the necessary permits. The advice of experts, including CITES officials in both exporting and importing countries, can be invaluable in preparing complete documentation. Determining the date of manufacture is of primary importance. Finally, one should consider obtaining a waiver of port, if advantageous, and make sure all endangered species laws, both state and federal, have been reviewed for compliance.

NOTES

1. Lacey Act provisions requiring humane treatment of live animals and protection against injurious species are discussed separately.

United States Fish and Wildlife Service
Division of Law Enforcement
P. O. Box 3247
Arlington, Virginia 22203-3247

U.S. Fish & Wildlife Service Designated Ports (50 CFR 14.12)

ATLANTA, GA
P. O. Box 45287
Atlanta, GA 30320
(404) 763-7560 fax

BALTIMORE
40 South Gay Street
Room 107
Baltimore, MD 21202
(410) 962-7980 phone
(410) 962-0118 fax

BOSTON
120 Second Avenue
Building 120
Charlestown, MA 02129
(617) 424-5750 phone
(617) 424-5757 fax

CHICAGO
10600 Higgins Road
Suite 200
Rosemont, IL 60018-3770
(847) 298-3250 phone
(847) 298-3250 xl62 fax

DALLAS / FT. WORTH
P. O. Box 610069
DFW Airport, TX 75261
(214) 574-3254 phone
(214) 456-0811 fax

HONOLULU
3375 Koapaka St. #F275
Honolulu, I 96819
(808) 861-8525 phone
(808) 861-8515 fax

LOS ANGELES
370 Amapola Ave. #114
Torrance, CA 90501
(310) 328-6307 phone
(310) 328-6399 fax

MIAMI
10426 N.W. 31st Terrace
Miami, FL 33172
(305) 871-5015 phone
(305) 526-7480 fax

NEW ORLEANS
56707 Behrman St. #2
Slidell, LA 70458
(504) 589-4956 phone
(504) 589-4939 fax

NEW YORK / JFK
70 E. Sunrise Hwy. #419
Valley Stream, NY 11580
(516) 825-3950 phone
(516) 825-1929 fax

NEW YORK / NEWARK
Hemisphere Center
Routes 1 & 9 South
Newark, NJ 07114
(201) 645-5910 phone
(201) 645-6533 fax

PORTLAND
P. O. Box 55206
Portland, OR 97238
(503) 231-6135 phone
(503) 231-6133 fax

SAN FRANCISCO
1633 Bayshore Highway
Suite 248
Burlingame, CA 9401 0
(415) 876-9078 phone
(415) 876-9701 fax

SEATTLE
2580 South 156th Street
Seattle, WA 98158
(206) 764-3463 phone
(206) 764-3485 fax

U.S. Fish & Wildlife Service Non-Designated Ports / Border Ports

ANCHORAGE
(Border/Special)*
605 W. 4th Ave. Rm. 57
Anchorage, AK 99501
(907) 271-6198 phone
(907) 271-6199 fax

BLAINE (Border)
9925 Pacific Hwy.
Blaine, WA 98230
(360) 332-5388 phone
(360) 332-3010 fax

BROWNSVILLE (Border)
1500 E. Elizabeth St. #239
Brownsville, TX 78520
(210) 504-2035 phone
(210) 504-2289 fax

BUFFALO (Border)
405 N. French Rd. #120B
Amherst, NY 14228
(716) 691-3635 phone
(716) 691-3990 fax

DENVER
Rocky Mtn. Arsenal #619
Commerce City, CO 80022
(303) 287-2110 phone
(303) 287-1570 fax

DETROIT (Border)
Intl. Terminal Rm. 221
Detroit Metro Airport
Ann Arbor, MI 48242
(313) 941-6801 phone
(313) 941-6902 fax

DUNSEITH (Border)
U. S. Hwy. 281
Canadian Border
Dunseith, ND 58329
(701) 263-4462 phone
(701) 263-4463 fax

EL PASO (Border)
Bota, 3600 E. Paisano
#142A
El Paso, TX 79991
(915) 534-6660 phone
(915) 532-4776 fax

GUAM (Special)*
Haloda Bldg. 115
Marine Drive
Asan GU 96921
(671) 472-7146 phone
(671) 472-7151 fax

HOUSTON
4141 N. Sam Houston Pkwy. East,
Suite 260
Houston, TX 77032
(713) 672-4420 seaport
(713) 821-5714 air
(713) 821-799-3 fax

LAREDO (Border)
Convent & Zaragoza
Bridge # 1 200.9
Laredo, TX 78040
(210) 729-2234 phone
(210) 729-3718 fax

NOGALES (Border)
9 N. Grand Ave. #2229A
Nogales, AZ 85621
(520) 287-4625 phone
(520) 287-4604 fax

PUERTO RICO (Special)*
651 Federal Dr. #372-12
Guaynabo, PR 00965
(809) 749-4338 phone
(809) 749-4340 fax

ST. PAUL / MPLS. (Border)
HHH Terminal
7100 34th Ave. S.
Minneapolis, MN 55450
(612) 725-1715 phone
(612) 725-1716 fax

SAN DIEGO (Border)
9777 Via De La Amistad
Room 127
San Diego, CA 92173
(619) 661-3130 phone
(619) 661-3010 fax

TAMPA
9721 Exec. Ctr. Dr. #206
St. Petersburg, FL 33702
(813) 570-5398 phone
(813) 570-5549 fax

*wildlife origin/destination—Guam/Alaska/Puerto Rico/Virgin Islands

United States Department of the Interior Fish and Wildlife Service Jurisdictions and Offices

Jurisdiction	Regional Director	Law Enforcement
Region 1: California, Hawaii, Idaho, Nevada, Oregon, Washington, American Samoa, Commonwealth of the Northern Mariana Islands, Guam and the Pacific Trust Territories	Mike Spear Eastside Federal Complex 911 N.E. 11th Avenue Portland, OR 97232-4181 (503) 231-2234	Assistant Regional Director David L. McMullen Eastside Federal Complex 911 N.E. 11th Avenue Portland, OR 97232-4181 (503) 231-6125
Region 2: Arizona, New Mexico, Oklahoma, and Texas	Nancy Kaufmann P. O. Box 1306 Albuquerque, NM 87103 (505) 248-6282	Frank S. Shoemaker P. O. Box 329 Albuquerque, NM 97103 (505) 248-7889
Region 3: Illinois, Indiana, Iowa, Michigan, Minnesota, Missouri, Ohio, and Wisconsin	William F. Hartwig Bishop Henry Whipple Fed. Bldg.. One Federal Drive Fort Snelling, MN 55111-4056 (612) 725-3563	R. David Purinton Bishop Henry Whipple Fed. Bldg. One Federal Drive Fort Snelling, MN 55111-4056 (612) 725-3530
Region 4: Alabama, Arkansas, Florida, Georgia, Kentucky, Louisiana, Mississippi, North Carolina, South Carolina, Tennessee, Puerto Rico, and U. S. Virgin Islands	Noreen Clough 1875 Century Center Blvd. Room 324 Atlanta, GA 30345 (404) 679-4000	Cecil M. Halcomb P. O. Box 49226 Atlanta, GA 30359 (404) 679-7057
Region 5: Connecticut, Delaware, District of Columbia, Maine, Maryland, Massachusetts, New Hampshire, New Jersey, New York, Pennsylvania, Rhode Island, Vermont, Virginia, and West Virginia	Ronald E. Lambertson 300 Westgate Center Drive Hadley, MA 01035-9589 (413) 253-8300	G. Adam O'Hara P. O. Box 779 Hadley, MA 01035-0779 (413) 253-8274 Permits: (413) 253-8567
Region 6: Colorado, Kansas, Montana, Nebraska, North Dakota, South Dakota, Utah, and Wyoming	Ralph Morganweck P. O. Box 25496 Denver Federal Center Suite 700 Denver, CO 80225 (303) 236-7920	Terry Grosz P. O. Box 25486 Denver Federal Center Denver, CO 80225 (303) 236-7540
Region 7: Alaska	Dave Allen 1011 E. Tudor Road Anchorage, AK 99503 (907) 786-3542	John Gavitt P. O. Box 92597 Anchorage, AK 99509-2597 (907) 786-3311

Julia Fenn

OCCUPATIONAL HAZARDS IN MUSEUM REGISTRATION DEPARTMENTS

The responsibilities of registration departments usually extend far beyond record keeping. In some museums, registrars are expected to cope with almost anything from education to fund raising. Regardless of the duties involved, however, museum registration is not usually regarded as a hazardous profession. Nevertheless registration staff can unwittingly be exposed to dangerous artifacts and unsafe equipment in the course of their normal activities.

INDOOR AIR IN CULTURAL INSTITUTIONS

Indoor air is a source of a variety of toxins and allergens, especially in buildings with poorly maintained HVAC (heating ventilation and air conditioning) systems (Repace 1982; Rossnagel 1987). The debilitating effects of tight building syndrome are well documented (Burge 1989; Robb 1993; Sullivan and Krieger 1992), and the contaminants generated by museum activities tend to be even more diverse and plentiful than those in the average apartment or office building. Blameless administrative and clerical staff within the museum building may be inhaling sub-acute levels of solvents, pesticides and exhaust fumes, which weaken the immune system or cause sensitization in predisposed individuals, affecting their resistance to other infections and poisons.

OFFICE EQUIPMENT

Office hazards have traditionally either been ignored or made ridiculous in safety publications. Examples of the latter are safety guidelines that overemphasize the dangers of reckless inattention while stapling or the abusive use of correction fluid. However there are some more serious concerns about modern office equipment:

Personal Computers and Electromagnetic Fields

Personal computers are now an indispensable tool for record keeping and communications, and it is not unusual for registrars to spend in excess of five hours daily at video display terminals. The most commonly diagnosed health effects resulting from intensive computer use are repetitive strain injuries, muscle fatigue, eye strain, and circulatory disorders attributed to poorly designed office furniture or the glare from lighting fixtures. These problems are serious, but they are preventable.

All electrical equipment generates an electromagnetic field, and computer operators are exposed to these fields for extremely long periods. The effect of radiation on living cells depends on its frequency. High frequencies such as X-rays, which have sufficient energy to ionize atoms by removing electrons, are known to have mutagenic and potentially carcinogenic effects. The radiation emitted by modern video display terminals is non-ionizing, predominantly in the very low frequency (VLF) and extremely low frequency range (ELF), with energy levels supposedly too low to be harmful. Nevertheless, there is growing evidence, all disputed, to suggest that extremely low frequencies suppress immune response mechanisms, interfere with hormone secretion, and can disrupt the flow of ions through cell membranes, resulting in chemical imbalance that may increase the risk of cancer.

Computers also create an electrostatic field that attracts charged particles to the face and body; this

Acknowledgments: Terry Drayman-Weisser and Marie Malaro

may cause the eye inflammations and rashes which often afflict computer operators. There are shields on the market that claim to discharge the static field and to block over 90% of the non-ionizing radiation emitted through the screen. Some authorities claim that it is not possible to block ELFs adequately except by increasing distance.

Given conflicting information, the user is in a quandary. Avoiding personal computers is not always an option, not even for the young or the pregnant. Many offices and homes can no longer function without them. Lap-top screens use liquid crystal or gas plasma displays instead of the cathode ray tube, so they are reputed to be safer. They cannot, however, perform all the functions of the conventional monitors.

It *is* agreed that the emissions fall off rapidly with distance. It is also agreed that emissions are greater from the sides, back, and top of the monitors than they are from the screen. Accordingly, the current recommendation for the cautious user is to sit at least 28 inches (71 cm) back from the screen and at least four feet (122 cm) away from adjacent machines. Some of the shields, regardless of whether they screen ELFs effectively, do improve the quality of the image, making it easier to move back. In fact most screens are clearly visible from 40-50 inches away; it is the desk that usually limits how far the keyboard, and hence the operator, can be moved away from the screen.

Photocopiers

Photocopiers and some laser printers generate ozone, a reactive gas that is a severe irritant to eyes and mucous membranes and can cause lung hemorrhages. The ceiling threshold limit value is set very low, at 0.1 parts per million. In order to meet this standard, many offices keep copiers out of the main office area and put them in corridors or separate, well-ventilated rooms.

Earlier in the century ozone was believed to be healthy and invigorating and this belief persists. The ozone generated by electrostatic air fresheners is still being recommended as having deodorizing and cleansing properties. Ozone does have a pleasant smell at very low concentrations, but if the odor is perceptible the concentration is already above the threshold limit value (McCann 1986; Rossol 1996).

USE OF TOXIC CHEMICALS

In general, registration departments do not use many chemicals, but there are a few that could cause problems.

Inks

Many copiers use powdered inks that are easily spilled. In this concentrated form they can cause contact dermatitis and are easily inhaled. Inks often contain highly toxic materials including lead, manganese, and cadmium, and carbon black often contains impurities that have been associated with skin cancer (Rossol 1990).

Solvents

Labeling artifacts is a potential source of solvent exposure. Solvents, especially combinations of solvents, are associated with a variety of problems including liver and kidney damage, miscarriages, and cancer. Although the volume of ink and varnish solutions used for labeling artifacts is usually small, the way they are used may maximize exposure. For example, a top left off the varnish solution for easier dipping, or the face held close to the pen to ensure tiny, neat lettering, maximizes exposure.

Solvent mixtures and hot desk lamps are a fire risk; there is also the possibility of creating phosgene if chlorinated hydrocarbon solvents react with the ultra-violet light that is emitted by high-intensity halogen desk lamps. Even when labeling only a few artifacts, it is safer to use a fume hood.

Air Fresheners and Room Deodorants

When the office air smells stale or mildewed it is tempting to use chemical air fresheners. Some of them, such as lava rock and charcoal, are sorbents but others merely mask odors with volatile aromatics that contribute to the problems in the room. Solid, slow-release air fresheners may

contain ingredients such as paradichlorobenzene, pine oil, camphor, thymol, and naphthalene, which are very toxic and are gradually coming under stricter legislation. Older formulations also included formaldehyde, a sensitizer and a carcinogen that is now restricted.

If air fresheners are used both at home and in the office, exposure to the individual ingredients could easily exceed the recommended levels (based on an eight-hour working day), especially since the same substances are also present in other common products such as disinfectants and mothballs.

When paradichlorobenzene, naphthalene, thymol, or camphor vapors combine, their properties change. For example, some paints and plastics that are impervious to concentrated vapors from naphthalene or camphor break down if the two vapors combine. This suggests that mixtures of vapors probably affect the health risk as well.

DANGEROUS ARTIFACTS

The registration department is often in the front line when it comes to receiving new acquisitions or material sent in from the field. Packing materials can be contaminated with biocides, mold, unfriendly livestock, fire retardants, or asbestos fibers (e.g., in vermiculite or paper stock). Anyone present can unknowingly be exposed as the crate is opened and unpacked.

The artifacts/specimens may also be dangerous. This will only be of concern to registration departments that work directly with the collections: applying accession numbers, evaluating collections, preparing condition reports, or identifying materials etc. The hazards can be loosely grouped into the following categories: flammables and explosives, asbestos, radioactivity, poisons and pathogens.

Flammable and Explosive Artifacts

Among the obvious dangers are firearms that have never been unloaded, old boxes of ammunition, fireworks, boxes of matches, powder flasks, or mining explosives. The older the ammunition, the more touch-sensitive it is likely to be. Old guns from archaeological sites may be unrecognizable under the corrosion, and unfortunately this may also apply to rusted shells, booby traps, and grenades retrieved by the public as souvenirs. Contact your local police department for information on disposal or deactivation of weapons.

Other familiar explosives are old bottles of ether or perchlorates usually found in old medical supplies or chemistry sets. They should not be touched until the fire department can remove them.

During the 1970s sodium azide was occasionally used as a fungicide on waterlogged wood and leather. It forms an impact-sensitive explosive if it comes into contact with copper, silver, or lead—which was often a constituent of the artifact. Metal fittings in freeze-drying equipment could also react with the fungicide. There have been accidents in hospitals that used azide biocides, but no explosions have been recorded in museums as yet. Nevertheless, it is worth checking the treatment reports before handling organic materials from wet sites that were treated during this period. Large metal azide crystals are more unstable than finely divided powdery crystals.

Cellulose nitrate negatives (celluloid), especially reels of film stored in metal cans, have a reputation for spontaneous ignition, causing toxic fires that generate their own oxygen and are very difficult to extinguish. Many museums now keep their nitrate negatives frozen until they can be copied onto stable film.

Cellulose nitrate artifacts have been manufactured since the 1870s and are often distributed through the collections disguised as ivory or tortoiseshell. They are also flammable, but artifacts rarely ignite spontaneously because they are not as highly nitrated as the photographic film. They do eventually degrade giving off nitrogen dioxide, a poisonous, acidic, oxidizing gas that becomes a fire hazard when absorbed by dust or paper products. Fortunately there is a simple identification test for cellulose nitrate (Williams 1994) and for distinguishing which pieces are giving off dangerous amounts of nitrogen dioxide (Penn 1995). Sorbents

such as silica gel or activated charcoal should never be kept near cellulose nitrate or ammunition because they are known to absorb nitrates and become potentially explosive themselves.

Pathogens

All burial material should be treated with caution, since some soils have excellent preservative powers. Artifacts acquired from latrines, middens, and graves, where they have been in contact with fecal matter, parasites, and corpses, should not be put into storage with only minimal cleaning.

Fumigation is not equivalent to sterilization, since most fumigants and insecticides used today are useless against pathogenic microorganisms. Freezing, which kills insects, preserves many pathogens. Even though most pathogens may not survive long under normal museum conditions, there are exceptions. Oily artifacts from whaling sites are reputed to have caused "seal finger" (swollen fingers commonly caused by skinning sea mammals) and respiratory infections years after they were excavated.

Until recently molds have been regarded mainly as allergens, but it is now believed that they may play a prominent role in some debilitating illnesses (chronic fatigue syndrome, hypersensitivity asthma, and multiple chemical sensitivity). Mycotoxins have been found to interfere with the immune system, and at least one (afflatoxin) is a potent carcinogen (Flanningan and Miller 1994).

Molds also emit complex volatiles that are responsible for the typical moldy smell. These volatiles are mainly alcohols but also include aromatic mixtures of ketones, aldehydes, and various hydrocarbons. People who have become sensitized to molds may also become sensitized to the volatiles, with drastic consequences to their lifestyle and livelihood, since these substances are present in many plastics, paints, foods, glues, and cosmetics.

Poisons

Most social history and taxidermy collections are a record of the changing fashions in poison. Arsenic and mercury compounds are particularly common,

not only on textiles and furs but also on painted canvases, frames, and basketry. Arsenic is an acute gastric poison and a carcinogen at chronic, low-level exposures. Mercury is an acute gastro-intestinal poison, and repeated sub-acute doses cause tremors and neurological disorders, symptoms that are often mistaken for stress (Mad Hatters disease).

It is not always realized that metal artifacts can also be very poisonous. Metal arrows and spearheads may have residual aboriginal poisons. Lethal cyanide residues from old plating and cleaning mixtures have been found on copper, silver, and gold (Strahan 1983), and poisonous corrosion inhibitors were used on iron and copper alloys. Lead is still one of the commonest poisons, and the light powdery corrosion that frequently forms in museums is easily inhaled or ingested. The pigment lead white (lead carbonate) was used not only in paints but was a common constituent of gesso, plaster, and putty. Many lethal, old repairs to ceramics and statuary are now friable and crumbling.

It is safer to assume that all collections, including mounts, are extremely poisonous, and should be handled only with gloves.

Asbestos

There is no safe level of exposure to asbestos. Many collections contain asbestos in its most harmful form—tiny, respirable fibers, found sometimes in the most unexpected places. For example, modern suedes and Indian dance costumes were sometimes cleaned by rubbing them with blocks of asbestos, leaving fibers trapped in the nap. Apparently, it produced a wonderful finish.

Other better-known sources of asbestos hazards in collections are minerals such as tremolite and crocidolite, many papier-mâché artifacts, the stuffing inside some taxidermy specimens, protective clothing for firemen, and old stoves and heaters. Apart from the minerals, none of these is a problem unless the asbestos is exposed by breakage or incautious dismantling of the artifacts. Asbestos in "fireproof" fabrics is more dangerous because fibers are shed continually, especially when

handled. It was used in theatrical safety curtains, oven wear, and chef's clothing, as well as in some domestic hearth rugs and upholstery fabrics. All 20th-century textile collections are suspect. The Environmental Protection Agency (EPA) provides names of licensed operators who can check for the presence of airborne asbestos and discuss suitable abatement procedures.

Radioactive Hazards

Radium in radioactive soils has been known to concentrate in fossils because of its similarity to the calcium content of bone, e.g., in dinosaur fossils from the Morrison formation and Karoo fossils from South Africa. The decaying radium, and similar radioactive minerals in geology collections, emit radioactive gases such as radon (Carman 1984).

Radon is a heavy, odorless gas that produces electrically charged daughter products that have an affinity for dust. If inhaled, the dust stays permanently in the lungs, submitting them to ionizing radiation, which increases the risk of cancer. There is a very long latent period for most of the ionizing hazards in the collection. However, since we are of necessity exposed to diagnostic, medical radiation, there is no advantage to increasing the risk by unnecessary exposure. Information on radon and radon monitoring devices can be obtained from the EPA.

In the early 20th century, it was discovered that radioactive minerals mixed with powdered phosphorescent material could be used as a luminous paint. During the 1930s, '40s, and '50s, such paints were used on anything intended to glow in the dark, including instrument panels, clock faces, religious statuary, light switches, theatrical costumes, toys, Christmas ornaments, and chamber pots. Within a few years the paint usually lost its luminous properties as the phosphorescent compounds decayed, but the paint remained radioactive. With age, the paint becomes powdery and can contaminate adjacent surfaces or be picked up during handling. It is less of a problem in instrument panels where the paint is trapped under glass, because the glass absorbs much of the radiation and prevents the

paint from dispersing. Radioactive pottery glazes are also known. Research is currently underway to identify radioactive glasses and glazes.

Several science museums have followed the U.S. military guidelines (United States Air Force Museum 1988) for cleaning and isolating radioactive materials. However, it is also advisable to contact your state health department and radiation protection service, because cleaning and disposal of radioactive material is governed by regulations that often need official interpretation.

Protective Clothing

Traditional cotton or nylon gloves are of little use against poisonous or infectious artifacts. Contaminants trapped in the fibers can easily be transmitted to the eyes and face.

Lightweight surgical gloves made from thin nitrile are an effective barrier against storeroom dust and water-soluble toxins but not against organic solvents or pesticides. They must be replaced frequently (three to four times per hour). Hand creams weaken the gloves and increase their permeability.

There has been a dramatic increase in very serious allergies to latex products ranging from minor rashes to fatal anaphylactic shock. At the slightest sign of latex allergy it is better to discontinue using rubber products. The terms "latex" and "vinyl" are used rather loosely, so it is advisable to check the glove material with the manufacturer rather than relying on the label. Coveralls worn only in storage and cleaned regularly (not with the family wash) reduce the danger of exposing family and friends to lead and radioactive dusts, which are an especially severe hazard for young children. For some illogical reason head covers are never worn, but it wouldn't hurt.

Face masks and respirators are self-defeating unless they fit properly and have the appropriate filter for the specific contaminant(s). All of them increase breathing difficulty so they may actually reduce the oxygen intake, endangering people with heart or respiratory problems. They are intended for short-term, temporary exposures and should not

be considered as a solution to generic problems in the storage rooms. Most museum respirators are not kept in sterile conditions, and it has been shown experimentally that *Stachybotrys atra*, a truly horrible mold, can produce virulent mycotoxins on cellulose filters (Pasanen 1994).

DANGEROUS DISPLAY CASES AND STORAGE UNITS

The atmosphere is not the only hazard in storage areas; shelving is sometimes unstable. Two staff members narrowly escaped death when the upper section of a compact storage unit at which they were working collapsed (Penn 1990).

A recent series of accidents in a Canadian museum has also revealed dangerous design flaws in exhibit cases:

- A case was found to have missing bolts inside the winding mechanism, which allowed the top to crash down mere seconds before a staff member reached inside.
- A technician opened a case incorrectly and the plate-glass vitrine collapsed on him.
- A squat exhibition case containing a Renaissance marble relief proved to be top-heavy and fell when it was moved, smashing the case and the marble.

In the last two situations, despite the appalling noise, nobody was within hearing. Injuries under such circumstances could be aggravated by the lack of immediate assistance.

Off-site Problems

Working alone is always a serious risk, especially if staff are off-site in potentially unpleasant situations:

A museum assistant opening a rural historic house after the winter closure had an interesting encounter with a poisonous snake that dropped from the attic onto the reception desk. Another was confronted by squatters in an off-site warehouse who were reluctant to stop using the period furniture.

When working in other museums, visiting staff are rarely given adequate safety information even if they are expected to work alone in an unfamiliar building. There is an appalling practice of locking visiting staff in with the artifacts when there is a shortage of security staff. In the event of an emergency they would be unable to get out even if they did know the way.

One documentation clerk, checking condition reports on an incoming loan, found herself suddenly plunged into total darkness and was forced to grope her way across an unfamiliar space strewn with power tools and partly unpacked crates because nobody had mentioned that the lighting was automatically turned off during the lunch hour to save electricity.

High-Risk Individuals

Among staff and volunteers there will inevitably be some who are at much greater risk because of metabolic rate, body weight, pregnancy, substance abuse, medication, or pre-existing health problems. Legislation against discrimination may preclude the relevant inquiries.

People under great stress are also at risk. Chronic stress reduces antibodies and hence the ability of the body to cope with other poisons and infections to which it may be exposed.

Anything that affects the metabolic rate, such as dieting or pregnancy, can affect susceptibility to museum toxins, and individuals may become sensitive to exposures that previously did not harm them. Toxic levels that do not affect the mother may cross the placental barrier and harm the embryo, especially during the first few weeks of pregnancy.

People suffering from hereditary glucose-6-phosphate dehydrogenase deficiency are particularly susceptible to naphthalene, which causes haemolytic anemia. Newborn infants are also very susceptible to haemolytic anemia, and high levels of naphthalene have been found to accumulate in breast milk.

Medications such as antihistamines or barbiturates that affect the central nervous system (brain and spinal cord) are likely to be enhanced by chemicals such as camphor and alcohol, which are mild CNS depressants. Ethyl alcohol is known to react adversely with many types of medication, and because it is a very common museum pollutant, exposure is not confined to a liquid lunch.

Toxins discriminate; they are sexist, ageist, and sometimes even racist, and they preferentially attack the afflicted. The recommended exposure limits do not usually allow for this.

THE PLIGHT OF THE VICTIM

There is usually tremendous resistance to acknowledging safety hazards. The tendency is to shoot the messenger—usually the first victim. Already ill and probably in pain, the victim's credibility is attacked by insinuations of hypochondria (or premenstrual syndrome, menopause, sexual frustration, senility, substance abuse, or hysteria). Colleagues often prefer to believe that the ailment is caused by a weakness in the victim, rather than the hazard to which he (and they) are exposed. It is not surprising that most victims give up the struggle and go away; but the hazard does not leave with them.

CONCLUSION

Most museum hazards are insidious. Ailments are characterized by the gradual onset of non-diagnostic, flu-like symptoms that makes diagnosis and treatment difficult. Even acute poisoning from well-known substances such as arsenic or mercury are not necessarily obvious, *especially if the victim is unaware that he has been exposed*. Medical practitioners might be misled because they do not realize what type of exposures can occur in cultural institutions.

Even knowing that damage from chronic exposure is often incurable, it is difficult not to become careless. Most museum hazards are too subtle. A vat of boiling acid would encourage caution; odd smells, invisible radiation, and artifacts with unseen poisons do not engender the same respect. Past exposures actually make future sensitization more likely, but there is an unfortunate tendency to believe the opposite and to treat familiar hazards in familiar situations with contempt.

The Whitney Museum of American Art, New York. Photo by Elizabeth Gill Lui.

DESCRIPTION OF THE POSITION

Individuals with the title or function of registrar have a varied range of responsibilities and activities. In this document the basic description of the position as defined in the glossary of *Museum Registration Methods* is adopted: "an individual with broad responsibilities in the development and enforcement of policies and procedures pertaining to the acquisition, management, and disposition of collections. Records pertaining to the objects for which the institution has assumed responsibility are maintained by the registrars. Usually, the registrar also handles arrangements for accessions, loans, packing, shipping, storage, customs, and insurance as it relates to museum material."

Registrars are usually specialists in the areas of information management, risk management, and logistics. The primary concerns of registrars are creating and maintaining accurate records pertaining to objects, including those documents that provide legal protection for their museum; ensuring the safety of objects; arranging insurance coverage for objects; and handling, transporting, and control of objects.

THE REGISTRAR, THE RECORDS, AND THE OBJECTS

Registrars' obligations to their museums' collections, to loaned objects, and to the associated records are paramount.

Management, Maintenance, and Preservation of the Records

The records and documents that form a body of information pertaining to the collections, and loaned objects are the responsibility of registrars and are the cornerstone of the registrarial function.

The records comprise legal documents establishing ownership or loan status of objects: records of accession, location, donor or vendor, exhibition, and publication. They may also include photographs, licenses and permits, exhibition bond notices, and historical records. Frequently, curators keep research files on the objects in their domain.

Registrars must maintain records that are meticulously complete, honest, orderly, retrievable, and current. Records should be created in a timely manner and accurately dated. Records must be stored in an archivally and technologically sound and secure manner, both to ensure their preservation and to prevent access by unauthorized persons. The expertise of legal counsel and archivists should be sought without hesitation.

Registrars must protect their museums and the objects in them against the risk of liability through the use of valid documents such as gift, sales, loan, and custody forms and receipts; by implementing all aspects of insurance coverage for owned or borrowed objects on the premises or in transit according to the terms of their insurance policy or indemnity; and by complying with pertinent laws and regulations governing such things as import and export or other movement of objects, or rights and reproductions of objects.

Registrars, through the records maintained, are accountable for the objects in the custody of their museums and must be able to provide current information on each object, its location, status, and condition.

Management, Maintenance, and Conservation of the Objects

In maintenance and physical care of the collections, registrars must work in close cooperation with curators, conservators, collections managers, and other museum staff, and must be guided by their museums' collections management policies. In management of loaned objects registrars also work in cooperation with exhibition, technical, and

security staff, and they must adhere to and enforce the lenders' conditions of loan.

In some museums it is not registrars but curators or collections managers who have responsibility for the physical care of collections in storage. Whichever is the case, the best and most secure environment possible should be ensured for the storage and preservation of objects. The condition of the collections should be reviewed periodically and the expertise of conservators should be sought without hesitation.

Objects in movement are the responsibility of registrars. As risk managers, registrars are responsible for determining and arranging for the correct methods of handling, packing, transporting, and couriering objects. They must also consider borrowers' capabilities and facilities. Registrars identify potential risks and complications and act to reduce or eliminate them.

Registrars share the responsibilities for loaned objects in the custody of their museums. They are responsible for their safe movement, temporary storage, and correct disposition. Registrars always must treat loaned objects of whatever value, quality, or type with the same care and respect given to objects in their museums' collections.

Registrars must complete condition reports in an honest and timely manner, be familiar with the terms of their insurance coverage and ensure that insurance reporting is accurate. In filing all insurance claims all relevant circumstances of loss or damage must be disclosed, even it if appears that the museum is at fault.

Acquisition and Disposal

Registrars must adhere to the acquisition and disposal policies of their museums; if no written policies exist, then registrars should encourage and assist in their formulation. In the absence of written museum policies registrars should develop written procedures of rules by their departments to ensure compliance with traditional but oral museum policies. Registrars should obtain the approval of their directors before implementing such

procedures, and strive to ensure that the policies and procedures are complied with at all levels within their museums.

Objects for acquisition or disposal are proposed, usually by curators, to the relevant museum committees for approval. Registrars' roles in acquisition are generally in an advisory capacity concerning the feasibility of storage, the risk of movement to the object under consideration, and certain legal aspects of the transaction. Prior to issuing an accession number reflecting the date and/or order in which the object was added to the collection, registrars are responsible for obtaining documentation of the decision to acquire the object, the document transferring title of an object to the museum, and the receipt of delivery of an object. Registrars should be aware of, and not contribute to, the violation of tax, wildlife, import, or other laws and regulations governing acquisition of objects by their museums and other institutions with which they are involved.

Registrars should ensure that at least one appraisal of an object is acquired and institute insurance coverage if applicable according to museum policy. In order to prevent their use as an appraisal for tax or other purposes, these appraisals should not be made available to the donor or vendor of an object. Appraisals for tax purposes are the responsibility of the donor, who can be informed whether an object is accepted for the collection, for sale, or for use by the museum.

Registrars' roles in deaccessions and disposal are primarily those of monitoring and documenting procedures. Registrars also should bring to the attention of the curator any object in irreparable condition or one jeopardizing the safety of the rest of the collections. Registrars should verify the museum's legal right to dispose of an object, and inform the curator and other appropriate museum staff of any restrictions attached to an object that may bear on its disposition. When restrictions are attached to an object, legal counsel should be sought so that the museum might be relieved of those restrictions by appropriate negotiation or legal procedure.

Once all the proper approvals have been granted, registrars must amend all the related records to show the date of deaccession, the authority for it, and the method of disposal. Records may also show the disposition of any funds realized through sale or an exchange acquired as a result of the deaccession. Donor credit for, and use of funds realized through, the sale of an object must comply with the policies of the museum.

Availability of Collections and Records

Museums hold and safeguard their collections for posterity, although they must allow reasonable public access to them on a nondiscriminatory basis. However, registrars must act according to the policies of their museums.

Registrars, along with curators and conservators, must ensure that objects from the collections are examined and viewed in a manner not detrimental to an object. They must also ascertain that a borrowing institution's facilities are acceptable when considering a loan request, so that an object will not be placed in jeopardy.

The records constitute part of a museum's accountability to the public. However, registrars must ensure by property supervision that sensitive or confidential material in their museum's records is not accessible to unauthorized persons. When in doubt registrars should consult their supervisors or their museum's legal counsel.

Truth in Presentation

Registrars are responsible for creating and maintaining accurate records and updating them in light of new research, and for ensuring that the records reflect the facts insofar as they are known.

Human Remains and Sacred Objects

Registrars must be tactful and responsible in giving access to collections of human remains and sacred objects, and must store, transport, and care for these objects in a manner acceptable to the profession and to peoples of various beliefs.

THE REGISTRAR AS STAFF MEMBER

General Deportment

Registrars are visible to the public, the profession, commercial representatives, and government agents in situations ranging from collecting objects from donors and lenders in their homes or museums to negotiating with customs inspectors in cargo sheds. Registrars must behave in a dignified and ethical manner and gain the respect of others by not creating embarrassments either to their museum or their profession. Because of their access to confidential matters and information, it is incumbent upon registrars to be discreet and circumspect in all their communications or actions in an effort to preserve the integrity of their museum.

In all activities and statements, registrars must make it clear whether they are speaking for their museums, their professional association, or themselves. They must be aware that any museum-related action may reflect upon their museums, be attributed to it, or reflect upon the integrity of the profession as a whole.

Conflict of Interest

Registrars must be governed by their museums' policies on conflict of interest and other ethical matters.

Registrars should be loyal to their museums and not abuse their official position or contracts within the museum community, nor act so as to impair in any way the performance of their official duties, compete with their museums, or bring discredit or embarrassment to any museum or the profession in any activity, museum-related or not.

Responsibility to the Collections and Other Museum Property

Registrars and their staff must never receive or purchase for their own or another individual's collections or purpose, even at public auction, objects deaccessioned from their museums' collections. Registrars' volunteers and interns should be guided by the codes governing their supervisors.

Registrars should never put to personal use objects in their museums' custody and they should guard information that would enable others to do so. Registrars must never abuse their access to information and to other museum assets by using them to personal advantage. Registrars must be particularly vigilant concerning their knowledge of museum security procedures.

Because of their experience and responsibility as risk managers, registrars are often regarded as authorities in the care and transport of valuable or problematical objects They must guard against giving the impression that their museums endorse the services of any specific vendor or supplier.

When recommending the services of conservators, appraisers, packers, shippers, customs brokers, or others, whenever possible registrars should offer the names of three qualified vendors to avoid favoritism in recommendation.

Personal Collecting and Dealing

Registrars must be governed by the policies of their museums, which usually are designed for curators and directors. If at the time of their employment their personal collections are similar to those of their museums, registrars should submit an inventory of their collections to the appropriate official and update their inventory in a timely manner. As to objects they acquire after they are employed, registrars may be required to give the museum the opportunity to purchase such objects at their acquisition cost for an appropriate period of time. In no case should registrars complete with their museums in any personal collecting activity. They should never act as dealers or for dealers.

Outside Employment and Consulting

In any situation where registrars work for another organization, an individual, or themselves on their own time, such work should not interfere with the performance of registrars' duties for their museums. The nature of the employment should be disclosed to and cleared by their director and they should conform to their museums' relevant personnel policy.

Gifts, Favors, Discounts, and Dispensations

Registrars often use the services of commercial companies. They must not accept gifts of more than a trifling nature, such as unsolicited advertising or promotional material, so that their judgment will not be impaired when selecting a vendor. Such selections should be made upon merit and not for personal reasons or obligations.

Registrars must not accept personal discounts from vendors who do business with their museums. Registrars must also avoid any appearance of being influenced by gifts or dispensations provided by vendors or services.

Teaching, Lecturing, Writing, and Other Creative Activities

Registrars should teach, lecture, write, and perform related professional activities for the benefit of others in the profession or those aspiring to such a position. They should also contribute to the general public understanding of museum registration.

Registrars should enhance their own knowledge in all registration matters, ensuring that they are up to date with current methods of records management, object care and handling, packing, transporting, insurance, personnel, and financial management, as well as changes in the laws affecting museums and their collections.

Registrars should obtain the approval of their director and conform to the museums' policies on questions of use of official time, royalties, and other remuneration for such activities.

Field Studies and Collecting

Because legal and ethical problems can arise more frequently in fieldwork, registrars must be particularly zealous in completing accurate and timely records. Registrars must monitor compliance with local, state, national, and international laws, as well as with their museums' acquisitions policies. They must also be sensitive to ethnic or religious beliefs.

THE REGISTRAR AND MUSEUM MANAGEMENT POLICY

Professionalism

Although the governing board of the museum is ultimately responsible for the museum, the director is the chief executive officer.

Registrars must carry out their duties according to established guidelines and under the directions of their supervisors, who may be the director, the assistant director, or curator of collections, or an administrative manager. In no case should they take direction from members of the governing board, who should confine their directives to the chief executive officer of the museum. If guidelines or delegations of authority are unclear, registrars should seek written clarification.

Registrars should not be required to reverse, alter, or suppress their professional judgment to conform to a management decision.

When a disagreement arises between the registrar and the director or other supervisor, the registrar should consider documenting the difference of opinion, but should also conform to the grievance procedures of the museum. Only when asked to falsify records or in some way compromise legal or ethical standards should the registrar consider writing a report to the governing board of the museum, and then only with the full knowledge of the museum director.

Interpersonal Relationships and Inter-Museum Cooperation

While registrars must strive for excellence in registration methods, they should understand that professional role within the total context of their museum and should act cooperatively and constructively with colleagues in the furtherance of the museum's goals and purposes. It is important for registrars to obtain the respect and trust of colleagues in their own and other museums.

Inter-museum cooperation may take the form of providing safe storage for duplicate sets of collections records, of providing the services of conservation or preparation of objects for transport, of consolidation of shipments or safe storage for traveling exhibitions between sites. Such cooperation may also take the form of providing professional help and temporary storage of objects or records in the event of fire, flood, or other disaster. When objects or records are so taken into their museums' custody, registrars should ensure that valid documentation of the terms and duration of the custody arrangements is provided.

CODE OF PRACTICE FOR COURIERING MUSEUM OBJECTS

Courier Policy

The consideration for using a courier is based on certain primary facts, which are that:

Certain museum objects are of a fragile nature, whether by construction or formation, size, materials used, deterioration by age or abuse, and/or require special handling or installation techniques.

Certain museum objects are irreplaceable, rare and unique, politically or culturally sensitive, of extreme artistic, historical, scientific worth, or are of extreme value for other reasons.

Certain shipping routes may prove dangerous to fragile museum objects because such routes expose the object to careless handling, excessive movement, changing and/or extreme temperatures, and other human and/or natural hazards.

Lending and borrowing museums must agree that:

The museum that owns the object may determine that a courier is necessary to lessen the hazards inherent in the object itself, and may specify the transportation methods and/or the route to preserve the object from loss by damage or theft and/or to assure that the object will not receive such wear as would cause future problems in the museum's efforts for preservation.

Both the lending and the borrowing museum are fully cognizant of and in accord with the limitations and requirements of third parties to the loan (such as insurance companies, transport companies, and forwarding companies) and are in agreement about which museum will take responsibility for actions not covered by such third parties.

The lending and borrowing museums accept that:

The care of museum objects is the top priority in the shipment, except in life-threatening situations.

The requirement of a courier will be established and agreed upon by the lending and borrowing museum by the time the loan agreement is signed and accepted.

The courier, acting as the agent of the lending museum, has full authority to act in protection of the object until the object is officially released to the borrowing museum.

Therefore:

The courier designated must be a museum professional (understanding the condition of the object and its special requirements, familiar with packing, trained in handling, and, as applicable, experienced with transport procedures), in whom the lending museum reposes complete trust for execution of all courier-related duties.

The museum which selects the courier is, in effect, bonding that person for knowledge of the problems of the object and of the transit, for ability to withstand the rigors of travel, and for taking full responsibility for protecting the object.

The courier will be made aware of and understand the responsibilities entrusted to him/her, and of all known or possible hazards which might be encountered in transit.

The lending and borrowing museums must agree in advance on costs related to the courier, on which museum shall pay for them, and on the method of reimbursement for expenses whether foreseen or unforeseen.

The shipment of a museum object will not become the basis for unrelated travel or activity.

Courier Procedures

Who Selects a Courier?

The decision to select a courier should be made in consultation among the director, curator, registrar, and conservator, or by one of these, in accordance with authority specified in museum policy.

Who Is Qualified to Be a Courier?

Directors, curators, registrars, conservators, and, in certain cases, senior preparators, should be the only people eligible to serve as couriers. People who serve as couriers must be those who are experienced in handling museum objects.

The courier must possess certain qualities: firmness, patience, stamina, and the ability to make intelligent decisions quickly. If the object is to be hand-carried, the courier must have the physical strength to do so. The courier should not carry any luggage while hand-carrying an object. He/she must possess packing skills, be able to make condition reports and effectively use a camera, and be familiar with shippers, brokers, customs, surface transportation, and airport and airline procedures.

Borrower and Lender Agreements and Responsibilities

The agreement to courier an object should be included as part of the loan agreement or a separate written agreement. If the lender has special requirements (that the object be a hand-carry, that it travel flat, that armed guards be required from the door of the aircraft to the door of the museum, that first-class travel is necessary, that an extended stay by the courier at the borrower's institution is required, or special installation instructions), these should be stipulated in writing at the outset. The borrower should clearly outline its courier procedures regarding all flight details or surface arrangements, arrival, unpacking, condition reporting, and installation, as they apply. All arrangements should be understood by all parties well in advance of the shipping date, including back-up plans for sudden schedule changes. Hotel accommodations and terms for daily expenses should be clearly set forth as part of the formal agreement. It is incumbent upon both borrowing and lending museums and their appointed couriers to make every effort to adhere to cost-effective planning and implementation of courier expenses.

Arrangements

The borrowing and lending institution registrars or loan officials make the arrangements for the loan and courier in accordance with accepted practice and the loan agreement.

The registrar or borrower's representative must meet the courier upon delivery. The courier must know exactly where he/she is to be met when arriving. For international shipments, the borrower's customs broker must be at plane-side if possible to supervise off-loading while the borrower is bringing the courier to cargo to meet the broker and shipment. The borrower should not move the shipment until the courier is present unless an emergency develops. The borrower's broker must make incoming customs clearance arrangements so that the objects are not jeopardized at the airport by having their crates opened for inspection. The borrower must provide suitable vehicles to get the courier and shipment from the airport to the museum, and provide personnel at the museum to help off-load the truck. If courier and object are in separate vehicles they should travel in tandem.

Once the courier is satisfied that the object is safely stored, the borrower should assist the courier in getting to his/her hostel, and should inform the courier how and when to return to the museum to unpack the object. Twenty-four hours should be designated for object acclimatization. The borrower should provide help to unpack, prepare and install the object as necessary, and should initial the courier's condition report.

The borrower must provide secure storage for the courier's objects. The borrower must recognize that the courier has authority over the object until the courier is satisfied with its disposition. The courier should act cooperatively with the borrower's staff and accommodate shipping arrangements and installation schedules.

Accompanied Shipment

An accompanied shipment is one in which a courier agrees to oversee other museum loans in the same shipment, but is not responsible for overseeing packing, unpacking, or making condition reports. Museums and couriers should have a written agreement regarding the accompaniment of their or other objects, clearly stating what the courier is

expected to do about other objects, with respect to both responsibility and authority.

Responsibilities of the Courier

The courier constitutes a continuous chain of accountability for the object, from the hands of the lender to those of the borrower. The implication is that the courier can take efficient, rapid, on-site action to preserve the object from, or through, high-risk situations in transit. Secure and expeditious movement of the object can reduce high risk to lower levels of risk.

Responsibilities to the Object

The courier is responsible for witnessing and supervising packing, unpacking after the acclimatization period, transportation, and examination of the object at the beginning and end of shipment.

The courier must stay with the shipment, physically and personally or via constant contact with centers of authority in direct control of the shipment (e.g., customs brokers) where physical presence by the courier is restricted.

The courier must do all that may be necessary to keep delays or possibilities of delays to a minimum. The courier is responsible for anticipating, solving, and reporting unforeseen problems. In the event of a major change in weather, for example, the courier must decide whether it is advisable for the shipment to proceed.

The courier must have no conflicting obligations or reasons for couriering the object. The courier's family/friends must not travel with the couriered shipment; the courier must not be required nor requested, nor allowed to visit other locations for personal or museum matters before the object is safely delivered; and the schedule of shipment of the object must not be forced to meet appointments nor to ease the courier's trip at the expense of the object.

Skill, Knowledge, and Abilities

The courier must understand and uphold the museum's standards as stated in institution policies. The courier must have vocational knowledge, founded upon practical experience in museums, to understand how these policies relate to "real life" circumstances. The courier must also understand the performance expectations of the borrower.

The courier should join in the pre-evaluation of shipment difficulties: dropped cases, fork-lift hazards, major temperature and humidity variations, palletization and containerization problems (e.g., objects that were wet, excessively heavy, or loose in the container with museum crates), insecure strapping, unscheduled unloading, etc.

The courier must have a knowledge of the object's construction techniques, material and condition, and must understand the sensitivity of materials and techniques to the varying conditions of transit. He/she must be able to recognize condition problems that require examination or treatment by a conservator.

The courier must know exactly where the object is going, to whom, and by what means, including alternate/back-up routes if schedules are delayed, altered, or canceled.

The courier should have available from his/her institution or from the borrower:

- a copy of the loan agreement
- business or home addresses, telephone and telex numbers of principals (both borrowers and lenders)
- schedules of transit, including alternates
- insurance restrictions, and a copy of the certificate of insurance
- crate numbers, sizes, weights, and object checklists
- handling instructions
- condition reports
- photograph(s) of the object(s)
- copy of the customs invoice

The courier should leave an itinerary with the registrar's office.

The courier should be prepared in advance for delays, cultural differences in conducting business, language barriers, international telephone and telegraphy procedures, possible strikes, and different local and national holidays.

The courier must understand and appreciate the support functions, procedures, restrictions, and authority of carriers, forwarders, customs agents, airport security, lenders, and borrowers. The courier must understand the extent of his/her own authority and responsibility, and ascribe neither too little nor too much authority to someone else.

The courier must have a sound knowledge of government regulations that can limit or curtail courier actions (e.g., restricted entry).

Information should be given only to priority individuals directly involved in the transit of the object and with a justified need to know. The courier should not tell them anything more than is necessary for them to do their job.

The courier should have some knowledge of shipping, including under-seat sizes, storage areas on board aircraft, and how to seal truck and container locks properly.

The courier must record any container numbers for crated objects, should know position numbers within aircraft, and be seated on the aircraft loading side to watch for unscheduled unloading of crates.

The courier must secure identification of anyone taking crated objects, before releasing the crates. The courier must obtain authorized signature and date on receipts.

The courier must carefully read and understand every document or receipt before signing it, requesting translations when necessary.

The courier must take neither alcohol nor medication that might in any way impair his/her physical mobility and/or ability to make decisions.

The courier should keep accurate accounting of expenses, including copies of all receipts.

Responsibility to the Borrower

The courier must know the borrower's requirements.

The courier is representing his/her institution and as such should conduct himself/herself fairly and ethically:

- The courier should expect to travel coach class unless hand-carrying an object.
- The courier should not make last-minute changes of plan unless essential to the shipment, but if necessary then the borrower should be immediately notified.
- No arrangements should be made that would cause unnecessary risks, complicated timetables, or extra expense.

Accession: (1) An object acquired by a museum as part of its permanent collection; (2) the act of recording/processing an addition to the permanent collection (Nauert 1979); (3) one or more objects acquired at one time from one source constituting a single transaction between the museum and a source, or the transaction itself (Burcaw 1997).

Accession number: A control number, unique to an object, whose purpose is identification, not description (Nauert 1979).

Accompanier: A courier who oversees transport of another museum's shipment while it is traveling with the courier's own shipment.

Accredited scientist: Any individual associated with, employed by, or under contract to and accredited by an accredited scientific institution for the purpose of conducting biological or medical research, and whose research activities are approved and sponsored by the scientific institution granting accreditation.

Accredited scientific institution: Any public museum, public zoological park, accredited institution of higher education, accredited member of the American Zoo and Aquarium Association, accredited member of the American Association of Systematic Collections, or any state or federal government agency that conducts biological or medical research.

Acetone: Dimethyl ketone, a colorless, low boiling, volatile liquid soluble in water and many other organic liquids. Commonly used for a solvent for adhesives. Highly flammable (Rose and de Torres 1992).

Acid migration: The transfer of an acid from a more acidic material to a less acidic material with which it is in contact (Nauert 1979).

Acid-free: A term loosely used for papers and other materials that are often pH neutral or alkaline buffered; could be any pH from 6 to 11 (Rose and de Torres 1992).

Acidic: Acid forming or containing an excess of acid-forming substances. Having a pH less than 7.

Actual notice: Written notice that is received in fact by the person to be notified.

Adverse possession: A method of acquiring title to property by possession under certain conditions including that the possession must be adverse to the owner, actual, continuous, and exclusive.

Airbill: See **air waybill**.

Air waybill: The basic shipping document in air freight; it is both the contract of carriage between the shipper and carrier and the receipt for the shipment (Case 1988).

Alkaline: Having a pH value greater than 7.

All-cargo aircraft: An aircraft able to accommodate large shipments and that does not carry passengers except couriers by arrangement.

All-risk: An insurance policy that covers damage by all perils except those specifically excluded in the policy. (Contrast with named or specific perils contract.) (Gallery Association of New York State 1985.)

Anoxic: Condition of having insufficient oxygen to sustain life.

Aperture: Hole in the lens through which light travels to strike the film. In most photographic lenses, the aperture size is adjustable and measured in f-stops.

Archival value: The value of documentary materials for continuing preservation in an archival institution (Daniels and Walch 1986).

Archives: (1) The non-current records of an organization or institution preserved because of their continuing value; (2) the agency responsible for selecting, preserving, and making available records determined to have permanent or continuing value; (3) the building in which an archival institution is located (Daniels and Walch 1986).

Arrangement: The archival process of organizing documentary materials in accordance with archival principles (Daniels and Walch 1986).

American Standards Association (ASA): System used to rate film speed.

Backup, full: Copying all computer files onto disk or, more usually, tape, for safe keeping.

Backup, incremental: Copying newly made computer files to disk or, more usually, tape, for safe keeping.

Bailment: A legal relationship created between a lender and borrower of property whereby the borrower keeps the property until the lender reclaims it.

Bailor, bailee: The bailor (lender) is the party who delivers the property to the bailee (borrower) in a bailment relationship.

Bar code: Variable-width stripes on packaging or tags that identify the item and provide other data when read by an optical scanner (Duckworth et al. 1993).

Batting: Non-woven natural or synthetic fiber wadded into a fibrous mass used for padding or stuffing (Rose and de Torres 1992).

Best: An independent rating firm that grades company on their financial soundness.

Bill of lading: The basic document in van, truck, or ocean shipping; it is both the contract of carriage between the shipper and carrier and the receipt for the shipment. See also: **air waybill** (Nauert 1979).

Blanket insurance policy: An insurance contract that covers several classes of property at a single location or at multiple locations (Gallery Association of New York State 1985).

Boom: The extension arm of a crane that allows the equipment to "reach" the object to be moved.

Breakaway case: Built with sides and top removable, leaving a pallet with the object on it.

Buffer: A substance containing both a weak acid and its conjugal weak base, used to restrain the acid migration of a material. Acid-free paper products are often buffered.

Cable release: A flexible wire that screws onto a shutter release button, making it possible to depress the shutter release button at a distance from the camera. It is also used to decrease vibrations during film exposure.

Calipers: A measuring device consisting of a pair of moveable, curved legs fastened at one end with a screw or rivet, used to measure the diameter or thickness of an object (Nauert 1979).

Cargo close-out: The time given by which shipments must be checked in to enable aircraft to be properly loaded and balanced.

Cargo terminal: A cargo-handling shed where shipments are loaded onto pallets or into containers, usually distant from the passenger terminal.

Case: Strong, closed, waterproof box constructed from a variety of hard materials. Used to protect museum objects during periods of movement or in storage.

Cause of action: Facts that give a person the right to bring his or her claim to court.

Cavity pack: To fit an object into a space specifically made to conform to its shape.

Center of gravity: The point of an object at which it will balance when lifted. For a safe and stable lift, the load line must be directly above this point. The ability to discern the center of gravity is the responsibility of the rigger.

Certificate of insurance: A document, signed by the insurance company or its agent, that is written evidence of insurance in force at the time of issuance. Museums or lenders often require certificates of insurance from one another before releasing objects on loan (Nauert 1979).

Chain fall: A reduction gear hoisting device that uses a continuous chain to raise or lower heavy objects. Used primarily with gantry or "A" frame; the capacity is rated by tons.

Claim: In insurance, a formal, written demand by the insured for payment for a loss coming under the terms of the insurance contract (Gallery Association of New York State 1985).

Climate control: The ability to adjust and regulate the temperature and relative humidity of a particular environment (Nauert 1979).

Climate-controlled van: One in which the temperature and relative humidity can be adjusted and regulated within certain limits (Nauert 1979).

Co-insurance clause: A property provision that requires that the policy-holder carry insurance equal to a specified percentage of the property's value (Gallery Association of New York State 1985).

Combination flight: An aircraft able to accommodate cargo containers and pallets as well as a reduced load of passengers.

Commercial activity: Related to the offering for sale or resale, purchase, trade, barter, or the actual or intended transfer in the pursuit of gain or profit, of any item of wildlife, and includes the use of any wildlife article for the purpose of facilitating such buying and selling provided, however, that it does not include exhibition of such articles by museums or similar cultural or historical organizations.

Commercial invoice: A document included in international shipping papers stating the object name, date, country of origin, materials, value, owner, and whether or not the object will be returned.

Common law: Refers to legal principles that do not rest for their authority on any express statue, but rather upon statements of principles found in court decisions.

Compactor storage: High-density storage system with moveable units on rails, accessed by one aisle whose location can be changed by moving units with manual or electric controls.

Condition: (1) the physical state of an object; (2) a contract provision or stipulation (Nauert 1979).

Condition photograph: A photograph or series of photographs that clearly document all defects, flaws, and the physical condition of an object (Nauert 1979).

Conservation: Maximizing the endurance or minimizing the deterioration of an object through time, with as little change to the object as possible (Lord and Lord 1991).

Conservator: Trained professional who treats objects to repair damage, maximize endurance, and minimize deterioration.

Constructive notice: Notice that is implied by law rather than notice that is actually mailed and received by the person being notified such as legal notices published in a newspaper.

Container number: Large identifying number on outside of each container usually three letters followed by four numbers to aid in tracking of shipments.

Continuous custody: (1) In contemporary U.S. usage, the archival principle that to guarantee archival integrity, archival material should either be retained by the creating organization or transferred directly to an archival institution; (2) in British usage, the principle that non-current records must be retained by the creating organization or its successor in function to be considered archival (Daniels and Walch 1986).

Contour bracing: Padded braces fitted to an object's contour, attached to the inside of a wooden crate to keep the object from moving. Generally used with large, heavy objects. Braces are removable.

Country of exportation: The last country from which the animal, plant, or object was exported before importation into the United States.

Country of origin: The country where the animal or plant was taken from the wild, the object was made, or the natal origin of the animal.

Courier: An individual, usually a representative of the owner of an object, who travels with the object to ensure its proper care and safe arrival.

Crane: A mobile unit equipped with boom, cable, and draw works, capable of 360-degree rotation around a center pin. Rated in ton capacity.

Crate markings: Symbols, numbers, and letters stenciled on the outside of a crate indicating proper handling, size, and weight of packed crate; identifying initials.

Cross docking: The transfer of a load one or more times from truck to truck.

Escort: A security guard who protects the shipment from unexpected interference during transit.

Cross-link: A crosswise part that connects parallel chains in a complex chemical molecule. In a polymer, two or more small molecules may combine to form larger molecules. The resulting molecules may have different chemical properties than the original molecules including solubility, etc.

Customs broker: An individual or firm that arranges customs clearance of objects traveling between countries; frequently employed also as a freight-forwarding agent for international shipments.

Customs seal: A warning tag or label affixed to a shipping box by a customs official at the original port-of-entry. It is a guarantee to the customs offi-cial who makes the inspection at the ultimate destination that the contents have not been tampered with (Nauert 1979).

Deaccession: (1) an object that has been removed permanently from the museum collection; (2) formal removal of accessioned objects from the museum's permanent collection. Objects removed from the unaccessioned collections of the museum are not considered deaccessions, but need to go through a formal removal process. See also: **disposal**.

Deed of gift: A contract that transfers ownership of an object or objects from a donor to an institution. It should include all conditions of the gift.

Depth of field: Zone from the points closest to the camera to the points farthest from the camera that are in acceptable focus.

Desiccation: Complete drying out; removal of all moisture.

Disposal: The act of physically removing object/s from a museum collection. See also: **deaccession**.

Dolly: A low, two- or four-wheeled flat cart or platform used to move objects.

Domestic shipment: The shipment of objects within one country (Nauert 1979).

Double-crating: One box or case inside another with cushioning between.

Emulsion: (1) A suspension of small globules of one liquid in a second liquid with which the first will not mix; (2) a photosensitive coating, usually of silver halide grains in a thin gelatin layer, on photographic film, paper, or glass.

Endangered species: Any species in danger of extinction throughout all or a significant portion of its range other than a species of the class *Insecta* determined by the secretary of interior, commerce, or agriculture to constitute a pest whose pro-

tection under the provisions of this act would present an overwhelming and overriding risk to man. A species of wildlife and plants listed as "endangered" pursuant to specific act. (e.g., Endangered Species Act, CITES)

Endorsement: In insurance, a form attached to the basic insurance contract that alters certain provisions in the policy (Gallery Association of New York State 1985).

Ephemera: Plural of ephemeron. Usually refers to paper objects that are intended to last only a short time.

Expired loans: Loans of limited duration for which the termination dates have passed.

Export: To depart from, to send from, to ship from, or to carry out of, or attempt to depart from, send from, ship from, or carry out of, or to consign to a carrier in any place subject to the jurisdiction of the United States with an intended destination of any place not subject to the jurisdiction of the United States.

Export license: Permission, usually granted by a governmental agency, to ship a native cultural object out of the country (Nauert 1979).

Export shipment: The shipment of an object or a group of objects out of the country (Nauert 1979).

Extended loan: An object loaned to a museum for long-term, sometimes indefinite, use. In terms of record keeping, extended loans are often treated as a part of the permanent collection.

Fish or wildlife: Any member of the animal kingdom, alive or dead, including without limitation any mammal, fish, bird (including any migratory, nonmigratory, or endangered bird for which protection is also afforded by treaty or other international agreement), amphibian, reptile, mollusk, crustacean, arthropod, coelenterate, or other invertebrate, whether or not bred, hatched, or born in captivity, and including any part, product, egg, or offspring thereof, or the dead body or parts thereof.

f-stop: Numerical indication of how large a lens opening (aperture) is. The larger the f-stop number, the smaller the opening; for example, f/16 represents a smaller aperture than f/2.

Flat-pack: Museum objects packed horizontally and separated by material (e.g., cardboard, Fome-Cor®). Generally has foam padding on sides, top and bottom of crate.

Foam core: Layer of plastic foam laminated on the outside by paper based material. (Rose and de Torres 1992).

Follow car: A vehicle carrying an escort and sometimes a courier that follows the van(s) containing the objects. An escort should not be the driver.

Fractional gift: A donation of an object or collection of objects to which the museum does not receive full title. Partial gifts are of two kinds. A fractional interest gift is one in which the museum is given a present fractional interest and the donor retains the remaining fractional interest. In these cases the museum is entitled to possession of the object for that portion of each calendar year equal to its fractional interest in the property (Nauert 1979.

Friable: Readily crumbled.

Gantry: Hoisting equipment consisting of vertical sides connected by a horizontal beam mounted high enough to provide a clear lift for an object below. Lift is usually provided by a chain hoist, and often a gantry can be constructed of two scaffolding towers connected by a beam.

Glassine: A dense, slick-surfaced translucent paper resistant to the passage of air and dirt; used as a wrapping material or for separation sheets (Nauert 1979).

Gross weight: For shipping purposes, the combined weight of the objects to be shipped, the packing materials, and the packing box. See also: **net weight**, **tare weight** (Nauert 1979).

Guillotines: See **contour bracing**.

Hand-carry: A packed object that can be carried by one person and is transported on or under an aircraft passenger seat or in a passenger vehicle.

Hand signals: Standardized and universal hand gestures developed by riggers to ensure proper operation without verbal communication. Proper use is critical in rigging.

Harass: In the definition of "take" in the Endangered Species Act, means an act that actually kills or injures wildlife. Such act may include significant habitat modification or degradation where it actually kills or injures wildlife by significantly impairing essential behavioral patterns, including breeding, feeding, or sheltering.

Herbarium: A collection of dried plant specimens, usually mounted and systematically arranged for reference; a place that houses such a collection (Rose and de Torres 1992).

Hitch: A method of temporarily connecting by loop, hook, or noose, an object to be moved to a lifting device such as a crane or gantry. Examples are single hitch, bridle hitch, basket hitch, and choker hitches.

Hoist: (1) A common piece of equipment used for lifting objects; (2) the process of moving an object.

HVAC: The acronym used to refer to heating ventilation and air conditioning systems.

Hygroscopic material: A material capable of absorbing moisture (Nauert 1979).

Hygrothermograph: An instrument that measures and records temperature and relative humidity changes (Nauert 1979).

Import: To land on, bring into, or introduce into, or attempt to land on, bring into, or introduce into any place subject to the jurisdiction of the United States, whether or not such landing, bringing, or introduction constitutes an importation within the meaning of the tariff laws of the United States.

Import shipment: The shipment of an object or a group of objects into the country (Nauert 1979).

Impounded shipment: Objects in transit without proper permits or licenses, which are seized by customs on arrival at an airport.

Incidental taking: Any taking otherwise prohibited, if such taking is incidental to, and not the purpose of, the carrying out of an otherwise lawful activity.

Incoming loan: An object borrowed by an institution. It is an incoming loan from the perspective of the borrowing institution; such a loan could be an **outgoing loan** to the lending institution (Nauert 1979).

Indefinite loans: Loans that have no set duration.

Inert materials: Materials that are devoid of active properties and unable or unlikely to form compounds.

Insurance claim: A formal, written demand to an insurance company for reimbursement for loss of or damage to an insured object (Nauert 1979).

Integrated Pest Management: The selection, integration, and implementation of pest management methods based on predicted economic, ecological, and sociological consequences. A decision-making process that helps one decide if a treatment is necessary and appropriate, where the treatment should be administered, when treatment should be applied, and what strategies should be integrated for immediate and long-term results (National Park Service 1990).

J-Bar: Large shipper's tool in the shape of a "J" that allows leverage to be used when lifting a corner of a heavy package

Laches: An unreasonable delay that makes it inequitable to give the relief sought by a party in court.

Lacquer: (1) Any varnish coating, particularly those found on metal; (2) a solution of cellulose nitrate that dries to form a film; (3) urushi, or oriental lacquer

Load line: The line that bears the weight of a lift.

Loan agreement: A contract between a lender and a borrower of an object or objects, specifying the object(s) and outlining the conditions of loan and the respective responsibilities of each party.

Loss limit: The maximum amount an insurance policy will pay for a single loss.

Marine mammal: Any mammal that (1) is morphologically adapted to the marine environment (including sea otters and members of the orders *Sirenia*, *Pinnipedia*, and *Cetacea*), or (2) primarily inhabits the marine environment (such as the polar bear); and, for the purpose of this act, includes any part of any such marine mammal, including its raw, dressed, or dyed fur or skin.

Material Safety Data Sheets (MSDS): Provided by manufacturers, these sheets include data on the volatility, flammability, toxicity, and other safety-related information about a specific chemical or material.

Microfoam: See **polyethylene/polypropylene foam**.

Micro-environment: A climate-controlled and secure space for the display or storage of artifacts or specimens within a sealed case or frame, used in buildings where such control is not feasible in entire rooms (Lord and Lord 1991).

Net weight: For shipping purposes, the weight of the object being shipped, exclusive of the weight of the box or packing materials. See also: **gross weight**, **tare weight**. (Nauert 1979).

Nitrile rubber: A synthetic rubber which is highly oil resistant.

Nomenclature: A system of terms used in a particular science or discipline.

Off-gassing: The process of releasing (usually slowly) volatile materials from woods, some paints, some polymers, etc. Many of these volatile materials contribute to the deterioration of objects (Rose and de Torres 1992).

Old loans: Expired loans or loans of unlimited duration left unclaimed by lenders at the museum; the term also includes unclaimed objects left at the museum under informal custody arrangements for study or examination by museum staff.

One-way case: Simple case used for a single transit of an object. Often destroyed after one use.

Original order: The archival principle that records should be maintained in the order in which they were placed by the organization, individual, or family that created them (Daniels and Walch 1986).

Outgoing loan: An object loaned by a museum to another institution. It is an outgoing loan from the perspective of the lending institution; such a loan would be an **incoming loan** to the borrowing institution (Nauert 1979).

Pallet: A low, portable platform, usually of wood or metal, on which a heavy or bulky object is placed for storage, transport, or shipment (Nauert 1979).

Password: Secret code word used for access. Used in computer and telephone systems, computer programs.

PCS Permit: Any document designated as a "permit," "license," "certificate," or any other document issued by the management authority or responsible agency or office to authorize, limit, or describe activity and signed by an authorized official.

pH: An expression indicating the hydrogen-ion concentration of a solution; the negative logarithm of the hydrogen-ion concentration.

Pick (pick point): The point above the center of gravity at which an object is lifted; the point at which the load line and the rigging meet.

Plant: Any member of the plant kingdom, including seeds, roots, and other parts thereof.

Polyethylene foam: Foam made by the introduction of gas or by inclusion of a gas-evolving chemical in molten polyethylene; sheets of polyethylene foam are inert and stable.

Polyprophylene foam: Foam made from polypropylene resin, similar in process to polyethylene foam. Sheets of polyprophylene are inert and stable.

Possession: The detention and control, or the manual or ideal custody of anything that may be the subject of property, for one's use and enjoyment, either as owner or as the proprietor of a qualified right in it, and either held personally or by another who exercises it in one's place and name. Possession includes the act or state of possessing and that condition of facts under which one can exercise his power over a corporeal thing at his pleasure to the exclusion of all other persons. Possession includes constructive possession, which means not actual but assumed to exist, where one claims to hold by virtue of some title, without having actual custody (endangered species article).

Powder coating: A coating made from spraying powdered thermosetting resins onto a metal substrate, which are then set by baking (Rose and de Torres 1992).

Provenance: For works of art and historical objects, the background and history of ownership. The more common term for anthropological collections is "provenience," which defines an object in terms of the specific geographic location of origin. In scientific collections, the term "locality," meaning specific geographic point of origin, is more acceptable (Nauert 1979).

Psychrometer: An instrument for measuring the relative humidity by means of an air flow across two thermometers, one of which (the "wet" bulb) is covered by a moistened wick. Often used to help with calibration of hygrothermographs and as an independent check of relative humidity.

Rail and trolley: A device that allows for the lateral movement of an object to be lifted. The trolley mounts to and rolls along the rail, the horizontal member of a gantry, usually an I-beam. Useful when an object is to be removed from a pedestal and then lowered to the floor or to a dolly.

Reciprocity law: The theoretical relationship between the length of the exposure (shutter speed) and the intensity of the light (aperture) that dictates that an increase in one will be balanced by a equal amount of decrease by the other. This means that if you meter a scene and decide the exposure will be f/5.6 at 1/60 second you could obtain the same exposure by doubling your f-stop and cutting your exposure in half: f/4 at 1/125 second. Or you could do the opposite obtaining an exposure of f/8 at 1/30 second.

Reciprocity failure: The failure of the reciprocity law to apply. This occurs at one second and longer when the normal ratio of aperture and shutter speed will underexpose the film and at 1/10,000 second and faster. When using black-and-white film with exposures of one second or longer, exposures just need to be increased to avoid underexposure. When using color film in these conditions, color shifts will occur because the three emulsions do not respond to the reciprocity effect in the same manner. To compensate, follow exposure and filtering instructions provided with the film, along with a little trial and error.

Re-export: Export of wildlife or plants that have been previously imported.

Registration: The process of developing and maintaining an immediate, brief, and permanent means of identifying an object for which the institution has permanently or temporarily assumed responsibility (Nauert 1979).

Relative humidity (RH): The proportion of actual vapor pressure of air to its saturation vapor pressure at that temperature.

Rigging: (1) The art of combining and securing the proper slings and hitches to the proper pick point of an object to be lifted. The person responsible for this is the rigger; (2) the actual slings and equipment used in moving large objects.

Risk assessment: Evaluation of museum object for suitability to travel.

Seal: A metal wire and numbered disc that is used to seal locks on vehicle or container doors to deter and monitor tampering with shipments in holding areas or in transit.

Seamless: A backdrop used in photography to create an even background for the main subject. Materials usually consist of large rolls of paper or large pieces of fabric.

Series: A body of file units or documents arranged in accordance with a unified filing system or maintained by the record creator as a unit because of some relationship arising out of their creation, receipt, or use (Daniels and Walch 1986).

Shellac: A preparation of lac, usually dissolved in alcohol, and used chiefly as a wood finish.

Sight line: The range of a guard's view of objects on display in which large objects do not obscure small objects.

Sight measurement: An approximate measurement of an object, usually a painting or a work of art on paper, taken when the full extremities of the piece are inaccessible (Nauert 1979).

Silica gel: A granular substance that has high moisture-absorbing and emitting properties and is used as a moisture stabilizer in packing, storing, and exhibiting humidity sensitive objects.

Slat/skeleton crate: Crate with solid bottom and wood slat sides. Sometimes lined with cardboard. May or may not have a top.

Sling psychrometer: An instrument used to determine relative humidity. It consists of a wet and dry bulb thermometer, with the difference between their readings constituting the measure of the moisture in the air (Nauert 1979).

Slings: The rope, cables, or woven straps used in rigging.

Soft packing: Packing an object without enclosing it in a hard-shell box or case, using a variety of soft materials.

Solander® Box: A ready-made box of acid-free board; frequently used for the storage of documents, unframed works on paper, etc. (Nauert 1979)

Species: Any subspecies of fish, wildlife, or plants, and any distinct population segment of any species or vertebrate fish or wildlife that interbreeds when mature.

Specimen: Any animal or plant, or any part, product, egg, seed, or root of any animal or plant.

Standard facility report: A form completed by the borrower of objects to demonstrate his or her institution's suitability as a venue to lenders of objects.

Statutes of limitations: Laws that require that claims be brought to court within a limited time period or otherwise the right to claim is barred.

Stowage requirements: The requirements based on the structure of an object that dictate which way up it can be placed, how far off center it can be tipped when handled, and which plane of travel is preferable.

Straight truck: A small truck, from 12 to 24 feet, designed with body and cab connected

Subgroup: A body of related records within a record group, usually consisting of the records of a primary subordinate administrative unit or of records series related chronologically, functionally, or by subject (Daniels and Walch 1986).

Substrate: In conservation, the immediate surface to which a coating or adhesive material is applied, e.g., the lacquer on a lacquered metal, not the metal seen beneath the lacquer.

Systematics: The science of classifying all organisms, both living and extinct, and of investigating the relationships between them; the field of science concerned with taxonomy and phylogeny (Duckworth et al. 1993).

Tag line: One or more control lines that are attached to an object before a lift takes place; used to control the sway, stability, and placement of the object.

Take: To harass, harm, pursue, hunt, shoot, wound, kill, trap, capture, or collect, or to attempt to engage in any such conduct.

Tare weight: For shipping purposes, the weight of the packing box, including packing materials, without the object it was build to contain. The term can also be used to indicate the weight of an empty vehicle. See also: **gross weight**, **net weight**.

Taxidermy: The process of preparing animal skins and stuffing them in a lifelike form.

Taxonomy: The science or technique of classification; the discipline devoted to the identification, naming and classification of organisms (Duckworth et al. 1993).

Temperature: A degree of hotness or coldness.

Threatened species: Any species that is likely to become an endangered species within the foreseeable future throughout all or a significant portion of its range. A species of wildlife or plants listed as "threatened" pursuant to specific act (e.g., Endangered Species Act, CITES).

Tractor trailer: A two-part truck. The tractor is the cab where the driver sits, and the trailer, hooked to the tractor, hauls the freight

Transportation: The act of shipping, conveying, carrying, or transporting by any means whatsoever and delivering or receiving for such shipment, conveyance, carriage, or transportation.

Travel frame: (1) New or replacement frame used for travel instead of the original frame; (2) wood collar to which an object is attached for travel to allow wrapping. Used on paintings with ornate frames, paintings without frames or with minimal frames, flat sculptural works, and unusual works where the surface may not be touched by packing material.

Traveling: Any horizontal movement.

Traveling case: Case built to withstand a multi-stop tour, usually with reusable fastening hardware on the lid. Usually water resistant.

Tray pack: Objects placed in a tray or drawer using a foam cut-out to cushion them. Trays or drawers can be stacked into a foam-lined case; the weight is absorbed by the sides of the tray or drawer, avoiding pressure on the object.

Undocumented objects: Objects in the collections that lack any useful documentation as to how they were acquired.

Ultraviolet filter: A filter that can be placed over windows, skylights, and fluorescent light tubes, between the light source and museum object, to remove or reduce harmful ultraviolet rays in the light (Nauert 1979).

Ultraviolet radiation: Radiation of wavelengths shorter than 400nm, found in light from the sun, sky, and most artificial light sources; it is invisible and has a strongly damaging effect on collections.

Vapor barrier: A treated paper or combination of papers used in lining a shipping box to protect the contents from the effects of water.

Varnish: A resin dissolved in a solvent or solvent mixture, used to coat a surface with a hard, glossy, transparent film.

Worksheet: An informal document used to record basic catalog information pertaining to an object. From the form, catalog cards can be prepared (Nauert 1979).

Yokes: See **contour bracing**.

CO-EDITORS

Rebecca A. Buck and Jean Allman Gilmore have been working together on AAM Registrars Committee projects since 1987, when they began editing *REGISTRAR*, the Registrars Committee's journal. Both have also served as regional chairs of the Mid-Atlantic Association of Museums Registrars Committee.

Buck, Rebecca A.

Rebecca A. Buck is registrar at The Newark Museum, Newark, N.J. She was formerly registrar at the Hood Museum of Art, Dartmouth College (1982-1990) and the University of Pennsylvania Museum of Archaeology and Anthropology, Philadelphia (1990-1995); she was curator of collections at the Cheney Cowles Memorial Museum, Eastern Washington State Historical Society, Spokane, Wash., after eight years at that museum (1975-1982). She holds degrees from Oberlin College and Boston University and teaches in the museum professions program at Seton Hall University.

Gilmore, Jean Allman

Jean Allman Gilmore has been registrar of the Brandywine River Museum, Chadds Ford, Pa., since 1982. She earned a B.A. degree from Wittenberg University and a M.A. degree from the University of Wyoming and completed the museum studies program at the University of Delaware. She has served as chairman of the Mid-Atlantic Association of Museums Registrars Committee, secretary of the MAAM Board of Governors, and co-editor, with Rebecca Buck, of the journal *REGISTRAR*, published by the AAM Registrars Committee.

SECTION EDITORS

Alexander, Kristi

Kristi Alexander, manager of collections and registration at the Frank H. McClung Museum, also serves as an adjunct instructor in museum studies at the University of Tennessee, Knoxville. She is vice chair of the RC-AAM at the time of publication, and has served the committee as development officer as well. She holds an M.B.A. from Oklahoma, and has also served the profession as an IMLS grant reviewer, a MAP II reviewer, advisor, and speaker.

Benas, Jeanne M.

Jeanne M. Benas has been the registrar at the Smithsonian's National Museum of American History since 1994. Her collections management career began at the Smithsonian in 1977. She inventoried collections at American History from 1979 to 1982; was the assistant registrar at the National Air and Space Museum from 1982 to 1985, primarily working with loans; in 1985 she returned to American History as manager of the acquisitions program. She served as co-chair of the Mid-Atlantic Association of Museums Registrars Committee's Old Loan Task Force, and she became chair of the MAAM Registrars Committee in 1996.

Cato, Paisley S.

Paisley S. Cato has 18 years of museum experience, most recently serving as curator of collections for the Virginia Museum of Natural History in Martinsville, Va. During her six years at VMNH, she developed and implemented an institution-wide program for collections care and management. During this time, she also spent a year as interim director. She has worked previously at Texas A&M University, the Museum of Texas Tech University, the Brazos Valley Museum in Bryan, Tex., as a member of the board of trustees, and the Denver Museum of Natural History.

Fulton, Martha

Martha Fulton, who is the production control manager at Corbis Corporation, has an M.A. in art history from the University of Iowa. She held several positions at the Nelson-Atkins Museum of Art from 1978-1984, and eventually became the registrar there. She also served as the registrar of the Museum of History and Industry in Seattle from 1985 to 1995. During that time she was active in the Washington State Registrars Committee, the WRC and the RC-WR, where she served as state representative, secretary, and vice chair. She served as a MAP II reviewer for AAM, and in 1992 was elected chair of RC-AAM. It was during Martha's tenure as chair that the effort to revise *Museum Registration Methods* began.

Longstreth-Brown, Kittu

Kittu Longstreth-Brown is registrar at the University of New Mexico Art Museum, Albuquerque. She previously served as head registrar at the Portland (Oregon) Art Museum and as chief registrar at the Fine Arts Museums of San Francisco. Longstreth-Brown has a B.A. from Oberlin College and an M.Ed. from Harvard University.

Lord, Allyn

Allyn Lord is assistant director at the Rogers Historical Museum, Rogers, Ark., having previously served as registrar at The University Museum, University of Arkansas. Lord has been involved in numerous museum organizations, serving as chair of the program committee and state director on the council of the Southeastern Museums Conference, chair and treasurer of the Southeastern Registrars Association, president and treasurer of the Arkansas Museums Association, organizer of regional natural history and historic house affinity groups, and a founding member of the Ozark group for Emer-gency Resources. She has written and co-edited *Basic Condition Reporting: A Handbook* and *Steal This Handbook! A Template for Creating a Museum's Emergency Preparedness Plan*. Having served as a field reviewer for MAP II and IMLS-GOS, Lord received the Southeastern Museums Conference Leadership Award in 1996.

Montgomery, Renee

Renee Montgomery, assistant director, collections at the Los Angles County Museum of Art, was formerly registrar at that museum. She holds an M.A. in art history from UC Riverside, and has served the RC-AAM as development officer, vice chair and, from 1988-90, chair.

Quigley, Suzanne

Suzanne Quigley is head registrar, collections and exhibitions at the Solomon R. Guggenheim Museum. She previously served as head registrar at the Detroit Institute of Arts and as audio-visual librarian at Olin Library, Kenyon College. Quigley holds an M.L.S. degree from UW-Madison and has published and lectured widely on museum computerization. She has also been a board member of the Museum Computer Network and editor of its quarterly magazine, *SPECTRA*.

AUTHORS

Adkins, Lynn

Lynn Adkins is the former curator of collections at Historical Belmar Village, Lakewood, Colo., and past chair of the Mountain-Plains Museum Association Registrars Committee (RC-MPMA). Previously she held the position of head registrar at the Museum of New Mexico.

Awerdick, John

John H. Awerdick is a partner at Williams, Caliri, Miller, and Otley, Wayne, N.J. He concentrates in advertising, intellectual property, and trade regulation. He has spoken throughout the country and written extensively about legal and policy issues involving these areas of law. Prior to joining the law firm he was an attorney and vice president at Columbia House, a division of CBS. He received his Juris Doctor from Fordham University Law School.

Bakke, Julia A.

Julia A. Bakke has been registrar of the Menil Collection in Houston since 1985. Before that she served as assistant registrar for loans at the Philadelphia Museum of Art. She holds a degree from Mount Holyoke College.

Bennett, K. Sharon

K. Sharon Bennett is archivist for The Charleston Museum and project consultant for the South Carolina Education Project. She is a frequent lecturer on preservation topics and a specialist in disaster planning and recovery.

Berkow, Racine

Racine Berkow, president of Racine Berkow Associates, licensed freight forwarders and customs brokers, was formerly registrar at The Jewish Museum. Berkow was a founding member of the Registrars Committee of the American Association of Museums. She is an active member of ArtTable and a lecturer in the area of fine arts transport.

Bitz, Gwen

Gwen Bitz is registrar at Walker Art Center, Minneapolis, where she began museum work in 1972. In 1983 she left the Walker to serve as registrar, three years each, for The Museum Fund, Minneapolis and New York, and for The Minneapolis Institute of Arts. She returned to Walker as registrar in 1990.

Bothwell, Joseph

Joseph Everett Bothwell is an art appraiser for the IRS Art Appraisal Services in Washington, D.C. He studied at The American College in Paris, France, received a B.A. in art history and history from San Diego State University, and has an M.A. in art history from George Washington University. Bothwell served as a copy cataloger at the National Gallery of Art Library and has been with the IRS since 1978.

Breisch, Nancy L.

Nancy L. Breisch is a specialist in urban entomology and integrated pest management at the University of Maryland in College Park. Her research interests include the ecology and behavior of termites, carpenter ants, and social wasps. Active in technical outreach efforts, Breisch coordinates one of the principal annual training and recertification conferences for the structural pest control industry.

Carnell, Clarisse

Clarisse Carnell is registrar for the collections at the Philadelphia Museum of Art. She began work in the library of the museum in 1975 and has been in the registrar's office since 1980. Carnell is also a classically trained pinhole photographer with works in the permanent collection of the Victoria and Albert Museum, the International Center for Photography, and the George Eastman House.

Collier, Malinda W.

Malinda W. Collier has been on the staff of The Museum of the Confederacy for 12 years. Hired as the museum's first registrar, she is now the director of collections. Collier serves as a MAP II surveyor, IMLS-GOS reviewer, and adjunct faculty for museum studies at Virginia Commonwealth University.

Cowan, Suzanne

Suzanne Cowan is chief of collections at the New Mexico Museum of Natural History and Science. She has previously worked at the Maxwell Museum of Anthropology, University of New Mexico, in the collections and photo archives. Cowan has a B.A. in anthropology from the University of California, Los Angeles, and an M.A. in anthropology from the University of New Mexico, Albuquerque.

DeAngelis, Ildiko Pogany

Ildiko P. DeAngelis serves as assistant general counsel of the Smithsonian Institution. After graduating from the Washington College of Law, she joined the firm of Steptoe & Johnson in Washington, D. C., and thereafter joined the Smithsonian's legal staff. Her practice includes legal advice on management of museum collections maintained by the 16 museums and bureaus of the Smithsonian Institution. She teaches part-time at the George Washington University's Graduate School in Museum Studies, and is the author of many articles related to laws affecting the management of museum collections.

Demeroukas, Marie

Marie Demeroukas has been registrar at the Rogers Historical Museum, Rogers, Ark., since 1987. She has been active in several museum-related organizations including state director and membership chair, Southeastern Museums Conference, and state representative and vice chair, Southeastern Registrars Association (SERA). Marie has produced two SERA publications, *Steal This Handbook: A Template for Creating a Museum's Emergency Preparedness Plan* (co-author) and *Basic Condition Reporting: A Handbook* (editor, 3rd edition).

Douglas, Anne Fuhrman

Anne Fuhrman Douglas has worked in the field of collections management for 15 years. Working as the registrar at the Ackland Art Museum (University of North Carolina at Chapel Hill) since 1991, she has also been employed at the Metropolitan Museum of Art and the Philadelphia Museum of Art. Douglas received her M.A. from the College of William and Mary, and her B.A. from Drew University.

Estep, Connie

Connie Estep has been registrar at the Museum of the Rockies in Bozeman, Mont., since 1991. She served as a registrar in the National Park Service in Alaska from 1989 to 1991. Estep has degrees in biology, history, and anthropology with a specialty in museum studies.

Fenn, Julia

Julia Fenn is currently the ethnographic conservator at the Royal Ontario Museum in Toronto, Canada. She has worked in the field and in museums on three continents and has observed hazardous practices on an international scale. She has been writing and lecturing on the topic of hazards in the workplace for more than a decade.

Fisher, Genevieve

Genevieve Fisher is registrar at the Peabody Museum of Archaeology and Ethnology, Harvard University, Cambridge, Mass. She has lectured in museum studies courses at both Tufts and Harvard Universities.

Francell, Larry

Larry Francell is a visiting lecturer at the Department of Museum Studies at Baylor University, Waco, Tex.; a member of the P.A.C.I.N. task force of RC-AAM; a trustee of the Arlington Museum of Art, Arlington, Tex.; and vice president of FAE, Inc. He was formerly director of the Wichita Falls Museum and Art Center, manager for the construction of the Dallas Museum of Art, and director of operations for the Dallas Museum of Art. He was a member of TexPrep, a Texas Association of Museums committee appointed to publish a disaster planning manual.

Freitag, Sally

Sally Freitag has been chief registrar at the National Gallery of Art since 1992. She was previously registrar at the Worcester Art Museum, Worcester, Mass. She also served as associate registrar at National Gallery of Art from 1973 to 1983 and has served on the Art and Artifacts Indemnity Panel.

Freund, Leslie

Leslie Freund has worked in university, federal, state, and private museums in the fields of collections management and registration for the past 12 years. She has an M.A. in museum science from Texas Tech University and is presently collections manager at the Phoebe Apperson Hearst Museum of Anthropology.

Gibbons, Monique Maas

Monique Maas Gibbons has been assistant registrar at the J. Paul Getty Museum since 1995. She has a B.A. in Near Eastern archaeology from Wellesley College and a M.Phil. in Islamic art and architecture from Oxford University. She previously served as assistant registrar at the J. Paul Getty Museum.

Gilboe, Roberta Frey

Roberta Frey Gilboe is an associate registrar at the Detroit Institute of Arts. She has worked on documentation and computer implementation issues both at the DIA and at the Historic New Orleans Collection, where she worked as the curatorial cataloguing coordinator

Greene, Albert

Albert Greene developed and oversees the integrated pest management program for the General Services Administration's (GSA) Public Building Service, which operates or leases about 8,000 federal government buildings nationwide. His responsibilities include contract administration, technical policy, and interagency liaison on the federal, state, and municipal levels. Greene also supervises regional GSA programs in horticulture, solid waste management, and custodial services.

Haifley, Julie L.

Julie L. Haifley is registrar at the National Museum of African Art, Smithsonian Institution, Washington, D.C. She is currently dealing with copyright issues as well as CITES requirements associated with the museum's new collecting initiative focusing on contemporary African art. Haifley was formerly registrar at the Textile Museum, Washington, D.C., where she was responsible for initiating the museum's first collections management policy.

Hennum, Paulette Dunn

Paulette D. Hennum has been registrar at the Crocker Art Museum in Sacramento, Calif., since 1985. She had previously served as assistant registrar at the San Diego Historical Society and at the San Diego Museum of Art. Her degree is from the University of California at San Diego.

Holahan, Mary F.

Mary F. Holahan has been registrar of the Delaware Art Museum since 1977. She received her Ph.D. in art history from the University of Delaware in 1978. Holahan has taught and lectured widely on art history and fine arts collections management. She has also been active in various professional committees.

Hummel, Charles

Charles Hummel is curator emeritus and adjunct professor of advanced studies at Winterthur Museum, Winterthur, Del. He retired from Winterthur in 1991 as deputy director for the museum and library department. Hummel has served as secretary of the American Association of Museums and was the recipient of the Katherine Coffee Award from the Mid-Atlantic Association of Museums in 1989.

Jacobson, Claudia

Claudia Jacobson is registrar at the Milwaukee Public Museum in Wisconsin. She was a participant in the National Science Foundation and Bay Foundation Pilot Training program in anthropology collections management and currently teaches museum methods and curation at the joint University of Wisconsin-Milwaukee/Milwaukee Public Museum graduate-level museum studies program.

Johnston, Elaine

Elaine Johnston is assistant general counsel, Smithsonian Institution, Washington, D.C. She has held this position since 1985.

Jones, Reba

Reba Jones is collections manager at the Amarillo Museum of Art, Amarillo, Tex. She interned at the Texas Conservation Center and for her master's in museology wrote a handbook for art handlers. She is an IMLS-GOS reviewer and has served RC-AAM as chair of the nominating committee, the Mountain-Plains Museum Association Registrars Committee (RC-MPMA) as councilor-at-large, and RC-MPMA as secretary and nominating committee chair.

Kettle, John R.

John R. Kettle III is counsel at Stryker, Tams & Dill in Newark, N.J. and New York. He concentrates in intellectual property, entertainment, arts, and publishing law. He is also an adjunct professor at Rutgers Law School-Newark and Seton Hall University School of Law, where he teaches copyright, trademark, intellectual property, and entertainment law. He received his Juris Doctor from Rutgers University School of Law-Newark.

McKeown, C. Timothy

C. Timothy McKeown is an archaeologist with the National Park Service, Department of the Interior. His office implements the Native American Graves Protection and Repatriation Act (NAGPRA). McKeown lectures widely and writes on the subject of repatriation.

McLaren, Suzanne B.

Suzanne B. McLaren is collection manager of the Section of Mammals at the Carnegie Museum of Natural History, Pittsburgh, where she has been employed since 1977. She is a charter member of the Society for the Preservation of Natural History Collections (SPNHC), serving on the Documentation Committee, as co-chair of the Finance Committee, and council member-at-large. In 1993, McLaren received the SPNHC President's Award. She is also active in the American Society of Mammalogists, serving as chair of the Information Retrieval Committee and as a member of the ASM Board of Directors.

Morris, Martha

Martha Morris is deputy director of the National Museum of American History. Morris was registrar of the Corcoran Gallery of Art and has also served the National Museum of American History as assistant registrar, registrar, and assistant director, collections management. She holds degrees from George Washington University and the University of Maryland and is adjunct professor in museum studies at George Washington University.

Murphy, Amanda

Amanda Murphy assists C. Timothy McKeown in the office of the Departmental Consulting Archaeologist, National Park Service, Washington, D.C., in the implementation of the Native American Graves Protection and Repatriation Act (NAGPRA).

Pointer, Victoria A.

Victoria A. Pointer studied photography at the Maryland Institute College of Art and at the University of Delaware. She has been involved in photography for over 12 years, winning awards and showing her work in exhibitions. She has worked as a darkroom technician, a free-lance photographer, and as assistant registrar at the Brandywine River Museum, where she was responsible for collections documentation photography.

Ralston, Patrick L.

Patrick L. Ralston is the former registrar of the Anniston Museum of Natural History, with more than five years of experience in museum facility planning. He holds a master of public administration, and currently serves as a public policy analyst with the Arkansas Legislative Council.

Rose, Cordelia

Cordelia Rose is registrar at the Cooper-Hewitt National Design Museum, Smithsonian Institution, New York. She trained at the Victoria and Albert Museum in London, and was formerly head of the Technical Department at the National Museum of Kenya, Nairobi. She received the Smithsonian Regents Publication Award in 1992 to write *Courierspeak*. She served on the RC-AAM board and produced the *Code of Ethics for Registrars* and the *RC-AAM Operations Manual*. She also served as an AAM board member-at-large and was chair of the AAM nominating committee in 1991.

Ryan, David

David Ryan is the registrar at the Colorado Springs Pioneers Museum. He served as assistant curator of collections and registrar at the Albuquerque Museum from 1987 to 1989. He holds a master's of liberal studies with a museum emphasis from the University of Oklahoma and has served as chair of the Mountain-Plains Museum Association Registrars Committee (RC-MPMA).

Saito, Kim

Kim Saito is a trademark examining attorney at the U.S. Patent and Trademark Office, Arlington, Va. She received her B.A. in history from the University of Virginia and J.D. from the George Mason School of Law. Saito authored *A Primer to Endangered Species Law* while serving as an intern for the Office of Registrar, Smithsonian Institution, Washington, D.C., from 1991 to 1992.

Schansberg, Jennifer

Jennifer Schansberg assists C. Timothy McKeown in the office of the Departmental Consulting Archaeologist, National Park Service, Washington, D.C., in the implementation of the Native American Graves Protection and Repatriation Act (NAGPRA).

Schmiegel, Karol A.

Karol A. Schmiegel is director of the Sewell C. Biggs Museum of American Art in Dover, Del. She was for many years the registrar of the Winterthur Museum, and has been active in both writing and lecturing on topics of interest to registrars. Among her many positions of service to the profession, Schmiegel has served as chair of the RC-AAM and as president of the Mid-Atlantic Association of Museums.

Schultes, Dominique

Dominique Schultes has served as registrar of the Wyoming State Museum in Cheyenne since 1986. She has a B.A. in anthropology from Beloit College and an M.A. in museum/interdisciplinary studies from the University of Idaho. She previously served as technician for the National Park Service.

Segal, Terry

Terry Segal is associate registrar at the Detroit Institute of Arts. She is a graduate of the museum studies program of George Washington University and served as chairperson of the Midwest Registrars Committee from 1988-1992. Her past experience includes training at the Columbia Historical Society, Washington, D.C., the Smithsonian Institution Traveling Exhibition Service (SITES), and Henry Ford Museum & Greenfield Village.

Slaney, Deborah C.

Deborah C. Slaney has been registrar of The Heard Museum since 1991. She holds a B.A. in anthropology from the University of Arizona and an M.L.S./Museum Emphasis from the University of Oklahoma.

Smallwood, Michael

Michael Smallwood has been associate registrar, National Museum of American Art, Smithsonian Institution, from 1979 to the present. He served as chairperson, P.A.C.I.N., Registrars Committee of AAM, 1989-1992.

Sugg, Perry

Perry Sugg is general maintenance supervisor at the Smithsonian Institution's Museum Support Center, Washington, D.C. His former jobs at the Smithsonian have included laborer, mobile equipment operator leader, general maintenance worker, and rigging foreman.

Summers, Cherie

Cherie Summers has been registrar at the Santa Barbara Museum of Art since 1988. She was formerly chief registrar at the Solomon R. Guggenheim Museum, and associate registrar at the Museum of Modern Art. Through the years she has participated in panels and workshops in both regional and national conventions, focusing on topics such as soft packing, vendor selection, traveling exhibitions, and couriering works of art. She has also written articles on various subjects on registration and is a MAP surveyor.

Swain, Lynn

Lynn Swain is an independent museum contractor. She has served as vice president of development for the Independence Hall Association, and outreach director for Historic Philadelphia, Inc. She has worked at Historic Deerfield, in Deerfield, Mass., Fogg Art Museum of Harvard University, Denver Art Museum, Colorado Historical Society, Denver Museum of Natural History, and Rocky Mountain National Park. She was also curator of collections, and then director of the Estes Park Area Historical Museum, in Estes Park, Colo.

Tanner-Kaplash, Sonja

Sonja Tanner-Kaplash has taught in the Cultural Resource Management Program, University of Victoria, Victoria, B.C., Canada, since 1983. She has edited *Museum Quarterly*, has been registrar at the Royal Ontario Museum, and has spoken and published widely on the museum profession. She received her Ph.D. in museum studies from the University of Leicester, U.K.

Tarpey, Sean B.

Sean B. Tarpey has been the registrar at the Mount Holyoke College Art Museum, South Hadley, Mass., since 1984. He also participates in the Five College/Historic Deerfield collaborative (Amherst, Hampshire, Mount Holyoke and Smith colleges, the University of Massachusetts at Amherst, and Historic Deerfield, Inc.) While at Mount Holyoke, he has been active in the New England Registrars Association, serving as vice chairman and chairman many years ago.

Taurins, Irene

Irene Taurins is senior registrar at the Philadelphia Museum of Art, where she has been since 1978. From 1972 to 1978 she was registrar/administrator for Sotheby's, New York. She is a member of AAM, MAAM, ICOM, and MCN. As registrar at the Philadelphia Museum of Art, she has safely shipped countless museum objects.

Tompkins, William G.

William G. Tompkins is national collections coordinator of the National Collections Program, Smithsonian Institution, Washington, D.C. He is responsible for the development and implementation of institutional collections management policy and standards, coordination of the review of individual museum policies, and the compilation of collections management information and collection statistical data. Tompkins was formerly assistant to the director, Office of the Registrar, Smithsonian Institution. Previously, he was collections manager of the National Numismatic Collection at the National Museum of American History, Smithsonian Institution.

Vehrs, Kristin L.

Kristin L. Vehrs is deputy director of the American Zoo and Aquarium Association, Bethesda, Md. In addition, she continues to oversee all AZA legislative and regulatory issues. Prior to her employment with the AZA, Vehrs owned and operated her own consulting and lobbying firm, which specialized in natural resources and environmental issues. Previously, she worked on legislative and regulatory issues for the firm of Steele & Utz for clients involved in the fishing industry.

Williams, Stephen L.

Stephen L. Williams is the collections manager of the Strecker Museum Complex and an assistant professor of the Department of Museum Studies of Baylor University. He worked previously at The Carnegie Museum of Natural History and the Museum of Texas Tech University. Williams has authored many papers on management and care of collections, and provided leadership in the Society for the Preservation of Natural History Collections.

Young, Holly

Holly Young is curator of collections at the Pueblo Grande Museum, Phoenix. Formerly at the Arizona State Museum, she specializes in the curation and management of systematic and archaeological project collections.

GENERAL

Case, M., ed. *Registrars on Record*. Washington, D.C.: American Association of Museums, 1988.

Dudley, Dorothy H., and Irma B. Wilkinson. *Museum Registration Methods*. Washington, D.C.: American Association of Museums, 1979.

Malaro, M. C. *A Legal Primer on Managing Museum Collections*. Washington, D.C.: Smithsonian Institution Press, 1985.

The National Committee to Save America's Cultural Collections, Arthur W. Schultz, Chairman. *Caring for Your Collections*. New York: Harry N. Abrams, Inc., Publishers, 1992.

Perry, K. D., ed. *The Museum Forms Book*. Rev. ed. Austin, Tex.: Texas Association of Museums, 1990.

DOCUMENTATION

Art and Architecture Thesaurus. 2d ed. New York: Oxford University Press, 1994.

Blackaby, James R., Patricia Greeno, and the Nomenclature Committee. *The Revised Nomenclature for Museum Cataloging*. Nashville, Tenn.: American Association for State and Local History, 1988.

Chenall, Robert G., and David Vance. *Museum Collections and Today's Computers*. Westport, Conn.: Greenwood Press, 1988.

Ensman, Richard G., Jr. "Caring for Your Computer System." *Management Insight* 8, no. 1. Museum Store Association.

Gorman, Michael, and Paul W. Winkler, eds. *Anglo-American Cataloguing Rules*. 2d ed. London: Library Association, 1988.

Grant, Alice, ed. "SPECTRUM: The U.K. Museum Documentation." Cambridge: The Museum Documentation Association, 1994.

Grey, Vyle. "Show and Tell at the ASIN Meeting." *Conservation News* 14, no. 4. Arizona Paper and Photograph Conservation Group.

Hourihane, Colum. "A Selective Survey of Systems of Subject Classification." In *Computers and the History of Art*, edited by Anthony Hamber, Jean Miles, and Vaughan William, pp. 117-29. London: Mansell Publishing Limited, 1989.

Humanities Data Dictionary of the Canadian Heritage Information Network. Ottawa: Canada: Communications Canada, 1993.

International Documentation Committee, International Council of Museums (CIDOC). *Directory of Thesauri for Object Names*. Text in English and French. Prepared by Josephine Nieuwenhuis and Toni Peterson. Translated by Catherine Arminjon. Williamstown, Mass.: Art and Architecture Thesaurus for CIDOC, 1994.

International Organization for Standardization. "Guidelines for the Establishment and Development of Monolingual Thesauri, ISO 2788-1986." Geneva: International Organization for Standardization, 1986.

Justman, Sharona. "'A Stitch in Time . . .': Disaster Preparedness." *SPECTRA* 22, no. 2: 14-15. Museum Computer Network.

Kent, Allen, ed. *Encyclopedia of Library and Information Science*. Vol. 45, Supplement 10. New York: Marcel Dekker, Inc., 1990.

Kenworthy, Mary Anne, et al. *Preserving Field Records*. Philadelphia: The University Museum, University of Pennsylvania, 1985.

Lancaster, F. W. *Vocabulary Control for Information Retrieval*. 2d ed. Arlington, Va.: Information Resources Press, 1986.

Levine, John R., and Carol Baroud. *The Internet for Dummies*. San Mateo, Calif.: IDG Books, 1993.

The MDA Data Standard. Cambridge: Museum Documentation Association, 1991.

Parker, Elizabeth Betz, ed. *LC Thesaurus for Graphic Materials: Topical Terms for Subject Access*. Washington, D.C.: Cataloging Distribution Service, Library of Congress, 1987.

Parker, Elizabeth Betz, and Helena Zinkham, eds. *Descriptive Terms for Graphic Materials: Genre and Physical Characteristic Headings*. Washington, D.C.: Cataloging Distribution Service, Library of Congress, 1986.

Peterson, Toni, and Patricia Barnett, eds. *Guide to Indexing and Cataloging with the Art & Architecture Thesaurus*. New York: Oxford University Press, Inc., 1994.

Roberts, Andrew, ed. *Terminology for Museums: Proceedings of the Second Annual Conference of the Museum Documentation Association*, Cambridge, England, September 1988. Cambridge: Museum Documentation Association, 1990.

Sunderland, John. "The Catalogue as a Database: The Indexing of Information in Visual Archives." In *Computers and the History of Art*, edited by Anthony Hamber, Jean Miles, and Vaughan William, pp. 130-143. London: Mansell Publishing Limited, 1989.

Thompson, John M. A., ed. *Manual of Curatorship: A Guide to Museum Practice*. 2d ed. Oxford, England: Butterworth-Heinemann, Ltd., 1984.

Union List of Artist Names. New York: G. K. Hall & Co., 1994.

Van de Waal, H. *ICONCLASS—An Iconographic Classification System*. Amsterdam: North Holland Publishing Co., for Koninklijke Nederlandse Academie van Wetenschappen, 1973-85.

Williams, David W. *A Guide to Museum Computing*. Nashville, Tenn.: American Association for State and Local History, 1987.

HANDLING

Cottrell, Bob. "The Challenges of Collections Care in Living History Museums." *History News* 50, no. 3 (summer 1995): 14-19.

Guldbeck, Per E. *The Care of Historical Collections.* Nashville, Tenn.: American Association for State and Local History, 1972.

Harris, K. J. "Perishable: Handle With Care." *Museum News* 56, no. 2 (November/December 1977): 43-45.

Howie, Frank M. *The Care and Conservation of Geological Material: Minerals, Rocks, Meteorites and Lunar Finds.* Oxford: Butterworth-Heinemann Ltd., 1992.

_____, ed. *Safety in Museums and Galleries.* London: Butterworths, 1987.

Keck, Caroline. *A Handbook on the Care of Paintings.* 2d ed. Nashville, Tenn.: American Association for State and Local History, 1967.

National Park Service. *Museum Handbook, Part 1: Museum Collections.* Rev. ed. Washington, D.C.: National Park Service, 1990.

Rowlinson, E. B. "Rules for Handling Works of Art." *Museum News* 54, no. 7 (April 1975): 10-13.

Shelley, Marjorie. *The Care and Handling of Art Objects.* New York: The Metropolitan Museum of Art, 1987.

Ward, Fred. *Gem Care.* Bethesda, Md.: Gem Book Publishers, 1995.

Williams, S. L., R. Laubach, and H. H. Genoways. *A Guide to the Management of Recent Mammal Collections.* Special Publication No. 4. Pittsburgh: Carnegie Museum of Natural History, 1977.

MEASURING

Anderson, Rudolph Martin. "Methods of Collecting and Preserving Vertebrate Animals." *Natural Museum of California Bulletin* no. 60 (1965), Biological Series no. 18.

Andrew, Laura L. *Measuring Procedures.* Pueblo Grande Museum, Phoenix, manuscript on file, 1993.

Bass, William H. *Human Osteology: A Laboratory and Field Manual of the Human Skeleton,* Special Publications of the Missouri Archaeological Society. Columbia, Mo.: University of Missouri, 1971.

Clapp, Anne F. *Curatorial Care of Works of Art on Paper.* New York: Lyons & Burford, 1987.

Haas, Jonathan, et al. "Standards for Data Collection from Human Skeleton Remains." *In Proceedings of a Seminar at the Field Museum of Natural History,* edited by Jane E. Buikstra and Douglas H. Ubelaker. Arkansas Archeological Survey Research Series no. 44. Fayetteville, Ark.: Arkansas Archeological Survey, 1994.

Jacobs, Mike, Jan Bell, and Diane Dittemore, eds. *Cataloging Guide for Archaeological Specimens.* Tucson, Ariz.: Arizona State Museum, 1987.

Keck, Caroline K. *A Handbook on the Care of Paintings.* 2d ed., rev. Nashville, Tenn.: American Association for State and Local History, 1965.

Lewis, Ralph H. *Manual for Museums*. Washington, D.C.: National Park Service, United States Department of the Interior, 1976.

McGiffin, Robert F. *Furniture Care and Conservation*. 3d ed., rev. Nashville, Tenn.: American Association for State and Local History, 1992.

Rattenbury, Richard. "Management of Firearms Collections." AASLH Technical Leaflet #136. *History News* 36, no. 3 (1981).

Reibel, Daniel B. *Registration Methods for the Small Museum*. Nashville, Tenn.: American Association for State and Local History, 1978.

Williams, Stephen L., René Laubach, and Hugh H. Genoways. *A Guide to the Management of Recent Mammal Collections*. Special Publication No. 4. Pittsburgh: Carnegie Museum of Natural History, 1977.

CONDITION REPORTING

Appelbaum, Barbara. *Guide to Environmental Protection of Collections*. Madison, Conn.: Sound View Press, 1991.

Bachmann, Konstanze, ed. *Conservation Concerns: A Guide for Collectors and Curators*. Washington, D.C.: Smithsonian Institution Press, 1992.

Bragonier, Reginald Jr., and David Fisher. *What's What: A Visual Glossary of the Physical World*. Maplewood, N.J.: Hammond, Inc., 1981.

Buck, Richard D. "Inspecting and Describing the Condition of Art Objects." In *Museum Registration Methods*. Washington, D.C.: American Association of Museums, 1979.

O'Reilly, Priscilla, and Allyn Lord, eds. *Basic Condition Reporting: A Handbook*. Southeastern Registrars Association, 1988.

Whelchel, Harriet. *Caring for Your Collections*. New York: Harry N. Abrams, Inc., 1992.

MARKING

Published Works

Alten, Helen. "Materials for Labeling Collections." *The Upper Midwest Collections Care Network* 1, no. 6 (Winter 1996): 1-7.

"Applying Accession Numbers to Textiles." *CCI Notes*, 13, no. 8. Ottawa: Canadian Conservation Institute, Government of Canada, 1994.

"Applying Registration Numbers to Paintings and Sculptures." *CCI Notes*, 1, no. 5. Ottawa: Canadian Conservation Institute, Government of Canada, 1994.

Blank, Sharon. "An Introduction to Plastics and Rubbers in Collections." *Studies in Conservation* 35 (1990): 53-63.

Cottrell, Bob. "The Challenges of Collections Care in Living History Museums." *History News*, Summer 1995: 14-19.

Down, J. L. "Adhesive Testing at the Canadian Conservation Institute—An Evaluation of Selected Poly (Vinyl Acetate) and Acrylic Adhesives." Canadian Conservation Institute, Environmental and Deterioration Report 1603 (1992): 1-37.

Gillies, Teresa and Neal Putt. *The ABCs of Collections Care.* Rev. ed. Winnipeg: Manitoba Heritage Conservation Service, 1991.

Gispert, J., Palacios, F., and Garcia-Perea, R. "Labeling Vertebrate Collections with Tyvek Synthetic Paper." *Collection Forum* 6, no. 1 (1990): 35-37.

Grimm, Martha Winslow. "Applying Labels to Textiles, Costumes and Accessories." *Registrars Quarterly*, Registrars Committee—Western Region (Spring 1994): 6.

_____. *The Directory of Hand Stitches Used in Textile Conservation.* New York: Textile Conservation Group, Inc., 1993.

Hawks, C. A., and S. L. Williams. "Care of specimen labels in vertebrate research collections." *In Proceedings of the 1985 Workshop on Care and Maintenance of Natural History Collections*, edited by J. Waddington and D. M. Rudkin. Toronto: Life Sciences Miscellaneous Publications, Royal Ontario Museum, 1985.

Hughes, Elaine, and Carolyn Leckie. "Labeling Systems at the Denver Museum of Natural History." *Registrars Quarterly*, Registrars Committee—Western Region (Spring 1994): 7-8.

Kishinami, C.H. "Archival storage of disintegrating labels from fluid-preserved specimens." *Collection Forum* 5, no. 1 (1989): 1-4.

"Marking Paper Manuscripts." Preservation Leaflets, f.f. series 1-5, no. 4. Washington, D.C.: Library of Congress, March 1983 (revised).

Norton, Ruth. "The Conservation of Artifacts Made from Plant Materials: Labeling Artifacts." *Conservation*. Marina del Rey, Calif.: The Getty Conservation Institute, The J. Paul Getty Trust, 1990.

_____. "Was There Life Before the Café Bar? Some Pre-1940's Plastics." *Museum National*, 1992.

Sease, Catherine. *Conservation Manual for the Field Archeologist.* 3d ed. Los Angeles: Institute of Archeology, University of California, 1994.

Shelley, Marjorie. *The Care and Handling of Art Objects: Practices in the Metropolitan Museum of Art.* Rev. ed. New York: The Metropolitan Museum of Art, 1987.

Sullivan, Brigid, and Donald R. Cumberland, Jr. "Use of Acryloid B-72 Lacquer for Labeling Museum Objects." *Conserve O Gram*, 1, no. 4. Washington, D.C.: National Park Service, Curatorial Services Division, 1993.

Townley, Pat. *The Marking of Objects.* New South Wales: The New South Wales Branch of the Museums Association of Australia, Inc., 1984.

Tye, Henrietta, and Janet Ruggles. "Labeling Prints, Drawings, Photographs and Negatives." *Registrars Quarterly*, Registrars Committee—Western Region (Spring 1994): 9.

Williams, Stephen L. "Resistall Paper and Its Use in Natural History Museums." *Society for the Preservation of Natural History Collections Newsletter* 4, no. 2 (1990): 4.

Williams, Stephen L., and Catherine A. Hawks. "A Note on 'Inks . . .'" *Society for the Preservation of Natural History Collections Newsletter* 2, no. 1 (1988): 1.

_____. "History of Preparation Materials Used for Recent Mammal Specimens." In *Mammal Collection Management*, edited by H. H. Genoways, C. Jones, and O. L. Rossolimo. Lubbock, Tex.: Texas Tech University Press, 1987.

_____. "Inks for Documentation in Vertebrate Research Collections." *Curator* 29, no. 2 (June 1986): 93-109.

Wolf, Sara J., and P. Lynn Denton. "Labeling Museum Specimens." *Conservation Notes* 11. Austin, Tex.: The Material Conservation Laboratory, Texas Memorial Museum, The University of Texas at Austin, January 1985.

Wood, Rose, and Stephen L. Williams. "An Evaluation of Disposable Pens for Permanent Museum Records." *Curator* 36, no. 6 (September 1993): 189-200.

Unpublished Notes

Brown, Geoffrey I. Unpublished notes on marking methods and materials. Curator of conservation and assistant to the director, Kelsey Museum of Archeology, University of Michigan, Ann Arbor.

Hutchins, Jane. Unpublished notes on marking textiles. Private practice textile conservator, Winnipeg, Canada.

PHOTOGRAPHY

Brown, Kim. *How to Photograph Your Artwork.* Ransom Canyon, Tex.: Canyonwinds, 1995.

Collins, Sheldon. *How to Photograph Works of Art.* Nashville, Tenn.: The American Association for State and Local History, 1986.

Eastman Kodak Company editorial staff. *The Joy of Photography: A Guide to the Tools and Techniques of Better Photography.* Rochester, N.Y.: Eastman Kodak Company, 1979.

Hart, Russell. *Photographing Your Artwork.* Cincinnati: North Light Books, 1987.

Hirsch, Robert. *Exploring Color Photography.* 2d ed. Madison, Wis.: Brown & Benchmark Publishers, 1993.

Lewis, John, and Edwin Smith. *The Graphic Reproduction of Photography and Works of Art.* London: W. S. Cowbell Ltd., 1969.

Roberts, Helene E. *Art History Through the Camera's Lens.* Australia and United States: Gordon and Breach, 1995.

Titus, William H. *Photographing Works of Art: Techniques for Photographing Your Paintings, Drawings, Sculpture, and Crafts.* New York: Watson-Guptill, 1981.

PREVENTIVE CARE

Creahan, Julie. "Controlling Relative Humidity with Saturated Calcium Nitrate Solutions." *Western Association for Art Conservation Newsletter* 13, no. 1 (1991a): 17-18.

_____. "Update and Feedback: Controlling Relative Humidity with Saturated Calcium Nitrate Solutions." *Western Association for Art Conservation Newsletter* 13, no. 2 (1991b): 11.

Erhardt, David, and Mecklenburg, Marion. "Relative Humidity Re-examined." In *Preventative Conservation: Practice, Theory and Research*, edited by Ashok Roy and Perry Smith, pp. 32-38. London: The International Institute for Conservation of Historic and Artistic Works, 1994.

Harmon, J. *Integrated Pest Management in Museum, Library, and Archival Facilities: A Step-by-Step Approach for the Design, Development, Implementation and Maintenance of an Integrated Pest Management Program.* Indianapolis: Harmon Preservation Pest Management, 1993.

International Federation of Library Associations and Institutions. "Care, Handling, and Storage of Photographs." Information Leaflet, 1992.

Lafontaine, Raymond H. "Silica Gel." Technical Bulletin no. 10. Ottawa: Canadian Conservation Institute, 1984.

Lull, William P., and Merk, Linda. "Lighting for Storage of Museum Collections." *Technology and Conservation* 7 (1982a): 20-25.

_____. Preservation Aspects of Display Lighting. *Electrical Consultant* (1982b): 8-39.

Piechota, Dennis. "Storage and Containerization: Archeological Textile Collections." *Journal of the American Institute for Conservation* 18, no. 1 (1978): 10-18.

_____. "Humidity Control in Cases: Buffered Silica Gel Versus Saturated Salt Solutions." *Western Association for Art Conservation Newsletter* 15, no. 1 (1992): 19-21.

Plenderleith, H. J., and Philippot, P. "Climatology and Conservation in Museums." *Museum* 13 (1960): 242-249.

Randolph, Pamela Young. *Museum Housekeeping: Developing a Collections Management Program.* Richmond, Va.: Virginia Association of Museums, 1987.

Thomson, Gerry. *The Museum Environment.* 2d ed. London: Butterworths, 1986.

Webster, Laurie. "Altered States: Documenting Changes in Anthropology Research Collections." *Curator* 33, no. 2 (1990): 130-160.

STORAGE

Bachmann, Konstanze, ed. *Conservation Concerns: A Guide for Collectors and Curators.* Washington, D.C.: Smithsonian Institution Press, 1992.

Butcher-Younghams, Sherry. *Historic House Museums.* New York: Oxford University Press, 1993.

Cassar, May. *Environmental Management: Guidelines for Museums and Galleries.* London: Routledge, 1995.

Daifuku, Hiroshi. "Collections, Their Care and Storage." In *The Organization of Museums: Practical Advice.* Paris: UNESCO Press, 1974.

Dunn, Walter S. "Storing Your Collections: Problems and Solutions." Technical Leaflet no. 5. Nashville, Tenn.: American Association for State and Local History, 1970.

Johnson, E. Verner, and Joanna C. Horham. *Museum Collections Storage.* Paris: UNESCO, 1979.

MacLeish, A. Bruce. *The Care of Antiques in Historical Collections.* 2d ed., rev. and exp. Nashville, Tenn.: American Association for State and Local History, 1985.

Miles, C. A. "Wood Coatings for Display and Storage Cases." In *Studies in Conservation* 31 (1986): 14-124.

Rose, Carolyn L., and Amparo R. de Torres, eds. *Storage of Natural History Collections: Ideas and Practical Solutions.* Pittsburgh: Society for the Preservation of Natural History Collections, 1992.

Shelley, Marjorie. *The Care and Handling of Art Objects.* New York: The Metropolitan Museum of Art, 1987.

INVENTORY

Ambrose, Timothy, and Crispin Paine. *Museum Basics.* London: Routledge, 1993.

Traina, Veronica. "Just the Facts! Animal Inventories at Zoo Atlanta." *Registrars' Quarterly* (Spring 1993): 11.

PREPARATION

American Association of Museums. *Caring for Collections: Strategies for Conservation, Maintenance and Documentation.* Washington, D.C.: American Association of Museums, 1992.

Applebaum, Barbara. *Guide to the Environmental Protection of Collections.* Madison, Conn.: Sound View Press, 1991.

Bachman, Konstanze, ed. *Conservation Concerns.* Washington, D.C.: Smithsonian Institution Press, 1992.

Barclay, R., R. Eames, and A. Todd. "The Care of Wooden Objects." Technical Bulletin no. 8. Ottawa: Canadian Conservation Institute, 1980.

Brunton, C. H. C., T. P. Besterman, and J. A. Cooper, eds. "Guidelines for the Curation of Geological Materials." Miscellaneous Paper No. 17. London: Geological Society, 1985.

Butcher-Younghans, Sherry. *Historic House Museums.* New York: Oxford University Press, 1993.

Butcher-Younghans, Sherry, and Gretchen E. Anderson. "A Holistic Approach to Museum Pest Management." Technical Leaflet no. 171. Nashville, Tenn.: American Association for State and Local History, 1990.

Canadian Conservation Institute. "Rolled Storage for Textiles." *CCI Notes* 13, no. 3. Ottawa: Canadian Conservation Institute, 1983.

_____. "Hanging Storage for Textiles." *CCI Notes* 13, no. 5. Ottawa: Canadian Conservation Institute, 1983.

_____. "Anionic Detergent." *CCI Notes* 13, no. 9. Ottawa: Canadian Conservation Institute, 1983.

_____. "Environmental and Display Guidelines for Paintings." *CCI Notes* 10, no. 4. Ottawa: Canadian Conservation Institute, 1986.

_____. "The Cleaning, Polishing, and Protective Waxing of Brass and Copper Objects." *CCI Notes* 9, no. 3. Ottawa: Canadian Conservation Institute, 1983.

_____. "Storage Systems for Paintings." *CCI Notes* 10, no. 3. Ottawa: Canadian Conservation Institute, 1986.

Clapp, Anne F. *Curatorial Care of Works of Art on Paper*. Oberlin, Ohio: Intermuseum Laboratory, 1974.

Crafts Council. "Adhesives and Coatings." *Science for Conservators*, Book 3. London: Crafts Council, 1983.

_____. "An Introduction to Materials." *Science for Conservators*, Book 1. London: Crafts Council, 1982.

_____. "Cleaning." *Science for Conservators*, Book 2. London: Crafts Council, 1983.

de Torres, Amparo R. *Collections Care: A Basic Reference Shelflist*. Washington, D.C.: National Institute for the Conservation of Cultural Property, 1990.

Duckworth, W. Donald, Hugh H. Genoways, and Carolyn L. Rose. *Preserving Natural Science Collections: Chronicle of Our Environmental Heritage*. Washington, D.C.: National Institute for the Conservation of Cultural Property, 1993.

Edwards, S. R., B. M. Bell, and M. E. King. *Pest Control in Museums: A Status Report*. Lawrence, Kans.: Association of Systematics Collections, 1981.

Ellis, Margaret Holben. *The Care of Prints and Drawings*. Nashville, Tenn.: American Association for State and Local History, 1980.

Florian, Mary-Lou E., D. Kronkright, and R. E. Norton. *The Conservation of Artifacts Made from Plant Materials*. Malibu, Calif.: The Getty Conservation Institute, 1990.

Florian, Mary-Lou. "Biodeterioration of Museum Objects: An Ecological Approach to Control and Prevention." *Museum Round-Up* (1978): 35-43.

Forman, Leonard, and Diane Bridson, eds. *The Herbarium Handbook*. Kew, England: Royal Botanic Gardens, 1989.

Gehlert, Sarah. *Curation in a Small Museum: Human Bones*. Columbia, Mo.: Museum of Anthropology, University of Missouri, 1978.

Guldbeck, Per E., and A. Bruce Macleish. *The Care of Historical Collections*. Nashville, Tenn.: American Association for State and Local History, 1985.

Hodges, Henry. *Artifacts*. Kingston, Canada: Ronald P. Frye, 1988.

Hower, Rolland O. *Freeze-Drying Biological Specimens: A Laboratory Manual*. Washington, D.C.: Smithsonian Institution Press. 1979.

Keck, Caroline K. *A Handbook on the Care of Paintings*. 2d ed. Nashville, Tenn.: American Association for State and Local History, 1967.

_____. "Care of Textiles and Costumes: Adaptive Techniques for Basic Maintenance. "Technical Leaflet no. 71. Nashville: American Association for State and Local History, 1974.

_____. *How to Take Care of Your Paintings*. New York: Scribner's, 1978.

Kenworthy, Mary Anne, et al. *Preserving Field Records*. Philadelphia: The University Museum, University of Pennsylvania, 1985.

LaFontaine, R. H. "Recommended Environmental Monitors for Museums, Archives, and Art Galleries." *CCI Technical Bulletin* no. 3. Ottawa: National Museums of Canada, 1978.

_____. "Environmental Norms for Canadian Museums, Art Galleries and Archives." *CCI Technical Bulletin* no. 5. Ottawa: National Museums of Canada, 1979.

_____. "Silica Gel." *CCI Technical Bulletin* no. 10. Ottawa: National Museums of Canada, 1984.

_____. "Fluorescent Lamps." *CCI Technical Bulletin* no. 7. Ottawa: National Museums of Canada, 1980.

Lewis, Ralph H. *Manual for Museums*. Washington, D.C.: National Park Service, 1976.

Mallis, Arnold. *Handbook of Pest Control: The Behavior, Life History, and Control of Household Pests*. 6th ed. Cleveland: Franzak Foster Co., 1982.

Martin, J. E. H., comp. " Collecting, Preparing, and Preserving Insects, Mites, and Spiders." In *The Insects and Arachnids of Canada, Part I*. Ottawa: Biosystematics Research Institute, 1977.

Mecklenburg, Marion R., ed. *Art in Transit: Studies in the Transport of Paintings*. Washington, D.C.: National Gallery of Art, 1991.

_____, ed. *Art in Transit: Handbook*. Washington, D.C.: National Gallery of Art, 1991.

Nagorsen, D.W., and R. L. Peterson. *Mammal Collectors' Manual*. Toronto: Royal Ontario Museum, 1980.

National Committee to Save America's Cultural Collections. *Caring for Your Collections*. New York: Harry N. Abrams, 1992.

National Park Service. *Museum Handbook, Part I: Museum Collections*. Washington D.C.: National Park Service, 1990.

Paine, Shelley Reisman. "Basic Principles for Controlling Environmental Conditions in Historical Agencies and Museums." Technical Report no. 3. Nashville, Tenn.: American Association for State and Local History, 1985.

Pinniger, David. *Insect Pests in Museums*. London: Archetype Publications, 1994.

Rogers, Stephen P., Mary Ann Schmidt, and Thomas Gütebier. *An Annotated Bibliography on Preparation, Taxidermy, and Collection Management of Vertebrates with Emphasis on Birds*. Special Publication no. 15. Pittsburgh: Carnegie Museum of Natural History, 1989.

Rogers, Stephen P., and D. Scott Wood, comps. *Notes from a Workshop on Bird Specimen Preparation Held at The Carnegie Museum of Natural History in Conjunction with the 107th Stated Meeting of the American Ornithologists' Union*. Pittsburgh: Carnegie Museum of Natural History, 1989.

Rose, Carolyn L., and Amparo R. de Torres, eds. *Storage of Natural History Collections: Ideas and Practical Solutions*. Pittsburgh: Society for the Preservation of Natural History Collections, 1992.

Shelley, Marjorie. *The Care and Handling of Art Objects*. New York: Metropolitan Museum of Art, 1987.

Stolow, Nathan. *Conservation and Exhibitions: Packing, Transport, and Environmental Storage Considerations*. London: Butterworths, 1987.

Story, Keith O. *Approaches to Pest Management in Museums*. Washington, D.C.: Smithsonian Institution, 1985.

Thompson, John M. A. *Manual of Curatorship*. London: Butterworths, 1986.

United Kingdom Institute for Conservation. "Environmental Standards for the Permanent Storage of Excavated Material from Archaeological Sites." *Conservation Guidelines* no. 3. London: United Kingdom Institute for Conservation, 1984.

_____. "Packaging and Storage of Freshly-Excavated Artifacts from Archaeological Sites." *Conservation Guidelines* no. 2. London: United Kingdom Institute for Conservation, 1983.

_____. "Excavated Artifacts for Publication: UK Sites." *Conservation Guidelines* no. 1. London: United Kingdom Institute for Conservation, 1982.

Waddington, J., and D. M. Rudkin, eds. *Proceedings of the 1985 Workshop on Care and Maintenance of Natural History Collections*. Ottawa: Royal Ontario Museum, 1986.

Ward, Philip R. "In Support of Difficult Shapes." *Museum Methods Manual* no. 6. Victoria: British Columbia Provincial Museum, 1978.

_____. *Getting the Bugs Out*. London: ICOM The Museums Council, 1976.

Watkinson, David, et al. *First Aid for Finds*. 2d ed. London: Rescue, 1987.

Williams, R. Scott. "Display and Storage of Museum Objects Containing Cellulose Nitrate." *CCI Notes* 15, no. 3. Ottawa: Canadian Conservation Institute, 1988.

Williams, R. Scott. "Stable Materials for Storage, Display and Packing." Lecture manuscript and notes, 1987.

PACKING AND CRATING

Atthowe, Scott, and Michael Smallwood, comps. "Packing and Crating Information Network (P.A.C.I.N.)." Conference Notebook, April 25, 1992. Baltimore, Md.: P.A.C.I.N. Task Force of the Registrars Committee of the American Association of Museums, 1992.

Mecklenburg, Marion F., ed. *Art in Transit, Studies in the Transport of Paintings* (International Conference on the Packing and Transport of Paintings, September 9, 10, and 11, 1991.) Washington, D.C.: National Gallery of Art, 1991.

P.A.C.I.N. Task Force of the Registrars Committee of the American Association of Museums, comp. *Technical Drawing Handbook of Packing and Crating Methods*, 1993.

Powell, Brent A. comp. "Soft Packing, Methods and Methodology for the Packing and Transport of Art and Artifacts." Conference Notebook, April 23, 1994. Seattle, Washington: P.A.C.I.N. Task Force of the Registrars Committee of the American Association of Museums, 1994.

Richard, Mervin, Marion F. Mecklenburg, and Ross M. Merrill, eds. *Art in Transit Handbook for Packing and Transporting Paintings*. Washington, D.C.: National Gallery of Art, 1991.

Stolow, Nathan. *Conservation and Exhibitions: Packing, Transport, Storage and Environmental Considerations*. London: Butterworths, 1987.

SHIPPING

Dudley, Dorothy H., and Irma B. Wilkinson, et al. *Museum Registration Methods*. 3d ed., rev. Washington, D.C: American Association of Museums, 1979.

Francell, Larry. "Transportation: Van and Shuttle Services." In *Soft Packing, Methods and Methodology for the Packing and Transport of Art and Artifacts*, compiled by Brent A. Powell. P.A.C.I.N. Task Force of the Registrars Committee of the Ameri-can Association of Museums, 1994.

O'Connell, Robert E. "A Clean Bill of Lading: Waiving Your Subrogation Rights." *Museum Insurance Newsletter*, spring 1995.

Segal, Terry. "Transportation: Options for Shipping." In *Soft Packing, Methods and Methodology for the Packing and Transport of Art and Artifacts*, compiled by Brent A. Powell. P.A.C.I.N. Task Force of the Registrars Committee of the American Association of Museum, 1994.

COURIERING

Buchanan, John. "The Courier's Art." *Museum News* 63, no. 3 (1985): 11.

Case, M., ed. *Registrars on Record*. Washington, D.C.: American Association of Museums, 1988.

Cannon-Brookes, Peter. "A Draft Code of Practice for Escorts and Couriers." *The International Journal of Museum Management and Curatorship* 1 (1982): 41.

_____. "Art Exhibition Transport: The Case for Alternative Strategies." *Museum International* 47, no. 2 (1985): 55.

Leback, Karen F. "The Art of Couriering, Shipping and Packing of Objects." *The International Journal of Museum Management and Curatorship* 5 (1986): 391-394.

O'Biso, Carol. *First Light: A Magical Journey*. New York: Paragon House, 1989.

Print Council of America. *Guidelines for Lending Works of Art on Paper*. Cambridge, Mass.: Print Council of America, 1995.

Registrars Subcommittee for Professional Practices. "A Code of Practice for Couriering Museum Objects." *Registrar* 3 (1987).

Richard, Mervin, et al. *Art in Transit. Handbook for Packing and Transporting Paintings.* Washington, D.C.: National Gallery of Art, 1991.

Rose, Cordelia. *Courierspeak: A Phrase Book for Couriers of Museum Objects.* Blue Ridge Summit, Pa.: Smithsonian Institution Press, 1993.

Stuhler, Waldemar. "Einwirkungen von Erschütterungen auf Kunstgegenstande beim Transport mit Kurier-Koffern." *Museumskunde* 51 no. 3 (1986): 165-172.

ACQUISITIONS AND ACCESSIONING

Dudley, Dorothy H., and Irma B. Wilkinson. *Museum Registration Methods.* 3d ed. Washington, D.C.: American Association of Museums, 1979.

Malaro, M. C. *A Legal Primer on Managing Museum Collections.* Washington, D.C.: Smithsonian Institution Press, 1985.

DEACCESSIONS

ALI-ABA Course of Study Transcript, Legal Problems of Museum Administration. Philadelphia: American Law Institute/American Bar Association. 1974-present.

Association of Art Museum Directors. *Considerations for Formulating a Deaccessioning Policy.* January 1987.

_____. *Professional Practices in Art Museums.* New York: Assocation of Art Museum Directors, 1992.

Besterman, Tristram. "Disposal from Museum Collections," *Museum Management and Curatorship* 11 (1992).

Case, M., ed. *Registrars on Record.* Washington, D.C.: American Association of Museums, 1988.

Drohojowska, Hunter. "The Pasadena Case: Litigation Concerning the Deaccessioning of Works from the former Pasadena Museum of Modern Art. . . ." *Art in America* no. 5 (May 1981): 11-17.

DuBoff, Leonard. *The Deskbook of Art Law.* Washington, D.C.: Federal Publications, 1977.

Failing, Patricia. "Fading Impressions?" *ARTNews,* January 1996, p. 106.

Feldstein, Martin. "Rich and Poor." *Museum News,* May/June 1991, p. 53.

Ferretti, Fred. "Dick Cavett returns four artifacts to Museum of American Indian." *New York Times,* November 7, 1976, p. 21.

Fleming, David. "Immaculate Collections, Speculative Conceptions." *Museum Management and Curatorship* 10 (1991).

Garfield, Donald. "Unusual Obstacles." *Museum News*, March/April 1990, p. 52.

Gleuck, Grace. "Fogg Warned on Selling Art." *New York Times*, September 20, 1981, p 78.

Guthrie, Kevin. *The New-York Historical Society: Lessons From One Nonprofit's Long Struggle for Survival.* San Francisco: Jossey-Bass, 1993.

Ham, F. Gerald. *Selecting and Appraising Archives and Manuscripts.* Society of American Archivists, 1993.

Hamp, Steven K., and Michael J. Ettema. "To Celebrate or to Educate." *Museum News* 65, no. 3 (September/October 1989).

Jacoby, Beverly S. "Caveat Pre-Emptor." *Museum News*, January/February 1996, p. 34.

Kamholtz, Janathan. "The Rate of Exchange: Deaccessioning at the Cincinnati Art Museum." *Journal of the Cinncinnati Historical Society* 45 (winter 1987): 33.

Kaye, Myrna. "Deaccessioning: The Curator's Dilemma, Part I and Part II." *Maine Antiques Digest*, September and October 1987, pp. 1-C, 4-C.

Konecny, Tania. "Less in More." *Museum Management and Curatorship* 10 (1991).

Lester, Joan. "A Code of Ethics for Curators." *Museum News* 61, no. 3 (February 1983).

Lewis, Geoffrey. "Attitudes to Disposal from Museum Collections." *Museum Management and Curatorship* 11 (1992).

Lister, Kenneth R. "Deaccessioning and Ethnographic Material Culture: Implications and Considerations." *The Museologist* 164 (Summer 1983): 12-15.

Macdonald, Robert R. "Collections, Cash Cows, and Ethics." *Museum News*, January/February 1995.

Malaro, M. C. *A Legal Primer on Managing Museum Collections.* Washington, D.C.: Smithsonian Institution Press, 1985.

_____. *Museum Governance.* Washington, D.C.: Smithsonian Institution Press, 1994.

Miller, Steven. "Selling Items from Museum Collections." *The International Journal of Museum Management and Curatorship* 4 (1985): 289-294.

_____. "Guilt-Free Deaccessioning." *Museum News*, September/October 1996, p. 32.

Phagans, Peter. "The Big Swap and Shop." *Newsweek*, May 21, 1990, pp. 88-90.

Phillips, Charles. "The Ins and Outs of Deaccessioning." *History News* 38, no. 11 (November 1983): 6-13.

Richard, Paul. " The Met Under Siege." *The Washington Post*, February 18, 1973, p. 2.

Roth, Evan. "Deaccession Debate." *Museum News*, March/April 1990, p. 42.

Sonderman, Robert. "Primal Fear, Deaccessioning Collections." *Common Ground*, National Park Service, summer 1996, p. 27.

Sande, Theodore A. "Plying the Proceeds." *Museum News*, March/April 1990, p. 47.

Sorgenti, Harold A. "Let Museums Sell Off Some Assets." *The Philadelphia Inquirer*, January 2, 1995, p. A-9.

Tesseler, Sandra R. "Harold Skramstad and the Strife at Henry Ford Museum." *The Detroit News*, July 26, 1987.

Weil, Stephen E. *Rethinking the Museum and Other Meditations*. Washington, D.C.: Smithsonian Institution Press, 1990.

_____. "The Deaccession Cookie Jar." *Museum News*, November/December 1992, pp. 54-55, 63.

_____. *A Deaccession Reader*. Washington, D.C.: American Association of Museums, 1997.

HOSTING TRAVELING EXHIBITIONS

Conway, Mary Ellen. "Importing and Exporting under CITES." *Registrars' Quarterly*, winter 1993. Registrars' Committee—Western Region.

Daifuku, Hiroshi, et al. *Temporary and Travelling Exhibitions*. Düsseldorf, Germany: UNESCO, 1963.

Keck, Caroline K. *Safeguarding Your Collection in Travel*. Nashville, Tenn.: American Association for State and Local History, 1970.

King, Susan, and Kristen McCormick. "Circulating Exhibitions." *Registrars' Report* 1, no. 7 (1979).

Pearson, Virginia, and Elizabeth L. Burnham. "Preparing Art Exhibitions for Travel." *Museum Registration Methods*, 3d ed., rev. Washington, D.C.: American Association of Museums, 1979.

Stolow, Nathan. *Conservation and Exhibitions*. London: Butterworths, 1987.

ADMINISTRATIVE FUNCTIONS

American Association of Museums. "Staff Development: Innovative Techniques." *Resource Report*. Washington, D.C.: American Association of Museums, 1989.

American Association of Museums. *Code of Ethics for Museums*. Washington, D.C.: American Association of Museums, 1994.

Blackmon, C. P., T. K. LaMaster, L. C. Roberts, and B. Serrell. *Open Conversations: Strategies for Professional Development in Museums*. Chicago: Field Museum of Natural History, 1988.

Browne, R. V. "Contracts with Guest Curators and Other Consultants: Outsourcing." In *ALI-ABA Course of Study, Legal Problems of Museum Administration* (1993), pp. 371-385.

Case, M., ed. *Registrars on Record*. Washington, D.C.: American Association of Museums, 1988.

Case, M. "GS1016: museum specialist." *Museum International* 65, no. 4 (1993): 22-26.

Case, M., and W. Phillips. "A cooperative decision process." In *The Sourcebook*. Washington, D.C.: American Association of Museums, 1993.

Cato, P. S. "Summary of a study to evaluate collection manager-type positions." *Collection Forum* 7, no. 2 (1991): 72-94.

Cato, P. S., R. R. Waller, L. Sharp, J. E. Simmons, and S. L. Williams. *Developing Staff Resources for Managing Collections*. Martinsville, Va.: Virginia Museum of Natural History, Martinsville, 1996.

Cox, J., and E. A. Croog. "Checklist for exhibition agreements." In *ALI-ABA Course of Study, Legal Problems of Museum Administration* (1994), pp. 145-169.

Cox, T. *Volunteer Program Management Guide: A Practical Manual for Planning and Managing a Science Center*. Washington, D.C.: Association of Science and Technology Centers, 1980.

Danilov, V. J. *Museum Careers and Training: A Professional Guide*. Westport, Conn.: Greenwood Press, 1994.

Daughtrey, W. H., Jr., and M. J. Gross, Jr. *Museum Accounting Handbook*. Washington, D.C.: American Association of Museums, 1978.

Drucker, P. F. *Managing the Non-Profit Organization: Practices and Principles*. New York: Harper Collins Publishers, 1990.

Edward, D. Youth *Volunteer Programs in Museums*. 2d ed. Austin, Tex.: Austin Children's Museum, 1995.

Edwards, M. H. "Auditing your employment policies and practices." *Western Museums Association Newsletter* (1994): 1-4.

Emery, A. R. "Museum Staff: Defining Expectations." *Museum Management and Curatorship* 9, no. 3 (1990): 265-272.

Finkler, S. A. *The Complete Guide to Finance and Accounting for Nonfinancial Managers*. Englewood Cliffs, N.J.: Prentice-Hall, Inc., 1983.

Firstenberg, P. B. *Managing for Profit in a Nonprofit World*. New York: The Foundation Center, 1986.

Litsey, C. L. "Practical tips for creating or avoiding a contract: 'What (and what not) to say or do'." In *ALI-ABA Course of Study, Legal Problems of Museum Administration* (1994): 125-127.

Matelic, C. T., and E. M. Brick, eds. *Cooperstown Conference on Professional Training: Needs, Issues, and Opportunities for the Future*. Conference Proceedings, Nov.16-19, 1989. Nashville, Tenn.: American Association for State and Local History, 1990.

Miller, R. L. *Personnel Policies for Museums: A Handbook for Management*. Washington, D.C.: American Association of Museums, 1980.

National Park Service. *Museum Handbook. Part I. Museum Collections*. Rev. Washington, D.C.: National Park Service, Dept. of Interior, 1990.

Newstrom, J. W. "The Adult Learner." In *Human Resources Management and Development Handbook*, 2d ed., edited by W. R. Tracey. New York: American Management Association, 1994.

Registrars Committee. *Intern Preparation Manual: A Guide for Intern Supervisors*. Registrars Committee of the American Association of Museums, 1991.

Thompson, J. M. A., ed. *Manual of Curatorship*. 2d ed. Oxford, England: Butterworth-Heinemann, Ltd., 1992.

Tracey, W. R., ed. *Human Resources Management and Development Handbook*. 2d ed. New York: American Management Association, 1994.

Urice, S. K. "A contract law primer for the museum administrator." In *ALI-ABA Course of Study, Legal Problems of Museum Administration* (1994): 131-141.

Wilson, M. *The Effective Management of Volunteer Programs*. Boulder, Colo.: Volunteer Management Associates, 1976.

Yang, M. "Manuals for museum policy and procedures." *Curator* 32, no. 4 (1989): 269-274.

COLLECTIONS MANAGEMENT POLICIES

Alberta Museums Association. *Standard Practices Handbook for Museums*. Edmonton, Canada: Alberta Museums Association, 1990.

Alpert, G. D., and L. M. Alpert. "Integrated Pest Management: A Program for Museum Environments." In *A Guide to Museum Pest Control*, edited by L. A. Zycherman, and J. R. Schrock. Washington, D.C.: Association for Systematics Collections and American Institute for Conservation, 1988.

American Association of Museums. "Policy Regarding the Repatriation of Native American Ceremonial Objects and Human Remains." *Aviso*, March 1988, pp. 4-5.

_____. *Code of Ethics for Museums*. Washington, D.C.: American Association of Museums, Washington, 1994.

American Association of Museums Curators Committee. "Code of Ethics for Curators." *Museum* News 61, no. 3 (1983): 38-40.

American Association of Museums Registrars Committee. "Code of Ethics for Registrars." *Museum News* 63, no. 2 (1985): 42-46.

_____. "Statement of practice for borrowing and lending." *Registrar* 8 no. 2 (1991): 3-10.

American Institute for Conservation. *Perspectives on Natural Disasters: Papers Presented at 1991 AIC Workshop*. Washington, D.C.: American Institute for Conservation of Historic and Artistic Works, 1991.

American Institute for Conservation Committee on Ethics and Standards. *Code of Ethics and Standards of Practice for Art Conservators*. Washington, D.C.: American Institute for Conservation of Historic and Artistic Works, 1985.

_____. *Code of Ethics and Guidelines for Practice*, draft. Washington, D.C.: American Institute for Conservation of Historic and Artistic Works, 1993.

American Ornithologists' Union. "Report of the Ad Hoc Committee on Scientific and Educational Use of Wild Birds." *Auk* 92, no. 3 (1975): 1A-27A.

American Society of Ichthyologists and Herpetologists, The Herpetologists' League and Society for the Study of Amphibians and Reptiles. *Guidelines for Use of Live Amphibians and Reptiles in Field Research*, 1987.

American Society of Mammalogists. "Revised minimal standards for systematic collections of mammals." *Journal of Mammalogy* 59, no. 4 (1974): 911-914.

American Society of Mammalogists Ad Hoc Committee on Acceptable Field Methods in Mammalogy. "Acceptable Field Methods in Mammalogy: Preliminary Guidelines Approved by the American Society of Mammalogists." *Journal of Mammalogy* 68, no. 4, suppl. (1987): 1-18.

Ames, P. "Guiding Museum Values: Trustees, Missions, and Plans." *Museum News* 63, no. 6 (1985): 48-54.

Appelbaum, B. *Guide to Environmental Protection of Collections*. Madison, Conn.: Sound View Press, Madison, 1991.

ASIS Standing Committee on Museum, Library and Archive Security. *Suggested Guidelines in Museum Security*. Arlington, Va.: American Society for Industrial Security, 1990.

Association of Art Museum Directors. *Professional Practices in Art Museums*. Savannah, Ga.: Association of Art Museum Directors, 1991.

Association of Systematics Collections. "ASC Position on Collections Use Agreements." *ASC Newsletter* 19, no. 1 (1991): 1-4.

_____. "Guidelines: The Ethics and Responsibilities of Museums with Respect to Acquisition and Disposition of Collection Materials. *ASC Newsletter* 19, no. 6 (1991): 77-79.

_____. "ASC Guidelines on Foreign Field Research and Collecting." *ASC Newsletter* 21, no. 3 (1993): 35-36.

Barsook, B. "A Code of Ethics for Museum Stores." *Museum News* 60, no. 3 (1982): 50-52.

Besterman, T. "Disposals from Museum Collections: Ethics and Practicalities." *Museum Management and Curatorship* 11, no. 1 (1992): 29-44.

Bohnert, A. S., and M. Surovic-Bohnert. "Destructive Analysis of Archaeological Collections: Between Scylla and Chrybdis." In *Natural History Museums: Directions for Growth*, edited by P. S. Cato and C. Jones. Lubbock, Tex.: Texas Tech University Press, 1991.

Boyd, W. L. "Museum Accountability: Laws, Rules, Ethics, and Accreditation. *Curator* 34, no. 3 (1991): 165-177.

Brunton, C. H. C., T. P. Besterman, and J. A. Cooper, eds. *Guidelines for the Curation of Geological Materials*. Miscellaneous Paper No. 17. London: Geological Society, 1985.

Buchanan, S. A. *Resource Materials for Disaster Planning in New York Institutions*. Albany, N.Y.: New York State Program for the Conservation and Preservation of Library Research Materials, 1988.

Cato, P. S. "Guidelines for Managing Bird Collections." *Museology*, Texas Tech University 7 (1986): 1-78.

_____. " Institution-Wide Policies for Sampling." *Collection Forum* 9, no. 1 (1993): 27-39.

_____. "Collection Management and Preservation." *ASC Newsletter* 18, no. 1 (1990): 12-13.

Cato, P. S., and S. L. Williams. "Guidelines for Developing Policies for the Management and Care of Natural History Collections." *Collection Forum* 9, no. 2 (1993): 84-107.

Center for Occupational Hazards. *Fire Prevention in the Conservation Laboratory*. New York: Center for Occupational Hazards, 1985.

_____. *A Health and Safety Program for Conservation Laboratories.* New York: Center for Occupational Hazards, 1985.

_____. *Emergency Plans for Museum Conservation Laboratories.* New York: Center for Occupational Hazards, 1986.

Deiss, W. A. *Museum Archives: An Introduction.* Chicago: Society of American Archivists. Chicago, 1984.

Dudley, D. H., and I. B. Wilkinson. *Museum Registration Methods.* 3d ed. Washington, D.C.: American Association of Museums, 1979.

Emery, A. R. "Museum Staff: Defining Expectations." *Museum Management and Curatorship* 9 no. 3 (1990): 265-272.

Fenn, J. "Danger in the Discovery Room. *Museum Quarterly: The Journal of the Ontario Museum Association* 16, no. 2 (1987): 8-11, 26.

Fitzgerald, G. R. "Documentation Guidelines for the Preparation and Conservation of Paleontological and Geological Specimens." *Collection Forum* 4, no. 2 (1988): 38-45.

Hoagland, E., ed. *Guidelines for Institutional Policies and Planning in Natural History Collections.* Washington, D.C.: Association of Systematics Collections, 1994.

Howie, F. *Safety in Museum and Galleries.* London: Butterworths, 1987.

_____. "Safety Considerations for the Geological Conservator." In *The Conservation of Geological Material,* edited by P. R. Crowther and C. J. Collins, pp. 379-401. *Geological Curator* 4, no. 7 (1987): 375-475.

Hutchins, J. K. *Conservation Surveys.* Virginia Association of Museums Technical Information, Winter/Spring (1987): 3-4.

Garrett, K. L. "Documentation Guidelines for the Preparation and Conservation of Biological Specimens." *Collection Forum* 5, no. 2: 47-51.

International Council of Museums. *Statutes and Code of Professional Ethics.* Paris: International Council of Museums, 1990.

International Institute for Conservation—Canadian Group and Canadian Association of Professional Conservators. *Code of Ethics and Guidance for Practice for Those Involved in the Conservation of Cultural Property in Canada,* 2d ed. Ottawa, Canada: International Institute for Conservation—Canadian Group and Canadian Association of Professional Conservators, 1989.

Jessup, W. C. "Pest Management." In *Storage of Natural History Collections: A Preventive Conservation Approach,* edited by C. L. Rose, C. A. Hawks, and H. H. Genoways. Iowa City: Society for the Preservation of Natural History Collections, 1995.

Jones, B. G. *Protecting Historic Architecture and Museum Collections from Natural Disaster.* London: Butterworths, 1986.

Kovach, C. "Strategic Management for Museums." *International Journal of Museum Management and Curatorship* 8, no. 2 (1989): 137-148.

Lee, W. L., B. M. Bell, and J. F. Sutton, eds. *Guidelines for Acquisition and Management of Biological Specimens.* Lawrence, Kans.: Association of Systematics Collections, 1982.

Lewis, G. "Attitudes to Disposal from Museum Collections." *Museum Management and Curatorship* 11, no. 1 (1992): 19-28.

Malaro, M. "Deaccessioning, the Importance of Procedure." *Museum News* 66, no. 4 (1988): 74-75.

_____. "How to Protect Yourself from Not-So-Permanent Loans." *Museum News* 68, no. 5 (1989): 22-25.

McGinley, R. J. "Entomological Collection Management—Are we really managing?" *ASC Newsletter* 18, no. 2 (1990): 30-31.

McHugh, A. "Strategic Planning for Museums." *Museum News* 58, no. 6 (1980): 23-29.

McKeown, T. "Study Materials (NAGPRA)." In *ALI-ABA Course of Study Materials, Legal Problems of Museum Administration*, March 24-26, 1993, pp. 387-412.

McLaren, S. B. "Guidelines for Usage of Computer-Based Collection Data." *Journal of Mammalogy* 69, no. 1 (1988): 217-218.

Merritt, E. "Conditions on Outgoing Research Loans." *Collection Forum* 8, no. 2 (1992): 78-82.

Messenger, P. M., ed. *The Ethics of Collecting Cultural Property: Whose Culture? Whose Property?* Albuquerque, N.Mex.: University of New Mexico Press, 1989.

Michalski, S. *A Systematic Approach to the Conservation (Care) of Museum Collections.* Ottawa: Canadian Conservation Institute, 1992.

Murray, T. Basic *Guidelines for Disaster Planning in Oklahoma.* Tulsa, Okla: University of Tulsa Preservation Office, 1990.

Museums & Galleries Commission. *Standards in the Museum Care of Archeological Collections.* London: Museums & Galleries Commission, 1992.

_____. *Standards in the Museum Care of Biological Collections.* London: Museums & Galleries Commission, 1992.

_____. *Standards in the Museum Care of Geological Collections*, draft. London: Museums & Galleries Commission, 1992.

National Institute for Conservation. *Emergency Preparedness and Response: Materials Developed from the NIC Seminar.* Washington, D.C.: National Institute for Conservation of Cultural Property, 1990.

National Fire Protection Association. NFPA 911. *Protection of Museums and Museum Collections*, 1991 ed. Quincy, Mass.: National Fire Protection Association, 1991.

National Park Service. *Museum Handbook. Part 1: Museum Collections.* Washington, D.C.: National Park Service, 1990.

Ogden, S., ed. *Preservation of Library and Archival Materials: A Manual.* Andover, Mass.: Northeast Documentation Center, 1992.

Pearce, S. *Archaeological Curatorship.* Washington, D.C.: Smithsonian Institution Press, 1990.

Peltz, P., and M. Rossol. *Safe Pest Control Procedures for Museum Collections.* New York: Center for Occupational Hazards, 1983.

Phelan, M. *Museums and the Law*. Nashville, Tenn.: American Association of State and Local History, 1982.

_____. *Museum Law: A Guide for Officers, Directors and Counsel*. Lake Forest, Ill.: Kalos Kapp Press, 1994.

Pinniger, D. *Insect Pests in Museums*. London: Institute of Archaeology Publications, 1989.

Porter, D. R. *Current Thought on Collections Policy: Producing the Essential Document for Administering Your Collections*. American Association of State and Local History, Technical Report 1 (1985): 1-12.

Ritzenthaler, M. L. *Archives & Manuscripts: Conservation*. Chicago: Society of American Archivists, 1983.

Rose, C. L. "Conservation of Natural History Collections: Addressing Preservation Concerns and Maintaining the Integrity of Research Specimens." In *Natural History Museums: Directions for Growth*, edited by P. S. Cato and C. Jones. Lubbock, Tex.: Texas Tech University Press, 1991.

Rose, C. L., and C. A. Hawks. "A Preventive Conservation Approach to the Storage of Collections." In *Storage of Natural History Collections: A Preventive Conservation Approach*, edited by C. L. Rose, C. A. Hawks, and H. H. Genoways. Iowa City: Society for the Preservation of Natural History Collections, 1995.

Rose, C. L., C. A. Hawks, and H. H. Genoways, eds. *Storage of Natural History Collections: A Preventive Conservation Approach*. Iowa City: Society for the Preservation of Natural History Collections, 1995.

Simmons, J. E. *Herpetological Collecting and Collections Management*. Society for the Study of Amphibians and Reptiles, 1987.

_____. "University of Kansas Working Paper on Collections Management Policy." *Association of Systematics Newsletter* 19, no. 2 (1991): 25-26.

Society for the Preservation of Natural History Collections. "Guidelines for the Care of Natural History Collections." *Collection Forum* 10, no. 1 (1994): 32-40.

Solley, T. T., J. Williams, and L. Baden. *Planning for Emergencies: A Guide for Museums*. Washington, D.C.: Association of Art Museum Directors, American Association of Museums, 1987.

Stolow, N. *Conservation and Exhibitions: Packing, Transport, Storage, and Environmental Considerations*. London: Butterworths, 1986.

Thomson, G. *The Museum Environment*. 2d ed. London: Butterworths,1986.

Waddington, J., and J. Fenn. "Health and Safety in Natural History Museums: An Annotated Reading List. In *Proceedings of the 1985 Workshop on Care and Maintenance of Natural History Collections*, edited by J. Waddington and D. M. Rudkin. Toronto: Royal Ontario Museum, Life Sciences Miscellaneous Publications, 1986.

Webster, L. "Altered States: Documenting Changes in Anthropology Museum Objects." *Curator* 33, no. 2 (1990): 130-160.

Weil, S. "Deaccession Practices in American Museums." *Museum News* 65, no. 3 (1987): 44-49.

_____. *A Deaccession Reader*. Washington, D.C.: American Association of Museums, 1997.

Williams, S. L., R. Laubach, and H. H. Genoways. *A Guide to the Management of Recent Mammal Collections*. Special Publication No. 4. Carnegie Museum of Natural History, 1977.

Wolf, S. J., ed. *The Conservation Assessment: A Tool for Planning, Implementing, and Fundraising.* Los Angeles: Getty Conservation Institute and the National Institute for the Conservation of Cultural Property, 1990.

Yang, M. "Manuals for Museum Policy and Procedures." *Curator* 32, no. 4 (1989): 269-274.

Zycherman, L. A., and J. R. Schrock, eds. "Recommended Institutional Policies." In *A Guide to Museum Pest Control.* Washington, D.C.: Association of Systematics Collections and American Institute for Conservation, 1988.

A R C H I V E S

Bowser, Eileen, and John Kuiper. *A Handbook for Film Archives.* New York: Garland Publishing, Inc., 1991.

Bressor, Julie P. *Caring for Historical Records.* Storrs, Conn.: University of Connecticut, 1990.

Ham, F. Gerald. *Selecting and Appraising Archives and Manuscripts.* Chicago: Society of American Archivists, 1993.

Miller, Frederic M. *Arranging and Describing Archives and Manuscripts.* Chicago: Society of American Archivists, 1990.

Pederson, Ann, ed. *Keeping Archives.* Sydney: Australian Society of Archivists, Inc., 1987.

Porter, Elsa. *The Archives of the Future: Archival Strategies for the Treatment of Electronic Databases.* A Report for the National Archives and Records Administration. Springfield, Va.: U.S. Department of Commerce, 1991.

Ritzenthaler, Mary Lynn. *Preserving Archives and Manuscripts.* Chicago: Society of American Archivists, 1993.

University of the State of New York, The State Education Department, and New York State Archives and Records Administration. *Guidelines for Arrangement and Description of Archives and Manuscripts.* Albany, N.Y.: The University of the State of New York, 1991.

Wilhelm, Henry. *The Permanence and Care of Color Photographs.* Grinnell, Iowa: Preservation Publishing, 1993.

Wilsted, Thomas, and William Nolte. *Managing Archival and Manuscript Repositories.* Chicago: Society of American Archivists, 1991.

Yakel, Elizabeth. *Starting An Archives.* Metuchen, N.J.: Society of American Archivists and Scarecrow Press, 1994.

R I S K M A N A G E M E N T

Allen, C. G. "Insurance: Risk Management Techniques: Choosing What Not to Insure." *Museum Management and Curatorship* 11, no. 3: 322-323.

Fennelly, L. J. Museum, *Archive, and Library Security.* Boston: Butterworths, 1983.

Gallery Association of New York State. *Insurance and Risk Management for Museums and Historical Societies*. Hamilton, N.Y.: Gallery Association of New York State in cooperation with The Division of Educational Services of The Metropolitan Museum of Art, 1985.

Phelan, M. E. *Museum Law: A Guide for Officers, Directors, and Counsel*. Evanston, Ill.: Kalos Kapp Press, 1994.

Waller, Robert R. "Risk Management Applied to Preventive Conservation." In *Storage of Natural History Collections: A Preventive Conservation Approach*, edited by C. L. Rose, C. A. Hawks, and H. H. Genoways. Iowa City: Society for the Preservation of Natural History Collections, 1995.

DISASTER MITIGATION PLANNING

Darling, Pamela W. *Preservation Planning Program: An Assisted Self-Study Manual for Libraries*. Washington, D.C.: Association of Research Libraries, 1993.

Emergency Preparedness and Response. Washington, D.C.: National Institute for the Conservation of Cultural Property, 1991.

Harris, Michael R. "Emergency Cart for Protecting Collections from Water Damage." In *Storage of Natural History Collections: Ideas and Practical Solutions*, edited by C. L. Rose and A. R. de Torres. Pittsburgh: Society for the Preservation of Natural History Collections, 1992.

Inland Marine Underwriters Association Arts & Records Committee. *Libraries & Archives: An Overview of Risk and Loss Prevention*. New York: Inland Marine Underwriters Association, 1993.

Jones, Barclay, ed. *Protecting Historic Architecture and Museum Collections from Natural Disasters*. Stoneham, Mass.: Butterworth Publishers, 1986.

Lord, Allyn, Carolyn Reno, and Marie Demeroukas. *Steal This Handbook! A Template for Creating a Museum's Emergency Preparedness Plan*. Columbia, S.C.: Southeastern Registrars Association, 1994.

Roberts, Barbara O. "Emergency Preparedness." In *Storage of Natural History Collections: A Preventive Conservation Approach*, edited by C. L. Rose, C. A. Hawks, and H. H. Genoways. Iowa City: Society for the Preservation of Natural History Collections, 1995.

SECURITY AND FIRE PROTECTION SYSTEMS

Advisory Council on Historic Preservation. *Fire Safety Retrofitting in Historic Buildings*. Washington, D.C.: Advisory Council on Historic Preservation and the General Services Administration, 1988.

American Association for Industrial Security Standing on Museum, Library and Archive Security. *Suggested Guidelines in Museum Security*. Arlington, Va.: American Association for Industrial Security, 1989.

American National Standards Institute (ANSI)/National Fire Protection Association (NFPA). *Protection of Museums and Museum Collections*. ANSI/NFPA 911. Quincy, Mass.: National Fire Protection Association, 1991.

Burke, R. B., and S. Adeloye. *A Manual of Basic Museum Security*. Washington, D.C.: International Committee on Museum Security and Leicestershire Museums, 1986.

Fennelly, L. J., ed. *Museum, Archive, and Library Security*. London: Butterworths, 1983.

Harris, M. R. "Emergency Cart for Protecting Collections from Water Damage." In *Storage of Natural History Collections: Ideas and Practical Solutions*, edited by C. L. Rose and A. R. de Torres. Pittsburgh: Society for the Preservation of Natural History Collections, 1992.

Keller, Steven R., and Darrell R. Willson. "Security Systems." In *Storage of Natural History Collections: A Preventive Conservation Approach*, edited by C. L. Rose, C. A. Hawks, and H. H. Genoways. Iowa City: Society for the Preservation of Natural History Collections, 1995.

Waller, Robert R. "Risk Management Applied to Preventive Conservation." In *Storage of Natural History Collections: A Preventive Conservation Approach*, edited by C. L. Rose, C. A. Hawks, and H. H. Genoways. Iowa City: Society for the Preservation of Natural History Collections, 1995.

Wilson, J. A. "Fire Fighters: An Automatic Fire Suppression System Is Among Your Museum's Best and Safest Forms of Insurance." *Museum News* 68, no. 6 (1989):68-72.

Wilson, J. Andrew. "Fire Protection." In *Storage of Natural History Collections: A Preventive Conservation Approach*, edited by C. L. Rose, C. A. Hawks, and H. H. Genoways. Iowa City: Society for the Preservation of Natural History Collections, 1995.

INTEGRATED PEST MANAGEMENT

Appelbaum, B. *Guide to Environmental Protection of Collections*. Madison, Conn.: Sound View Press, 1991.

Bennett, G. W., J. M. Owens, and R. M. Corrigan. *Truman's Scientific Guide to Pest Control Operations*. Duluth, Minn.: Edgell Communications, 1988.

Harmon, J. D. *Integrated Pest Management in Museum, Library and Archival Facilities*. Indianapolis: Harmon Preservation Pest Management, 1993.

Jessup, W. C. "Pest Management." In *Storage of Natural History Collections: A Preventive Conservation Approach*, edited by C. L. Rose, C. A. Hawks, and H. H. Genoways. Iowa City: Society for the Preservation of Natural History Collections, 1995.

Mallis, A. *Handbook of Pest Control*. Cleveland: Franzak & Foster Co., 1990.

McKenna & Cuneo and Technology Sciences Group, Inc. *Pesticide Regulation Handbook*. New York: McGraw-Hill, Inc., 1993.

Pinniger, D. *Insect Pests In Museums*. Clwyd, U.K.: Archetype Publications Ltd., 1990.

Williams, S. L., and S. McLaren. "Modification of Storage Design to Mitigate Insect Problems." *Collection Forum* 6, no. 1 (1990): 27-32.

Zycherman, L. A., and J. R. Schrock, eds. *A Guide to Museum Pest Control*. Washington, D.C.: Foundation of the American Institute for Conservation of Historic and Artistic Works and the Association of Systematics Collections, 1988.

ARCHITECTURAL PLANNING

Hilberry, J. D. "Architectural Design Considerations." In *Storage of Natural History Collections: A Preventive Conservation Approach*, edited by C. L. Rose, C. A. Hawks, and H. H. Genoways. Iowa City: Society for the Preservation of Natural History Collections, 1995.

_____. "The Building Design and Construction Process." In *Storage of Natural History Collections: A Preventive Conservation Approach*, edited by C. L. Rose, C. A. Hawks, and H. H. Genoways. Iowa City: Society for the Preservation of Natural History Collections, 1995.

Lord, G. D., and B. Lord. *The Manual of Museum Planning*. Manchester and London: Museum of Science and Industry and HMSO, 1991.

Sebor, A. J. "Heating, Ventilating, and Air-Conditioning Systems." In *Storage of Natural History Collections: A Preventive Conservation Approach*, edited by C. L. Rose, C. A. Hawks, and H. H. Genoways. Iowa City: Society for the Preservation of Natural History Collections, 1995.

Wilcox, U. V. "Facility Management." In *Storage of Natural History Collections: A Preventive Conservation Approach*, edited by C. L. Rose, C. A. Hawks, and H. H. Genoways. Iowa City: Society for the Preservation of Natural History Collections, 1995.

PROFESSIONAL ETHICS

Malaro, Marie C. *Museum Governance: Mission, Ethics, Policy*. Washington, D.C.: Smithsonian Institution Press, 1994.

OLD LOANS

Benas, Jeanne M. "The Practical Application of Resolving Old Incoming Loans: A Work in Progress." *ALI-ABA Course of Study, Legal Problems of Museum Administration* (1992): 311-313.

DeAngelis, Ildiko P. "'Old' Loans: Laches to the Rescue?" *ALI-ABA Course of Study, Legal Problems of Museum Administration* (1992): 301-310.

Gilmore, Jean A. "Old Loans: A Cautionary Tale." *MAAM Courier* 14, no. 5 (September/October 1994): 15-16.

Malaro, Marie C. *A Legal Primer on Managing Museum Collections*. Washington, D.C.: Smithsonian Institution Press, 1985.

_____. "Practical Steps Toward Resolving Ownership Questions. *ALI-ABA Course of Study, Legal Problems of Museum Administration* (1989): 580-588.

Tabah, Agnes. Old Loans: State Legislative Solutions. Unpublished research paper prepared for the George Washington University Museum Studies Program course on "Collections Management: Legal and Ethical Issues," December 4, 1991.

_____. "The Practicalities of Resolving 'Old' Loans: Guidelines for Museums." *ALI-ABA Course of Study, Legal Problems of Museum Administration* (1992): 315-344.

Teichman, Judith L. "Museum Collections Care Problems and California's 'Old Loans' Legislation." *Comment: Hastings Communications and Entertainment Law Journal* 12, no. 3 (spring 1990): 423-452.

———. "In Support of a Legislative Solution to the Problems of Objects of Uncertain Status in Museum Collections." *ALI-ABA Course of Study, Legal Problems of Museum Administration* (1983): 291-324.

———, et al. "Collection Objects of Uncertain Status: Indefinite Loans, Deposits, and Undocumented Objects—What Are the Museum's Alternatives?" *ALI-ABA Course of Study, Legal Problems of Museum Administration* (1983): 261-273.

Ward, Nicolas D. "Winning an Indefinite Loan Case." *ALI-ABA Course of Study, Legal Problems of Museum Administration* (1990): 34-58.

Wise, L. K. "Old Loans: A Collections Management Problem." *ALI-ABA Course of Study, Legal Problems of Museum Administration* (1990): 44.

APPRAISALS

International Council of Museums. "Code of Professional Ethics, 1968, Buenos Aires, Argentina." In *Museum Basics*, by Timothy Ambrose and Crispin Paine. London: Routledge & ICOM, 1933.

U.S. Department of the Treasury, Internal Revenue Service. "Determining the Value of Donated Property." Publication 561. Washington, D.C.: U.S. Department of the Treasury, 1987.

Revenue Canada, Customs, Excise & Taxation. "Gifts in Kind." Ottawa: 1993.

INTERNATIONAL MOVEMENT OF CULTURAL PROPERTY

Able, Edward H., Philip Speser, Jan Fontein, and Marie C. Malaro. "Materials Relevant to a Consideration of Proposed AAM Guidelines on the International Movement of Cultural Property." *ALI-ABA Course of Study, Legal Problems of Museum Administration* (1987): 253-294.

Armstrong, Frances A. "Bilateral Agreements under President's Authority in Foreign Affairs." *ALI-ABA Course of Study, Legal Problems of Museum Administration* (1984): 595-604.

Burnham, Bonnie. *The Protection of Cultural Property: Handbook of National Legislations.* Paris: International Council of Museums, 1974.

Coggins, Clemency. "Archaeology and the Art Market." *Science* 75, no. 4019: 263-266.

International Council of Museums. *Statutes: Code of Professional Ethics.* Paris: International Council of Museums, 1987.

Kouroupas, Maria Papageorge. "U.S. Efforts to Protect Cultural Property: Implementation of the 1970 UNESCO Convention." *African Arts,* Autumn 1995, pp. 32-37.

May, Karen. The 1995 UNIDROIT Convention on Stolen or Illegally Exported Cultural Objects. Unpublished, 1997.

Prott, Lyndel V., and Patrick J. O'Keefe. *Handbook of National Regulations Concerning the Export of Cultural Property.* Paris: UNESCO, 1988.

FISH AND WILDLIFE

American Law Institute-American Bar Association. *ALI-ABA Course of Studies Materials: Legal Problems of Museum Administration*. Philadelphia: American Law Institute-American Bar Association Committee on Continuing Professional Education, 1993.

American Zoo and Aquarium Association. *Manual to Federal Wildlife Regulations*. Vol. I: Protected Species. Bethesda, Md.: American Zoo and Aquarium Association, 1994.

Association of Systematics Collections. *ASC Newsletter*. Washington, D.C.: Association of Systematics Collections.

National Archives and Records Administration, Office of the Federal Register. *Code of Federal Regulations 50: Wildlife and Fisheries*. Washington, D.C.: U.S. Government Printing Office.

Estes, Carol, and Keith W. Sessions. *Controlled Wildlife, Volume II: Federally Protected Species*. Lawrence, Kans.: Association of Systematics Collections, 1983.

Henley, Ginette, ed. *International Wildlife Trade: A CITES Sourcebook*. Washington, D.C.: World Wildlife Fund, 1994.

King, Steven T., and John R. Schrock. *Controlled Wildlife, Volume III: State Wildlife Regulations*. Lawrence, Kans.: Association of Systematics Collections, 1985.

Littell, Richard. *Endangered and Other Protected Species: Federal Law and Regulation*. Washington, D.C: Bureau of National Affairs, Inc., 1992.

_____. *Controlled Wildlife, Volume I: Federal Permit Procedures*. 2d ed. Washington, D.C.: Association of Systematics Collections, 1993.

Malaro, M. C. *A Legal Primer on Managing Museum Collections*. Washington, D.C.: Smithsonian Institution Press, 1985.

National Marine Fisheries Service. *Marine Mammal Protection Act Bulletin*. Silver Spring, Md.: NMFS Office of Protected Species, September 1994.

Saito, Kim. "Animal Rights and Wrongs." *Museum News*, May/June 1993, pp. 72-74.

Smithsonian Institution Office of the Registrar. *A Primer to Endangered Species Law: Obtaining Federal Permits for Specimens Protected by Endangered Species Laws*. 3d ed. Washington, D.C.: Smithsonian Institution, 1993.

United States Fish & Wildlife Service. *Fact Sheet Series*. Arlington, Va.: U.S. Department of the Interior, USFWS.

United States Fish & Wildlife Service. *CITES: Appendices I, II, and III to the Convention on International Trade in Endangered Species of Wild Fauna and Flora*. Washington, D.C.: U.S. Government Printing Office.

United States Fish & Wildlife Service. *Endangered and Threatened Wildlife and Plant*. Washington, D.C.: U.S. Government Office.

United States Department of the Interior. *Endangered Species Technical Bulletin*. Washington, D.C.: U.S. Department of the Interior:

HAZARDS IN THE WORKPLACE

Indoor Air Quality

Burge, H. A., and M. Hodgson. "Health Risks of Indoor Pollutants." *ASHRAE Journal*, July 1989, pp. 34-38.

Repace, J. L. "Indoor Air Pollution." *Environment International* 8 (1982): 21-36.

Robb, N. "The Faces of Sick Building Syndrome." *Occupational Health and Safety Canada 9*, no. 2 (March/April 1993): 46-58.

Rossnagel, P. E. "Indoor Contaminants and How to Reduce Them." *Haztech International Conference Proceedings*, August 1987, pp. 302-316. Pudvan Publ. Co., Inc., 1987.

Sullivan, J. B., and G. R. Krieger. "Indoor Air Quality and Human Health." In *Hazardous Materials Toxicology, Clinical Principles of Environmental Health*. Baltimore: Williams and Wilkins, 1992.

Clerical Hazards

Borrell, J. "Is Your Computer Killing You?" *Macworld*, July 1990, pp. 23-26.

Brodeur, P. "The Magnetic-Field Menace." *Macworld*, July 1990, pp. 136-146.

Emissions from Video Display Terminals and their Measurement: A Training Manual. Hamilton, Ontario: Canadian Centre for Occupational Health and Safety, 1986.

McCann, M. "Air Purifiers: Cure or Bane?" *Art Hazards News* 6, no. 8 (October 1986): 1, 4.

National Institute For Occupational Safety and Health. *Proceedings of the Scientific Workshop on the Health Effects of Electric and Magnetic Fields*. Cincinnati: U.S. Department of Health and Human Services, 1991.

Rossol, M. Hazards of Laser Printers and Copiers. *Acts Facts Newsletter* 4, no. 10 (October 1990): 2-3.

———. "FTC to Bar Phoney Ads for Air Purifiers." *ACTS Facts Newsletter* 19, no. 5 (May 1996).

Collections Hazards

Ashton, J. "Radiation Hazards in Museum Aircraft." In *Saving the Twentieth Century: The Conservation of Modern Materials*, edited by D. Grattan. Ottawa: Canadian Conservation Institute, 1991.

Carman, M. R., and J. D. Carman. "Health Considerations of Radon Source Fossil Vertebrate Specimens." *Collections Forum* 5, no. 1 (spring 1989).

Douglass, M. "Do Your Artefacts Glow in the Dark?" *Museum News*, September/October 1992, pp. 64-66.

Fenn, J. "Hazards in the Collections: Parts 1 and 2." *Ontario Museum Quarterly* 17, nos.1 and 2 (February 1989 and May 1989): 27-32 and 28-32.

———. "An Unexpected Hazard in a Textile Storage Room." *Textile Conservation News*, no.18 (Spring 1990).

_____. "The Celluloid Timebomb: Using Sulphonephthalein Indicators to Evaluate Storage Strategies." In *From Marble to Chocolate: The Conservation of Modern Sculpture*, edited by Jackie Heuman. London: Archetype Publications, 1995.

Glenn, W. Mercury. *Occupational Health and Safety Canada* 4, no. 4 (July/August 1988): 18-21.

Lambert, M. "Ionising Radiation Associated with the Mineral Collection of the National Museum of Wales." *Collection Forum* 10, no. 2 (1994): 65-68.

Lomuscio, J. "Mercury Banned." *Practical Homeowner*, October 1990, pp. 31-2.

Rossol, M., and W. C. Jessup. "No Magic Bullets: Ethical Considerations for Pest Management Strategies." *Journal of Museum Management and Curatorship* 14, no. 1 (1996).

Strahan, D. "A Cautionary Note on the Presence of Silver Cyanide on Museum Objects." *Journal of the American Institute for Conservation* 23 (1983): 63-64.

United States Air Force Museum Program Handbook. Wright-Patterson Air Force Base, Ohio: United States Air Force Museum, 1988.

Williams, R. S. "The Diphenylamine Spot Test for Cellulose Nitrate." *Canadian Conservation Institute Notes* 17, no. 2 (1994).

Moulds and Biohazards

Flannigan, B., and J. D. Miller. "Health Implications of Fungi in Indoor Environments—An Overview." In *Air Quality Monographs*, Vol. 2, edited by R. A. Samson, et al. New York: Elsevier, 1994.

Glenn, W. "Getting Rid of Unwanted Guests." *Occupational Health and Safety, Canada*, November/December 1993, pp. 40-46.

Kolmodin-Hedman, B., et al. "Mould Exposure in Museum Personnel." *International Archives of Occupational and Environmental Health* 57 (1986): 321-323.

Morey, P. R., et al. "Environmental Studies in Moldy Office Buildings: Biological Agents, Sources and Preventative Measures." *Annals of the American Conference of Governmental Industrial Hygienists* 10 (1984): 21-35.

Pasanen, A., et al. "Stachybotrys Atra Corda May Produce Mycotoxins in Respirator Filters in Humid Environments." *Journal of the American Industrial Hygienists Association* 55 (January 1994): 62-65.

Rossol, M. "Mold Exposure Triggers $400 Million Suit Against Museum." *Acts Facts Newsletter* 8, no. 5 (May 1994): 1.

_____. "Biological Hazards." *Acts Facts Newsletter* 8, no. 5 (May 1994): 3.

"Significance of Fungi in Indoor Air: Report of a Working Group." *Canadian Journal of Public Health*, March/April 1987, pp. S1-S14.

GLOSSARY

Burcaw, G. Ellis. *Introduction to Museum Work*. Walnut Creek, Calif.: Altamira Press and American Association for State and Local History, 1997.

Case, M., ed. *Registrars on Record*. Washington, D.C.: American Association of Museums, 1988.

Daniels, Maygene, and Timothy Walch, eds. *A Modern Archives Readers*. Washington, D.C.: National Archives Trust Fund Board, August 1984.

Duckworth, W. D., H. H. Genoways, and C. L. Rose. *Preserving Natural Science Collections: Chronicle of our Environmental Heritage*. Washington, D.C.: National Institute for the Conservation of Cultural Property, 1993.

Gallery Association of New York State. *Insurance and Risk Management for Museums and Historical Societies*. Hamilton, N.Y.: Gallery Association of New York State, 1985.

Lord, G. D., and B. Lord, eds. *The Manual of Museum Planning*. London: HMSO, 1991.

National Park Service. *Museum Handbook: Part I, Museum Collections*. Washington, D.C: Department of the Interior, United States Government, 1990.

National Park Service. Natural Resources Management Guidelines, NPS-77. Washington, D.C.: Department of the Interior, United States Government.

Nauert, Patricia. Glossary in *Museum Registration Methods*, by Dorothy H. Dudley and Irma B. Wilkinson. Washington, D.C.: American Association of Museums, 1979.

Rose, C. L., and A. R. de Torres, eds. *Storage of Natural History Collections: Ideas and Practical Solutions*. Pittsburgh: Society for the Preservation of Natural History Collections, 1992.

Kimbell Museum of Art, Fort Worth, Tex. Photo by Elizabeth Gill Lui.

A

M

N

O

Q

R

X

Y

Z